Flash™ MX

Advanced ActionScript

**James L. Mohler, M.S.Ed.
and Nishant Kothary**

THOMSON

DELMAR LEARNING™

Australia Canada Mexico Singapore Spain United Kingdom United States

THOMSON
—★—
TM
DELMAR LEARNING

Flash™ MX: Advanced ActionScript
James L. Mohler, M.S.Ed., and Nishant Kothary

Business Unit Director:
Alar Elken

Executive Editor:
Sandy Clark

Acquisitions Editor
James Gish

Editorial Assistant:
Jaimie Wetzel

Executive Marketing Manager:
Maura Theriault

Channel Manager:
Mary Johnson

Marketing Coordinator:
Sarena Douglass

Executive Production Manager:
Mary Ellen Black

Production Editor:
Thomas Stover

Cover Image:
Nicole Reamer

Technology Project Manager:
David Porush

Editorial:
Carol Leyba and Daril Bentley

NOTICE TO THE READER

About the Authors

James L. Mohler is an associate professor in the Department of Computer Graphics Technology at Purdue University. He has authored, coauthored, or contributed to over 15 texts related to multimedia and hypermedia development, presented over 40 papers and workshops at national and international conferences, and written numerous articles for academic and trade publications. He has received several teaching awards at Purdue University and is a Fulbright Distinguished Chair in Multimedia. Mr. Mohler has served as webmaster for the School of Technology at Purdue University, lead developer for the Interactive Multimedia Development specialization within the department, webmaster for the Purdue University Virtual Visit web site, and executive editor of the *Journal of Interactive Instruction Development,* published by the Society for Advanced Learning Technologies.

James also enjoys serving as Praise and Worship Leader at Living Word Ministry Center in Frankfort, Indiana. He and his wife Lisa have three children: Meisha Danielle, Christian Alexander, and Treyton James. James can be contacted via e-mail at *jlmohler@tech.purdue.edu.*

Nishant Kothary is a multimedia developer and budding entrepreneur specializing in the field of web applications and emerging technologies. He teaches courses at Purdue University dealing with the fundamentals of scripting and tagging, as well as development in Flash MX. Nishant is currently completing a bachelor's with honors in Computer Graphics Technology at Purdue University, with a concentration in Interactive Multimedia Development.

Nishant graduates in the spring of 2003, whereupon he plans to pursue a master's degree in computer science. His current academic interests are object-oriented programming, application development in Flash, and designing Lego Mindstorms robots.

When he's not at his computer, Nishant enjoys playing jazz guitar, working out, arguing with his friends about politics, and reading just about anything.

Acknowledgments

First the authors would like to thank the wonderful team at Delmar who, once again, were willing to go out on a limb and take a leap forward as it relates to content concerning Macromedia Flash. To Jim Gish, Jaimie Wetzel, and Thomas Stover, thumbs up and thanks for the ride. It has been enjoyable. To Daril Bentley and Carol Leyba, the authors thank you for the wonderful editing and layout, making us look and sound better than we probably are.

The authors would also like to thank Steve Ragan from IBM for the incredible server-side script he threw together within a few days of a panicked phone call. The final chapter of the book would have been impossible to complete without Steve's contribution. Thanks also goes to Cheryl Balbach from Casio Instruments for loaning us the Cassiopeia E-200 for testing purposes concerning Chapter 12.

Last but certainly not least, the authors would like to thank their families, friends, and colleagues for putting up with all the authors sacrificed in way of meeting other demands during the writing of this manuscript.

———————————

To my students, past, present and future. It is you who keep me sharpening the saw.

—j. m.

This book is dedicated to my parents, whom I love with all my heart.

—n. k.

Contents

Introduction

Undoubtedly one of the fastest growing technologies in use on the Web is Flash. With it, developers are finding that almost anything can be created and delivered. Indeed, the basic, intermediate, and advanced applications possible with Flash are pretty impressive. Not a day goes by that someone does not send an e-mail referencing some new Flash web site.

The future for Flash—when one considers the range of wireless devices, wearable devices, and even implantable devices (within which file size and resolution independence are of the utmost importance)—appears to be never ending. As of this writing, the Flash Player has yet to be ported to an entire range of available wireless devices. No doubt by the time of publication, the Flash Player will be finding its way into further venues.

▪ ▪ ▪ Why Another Book on Flash?

After the release of *Flash MX: Graphics, Animation & Interactivity*, many people commented on the fact that it did a good job of teaching people the how and why of Flash development. Indeed, that was the goal. Thus, the examples in the first part of that volume focused on concepts and small tasks, based on methods used in the classroom. Rather than presenting extremely complex examples throughout—that is, examples that cover a lot of ground in a single swipe (you know, the ones that make you think "huh?")—that volume uses simpler examples in the early chapters.

For many, this approach provided exactly what they needed. Others commented that they would like more complex examples, but all in all, everyone came away from the book with a good understanding of the way Flash worked and the general processes associated with Flash development, as well as a toolbox full of tips and techniques.

The reason for this second volume is twofold. First, many who have e-mailed have asked why the Flash MX book did not cover some of the more advanced capabilities, such as the extrinsic programming objects, issues of utilizing XML, and integration. The simple answer is that to do

so would have made the book well over 1,000 pages! Yet the need exists, and this book attempts to fulfill that need.

A second reason for writing this volume, as with the first, is to create a highly useful book for both the classroom and non-classroom settings—a book that gets you doing as well as reading. No single book can cover everything, nor approach a subject in the same way. And this volume should not be considered the be-all, end-all as it relates to Flash MX. Indeed, it is in part an extension of the basic Flash MX book.

Additionally, it is ridiculous to believe that you can digest 5 to 10 examples or spend 24 hours, 48 hours, or even a couple of weeks and completely understand everything there is to know. It is just not possible. Like it or not, learning takes time—not just reading about something or dissecting examples but real driving time with the software on your own. As a past mentor of mine used to say, "There is no substitute for drive time in the application."

As with many of you, we have bought and read many of the new Flash books but find them lacking in their support of teaching advanced Flash development and in their coverage of advanced development and integration. There are books that provide examples, but they still often miss the needed "hows" and "whys" to make them good classroom books. There are those that have excellent sections, but none seems to fulfill the requirements of an advanced course. This book attempts to fulfill (at least partially) that need.

Audience

This book is designed for educators, students, and practitioners in the field who want to understand advanced web development with Flash. It is designed so that it can be used in an advanced Flash course, but it is in no way limited in its practicality to the classroom. As with the Flash MX basic book, this volume is not designed to be a quick reference (although you can probably use it to that extent in some ways) or a book with canned examples. It is designed so that you will learn advanced Flash development on your own and really understand what you are doing.

Philosophy and Approach

The approach and methodology of this book is the result of many years of schooling and teaching. The approach starts from the standpoint of using small, concrete examples and exercises to help you understand basic concepts in Flash. Then, based on those small things, you can build much larger, and more complicated, elements. That was the strategy in *Flash MX: Graphics, Animation & Interactivity*, and it is the strategy in this text.

Using This Book

There is a lot of ground to cover between Chapter 1 and Chapter 12, but the approach taken in this book allows you to move forward in manageable segments. We hope you find the book enlightening, enjoyable and, most of all, a good learning investment.

 NOTE: *As you are working along, feel free to e-mail us at jlmohler@tech.purdue.edu with problems, questions, and comments concerning the book. Your input is important, and we look forward to hearing from those who use the book.*

Version Specificity and Prerequisites

The files found on the companion CD-ROM are specific to Flash MX and are not backward compatible. If you have an older version of Flash, you will not be able to open the Flash files. However, there is a 30-day trial version of Flash located in the *Macromedia* folder on the companion CD-ROM. Feel free to install it to get up and running with the exercise files.

As to prerequisites, this book assumes that you have a working knowledge of Flash basics as well as the rudiments of ActionScript (even though Chapter 1 reviews the ActionScript basics). It is suggested that you have read, used, and understood *Flash MX: Graphics, Animation and Interactivity.* If you have the text, where remediation might be needed to support material explained in this book, the authors refer to that text.

Book Features and Conventions

The sections that follow discuss the major features of this book. This edition includes a tear-out quick-reference card that provides a macro-organizer for ActionScript. A companion web site also supports this book (see "About the Companion Web Site" at the end of this section).

 NOTE: *In addition to files in support of the text, the companion CD-ROM contains trial versions of Macromedia Flash, Swift3D, and Vecta3D. See the section "About the Companion CD-ROM," at the end of this introduction, and Appendix D for more information.*

Quick-reference Card

The tear-out quick-reference card at the back of the book contains a macro-organizer for ActionScript. It provides the core programming items

and then an object-by-object analysis. The goal of this card is to give you a quick reference sheet that you can keep handy as you code.

Glossary, Appendices, and Index

You will find at the back of the book a glossary of Flash-specific terms, as well as general terms related to the areas of functionality Flash incorporates. The glossary serves as a study in its own right. Four appendices offer information and associated topics. The last appendix explains what is on the companion CD-ROM and how to make use of it. A thorough index covers all text content, including entries that allow you to locate conceptual material. The sections that follow explain text conventions used in the book and the companion CD-ROM and the companion web site.

Text Conventions

Italic font in regular text is used to distinguish certain command names, code elements, file names, directory and path names, user input, and similar items. Italic is also used to highlight terms and for emphasis.

The following is an example of the monospaced font used for numbered code examples (i.e., command statements) and computer/operating system responses, as well as passages of programming script.

```
var myimage = InternetExplorer ? parent.¬
cell : parent.document.embeds[0];
```

As you will note in the code above, the line is too long to fit within the text area of the layout. Throughout the text, we will break lines that are two long and acknowledge this with a continuation character (¬). When you see this, realize that the line, and the one that follows it, would be a single line in the Actions panel.

The following are the design conventions used for various "working parts" of the text. In addition to these, you will find that the text incorporates many exercises, examples, and sidebars. All of these elements are easily distinguishable and accessible. Sidebar material highlights or supplements topics discussed in the text.

 NOTE: *Information on features and tasks that requires emphasis or that is not immediately obvious appears in notes.*

 TIP: *Tips on command usage, shortcuts, and other information aimed at saving you time and work appear like this.*

 WARNING: *The warnings appearing in this book are intended to help you avoid committing yourself to results you may not intend, and to avoid losing data or encountering other unfortunate consequences.*

 CD-ROM NOTE: *These notes point to files and directories on the companion CD-ROM that supplement the text via visual examples and further information on a particular topic.*

▪ ▪ ▪ About the Companion CD-ROM

The companion CD-ROM located at the back of the book is one of the most important things about this book. There are well over 25 example files you will be prompted to use throughout the book. You will find that the CD-ROM is PC and Macintosh compatible, and versions of the example files exist for both platforms, as do the trial versions of Macromedia Flash, Swift3D, and Vecta3D. For PC users, there is an additional trial software available called SwiSH.

 NOTE: *See also Appendix D, which provides a complete directory structure of the content of the companion CD-ROM.*

Because some operations in Macromedia Flash (particularly the Control | Test Movie command) require Flash to write to the drive of the computer, you may find it more helpful to copy the instructional example files to a local drive. If you are on a PC, an installation routine is available that allows you to install all files, or individual chapters, as you need them. If you are on a Macintosh, you will need to copy the chapter files manually by dragging and dropping them to a local drive.

If you choose not to copy the files to a local drive from the very start, to be able to use Control | Test Movie in Flash at some point you will have to save the files to a local drive. A Read Me file is located on the companion CD-ROM that details this information. On the PC side, the Read Me file details how to run and use the setup program.

▪ ▪ ▪ About the Companion Web Site

The companion web site for this book is located at the following address. You will find a variety of information there, including any errata items.

www.tech.purdue.edu/textbooks/fmxas/

1

ActionScript 101

▪▪▪ Introduction

ActionScript is the name of Flash's internal scripting capabilities. ActionScript is not a singular feature or command. Rather, it is a language integrated through actions, and thus the name ActionScript. In addition, it is built upon the object-oriented programming (OOP) paradigm and is modeled after the JavaScript Core Language, more specifically, the ECMA-262 scripting specification. Thus, if you have experience with JavaScript or even other OOP language experience, you will find that ActionScripting will come more easily.

This chapter quickly reviews ActionScript and related concepts. It does not delve into all of the basic aspects of the language, as it assumes you have read the text *Flash MX: Graphics, Animation & Interactivity* (OnWord Press). However, this chapter will provide a quick overview and review to the language basics presented in that book.

For those who purchased *Flash MX: Graphics, Animation & Interactivity*, you may question why this chapter is included in the advanced book. It is primarily to refresh your memory concerning the basics. It is recommended you understand the material presented in this chapter, because it is prerequisite to being able to understand the rest of this book. Latter chapters do not focus on the minutiae of the basics; rather, focus is placed on built-in programming objects.

▪▪▪ Objectives

In this chapter you will:

- Take a holistic look at the ActionScript language
- Review the basic programming terminology used in this book

- Examine the dual strategy for coding in Flash MX
- Have another look at the basic syntactical issues associated with coding ActionScript
- Revisit the basic commands, functions, and operators in ActionScript
- Canvas the general actions available in Flash MX

ActionScript: A Holistic View

Much of the scripting in Flash 5 revolved around a hybrid procedural-/event-driven approach, which was appropriate for the development and delivery of multimedia content. However, if you want to create something more than just multimedia content, say a web application in Flash 5, the hybrid approach quickly becomes self-defeating and inefficient.

Flash MX continues to support the hybrid approach as well as the object-oriented programming (OOP) approach that most developers used in Flash 5. The major difference between Flash 5 and Flash MX are the structures of their event and object models. Flash MX employs a new event model that facilitates a better implementation of OOP techniques. Whereas these techniques could be simulated in Flash 5, they are simply inherent parts of Flash MX.

As it relates to OOP, Flash 5 can do almost everything Flash MX can do. However, the ease and simplicity in implementing the same techniques has increased drastically with the introduction of the Flash MX event model. OOP was always a part of the Flash development environment. Flash MX simply marks a turning point for Flash development because of its integrated and highly publicized new features. This is much like the discovery of the Internet. The Internet existed before 1994, the year generally acknowledged as the year the Internet came into being. The fact is that it simply gained mass popularity and accessibility in 1994. The same will likely be true of Flash and its OOP features. MX will be known as the version that is OOP enabled.

Terminology

The following are ActionScript terms, as used in this book, with which you need to be familiar.

- *Classes* are templates used to create the objects in an application.
- *Objects* are a group of functions and properties that adhere to a class.

- *Instances* are individual objects created based on a class.

- *Methods* are the predefined routines that perform a specific task for a particular class or object (could be considered "action verbs" that describe the class or object).

- *Properties* are the characteristics or attributes of an object (could be considered "adjectives" that describe the object).

- *Functions* are sets of reusable code that typically receive a value, do something to that value, and return the result. There are typically two types: built-in and user-defined. Flash provides many built-in functions, most of which are designed to evaluate a type of data or to convert data from one type to another. User-defined functions can also be created using the *function* constructor.

- *Commands* are what can be considered "utility" code words that do something in the environment.

- *Event handlers* are the events to which an object can respond.

- *Arguments*, sometimes called *parameters*, are optional bits of information you send to methods and functions. Usually, a method or a function will use the data sent to it in some way, and may return a value.

- A *variable* is a container for data and is defined by a scope (length of existence) and a data type [such as string (text) or numeral]. *Global variables* are variables that are active and accessible during the entire movie and are defined using the *_global* keyword. *Local variables* are temporary variables used within the context of user-defined functions, and they are defined using the *var* keyword. All other variables (any that are defined without the *var* or *_global* keywords) are called *timeline variables* and exist as long as the timeline they belong to is loaded into the player.

- A *string* is any data element that consists of text, whereas a *numeral* is an actual number on which mathematical operations may be executed.

- *Operators* are programming elements that perform calculations (operations), comparisons, or assignments.

- An *expression* is a combination of code statements that may include variables, functions, methods, properties, and operators. Usually, expressions must be evaluated.

- An *array* is a special type of variable that can store multiple values. Chapter 3 deals exclusively with arrays.

Built-in Objects: Environment Versus Programming

Flash incorporates two generic types of built-in objects. For the sake of a holistic view and understanding of ActionScript, this text classifies these groups as "environment objects" and "programming objects."

The primary environment object in Flash is the movie, but this group also includes movie clips and buttons. Given these objects, you should guess that there are methods and properties associated with them, and indeed there are. Methods such as *gotoAndPlay();, getURL();,* and *loadMovie();* (to name a few, which Macromedia identifies as Actions in the Actions panel) deal with the main movie timeline, as do properties such as *currentframe, x,* and *y.* The first column in table 1-1 lists methods designed to work with movie, movie clip, and button objects. Properties associated with these are listed in the second column.

As shown in table 1-1, you will note that ActionScript provides several other conventional core programming items, including functions, constants, command statements, and operators. These are discussed in greater detail later in this chapter.

In addition to the environment objects, Flash provides special "programming" objects that give extended functionality, in one way or another, as you use ActionScript coding. This book focuses on the use of many of these objects.

The programming objects are predominantly designed to facilitate working with data in one form or another (as well as the range of ActionScript functionality) by extending the developer's control within the environment. Tables 1-2 and 1-3 outline the programming objects available in Flash, including their methods, properties, event handlers, and listeners.

... **Coding Strategies**

The Flash environment has three primary objects that can react to events: the frame, the button, and the movie clip. In other words, these are entities that can be associated with methods, functions, and event handlers. These objects can respond to two primary events: events related to user interaction (mouse or keyboard) and events associated with the occurrence of frames in the timeline.

ActionScript is typically written in Flash in two ways, depending on whether you want the code to execute when the movie reaches a certain frame (a frame action) or when the user does something to a button or movie clip (an instance action). The text *Flash MX: Graphics, Animation*

Table 1-1: Core ActionScript Methods, Properties, Functions, Command Statements, and Operators

Actions (Methods)

Movie Control
- gotoAndPlay()
- gotoAndStop()
- nextFrame()
- nextScene()
- on()
- play()
- prevFrame()
- prevScene()
- stop()
- stopAllSounds()

Browser/Network
- fscommand()
- getURL()
- loadMovie()
- loadMovieNum()
- loadVariables()
- loadVariablesNum()
- unloadMovie()
- unloadMovieNum()

Movie Clip Control
- duplicateMovieClip()
- onClipEvent()
- removeMovieClip()
- setProperty()
- startDrag()
- stopDrag()
- updateAfterEvent()

Printing
- print()
- printAsBitmap()
- printAsBitmapNum()
- printNum()

Properties

Global
- _focusrect
- _quality
- _soundbuftime

Object-specific
- _alpha
- _currentframe*
- _droptarget*
- _framesloaded*
- _height
- _name
- _rotation
- _target*
- _totalframes*
- _url*
- _visible
- _width
- _x
- _xmouse*
- _xscale
- _y
- _ymouse*
- _yscale

Prefixes
- _global
- _levelX
- _parent
- _root
- this

Property cannot be set

Functions

Global
- escape()
- eval()
- getProperty()
- getTimer()
- getVersion()
- targetPath()
- unescape()

Conversion
- Array()
- Boolean()
- Number()
- Object()
- String()

Mathematical
- isFinite()
- isNaN()
- parseFloat()
- parseInt()

Constants
- false
- newline
- null
- true
- undefined

Command Statements

Variables
- delete
- set variable
- var
- with()

Conditions/Loops
- break
- continue
- do.. while
- if.. else if... else
- for
- for.... in
- switch... case... default
- while

User-defined Functions
- call()
- call function()
- function()
- method
- return

Miscellaneous Actions
- #endinitclip
- #include
- #initclip
- clearinterval()
- comment
- setinterval()
- trace()

Operators

Global

Operator	Meaning
" "	String delimiter
()	Parenthesis
.	Dot access
{}	Curly brackets
[]	Array access

Arithmetic

Operator	Meaning
+	Addition
*	Multiplication
/	Division
%	Modulo
-	Subtraction

Assignment

Operator	Meaning
-=	Subtraction and assignment
%=	Modulo and assignment
&=	Bitwise And and assignment
*=	Multiplication and assignment
/=	Division and assignment
^=	Bitwise Xor and assignment
+=	Addition and assignment
<<=	Bitwise shift left and assignment
=	Assignment
>>=	Bitwise shift right and assignment
>>>=	Shift right zero fill and assignment

Bitwise

Operator	Meaning	
&	Bitwise And	
~	Bitwise one's complement	
		Bitwise Or
^	Bitwise Xor	
<<	Shift left by a number of bits	
>>	Shift right by a number of bits	
>>>	Shifts right by a number of bits (unsigned)	

Comparison

Operator	Meaning
!=	Inequality
!==	Strict inequality
<	Less than
<=	Less than or equal
==	Equality
===	Strict equality
>	Greater than
>=	Greater than or equal

Logical

Operator	Meaning		
&&	Logical AND		
			Logical OR
!	NOT		

Miscellaneous

Operator	Meaning
--	Decrement
?:	Conditional
++	Increment
instanceof	
typeof	
void	

String Escape Characters

Escape	Meaning
\b	Backspace
\f	Form-feed
\n	Line-feed
\r	Carriage return
\t	Tab
\"	Double quotation
\'	Single quotation
\\	Backslash
\000-\377	An octal byte
\x00-\xF	A hexadecimal byte
\u0000-\uFFFF	A 16-bit Unicode char in hexadecimal

Table 1-2: ActionScript Programming Object Reference, Part 1

Core Grouping

Global Properties
_global
super
this

Arguments

Properties
callee
caller
length

Array

Methods	Properties
.concat()	length
.join()	
.pop()	
.push()	
.reverse()	
.shift()	
.slice()	
.sort()	
.sortOn()	
.splice()	
.toString()	
.unshift()	

Boolean

Methods
.toString()
.valueOf()

Date

Methods
.getDate()
.getDay()
.getFullYear()
.getHours()
.getMilliseconds()
.getMinutes()

Date cont'd

Methods	Properties
.getMonth()	
.getSeconds()	
.getTime()	
.getTimezoneOffset()	
.getUTCDate()	
.getUTCDay()	
.getUTCFullYear()	
.getUTCHours()	
.getUTCMilliseconds()	
.getUTCMinutes()	
.getUTCMonth()	
.getUTCSeconds()	
.getYear()	
.setDate()	
.setFullYear()	
.setHours()	
.setMilliseconds()	
.setMinutes()	
.setMonth()	
.setSeconds()	
.setTime()	
.setUTCDate()	
.setUTCFullYear()	
.setUTCHours()	
.setUTCMilliseconds()	
.setUTCMinutes()	
.setUTCMonth()	
.setUTCSeconds()	
.setYear()	
.toString()	
.UTC()	

Function

Methods	Properties
.apply()	prototype
.call()	

Math

Methods	Constants
.abs()	E
.acos()	LN2
.asin()	LN10
.atan()	LOG2E
.atan2()	LOG10E
.ceil()	PI
.cos()	SQRT1_2
.exp()	SQRT_2
.floor()	
.log()	
.max()	
.min()	
.pow()	
.random()	
.round()	
.sin()	
.sqrt()	
.tan()	

Number

Methods	Constants
.toString()	MAX_VALUE
.valueOf()	MIN_VALUE
	NaN
	NEGATIVE_INFINITY
	POSITIVE_INFINITY

Object

Methods	Properties
.addProperty()	__proto__
.registerClass()	
.toString()	
.unwatch()	
.valueOf()	
.watch()	

String

Methods	Properties
.charAt()	length
.charCodeAt()	
.concat()	
.fromCharCode()	
.indexOf()	
.lastIndexOf()	
.slice()	
.split()	
.substr()	
.substring()	
.toLowerCase()	
.toUpperCase()	

Authoring Grouping

CustomActions

Methods
.get()
.install()
.list()
.uninstall()

Live Preview

Methods
.onUpdate()

Client/Server Grouping

XMLSocket

Methods	Events
.close()	onClose
.connect()	onConnect
.send()	onData
	onXML

Client/Server Grouping cont'd

LoadVars

Methods	Properties	Events
.getBytesLoaded()	contentType	onData
.getBytesTotal()	loaded	onLoad
.load()		
.send()		
.sendAndLoad()		
.toString()		

XML

Methods	Properties	Events
.appendChild()	attributes	onData
.cloneNode()	childNodes	onLoad
.createElement()	contentType	
.createTextNode()	docTypeDecl	
.getBytesLoaded()	firstChild	
.getBytesTotal()	ignoreWhite	
.hasChildNodes()	lastChild	
.insertBefore()	loaded	
.load()	nextSibling	
.parseXML()	nodeName	
.removeNode()	nodeType	
.send()	nodeValue	
.sendAndLoad()	parentNode	
.toString()	previousSibling	
	status	
	xmlDecl	

Table 1-3: ActionScript Programming Object Reference, Part 2

Movie Grouping

Global Properties
- _level
- _parent
- _root

Accessibility
Methods:
- .isActive()

Capabilities
Properties:
- hasAccessibility
- hasAudio
- hasAudioEncoder
- hasMP3
- hasVideoEncoder
- pixelAspectRatio
- screenColor
- screenDPI
- screenResolutionX
- screenResolutionY

Color
Methods:
- .getRGB()
- .getTransform()
- .setRGB()
- .setTransform()

Movie Clip
Methods:
- .attachMovie()
- .createEmptyMovieClip()
- .createTextField()
- .duplicateMovieClip()
- .getBounds()
- .getBytesLoaded()
- .getBytesTotal()
- .getDepth()
- .getURL()
- .globalToLocal()
- .gotoAndPlay()
- .gotoAndStop()
- .hitTest()
- .loadMovie()
- .loadVariables()
- .localToGlobal()
- .nextFrame()
- .play()
- .prevFrame()
- .removeMovieClip()
- .setMask()
- .startDrag()
- .stop()
- .stopDrag()
- .swapDepths()
- .unloadMovie()

System
Properties:
- capabilities

Video
Methods:
- .clear()

Key

Key
Methods:
- .addListener()
- .getAscii()
- .getCode()
- .isDown()
- .isToggled()
- .removeListener()

Constants:
- BACKSPACE
- CAPSLOCK
- CONTROL
- DELETEKEY
- DOWN
- END
- ENTER
- ESCAPE
- HOME
- INSERT
- LEFT
- PGDN
- PGUP
- RIGHT
- SHIFT
- SPACE
- TAB
- UP

Listeners:
- onKeyDown
- onKeyUp

Button
Methods:
- .getDepth()

Properties:
- _alpha
- enabled
- _focusrect
- _height
- _highquality
- _name
- _parent
- _quality
- _rotation
- _soundbuftime
- tabEnabled
- tabIndex
- target
- trackAsMenu
- _url
- useHandCursor
- _visible
- _width
- _x
- _xmouse
- _xscale
- _y
- _ymouse
- _yscale

Events:
- onDragOut
- onDragOver
- onKillFocus
- onPress
- onRelease
- onReleaseOutside
- onRollOut
- onRollOver
- onSetFocus

Movie Clip
Properties:
- _alpha
- _currentframe
- _droptarget
- enabled
- focusEnabled
- _focusrect
- _framesloaded
- _height
- _highquality
- hitArea
- _name
- _parent
- _rotation
- _soundbuftime
- tabChildren
- tabEnabled

Movie Clip cont'd

Properties:
- tabIndex
- target
- _totalframes
- trackAsMenu
- _url
- useHandCursor
- _visible
- _width
- _x
- _xmouse
- _xscale
- _y
- _ymouse
- _yscale

Events:
- onData
- onDragOut
- onDragOver
- onEnterFrame
- onKeyDown
- onKeyUp
- onKillFocus
- onLoad
- onMouseDown
- onMouseUp
- onPress
- onReleaseOutside
- onRollOut
- onRollOver
- onSetFocus
- onUnload

Drawing Methods:
- .beginFill()
- .beginGradientFill()
- .clear()
- .curveTo()
- .endFill()
- .lineStyle()
- .lineTo()
- .moveTo()

Selection
Methods:
- .addListener()
- .getBeginIndex()
- .getCaretIndex()
- .getEndIndex()
- .getFocus()
- .removeListener()
- .setFocus()
- .setSelection()

Listeners:
- onSetFocus

Mouse
Methods:
- .addListener()
- .hide()
- .removeListener()
- .show()

Listeners:
- onMouseDown
- onMouseMove
- onMouseUp

Sound

Methods:
- .attachSound()
- .getBytesLoaded()
- .getBytesTotal()
- .getPan()
- .getTransform()
- .getVolume()
- .loadSound()
- .setPan()
- .setTransform()
- .setVolume()
- .start()
- .stop()

Properties:
- duration
- position

Events:
- onLoad
- onSoundComplete

Stage

Methods:
- .addListener()
- .removeListener()

Properties:
- align
- height
- scaleMode
- showMenu
- width

Events:
- onResize

Text Format

Methods:
- .getTextExtent()

Properties:
- align
- blockIndent
- bold
- bullet
- color
- font
- indent
- italic
- leading
- leftMargin
- rightMargin
- size
- tabStops
- target
- underline
- url

Text Field

Methods:
- .addListener()
- .getDepth()
- .getFontList()
- .getNewTextFormat()
- .getTextFormat()
- .removeListener()
- .removeTextField()
- .replaceSel()
- .setNewTextFormat()
- .setTextFormat()

Properties:
- autoSize
- background
- backgroundColor
- border
- borderColor
- bottomScroll
- embedFonts
- hscroll
- html
- htmlText
- length
- maxChars
- maxhscroll
- maxscroll
- multiline
- password
- restrict
- scroll
- selectable
- tabEnabled
- tabIndex
- text
- textColor
- textHeight
- textWidth
- type
- variable
- wordWrap

Listeners:
- onChanged
- onKillFocus
- onScroller
- onSetFocus

& *Interactivity* approached ActionScript from the older paradigm (attaching scripts directly to objects), primarily because it is still a valid approach for basic creations and is much easier for the beginner to deal with.

When developing basic multimedia content, most people simply use this approach (which evolved with Flash 5). Using this approach, if a button is to do something specific, code is attached directly to the button. If something is to happen at a particular point in time in the movie, code is attached to a frame.

However, in Flash MX, the strategy for ActionScript coding can now be done in one of two ways. Indeed, you can use the older method of attaching scripts to objects (buttons or movie clips), or to frames when and where the code is needed. This is quite useful and quick to do for multimedia content, such as interactive animations, basic web site navigation, and the like. For basic creations, the traditional approach is usually best and is much faster to code. Yet, if you want to do more advanced things, such as creating complex applications, the traditional approach can become quite involved, and finding and editing scripts is more difficult. The traditional approach also involves the additional overhead of waste of memory, inconsistent coding, and inefficient solutions.

▪ ▫ ▪ **The New Approach**

Although the next chapter delves into object-oriented programming and how to write ActionScript such that it uses that logic, note two very important things related to this approach at this point. First, the new coding approach in Flash encourages the writing of all scripts in frames, rather than attaching such code to buttons or movie clips. This has to do with a change to the Flash event model more than anything else (see Appendix A, on the event model). You can now write code for a button or movie clip in a frame, rather than having to attach that code directly to a button or movie clip. In essence, frames, buttons, and movie clips can handle events for (and associated with) other objects.

NOTE: *In many cases, which coding strategy you choose is not a right and wrong issue. Often it is more of a preference issue.*

Recall that when you designate code to a frame, a lowercase letter *a* will appear in the nearest left-hand keyframe. As opposed to the lowercase letter *a* that appears in a frame when code is assigned to it, there is no visual indicator that tells you that a symbol instance has an action. To find out whether or not an instance has an action, click on it and view the Actions panel.

As you will learn, code in a frame may be executed as the result of user interaction with a button or movie clip, too. In short, by attaching all

code to frames, rather than to objects, you can easily see where your code is (rather than having to search for the button or movie clip to which the code is attached). This localized approach is strongly encouraged (where it is logical to do so) for advanced creations in Flash MX.

The second thing to note about the new approach is that keyframes in a movie (or sets of looping frames that return to a keyframe) can and should be used as application states. Global functions and code you want to be able to access throughout a movie should be defined in a layer that spans the entirety of the movie, whereas state-specific functions and code should be in a second layer for coding that has keyframes at specific application states. As you work through the chapters in this book, you will see application of this.

▪ ▪ ▪ ActionScript Syntax Issues

When dealing with any language, whether it is a spoken language or a programming language, there are rules you must follow for communication. There are two types of errors in programming: logical and syntactical. Logical errors are resolved or overcome through knowledge of programming constructs and methodically thinking through a problem. Syntactical errors are overcome by carefully paying attention to the rules regarding the language and vehemently adhering to them. When dealing with Flash, there are four things you need to pay attention to in regard to syntax.

- Structural details such as brackets, semicolons, and parentheses
- Case sensitivity issues
- Comments and what they are for
- Dot syntax

The sections that follow examine each of these points in more detail. In regard to syntax errors, it cannot be stressed enough that failing to follow one of the foregoing items is the most frequent cause of errors in scripts. You cannot depend on Flash to catch all of these problems. The help Flash offers regarding error codes placed in the Output window will often point you in the right direction and tell you the line the error occurs on, but seldom provides the exact solution to the error. This is where knowing the syntax issues and being able to quickly see them in code is important.

Brackets, Semicolons, and Simplification

One of the first things you probably noticed earlier is that curly brackets ({}) are used in ActionScript coding. There is really nothing mysterious about these characters, and indeed JavaScript, Java, and many other lan-

guages use them. Much like the logic of HTML angle brackets (< >), which enclose tag keywords, curly brackets are used to denote logical blocks of code that function as a single unit. In this regard, and like the JavaScript standard ActionScript mimics, curly brackets are always used in matched pairs in coding. Most often, curly brackets are used to define function definitions (i.e., code subroutines and/or handlers you write) and control structures (such as *if* statements).

As you write ActionScript or JavaScript, the location of curly brackets in code is not that important, as long as they enclose (delimit) lines of code that should function together. For example, the three items in code example 1-1 would all be valid and interpreted by Flash the same way. The physical location of curly brackets is not imperative, as long as a pair encloses logical code groupings.

 NOTE: *The two slashes (///) in code example 1-1 are used to denote comments, discussed later in this section.*

Code Example 1-1: Use of Curly Brackets

```
//Item 1
with (_parent.myclip) {
     gotoAndPlay (1);
     stopAllSounds();
}
//Item 2
with (_parent.myclip)
{
     gotoAndPlay (1);
stopAllSounds();
}
//Item 3
with (_parent.myclip) { gotoAndPlay (1);
stopAllSounds();}
```

 NOTE: with() *is a command used to direct ActionScript methods to a specific object. The previous code tells a movie clip named* myclip *to go to frame 1 and play, and then to stop all currently playing sounds.* with() *is discussed later in this chapter.*

The main thing to keep in mind when writing ActionScript is that curly brackets must be in matched pairs. When you are working in Expert mode, it is not uncommon to forget one, particularly when you start interjecting *if*, *with*, or similar statements. Even though you can write scripts such as any of the three shown in code example 1-1, it is recommended

you develop the style represented by item 1, because it is a de facto standard (at least as far as the JavaScript community is concerned). It also makes it easier to go back and forth between Expert mode and Normal mode in the Actions panel.

Another syntax issue you must deal with in Flash is the use of the semicolon (;). Semicolons are not important if you are dealing with the first two methods of writing scripts shown in code example 1-1 (items 1 and 2). Although code example 1-1 shows semicolons following the *gotoAndPlay (1);* methods, you could omit these. However, if you are using the style of notation shown in item 3 in the previous code, semicolons are important because they identify where one statement ends and another begins, as shown in the following.

```
with (_parent.myclip) { gotoAndPlay (1); stopAllSounds();}
```

The issue of semicolons and their appearance in Flash and JavaScript is a carryover from Java, in which semicolons are required to separate commands and a variety of other things. The only scenario in Flash or JavaScript for which semicolons are imperative is when you are writing multiple commands in a single line. Unless you are writing ActionScript in a single-line field in Normal mode, you probably will not have to deal with this.

A final note concerns simplification of code. Much like working with algebra in mathematics, there are many ways to simplify the code you write. For example, the items listed in the previous examples could be written as follows.

```
_parent.myclip.gotoAndPlay(1);
```

Dot syntax makes it relatively easy to shorten code through simplification.

Case Sensitivity

A common programming question has to do with case sensitivity. It is always a good idea to be consistent in your capitalization of items, regardless of the rules of a particular language. Most, if not all, ActionScript code words are case sensitive. Properties are the only items that are not case sensitive. Thus, only the items in the Properties column in table 1-1 are not case sensitive. All other code words found in the table are case sensitive.

 NOTE: *Macromedia has provided a standard practices document on its web site concerning ActionScript coding for application development. This is accessible at www.macromedia.com/des-dev/mx/flash. Although much of it is related to advanced coding using the OOP approach, there are some very good recommendations concerning naming conventions and case sensitivity issues.*

Comments

A common practice in programming is to include internal documentation in code. Comments allow you to leave notes for yourself or others in your code so that you can remember what something does, or anything else concerning the code you might later forget. Comments entered into code are ignored by the Flash Player and do not appear when the user views your movie.

In Flash, single-line comments are identified by double slashes that precede them. Code example 1-1 used comments to identify the sections of code that were highlighted as single-line comments. If you need to include multi-line comments, you use a special set of characters. A slash followed by an asterisk (/*) begins the comment, whereas an asterisk followed by a slash (*/) ends the comment. Code example 1-2 shows an example of a multi-line comment format containing these conventions.

Code Example 1-2: Multi-line Comment Format

```
/* This is an example of a multi-line comment.
All of the items written here are ignored by the
player. */
with (_parent.myclip) {
     gotoAndPlay (1);
     stopAllSounds();
}
```

If you are developing Flash applications, you should use comments freely. It is common for application developers to use comments for a variety of tasks, particularly when there are many developers working on a single project. It is recommended that you use comments to identify code that:

- Is incomplete or needs modification
- Generates a known error or bug
- May not follow standard conventions adopted by the organization or development group
- May be particularly difficult, complex, or involved
- May be particularly finicky to resolve

An important aspect of using comments effectively is to make sure you adopt a consistent manner of notation. For example, you might precede a comment concerning a known bug or error with /*KNOWN_BUG, or a particularly tricky section of code with /*TRICKY. The particular

terms you choose are up to you, but you should adopt something logical, and be consistent throughout the application.

Dealing with Dot Syntax and Targets

One of the most crucial concepts in Flash is knowing how to specifically target and talk to objects. By targeting objects such as buttons or movie clips, you can control them. For example, you could tell a movie clip to play, stop, or a number of other things. Similarly, by talking to programming objects, you can evoke their methods or access their properties. A target is simply a straightforward way of specifying the location of an object in the movie hierarchy and what you want to do to or with that object. You define a target in dot syntax.

Many of the general actions in Flash do not require the use of targets. For example, the *getURL()*, *play()*, and *loadMovie()* methods (and others) do not require a target, as they are automatically directed to the main movie timeline (and executed using it as the assumed object). Thus, when you want to execute one of the general methods (Macromedia calls them actions; see table 1-1) using the new manner of coding, you simply associate the action with an event handler in a frame, as in the following.

```
mybutton.onPress = function () {
     getURL("http://www.purdue.edu/");
};
```

This code is written such that when the button named *mybutton* is pressed, the method function associated with it is called. If you are used to the older method of coding (in which the code is attached directly to the button object), it would look like the code that follows. Compare the two so that you can see the primary difference in coding styles in this simple example. For now, do not be too concerned with understanding it all. Chapter 2 explores this in detail. Simply note that there is a difference.

```
On (press) {
     getURL("http://www.purdue.edu/");
};
```

 NOTE: *The terms* method function *and* event method *may be used interchangeably. Both describe the new approach to coding events.*

 TIP: *One of the things you will find interesting about Flash MX is that you can combine the new and old approaches. That is, there can be code in a frame and attached to an object (movie clip or button), both of which execute following a given event. This provides some tremendous flexibility, as you will see in later chapters.*

Accessing Methods and Properties

To access a method or property that belongs to a programming object, you use dot syntax to target or call upon the item. For example, one of the programming objects in Flash is the Math object, which allows you to perform a variety of tasks. One such task is the generation of random numbers. For this purpose, the Math object has a method called *random()*.

In dot syntax, to access the *random()* method of the Math object you use *Math.random();*. In general, to access any object method, you use the following form.

```
object.method();
```

Often methods will need to receive some data to be able to execute. The data sent to a method is called a parameter or argument and is typically included within the parentheses of the method. If a method needs more than one argument for execution, a comma separates each method.

You can create compound statements with methods quite easily. For example, to generate a random number between 1 and 25, you would use the following.

```
Math.floor(Math.random() * 25) + 1;
```

 NOTE: *The general form to generate a random number between 0 and some maximum number is* Math.floor(Math.random() * n), *where* n *is the maximum number generated. To generate a random number between any two numbers, use* Math.floor(Math.random()* n) + m, *where* n *is the top number of the range and* m *is the lowest possible value.*

Math.random() generates a random number between 0.0 and 1.0. Thus, to capture a whole number portion when multiplying by some maximum number, you insert the *Math.random()* method inside the *Math.floor()* method.

You use similar syntax to access properties of programming objects. For example, one of the new objects in Flash MX is the Stage object. You could retrieve the current width of the stage using *Stage.width;*. Thus, for most programming objects, the general form for accessing a property is

```
object.property();
```

 NOTE: *Some programming objects require instantiation before you can use them. For example, the Color object requires you use* new Color(); *before you can "talk to" the object. Once the object is instantiated, however, calling a method or property is done as described previously. Throughout this book, instantiation required for any object is noted.*

Controlling Movie Clips and Buttons

One of the interesting things about Flash is the level of control you actually have in the environment. In addition to being able to work with programming objects and their methods and properties, you can control movie clips and buttons, as well as other movies (which you will learn about later). Let's deal with the former of these, movie clips and buttons.

When you add instances of movie clips or buttons to the stage, you can easily control them with ActionScript. The primary thing you must do to be able to "talk to" a movie clip or button is to name it in the Properties panel. If you select a movie clip or button on the stage, you will find that the Properties panel provides a field named Instance Name. If you enter a name for a movie clip or button, you can direct commands to it.

For example, one of the properties of a movie clip instance is _alpha_, which is the opaqueness of the instance. If you wanted to change the opaqueness of a movie clip instance using ActionScript coding, you would use a statement such as the following.

```
MC1._alpha=50
```

 NOTE: _Almost all property names are preceded by an underscore._

This code assumes that the movie clip is named _MC1_ and would consequently set the opaqueness of the movie clip instance to 50 percent. Thus, the general dot syntax form for accessing the property of an instance is

```
targetpath.property;
```

Understanding Targets

Targets are required for talking to programming objects (calling their methods or accessing their properties); talking to environment objects such as movies, movie clips, or buttons (directing actions to them or accessing their properties); and creating, accessing, or changing global or timeline variables.

Imagine you have a movie with three movie clips and a button loaded into its timeline. The instances of the movie clips are named _MC1, MC2,_ and _MC3,_ and the button is named _ButtonA_. Remember that instance names are assigned to movie clips or buttons using the Properties panel's Instance Name field. To make this example more interesting, nested inside _MC1_ are two other movie clips, named _MC1a_ and _MC1b_. _MC1b_ also has a button in it, named _ButtonMC1b_. Figure 1-1 shows a graphical representation of this hierarchy.

```
┌─────────────────────┐
│ Main Movie Timeline │
└─────────────────────┘
    ├── Movie Clip (MC1)
    │      ├── Movie Clip (MC1a)
    │      └── Movie Clip (MC1b)
    │              └── ButtonMC1b
    ├── Movie Clip (MC2)
    ├── Movie Clip (MC3)
    └── Button (ButtonA)
```

Figure 1-1. Hierarchy of symbols contained within a movie.

Dot syntax facilitates seamless communication between objects. The *with()* command also uses targets. The most difficult part of the process is identifying the actual target specification. The next section examines how to talk from one object to another using target specifications, and discusses the issue of absolute and relative targeting.

Absolute Versus Relative Targets

When you want an object to talk to something else in an environment, you have to point the talking object to the receiving object based on (1) the current talking object's location in the hierarchy or (2) a fixed point in the hierarchy. When you specify targets based on the object that is doing the taking, it is called a relative target; that is, based on where the receiving object is in relation to the talking object. If you specify the location of the receiving object based on a fixed point, it is called an absolute target. When defining absolute targets in Flash, the fixed point is usually the main movie timeline.

The only situation in which relative versus absolute targeting becomes very important is when you want to create reusable, self-contained movie clips—which is most of the time! For example, let's say you set up a movie clip and you want to be able to drag and drop it into other movies. If you use absolute paths, the clip will not likely work when relocated, because its position in the movie hierarchy has changed. Thus, when absolute targets are used, you have to go back and modify the targets in relation to the object's new location in a movie. If you use relative paths, code can be made so that it is self-contained and not dependent on hierarchical location in a movie. Thus, objects coded with relative paths (and therefore self-contained) are much more portable.

 TIP: *As much as possible, use relative targeting. It will make your code much more portable and will often decrease the length of your code. In addition, there are internal processes that increase the performance of your application when you use relative targets.*

Relative versus absolute targets can be explained another way. An example you may be familiar with (where you deal with absolute versus relative paths) is the HREF attribute of the anchor tag in HTML. Let's say you have a home page that resides at the root level of your web site. The site URL is *http://www.somesite.com/*. When you specify URLs (in the < A > tag) from the home page at the URL, you can use either absolute or relative links.

Let's say you have a page *(newpage.html)* that resides in a folder *(myfolder)* at the root level of the server. You can use an absolute HREF

based on a fixed point in the web structure. The HREF, then, would look as follows.

```
http://www.somesite.com/myfolder/newpage.html
```

However, you could also use a relative path, from the home page itself, and save a little typing. It would look as follows.

```
myfolder/newpage.html
```

Relative and absolute paths in Flash are basically the same thing and work in much the same way. In the HTML example, the URL (*http://www.somesite.com/*) is the fixed point in the structure. In Flash, you use the keyword *_root* to identify the main timeline in the current movie. Table 1-4 outlines some example targets for talking to objects in a movie. These absolute paths could be used to have any of the objects shown in figure 1-1 talk to any other object in the movie. (See also exercise 1-1 for examples of absolute targets.)

 NOTE: *Refer to figure 1-1 when examining table 1-4.*

Table 1-4: Absolute Targets for Accessing Objects

Target	Absolute Target
MC1	_root.MC1
MC1a	_root.MC1.MC1a
MC1b	_root.MC1.MC1b
ButtonMC1b	_root.MC1.MC1b.ButtonMC1b
MC2	_root.MC2
MC3	_root.MC3
MC1a	_root.MC1.MC1a
MC1b	_root.MC1.MC1b
ButtonA	_root.ButtonA

Exercise 1-1: Examples of Absolute Targets

CD-ROM NOTE: *To see an example file that displays absolute paths, open the file ch01_01.fla located in the fmxas/chapter01/ folder, installed from the companion CD-ROM. Examine the actions associated with* buttonA *and* buttonMC1b.

When working with loaded movies, *_levelX* is used to define a movie level, where *X* is the level of the movie. For example, *_level0* is the main movie, *_level1* is the movie loaded on level

 1, and so on. _levelX is used in absolute targets for loaded movies, just as _root is used for single-level movies.

Now let's examine relative paths. When you use relative paths, you must know the object from which you want to target (the object doing the talking), as well as the object you wish to target (or talk to). With absolute targets, you need only know the target object.

Two keywords, _parent and this, help you define a relative path. The keyword _parent refers to "one step up in the movie hierarchy." The keyword this refers to the object the script is attached to.

Let's begin with an example so that you can see how it works. Imagine you wanted ButtonA to control movie clip MC1a in some way, such as changing its _alpha property (see figure 1-1). If you wanted the path to be relative, it would be specified from ButtonA's location in the movie hierarchy to movie clip MC1a's location, as follows.

```
MC1.MC1a._alpha=50;
```

Note that MC1a is deeper in the movie hierarchy. To target down to it from ButtonA you simply use the name of each movie clip or button down to the object you are targeting. You then end the statement with the property (as shown previously) you want to manipulate. You can also have a method applied to the object, as follows.

```
MC1.MC1a.stop();
```

In addition, you can access a variable, if it happened to belong to MC1a, as follows.

```
MC1.MC1a.myvar="newvalue"
```

As you can see, it is pretty easy to target from an object higher in the movie hierarchy to an object lower in the hierarchy. But what if you wanted to go the other direction? Say you wanted to target movie clip MC3 from ButtonMC1b (see figure 1-1), how would you define it? This is where the keyword _parent comes in.

To define the location of the movie clip MC3 in relation to the button ButtonMC1b, you have to have a way to "step up" the hierarchy, and _parent would be the way to do so. The target would look as follows.

```
_parent._parent.MC3._alpha=50;
```

Note that _parent is used twice. The first _parent steps up to the timeline contained in MC1, and the second steps up to the main movie timeline. To help you better understand this, examine table 1-5, which provides further details on absolute and relative targets in dot syntax.

Table 1-5: Absolute and Relative Targets in Dot Syntax

Target	From Object	Absolute Target	Relative Target
MC1a	Button A	_root.MC1.MC1a	MC1.MC1a
MC1b	Button A	_root.MC1.MC1b	MC1.MC1b
MC2	Button A	_root.MC2	MC2
MC3	Button A	_root.MC3	MC3
MC1a	Button MC1b	_root.MC1.MC1a	parent.MC1a
MC1b	Button MC1b	_root.MC1.MC1b	parent.MC1b
MC2	Button MC1b	_root.MC2	parent._parent.MC2
MC3	Button MC1b	_root.MC3	parent._parent.MC3

NOTE: *Refer to figure 1-1 when examining table 1-5.*

Table 1-5 is quite important, and you must compare it to figure 1-1 to fully appreciates what is going on. Again, when specifying absolute paths, everything is referenced from the main movie timeline. Thus, all of the targets in the Absolute Target column begin with *_root*, regardless of which object it is attached to.

You specify relative targets, on the other hand, from a specific object. Notice the special term *_parent*, which refers to the parent timeline of the current object (in other words, one step up in the structure). Each time you specify *_parent*, you take one step back (up) in the movie clip (timeline) hierarchy, which can be done multiple times in a single target specification, as shown in the Relative Targets column of table 1-5. Exercise 1-2 provides an example of the use of relative targets.

Exercise 1-2: Relative Targets in a Movie

CD-ROM NOTE: *To see an example file that displays relative paths (targets), open the file* ch01_02.fla *located in the* fmxas/chapter01/ *folder, installed from the companion CD-ROM.*

Examine the actions associated with *buttonA* and *buttonMC1b*.

▪▪▪ **Language Overview**

Although this section is devoted to a discussion of programming fundamentals, you have already had some exposure to the general terminology. If you want to review the common terms used, see Chapter 11 of Macromedia's *Using Flash* reference book, which comes with the software.

The sections that follow deal with other conceptual issues and include simple examples that help clarify these programming concepts.

Variables

One of the fundamental concepts associated with any scripting or programming language is that of variables. The following section provides an overview of variable use in Flash MX.

Rules for Variables

The three main concerns in Flash are the variable's name, the scope of the variable, and the type of data contained in the variable. Scope simply signifies how long the variable and its data are active. The data type signifies what type of data is in the variable. Let's begin by examining variable naming.

Variable Names

The way you name your variables is very important. Flash variable names must adhere to the following rules.

- All characters in a variable's name must be a letter, number, underscore (_), or dollar sign ($). Thus, you cannot use other symbol characters, such as an asterisk (*) or a slash (/), in a variable's name.
- Variable names cannot be any of the ActionScript words. (See table 1-1.)
- All variable names must be unique within their scope (see the section "Variable Scope," which follows).

Data Types

In many programming languages, you must specify the type of data contained in the variable before you can use it. Typically, scripting differs from programming in several ways, and one of these differences is how stringently variables are dealt with.

In basic Flash creations, you generally do not have to be concerned with data types. You usually only worry about whether the data is a string or a number. However, in more advanced creations, you do have to be aware of the type of data in a variable, so that you can properly code methods and properties without generating errors or bugs. Flash incorporates the following seven data types.

- *Strings:* Basic sequences of alphanumeric characters and punctuation marks. Strings are identified by quote marks around them in code (such as *"Nishant"*, where the text *Nishant* is the string).

- *Numbers:* These are double-precision floating-point numbers on which you can perform mathematical operations.
- *Boolean:* A binary data type, meaning that it is either 0 (false) or 1 (true).

 NOTE: *Some would argue that the next two data types (as they consist of a collection of values rather than a single value) are not properties in the traditional sense of the word. They are included here for consistency with Macromedia's organization.*

- *Object:* A collection of properties and methods. The properties themselves can consist of any of the other data types.
- *Movie clip:* The only data type directly associated with graphical elements on the stage. Using this data type, you can control graphical elements on the stage.
- *Null:* The representation of no data. Typically this data type is used to indicate that something has no data.
- *Undefined:* Used to represent a variable that has not been assigned a value.

Where data types become important in Flash is when you want to use a particular value in a variable within a method, function, or other code entity. When simply using the basic actions, you do not need to deal with data types. However, as you move into subsequent chapters, you will start to see where it is imperative to know and control a variable's data type.

Scope

Scope refers to the length of time a variable exists, and also indicates how you access the variable so that you can read or change its data. In Flash, you can define global, timeline, and local variables. How and where you declare the variable determines the type of variable created. Let's first look at global variable declaration in Flash.

Global Variables

When you precede a variable with the *_global* keyword, it is treated in a particular way; that is, it is a true global variable and is not owned by a timeline per se. You do not need to provide a target path to access a global variable's data. Simply precede the variable name with *_global* and you can access or change it. The *_global* keyword is also special in that it supercedes any individual movie. If your scenario uses loaded movies, all movies can access the global variables using the *_global* prefix.

Local Variables

To declare a local variable in Flash, you use the *var* keyword. Local variables are usually used for "short-lived" data, such as temporarily storing a value. They are commonly used in *for* loops. For example, the following would create a local variable.

```
var mylocal1="blah"
```

The reality is, however, that local variables can only truly be created in user-defined functions you write (not to be confused with the built-in data conversion or evaluation functions listed in table 1-1). Once the user-defined function is done executing its code, the local variable is deleted.

 NOTE: *Use of the* var *keyword outside a* function *container is futile. All variables created outside user-defined functions, whether* var *is used or not, are created as timeline variables.*

Timeline Variable Scope

The last type of variable is the timeline variable. When a variable is created that (a) does not use the *_global* prefix and (b) does not use the *var* keyword inside a function, a timeline variable is created.

Timeline variables created in Flash are scoped according to timelines; that is, they are owned by the timeline that created them and are accessed by providing a path to that timeline. A timeline variable will exist as long as the timeline that created the variable exists within the player. For example, if a movie clip named *MC1* creates a variable named *gfinal*, accessing the variable's data could be done using an absolute target path, such as

```
_root.MC1.gfinal
```

If you wanted to use a relative path, the entry would be dependent on the relative position between the object trying to access the variable and *MC1*. Nevertheless, you would undoubtedly use the keyword *_parent*. The next section discusses variable targets in more detail.

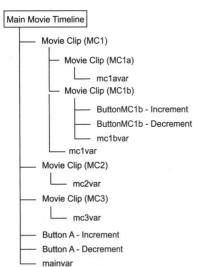

Figure 1-2. A movie structure in which a variable is defined in each timeline.

Variables and Target Paths

Let's review one more example. Examine figure 1-2. This example was used earlier in this chapter. However, this time a variable has been added to each of the movie clip timelines, as well as to the main movie timeline.

Table 1-6: Valid Target Paths for Button Variables Using Dot Syntax

From Button A (Increment)				
To	**Relative Path**	**Relative Expression**	**Absolute Path**	**Absolute Expression**
mainvar	*mainvar*	*++mainvar*	*_root.mainvar*	*++_root.mainvar*
mc1avar	*MC1.MC1a.mc1avar*	*++MC1.MC1a. mc1avar*	*_root.MC1.MC1a. mclavar*	*++_root.MC1.MC1a. mclavar*
mc1bvar	*MC1.MC1b.mc1bvar*	*++MC1.MC1b. mc1bvar*	*_root.MC1.MC1b. mclbvar*	*++_root.MC1.MC1b. mclbvar*
mc2var	*MC2.mc2var*	*++MC2.mc2var*	*_root.MC2.mc2var*	*++_root.MC2.mc2var*
mc3var	*MC3.mc3var*	*++MC3.mc3var*	*_root.MC3.mc3var*	*++_root.MC3.mc3var*

From Button MC1b (Increment)				
To	**Relative Path**	**Relative Expression**	**Absolute Path**	**Absolute Expression**
mainvar	*_parent._parent.mainvar*	*++_parent._parent. mainvar*	*_root.mainvar*	*++_root.mainvar*
mc1avar	*_parent.MC1a.mclavar*	*++_parent.MC1a. mclavar*	*_root.MC1.MC1a. mclavar*	*++_root.MC1.MC1a. mclavar*
mc1bvar	*mc1bvar*	*++ mc1bvar*	*_root.MC1.MC1b. mclbvar*	*++_root.MC1.MC1b. mc1bvar*
mc2var	*_parent._parent. MC2.mc2var*	*++_parent._parent. MC2.mc2var*	*_root.MC2.mc2var*	*++_root.MC2.mc2var*
mc3var	*_parent._parent. MC3.mc3var*	*++_parent._parent. MC3.mc3var*	*_root.MC3.mc3var*	*++_root.MC3.mc3var*

How do you reference each variable from the two buttons shown in figure 1-2? See table 1-6 for the answer. Exercise 1-3 provides practice in working with target paths.

Exercise 1-3: Target Paths

CD-ROM NOTE: *To see an applied example of figure 1-2 using absolute targets, open the file* ch01_03a.fla *located in the* fmxas/chapter01/ *folder, installed from the companion CD-ROM. To see an applied example of figure 1-2 using relative targets, open the file* ch01_03b.fla *located in the* fmxas/chapter01/ *folder.*

NOTE: *The keywords* _global, _levelX, _parent, _root, *and* this *are used as prefixes.*

Operators

At the heart of expressions are operators, which in ActionScript are specific symbols denoting a type of operation to be performed on one or more operands. Depending on the data, and on the results you are trying to obtain, different operators are used. Thus, there are specific operators that apply to numerical expressions only, and specific operators that apply to

string expressions only. There are also general, comparison, logical, and bitwise operators. The operators are discussed in the sections that follow.

 TIP: *You may find it helpful to reference table 1-1 as you progress through the discussion of specific ActionScript items.*

General Operators

The general operators include the following delimiter items.

- *String delimiters:* Sets of double quote marks (" ") used to signify string data elements
- *Parentheses:* Used to offset arguments sent to functions or methods
- *Dot access delimiter (.):* Used to reference hierarchical object order in target paths
- *Curly brackets ({ }):* Used to denote logical code groupings
- *Square brackets ([]):* Used to access or assign specific values in an array

Equality Versus Assignment Operators

The assignment and equality operators are pretty straightforward. One of the biggest issues concerning the use of operators is that of equality versus assignment. ActionScript follows the JavaScript rule in which a single equals sign represents "set this equal to this" and a double equals sign represents "does this equal that?" Thus, the following lines do not mean the same thing.

```
myvar = 1
myvar == 1
```

The first of the previous lines is assigning the value 1 to the variable *myvar*, whereas the second line is asking, "does *myvar* equal a value of 1?" As you begin writing your code, this is important to remember. Already you have seen examples of assignment (via the variable exercise). Equality (==) operators are examined in greater detail later in this chapter, under a discussion of conditional statements.

Strict Equalities

One of the new items in Flash MX is the strict equality operator (===) and strict inequality (!==) operator. Typically when Flash compares two values, if the values are not of the same data type Flash will convert them to the same data type before doing the evaluation of equality. The strict equality operator forces Flash to evaluate the two elements without type conversion. For example, consider the following.

1 == "1"

This statement says, "does the numeral 1 equal the string 1." Flash sees the values on either side of the operator as equal because it converts the latter to a numeral before performing the evaluation. The strict equality or inequality operator allows you to force Flash to evaluate two values without data conversion. Using the strict equality operator on the values in this statement would force Flash to recognize that the two values are not the same.

Operation and Assignment

As you peruse the listing of equality and assignment operators, beyond equality, assignment, and inequality you will find that the remaining operators (called compound operators) represent shorthand methods of performing certain tasks. They allow you to do two things (usually a mathematical operation and assignment) at the same time.

Numeric and String Operators

Numeric expressions are most often used to perform math operations on numbers. These include addition (+), subtraction (–), multiplication (*), and division (/). Flash also includes Modulo (%), as well as Increment (+ +) and Decrement (––). When the function itself returns a numerical value, numeric expressions may also integrate functions. Examples of this include *eval()*, *parseFloat()*, *parseInt()*, and *Number()*. Properties may also be used with operators when their values yield numbers.

Logical

Logical operators differ from other operators in that they are used to concatenate (join) two comparison statements. You should use the double ampersand (&&) for *logical and* (e.g., if this and that are true), double pipes (||) for *logical or* (e.g., if this or that is true), and the exclamation mark (!) for *logical not* (e.g., if this is not true).

Comparison

Comparisons (as well as logical operators) are elements used most commonly within *if* statements and conditional loops. Comparison operators compare two elements. The result of a comparison operation is a binary value of either TRUE (1) or FALSE (0). When integrated into an *if* statement or a conditional loop, appropriate actions are either initiated or ignored.

Bitwise

Bitwise operators are special operators that allow the computer to deal with its native language for data: binary. Bitwise operators treat their operands (the values on either side of the operator) as bits (binary data) as opposed to decimal numbers. When ActionScript encounters a bitwise operator, it takes the operands presented as decimal numbers and converts them to binary representations. It performs a requested bitwise operation and then returns a decimal result.

Because bitwise operations occur at the bit level (thus the term), bitwise operators provide a faster way to process certain operations, particularly multiplication or division by powers of 2. When multiplying by powers of 2, the bitwise left shift operator can be used as a more efficient replacement for the mathematical operation of multiplication. The bitwise right shift operator can be used to replace division by powers of 2. Just as it is easier for humans to multiply and divide decimal numbers by powers of 10, so it is much easier for the computer to multiply and divide binary numbers by powers of 2.

To really be able to think in terms of bitwise operators requires extensive experience in numerical systems of representation. Bitwise operations are dealt with in detail where applicable in subsequent chapters, including examples of the use of bitwise operators so that you can see how they work.

More Variables

The Actions | Variables group in the Actions toolbox list includes four items, two of which you have already examined (*var* and *set variable*). The following sections discuss the *delete* and *with()* commands.

delete

As you start working with variables and objects (such as arrays), you have to keep in mind, particularly with large arrays, that they take up memory. It is possible to create so many arrays or variables that you bog down the machine or cause the application to lock up due to using too much RAM.

The *delete* command, however, allows you to free up memory by deleting a specified variable, array, or other object from memory. It is good and common practice to free up memory by deleting variables or arrays you are no longer using.

Generally when you delete an object, Flash will return a Boolean TRUE if the operation was successful. Therefore, if you wanted to see if an object was successfully deleted from memory, such as the *grocerylist* array used earlier, you could create a temporary variable and check its value to see if

it was successfully deleted. The following code does this, using a *trace()* action to print the results of the *delete* command to the Output window.

```
var tempvar = delete grocerylist;
trace tempvar;
```

If you tell Flash to delete an object and it is unsuccessful, a Boolean FALSE will be output. You cannot delete predefined objects, properties, or local variables.

with()

You have seen that you can talk to movie clips, buttons, and movies using dot syntax. However, there may be times when you want to send a series of code statements to an object. The *with()* command gives you a shorthand way of doing so. For example, imagine you wanted to tell a movie clip named *MC1* to do several things. You could write it out longhand using the following.

```
_root.MC1._alpha=50;
_root.MC1.gotoAndPlay("m1");
_root.MC1.stopAllSounds();
```

Another way to write this is to use the *with()* statement, as follows.

```
with(MC1) {
     _alpha=50;
     gotoAndPlay("m1");
     stopAllSounds();
}
```

More concisely, this would be written as follows.

```
with(MC1) { _alpha=50; gotoAndPlay("m1"); stopAllSounds(); }
```

Conditionals

Being able to respond to certain conditions allows you to control program flow. There two general types of flow control statements: conditionals and loops. In the Actions panel, these two are grouped together under Actions | Conditionals/Loops. Here, they are separated for purposes of discussion.

In Flash, you can use the *if* or *switch* constructs to react to a specific condition in a program. With the *do...while/while* and *for/for...in* constructs you can create repeating segments. Conditional statements allow you to create sets of actions that may or may not execute, depending on the condition. Loops allow you to create sets of actions that repeat themselves with various settings, which in essence is a means of shortening ActionScript code segments.

if...else/else if

The *if* construct is a control-of-flow feature in most languages. As a basic programming capability, the *if* statement allows you to write a set of statements that executes *if* a particular condition (or multiple conditions) is found to be *true* or *false*. It also allows you to set up alternatives to specific conditions. Thus, you can create binary conditions, as well as conditions that respond to a variety of conditions. The general form for use of the *if* construct is as follows.

```
if (condition) {
        //code to execute if true
} else {
        //code to execute if false
}
```

Ternary Operator

The previous discussion of general operators did not include the conditional operator (often called a ternary operator) consisting of a question mark and a colon (? :) This operator allows you to create conditional statements quickly and easily when there are only two possible values for a condition. In other words, if you have a binary condition, use the conditional operator as a shortcut. The form for the use of the condition operator is as follows.

```
condition ? do_this_if_true : do_this_if_false
```

Examples of the use of the conditional operator follow.

```
myval == 1 ? gotoAndPlay(1) : gotoAndStop(3);
```

In this example, if *myval* equals 1, the movie will go to and play frame 1. If *myval* does not equal 1, the movie will go to frame 3 and stop.

```
_framesloaded < 100 ? gotoAndPlay("Loop") : gotoAndPlay("Start")
```

In this example, if the *_framesloaded* property (the number of frames loaded) is less than frame 100, the movie returns to a label named *Loop*. If the *_framesloaded* property is greater than frame 100, the movie goes to the frame label *Start*.

```
MC1._x <= 75 ? MC1._x=0 : MC1._x=200
```

In this example, if the *x* location of the movie clip *MC1* is less than or equal to 75, the *x* location of movie clip *MC1* is assigned to 0. If not, the *x* location of movie clip *MC1* is set to 200.

 NOTE: *To use the conditional operator you must work in Expert mode. If you revert from Expert to Normal mode in the Actions panel, conditional operators are "erased."*

switch...case/default

The *switch, case,* and *default* items are new to Flash MX. Like an *if* statement, *switch* statements allow you to test for any number of conditions and then respond uniquely to each. Where *switch* statements are useful is when you have many conditions for which you would like to perform certain actions. In such cases, *if* statements can become quite lengthy, and at times confusing. The *switch* statement provides a more concise method of creating multi-case conditional statements. For example, let's use the scenario in which you have a button you want to go to different places at different times. You could create a *switch* statement that would detect the current frame and then respond appropriately, as follows.

```
switch (_currentframe) {
  case 10:
      getURL("http://www.google.com/", "_blank");
      break;
  case 20:
      getURL("http://www.yahoo.com", "_blank");
      break;
  case 30:
      getURL("http://www.excite.com", "_blank");
      break;
  default:
      getURL("http://www.lycos.com", "_blank");
}
```

Note here how *switch, case,* and *default* are used. The statement is opened by the *switch* keyword followed by a variable or property. It is the state of the variable or property that is used as the condition. Thus, the first *case* looks for *_currentframe* to yield 10, the second looks for *_currentframe* to yield 20, and so on. That is, you define the states directly following the *case* keyword.

In the previous code, note also the *default* keyword. This is like the *else* aspect of the *if* statement. If the *switch* statement checks all cases and finds none that match, it will execute the code in the *default* section.

A final note about *switch* statements concerns the use of the *break* command. Note that *break* is used at the end of each *case* section. *switch* statements are significantly different from *if* statements in that once a matching case is found the code defined in that *case* will execute.

However, unless a *break* command is found (which makes the *switch* statement cease operation altogether), the *switch* statement will continue executing the code found in the remaining cases, until it either encounters a *break* or reaches the end of the cases in the *switch*. With *if* statements, once a matching *if* or *else if* section is found, only that section is executed. With *switch* statements, once a matching *case* is found, all subsequent cases will execute their code unless a *break* is encountered.

 TIP: *When a default case is used, it is generally the last item in the* switch *statement. Thus, a* break *is not needed. Regardless,* break *is not needed in the last case of a* switch *statement.*

Loops

As you read earlier, in the Actions panel, the conditional and loop statements are contained together. In the previous section, you examined the conditional statements. In the following section, you will finish by examining the loop commands that exist in Flash.

for/for...in

As you write ActionScript, you often want to perform an operation on several items at once, or repeat a section of code multiple times. The *for* and *for...in* repeat loops, using a counter, let you repeat something a specific number of times. The form for creating an incrementing or decrementing counter would look as follows.

```
//incrementing counter
for ( var i = minvalue; i <= maxvalue; ++i ) {
  statements you want to repeat with the value of i
}
//decrementing counter
for ( var i = maxvalue; i >= minvalue; -i ) {
  statements you want to repeat with the value of i
}
```

 NOTE: *In this code, as well as other places you use* for *loops, keep in mind that the* var *keyword will only work properly if the* for *loop is within a user-defined function. In all other instances, the* var *keyword is ignored and a timeline variable is created.*

The primary difference between the *for* and *for...in* actions is that *for...in* allows you to find out or modify things relative to a specific object. When you begin working with programming objects (such as the Array object) in later chapters, *for...in* becomes more important.

while/do...while

The *do...while* and *while* loops repeat a set of actions as long as a particular condition is true. Whereas the *for* and *for...in* loops provide a counter and respond to that internal counter's condition or state, the *do...while* and *while* loops assume a condition is TRUE and continually repeat the code statements until the condition is FALSE. *While* loops are pretty easy to understand. The following is an example.

```
while ( condition ) {
     statements to perform
}
```

In general, as long as the condition is evaluated as true, the statements will react. The minute the condition no longer exists, the statements cease. The main thing to keep in mind is that the condition must be TRUE upon encountering the *while* statement; otherwise, the statements inside will not execute. The *do...while* repeat looks as follows.

```
do {
     statements to perform
} while ( condition )
```

The primary difference between the two types is that *do...while* allows you to execute the statements once before the condition is examined. Thus, the condition would not have to be true for the statements to execute once. However, the condition would have to be true for the statements to execute multiple times. When you use the *while* repeat only, the condition must be true for the statements to ever execute.

break and continue

break and *continue* are predominantly used with repeat loops, as well as in *switch* statements. For example, you may find that for a particular value in a *for* loop you want to break out of the loop when the particular case is found, or skip over a particular value when a particular case is found.

Functions

Flash MX provides three basic types of built-in functions, all of which expect to receive data, do something to that data, and return a result. The following sections discuss the global, conversion, and mathematical functions available in Flash.

Global Functions

The following global functions in Flash are in most cases designed to perform specialized tasks with data in the environment.

- *escape()* and *unescape():* Specialized functions for encoding and decoding strings to URL-encoded formats.
- *eval():* Used to define a variable, property, object, or movie clip in code by entering the respective name as the expression. Chapter 2 describes this in more detail.
- *getProperty():* Allows you to retrieve the value of any of the properties listed in table 1-1.
- *getTimer():* Provides a facility for measuring elapsed time within a movie since the start of the movie.
- *getVersion():* Returns the current version of the Flash Player, as well as the platform the player is running on.
- *targetPath():* Provides a means of retrieving the target path to an object specified by the argument.

Conversion Functions

In addition to the global functions, Flash provides two sets of utility functions, conversion functions, and mathematical functions. The following are the conversion functions.

- *Boolean():* Converts the specified value or expression to a Boolean result
- *Number():* Converts a specified value to a number
- *String():* Converts a specified value to a string
- *Array():* Converts the specified value or values to an array
- *Object():* Converts the specified value or values to an object

The following are the mathematical functions.

- *isFinite():* Allows you to determine if the specified value is a finite number
- *isNaN():* Allows you to determine if the specified value is a number
- *parseFloat():* Converts the specified value to a floating point number
- *parseInt():* Converts the specified value to an integer of a specified base

■ ■ ■ General Actions/Methods

The following sections provide a brief overview of the general actions found under the Actions grouping. *Flash MX: Graphics, Animation &*

Interactivity provides more information about the details of working with these actions, as well as relevant examples of each. Here they are quickly described and reviewed to provide an adequate introduction to this text. Each of these actions is designed to work with the main movie timeline, and with movie clips and buttons.

Movie Control

The following are the movie control actions.

- *goto:* Can be used to jump to frames, labels, or named anchors in the current scene or in another scene.

- *play()* and *stop():* Give you the ability to play or stop the movie or movie clip at will.

- *stopAllSounds():* Allows you to stop all currently playing sounds. Sounds assigned later in the movie will play normally.

Browser/Network

The following are the browser/network actions.

- *getURL():* Can be used to load a new web page into the browser, open a blank e-mail (given that an e-mail is set up on the user's machine), or to pass information to external technologies, such as JavaScript.

- *loadMovie()* and *unloadMovie():* Allow one or more web-ready Flash files (SWF) to be loaded into and overlaid upon another movie; creates a "movie in a movie."

- *loadVariables()* and *loadVariablesNum():* Allow a Flash movie to load variables from an external source into the current timeline or into a specific movie level.

- *fscommand():* Special action that allows Flash to pass two values to an external technology, including the standalone Flash Player.

Movie Clip Control

The following are the movie clip control actions.

- *duplicateMovieClip()* and *removeMovieClip():* Permit the duplication and removal of movie clip instances.

- *setProperty():* Allows the properties associated with the movie, movie clips, or buttons to be set during runtime.

- *startDrag(), stopDrag()* and *updateAfterEvent():* Drag actions allow the creation of draggable movie clip instances. The

updateAfterEvent() method is a utility item that keeps the mouse from flickering during dragging operations.

▪ ▪ ▪ Summary

In this chapter you have reviewed the basics of ActionScript programming. Although there is much more that can be said concerning ActionScript basics, it is assumed you have read *Flash MX: Graphics, Animation & Interactivity* and thus lengthy explanations are not reiterated here. In the next chapter you will go beyond the basics and start learning about object-oriented programming and how you apply it in Flash.

Object-oriented Programming

▪▪▪ Introduction

In the previous chapter, you examined ActionScript and related concepts. You were introduced to the syntax, objects, and basic concepts related to ActionScript. You were also introduced to important terminology and general actions within Flash MX. However, Chapter 1 barely scraped the tip of the iceberg when it comes to programming applications in Flash MX. This chapter will bring you up to speed on how to maximize Flash MX's object-oriented structure and use it effectively.

Flash has always been an object-oriented development environment. If you do not know what object-oriented programming (OOP) means right now, by the end of this chapter you will have an in-depth knowledge of it, both from a global standpoint and how it is implemented within Flash. This chapter explores the roots of OOP, related concepts, OOP terminology, and its implementation within Flash MX.

This chapter is designed to teach a complete newcomer about OOP in Flash. For someone coming from an OOP background, it will serve as both a review of key concepts as well as a bridge toward implementing OOP in Flash. For someone with intermediate experience with programming and Flash, this chapter should help sharpen those blunt edges enough to make you an even better Flash developer. Regardless of which genre you fit into, this chapter is of key importance to understanding several chapters and examples that follow.

▪ ▪ ▪ Objectives

In this chapter you will:

- Learn about the history and concepts of object-oriented programming
- Get an overview of Flash MX's prototype-based scripting language, ActionScript
- Learn about concepts such as classes, encapsulation, inheritance, polymorphism, and reusability
- Learn how to implement key concepts such as classes, constructors, objects, instances, methods, subclasses, and superclasses
- Learn how to encapsulate classes in movie clips
- Build your own prototypes and extend those inherent to Flash

▪ ▪ ▪ The Old Days

Before the advent of object-oriented programming, most languages were either *procedural* or *structured*. Both programming paradigms have some serious longevity-related fallbacks examined in the next few sections.

Procedural Programming

Most of the earlier languages (such as C, Fortran, Pascal, Basic, and similar languages) are *procedural*. A procedural language simply gets some input, performs an operation, and displays the result. This is perfectly fine for really small programs and applications, as it gets the job done and gets it done fast. However, realistically speaking, most programs are not really that small or simple. Hence, procedural programming miserably fails to deliver the infrastructure for intelligent application development. In the late 1960s and early 1970s, programmers identified this problem and decided it was time to rethink their programming paradigm.

Structured Programming and Functions

It quickly became evident to most programmers that procedural programs lacked organization, efficiency, and logic in implementation. A procedural program is virtually impossible to read after a few hundred lines of code. It is also very difficult for a programmer to decipher another programmer's code. The shortcomings of procedural programming led to the formulation of *structured programming*.

The only difference between procedural and structured programming is the availability of a construct known as a *function*. Other names for a

function are *subroutine, routine,* and *procedure.* Functions are modules of related code that have defined purposes. Procedural code evolved into modular code with functions, which made it easier for programmers to add some readability and transferability to their code.

However, structured programming, too, was a far cry from a comprehensive solution. As programs got larger and more complicated, even the modular approach became cumbersome and inefficient. Programmers acknowledged it was time to sit down and do it right. The first step was to realize the shortcomings of the procedural and structured approaches; that is, readability, global access, and dealing with data types.

Readability

It is extremely difficult for a programmer to try to read another's procedural code. This is simply because of the linear nature of procedural code, as well as the fact that one would have to understand the syntax of the language very well. If you do not know what a statement or command means, chances are you will never move ahead from that point. It is much like walking into a movie midway: you almost know what is going on, but have a sense you are missing some key information that would shed a lot of light on the issue at hand.

Global Access

Procedural programs such as C are characterized by two types of data: local and global. *Local* data is any data used exclusively by a function. For instance, if you had a function that tracked the position of a player on stage, you could store it in a local variable within the function. However, if you had data that needed to be accessed by more than one function, procedural programs demand that this data be stored in a *global* location. This implies that any function may gain access to this data at any time.

The problems become evident with large programs that potentially have extensive local and global content. Procedural programs add to the complexity of large programs, causing several critical problems by making global data unprotected. Global data is usually accessed by several functions, and when you need to change the nature of some global data, you end up having to change the numerous functions accessing it. Due to this, such programs are often very difficult to visualize.

Data Types

Procedural programming languages are carved in stone and are very rigid as it relates to data. In most cases, you must use the data types available in the language or not use the language at all. It is very difficult to make

up your own data type with custom characteristics and unique structure. For instance, suppose an Array data type were not available in your procedural programming environment. In this case, it would be close to impossible to make your own Array data type.

There are several other problems with procedural and structural languages, but those previously mentioned are the major ones. In light of these problems, it became increasingly necessary to shift the programming paradigm, and to create a methodology more closely fitting real-world scenarios. Thus the advent of object-oriented programming (OOP).

Object-oriented Programming

Object-oriented programming, more commonly known as OOP, was introduced to compensate for the shortcomings of its predecessor programming paradigms. OOP is not really something on which you can get a single tutorial or a solid example to understand all of its ramifications. This is because OOP is not really a programming language or something you can associate with a specific object. It is, rather, a very logical way of thinking about programming. In fact, OOP is so logical it applies to almost every aspect of computing.

In its simplest form, OOP is a set of logical rules that facilitates the reuse of programming code. Procedural programming allowed functions to reuse code, but imposed several limitations. Functions, as they related to procedural programming, were simply clusters of related code. They were nothing more than tiny routines that had a name. OOP completely changed the nature of this structured methodology.

OOP requires a change in the way you think. It may take a while to completely grasp the concept, but once you do, it opens up a whole new world of elegant solutions and logical strategies for solving problems. Let's look at a simple analogy to shed more light on OOP.

Consider how a university is set up. Every university is divided into numerous departments, either academic or administrative. Each department is responsible for a particular set of tasks and duties. For instance, the Math department is responsible for setting up its own curricula, classes, registration methods, tests, and so on. It even has a building of its own, but this building usually resides within the university campus. Furthermore, even though the Math department is an individual entity, it still answers to the university at a higher level. The university lays down a template for the formulation of various departments, and the Math department (or any department) is charged with fitting into that framework (see figure 2-1).

Figure 2-1. An example of an "OOP university."

One university regulation might demand that every department conduct final exams in the last week of the semester. If a department were to disobey, the system would fail, as it would ruin administrative processes such as posting of grades, registration procedures, and so on. OOP follows the exact methodology as the university analogy. Why is this the right way? Let's set up the university in a *procedural* way to see the advantages of an OOP methodology.

If you were to think in procedural terms, a university would be nothing but a collection of identical buildings, departments, and people. Every building would function as a department with a generic set of people for an indefinite amount of time. Let's say building A is the Math department, and building B is the Physics department. Tomorrow, building B could possibly be the Math department, and building A the Physics department. This would add the unnecessary overhead of training all university employees to be able to professionally perform every task at the universi-

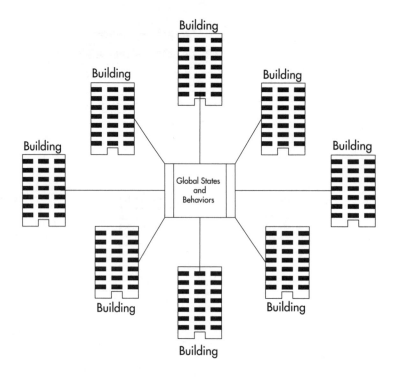

Figure 2-2. An example of a "procedural university."

ty. The list of weaknesses for this approach is endless, but you get the idea, depicted in figure 2-2.

Hopefully, this gave you a better insight into how OOP works. If not, do not worry, because this concept is quite abstract and is best understood in practice. Most people new to OOP shy away after a few tries at understanding it completely. However, keep trying. At some point you will definitely experience the "Eureka!" feeling, and it should be downhill from there.

■ ■ ■ Critical Concepts

It is important to be aware of the key strengths of OOP. There are several buzz words you will hear often in regard to OOP, such as *inheritance*, *encapsulation*, *abstraction*. The point is to be able to implement such concepts, but to do so most effectively it is also important to understand why. This section provides an overview of such concepts. You are encouraged to understand these concepts well before reading further.

Abstraction and Conceptualization

As you develop an OOP-based application, you will spend a lot of time solidifying your own OOP model for the application. The nature of OOP is such that many of its aspects are *abstract* in nature. For instance, your *Ball* class could have a couple of properties, *x* and *y*, that store the current positions of the ball. These properties exist only in theory and are in no way associated with the methods and functions that move the ball or get its position on the stage. They are simply *abstract* representations that exist in the scope of the *Ball* object. In essence, most methods and properties are abstract in nature until they are used; that is, until they become actual functioning units in a program.

Inheritance

Inheritance is what brings OOP to life. It is based on a real-world hierarchical methodology. Inheritance is a part of our daily lives, whereby we group information into classes and divide classes into subclasses. For instance, we know that animals (for the sake of argument here, a *class*) collectively consist of several subclasses, such as mammals, birds, and insects. These subclasses have further subclasses, such as mammals subdivided into humans, whales, and so on. This sort of tree structure persists until it arrives at a subclass that may no longer be subdivided.

All subclasses are *derived* from their parent classes, and share characteristics with their parents (i.e., they *inherit* characteristics of their parents, as depicted in figure 2-3). For instance, consider the parent class automo-

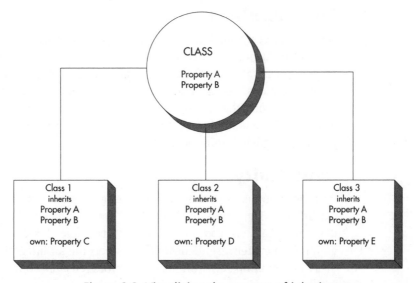

Figure 2-3. Visualizing the concept of inheritance.

biles, with subclasses cars, trucks, and buses. Even though each subclass has completely unique attributes, they all have a few basic things in common. For instance, they run on wheels, have seats, utilize fuel, and so on. They inherit these common characteristics from their parents (called *superclasses*).

The power of inheritance will become all too evident to you by the time you finish reading this chapter. Inheritance is definitely the backbone of OOP. It allows a programmer to take an existing class, inherit its states and behaviors, and then build upon them to customize them. This is the true power of OOP.

Encapsulation

The neat thing about OOP is the way it is modeled after the real world. It follows that most of its concepts are real-world terms that mean exactly the same as they mean in the real world. *Encapsulation* in the real world means "the act of enclosing in a capsule." It means exactly the same in OOP.

One of the fallbacks of procedural programming was the fact that all functions have unlimited data access. For instance, if you had an abstract *Dog* class and another abstract *dogLeg* class, you could change characteristics of the *Dog* class using the *dogLeg* class. This represents a violation of the hierarchy, even in the real world. Encapsulation enables you to lay down a hierarchy that is rigid and *protected*. It simply defines a way by which all states and behaviors of a class are stored within a class, restricting access to only parents of that class.

Polymorphism

Polymorphism means "the capability of assuming different forms" in the real world. Again, this is exactly what it means in OOP. Another neat idea, polymorphism allows a function or method to take different forms in different situations. For instance, you could write a generic function called *getArea()* to find the area of a shape. Based on the type of shape you feed it, it would calculate the area using a different formula each time. This is yet another great feature of OOP.

Reusability

Last, but not the least, there is the aspect of *reusability*. This term is self-explanatory. The nature of OOP allows you to create a class once and use it infinite times. It also allows you to distribute this class to other programmers for their use. Reusability has become an integral part of almost every programming environment. The more reusable your code, the longer its life span.

▪ ▪ ▪ **Flash MX and OOP Concepts**

ActionScript is not a purely OOP language, which may surprise you. Many developers would argue this statement, but its truth becomes evident when you examine the subtle differences between Flash and, for example, Java. ActionScript models itself after the ECMAScript prototype and object model; specifically, EMCA-262. You will be introduced to objects, prototypes, and related concepts in the sections to follow. However, for practical purposes, ActionScript is as object-oriented as it needs to be, and so we will refer to it as an OOP language for the remainder of the book. With that said, it is time to understand what OOP is all about.

Objects

If you had not guessed it already, the heart of OOP lies in the object. An object is comparable to objects we see in our lives every day, such as chairs, tables, lamps, cats, and so on. Objects in programming are characterized by the following two main attributes.

- State
- Behavior (function)

The *state* of an object is simply something that describes one of its physical characteristics. For example, cats have state (name, weight, color, cranky, sleepy, and so on). The *behavior* of an object is something that describes an action performed by it. For instance, cats have behaviors (yawn, purr, scratch, and so on).

In programming, objects are characterized by *state* and *behavior*. Objects store their state in *variables* and *properties*, whereas their behavior is stored in *methods* and *functions*. These concepts will become more "solid" as applied to examples in material to follow.

Classes and Instances

A class is simply a "conceptual" template for an object. A class defines what *state* and *behavior* that object will possess. For instance, think of the word *dog* as a class. You cannot really touch the "idea" of a dog because it is simply a set of *states* and *behaviors* that define a real dog. The tough thing about OOP is that you have to change the way you think. Once you can see things in an OOP way, it will open up boundless opportunities for you as far as application development is concerned.

CD-ROM NOTE: *To follow along with the example file, open the file ch02_01.fla located in the* fmxas/chapter02/ *folder, installed from the companion CD-ROM. Examine the actions on frame 1. To view the output, select Control | Test Movie.*

Let's use a simple example to illustrate the respective meanings of *class*, *object*, and *instance*. We have not examined instances in depth, but they are better explained in regard to code example 2-1.

Code Example 2-1: A Dog Class

```
//Dog Constructor
Dog = function (name) {
        this.name = name;
        this.legs = "4";
}
myDog1 = new Dog ("Bonzo");
myDog2 = new Dog ("Oliver");
trace (myDog1.name); //Bonzo
trace (myDog2.name); //Oliver
trace (myDog1.legs); //4
trace (myDog2.legs); //4
```

Code example 2-1 demonstrates some key OOP principles. Let's look at them one by one. First, this code declares a *Dog* class using a function with a *name* parameter. The *Dog* class defines the following states.

- Every dog will have a name. This name will be decided by the creator of the dog.

- *This* (instance) particular dog will have four legs.

After defining the class, some simple code is used to make an *instance* of the *Dog* class. Instances are simply objects. Every instance may have properties, variables, and methods associated with it. The previous example incorporates an instance of the *Dog* class called *"Bonzo"*, which is stored in the object *myDog1*. The code incorporates another instance of the *Dog* class, called *"Oliver"*, which is stored in the object *myDog2*. Now *myDog1* and *myDog2* are completely different objects (instances) of the type (class) *Dog*.

> **NOTE:** *The* Dog *class function is formally called the* constructor *function. This is because it actually* constructs *a Dog. It is important to practice to have a constructor function for every class, even if it is empty.*

For those who come from an OOP background, you must have already noticed a major flaw in this code. It is almost right, but not quite, just yet. To completely capitalize on the OOP programming structure, you need to look at a few more concepts.

Examining the Flaw

Let's look at code example 2-1 again to see what is wrong with it. Begin by thinking about the *Dog* class. You want to be able to name a particular dog, and have provided a mechanism for doing so. You have also defined every dog as something that will have four legs. Using the previous code, every time you make a *Dog* object (i.e., specify a dog name), you are creating a new *instance* of that *Dog* object's *legs* property. If you were to make a hundred dogs using this code, you would be defining the *legs* property in each instance and thereby end up using a lot of memory to make a hundred instances. That simply makes for waste of space, slows your movie down, and eats up unnecessary resources. Fortunately, there is a solution to this problem, called the *prototype*.

Understanding the Prototype

To understand a prototype, you need to further understand a class. You know that a class is a template objects use to *instantiate* (make an instance of) themselves. However, due to how a prototype-based language is set up, there is no way to access the properties of a class. For instance, in the previous example, you could not trace the *Dog* class's properties, as is done in code example 2-2. This would result in the output being undefined, meaning that the *legs* property does not exist. This is because the *legs* property belongs to the class, not the instance. Because the instance cannot access the class's properties, *undefined* is returned when you attempt to trace the *Dog.legs* property.

Code Example 2-2: Tracing a Class's Property

```
Trace (Dog.legs); //results in the output undefined
```

What would you do if you needed to hypothetically change the *legs* property for all instances of *Dog* to 5? This is where the prototype comes into the picture. The prototype object is simply a place where a class stores its properties. Everything owned by a class is stored in the prototype object. This makes for efficient coding because it uses the concept of inheritance. Let's rewrite code example 2-1 to understand the concepts of inheritance and prototypes, as shown in code example 2-3.

Code Example 2-3: Assigning Inherited Properties to the Prototype Object of a Class

```
//Dog Constructor
Dog = function (name) {
```

```
        this.name = name;
}
Dog.prototype.legs = "4";
myDog1 = new Dog ("Bonzo");
myDog2 = new Dog ("Oliver");
trace (myDog1.name);        //Bonzo
trace (myDog2.name);        //Oliver
trace (myDog1.legs);        //4
trace (myDog2.legs);        //4
trace (Dog.prototype.legs); //4
```

Let's examine this code. As earlier, this code creates a *Dog* class. This time, however, the class simply says the following.

- Every dog will have a name, and the creator of the dog will decide this name.

The code then uses the prototype object of the *Dog* class. It creates a property (called *legs*) in the prototype object of the *Dog* class and assigns it a value of *4*. This creates one master copy of the *legs* property for all dog objects. Now, all dog objects would have four legs, but the neat thing is that you do not end up making a copy of the *legs* property for every new instance of *Dog*. Instead, each instance of *Dog inherits* the *legs* property of its class. This means that every time the *legs* property of an instance is called, it looks in the object's prototype to see if *legs* exists. If *legs* does exist, this is what is returned.

 NOTE: *The prototype object of a* class *is automatically created when an object of the type* class *is instantiated. You simply attach properties and methods to that prototype.*

It is tough to visualize a prototype. The simplest way to think of a prototype is as a window that lets you look into a class. Think of a prototype as an object that contains all properties that a class possesses (that is, those properties you assign the prototype) and lets you manipulate those properties. Another way to look at it: a prototype is a ticket that lets you enter into a class and look at, add, delete, or manipulate stuff in the class.

When Should a Prototype Be Used?

Even though the prototype is a powerful tool, it is best reserved for use in the following circumstances.

- Use prototypes when you want to make something unique that will remain constant for all instances of a class; that is, to make something inheritable (for example, *legs*).

- Use prototypes when you need to define an inherited *method* available to all instances of a class (for example, a *bark()* method for all dogs).

__proto__ and instanceof

Two other unique things you should be aware of are the *__proto__* property and the *instanceof* operator. These are examined in the sections that follow.

__proto__

The *__proto__* (two underscores on either side of the word *proto*) property is created automatically when an object is created. It is a reference to the prototype of that object's constructor function. The *__proto__* property is useful for checking whether an object belongs to a particular class or not. In Flash 5 it was extensively used to facilitate superclass and subclass inheritance scenarios. However, it is recommended that you use the *__proto__* property only for verification purposes. Essentially, *__proto__* is used by the Flash interpreter to access constructor prototypes internally. For example, if you wished to check whether an object belonged to a particular class, you might write the code shown in code example 2-4.

Code Example 2-4: Checking to See What Class an Object Belongs To

```
trace (Dog.prototype == myDog1.__proto__); //true
```

In code example 2-4, if the object's *__proto__* property is equal to the class's prototype, the *trace()* method will return *true*. Often you will want to see what class an object belongs to.

instanceof

The alternative way of checking whether an object belongs to a class in Flash MX is by using the *instanceof* operator. Examine the following code.

```
trace (myDog1 instanceof Dog); //true
```

This statement returns *true* if the object specified is an instance of the class specified.

Inherited Methods

To take inheritance a step further, you can even assign methods to the prototype object of a class. For instance, consider code example 2-5.

Code Example 2-5: Making Inherited Methods

```
//Dog Constructor
Dog = function (name) {
     this.name = name;
}
Dog.prototype.legs = "4";
//Inherited Method
Dog.prototype.bark = function () {
     return (this.name + " is barking!");
};
myDog1 = new Dog ("Bonzo");
trace (myDog1.bark()); //Bonzo is barking!
```

What is the benefit of doing it this way? This way you avoid making a *bark()* method for every instance generated from the *Dog* class. Instead, by assigning a *bark()* method to the prototype, you create the method universal to all *Dog* instances and let a *Dog* instance borrow the method from the class every time it needs to bark. This is yet another perk OOP offers.

Overriding and Overwriting

Overriding and *overwriting* are two terms common to programming that are used quite loosely. Although the difference is subtle, it is important to make a distinction between them, so as to understand more advanced concepts. Often you will hear or read these terms in OOP discussions or literature, and thus understanding such material requires understanding the terms.

Both overriding and overwriting are used in cases where unique instances of a class need to be generated. As you have already learned, classes can inherit methods or properties from other classes, the advantage of which is reducing the number of redundant methods or properties that exist in memory. When one class inherits its methods or properties from another, Flash traverses the OOP hierarchy to find the parent class that actually contains the method or property needed.

However, there are times when a specific instance of a class needs to have its own unique property setting or method, apart from that contained within the class. When you change a method or property of an instance to something different from that contained in the class, but which uses the same method or property name, it is called overriding—meaning you are overriding the original definition of the method or property within the new instance. Overriding ensures that the method or property is changed at the instance level, not at the class level.

So far, all of our "dogs" have their own names and four legs. Let's say, however, that Bonzo was a gifted dog and got one extra leg. How do you incorporate this in code? You have already defined that all dogs have four legs. Using this, you might write the following.

```
Dog.prototype.legs = "5";
```

However, this would make all dogs five-legged. This is not what you intend. You want only one particular instance to be five-legged. So how does OOP let you give Bonzo five legs without changing the number of legs for every dog? The answer is via overriding, an example of which is shown in code example 2-6.

Code Example 2-6: Overriding the legs Property

```
//Dog Constructor
Dog = function (name) {
      this.name = name;
}
Dog.prototype.legs = "4";
myDog1 = new Dog ("Bonzo");
trace (myDog1.legs); //4
myDog1.legs = "5";
trace (myDog1.legs); //5
//Overriding the legs property for myDog1
```

You originally gave all dogs four legs via the prototype. Here, however, the instance *"Bonzo"* is defined as having five legs. Again, this process is called *overriding*, which works because of the hierarchical nature of the OOP structure.

When you request the *legs* property, what Flash really does is look for the closest reference to *legs*. This implies that Flash will search for the *legs* property within the object itself, and if it does not find it there, will search in the object's parent. What if it does not find it in the parent? It looks in that parent object's parent, and so on.

The great thing about overriding is the fact that it does not write over the original property; in this case, the *legs* property common to all dogs. Overriding changes only one instance of the property. All dogs other than Bonzo (i.e, all other instances of the property) will have four legs. Code example 2-7 is another example of this, which shows that even after overriding the original number of legs for other instances of the *legs* property for *Dog* has not changed from four.

Code Example 2-7: Demonstrating the Power of Overriding

```
MyDog2 = new Dog ("Oliver");
trace (myDog2.legs); //4
```

Overwriting, on the other had, is destructive. To overwrite something means to change its value permanently. If you wanted to return Bonzo to his normal state (with four legs), you would overwrite his *legs* instance property so that he has five legs, as shown in code example 2-8.

Code Example 2-8: Overwriting a Property

```
myDog1.legs = "5";
trace (myDog1.legs); //5
```

Now Bonzo will have four legs for the remainder of the program, or until someone overwrites Bonzo's *legs* property again.

NOTE: *Code example 2-8 may look exactly like what is going on in code example 2-7, but there is a subtle but very important difference. In this case, you changed the instance property* legs *that was already "overriding" the property defined for the class. However, in the scope of the instance, this is permanent and hence it is called "overwriting." What you really did was "overwrite" an "overridden" property. The important thing to remember is that all other "dogs" still have four legs.*

Superclasses and Subclasses

Often, you need to share the methods and properties of a class with another class. One way of doing this would be to simply declare all methods and properties all over again for the new class. However, this uses excess memory and defeats the purpose of inheritance. To make use of inheritance you need to be able to inherit all methods and properties of a class into a new class, and then build onto the new class to customize it. This is entirely possible with OOP.

Let's use a new example for the next few concepts. Here, a class called *Shape* serves as the superclass for all shapes. Its subclasses would be the types triangle, rectangle, circle, and so on. Each of these subclasses may have subclasses of its own. For instance, right triangle and isosceles triangle would be subclasses of the type triangle. Superclasses and subclasses share a parent-child relationship. Hence, a child will have everything a parent has, and potentially more if specified by additional code. (See code example 2-9.)

 CD-ROM NOTE: *To follow along with the example file, open the file ch02_02.fla located in the fmxas/chapter02/ folder, installed from the companion CD-ROM. Examine the actions on frame 1. To view the output, select Control | Test Movie.*

Code Example 2-9: Superclasses and Subclasses Example

```
Shape = function() {}
Shape.prototype.method = function() {
   trace("New Shape created!");
}
Triangle = function () {}
Triangle.prototype = new Shape();
Triangle.prototype.method = function() {
   super.method();
   trace("New Triangle created!");
};
SubTriangle = function (name) {
   this.name = name;
};
SubTriangle.prototype = new Triangle();
SubTriangle.prototype.method = function () {
   super.method();
   trace ("New SubTriangle created!");
};
SubTriangle.prototype.getName = function() {
   trace ("New SubTriangle is a " + this.name + " triangle!");
};
myRightTriangle = new SubTriangle("right");
myRightTriangle.method();
myRightTriangle.getName();
```

Let's dissect code example 2-9. Let's begin with the first two pieces, shown in the following. Comments have been added to help you decipher what is happening.

```
//Shape Class
Shape = function() {}
//Shape Method
Shape.prototype.method = function() {
      trace("New Shape created!");
   }
```

First, a class named *Shape* is declared. All shapes will inherit from this class, making *Shapes* a superclass. Then the *Shape* class is assigned an inheritable method called *method*. This method simply traces a string, indicating that a shape has been instantiated. Then a class named *Triangle* is declared, as follows.

```
//Triangle Class
Triangle = function () {}
//Triangle Class inherits Shape Class
Triangle.prototype = new Shape();
```

Because *Triangle* is a subclass of the *Shape* class, it inherits (using the class's prototype object, defined as *new*) all of the *Shape* class's properties and methods. This usage of *new* in Flash MX's event model facilitates the creation of a subclass (see Appendix A for an explanation of the event model). You can then override the *Shape* class method *method* using the *super* keyword, as follows.

```
//Triangle Method
Triangle.prototype.method = function() {
    super.method();
    trace("New Triangle created!");
};
```

Here, *method* is also extended by adding a *trace()* method that indicates the instantiation of a *Triangle* object.

> **NOTE:** super *is Flash MX's answer to superclass and subclass inheritance scenarios.* super.method() *refers to the method of the parent class of the current object. It would be worth your time to read about* super *in the ActionScript dictionary that ships with Flash MX.*

Similarly, you could create a *SubTriangle* class, as follows.

```
//SubTriangle Class
SubTriangle = function (name) {
    this.name = name;
};
```

This class accepts an argument called *name*. Consequently, the *SubTriangle* class is simply a type of a *Triangle* object, and therefore inherits the *Triangle* class properties and methods by using the prototype object, as shown in the following.

```
//SubTriangle Class Inherits Triangle Class
SubTriangle.prototype = new Triangle();
```

You can then override the *Triangle* method *method*, as previously, via the following.

```
//SubTriangle Method
SubTriangle.prototype.method = function () {
      super.method();
      trace ("New SubTriangle created!");
};
```

As follows, you can then add a new method to the *SubTriangle* prototype object called *getName()*.

```
//Return name of SubTriangle
SubTriangle.prototype.getName = function() {
      trace ("New SubTriangle is a " + this.name + ¬
" triangle!");
}
```

This method returns the name of *SubTriangle*. This completes the coding. Now let's provide some code that will test it, as follows.

```
myRightTriangle = new SubTriangle("right");
myRightTriangle.method();
myRightTriangle.getName();
```

This code creates a right-angle triangle of type *SubTriangle* and passes it a name. The output would be displayed in the Output window as follows.

```
New Shape created!
New Triangle created!
New SubTriangle created!
New SubTriangle is a right triangle!
```

The *SubTriangle* class inherits the *Triangle* class, which in turn inherits the *Shape* class. Further, *SubTriangle*'s method *method* overrides *Triangle*'s method *method*, which in turn overrides the *Shape*'s method *method*. This is how the chain of objects works in OOP. It is very logical and very efficient. Although the example may seem simple, it is very important to understand how it works. It is foundational to being able to properly apply OOP logic and constructs to your Flash creations.

With this, you have covered most of the important concepts related to OOP in Flash MX. It is time to deal with the nitty-gritty hands-on details. Previous sections demonstrated the power of OOP. The remainder of this chapter applies the OOP model to real-world problems.

▪ ▪ ▪ Classes and Movie Clips

One of the toughest things about abstraction in Flash MX is figuring out how that abstraction relates to using Flash symbols with real data.

Previous examples work great in theory, but do not offer any functionality as far as real-world Flash MX development is concerned. One of the problems with the new event model lies in the way objects are instantiated. Flash MX incorporates a mechanism that facilitates the instantiation of a movie clip that inherits the methods and properties of a class. Let's examine what this means.

Imagine you have a *Ball* class with a set of defined methods and properties (similar to that used in code example 2-9). You also have a movie clip with a ball graphic you want to use in conjunction with this class. How do you write the code such that the movie clip uses the methods and properties declared in the *Ball* class?

The recommended way of doing this is to use the *#initclip* and *#endinitclip* pragmas in combination with the *object.registerClass* method. If you do not know what this means, do not worry. This is a completely new concept, examined for the first time in the section that follows.

> **NOTE:** *A pragma is a standardized form for a comment (usually in some specific syntax) that has special meaning to a compiler or interpreter. In Flash, the code words that begin with the pound sign (#), such as #include and #initclip, are pragmas that provide special functionality. #include is for including external script files in a Flash movie, whereas #initclip and #endinitclip let you immediately instantiate and use an object.*

Associating a Movie Clip with an Object Class

This example will teach you how to associate a class with a movie clip using the *#initclip* and *#endinitclip* pragmas in combination with the *object.registerClass* method.

> **CD-ROM NOTE:** *To work along with the tutorial, open the file ch02_03.fla located in the* fmxas/chapter02/ *folder, installed from the companion CD-ROM. The completed example is in the same folder and is named ch02_03s.fla.*

Once you have your starter file open, make sure there is a movie clip named *ball* in it. The *ball* movie clip should contain only the graphic of a ball. You should also see a text field named *output* on the stage. You will be using this text field to output the mathematical areas of the *ball* objects.

Building a Class Within a Movie Clip

You will first build the *Ball* class and declare its methods and properties in the *ball* movie clip. Double click on the *ball* movie clip in the library, select

the first frame on its timeline, and go to the Actions panel. Make sure you are in expert mode (use the View Options button to toggle between modes). Type the code shown in code example 2-10 in the Actions panel to create the first frame of the *ball* clip.

Code Example 2-10: Adding the Code to the ball *Movie Clip*

```
#initclip
function Ball () {}
Ball.prototype = new MovieClip();
Ball.prototype.getR = function() {
     return this._width/2;
};
Ball.prototype.getArea = function () {
     return (this.getR() * this.getR() * Math.PI);
};
Ball.prototype.onPress = function () {
     this.startDrag();
     _root.output = Math.round(this.getArea());
};
Ball.prototype.onRelease = function () {
     this.stopDrag();
     _root.output = "";
};
Object.registerClass ("ball", Ball);
#endinitclip
```

NOTE: *As you enter this code, make sure you enter it as present-ed. Do not forget punctuation, such as the semicolon that follows the curly brackets. Flash, like most programming environments, is very unforgiving as it relates to syntax errors.*

Before proceeding, let's examine what you just did. Note the opening line, which follows.

```
#initclip
```

This is a new pragma available in Flash MX. Prior to MX, if you instantiated an object (created a movie clip using *attachMovie()* or *duplicateMovieClip())*, you would have to wait for the next frame of the movie to use its methods. *#initclip* allows you to overcome that hurdle. It tells the Flash interpreter to load the class before the first frame of the movie, whereby the class's methods become available to you immediately at runtime, with no waiting.

 NOTE: *There are a few nitty-gritty details you need to know about #initclip. You are encouraged to visit the* ActionScript Reference *within the Flash application to learn more about it. Although this method is used primarily with components, it can also be used quite effectively with classes.*

The next two lines should look familiar to you (comments have been added to the code to help).

```
//Ball Class
function Ball () {}
//Inherit MovieClip Class
Ball.prototype = new MovieClip();
```

The first line is the *Ball* constructor. This creates instances of the *Ball* object when the movie clip is loaded onto the stage. Then, the *Ball* prototype object is used to inherit the *MovieClip* class methods and properties (subclass and superclass scenario). In essence, the *Ball* class inherits all of the already existing methods and properties from Flash's built-in Movie Clip object, so you need not manually program the functionality inherent to the Movie Clip object. The next section, as follows, is an inherited method that returns the radius of a ball.

```
//Find Radius of ball
Ball.prototype.getR = function() {
     return this._width/2;
};
```

Later in your movie you can call the *getR()* method from *ball* instances. The next section, as follows, is an inherited method that returns the mathematical area of a ball.

```
//Inherited event method to calculate area
Ball.prototype.getArea = function () {
     return (this.getR() * this.getR() * Math.PI);
};
```

Like *getR()*, you will be able to extract the area of a ball instance by calling the *getArea()* method. The following code creates an inherited event method for the *onPress* event (when the mouse is clicked on the movie clip).

```
//Inherited event method to update text field on stage
Ball.prototype.onPress = function () {
     this.startDrag();
     _root.output = Math.round(this.getArea());
};
```

This event method toggles the dragging of the current *ball* object to On, and sets the area of the current ball in the text field on the stage. Each ball instance will also have an inherited event method for the *onRelease* event (when the mouse is released on the movie clip), as follows.

```
//Inherited event method to stop drag and update
text field
Ball.prototype.onRelease = function () {
     this.stopDrag();
     _root.output = "";
};
```

This event method toggles the dragging of the ball object to Off and sets the text field to empty. The following statement uses the *registerClass()* method and associates the *ball* movie clip symbol with the ActionScript object class (the *Ball* class).

```
//Register the Ball class with the ball clip
Object.registerClass ("ball", Ball);
```

The last line, as follows, is the closing pragma for *#initclip*.

```
#endinitclip
```

This line denotes the point where the ActionScript interpreter should stop preloading the class. To add the code to the first frame of the movie, you would type the code shown in code example 2-11 in the Actions panel in the first frame of the main movie timeline.

Code Example 2-11: Adding the Code to the First Frame of the Movie

```
function init() {
     for (i=0; i<10; i++) {
          myRandomX = Math.random()*200;
          myRandomY = Math.random()*200;
          myRandomScale = Math.random()*200;
          attachMovie("ball", "ball"+i, i);
          this["ball"+i]._x = myRandomX;
          this["ball"+i]._y = myRandomY;
          this["ball"+i]._xscale = myRandomScale;
          this["ball"+i]._yscale = myRandomScale;
     }
}
init();
```

An in-depth understanding of the syntax of the initialization code you just typed is not important. Basically, this syntax creates 10 instances of the ball movie clip and assigns a random position and random size to each instance. If you want to view what this code accomplishes, select Control | Test Movie. You can move the balls around to see how the field is updated and how the drag and drop works.

Underlying Concepts

You just learned one of the most crucial implementations of OOP in Flash MX. This technique for creating content in Flash MX serves as the backbone of Flash application development. Let's review what you just did in simple English.

In the first step, you created the *Ball* class in the movie clip's first frame. You declared several inherited methods, event methods, and properties for a *ball* object. You then associated the class with a movie clip using the *registerClass* method. You performed all of this initiation within the *#initclip* and *#endinitclip* pragmas, so that Flash would at runtime load the class before anything else.

In the first frame of the main timeline, you instantiated 10 *ball* objects using the *attachMovie()* method. However, when you did this, something occurred in the background that you did not know about. When you instantiated the ball objects using the *init()* function, they automatically inherited the *Ball* class's states and behaviors. This is due to the way you set up the *Ball* class within the movie clip. The following are necessary for this process to work correctly.

- The class must be declared on the first frame of the movie clip associated with it.

- The linkage properties must be set appropriately (to access the linkage properties, right-click on the movie clip symbol in the library and select Linkage from the Content menu).

This would probably be a good time to shed some light on the Linkage dialog box. When you create a movie clip, Flash asks you to define its linkage properties. These affect the way the movie clip will be treated when the movie is exported or used in other movies. The Linkage dialog box appears often in Chapter 7. For now, you need to ensure that your linkage dialog looks similar that shown in figure 2-4.

Figure 2-4. The Linkage dialog box settings required for the scenario to work correctly.

■ ■ ■ **Using addProperty()**

This section introduces another powerful new feature Flash MX offers in regard to *getter* and *setter* functions. Getters and setters are properties available to objects. Getter properties return some property of an object, whereas setters set a value for an object's property. The neat thing about getters and setters is that they use the same keyword to perform both tasks. Examples of getter and setter properties are *_alpha, _x,* and *_xscale.* Typically, all properties that begin with an underscore within Flash are getters and setters. However, there are a few that cannot be set.

NOTE: *See table 1-1 of Chapter 1, which outlines which properties cannot be set.*

The *addProperty()* method is a nifty little addition to Flash MX's large repertoire of new features. Whenever you use getters and setters, you simply refer to them as properties. For instance, *_alpha* can get the current alpha level of a symbol, as well as set it to something new. So, why should we have to do something like *getArea()* to get the area of an object? Why not just set it up so that it is as easy as changing *_alpha* or *_x;* that is, accessing and setting *_area*? In Flash MX you can now use the *addProperty()* method to set methods to behave as getters and setters, as demonstrated in code example 2-12.

CD-ROM NOTE: *To follow along with the example file, open the file* ch02_04.fla *located in the* fmxas/chapter02/ *folder, installed from the companion CD-ROM. Examine the* addProperty() *usage in the* ball *movie clip.*

Code Example 2-12: Using the **addProperty()** *Method*

```
//Changing a method to behave like a getter property
Ball.prototype.addProperty('_area', Ball.prototype.¬
getArea, Ball.prototype.setArea);
```

As long as you have two properly defined methods (such as *Ball.prototype.getArea* and *Ball.prototype.setArea*), *_area* will behave like any other getter or setter property available within Flash MX. The general usage (as described in the ActionScript Reference in Flash MX) is as follows.

```
myObject.addProperty(prop, getFunc, setFunc);
```

Note the following about this line.

● *prop* is the name of the object property to be created.

- *getFunc* is the function invoked to retrieve the value of the property. This parameter is a function object.

- *setFunc* is the function invoked to set the value of the property. This parameter is a function object. If you pass the value *null* for this parameter, the property is read-only.

What does this mean? Now you can use *_area* as if it were like any other getter or setter property. For instance, the following would set the *_area* of *myBall* to 50.

```
myBall._area = 50;
```

Similarly, the following would output the area of *myBall* to the Output window.

```
trace (myBall._area);
```

You should get into the habit of using this technique wherever applicable, as it helps to differentiate properties from methods in the objects you construct. It also becomes more important when you need to use getters and setters frequently.

▪ ▪ ▪ Building Custom Prototypes and Extending Existing Ones

You must already be excited about how OOP works in Flash, because it gives you a chance to create extremely powerful and reusable classes. OOP implementation also allows you to expand on the available built-in Flash objects, such as the Math object, the Array object, and so on. There are a few intricacies involved, but on the whole it is very simple. Let's create a simple custom method for the Math object that converts degrees to radians. The code for doing so follows.

```
Math.radian = function (degrees) {
     return (degrees * Math.PI/180);
};
```

This method would be called in the following manner.

```
Math.radian(180); //result - 3.14159265358979
```

However, this will not work with, for example, the Movie Clip object. To see why, let's create a custom method for the Movie Clip object that finds the distance between two clips on stage. Code example 2-13 shows what the code would look like.

Code Example 2-13: Creating a Custom Prototype Method for the Movie Clip Object

```
MovieClip.prototype.distance = function (tc){

    var dx = Math.floor (Math.sqrt(((this._x - tc._x) ¬
* (this._x - tc._x))));
    var dy = Math.floor (Math.sqrt(((this._y - tc._y) ¬
* (this._y - tc._y))));
    distance = dx + dy;
}
```

The only difference this method and the previous is the manner in which it is declared. The difference is that some objects require instantiation in Flash before they are used, whereas others do not. For instance, the Array object is used in the following manner.

```
myArray = new Array ();
```

If you needed to create a custom method for the Array object, you would have to declare it as follows.

```
Array.prototype.myMethod = function ([args]) {
        //code
}
```

On the other hand, if you are dealing with an object such the Math object, for which you call methods simply by coding *Math.sin()* (where instantiation is not required), you need to declare the method as follows.

```
Math.myMethod = function ([args]) {
        //code
}
```

If you run into problems extending a built-in Flash object, it is likely because you are declaring it in the wrong way. Be aware of whether the object requires instantiation or not, as this affects the approach to declaring additional methods or properties.

▪ ▪ ▪ **Summary**

In essence, this chapter covered most of the important aspects of intermediate to advanced OOP concepts implemented in Flash MX. However, the nature of OOP allows refinements to implementations and provides for better algorithms, which in turn add to the beauty of OOP-based code.

Although this chapter is intended to refine your thinking about application development, you should remember that this is simply one methodology for implementing OOP techniques in Flash MX. Other developers will argue in favor of their way of using OOP. In fact, the best way is the one that suits you.

Regardless of which methodology or techniques you employ in your development cycle, the thing to remember is that you must use the appropriate approach for the task at hand. There are still numerous scenarios that would work as efficiently if they were coded using the Flash 5 event-driven methodology. We encourage you to research online, as well as use other books and resources to gain more experience with OOP in Flash MX. This will be time well spent, and you will reap the benefits quickly.

3

Working with Arrays

▪ ▪ ▪ ▪ Introduction

Chapter 1 reviewed ActionScript basics. In that chapter you were provided with a basic overview of the three types of variables available in Flash, as well as the various types of data that can be stored.

However, what if you want to track a collection of values related to one another? For example, what if you wanted to keep track of the names of a series of movie clips so that you could randomly choose one of the movie clips at a later point in the movie? How would you do it?

Indeed, you could use a series of variables whose names are numerically incremented (such as *animal1, animal2,* and *animal3)* to perform this. As a matter of fact, prior to Flash 5, tracking interrelated data was done exactly this way, because Flash 4 did not support arrays. However, in implementations such as this you invariably end up with a superfluous collection of variables floating in the digital ether—all of which you have to manually keep track of. Without arrays, tracking collections of data becomes rather laborious.

Whenever you have a collection of data, there is usually some type of relationship among the data. In arrays that contain a single attribute, you usually track the order of the objects, and thus the order constitutes the relationship. In much larger arrays, in which you track numerous characteristics about an object, usually one of those characteristics links all of the data. Such arrays are called *databases*, and the shared characteristic is referred to as the *key* or *database key*. In some cases, the key may be some ordinal characteristic, or it may be something totally different.

Nevertheless, most arrays in programming are used to store a single characteristic of an object, such as its name, related to the order of something. Such arrays are called *linear arrays,* the most common type of array. Linear arrays are frequently used as look-up tables to link something to something else. However, the important thing to remember about linear arrays is that they are *ordinal*, which refers to the fact that they are used to track order.

A second type of array, called an *associative array,* allows you to store name and value pairs. In most environments, associative arrays are useful for tracking pairs of values as well as order. An example might be if you created a list of first names and last names. In such an array, you could retrieve a first name based on a last name, or vice versa, and you could determine the first name and last name in a certain position in a list. Associative arrays, therefore, give you the ability to track three things: a name, a value, and a position.

Finally, a third type of array, called a *multidimensional array,* also exists in most programming environments. With these types of arrays you can store multiple characteristics about a single object, allowing you to simulate virtually all capabilities found in most database software packages.

In this chapter, you will examine the various aspects of arrays and their use. As you progress through this chapter, you will familiarize yourself with the Array object, as well as its methods and property. In the process, you will explore arrays in depth, including how they are used. The Array object is fundamental to many of the processes described in subsequent chapters, and you will see them integrated into many of the exercises. Pay special attention to the content in this chapter and make sure you understand how the methods work, as this will be key later on.

▪ ▪ ▪ Objectives

In this chapter you will:

- Examine what arrays are, as well as how and why they are used
- Learn about direct versus indirect population and access
- Find out about linear and associative arrays in Flash
- Discover the methods designed for creation, extraction, manipulation, and sorting
- Learn about the basics of recursion and how recursive functions can be used in Flash
- Uncover advanced techniques for utilizing arrays in your projects

▪ ▪ ▪ **What Are Arrays?**

As stated, an *array* is a collection of related data stored under a single variable name. There are two analogies you can use to describe an array, depending on your background. You can think of an array as a single-column spreadsheet or as a single-column database.

Whichever analogy you use, in both cases an array stores multiple values that are usually related to one another in some way. The individual pieces of data are numbered and form the rows in the column, much like a spreadsheet or database. As you add pieces of data to the array, they are strictly numbered, beginning from 0 and incremented as subsequent rows in the column. The row number is called the *index* of the array, and you use the index number to retrieve data from the array. You can also use the index to insert data into or extract data from a specific location in the array.

Let's work with an example that makes the point. Arrays are nothing more than an extension of what many of us use on a daily basis; that is, a list. As a matter of fact, some programs (such as Director) call them just that. A commonly used "array" is a grocery list. Figure 3-1 shows a graphical representation of a basic grocery list. Note that the index numbers begin at 0 and progress through the number of items in the array.

Index #	grocerylist
0	"milk"
1	"bread"
2	"carrots"
3	"potatoes"
4	"ice cream"

Figure 3-1. A graphic representation of a grocery list "array."

As shown in figure 3-1, a grocery list might contain five items. If you wanted to pull an item out of this "array," you would simply need the name of the array *(grocerylist)* and the position *(index)* in the array. For example, *grocerylist(3)* would give you the string "potatoes." As you will learn later, you can also use a *for* loop to retrieve the index number of a particular value. In this way, you can use an array to track order.

One of the main things to keep in mind is that arrays always begin with 0. Therefore, if you have a list whose last index number is 4, you know that the length of (number of items in) the array is 5. All indices (whether arrays in ActionScript, JavaScript, or other languages; arrays for images or form controls in HTML; or pixel references in bitmap images) begin counting from 0.

A nice thing about arrays is that their content is dynamic. You could easily add an item to the grocery list. By default, the item would be added to the end of the array. However, you could force the added item to be placed at index position 0 (or any other position). If you where to do this, you could either displace each of the remaining array elements by one

position or directly replace the content at position 0. In this regard, arrays are extremely flexible. In addition, just as you can put an element in an array at any position, you can remove an item altogether, from any position.

Arrays provide several other unique capabilities, as compared to working with a series of consecutive variables, as described at the beginning of this chapter. When you use arrays in your coding, you can add items to the array (as you have already seen), sort the array, pull out sections of the array, and combine arrays to create new arrays. You can also manipulate the data in a variety of ways. Examples later in this chapter will highlight how to manipulate array data in each of these ways.

A final note about arrays is that there may be times when you will want to insert various types of data into an ActionScript array. Although you normally do not have to worry about data types in Flash (except when sending data to a particular method or property that is expecting to receive data in a particular form), realize that you can create an array that contains a mix of numbers and strings in the various index positions. In other words, you can have a single array that stores numbers, strings, and object references concurrently. Additionally, you can create arrays of arrays, which yields a multidimensional array.

Why Use an Array

The biggest advantage of using arrays is that with them you can track, sort, and manipulate a series of data elements. Although arrays are usually "utility" elements in programming—that is, they are not extremely interesting to examine as a standalone concept or element—but without them, many of the advanced ActionScript techniques would be much more difficult.

Many times arrays will be used to track elements in your movies and will serve as a lookup table of sorts. For example, you could use an array to track the names of a series of movie clips and the order in which the clips were created. Another example would be to use an array to record all of the labels and their order of occurrence within the movie. In both scenarios, the array is tracking the order of something. This is the primary purpose of linear arrays: to track the order of something in relation to something else, such as time or a group of other elements.

Although you will review FLA array examples later in this chapter, you first need to understand why arrays are important at all. In the case of tracking the names of a series of movie clips, imagine you are using the *duplicateMovieClip();* method to create multiple instances of a particular object within a game or other application. An array could be used to keep track of the instance names of the movie clips (or, in fact, any other prop-

erty associated with those objects). In this case, you would be keeping track of the order of creation by name. Thus, you could use an array to determine the instance name of the third movie clip created. You could also reverse this and determine, for example, when (in regard to order of creation) the movie clip named *lilac* was created. Thus, you can use arrays to find a value based on array position (index) or to find a position (index) based on value.

Let's review one more example. Imagine you use an array to keep track of all label names in a movie, so that you can more easily create "next" and "previous" buttons to go "to and from" the next and previous labels. Although you could set this up using named anchor frame labels, you can also create it using an array. In this scenario, you could use the array to determine what the next label is (based on the current label's index number plus 1), or to determine what the previous label is (based on the current label's index number minus 1).

This minor operation would actually utilize the array in both ways to perform the lookup operation. It would have to look up the index based on a value (the value would be the name of the current label). Then you would extract the value based on the current index plus 1, or the current index minus 1, to get, respectively, the next or previous label name. Again, later in this chapter you will see examples of both.

When to Use an Array

As you begin working on advanced Flash movies, one of the things you need to realize is that often it will appear that an array is the appropriate way to accomplish a task. Indeed, arrays provide quick means of recording and looking up values. However, be clear on the use of arrays. Often, those new to programming encounter a particular problem and believe that an array is needed.

Frequently, instead of using arrays (to serve as lookup tables), it is more appropriate to use math to solve the problem. Generally, whenever the values in the array are pattern based you should consider whether an algorithm or expression could be generated, instead of using an array. Often you may find that a simple linear transformation or other type of mathematical formula is more efficient than an array. As you progress through this book you will begin to develop a sense for when each is appropriate.

Array Methods and Property

As you progress through the rest of this chapter, you will find that the Array object provides several methods and a single property. The only property

for arrays is *length*, which simply tells you how many items are in the array. The only trick to the *length* property is remembering that the length is the last index of the array plus 1, in that arrays begin counting at 0.

Of importance here, however, is that you understand that the Array methods fall into one of four categories, based on purpose. Methods for the Array object are designed for creation, extraction, manipulation, and sorting. Table 3-1 outlines the available methods that will be discussed throughout the rest of this chapter.

Table 3-1: Array Methods

Category	Method	Description
Creation	concat()	Concatenates the content of two arrays into a single array without destroying the original arrays
	slice()	Extracts a section of an array and makes it a new array without affecting the original array
String Extraction	join()	Concatenates the values in an array into a single string value and allows a separator element to be specified and inserted between array values; does not affect the original array
	toString()	Concatenates the values in an array into a single, continuous string value; the original array remains intact
Manipulation	pop()	Removes the last item from an array and returns its value
	push()	Adds one or more elements to the end of an array and returns the new length
	shift()	Removes the first element from an array and returns its value
	unshift()	Adds one or more elements to the beginning of an array and returns the new length
	splice()	Adds or removes elements from any position within the array
Sorting	reverse()	Reverses the direction of the array
	sort()	Sorts an array in either ascending or descending order, or with a custom order function
	sortOn()	Sorts an array based upon a field name within the array

▪▪▪ Array Creation

Now that you understand why arrays are beneficial and when they should be used, let's begin looking at how to create them. To begin using arrays, the first step is to define the array, by instantiating it. You then populate the array with data. There are several means of performing these two steps. The sections that follow briefly describe methods of creating arrays.

Array Instantiation

Arrays can be created in one of two ways. The first is called the *direct* method because the items to be in the array are specified directly within the Array object at the time of instantiation. The second method, the *indirect* method, instantiates the Array object and then adds the content of the array, one at a time. There are four general forms for instantiating an array, as follows:

```
variablename = new Array();
```

or

```
variablename = [];
```

or

```
variablename = new Array(value1, value2, value3,...valueN);
```

or

```
variablename = [value1, value2, value3...valueN];
```

The first two lines of code show indirect instantiation, the first of which uses the new keyword and the second of which uses the shorthand bracket method. The second two lines of code show direct instantiation. Again, the first uses the new keyword and the second uses brackets.

Once a variable contains an instance of an object, you can access or call upon the object methods or properties using the variable, such as

```
variablename.reverse();
```

or

```
variablename.length
```

> **NOTE:** *You can also create an empty array with a specific number of elements by specifying the number of elements to be in the array as the argument for the* Array(); *method, such as*
>
> ```
> myarray = new Array(17);
> ```

This would create an array with 17 null values, indexed from 0 to 16. You could then use the indirect method to assign values to those 17 blank positions.

Direct and Indirect Techniques

Now that you have investigated Array object instantiation, let's begin by looking at the direct method, in which you instantiate and populate an array concurrently. For the example, let's continue to use the grocery list discussed earlier. Let's say you have five items on your list. To create an array for this, you could write:

```
grocerylist = new Array("coffee", "milk", "potatoes", ¬
"flour", "chocolate");
```

Note in this line of code that you are directly populating the array by passing the array elements as string arguments. Note that the content of an array can also be numerical, such as the following.

```
mylist = new Array(1, 2, 3);
```

Arrays can also be used to store a list of object references, as in the following.

```
myobjects = new Array(_root.MC1, _root.MC2, _root.MC3);
```

Although any of these lines of code is a valid method of creating an array, it is not necessarily the preferred method. The direct method is usually quite limited because it creates a "hard-wired" array; that is, the *grocerylist* array will always begin with "coffee," "milk," and so on and *mylist* will always begin with 1, 2, and 3. Indeed, when you have a list of constants you want to keep track of, the direct method may be applicable. However, when you use arrays you typically want the array to be wholly dynamic; that is, all content of the array generated dynamically. In these cases, the indirect method is much more applicable. Let's take a look.

Using the indirect method of creation, you begin by instantiating the array and assigning it to a variable. You then use the array access brackets to assign values to the array positions. This type of data access is called *bracket access*. The grocery list analogy is still valid. However, this time the content for the list will be added using indirect population:

```
grocerylist = new array();
grocerylist[0] = "coffee"
grocerylist[1] = "milk"
grocerylist[2] = "potatoes"
grocerylist[3] = "flour"
grocerylist[4] = "chocolate"
```

Notice in this example that the content of the array is added as a separate operation from the instantiation of the array. Because this is possible, once the Array object had been instantiated, it was possible to populate the *grocerylist* with anything. Similarly, it could be populated or added to at any time in the movie.

Often arrays are instantiated and then populated (or repopulated) at various points in a movie, which you will see examples of later in this chapter. However, for now, simply note the difference between the direct method (in which instantiation and population occur concurrently) and the indirect method (in which instantiation and population occur independently and, potentially, at different times).

Creating Arrays from Other Arrays

In addition to being able to generate arrays from scratch, you can also use two unique array methods, *concat()* and *slice()*, to combine already existing arrays or to extract part of an array as a new array. The next two sections describe these methods in more detail.

concat

The *concat()* method allows you to concatenate the values of two arrays into one array. In essence, the values in one array are "added to the end" of the other and placed into a new array. To some extent you can think of it as a way of merging two arrays into one (creating a master array, as it were). However, note that the *concat()* method is not destructive; that is, the two original arrays remain intact. For example, let's say you have two arrays of playing cards (where *h* is hearts, *d* is diamonds, *s* is spades, and *c* is clubs), as in the following.

```
deal1 = new Array("10h", "4d", "2d", "5s");
deal2 = new Array("9h", "2c", "4s", "8d");
```

Thus, using the *concat()* method you could quickly generate an array that merges the two arrays, as follows.

```
dealtlist = deal1.concat(deal2);
```

Here, the content of *dealtlist* would be:

"10h", "4d", "2d", "5s", "9h", "2c", "4s", "8d"

If you reversed the concatenation to append *deal1* on *deal2*,

```
dealtlist = deal2.concat(deal1);
```

would result in:

"9h", "2c", "4s", "8d", "10h", "4d", "2d", "5s"

slice()

Similar to *concat()*, *slice()* can also be used to create arrays. However, instead of combining the content of two arrays, *slice()* extracts a consecutive set of values from an array and creates a new array without destroying the original array from which the values are extracted. The general form for the *slice()* method is:

```
newarray = array.slice(start, end);
```

Here, *start* is the index value where you want to start the extraction and where *end* is the ending point for extraction. When you use *slice()* the resulting array will include the item at index *start*, but will not include the item specified by *end*. In essence, the extraction goes up to, but does not include, the index represented by *end*. When using *slice()*, remember that array indices begin at 0. Thus, both the *start* and *end* are usually one value less than normally thought. That is, for example, if you want to start with array item 2, the array index number is 1. If you want to end with array item 6, the array index number is 5, and so on.

 NOTE: *The most important thing to remember about the* slice() *method is that it does* not *include the* end *value in the slice.*

For example, imagine you wanted to extract content from the *dealtlist* array generated in the last section to create a new array. Table 3-2 specifies the results of various slices of the *dealtlist* array, where:

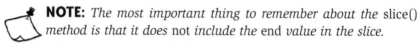
```
dealtlist=["9h", "2c", "4s", "8d", "10h", "4d", ¬
"2d", "5s"]
```

Table 3-2: Results of Various dealtlist *Array Slices*

Code	Resultant *subdlist* Content
subdlist=dealtlist.slice(2,5)	"4s", "8d", "10h"
subdlist=dealtlist.slice(0,5)	"9h", "2c", "4s", "8d", "10h"
subdlist=dealtlist.slice(5,6)	"4d"
subdlist=dealtlist.slice(0,7)	"9h", "2c", "4s", "8d", "10h", "4d", "2d"

TIP: *Because* concat() *and* slice() *are both nondestructive methods (i.e., they do not destroy the original arrays from which they are generated), it is important that you pay attention to the number of arrays you have floating around in the digital ether. If you use con-cat() or slice(), you should consider whether or not you still need the original arrays from which they are created. If you do, just keep in mind that the original arrays require a certain amount of memory and will exist until you delete them. If you no longer need the*

original arrays, use the delete *command to get rid of them to free up more memory for other things.*

 NOTE: *Later in this chapter you will see an example of the* concat() *and* slice() *methods in use, after discussion of accessing elements in an array.*

Automatic Population Using Loops

Many times arrays are used to track objects or some other numerically related attributes. Anytime you start working with a lot of data, particularly if it is (or can be) numerically represented, you should think about ways you can automate the population of the data using a *for* loop. Having to indirectly populate an array with a lot of values manually can be monotonous. Therefore, you should always look for ways to make your programming tasks more efficient. Let's look at a couple of examples.

The first example involves a deck of cards because this type of object is most appropriate for using a *for* loop to populate it. Later in this chapter you will see e simulation of cutting, shuffling, and dealing (legally and illegally) the deck. For now, let's just focus on creating a new, unshuffled deck of cards.

In this process, you will use a numbering system to represent the cards as well as the suit for the card. Note that if you want to use a *for* loop for automatic population you must generally reduce whatever it is you are trying to represent to a number-based system. In this example you will let the ace equal the string *"0"*, the numbered cards represent strings of their standard numbers minus 1, the jacks equal the string *"10"*, the queens equal the string *"11"*, and the kings equal the string *"12"*.

As for the suits, let *"0"* equal clubs, *"1"* equal diamonds, *"2"* equal hearts, and *"3"* equal spades. To make life easier when it comes time to decode this system later in the chapter, you will represent the suit and then the card. Thus, using this representation system, the king of hearts would be *"212"*, the 2 of spades would be *"31"*, and the ace of diamonds would be *"01"*.

There are two things to acknowledge before we continue. First, you will note that this begins at 0 within the numbering system, even though the temptation is to skip the 0 position and begin with the 1 position. This is done so that the array is completely populated from 0. Some implementations of arrays skip the 0 position and instead begin with 1. The only problem with this is that the array's length is then not truly representative of the content in the array, which will be important later.

 TIP: *To better illustrate this problem, imagine creating an array and placing a single element into it at index position 1 (skipping position 0). If you use the length property to determine the length of the array you will find that the length is reported as 2, even though we have only one value in it. Skipping values in arrays is often problematic, and is sloppy at best. Thus, do it by the book and always begin at 0.*

The second thing to note about the numbering system for the cards is that you will use string representations of numbers within the array to represent the cards and the suits. This is done because if you represent them as true numerical values the ace of clubs will be reported as 0 instead of "*00*". Similarly, the 2 of clubs (as well as all the other cards) would be returned as 0. Because you want one of the string positions to represent the suit and the other position to represent the card, you must store them as strings so that in all cases where the suit is clubs ("*00*", "*01*", and so on) you can decipher both suit and card.

Now let's investigate how to populate the array using a *for* loop. In this scenario, you want to populate 52 cards for four suits. Knowing this, and what a *for* loop can do, you can quickly populate the deck using the script presented in code example 3-1.

Code Example 3-1: Script for Linearly Populating the Deck of Cards

```
function init() {
 mydeck = new Array();
 var deckpos = 0;
 for (var suit=0; suit<=3; suit++) {
  for (var i=0; i<=12; i++) {
   mydeck[deckpos] = String(suit)+String(i);
   deckpos += 1;
  }
 }
}
```

Let's review this function a little. It assumed that this array would be used from the start of a movie. Thus it is set up so that it is part of the initialization of the movie—that is, *init()* is called when the movie is started. Generally you should strive to place all initialization routines in one place—preferably the first frame of the movie.

The first line of code in the function instantiates the Array object. The second line creates a variable named *deckpos*. This keeps track of the posi-

tion at which the next card should be placed in the deck. Because you are simply placing the cards into the deck in a linear fashion, the *deckpos* variable is incremented each time a card is inserted into the deck. Note that it is incremented within the innermost *for* loop (*deckpos* + = 1).

 TIP: *Remember that* deckpos + = 1 *is the same as* deckpos = deckpos + 1.

In regard to the loops, the first loop controls the suit number and the second loop controls the card generated. By having one loop inside the other, it picks a suit, populates that suit with 13 cards; picks the next suit, populates it; and so on. When it gets to the fourth suit (where *suit* equals 3), the loop ceases.

Note the following line.

```
mydeck[deckpos] = String(suit) + String(i);
```

This line is where *mydeck* is actually populated using the indirect method. Note that the string representation of *suit* (the card's suit, which ranges from 0 to 3) and a string representation of *i* (representing card number, which ranges from 0 to 12) are concatenated and placed in the position *deckpos* (which extends from 0 to 51).

One of the things you should note in code example 3-1 is that the variables preceded with *var*, which are local variables, will be automatically deleted once the function ceases. The variable *mydeck* will be the only variable that remains and it is a timeline variable. Keep in mind that if this code snippet was not in function, the *var* keyword would have no effect.

 CD-ROM NOTE: *To see an example of this code running, open the file* ch03_01.fla *in the* fmxas/chapter03/ *folder, located on the companion CD-ROM.*

 NOTE: *As you review the example from the previous CD-ROM Note, look at how the code is structured. The* init() *function is in the uppermost layer, named* Global *(meaning global scripting). The function* frame *is the layer named* State *(meaning state scripting).*

Strings, Numerals, and the Output Window

Before moving on to extracting data, you need to understand the negative points of working with arrays and other variables in Flash. As stated, there are two main types of data in Flash: strings and variables. A common practice when scripting movies is to use the Output window to check the value contained in a variable or in an array. This is sometimes done just to check the status or value in the variable and, more importantly here, sometimes to see whether the data is a string or numeral. You could use the Debugger

(and some people do), but to check something small, such as a single variable, the Debugger is more than you need.

You might find yourself trying to write or debug code, wanting to see if a variable contains a string (identified by double quote marks) or numerals. Yet, one of the problems that exists in Flash is that when you use *trace()* to output data to the Output window it does not show the quote marks around string data. Thus, it is in essence useless in making this determination. Thankfully, when viewing the Variables tab in "debug" mode (Control | Debug as opposed to Control | Test Movie), it does show a differentiation between strings and numerals.

Extracting Data

Now that you have examined the basic methods of creating arrays, let's examine how to extract data once an array is set up. In this section you will explore how to use the array index to retrieve values, how to reassign values, and how to test against array values using the array index.

Retrieving Values

Retrieving values from an array is pretty straightforward. As you have seen, you assign values to an array by setting up an expression using bracket access. For example, earlier you assigned a value to a position in the *mydeck* array using:

```
mydeck[deckpos] = String(suit) + String(i);
```

Knowing this, you should be able to deduce that you can extract a value from an array by simply "informing" the application of the array and the index number without any assignment operator. For example, the following code would allow you to find out what value was in the array at index position 2 by having it print to the Output window.

```
trace( mydeck[2] );
```

However, outputting it to the window is not very useful. Usually you will set up an expression and place the content of an array position into a local variable, such as:

```
var temp = mydeck[2];
```

Or, you may want to test against the value in an array position, such as:

```
if ( mydeck[2]!=null) {
  //code for what to do if mydeck[2] is not null
}
```

As you can see, accessing array values is relatively simple. You can extract a value from any array if you simply know the array name and the index number. Note that if you request a value from an array index position that currently has no data, the output is *null*, or no value available.

Arrays Within Arrays

When you work with arrays, regardless of how you populate them, you can nest arrays within one another and then use bracket access to access any part of the array structure. For example, consider the following code.

```
mylist1=["glue", "scissors", "paper", "pencils", "erasers"]
mylist2=["paint", "brushes", "chalk", "knife"]
mylists=[mylist1, mylist2]
```

In these lines of code, what you are actually doing is nesting two arrays into a third array. Once the "master" or combined array is created, you can access any of the data points in the structure using compound bracket access, as outlined in table 3-3, which follows. Although it is not extremely common to use such structures, there are instances in which it may be helpful to nest a set of arrays into another.

Table 3-3: Using Bracket Access on Nested Arrays

Bracket Access	Element Accessed
mylist[0][3]	"pencils"
mylist[1][1]	"brushes"
mylist[1][3]	"knife"
mylist[0][0]	"glue"
mylist[0][4]	"erasers"

Reassigning Values

As easily as you can assign and retrieve values, you can also reassign values. The values you insert in an array are as changeable as the value of any variable. What you have to be conscious of is that you are placing the new value in the right index position in the array, in that it is the order of the data that is usually of importance. To reassign a value to an array, simply create an expression, such as:

```
mydeck[2]="newvalue";
```

If a value already exists at index position 2 of *mydeck*, it will be replaced with the new value assigned.

Alternative Methods

One thing that will help you as you start coding is to be able to see different ways of doing the same thing. Now that you understand how to retrieve and test against array values, let's return to the deck of cards and examine three alternative ways of populating the deck. The first will generate the deck of cards, as before. However, this time, it will randomly insert the cards instead of linearly populating the deck. The second example will demonstrate the use of a recursive function to generate the cards for each suit. The last example will demonstrate how to combine recursion with random population.

Random Insertion

When the deck of cards was built in code example 3-1, the cards were inserted linearly, as in a new deck of cards. With some minor modifications, you can insert the cards randomly so that they are already shuffled, as shown in code example 3-2.

Code Example 3-2: Script for Inserting the Cards in a Random Order

```
function init() {
  mydeck = new Array();
   for (var suit = 0; suit<=3; suit++) {
    for (var i=0; i<=12; i++) {
      do {
        var deckpos = Math.round(Math.random()*51);
      } while (mydeck[deckpos] != null);
        mydeck[deckpos] = String(suit)+String(i);
      }
    }
}
```

The primary difference between code examples 3-1 and 3-2 is the use of the *do...while* command to randomly pick a spot for the card in the deck. In essence, what this section says is "Keep generating random numbers—which represent the location in the deck for the new card—until a location is found that is empty."

Remember that the *do...while* command will continue to *do* until the condition specified after the *while* is found to be *null* or zero. In other words, the command will continue to operate until the condition is no longer true. As you read in the previous section, when you request a value

from an array and no value exists in the requested position, *null* is returned. Thus, the *do...while* in code example 3-2 is based on that fact; that is, it is when *null* is returned that you know you have found an open spot in the deck to insert the card. The remainder of code example 3-2 is just like code example 3-1.

 CD-ROM NOTE: *To see an example of this code running, open the file* ch03_02.fla *located in the* fmxas/chapter03/ *folder on the companion CD-ROM.*

Recursion and Linear Insertion

One of the questions often asked concerning ActionScript is whether it can handle recursive functions. Indeed, unless you are a serious programmer or mathematician, or are looking for an extremely suave (and often more complex, at least for the common person) means of solving a particular problem, recursion may have little meaning or importance to you.

However, for those who wonder about Flash's ability to handle recursion, where it seems applicable and understandable to all, this book examines specific examples of recursion. The limits of this book do not permit a lengthy discussion of all possibilities for recursive functions. However, a few simple examples serve to point out how Flash handles recursion. It is also beneficial to understand the why and how of recursion so that you can understand why it is important in the first place.

In short, recursion is the ability of a function to sequentially and repeatedly call itself to accomplish a particular task or solve a particular problem. Recursive functions are often the simplest answer to a particular calculation, especially when dealing with complex data structures. What recursion usually offers in comparison to loops is a decrease the amount of code required to solve a problem. In addition, recursion is often the best method of solving a problem from the standpoint of processing power.

Yet, thankfully, almost every example of recursion has a simpler, non-recursive solution available, typically involving the use of a *for* loop. Granted these solutions may lack the elegance desired by those highly skilled in mathematics or programming when compared to recursion, but they are generally more understandable to all developers.

 WARNING: *One of the things you must be very careful of when dealing with recursion is not getting stuck in an endless loop—where there is no event that stops the recursion. Flash does have a 25-second timeout limit—meaning that if you accidentally create an infinite recursive function, Flash should allow you to break out of the loop before it crashes by giving you a dialog box to allow you to cancel an operation. However, it depends on what you are doing.*

For example, if you duplicated a very beefy media element using recursion in Flash, you would probably crash it before the 25-second timeout. If you decide to try some recursion, just be careful! Although Flash is not prone to crashing—it is a very solid application—bad recursion can bring any computer or environment to its knees!

Both the linear insertion and random insertion of cards demonstrated in previous examples can be accomplished using a recursive function. Let's look at the linear example first. Code example 3-3 shows how recursion can be used to generate the cards in the deck.

Code Example 3-3: Script for Using Recursion to Populate the Deck of Cards

```
function init() {
 count = 0;
 mydeck = new Array();

 for (var suit = 0; suit<=3; suit++) {
  createcard(suit, 0);
 }

 function createcard(suit, card) {
  mydeck[count] = String(suit) + String(card);
  count += 1;
  if (card<12) {
   createcard(suit, card+1);
  }
 }
 delete count;
}
```

As you examine code example 3-3, you will find four major parts to this code: initialization of variables, a *for* loop (which handles the generation of each suit), the recursive function that populates the cards in each suit, and delete statement that performs a cleanup task. You could probably take this code one step further and make the entire thing recursive, but for the sake of clarity, the card generation in each suit is the only part that is recursive.

Let's begin by walking through this code. There are two variables initialized: *count* (which keeps track of the total number of cards in the deck) and *mydeck*, which is the array that contains the generated deck. Because the recursive function is called one time for each suit, the *count* variable

is relatively important. It is used later in the recursive function as the index number of the element (card) being placed in the array (deck).

The next part of the code is the *for* loop. As you can see, it calls the recursive function one time for each suit and passes the current suit number and the value 0 to the function. Each time the recursive function is called, you start with card 0 in the particular suit. The salient part of this code is the recursive function.

In the function you will note that to kick the entire thing off, the function *createcard()* is expecting to receive two values. One is the current suit number (from the *for* loop), and the second is the starting number for the variable *card*. This variable (*card*) is very important because it is the variable that keeps the function from repeating to infinity. To elaborate, the base case of this solution is the conditional, *if(card < 12)*. Each time the *for* loop calls *createcard()*, note that the value for *card* is restarted from 0 and repeats to 12 (13 cards in a suit).

The first thing the recursive function does is place the first card, defined by *String(suit) + String(card);*, into *mydeck* at position *count*. Next, you see that the variable *count* is incremented, because a card was just placed in the deck. This is really nothing new, as it is really the same as the very first example of the deck of cards.

The next part is the important part. Note that if the variable *card* is less than 12, the function calls itself and increments the variable *card* by 1. This causes the function to spawn itself again, with *card* now equal to *card + 1* (*card* now equals 1). Thus, this second iteration sticks another card into the deck, increments *count*, and encounters the *if* statement again. Because *card* is still less than 12, the function spawns again, with *card* equal to *card + 1* (*card* now equals 2).

Another card is inserted, the count is incremented, and so on until at some point *card* is found to be 12 and the *if* statement (the base case) stops spawning the function. A total of 13 cards are inserted into the deck: one at position 0 the first time through the function and 12 more due to recursion. The *if* statement finds *card* equal to 12 after the thirteenth iteration and stops the recursion.

When the *if* statement ceases spawning the recursive function, focus is returned to the *for* loop. As you have learned, the *for* loop increments its counter (*suit*), and the recursive function is put into action again for the second suit of cards. The *for* loop causes the recursive function to be used four times, once for each suit.

Two final things you should note are the deletion of the *count* variable and the overall structure of the *init()* function. First, note that once the deck is generated, you are done with the *count* variable. It is not imperative to delete this variable, but as a matter of standard practice it is delet-

ed at the end of the operation. Also, note that because the recursive part of this problem is not needed outside the *init()* function, the *createcard()* function is placed inside *init()*.

Although this example is far from complex in terms of what is possible with recursive functions, it does show how recursion can be used. If you are like most people, it takes some effort to think in terms of recursion. Recursion is not something most people deal with on a day-to-day basis. However, it does provide a more elegant way of dealing with certain programming problems, and for some problems it is also the easiest way to write concise code.

 CD-ROM NOTE: *To see an example of this code running, open the file* ch03_03.fla *located in the* fmxas/chapter03/ *folder on the companion CD-ROM.*

Recursion and Random Insertion

Let's examine one final example involving recursion and random insertion. Code example 3-4 shows how you could use the concept of recursion with the random insertion of cards into the deck.

Code Example 3-4: Script for Using Recursion with the Random Insertion of Cards

```
function init() {
 count = 0;
 mydeck = new Array();

 for (var suit = 0; suit<=3; suit++) {
  createcard(suit, 0);
 }

 function createcard(suit, card) {
  do {
   var deckpos = Math.round(Math.random()*51);
  } while (mydeck[deckpos] != null);
  mydeck[deckpos] = String(suit)+String(card);
  count += 1;
  if (card<12) {
   createcard(suit, card+1);
  }
 }
 delete count;
}
```

The main difference between code examples 3-3 and 3-4 is the inclusion of the *do...while* statement. As in code example 3-2, the *do...while* statement randomly finds a position in the deck that is not filled with a card already (by checking for *null* as a returned value from the array). Once it finds a position in the array that returns *null*, it knows it has an open spot and stops the *do...while*. It then utilizes recursion to continue populating the current suit.

 CD-ROM NOTE: *To see an example of this code running, open the file* ch03_04.fla *located in the* fmxas/chapter03/ *folder on the companion CD-ROM.*

As you can see, recursion is a nifty way of populating the deck of cards. If this is your first encounter with recursion, do not worry about immediately starting to think about (or seeing) ways of integrating it. However, if you do wish to become a more efficient programmer, try to pay special attention throughout the book to the examples that use recursion. You may also want to spend some time reading other books or materials that deal with recursion so that you can get a better handle on it. Indeed, recursion is advantageous from a processing point of view.

CD-ROM NOTE: *Just for fun, if you want to see an example of recursive functions for generating the suits and cards, open the file* ch03_05.fla *located in the* fmxas/chapter03/ *folder on the companion CD-ROM.*

Outputting Strings

Now that you have examined the creation of arrays and methods for accessing and modifying the data in them, you need to examine two special methods for arrays. These two methods are predominantly designed to allow you to output or convert your array values to string data that can then be manipulated. The next two sections discuss the *join()* and *toString()* methods.

join()

The *join()* method is designed to extract the content of an array as a string and then return it as delineated text. In essence, this would allow you to parse the returned data for some purpose, such as searching for a particular word or for inserting it into some external source, such as a database. The general form for using the *join()* method is:

```
array.join(separator);
```

Here, *separator* is the character you want inserted between the array elements in the output string. Note that if you do not include a character

to be used as a separator, a comma is used by default. To see an example of this, let's return to one of the original arrays discussed in this chapter, named *deal1*:

```
deal1 = new Array("10h", "4d", "2d", "5s");
```

Table 3-4 outlines the code and results of various *join()* methods and what would be printed to the Output window.

Table 3-4: Results of join() *Methods*

Code	Resultant Output
trace(deal1.join());	"10h,4d,2d,5s"
trace(deal1.join("; "));	"10h; 4d; 2d; 5s"
trace(deal1.join("/"));	"10h/4d/2d/5s"
trace(deal1.join("# "));	"10h# 4d# 2d# 5s"

toString()

The *toString()* method belongs to many of the built-in programming objects, including the Array object. The general form of the *toString()* method is:

```
array.toString();
```

In essence, the *toString()* method retrieves all values in the array and returns them as a concatenated string, separated by commas. The *toString()* method and the *join()* method (when no separator is specified) return the same results. Thus,

```
mydeal.toString();
```

would yield

```
"10h,4d,2d,5s"
```

Manipulating Array Data

Now that you have a basic understanding of arrays and how they operate, let's get into the real meat of the discussion: manipulating array data and using them to accomplish tasks. Although you can accomplish quite a lot using bracket access (as demonstrated to this point), the Array object provides several methods that give added flexibility and capability when working with arrays. These methods are examined in the sections that follow.

Adding, Extracting, and Deleting Data

Let's begin by examining how you can add, extract, and delete data entries to and from the beginning and end of an array. Already you have seen how to make assignments linearly and nonlinearly using bracket access. However, you can also add elements to the beginning and end of an array without overwriting already existing data. It is beneficial to be able to pull entries out of an array without leaving blank holes in the array structure.

Although the next couple of sections discuss in more detail the methods that make these operations possible, let's begin with a conceptual overview of what *pop()*, *push()*, *shift()*, *unshift()*, and *splice()* do. Continuing with the deck of cards as our example, figure 3-2 shows a very good representation of what these methods do.

As shown in figure 3-2, you will note that the array is inverted; that is, 0 is associated with the bottom card. Anytime you are working with arrays, you have to get straight in your mind the relationship between the array and the physical objects you are representing, while also remembering that arrays begin at 0. Usually what you want to do is to think about whatever it is you are trying to store in the array. Does the data you are storing have an absolute zero? Some data will not, but in the case of the deck of cards there is an absolute zero—the bottom of the deck. Thus, 0 in the

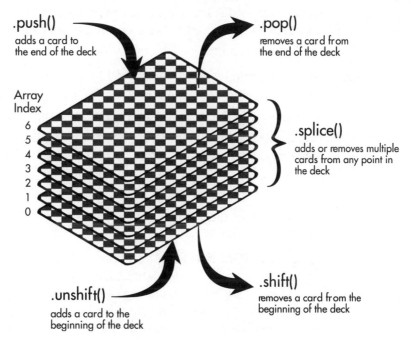

Figure 3-2. Methods available for adding and deleting data from an array.

array is associated with the bottom card on the deck (because the bottom card is usually fixed in all legal forms of card playing and dealing).

Also as shown in figure 3-2, note that *pop()* and *push()* are used to manipulate the top of the deck, which is the end of the array (array index 6), whereas *shift()* and *unshift()* are used to manipulate the bottom of the deck, which is the beginning of the array (array index 0). An easy way to remember which set is for the beginning and ending of the array is that when you modify the beginning of the deck, the remaining values in the array must "shift" to accommodate the addition or deletion. Thus, *shift()* and *unshift()* are for the beginning of the array, and *pop()* and *push()* are for the end of the array. The *splice()* method, on the other hand, can be used to add or delete data from anywhere in the array.

pop() and push()

As stated, the *pop()* and *push()* methods are for removing and adding values from the end of an array. The general form for using the *pop()* method is:

```
array.pop();
```

When you "pop" a value from an array (i.e., remove the last item in the array), the popped value is returned. If you use the general form, the value is simply discarded from the end of the array. If you wish to capture the popped value, insert it into a variable, as follows.

```
temp=array.pop();
```

As for the *push()* method, the general form for its use is:

```
array.push(value1, value2, value3...valueN);
```

Here, *value* is a string or a numeral you wish to insert at the end of the array. Note you can insert multiple values by listing them as multiple arguments, separated by commas. If you wish to track the new length of the array (after pushing the value into it), use the form:

```
temp=array.push(value)
```

In this case, the variable *temp* could be checked to see what the new length of the array is.

CD-ROM NOTE: *To see an example of* pop() *and* push() *being used, open the file* ch03_06.fla *located in the* fmxas/chapter03/ *folder on the companion CD-ROM. Examine the ActionScript in frame 1 of the* Global *and* State *layers. The file uses the recursive function demonstrated earlier to populate the original deck.*

shift() and unshift()

The *shift()* and *unshift()* methods, like the *pop()* and *push()* methods, allow you to respectively extract and insert values from an array. However, unlike *push()* and *pop()*, *shift()* and *unshift()* are designed to operate on the root index of the array; that is, array index 0. Assuming you wish to capture the extracted value, the general form for the *shift()* method is:

```
variablename=array.shift();
```

This will extract the value at array index 0 and place the value in the variable *variablename*. Keep in mind that this removes the item at index 0. It does not just capture it. If you wish to simply delete the value at array index 0, use the form:

```
array.shift();
```

This will cause all subsequent values in the array to "shift" in the array index list. That is, the value at index 1 will shift to index 0, the value at index 2 will shift to index 1, and so on. Alternatively, if you wish to insert values at the root of an array, you use the *unshift()* method. The general form for its use is:

```
array.unshift(value1, value2, value3,...valueN);
```

This will insert the values specified as arguments into index array position 0 and will "downshift" (unshift) the other values, where the item that was at position 0 is displaced by the number of arguments in the *unshift()* method. Like *push()*, if you wish to track the new length of the array, following the *unshift()* operation, use the form:

```
temp=array.unshift(value);
```

 CD-ROM NOTE: *To see an example of* shift() *and* unshift() *being used, open the file* ch03_07.fla *located in the* fmxas/chapter03/ *folder on the companion CD-ROM. Examine the ActionScript attached to frame 1 of the* Global *and* State *layers.*

splice()

Although the first four array methods are usually used to work with individual values at the beginning and ending of an array, the *splice()* method is designed to allow you to work with an individual value, or group of values, anywhere in the array. For example, you can use the *splice()* method to delete three values, beginning with index position 5. Alternatively, you can add three values, starting at position 2. In essence, the *splice()* method provides greater flexibility than *pop()*, *push()*, *shift()*, or *unshift()*. Let's begin by looking at how you can add data to an array using the *.splice()* method. The general form for adding data with it is:

```
array.splice(start, deleteCount, value0, value1, ¬
value2...valueN);
```

Here, *start* is the index position at which you want to begin insertion, where *deleteCount* is the number of items you want to delete (usually 0 when you are inserting) and where *value0, value1,* and so on are the values you want added. For example, imagine you have the following array:

```
dealtlist=["9h", "2c", "4s", "8d", "10h", "4d", ¬
"2d", "5s"]
```

Now let's say you want to add the following to the array, using *splice()*:

```
dealtlist.splice(5, 0, "11h", "12h");
```

This line of code says "Add two values (the strings *"11h"* and *"12h"*) into the *dealtlist* array. Place the first inserted value at index position 5 (which is immediately after *"10h"*) and do not delete any items from the array." If you were to use

```
trace(dealtlist);
```

to print the content of *dealtlist* to the Output window, *dealtlist* would contain

```
9h,2c,4s,8d,10h,11h,12h,4d,2d,5s
```

NOTE: *Keep in mind that string data is not properly formatted when output to the Output window.*

The new length of the array *dealtlist* array would be 10. If you deleted items as you added them (by specifying the second argument as 1 instead of 0), such as

```
dealtlist.splice(5, 1, "11h", "12h");
```

the traced content would appear as

```
9h,2c,4s,8d,10h,11h,12h,2d,5s
```

Note that the deleted item (*"4d"*) was located at the starting position (specified by the first argument, 5). Thus, when you delete items as you are adding items, the deletion begins with the starting position index toward the end of the array. That is, if the deletion number were 3, items *"4d"*, *"2d"*, and *"5s"* would be deleted. Then items *"11h"* and *"12h"* would be added to the array.

In addition to being able to delete elements while adding to an array with *splice()*, you can also use *splice()* for extracting and deleting, usually for the purpose of extracting a series of elements from somewhere in an array and placing them in a new array. If you want to simply delete elements from an array, use the form:

```
array.splice(start, deleteCount);
```

Here, *start* is the index position at which you want to start deletion (the item in position *start* is included) and *deleteCount* is the number of elements you want to delete. You must remember—and this is where most people get confused—that *deleteCount* includes the starting index value.

Finally, as when adding values, the *splice()* method can be made to return the length of the array after deletion by having it return to a variable, such as:

```
mylength= array.splice(start, deleteCount);
```

In this line of code, the *mylength* variable could be traced or used in some other fashion to reveal the length of the modified array.

 NOTE: *Aside from the fact that the Output window improperly formats strings (in that they look like numbers), arrays can pose a similar problem. While developing some of the examples in this chapter, the author found that when arrays are traced they are returned as a consecutive string of values, separated by commas. It is no surprise that even if the array values are strings the values are output without quote marks.*

One final note concerning the *splice()* method is that there may be times you will want to pull out all values currently in an array. One example would be if you were cutting a deck of cards (see the following CD-ROM Note). Let's say you wanted to generate a random point at which to cut a deck of cards. Usually when you cut cards, this point is somewhere close to the middle of the deck. Thus, to generate a random cut point, you might use the following.

```
midpoint=Math.round(mydeck.length/2);
myvariance=Math.round(Math.random()*mydeck.length*.2);
mysign=Math.round(Math.random());
if (mysign==0) {
      mydis=midpoint+myvariance
} else {
      mydis=midpoint-myvariance
}
```

In essence, you want to cut the cards at some point within the 40 percent in the center of the deck. The first line of the previous code finds the midpoint of the deck. You will note that it is not "hard-wired" and could be used for a deck of any size. The second line determines a 20-percent variance on either side of the midpoint, so as to truly simulate a cut on a deck of cards. The third line generates a random number, either 0 or 1, so

that the midpoint and variance are either added to or subtracted from each other, allowing the midpoint to vary around the median by 20 percent on either side.

Now, let's look at how *splice()* could be used to cut the cards. In the following, *concat()* is used to rejoin the two halves.

```
var temp1A=new Array();
var temp2A=new Array();
temp1A=mydeck.splice(0, mydis);
temp2A=mydeck.splice(0);
mydeck=temp2A.concat(temp1A);
delete temp1A;
delete temp2A;
```

The first two lines of this code create two arrays that will be used to contain the two halves of the deck. The third line places the values from the first half of the deck into the first array, and the fourth line places the values from the second half of the deck into the second array. Note how *splice()* is being used in the fourth line. When only a starting position is given, it extracts all remaining entries from the array. The final line concatenates the two halves back into the original *mydeck* variable.

 CD-ROM NOTE: *To see an example of the* splice() *method, open the file* ch03_08.fla *located in the* fmxas/chapter03/ *folder on the companion CD-ROM. In the movie, you can specify the number of cards to be moved, as well as the index number from which to splice. Examine the fields and the splice buttons to see how it works.*

Sorting

Now that you have examined the methods for pushing and pulling data in and out of an array, it is time to begin looking at the sorting capabilities in Flash. Flash provides three primary sorting capabilities: *reverse(), sort()* and *sortOn()*.

reverse() and sort()

The first of the two sorting methods is *reverse()*. As its name implies, *reverse()* will invert the order of the elements in the array very quickly. For example, consider the following lines of code.

```
myarray=new Array(1, 2, 3, 4, 5, 6);
trace("myarray contains " + myarray);
trace("the reverse is " + myarray.reverse());
```

The following would be output to the Output window.

```
myarray contains 1,2,3,4,5,6
the reverse is 6,5,4,3,2,1
```

Except for being a quick way of reversing the order of the items in an array, *reverse()* does not have a lot of usefulness. As you have already seen with the other methods available, you can easily push or pull data in or out of an array from any position without a lot of difficulty. Thus, *reverse()* would not be absolutely necessary. However, for instances in which you might need to reverse an array, you have such a method available.

 NOTE: *You will note in the previous lines of code that* trace() *was used to output the modified array. One thing to note about both the* reverse(), sort(), *and* sortOn() *methods is that they are destructive. That is, anytime they are called, the actual content of the array is rearranged, even if the sorting operation is called as part of something else, such as* trace(). *Thus, in the previous* trace() *statements, the* reverse() *is not just for the output that is modified. In actuality, the* reverse() *is executed, and then the* trace(). *This is important to note because if the order in your array is important and you invoke* reverse(), sort(), *or* sortOn() *on the array, you cannot get the original order back, unless the original order were the result of some other logical sort.*

Of greater significance than *reverse()* is the *sort()* and *sortOn()* methods. The *sortOn()* method is designed to work with property arrays and allows you to sort based on fields, where *sort()* works on the values in basic linear arrays. The default for the *sort()* method provides the ability to alphabetically sort data in an array. For example, given the following lines of code

```
mychildren = new Array("meisha", "alex", "treyton");
trace("mychildren contains " + mychildren);
trace("sorted, this list is " + mychildren.sort());
```

the following would be output to the Output window:

```
mychildren contains meisha,alex,treyton
sorted, this list is alex,meisha,treyton
```

 NOTE: *The scope of this book does not permit an examination of sorting types (such as sequential, binary, insertion, Quicksort, shell, and so on). However, for those who are interested, Flash uses QuickSort.*

As you can see in the previous code, when the *sort()* method is invoked and no argument is specified for the method, it uses the less than (<) comparison operation. The only negative consequence to the default

method of operation for the *sort()* method is that it does not treat numerical and alphanumeric data differently. Everything is sorted as alphabetical data. Thus, a line of code such as

```
numarray = new Array(110,15,1,20,111,10).sort();
```

will sort as

```
1,10,110,111,15,20
```

rather than as its numerical sort

```
1,10,15,20,110,111
```

This operation is also case sensitive and gives uppercase letters precedence or greater priority over lowercase letters. For example,

```
mypeers=new Array("terry", "mike", "sue", "judy", ¬
"Craig", "Mark", "Bill", "Gary", "Tony").sort();
```

will sort as

```
Bill,Craig,Gary,Mark,Tony,judy,mike,sue,terry
```

Although these two problems exist with the default operation of the *sort()* method, the default method is not the only way to work with *sort()*. The next section explores how you can customize the *sort()* method.

Order Functions

One of the special things you can do with the *sort()* function is to write and call your own order function, which basically contains the rules for comparing all entries in the sort. Essentially, when you want to use an order function, you place a function name in the parentheses of the *sort()* method. Then you write the rules for the sort operation by writing the function itself. Although the order function is usually written in the same place as the call to the *sort()* method—you usually write one right after the other—you could write the function in the main timeline and then use it for many different *sort()* methods. Nevertheless, let's first deal with the general way you write the sort method to call an order function. The general form looks like the following.

```
myarray.sort(mysort);
function mysort(a,b)
     //rules for sort
}
```

As you can see, this is really no different than many of the functions you have already written. The primary difference here is that the *sort()* method is specifically set up to allow external functions to be written and called. As stated, the call to the *sort()* method and the order function do not have to be in the same physical place as far as script location is concerned.

Generally, if a particular order function is only used once, it is no more or less efficient to place it in the same place as the *sort()* call than it is to place it in some other location. However, if you want to be able to reuse an order function, as opposed to writing it several times throughout a movie, place the order function in the main movie timeline, just like any other global function you want to write. Then, when you use *sort*, write the call as follows. This allows you to write order functions that can be shared throughout a movie.

```
myarray.sort(_root.mysort);
```

 TIP: *Given what you learned in Chapter 2, you could also extend the array object by adding your own custom sort method.*

Now that you have seen the general form for using order functions, let's examine sorting logic; that is, the content of the order function itself. It may sound difficult, and indeed the logic for the order function can sometimes be tricky, but once you see two or three order functions, you will start to pick up how to write them. Let's begin by saying you have an array, such as the following.

```
myarray = new Array(1,9,5,4,3,6,7,5,2,8);
```

Given this array, and ignoring the fact that the default *sort()* method could be used, let's manually construct an order function for sorting the data. Let's begin with a general overview of what happens when you perform a sort.

When you call the *sort()* method, it takes two of the values from the array, such as 1 and 9 (the first two values in the previous array) and passes them to the order function. Usually in the order function you assign the passed values to two variables, named here *a* and *b*. The order function then compares *a* and *b* and returns negative 1, 0, or positive 1, based on the rules of the comparison.

When dealing with simple comparison operations (such as greater than, less than, and equals), if *sort()* finds that *a* is less than *b*, it returns negative 1. If it finds that *a* is equal to *b*, it returns 0. If it finds that *a* is greater than *b*, it returns a positive 1. These returned values indicate to the *sort()* method whether *a* should be placed in front of *b*, whether *b* should be placed in front of *a*, or whether *a* equals *b* and the current order should not be changed. It then proceeds to the next set of values, compares them, and moves on. Thus, once *sort()* has performed the comparison multiple times between all values in the array, at some point it arrives at a sorted list of values, based on the comprehensive comparisons.

 NOTE: *In sorting, each value may be compared multiple times to determine its final resting place in the file sort order. As the dynam-*

ics and arrangement of elements in the array change, a particular value's location may change several times, depending on the type of sorting algorithm the software uses. When using order functions with the sort() *method, it is important to write them carefully. As with recursive functions, some sorting comparisons can bring the software to its knees—resulting in a* sort() *that takes longer than 25 seconds. In such cases, Flash times out and gives the user the option to kill the script.*

Given this procedural explanation, the default *sort()* method could be represented with *if* statements, using the following.

```
function mysort(a,b) {
 if (a<b) {
 //a should come before b
 return -1;
 } else if (a>b) {
 //a should come after b
 return 1;
 } else {
 //do not change current order
 return 0;
 }
}
```

Given this general form for order functions, you could write your own order functions to determine the comparisons. Table 3-5 describes several order functions that can be used. By writing your own order functions you can overcome the limitations noted earlier: the problem with numbers and the problem with capitalization. Table 3-5 shows how to create a true numerical sort, as well as a sort that ignores case. The remaining functions outlined in table 3-5 are other alternatives that may be useful to know.

CD-ROM NOTE: *To see an example of the order functions listed in table 3-5, open the file* ch03_09.fla *located in the* fmxas/chapter03/ *folder on the companion CD-ROM. In it you will be able to see the difference between the standard* sort() *method and when an order function is used.*

As you have seen in this section, although the *sort()* method has some minor limitations, they are easily overcome through the use of order functions. If you decide to try your hand at writing order functions (and you should, as this is quite a powerful capability), keep in mind that you want the order function to be as simple as possible. Due to the 25-second time-out, as well as the fact that an order function may be called over 100 con-

Table 3-5: Order Functions for Common Sorting Tasks

Numerical sort:	**Numerical sort (reverse):**
```function mysort(a,b) {    a=Number(a);    b=Number(b);    return a-b; }```	```function mysort(a,b) {    a=Number(a);    b=Number(b);    return b-a; }```
**Sort based on string length:**	**Sort based on reverse string length:**
```function mysort(a,b) {    return a.length > b.length; }```	```function mysort(a,b) {    return a.length > b.length; }```

Sort and ignore case:

```
function mysort(a,b) {
     return a.toLowerCase() > b.toLowerCase()
}
```

Sort based on last character:

```
function mysort(a,b) {
     return a.charAt(a.length-1) > b.charAt(b.length-1);
}
```

Sort based on string length, then alphabetical:

```
function mysort(a,b) {
     if (a.length==b.length) {
          return a.toLowerCase() > b.toLowerCase()
     } else {
          return a.length > b.length;
     }
}
```

secutive times (depending on the number of data entries in the array), it is important to conceive and write script concisely.

Generally, when constructing order functions, you might want to begin with a blank movie (the array), two text boxes (so that you can see a "before and after" of the array), and the order function. Instead of directly integrating an order function in some already complex movie—and this goes for any new piece of programming you are trying to create, debug, or utilize—begin with as few unknowns as possible. Start in a blank movie and get it to work there. Then move it to your main movie.

Sometimes, however, this method is not possible, as when an item dependent on something else must be created "in place." However, anytime you can code a complex component from scratch in a blank movie, do so. Then, once all of the problems are worked out with the new com-

ponent, integrate it into the main project. This approach is what "master programmers" use, as it allows you to isolate problems and forces you to separate local code problems in the component you are working on from integration problems. Try to break a problem down into its least elements. Big problems are easy to solve if you can break them down into small problems that are manageable!

■ ■ ■ Using Arrays

Now that you have looked at most of the ins and outs of using arrays, let's examine some intermediate to advanced examples. There are myriad ways of integrating arrays, and these methods are fundamental to many applications. As the deck of cards example provides an appropriate example, it is used in several of the following examples. However, keep in mind that the concepts shown can be reapplied to anything you want to track: a collection of books, volumes in a series, songs on a CD-ROM, CD-ROMs in a collection, and so on. The deck of cards is used here because the data is related and it is easier to explain. However, the techniques used in the beginning, as well as the remainder of this chapter, can be applied to many different scenarios.

 NOTE: *Although the following examples highlight array use, keep in mind that a good expression or algorithm, when one can be developed for a set of data, is much more efficient than an array. Make sure you always keep an eye out for patterns in data that will allow you to use an algorithm instead of an array.*

Function: Array Position Based on Value

Exercise 3-1 demonstrates how to show the face card on the discard pile. Although you will not build this functionality from scratch, you will be taken through the code to understand how it functions and, more importantly, why the code works the way it does. Figure 3-3 shows the file you will be working with.

 Exercise 3-1: Working with Array Position

CD-ROM NOTE: *Begin this exercise by opening the file ch03_10.fla from the* fmxas/chapter2/ *folder, located on the companion CD-ROM.*

Although you will pull out sections of code from the example in the text, it will be helpful for you if you follow along on screen as well.

1. Once you have opened the file, select Control | Test Movie to see how the movie works. You will note that this file is basically the *pop()* and *push()* example, with the faces of the cards added to the discard pile.

2. Let's begin by examining how the face card is inserted into the discard pile. Click on the graphic representing the discard pile (white rectangle with a circle in the middle of it). The instance name of this object is *pile*.

3. Double click on the *pile* instance to open its timeline.

4. Once inside the *deck-build* symbol, examine the timeline and move the playhead back and forth. You will see that at frame 2 a new symbol instance appears on the stage in layer *face*. This symbol instance looks like the checkerboard pattern found on the back of a deck of playing cards. The instance name of this element is *facecard*. Double click on the *facecard* instance to access its timeline.

5. Once inside the *card* movie clip, note that the movie clip contains each of the faces of the playing cards, as well as the checkerboard.

 If you remember the numbering sequence from earlier in the chapter, you will find that the cards are ordered in the timeline according to suit and card; that is, 00, 01, 02…010, 011, 012, 10, 11, 12…110, 111, 112, 20, 21…and so on. This will be important later because an array is used to track the relationship between frame number and card number.

 This means that when a card is dealt, a card is "popped" from the deck array. What you want to be able to do is look up that popped value and tell the *facecard* instance (*card* movie clip) to go to a particular frame. Thus,

Figure 3-3. Using an array as a lookup for the face card.

you need an array in which the array indices are relative to the frames of the card movie clip, and in which the values are the names of the cards in the order displayed in the movie clip *card*.

One side note here is that some may be thinking, "Why use frame numbers? Why not just use a label? Take the popped value from the deck array, and tell the card movie clip to *.gotoAndStop(poppedvalue)*?" Well, originally that was the idea. However, if you try it you will find that when you insert numbers as frame labels, Flash does not like it—particularly numbers that start with 0. In short, numbers as frame labels do not work well. Frame labels such as *animal1, animal2,* and so on do work, but straight-up numbers for frame labels are quirky at best. Thus, a lookup array is needed. Now that you know a lookup array is needed, let's see where it is created. Continue with the following.

6. Access frame 1 of the *Global* layer in the main timeline.

The *facelist* is built within the *generatefacelist()* function. This array is used to look up popped values to determine the appropriate frame for the card. Again, the important thing here is that the array matches the arrangement of frames in the *card* movie clip.

 NOTE: *You will note in the code that builds the* facelist *array that the array is deleted before it is built. This is simply a safety precaution. In most languages, if you try to instantiate an object that already exists, it will usually cause an error. It is rare that Flash will generate an error caused by the overwriting or redefining of an already existing object, but why take chances? You do not necessarily have to delete the array, but it is a good habit to adopt. Even if the object you are trying to delete does not exist, it will still execute the delete without any problems.*

Now that the preliminaries are out of the way, let's examine how you put the lookup array to use. Continue with the following.

7. In the main timeline, access frame 1 in the *State* layer and look at the code associated with the *toPile.Release* event (*toPile* is the instance name of the Move a Card button). The important parts are shown in the following.

```
var temp=mydeck.pop();
...
...
for ( var i=0; i<=facelist.length; i++) {
 var temp2=facelist[i];
 if (temp2==temp) {
  break;
 }
}
pile.facecard.gotoAndStop(i+1);
```

In this code, note that you first extract the card being moved from the deck using the *pop()* method. Then a *for* loop is used to step through the values in *facelist* so that you can figure out which frame contains the graphical representation of the popped card. To do this, a value from *facelist* is repeatedly retrieved and inserted into the local variable *temp2*. The value is then compared to the local variable *temp* (the variable that contains the value popped from the deck). If *temp2* equals *temp*, the loop is broken.

Note that when you break out of the loop, the counter used in the loop (*i*) retains the array index position at which *temp* was found in *facelist*. This is the key to looking up a value from one array in another. Once you have the proper value for *i* (again, the index position of *temp* in *facelist*), you tell the movie clip *card* (instance *facecard*) to go to and stop *i + 1*. You use *i + 1* because *facelist* begins at 0, whereas the frame numbers in movie clips, specifically movie clip *card,* start at 1.

One of the things you will find with programming is that there is often more than one way to write your code. The previous example demonstrates this in that there are probably other ways to solve this problem. In most instances, there is no right or wrong answer—there are myriad ways to solve a problem. However, often one is a little more efficient than the other, and this is usually what you want to consider. Whenever you are trying to decide which way to code something, think about it in terms of efficiency, rather than right and wrong.

Function: Value Based on Position

Early in this chapter you learned how to access the values in an array using bracket access. Exercise 3-2 demonstrates how to use arrays to look

up values as well as indices. Figure 3-4 shows the file you will be working with.

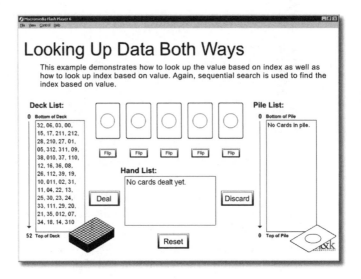

Figure 3-4. Using an array as a lookup for value and index.

 Exercise 3-2: Using Arrays to Look Up Values and Indices

 CD-ROM NOTE: *Begin this exercise by opening the file* ch03_11.fla *from the* fmxas/chapter03/ *folder, located on the companion CD-ROM.*

Although you will pull out sections of code from the example in the text, it will be helpful for you if you follow along on screen as well. Perform the following steps.

1. Once you have the file open, use Test Movie to see how it works.

 In essence, you deal five cards. Deck List shows the cards in the deck, Pile List shows the cards in the discard pile, and Hand List shows the cards in your hand. Once you deal, you can view the face of the each card using the respective flip buttons. If you click on Deal again, the cards in the hand are shifted to the discard pile and the hand is repopulated. You can also directly discard after a deal by clicking on the Discard button.

You will note that the last card in the hand is the card deposited on the top of the discard pile. Thus, the five cards remain in the same order they are passed from deck to hand and hand to pile.

2. Click in frame 1 of the *Global* layer and view the actions.

You will see that this code serves two purposes: to initialize the environment and to house the functions used throughout the movie. You will see that the top part of the script includes four functions (utility functions), which are designed to:

● Reveal a face card when the user clicks on one of the flip buttons (*findfaceandset()*)

● Determine the array index number of a value, provided an array name and a value (*returnindex()*)

● Choose the face card to be shown on the face pile (*updatepile-card()*)

The second set of functions (initialization functions) includes a function to:

● Set up the deck of cards (*generatedeck()*)

● Initialize the array for the discard pile (*generatepile()*)

● Initialize the array for the hand (*generatehand()*)

● Initialize the *facelist* array (*generatefacelist()*)

If you recall from the last example, the *facelist* array is used to look up the face for the cards as they are discarded. In this movie, however, *facelist* is used for the discard pile, as well as for each of the cards in the hand. If you wish to review the functions that initialize the *deck, hand, pile,* and *facelist* objects, scroll to the bottom of the script, skipping over the "utility functions" section.

Analyzing a Script

Let's procedurally step through the example used in exercise 3-2, in the manner in which the end user would operate. The first thing that would happen is that the user would click on the Deal button. The code associated with the Deal button is shown in code example 3-5. You will find this code in frame 1 of the *State* layer.

 NOTE: *The file on the companion CD-ROM includes several comments to help you understand the code. However, for the sake of*

brevity, and because the text describes what is going on in the code in more detail, comments are not included in code examples.

Code Example 3-5: Code Associated with the Deal Button

```
deal.onRelease = function() {
 if (mydeck.length>0) {
  if (myhand.length>0) {
   for (var i = 1; i<=myhand.length; i++) {
    mypile.push(myhand[i-1]);
    eval("card"+i).gotoAndStop(1);
    pile.nextFrame();
    pilecount += 1;
   }
   pilelist = mypile.join(", ");
   updatepilecard();
  }
  for (var i = 1; i<=5; i++) {
   var temp = mydeck.pop();
   if (temp != null) {
    myhand[i-1] = temp;
    eval("card"+i).gotoAndStop(2);
    deck.nextFrame();
    deckcount -= 1;
   } else {
    myhand.splice(i-1, 6-i);
    break;
   }
  }
  decklist = mydeck.join(", ");
  handlist = myhand.join(", ");
 } else {
  decklist = "No more cards in the deck. Hit reset ¬
to begin again.";
 }
};
```

At first glance, code example 3-5 might look intimidating. However, once you work your way through the explanation, you will find it easier to understand. The opening *if* statement shown in code example 3-5 checks to make sure that there are cards available in the deck (before you begin the process of dealing). If there are no cards in the deck, the user is

notified of this fact via the Deck List text box on the left side of the screen (see the ending *else* statement).

Beyond the opening *if* statement, there are basically three sections to the guts of this code. Let's deal with them in that manner. The first section is the *for* loop nested within the second *if* statement, as shown in code example 3-6.

Code Example 3-6: Script for Checking to See if There Are Cards in the Hand

```
if (myhand.length>0) {
    for (var i = 1; i<=myhand.length; i++) {
      mypile.push(myhand[i-1]);
      eval("card"+i).gotoAndStop(1);
      pile.nextFrame();
      pilecount += 1;
      }
    pilelist = mypile.join(", ");
    updatepilecard();
    }
```

This code segment checks to see if there are cards currently in the hand. If there are, they are pushed into the pile and several things are updated. To determine if there are cards in the hand, you would simply check the length of *myhand*, which is the name of the array that contains the cards in the hand. If it is greater than 0, you know that there are cards in the hand, which must be moved to the pile.

The *for* loop in the center of code example 3-6 does several things. First, it pushes values from *myhand* into *mypile* (remember from prior examples that *mypile* is the name of the array that contains the discards). Note how it is using the *for* loop's *i* value to do this. It uses *i - 1* because the *for* loop goes from 1 to length of *myhand* (which is 5), whereas the array index values in *myhand* progress from 0 to 4. Again, when working with arrays, this mismatch of values is what usually throws people off. Do whatever it takes to get this straight. Sketching it graphically or writing it down usually helps.

The next line in code example 3-6 tells the appropriate dealt card to return to the frame that shows the blank rectangle with a circle in it (representing "no card"). Remember that what you are doing in this loop is removing cards that had been dealt, meaning that the instances are currently showing some card face. When you tell one of the card instances to go to frame 1, it goes to the "blank card" frame.

Like the previous line, the *for* loop's *i* value is used to talk to the correct card. However, this time you simply use *i* because the card instance names on the stage (*card1*, *card2*, *card3*, and so on) are in sync with the loop values (1 through 5). In this line, also note the use of the *eval()* method. This forces the code *"card" + i* to be read as the object name *card1*. If you forget the *eval()* method, Flash will often interpret *"card" + i* as the string *"card1"*, which does not work.

The last two lines of this section simply tell the *pile* instance to advance (once for each card added to the pile) and to increment the dynamic text field to the lower left of the Pile List text box via the *pilecount* variable. The previous four lines of code are then incremented four more times due to the *for* loop. This removes all five cards from the hand and moves them to the pile.

Following the *for* loop are two remaining lines of code. The first, *pilelist = mypile.join(", ");*, updates the *pilelist* variable, which is associated with the Pile List text box on the stage. It uses the *join()* method to insert a comma and a space into the string of array values. The second line changes the top card displayed on the pile graphic, so that it shows the appropriate top-level discard. Discussion of the *updatepilecard()* function is revisited later in the chapter. For now, simply note that the *updatepilecard()* function changes the face card of the pile graphic in the lower right-hand corner of the stage. The second section of code example 3-5 is shown in code example 3-7. This section of code actually "deals" the cards to the blank spots (instances) on the stage.

Code Example 3-7: Script for Dealing the Cards to the Hand

```
for (var i = 1; i<=5; i++) {
  var temp = mydeck.pop();
  if (temp != null) {
    myhand[i-1] = temp;
    eval("card"+i).gotoAndStop(2);
    deck.nextFrame();
    deckcount -= 1;
  } else {
    myhand.splice(i-1, 6-i);
    break;
  }
}
decklist = mydeck.join(", ");
handlist = myhand.join(", ");
. . .
```

Code example 3-7, like the previous segment, uses a *for* loop to increment through the values of an array. However, in this section, you will "hard-wire" the loop by forcing it to loop through 1 to 5 values of *i*, rather than using an array length. This is because you want to specifically deal out five cards. You could extend this example and make it so that you could vary the number of cards dealt. In that case, it would be necessary to use a larger range for the loop.

The second line of code example 3-7 reveals that we use *pop()* to extract the top card from the deck and place it into a variable named *temp*. Because 52 (the number of cards) is not evenly divisible by 5 (the number consistently dealt), at some point you will end a deal with two cards remaining. In this case, you still want to deal the two leftover cards, but you do not want to try to pop a value from the deck and put it the hand when there is not really a value in the deck to move to the hand.

When there are no more cards in the deck, you want the hand to reflect this via its length property. If you move a *null* value into the hand (which is the result of popping a nonexistent value from an array), the length of the hand will not be truly representative of the cards that are there. This is the reason for the *temp* variable: to be able to test with an *if* statement to make sure the popped value from the deck does not contain *null*. If it contains *null*, you know that it popped a nonexistent value from the deck.

Given this, let's look at the code that executes if there is a value in *temp*. If a value is there (meaning there was a card), you want to transfer the returned value from the deck into the hand. You do so using *myhand[i-1] = temp;*. As before, note how the *for* loop's *i* value is being used. The counter *i* varies from 1 to 5, but the index of the hand varies from 0 to 4. Thus, you use *i-1* to place *temp* in the correct index position of *myhand*.

Again, similar to the first section of code, you next tell the appropriate card instance to change, tell the deck to advance a frame, and increment the *deckcount* variable. However, because you are dealing cards now, as opposed to removing them, you tell the card instances to go to frame 2, which contains the image of the back of the card (checkerboard), instead of frame 1, which has the "no card" representation.

Consider also what happens when you pop a nonexistent card from *mydeck* (that is, *temp = = null*). When only two cards are remaining in the deck, and the user hits the Deal button, the two cards are transferred from the deck to the hand, as discussed in the previous two paragraphs. However, when you get to the third card (which does not exist), *temp* is found to be *null* and the second half of the *if* statement executes.

When the first *null* card from the deck is found, *splice()* is used to delete any and all remaining cards in the hand that have not been popu-

lated during the current deal. This is done using the *for* loop's *i* counter. You specify the position to start deleting as *i-1* (recall there is a difference of 1 between the counter and the array index). You then specify the *deleteCount* as *6-i*. Even though in this example you will never end up with more or less than two odd cards (52 divided by 5 has a remainder of 2), the expression is written generically so that it could be applied to any remainder between 1 and 4.

For example, if you had one odd card left over it would be inserted into the hand. The *for* loop's counter would then be at 2 when the *splice()* was encountered. At that point, you would want to delete from array index position *i-1* (that is, 2-1 or array index 1) to *6-i* (6 minus 1 is 5). If you had three odd cards left over, the counter *i* would be at 3 and you would want to delete from array index position *i-1* (that is, 3-1 or array index 2) to *6-i* (6 minus 3 is 3). Finally, if you had four odd cards left over, the counter *i* would be at 4 and you would want to delete from array index position *i-1* (that is, 4-1 or array index 3) to *6-i* (6 minus 4 is 2).

Before moving on, you should understand why it is important to delete the remaining blank spots in the hand when a full deal (5 cards) is not available. If you did not delete the cards, you would have two problems. First, you see that following the *for* loop you use the *join()* method to place the string content of the array *myhand* into *handlist* for display purposes. If the *null* values are passed to *myhand*, *handlist* will contain *n* number of commas, where *n* is based on the number of *null* values inserted into *myhand*.

For all intents and purposes, this does not cause major problems, but it is not very aesthetic, particularly in that you can use *splice()* relatively easily to remove them. More of a concern, however, is the fact that the *length* of *myhand* (and then *mypile*, once you move the partial hand to the pile) would be inaccurate, which will cause problems later. The final two lines of code example 3-7 perform a simple string *join()* of the *mypile* and *myhand* arrays into their respective variables so that their content is displayed in the text boxes on the screen.

Now that you have examined the code attached to the Deal button, let's examine the Discard button. Its code is located beneath the deal section, in frame 1 of the *State* layer.

As you begin perusing the Discard code, you will find that it matches the second section of code from the Deal button. The only difference is that cards are being moved from the hand to the pile, instead of from the deck to the hand. Thus, in regard to the Discard code, to maintain consistency in the order of the cards as they pass from hand to pile, you use the *shift()* method instead of *pop()* to pull the card from the hand.

In the code for both the Deal and Discard buttons, you saw the use of the *updatepilecard()* function, which updates the face card that appears on the top of the pile. The five individual cards that are dealt also call a function, called *findfaceandset()*, to change their respective face cards.

First, let's see what happens when one of the Flip buttons is pressed, which is associated with the *findfaceandset()* function. All of the flip buttons do the same thing; they just do it to a different object. You will find that each of the flip buttons has a method function setup at the end of the code associated with frame 1 of the *State* layer. This code looks as follows.

```
flip1.onRelease = function() {
    findfaceandset(this._name);
}
```

Each of these method functions begins with the button's instance name, and all five of them call the *findfaceandset()* function, passing the button's instance name *(this._name)* to the function. Thus, the real code for the flip buttons (because they all essentially do the same thing) resides in one place: the *findfaceandset()* function. You will find this function, shown in code example 3-8, in frame 1 of the *Global* layer.

Code Example 3-8: Code for Revealing a Card's Face

```
function findfaceandset(mybutton) {
 var temp=mybutton.substring(4,5);
 if (myhand.length != 0) {
  if (eval("card"+temp)._currentframe<=2) {
   var temp2 = returnindex(myhand[temp-1], facelist); ¬
   eval("card"+temp).gotoAndStop(temp2+2);
  } else {
   eval("card"+temp).gotoAndStop(2);
  }
 } else {
  handlist = "There is no in the hand. Deal the ¬
  cards first.";
 }
}
```

As shown in code example 3-8, the *findfaceandset()* function receives the instance name of the object that called it (that is, one of the flip buttons) and puts it in a local variable called *mybutton*. The value in *mybutton* is then used to figure out which card should be flipped.

Recall that the buttons are named *flip1*, *flip2*, and so on, and that the movie clip instances above each button are named *card1*, *card2*, and so

on. Thus, the important part of the value in *mybutton* is the trailing number on the button's name. This number is the unique part of the button and card name, and it links the two. Therefore, the first line in the *findfaceandset()* function extracts the number on the end of the instance name (using the *substring()* method) and puts it into a variable called *temp*.

The next thing this code does is to make sure the hand currently has some cards in it, using an *if* statement to see if *myhand.length! = 0* (see if the *length* of *myhand* is not 0). If no cards have been dealt (*myhand.length* is 0), the user needs to be prompted to first deal some cards. This is so that the user cannot flip a card that is not there.

Assuming there are cards in the hand, the second *if* statement uses the *_currentframe* property to determine what to do. In essence, you want the user to be able to flip the card back and forth between the face and the back of the card. If *_currentframe* is less than or equal to 2—that is, either the "no card" frame (frame 1) or the back of the card is showing (frame 2)—you want to reveal the card face. Unless something goes awry, the card will be at frame 2 (the back of the card). Detection for the value of 1 is included as a "just in case." Aside from this, if the card face is already showing (that is, *_currentframe* is not less than or equal to 2), you want the card to return to frame 2, which is the back of the card. Thus, the second part of the *if* statement, *eval("card" + temp).gotoAndStop(2);,* does this.

Beyond the use of *_currentframe,* more important is the use of *eval()* in this *if* statement. Notice how *eval()* is being used to write the *if* statement generically so that this function will work for all the button and card combinations. By using *eval()* on the string/variable concatenation (*eval("card" + temp)),* the *if* statement examines the correct card based on the value in *temp.* All of this is dependent on the value in *temp,* which was captured in the line prior to the *if* statement.

The last aspect of this function to be examined is what happens when the face of the card needs to be shown. The following two lines of code handle this and are executed if the second *if* statement evaluates as *true.*

```
var temp2 = returnindex(myhand[temp-1], facelist);
eval("card"+temp).gotoAndStop(temp2+2);
```

The first line uses a utility function called *returnindex()* to retrieve the frame in the respective card instance that should be shown (such that the correct face card will be displayed). The *returnindex()* function is set up so that it will look up the array index of a value, provided a value to look for and an array to look in. The second line then sends the card instance to the correct frame using the *temp* and *temp2* variables. Again, note the

use of *eval()* such that this code will work for any of the card/button combinations.

The last thing to be examined in this example is the movement of data from the hand to the pile and how the uppermost card in the pile is revealed. You have already seen how card data is moved from the deck to the pile. Moving data from the hand to the pile functions similarly. If you compare the method functions associated with the deal and discard (located in frame 1 of the *State* layer), you can see that they essentially work the same way. The only additional thing to accommodate when discarding is showing the face card on the top of the discard pile. The *updatepilecard()* function, which is called from the discard method function, handles this.

If you quickly compare *findfaceandset()* and *updatepilecard()*, you will see the similarity between them. That is, the two lines of code in *updatepilecard()* are essentially the same as the last two lines of code examined in *findfaceandset()*. Both are used to reveal a face card, but for different objects. Let's finish this example by looking at this last function, presented in code example 3-9.

Code Example 3-9: Showing the Uppermost Pile Card's Face

```
function updatepilecard(){
 var temp=returnindex(mypile[mypile.length-1], ¬
 facelist);
 pile.facecard.gotoAndStop(temp+1);
}
```

This *updatepilecard()* function needs to do three things: (1) determine the last value in the array *mypile* (the uppermost card in the pile), (2) determine the array index number of that value (card) in the array *facelist*, and (3) use the returned index number from *facelist* to tell the movie clip *card-axono* (instance *facecard*) in the movie clip *deck-build-axono* (instance *pile*) to go to the correct frame. These three things are accomplished in two lines of code.

The first line of code simultaneously determines the last value in the array *mypile* (*mypile[mypile.length-1]*) and returns the array index of that value in the *facelist* array (*returnindex(mypile[mypile.length-1], facelist);*). It places the index position into the variable *temp*. The index position (in *temp*) is then used to tell the face card in the pile movie clip instance to go to the appropriate frame, and therefore the correct face card is revealed (*pile.facecard.gotoAndStop(temp + 1);*).

Applications of Sorting

As you have already seen, Flash provides some very unique capabilities as it relates to arrays. In exercise 3-3 you will examine a movie that uses the various array methods to manipulate a deck of cards. However, instead of focusing on dealing cards, as you did in the last example, you will use the array methods to cut, shuffle, and sort the cards. Figure 3-5 shows the file you will be working with.

Figure 3-5. Applying the sort to the deck of cards.

Exercise 3-3: Using Array Methods

CD-ROM NOTE: *Begin this exercise by opening the file* ch03_12.fla *from the* fmxas/chapter03/ *folder on the companion CD-ROM.*

Although you will pull out sections of code from the example in the text, it will be helpful for you if you follow along on screen as well. Once the file is open, use Test Movie to see how it works. Perform the following steps.

1. Begin by looking at how the data is placed into the four consecutive text boxes that show the Deck List. Click on frame 1 of the *State* layer and examine the actions.

 Like other files you have seen, the beginning of this script initializes the environment by calling functions that exist in the

Global layer. The important function to examine, shown in code example 3-10, is the *populatelist()* function. This function is called at the beginning of the movie, but also when each of the buttons (Cut Cards, Shuffle Cards, and so on) is pressed.

Code Example 3-10: Script for Populating the Consecutive Deck List Text Boxes

```
function populatedlist() {
 for (var i=1; i<=4; i++) {
  set("decklist"+i, "");
 }
 for (var i=0; i<mydeck.length; i++ ) {
  temp=i+1
  if ( i<=14) {
   decklist1+="Card "+temp+"="+mydeck[i]+"\n"
  } else if ( i<=29 ) {
   decklist2+="Card "+temp+"="+mydeck[i]+"\n"
  } else if ( i<=44 ) {
   decklist3+="Card "+temp+"="+mydeck[i]+"\n"
  } else if ( i<=52 ) {
   decklist4+="Card "+temp+"="+mydeck[i]+"\n"
  }
 }
}
```

Code example 3-10 reveals how the data is inserted into the series of deck list fields. The fields are dynamic and are associated with variables named *decklist1, decklist2,* and so on. The other important thing to realize is that you want to achieve more than simply placing the raw content of each value in *mydeck* into the deck lists. You want to format each list so that it reveals the physical card number and which card it is, such as Card 1 = 00.

 NOTE: *You could easily interject an additional lookup array to be able to specify that "Card 1 is the ace of clubs," given what you have already learned about arrays. However, let's stick with what we have for right now.*

To accomplish the numbering, you will see that the first *for* loop cleans out the current values in the deck list variables.

Because the second *for* loop appends each subsequent value (+ =) from *mydeck*, rather than replacing each value, you have to first flush out the old values before repopulating the lists with new values. You will note that the *set()* method is used here instead of a statement such as *eval("decklist" + i);*. This is one scenario in which *eval()* will not work, as discussed in greater detail in material to follow.

As you can see in the second *for* loop, once the lists are clean you funnel through all values in *mydeck* and place the first 14 values (1 to 15) in the first column (variable *decklist1*), the second 14 values (16 to 30) in the second column (variable *decklist2*), and so forth. The nice thing about all of this is that each time you manipulate the deck (whether it be to cut, shuffle, or sort) you can easily display the new card arrangement just by calling the function *populatelist()*.

2. Examine the method functions associated with the Cut Cards button, located in frame 1 of the *State* layer. Code example 3-11 shows the method functions associated with this button.

Code Example 3-11: Method Functions Associated with the Cut Cards Button

```
cutCards.onPress = function() {
 feedback = "Cutting cards...\n\n";
};
cutCards.onRelease = function() {
 //part 1: pick random cut location
 var midpoint = Math.round(mydeck.length*.5);
 var myvariance = Math.round(Math.random()*mydeck.¬
length*.2);
 var mysign = Math.round(Math.random());
 if (mysign == 0) {
  var mydis = midpoint+myvariance;
 } else {
  var mydis = midpoint-myvariance;
 }
 //part 2: cut the cards
 var temp1A = new Array();
 temp1A = mydeck.splice(0, mydis);
 var temp2A = new Array();
 temp2A = mydeck.splice(0);
 mydeck = temp2A.concat(temp1A);
```

```
//part 3: update the display
populatedlist();
feedback += "Done Cutting.\nThe cut point was ¬
"+mydis;
};
```

The first thing you will notice about code example 3-11 is that there are two method functions associated with the button. This is so that you can interactively provide feedback to the user before the output is generated. When the user presses the button, you want to let them know that the cut operation has begun. When the cards are cut, you want the Feedback text box to update to let the user know that the operation is complete.

This strategy is used for all buttons (Cut, Shuffle, and *Sort()*) in this example. If your computer is fast enough, you probably will not perceive the delay between the two posts to the Feedback text box, as the operation occurs rather quickly. However, for the last two buttons—Sort (By Cards) and Sort (By Suit)—you will likely see the effect.

 TIP: *When you create your movies, you should always consider how a slower computer would react to your code. When and where possible, include logical feedback loops that accommodate slower processing speeds.*

Let's turn now to the content of the *onRelease* method function, which is where all the action is (no pun intended). This code is divided into three parts (as noted by the comments in code example 3-11). The first part randomly picks a point near the middle of the deck to cut the cards. The second part actually cuts the cards, and the third updates the display.

The first part of the code chooses a random point in the middle of the deck, in an attempt to simulate reality. Seldom when you cut a deck of cards do you get the exact middle point. Thus, the code uses a little math to randomly select a point in the middle 40 percent of the deck.

To do this, you first find the midpoint of the deck by multiplying *mydeck.length-1* by .5 and placing it in a variable called *midpoint*. You subtract 1 from the *length* because you want the resulting number to be relative to the array index, not the number of items in the array. You then figure out what 20 percent of the deck would be by multiplying *mydeck.length* by .2 and placing it in a variable called *myvariance*.

Here, you want to work with the actual number of items in the array, rather than the array index. Thus, you do *not* subtract 1. By multiplying *Math.random()* by 20 percent of the deck, you end up with a number between 0 and 20 percent of the deck. You will also note that in both cases you want to work with whole numbers only. Thus, you use *Math.round()* to round to the nearest whole number.

 TIP: *When you are working with arrays and trying to figure out whether you should subtract 1 from array.length or not, think about whether you are trying to resolve a number relative to the array index or to the number of items in the array.*

You will recall that you want the midpoint to fluctuate in the middle 40 percent of the deck. Thus, sometimes you need to add *myvariance* to *midpoint,* and sometimes you need to subtract *myvariance* from *midpoint.* To do this, you generate one more random number, called *mysign.* The variable *mysign* will alternate between 0 and 1, and you simply use an *if* statement to either add *myvariance* to *midpoint* or subtract *myvariance* from *midpoint,* based on the value in *mysign.*

Once you have the random midpoint for the deck, you use a little slight of hand with some of the array methods to cut and rearrange the array. The second section of code example 3-11 shows that the *splice()* method is used to cut from 0 to the midpoint from *mydeck* and place it into a temporary array called *temp1A.* Then *splice()* is used again to cut the remaining cards in *mydeck* to *temp2A.* The final step is to use *concat()* to rejoin the two halves back into *mydeck.* Note that once you have reassembled the deck you repopulate the deck list text boxes and update the Feedback text box. Now let's quickly examine the content of the *shuffleCards, reverseCards,* and *sort()* method functions.

3. Examine the method functions related to the *shuffleCards* instance, located in frame 1 of the *State* layer.

 In this instance you will see that all you have to do is reapply the *do...while* section (discussed earlier in the chapter) to reshuffle the deck. Content is pulled from *mydeck,* the *do...while* is used to insert the cards into a new array, and then *mydeck* is set equal to the secondary array.

4. If you wish, examine the method functions associated with the *reverseCards* or the *sortCards* instances.

You will find that the *reverseCards* section uses the Array object's *reverse()* method, whereas the *sortCards* section uses the standard *sort()* method.

5. Examine the order functions used for the Sort (By Cards) button and the Sort (By Suits) button.

In the code in frame 1 of the *State* layer, you will find the method functions associated with these buttons. In the *sortByCards* method function, you will find the order function shown in code example 3-12. Because the order function is used only by the *sortByCards* method function, the *bycards()* function is directly nested with the *sortByCards* method function.

Code Example 3-12: Script for the Order Function for Sorting by Cards

```
function bycards (a,b) {
 var a1=a.charAt(0);
 var a2=a.substr(1,a.length);
 var b1=b.charAt(0);
 var b2=b.substr(1,b.length);
 if (a2==b2) {
  return a1-b1;
 } else {
  return a2-b2;
 }
}
```

As you examine code example 3-12, you see that the first thing you do is create four local variables to store the parts of the card reference. The variables *a1* and *b1* store the first number in *a* and *b*, which is the suit of the card. The local variables *a2* and *b2* store the rest of *a* and *b*, respectively, which is the actual card in the suit. You do this so that you can provide the logic needed by the *sort()* method to sort by card. Basically, you want the sort order to be 00, 10, 20, 30, 01, 11, 21, 31, 02, 12, 22, 32, and so on. Note that it is the ending numbers (cards) you want sorted first, and then by suit within matching cards.

To do this, you can use some simple logic. Because you want to match first by card and then by suit, you write the statement to check for two cards that match (in other words,

two aces, two 2s, two 3s, and so on). If you find two cards that match, you want to sort by suit. Thus, you return *a1-b1*. If *a1* is smaller than *b1*, a negative number is returned. If *b1* is greater than *a1*, a positive number is returned. As it relates to suit, once you have sorted by card you will not find the case in which *a1* = *b1*. Therefore, you do not have to worry about it. If you do not find that *a2* equals *b2*, you simply return *a2-b2*. That is, if you do not have two aces, for example, you need to look at the two cards you do have and sort based on these.

6. Examine code example 3-13.

The interesting thing about the Sort (By Suit) button's order function is that it is just the inverse of the order function for the Sort (By Card) button. Code example 3-13 is the Sort (By Suit) method function's order function.

Code Example 3-13: Script for the Order Function for the Sort (By Suit) Button

```
function bysuit (a,b) {
 var a1=a.charAt(0);
 var a2=a.substr(1,a.length);
 var b1=b.charAt(0);
 var b2=b.substr(1,b.length);
 if (a1==b1) {
  return a2-b2;
 } else {
  return a1-b1;
 }
}
```

Code example 3-13 reveals that sorting by suit is the inverse of sorting by card. When you sort by suit, you want the order of the cards to be 00, 01, 02, 03, 04, 05, 06, 07, 08, 09, 010, 011, 012, 10, 11, 12, and so on. Thus, to sort by suit you again begin with an equals case, but you use *a1* and *b1* this time. If you find that the two cards in *a* and *b* are the same suit, you simply return *a2-b2*. As for the case of sorting by cards, once you find that the suits match, you do not have to worry about having two of the same card in the same suit. Thus, you can ignore the case of *a2* equals *b2*. If you find that the two cards are not of the same suit, return *a1-b1* to sort the cards according to suit, ignoring card number.

Tracking Objects with Arrays

Earlier in this chapter it was stated that arrays could be used to track objects. Exercise 3-4 demonstrates how you can use arrays to keep track of a series of objects in your movie. Figure 3-6 shows and example of what you will be examining.

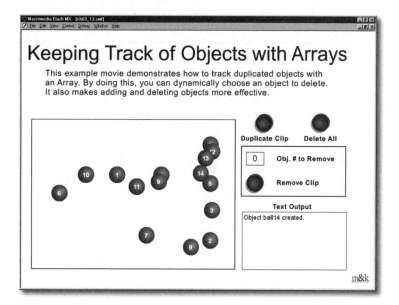

Figure 3-6. Tracking objects with arrays.

Exercise 3-4: Using Arrays to Track a Series of Objects

CD-ROM NOTE: *Begin this exercise by opening the file* ch03_13.fla *from the* fmxas/chapter03/ *folder on the companion CD-ROM.*

Although you will pull out sections of code from the example in the text, it will be helpful if you follow along on screen as well. Once the file is open, use Test Movie to see how it works. Note that this example uses the older style of coding, where there is ActionScript attached directly to objects (namely, code attached to the ball object). Following this exercise, a CD Note points to an object-oriented example of the same thing, in which all logic for the ball object is contained within a class.

 NOTE: *The code associated with moving the ball object is not examined in this chapter. The mathematics and logic involved in programming animation of this type are dealt with later in the book.*

1. Begin by examining the method function associated with the *dupClip* instance, located in frame 1 of the *State* layer (shown in code example 3-14).

Code Example 3-14: Code Associated with the dupClip Method Function

```
dupClip.onRelease = function() {
 //section 1
 var flag = 0;
 for (var j = 0; j<=myArray.length-1; ++j) {
  if (myArray[j] == null) {
   duplicateMovieClip("ball0", "ball"+j, j);
   myArray[j] = "ball"+j;
   flag = 1;
   output = "Object "+"ball"+j+" recreated.";
   eval("ball"+j).myval = j;
   break;
  }
 }
 //section 2
 if (objnum<=50 && flag == 0) {
  objnum++;
  duplicateMovieClip("ball0", "ball"+objnum, objnum);
  myArray[objnum] = "ball"+objnum;
  output = "Object "+"ball"+objnum+" created.";
  eval("ball"+objnum).myval = objnum;
 }
};
```

Code example 3-14 consists of two major parts, as denoted by the comments. If you tested the movie, you saw that you are able to duplicate the ball object, as well as delete all or specific instances of it. When the user duplicates the original ball (instance name *ball0*), the duplicate's name is inserted into an array. The names of the duplicates are incremented as they are created, such as *ball1, ball2,* and so on. This is what allows the user to specifically delete a particular ball object from the

screen. It is also what lets you specifically track which ones have been deleted.

The first section of code in code example 3-14 exists to allow the user to delete any of the ball objects she generates (in a different code section). When the user deletes one of the ball objects, the graphical object is deleted from the screen, but the data reference to that object that exists in the array used for tracking is also deleted by setting its position to *null*. Also, when the user duplicates the next ball, you want to be able to fill in the hole left in the array, as well as in the order of the objects bouncing around within the rectangle.

To do this, the first section of code example 3-14 uses a *for* loop to funnel through all of the entries in *myArray* to see if there are any holes—*myArray* is the array that keeps track of the balls currently on the screen. If a position is found to have a value of *null*, you fill that position and create the ball object. You also set the *flag* variable to 1, so that section 2 of code example 3-14 does not accidentally create a second ball.

Note also the line in section 1 that says *eval("ball" + j).myval = j*. This is how each ball contains its own unique identification number. In reality, each of the ball objects on the screen contains its own variable *myval*, which is set the moment it is created and is never changed. If you use Control | Debug Movie you can actually watch this happen as each ball is created. Again, note the use of the *eval()* method. It is used so that *"ball" + j* is interpreted as an object reference and not a string.

Now let's look at section 2 of code example 3-14. Much like the first section, it too creates a duplicate of the original ball object. However, it will not create a ball if the first section has executed (due to the *flag* variable), and it will also not permit the user to create more than 50 copies of the ball (based on the global variable *objnum*, which keeps track of the total number of ball objects created). The number 50 is arbitrary. The environment was not tested to determine how many copies it could handle. Additionally, this will vary based on the performance of a particular machine. As for the remainder of the code in section 2, it is much like the guts of section 1.

2. Examine the code associated with the *remClip* method function.

As you look at the code here, you should be able to figure out what is going on. The code begins by making sure that

objrem (the variable associated with the field on the stage) contains a number. If not, it needs to tell the user to enter a number first. Next, it ensures that *objrem* is not greater than the current number of objects on the screen *(objrem > objnum)*, and that the object specified by *objrem* has not already been deleted (by checking to see if it is *null*). If everything checks out, the object is deleted from the screen and from the array.

3. Examine the method function associated with the Delete All button (see code example 3-15).

Code Example 3-15: Code Associated with the Delete All Button

```
elAll.onRelease = function() {
    for (var j = myArray.length-1; j>=1; —j) {
        myresult = myArray.pop();
        if (myresult != null) {
            removeMovieClip("ball"+j);
        }
    }
    objnum = 0;
    output = "All objects where deleted.";
};
```

Although code example 3-15 does not need lengthy explanation, given what has already been covered in this chapter, consider the *for* loop. Notice that this code shows how to write a *for* loop that decrements, rather than increments. The main reason it is written this way is so that it models the *pop()* operation that is occurring on the array. That is, the values are being pulled from the end of the array (decrementing), and therefore everything else might as well do the same thing. Note that all other *for* loops in this chapter have been incrementing.

Also take note of the second parameter in the *for* loop. It is set so that item 0 in the array *(ball0)* is not deleted. Decrementing counters can be frustrating at times—mainly because most people are used to writing incrementing *for* loops. You may want to tag or mark this page in case you need a decrementing counter in your future projects. You do not encounter them very often.

CD-ROM NOTE: *The ball example presents a good opportunity to look at an applied example of object-oriented programming. The file ch03_14.fla shows the ball created as a class. When done this way, the* ball *movie clip contains all logic necessary to set itself up on the stage, as well as to update the array used for tracking.*

Creating Arrays from External Data

The final exercise (3-5) in this section seems very simple, but is very, very important, particularly when you start integrating Flash elements with

![Macromedia Flash MX window titled "Creating an Array from a String"]

> **Creating an Array from a String**
>
> This little example shows how to take a string for an array name and a string of values and make them into an array.
>
> Array Name: `myarray`
>
> Item 1: `potatoes`
> Item 2: `tomatoes`
> Item 3: `beans`
> Item 4: `corn`
> Item 5: `sprouts`
>
> Create Array
>
> Output:
>
> The array myarray has been built.
> It contains:
> myarray0=potatoes
> myarray1=tomatoes
> myarray2=beans
> myarray3=corn
> myarray4=sprouts

Figure 3-7. Tracking objects with arrays.

external technologies. The primary aspect you should glean from this example is how to write a function that receives two values and automatically turns them into an array in Flash. It sounds simple, but coding it is another story. This example has many applications and could be modified to suit a number of scenarios. Figure 3-7 shows the file you will be working with.

Exercise 3-5: Creating Arrays from External Data

CD-ROM NOTE: *Begin this exercise by opening the file* ch03_15.fla *from the* fmxas/chapter03/ *folder on the companion CD-ROM.*

Although you will pull out sections of code from the example in the text, it will be helpful if you follow along on screen as well. Once the file is open, use Test Movie to see how it works.

If you tested the file, you saw that you could enter a name for an array, enter values in each of the fields, and then generate your own array from those entries. The important part of this exercise (as far as array building is concerned) is the *buildArray()* function in the first frame of the movie.

1. Access the *buildArray()* function to view the code. Code example 3-16 shows the very short, but very important, section you should examine. The rest of the function you should be able to decipher given previous discussion in this chapter.

Code Example 3-16: Key Portion of the Script

```
function buildArray (arrayname, mystring) {
...

...
 set(arrayname, new Array());
 for (var j=0; j<=temp; j++) {
  temp3 = j+1;
  eval(arrayname)[j] = eval("myvar"+temp3);
 }
...

...
}
```

If you compare code example 3-16 to the exercise file, you will see that some of the script has been omitted (for the sake of brevity). At this point you should be able to interpret the excised sections. The first line has been retained so that you can see that the function *buildarray* receives two values. These values are the name of the array, which is placed in the variable *arrayname*, and the values to be placed in the array (a comma-delimited string placed in the variable *mystring*). The values you enter in the item field are concatenated into a comma-delimited string in the Create Array button's method function.

Several times throughout this and Chapter 1 you have been encouraged to pay special attention to the *eval()* method. Code example 3-16 reveals two very important things as it related to *eval()*.

Already you have seen how to use *eval()* to make something evaluate as an object reference so you could modify its properties. For example, in code example 3-5 *eval()* was used to resolve the card to be manipulated (*eval("card" + i).gotoAndStop(1);*). In code example 3-8, *eval()* was used within an *if* statement to resolve an object reference so the object's property could be tested against (*eval("card" + temp)._currentframe < = 2*). Code example 3-16 shows two things, one related to variable names and the other related to arrays and array indices.

Note the line that says *set(arrayname, new Array());.* One significant change to Flash MX is that *eval()* cannot be used on a variable name. For

example, if you were to try to set one variable in a series using the following, where *i* is a number (hard-coded, this would be the same as the expression *myvar1* = *"new_value"*), you would find that Flash will not let you.

```
eval("myvar"+i)="new_value"
```

This line used to be a suitable alternative to *set(arrayname, new Array());*. However, the *eval()* function cannot be used on variable names any longer. Instead, use the following form.

```
set("myvar"+i, "new_value");
```

In regard to this technique, the value you assign to the variable can actually be anything. In code example 3-16, note that the variable is being set to a new array, as follows.

```
set(arrayname, new Array());
```

As it relates to *eval()* and arrays, look at the *for* loop and its content. This is new and vitally important. In an earlier section of this script, the comma-delimited string is divided into separate values (parsed) and inserted into a series of variables, called *myvar1, myvar2,* and so on. The *for* loop increments through these and automates the insertion of their content into the array. However, it is dynamically generating the value for the array position, the array position itself, and the array name. This is powerful. The key is to understand how to write the evaluation of an array name and position. If you follow the logic from evaluating variable names, it will lead you down the wrong path. The following code shows the general form.

```
eval(variable1)[variable2]=eval(variable3)
```

Make a special note of this. Table 3-6 summarizes how *eval()* can and cannot be used. In the table, the first column is a description of what you

Table 3-6: Valid and Invalid Uses of the eval() *Method*

Evaluate As	*eval* Statement	Interpreted
Variable	*set("card"+i, 4)*	*card1=4*
	NOT: eval("card"+i)=4	
	set("animal"+i, "camel")	*animal1="camel"*
	NOT: eval("animal"+i)="camel"	
Object	*eval("ball"+i)._x=25*	*ball1._x=25*
	eval("plate"+1)._alpha=50	*plate1._alpha=50*
	eval("disk"+1)._visible=false	*disk1._visible=false*
Array	*eval("myarray")[i]="blue"*	*myarray[1]="blue"*
	eval("mylist")[i]=24	*mylist[1]=24*

want the content of the *eval()* method to be evaluated as. The second col-
umn is the code with the *eval()* statement, and the third column is what
ActionScript will interpret it as.

■ ■ ■ Summary

In this chapter you have closely examined the Array object through sever-
al basic to advanced examples. In this process you have been introduced
to several advanced concepts, including the basics of recursion, order
functions, and detailed manipulations of arrays. As you proceed to the
next chapter, where you will dive into the use of the Color object, you will
continue to see how arrays are used as part of more advanced program-
ming.

chapter

4

Digital Color and Flash's Color Object

■ ■ ■ **Introduction**

For most people, dealing with color in the digital environment is peculiar, especially for those who come from a traditional art environment. Within the computer, color is natively defined by color components rather than by attributes, and thus the artist must don a technician's hat to be really effective with color.

This chapter demonstrates how to use the Color object in Flash. The Color object has four methods that are fairly straightforward to use. However, of greater concern is an understanding of digital color and digital color models. It is this knowledge that will make you feel confident in working with color on the computer, regardless of application.

Similarly, an understanding of hexadecimal numbering is also important if you want to work with color on the Web. Just when you thought you could leave those funny color representations behind, you will find that these remain important when you work with the Color object in Flash.

Therefore, unlike previous chapters, you will be exposed to a little theory before diving into an examination of the Color object and examples of it. This knowledge is vital to understanding how graphically based color controls in graphics applications work, as well as how they are created and programmed for use.

▪ ▪ ▪ Objectives

In this chapter you will:

- Examine the basics of digital color theory and why digital color is often unwieldy for the nonspecialist
- Learn about component-based color models, including the RGB and CMY models
- Find out why many people prefer attribute-based models, such as HLS, HSB, and HSV
- Discover the Color object methods and how they can be used to modify the color of movie clips
- Examine numerous examples that demonstrate the advanced uses of the Color object, and of scripting in general

▪ ▪ ▪ Understanding Digital Color

For most students, one of the most complex things to understand and visualize when dealing with computer graphics is the creation and reproduction of color. However, color is also a challenge for the professional. For example, artists striving to recreate reality within a digital painting must deal with color creation and reproduction. Graphics designers, who must be concerned with exactness in printed colors from the computer, must deal with these issues as well.

Computer scientists searching for the new algorithm or engineers striving to create applications that seamlessly satisfy the breadth of input and output devices also deal with understanding digital color. This issue also faces web developers, who may be constrained to design around the limits of a 256-color environment. The commonality among these professionals is that each must represent color with accuracy appropriate to the situation, and to do that efficiently and effectively requires intimate knowledge of digital color and how it works.

Quantifying Color

Depending on where you fall within the artist/scientist spectrum, you have likely learned some method of quantifying and specifying color. If you are an artist, you are likely used to dealing with *attribute-based color*; that is, you specify a particular color by hue (usually associated with a paint name in traditional artistry, such as ultramarine blue, or a simple color name, such as blue), and then specify a certain level of saturation and value.

For those unfamiliar with these terms, let's define them. A *hue* is the name of the color, and each hue is defined by a specific, measurable wave-

length. Thus, red is a hue, blue is a hue, and so on. Note that usually the generic term *color* is not synonymously used for *hue* in technical circles; a color has a hue, saturation, and value.

The purity of a color is called *saturation*. You can think of saturation as how intense a color is. Fluorescent colors are said to be highly saturated (sometimes *oversaturated* or *supersaturated*). Dull colors are called *desaturated* colors.

If you have ever played with color, you realize that colors across from one another on an artist's color wheel are called *complements* of each other. By adding a color's complement, you are able to desaturate the color. For example, orange and blue are complements of each other. Adding orange to a pure, 100-percent-saturated blue will dull the blue. Conversely, adding blue to orange dulls the orange. As a color is desaturated (by adding its complement), the color approaches gray. Theoretically, if you mixed equal amounts of blue and orange you would get a gray. The resultant gray is the *mean of the values* of the original hues mixed.

The last attribute to mention is *value*. Value is the relative lightness or darkness of a color. In art circles, value is usually described as the amount of white or black in a color, or the amount of black or white that must be added to a color to get a particular tint (when you add white to the color) or shade (when you add black to the color). However, in scientific terms it is better to think of value as lightness or darkness, or more specifically, *luminosity*.

In attribute-based color, the three attributes (hue, saturation, and value) are used to quantify a specific color. Granted, in artistry, color is often loosely defined, as artistry is usually only concerned with perception; that is, qualitative value, not quantitative value. However, any color an artist uses could be accurately pinpointed by providing a combination of a specific hue, saturation, and value measurement.

On the other side of the spectrum (that is, scientist, engineer, and technologist, or SETs for short), you are likely used to quantifying color based on the color components used to recreate the color on some device, called *component-based color*. For example, when representing a color on a computer monitor, you quantify a color based on the amount of red, green, and blue needed from the monitor's phosphor guns. Again, note the use of three values to quantify the specific color. Most SETs are familiar with dealing with color quantitatively.

Regardless of point of reference, there is a means of accurately specifying color, and algorithms exist that allow you to "convert" colors from one method to another. Within a computer graphics application, it is not only beneficial but required that you be able to convert colors back and forth between color modes.

Let's examine an applied example, discussed further later in this chapter. Imagine you are creating a Flash movie, designed to teach people about color. In general, you want people to be able to specify a color based on hue, saturation, and value, and in turn derive the red, green, and blue components of that color. It is a given that the end user is going to be presented with attribute-based controls. Yet Flash cannot specify color based on hue, value, and saturation; it requires component-based color specification. Thus, this is a prime instance in which color conversion (and an understanding of how it is done) is very important.

The biggest problem is, of course, that most people fall into either the artist or SET camp, and only truly understand one or the other of these two approaches. Which one they are familiar with depends on their background. Yet, to be effective with computer graphics tools such as Flash requires an understanding of both.

When you are creating content, you generally want to deal with colors based on attributes. You choose a hue, a level of purity (saturation), and then a value (lightness or darkness). You will find that most computer graphics applications primarily provide attribute-based controls as the default. However, if you want to be able to add programming to control color, you must also understand component-based color—as the computer deals with color in this way—as well as how to fluidly translate between the two methods of defining color.

Later examples in this chapter demonstrate how to create controls that modify color based on components of a particular Flash movie clip. Flash's Color object is set up to deal with RGB colors (in hexadecimal form, and thus the discussion of hexadecimal numbering in material to follow). Examples of this type are fairly easy to create and are prevalent on developer web sites and in other Flash books. However, this book does not stop there. You will also explore how you can create attribute-based controls and the algorithms required for doing so. However, let's first briefly examine four of the most common color models and their applications.

Color Models

Color models are simply a means of graphically and mathematically representing the totality of all color as it relates to a particular color system, usually presented as a 3D representation. 3D models are used because both component- and attribute-based models use three values to describe a specific color.

Color models also allow you to define the range of color for a device. A hardware component that deals with color, such as a monitor or printer, has a maximum number of colors that can be output on that device.

The maximum set of colors is typically called the device's *gamut of colors*. Similarly, attribute-based color has some maximum number of colors that can be represented within it. Thus, the color model representation for each of these gamuts of color constitutes a means of visualizing the colors that are possible within the given system or device. Although models are not necessarily equal in size, they nonetheless provide a visual representation of the device's colors.

Why Visualize Color?

With reflection, perhaps you recall plotting functions on grid paper in high school or college algebra as a means of "visualizing mathematical functions," in which you dealt with equations such as $y = kx + b$ or $y = x^2$, finding that the graphical representation of the former was a line and the later a parabolic-type curve. To some it may have seemed an exercise in monotony. However, there is something very valuable that *should* have happened. The process of creating the graphic representation helps you visualize and understand the abstract function and what it really means. Color models provide the same assistance; each is a visualization aid that "gives you a feel" for data that is otherwise abstract and difficult to grasp.

The unique thing about color models, as opposed to plotting math functions, is that they are 3D, as shown in figure 4-1. Attribute-based colors and component-based colors are quantified by three values. Therefore, if you plotted each tracked value on an axis in 3D space, you could specify points in 3D space and better understand what the device's gamut is, as well as where any particular color lies in 3D space.

With that in mind, let's begin by examining the component-based color models for RGB (red, green, blue) and CMY (cyan, magenta, and yellow) color spaces. As you move through the discussion of each model, you

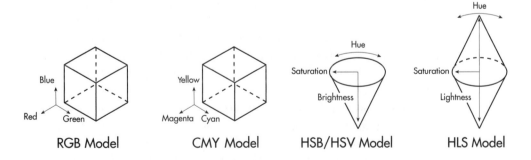

Figure 4-1. Color models are 3D visualizations of color gamuts.

will use a Flash movie to help visualize the models. The file allows you to see the relationship between the color component numbers and what the numbers actually mean, as well as the relationship from color model to color model. Chapter 11 dissects this beefy example and shows how the whole thing works.

Component-based Models

There are two fundamental component-based color models discussed in this chapter. They are the RGB model and the CMY model. The former describes the component colors used within monitors, most computer projection units, and projection televisions. The primary colors (that is, the three colors from which all other colors are derived) are red, green, and blue.

The CMY model, on the other hand, describes the raw colors generally associated with four-color process printing. Note that the CMY model is somewhat special; that is, it only partially describes the printing inks used in four-color processing. The difference is that black is added, not as a hue, but to make blacks richer and to reduce the amount of primary inks printed. Thus, four-color process printing includes cyan, magenta, yellow, and black. However, the color model includes only cyan, magenta, and yellow.

At a fundamental level, the RGB and CMY systems are "inverses" of each other. When you look at the graphical representation, you will see this as well. For example, in RGB, the secondary colors are cyan, magenta, and yellow. Note that a secondary color is created from mixing equal amounts of two primaries. In CMY, red, green, and blue are secondary colors. Thus, the RGB primaries are CMY secondaries, and vice versa.

Additive Versus Subtractive

The terms *additive* and *subtractive* are often used, respectively, to describe RGB and CMY color systems. RGB color is called *additive color* because you are adding or projecting color to a black or darkened screen. An easy way to remember this: When red is zero, green is zero, and blue is zero, the screen is black (i.e., off). When all primaries are at maximum (a value of 255), the screen is white. Figure 4-2 shows the basic premise of the additive primaries.

CMY, alternatively, is called *subtractive color*. Understanding why it is called "subtractive" is a little trickier. Knowing that CMY has to do with print, understand that when no color is printed, the page is white. This means that all parts of the visible spectrum (white light) are being reflected at you (the white page is absorbing no color at all, and is thus white), as shown in figure 4-3.

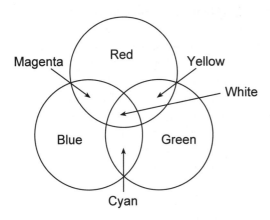

Figure 4-2. The additive primaries are red, green, and blue.

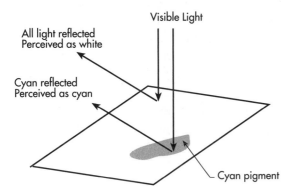

Figure 4-3. Color is perceived (or not perceived) because of the portion of white light reflected back.

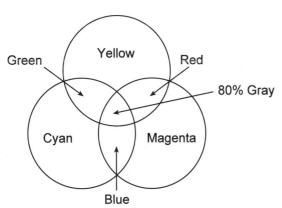

When you add pigment to the page, it begins to absorb all colors, except the one you perceive as the pigment color. Thus, if you see cyan color on a page, the page is absorbing all color except for cyan at that spot of color. You see cyan because it is not being absorbed. That is, it is being reflected (i.e., subtracted out of white light and reflected back). Thus, you can think of print pigments as being "filters" that absorb all parts of white light except for that color you perceive.

One other thing that is special about CMY is that when cyan, yellow, and magenta are all set to maximum (100%), the color created is actually about 80 percent gray, not pure black, as shown in figure 4-4. Thus, when you talk about CMY(K) printing, K (or black) is added so that blacks are true black, rather than composite black. In addition, black is used as a substitution for equal amounts of cyan, magenta, and yellow to reduce the cost of printing by reducing the amount of ink printed on the paper. You can imagine that a large black area could easily build up too much ink on a printing press (and wrinkle or tear) if the black is created by equal amounts of cyan, magenta, and yellow printed one over the other.

Concerning absorption and reflection, when cyan, magenta, and yellow are at 100 percent, the printed area is absorbing all colors and reflecting none. Thus, it is near black (80 percent gray). This explains why black items, such as a black T-shirt or a car with a black interior or

Figure 4-4. The combination of subtractive primaries creates 80 percent gray.

exterior, get so hot. The object is absorbing all (or maximum parts of) visible light and is thus collecting heat.

Now that you understand some of the generalities of digital color, let's begin looking at some specific color models. Let's start with the RGB color model. As you examine it, pay special attention to how the model works. If you are an artist (used to dealing with hue, saturation, and value) both the RGB and CMY models may seem somewhat counterintuitive because there is no ready way of directly modifying value or saturation. However, after the next two sections you will be able to better visualize how the RGB model relates to the color attributes hue, saturation, and value.

RGB

As shown in figure 4-5, the RGB model is a basic cube. Again, the RGB model describes the color gamut for computer monitors and other projection-based devices. In figure 4-5a, you see the typical image portrayed in most scientific texts. Because the image is an isometric projection, it is difficult to perceive the front and back corners of the cube. Additionally, you cannot see the line connecting the white and black points, which represents the grayscale values. Figure 4-5b provides a better visualization because the grayscale, as well as the points representing black and white, is visible.

Regardless whether you prefer (a) or (b) in figure 4-5, note that each color is plotted in 3D space. In RGB, each component can vary from 0 to 255. When any of the RGB components (or a combination of two components) is at maximum (255), you are at a corner of the cube and the result-

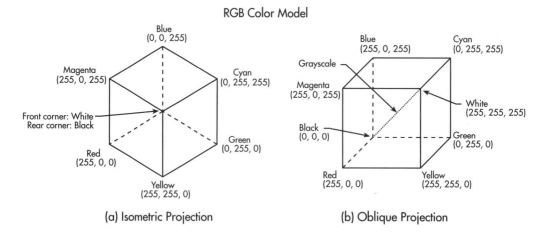

Figure 4-5. The RGB cube shown (a) in its typical isometric projection and (b) as an oblique projection.

ing hue is at its purest saturation. Any time all three components are equal (such as 128, 128, 128 or 43, 43, 43), you have a gray and are somewhere along the grayscale line in the cube (see figure 4-5b).

 CD-ROM NOTE: *To learn more about how the RGB color model works, open the file ch04_01.fla on the companion CD-ROM and click on the RGB tab. Make sure you interact with the R, G, and B fields, the HLS controls in the lower left, and the 3D model on the right. In addition, use the various options in the drop-down menu to the upper right. By trying all of these you will get a better understanding of how the RGB color model works.*

 NOTE: *As you peruse the example referenced in the previous CD-ROM Note, realize that it is not a truly object-oriented example, nor does it present everything that could be done. When it is referenced in the CD-ROM Notes in this chapter, use it to learn about how color models work. Chapter 11 dissects this example in detail, describing its construction.*

CMY

As stated, the CMY model and the RGB model are inverses of one another. Thus, you will find that the cube is flipped, with white replacing black, and vice versa. Recall that with CMY when no color is applied you should get white. As with the RGB model, equal amounts of the cyan, magenta, and yellow primaries result in gray, represented by the grayscale line, as shown in figure 4-6.

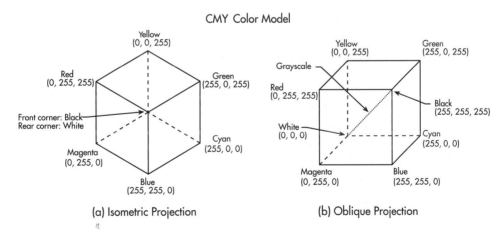

Figure 4-6. The CMY cube shown (a) in its typical isometric projection and (b) as an oblique projection.

 CD-ROM NOTE: *To learn more about how the CMY color model works, open the file ch04_01.fla on the companion CD-ROM and click on the CMY tab. In the CMY tab, you will notice separate numbers for the CMY and CMYK values. Keep in mind that black (K) is added in printing to replace equal amounts of cyan, yellow, and magenta for richer blacks and grays and to reduce ink costs.*

Attribute-based Models

Now that you have examined the RGB and CMY models, let's explore the two basic attribute-based models, HLS and HSB (HSB is also sometimes called HSV). These two are very common in computer graphics applications because they allow the artist to work directly with saturation and value. If you are incorporating color controls into programming, attribute-based controls are a must!

HLS

As shown in figure 4-7, the HLS model consists of two cones attached at the base. In some scientific texts, you may see this model displayed as attached hexacones. Nevertheless, within the model, hue is based on rotation around the cone. Saturation is purest at the outer edges of the model, whereas the grayscale runs through the center of the model. As you move linearly up or down, value changes. The coordinates for colors are provided as hue (in degrees), lightness (on a scale of 0 to 100), and saturation (on a scale of 0 to 100). For example, a pure red would be (0 degrees, 50, 100). Note that whenever saturation is 0, the color is a grayscale value. Additionally, when saturation is 0, hue is automatically 0 (by default).

 CD-ROM NOTE: *To learn more about how the HLS color model works, open the file ch04_01.fla on the companion CD-ROM and click on the HLS tab. Try selecting colors in RGB or CMY mode and then viewing the result in the HLS tab.*

Figure 4-7. The HLS model provides the ability to work with saturation and value directly.

HSB/HSV

The HSB (hue, saturation, and brightness) model is sometimes called the HSV (hue, saturation, and value) model. The HSB/HSV model is shown in figure 4-8.

The HSB model is somewhat peculiar in that it has a limited range of value, as compared to the HLS model. Nevertheless, the Mixer panel's color selector, shown in figure 4-9, is based on the HSB color system.

As shown in figure 4-10a, the Mixer panel's color selector (when partially minimized) is basically the outer skin of the HSB model. Note that Macromedia has "unfolded" the model's skin to create the color selector area. Compare the points in the model to those labeled in the color selector shown in figure 4-10 to better understand the selector. The limitation of this approach is that you cannot easily select intermixed ratios of saturation and brightness. Similarly, with the selector alone you cannot easily choose pure grayscale values. When you maximize the color selector (see 4-10b), it presents controls that more closely mimic HLS, which are what is typically presented in graphics applications.

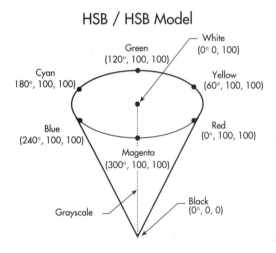

Figure 4-8. The HSB/HSV model resembles the HLS model and is used in the Flash color picker.

(a)

(b)

Figure 4-9. Flash's color selector is based on the HSB model.

Figure 4-10. Relationship between the Mixer panel's color selector area and the HSB model.

> **CD-ROM NOTE:** *To learn more about how the HSB color model works, open the file* ch04_01.fla *on the companion CD-ROM and click on the HSB tab. In comparison to other models, particularly HLS, HSB is not as intuitive.*

Hexadecimal Numbering System

As with HTML colors, the Color object in Flash uses hexadecimal numbering for color specifications. Thus, it is relatively important to be able to fluidly go back and forth between decimal RGB values and hexadecimal. There are some "Flash-specific" things you need to know, as well as some general information.

What Is Hexadecimal?

Most technical explanations describe hexadecimal this way: a hexadecimal number is simply a way of specifying an RGB value using Base16 numbering, instead of Base10. In essence, Base16 is a shorthand way of writing a color specification, in that each RGB can be written using only two digits.

RGB values—such as 255, 255, 255 (white) and so on—are Base10, the system most familiar to humans. Remember from Chapter 1 that the computer generally prefers binary (Base2)—its natural language—and octal (Base8) or hexadecimal (Base16), shorthand ways of representing binary numbers. However, hexadecimal numbering has much broader use than just RGB values. It can also be used as a shorthand (and this is really where it came from) for binary data, which is why hexadecimal exists and why it is based on Base16 arithmetic.

Representing Binary Numbers

Recall from Chapter 1 that at its heart the computer deals in lengthy series of zeros and ones. For example, a binary number such as 1011010000011111 is relatively difficult to remember or interpret—at least for humans. Thus, one thing that can make interpretation easier is to break the binary number into four sets of four bits, such as 1011 0100 0001 1111. Each of these sets is called a *nibble*.

Once the binary number is grouped, a single hexadecimal character can be used to represent each nibble. Note that each nibble has sixteen possible combinations (that is, two possible values for each of the four spots, or 2^4). Thus, to represent each nibble with a single character, you need sixteen unique characters. This is why hexadecimal is Base16.

Continuing, you encounter one problem. The Base10 numbering system has 10 single characters (0 through 9). Thus, you can represent the first 10 combinations in the nibbles with the decimal representations 0 through 9. However, what about the eleventh through the sixteenth combination; how do you represent these? The solution devised long ago was to use the alphabetical characters A through F. Thus, hexadecimal counting begins at zero, counts to 9, and then A through F, thus: 0, 1, 2, 3, 4, 5, 6, 7, 8, 9, A, B, C, D, E, F. Table 4-1 shows the relationship among binary, hexadecimal, and decimal numbering systems.

Table 4-1: Relationship Among Binary, Hexadecimal, and Decimal Numbers

Binary	Hex.	Dec.	Binary	Hex.	Dec.	Binary	Hex.	Dec.
0000	0	0	0111	7	7	1110	E	14
0001	1	1	1000	8	8	1111	F	15
0010	2	2	1001	9	9			
0011	3	3	1010	A	10			
0100	4	4	1011	B	11			
0101	5	5	1100	C	12			
0110	6	6	1101	D	13			

Given the binary number you were working with earlier, and table 4-1, the hexadecimal representation would be B41F (1011 = B, 0100 = 4, 0001 = 1, 1111 = F).

Hexadecimal for Colors

Now that you have seen where hexadecimal comes from, let's look at how hexadecimal is used to represent color, and the math that allows you to convert directly from decimal to hexadecimal, and vice versa. You will see this implemented in Flash a later example.

When you use a hexadecimal number to represent a color in Flash, HTML or wherever else it might apply, you will have a number such as 34FF56. Note that each pair of hexadecimal digits represents one of the RGB components. The first two digits represent the red component, the second two digits represent the green component, and the last two represent the blue component. In some programs, including Flash, you might see the number represented as 0x34FF56. In others, such as HTML, you will see it as #34FF56. These are simply ways of acknowledging to the program that the presented number is a hexadecimal number.

As to converting back and forth between decimal and hexadecimal, indeed most calculators have this ability. However, what if you are trying to program that ability into one of your Flash movies? You need to know how it is done.

Converting Decimal RGB to Hexadecimal

To convert a decimal RGB specification to hexadecimal, you deal with each color component separately, converting each component to hex. To convert a decimal value to hex, you divide each by 16 and look up the whole number result and dividend in a table, such as table 3-1. You then concatenate the results to form the complete hexadecimal value.

For example, let's say you want to convert the RGB value *27, 221, 64* to hexadecimal. You begin by working with the red component. Because 16 goes into 27 once, the first part of the red component hex value is 1. The remainder 11, as shown in table 4-1, corresponds to B. Thus, the hex representation of 27 is 1B.

For the green component, 16 goes into 221 thirteen times. Therefore, the first part of the hex value for the green component is D. The remainder is also 13, as shown in table 4-1, and therefore the second value is also D. Thus, the hex representation of 221 is DD.

The decimal value of the blue component is 64. Because 16 goes into 64 four times, the first part of the hex value for the blue component is 4. Note that 64 is wholly divisible by 16. Thus, the remainder is zero and the hex representation of 64 is 40.

 NOTE: *If there is no whole portion when you divide the decimal value by 16 (that is, if the decimal number is less than 16), the first number in the hex pair may be zero. For example, a decimal value of 15 divided by 16 yields 0, with a remainder of 15. Thus, the hex representation of the decimal 15 is 0F.*

Once you have the three hexadecimal pairs, you put them together to create the hexadecimal RGB representation. In this example, the hexadecimal representation of the decimal RGB value of *27, 221, 64* is 1BDD40.

Converting Hexadecimal to Decimal RGB

Converting hexadecimal RGB values to decimal RGB values is relatively easy. In Flash, as you will see later, you can use the *parseInt()* method to do this. However, to ensure understanding, let's look at the math. As hexadecimal is Base16, to convert any hexadecimal pair to a decimal equivalent you use the basic equation

$$x = 16 * h1 + h_2,$$

where h_1 is the first of the two hex digits and h_2 is the second of the two hex digits. Note that for h_1 and h_2 you use the decimal equivalent of the hex value. Also, when using this equation, make sure you follow the order of operations. If you add before you multiply, you will not get the right answer!

You can use the example from the previous section to see how this works. Given the hexadecimal value 1BDD64, you can convert it back to decimal RGB by dealing with each hex pair. Note in this process that you use table 4-1 to convert hex letters to decimal numbers so that you can plug them into the equation, as follows.

$$x = 16 * 1 + 11 = 27 = red\ component$$
$$x = 16 * 13 + 13 = 221 = green\ component$$
$$x = 16 * 4 + 0 = 64 = blue\ component$$

 TIP: *Later in this chapter you will see that you can use the* parseInt() *method, instead of the equation described here, to convert hex to decimal. For example,* parseInt("1B", 16) *will convert the string 1B to the decimal number 27. The key is to include the numerical argument 16 after the hex data. Similarly, you can use* parseInt() *to convert the hex representation 1B back to its decimal equivalent, using* parseInt(0x1B).

The Browser-safe Palette

This section looks at the browser-safe palette and its origin. Later in this chapter you will see an example that replicates the 216 standard colors of the browser-safe color palette, creating a palette from which a user could select color. To see the relevance of this, consider how you would program a palette of swatches based on the browser-safe palette in your Flash movie. What are the browser-safe colors based on? Would you have to figure out and manually write down all the RGB numbers for those colors so that you could create swatches of all 256 of them?

In reality, it is much easier and there is logic to the way the 256 browser-safe colors were chosen. And, you guessed it, the logic is based on—what else—hexadecimal colors!

What Is the Browser-safe Palette For?

Before looking at how the colors where "chosen," first keep in mind that the browser-safe color palette is really only important when you believe a large portion of your audience may be viewing in 256 colors. Fewer and fewer computers are limited to 8-bit color. However, when you consider an international audience, there are still many people limited to viewing web content at 256 colors.

The browser-safe color palette consists of 216 specific colors, as well as 40 other colors, for a total of 256. The colors selected for the additional 40 colors depend on the browser or the operating system for which the palette is designed. These are the colors used for the interface of the browser or operating system.

Note that specific palettes were first used for multimedia development—circa 1990—when computer-based multimedia as we know it today truly started to emerge. Thus, the browser-safe color palette is a continuation of this and serves a similar purpose. However, the palettes used for the operating system (that is, the Windows System palette and the Macintosh System palette) are not the same as the browser-based palettes. Further, various browsers may use different sets of colors for their palette.

The basic premise of using any 256-color palette, whether dealing with the web palette for web content or another palette for multimedia, is that you are trying to control the way the content will look for the audience members who are viewing in 256 colors. Whenever a machine is set on 256 colors (8-bit), everything in that environment must be rendered and displayed using the same 256 colors. If you happen to run into an image that uses colors not in the current palette being used for the system (usually the Windows or Macintosh System palette), the image can range in quality from slightly affected to rainbow soup! The goal of using a specific palette (in the case of web development, the goal of using the browser-safe palette) is to try to stay on the "slightly affected" end of the continuum, rather than the rainbow soup end.

A Few Words About Palletized Color

Many graphics professionals do not fully realize the potential of palletized color—or simply say, "If you can't view millions of colors, don't come to my site." Neither of these is good.

To better understand palletized color, you can do some simple testing on your computer. In Windows, simply go to the Control Panel I Display icon and select the Settings tab. Change the Color Palette setting to 256 colors, which may require you to restart your computer, depending on your video card and OS version. On the Macintosh, use the Monitors and Sound Control panel.

Once your system is set to 256 colors (8-bit), go out to the web and take a gander at some various sites (just surf for a while) and you will start to get a feel for what happens to the colors in a 256-color environment. It should not take you long to find a good site that makes pretty rainbow colors all over the images in the page. Problems like these could be easily solved with a little forethought and conscientiousness.

Now you may ask, "What types of audiences are likely to have 8-bit environments?" Typically, elementary and secondary schools and audiences of an international venue are often limited to a 256-color environment. Not all, mind you, but enough of a majority that when designing for them you should consider sticking to browser-safe colors. Some specialized professional audiences may also require browser-safe color palettes.

"Businesses in America limited to 8-bit color; you've got to be kidding" you say. They do exist. For example, the author once designed an intranet web site for a local law firm. They desired to do some pretty graphical things, because most of what they see day to day is just text. Yet, everyone in the firm had computers with nothing more than 4-bit color (that is right, 16 whopping colors). Thus, do not assume that everyone's computer can handle 16 million colors. Research your audience and try to design for the majority of users.

Where the Browser-safe Palette Came From

As you read earlier, the colors in the browser-safe palette are not a hodge-podge of RGB colors. Rather, they are logically chosen sets of color from the RGB model itself. An easy way to visualize this is that the colors consist of six "slices" from the RGB cube, taken at decimal increments of 51. Thus, a slice is taken at 0, 51, 102, 153, 204, and 255, as shown in figure 4-11. Note that each slice represents a value of red, from 0 to 255.

As you can see in figure 4-11, however, it is much easier to think about the slices in terms of hexadecimal numbers (that is, 00, 33, 99, CC, and

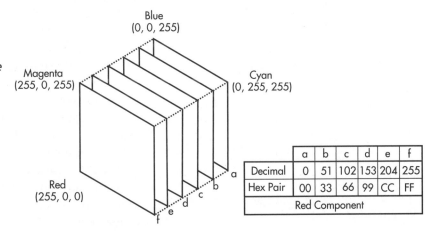

Figure 4-11. The browser-safe palette consists of colors obtained by six slices through the RGB cube, at decimal increments of 51.

	a	b	c	d	e	f
Decimal	0	51	102	153	204	255
Hex Pair	00	33	66	99	CC	FF
Red Component						

FF). In reality, all of the colors taken from the RGB cube for the browser-safe palettes are raw combinations of these five hexadecimal pairs.

If you do the math, you will find that six slices multiplied by 256 colors per slice does not add up to 256 colors. You would run out of hexadecimal combinations if you had to represent 256 colors on each slice.

Thus, the RGB cube is actually sliced six times, parallel to each axis (that is, a total of 36 times), as shown in figure 4-12. The colors in the browser-safe color palette are taken from the intersection of the three slices (or planes). On each color plane there are 36 points at which that plane is intersected by the other two planes. Figure 4-12 labels three points, on each side of the cube, to help you understand.

You can also think of the browser-safe colors as a cube consisting of smaller cubes. In this alternative viewpoint, the color-safe RGB cube is 6 x 6 x 6, as shown in figure 4-13. Instead of visualizing each color as a point defined by intersecting planes, each color is conceived as a cube. The cubes are stacked upon each other to create the total browser-safe cube.

You may be wondering what relevance an understanding of this has. The reason this book mentions the 6 x 6 x 6 cube idea is that the arrangement of swatches in Flash's Swatches panel makes more sense if you understand how the browser-safe colors are selected from the RGB cube. If you examine the Swatches panel, you will find that the default colors are arranged according to slices of red in the 6 x 6 x 6 cube. Examine figure 4-14. Note that the first "strip" of colors is simply for "quick-picking" of the standard grays and raw primaries and secondaries. The remaining colors are divided into groups of 36, progressing from 00 to FF for the red component.

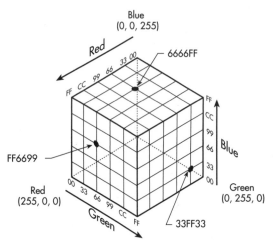

Figure 4-12. The six slices actually consist of a six-by-six number of colors, or a total of 36 colors per slice.

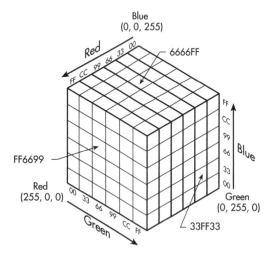

Figure 4-13. You can conceive of the browser-safe colors as cubes.

 TIP: *If the colors in your Swatches panel do not quite match the order shown in figure 4-14, use the Web 216 menu option from the Swatches panel menu to set the swatch order back to the default.*

As you can see, it is helpful to know how the 216 browser-safe colors are derived. It is the logic of the 6 x 6 x 6 cube, as shown in figure 4-15, that explains the arrangement of colors in the Swatches panel.

 CD-ROM NOTE: *To learn more about the browser-safe color palette, open the file ch04_02.fla on the companion CD-ROM. It allows you to interactively learn about the browser-safe colors and reveals the methods of extracting the six slices from the RGB cube. Note that Flash's Swatches panel orders the slices by red.*

Figure 4-14. The swatches in the Swatches panel are arranged according to the progression of the red component.

Figure 4-15. The 6 x 6 x 6 cube helps you visualize the arrangement in the Swatches panel.

▪ ▪ ▪ **The Color Object**

The Color object in Flash is pretty interesting, and allows you to do quite a few things. The Color object provides four methods you can use: *getRGB(), setRGB(), getTransform(),* and *setTransform().* The first two methods are designed for establishing or retrieving the totality of color in or from a movie clip instance. The *getRGB()* method retrieves the color of a movie clip, whereas the *setRGB()* method sets the color of a movie clip.

TIP: *The* getRGB() *method can only be used when color has previously been assigned using the* setRGB() *method. Similarly, the* getTransform() *method only works when* setTransform() *has been used previously.*

What makes the *setRGB()* method unique is that it fills the entire movie clip with color. Any lines or fills previously present in the movie clip are replaced with the assigned color. Although this is unconfirmed, this result is presumably because the color "injected" into the movie clip by the Color object is inserted at the highest level in the clip, much like duplicating a movie clip (*duplicateMovieClip()*) in which the duplicated clip is copied in front of the original. Nevertheless, if you want other elements to appear with, or to be overlaid on, the injected color, you can use nested movie clips inside one another. You will see examples of this later.

As for the *getTransform()* and *setTransform()* methods, they are designed to add or subtract a "tint" of color to or from a movie clip, rather than assigning a total color as the content for the clip. When you use the *setRGB()* method, the color assigned overrides all content in the clip, whereas *setTransform()* modifies the already existing elements. Additionally, these transform methods can be used to set alpha at the same time hue-based changes are applied.

All four of these methods can be used on movie clips or buttons. Although it is probably not necessary to discuss at length the rules of symbol naming and targeting, make sure you follow the rules of working with movie clips and buttons. In addition, like the Array object, you must instantiate the Color object before you can use it. You will examine both the longhand and shorthand ways of doing this in the sections that follow.

TIP: *An easy way to determine whether to use* setRGB() *or* setTransform() *is to think about what you are coloring. If you want to fill the totality of a movie clip as a flat or solid fill, use* setRGB(). *If you want to apply a tint (or shade) of a color to the content in a movie clip, use* setTransform(). *Finally, although related to the Movie Clip object rather than the Color object, you*

can also generate flat fills, gradient fills, and lines dynamically using the new drawing methods of Flash MX (explored later in the book).

The *getRGB()* method and the *setRGB()* method, as their names imply, are for retrieving and setting the color of a movie clip using an RGB value. Both methods require the use of a hexadecimal specification for the RGB color. Thus, *getRGB()* returns a hexadecimal RGB value, whereas *setRGB()* expects to receive a hexadecimal RGB value.

getRGB()

Let's first deal with the *getRGB()* method. The longhand method for using the Color object is to first instantiate the object. You then call upon its method, as in the following.

```
var myobj = new Color(clipname);
var clipcolor = myobj.getRGB();
```

In these two lines, you see the instantiation in the first line, and the retrieval of the object's color in the second, both of which are inserted into local variables (presumably in a user-defined function). If you use *trace()* on the variable clip color, a hexadecimal color would be placed in the Output window.

In the previous code snippet, the movie clip's name is *clipname*. If the movie clip were somewhere else in the movie structure, you could append a path to the beginning, such as *_root.mc1.mc1a.clipname*. Thus, you would insert that entire object reference as the argument for the *getRGB()* method.

As noted in Chapter 1, reducing code to its most basic form often breeds efficiency and reduces typing. The previous two lines of code can be shortened (and made more efficient) by using the following shorthand form.

```
var clipcolor = new Color(clipname).getRGB();
```

Throughout the remainder of this chapter, you will use the shorthand form, where initialization and the method call are preformed in a single statement.

setRGB()

The form for the *setRGB()* method is much like the *getRGB()* method. The general (shortened) form for use is as follows.

```
new Color (clipname).setRGB(hexval);
```

Here, *clipcolor* is a local variable, *clipname* is the name of a movie clip (with a path if needed), and *hexval* contains a hexadecimal RGB value.

Dealing with Hex

Before looking at ways of combining these two methods, let's explore manipulation of a hexadecimal value. In general, the simplest way to use the *setRGB()* method is to hard-code a hex value in the method, as in the following.

```
new Color (clipname).setRGB(0xFFFFFF);
```

You will note in this line of code that there are no quotes around the hex value and that it is preceded by *0x*. The *0x* tells Flash that the value is a hexadecimal value. Yet, if you want to change the color of the object very frequently, this is not a very effective way to do the coding. Instead, you will usually place a hex value inside a variable and use the variable as the argument instead, as in the following.

```
var myval = 0xFFFFFF
new Color(clipname).setRGB(myval);
```

 NOTE: *Although these two lines are shown together here, realize that they would probably be in different locations. For example, the first line may be in a frame, whereas the second might be attached to a button.*

As you look at the previous two lines of code, note that code *0xFFFFFF* has no quotes around it, as with the previous code example. This is important. If you place quotes around the hex code, Flash will interpret it as a string, and consequently the *setRGB()* method will not work.

Recall that you generally do not have to worry about whether a variable is a string or a number, but when working with hex values you do need to pay attention. The following two lines of code show what you would need if the variable were a string.

```
var myval = "FFFFFF"
new Color(clipname).setRGB(parseInt(myval,16));
```

In these lines, you see two changes that must be made if the hex value is a string in the variable. First, the *0x* is truncated from the hex value. The only time you want to add the *0x* is when you want the item to be interpreted as a hex value—when it is presented without quote marks. The second thing you see is the use of the *parseInt()* method. Note that the form *parseInt(variable, 16)* is used. The *16* tells the method to parse the variable as a Base16 (hexadecimal) value. In reality, the *parseInt()* method can be used to parse any arithmetic from Base2 to Base36. As a side note, later in this chapter you will see an example in which you need Base6 arithmetic.

 TIP: *If something goes awry with the* setRGB() *method, the movie clip will typically turn black. This is the way to tell if there is an error when you are trying to use the* setRGB() *method. Given that, when you are trying to set up a scenario that changes a color of a movie clip using* setRGB(), *do not use black as your test color!*

Combining the Methods

You are aware of the importance of hexadecimal data to the *getRGB()* and *setRGB()* methods. Note that the returned data from *getRGB()* can be used in a couple more ways. For example, you can use the *getRGB()* method directly in a *setRGB()* method, as in the following.

```
new Color(cliptochange).setRGB(new ¬
Color(clipname).getRGB());
```

This would set the color of one object equal to that of another. Yet there are times you want to convert the data from the *getRGB()* method to a string, so that you can do something to it. To convert the returned RGB value to a hex string instead of a hex number, you would use the following.

```
new Color(clipname).getRGB().toString(16);
```

This line of code will convert the returned value to a string instead of a hex value. However, one caution needs to be made about converting hex values to strings. When the returned hex value includes a hexadecimal number, such as 0033FF or 0000FF, the preceding zeros are truncated from the resulting string. Thus, 0033FF becomes 33FF and 0000FF becomes FF. This is not necessarily problematic if you are using the returned results directly in the *setRGB()* method, which is common (that is, as long as you use the *parseInt()* method so that it is interpreted correctly). For example, you could write the following.

```
new Color(cliptochange).setRGB(parseInt(new ¬
Color(clipname).getRGB().toString(16),16));
```

Although this code includes an unnecessary step (the conversion to a string and then a parse back to hexadecimal value), it is included to show the relationship between *parseInt(x, 16)* and *toString(16)*. In the previous code, the *getRGB()* method is being used to extract the current color of the movie clip *clipname*. When it does, it converts the result to a string, recognizing it as Base16. The result is used directly and assigned to the movie clip *cliptochange* using the *setRGB()* method. You can see that *parseInt()* is used around the entire color retrieval statement, as in the following.

```
new Color(clipname).getRGB().toString(16))
```

The *parseInt()* method is required because the resulting data from the *getRGB()* is a string. If you omitted the *parseInt()* method, you would get an error. Thus, you can think of *parseInt(x, 16)* and *toString(16)* as inverses of each other. The former converts a Base16 number to a string representation. The latter converts a string representation of a Base16 number to a true Base16 number.

The whole point in even mentioning *toString(16)* is that if you convert a hex value to a string, it is assumed that you are going to want to do something with all three pairs of values (as each represents part of the RGB combination). Just be aware that if you use *toString(16)* on a hex value, preceding zeros are omitted, resulting in a "shorter-than-normal" string representation of the hex value.

getTransform() and setTransform()

The *getTransform()* and *setTransform()* methods require the use of a generic object to define the color transformation data, and they are a little more difficult to work with than the *getRGB()* and *setRGB()* methods. The general form for their use is

```
new Color (clipname).getTransform();
```

and

```
new Color (clipname).setTransform(colorTransformObject);
```

where the *getTransform()* method returns an object containing a series of color properties and where the argument *colorTransformObject* for the *setTransformObject()* method is also an object containing color properties. Let's examine these color properties. The properties within the defined *colorTransformObject* consist of eight values, two for each R, G, and B color component and two for alpha. The properties are akin to using the Advanced option from the Color drop-down menu in the Properties panel. Recall that this drop-down menu is typically used to assign an alpha (transparency) value for a symbol instance. When Advanced is chosen, you can adjust two values related to red, green, blue, and transparency values using the Settings button.

The transform, applied by the Advanced color setting and the transform methods, is defined by the function $a * y + b = x$. Each of the two values associated with each color component is plugged into this function and applied to each color component. Thus, the function is applied to red, green, blue, and alpha, and a different transform function can be applied to each component simultaneously, depending on the values entered for a and b for each component.

In the equation $a * y + b = x$, a represents the percentage of the existing color component value being adjusted (how much of the already

existing color to apply the transform to), b is the amount the color is shifted (how far you want to offset the component, given the percentage to be affected as defined by a), y is the existing color (the current amount of the component in the object), and x is the resulting color after application of the function. The value defined for a can vary from -100 to $+100$, and the value defined for b can vary from -255 to $+255$. When working in the Advanced Color Effect Settings dialog box, shown in figure 4-16, the fields to the left are used for a, and the fields to the right are used for b.

Figure 4-16. Given the transformation function a * y + b = x, the fields to the left are plugged in for a, and the fields to the right are plugged in for b.

When using the transform methods, the values for a and b for each color component are defined using the generic, built-in Object object, of the following form.

```
colorTransformObject = new Object();
colorTransformObject.ra = 75;
colorTransformObject.rb = 200;
colorTransformObject.ga = 75;
colorTransformObject.gb = 200;
colorTransformObject.ba = 75;
colorTransformObject.bb = 200;
colorTransformObject.aa = 0;
colorTransformObject.ab = 0;
```

The shorthand form of the previous is:

```
colorTransformObject = { ra: `75', rb: `200', ¬
ga: `75', gb: `200', ba: `75', bb: `200', aa: ¬
`0', ab: `0'}
```

As you compare these two sets of methods, *getTransform()* and *setTransform()* may not make a lot of sense at this point. Later in this chapter you will take a look at an example that provides more insight into them. The key thing to remember concerning the four methods for the Color object is that the *setRGB()* method replaces all color in a movie clip, whereas *setTransform()* modifies the colors in the movie clip by affecting the individual color components of the entire clip.

▪ ▪ ▪ Applications of the Color Object

Now that you have been exposed to methods used with the Color object, let's begin dissecting some examples. In the examples that follow, you will be focusing on the use of the *getRGB()* and *setRGB()* methods, as well as ways of setting up controls and general color algorithms that allow you to convert colors back and forth from different color spaces. Toward the end of this section, you will also examine a file that uses the *getTransform()* and *setTransform()* methods.

Using getRGB() and setRGB()

As with most of the material in this book, you will begin with some basic examples. All three of these beginning examples are "coloring-book" types of examples, in which you select a color from a palette and then dynamically color an image. The first example demonstrates the basic use of the *getRGB()* and *setRGB()* methods, using a coloring example and a basic palette of colors. The color swatches are dynamically generated. However, the color assignment (hex color) is hard-coded. Additionally, there are only 30 colors available in these beginning examples.

The second example extends the first by generating a palette of colors that includes all 216 browser-safe colors, as well as a quick-pick list of standard grays (and RGB primaries and secondaries) presented in a linear fashion. The final example again generates the 216 browser-safe colors, but provides the ability to sort the colors.

 NOTE: *As the examples progress, in several places you are provided with multiple versions of the same file, in most cases to let you see how the problem might be solved using algorithms and/or recursion. Although space prohibits being able to explain them all at length, be aware that there are several files on the companion CD-ROM that would be beneficial to digest beyond the textural content provided in the chapter.*

A Rudimentary Color Palette

This beginning example demonstrates the basics of using *setRGB()* and *getRGB()* methods. A basic palette of colors is generated, which allows the user to select a color and then colorize the image, as shown in figure 4-17.

 CD-ROM NOTE: *The section that follows will examine code and aspects of the file* ch4_03.fla *located in the* fmxas/chapter3/ *folder on the companion CD-ROM. Open it into Flash and review it throughout the following discussion.*

If you have not done so already, open the file *ch3-02.fla* and use Test Movie to see how it works. There are basically three things going on in this movie: the building of swatches, the transfer of color from swatch to image piece, and the scripting that makes the cursor change while it is over the image to be colored. Each of these is examined in this order.

Figure 4-17. A basic example that shows the use of the setRGB() *and* getRGB() *methods.*

Building the Color Swatches

The *init()* function that builds the swatches is located in frame 1 of the *Global* layer in the main timeline. The swatches themselves use the OOP approach; that is, they include the definition of a Swatch class (examined later in the chapter). As a general process, the function creates an array for holding the hexadecimal values for the colors and then duplicates and positions the swatch chips (which are blank to begin with). Let's look at each of these more closely.

In the *init()* function, you will see three defined sections that perform the described tasks. The first part builds global variables for sound objects to be used later. As well, a global variable called *swatchlist* is created that houses the color names that will be applied to the color swatches at the end of the process. At this point, arrays should be old hat for you. However, note that true hexadecimal values are being inserted into the array, as denoted by the preceding *0x*, as well as the lack of quote marks around the values. When you start doing your own coding, keep in mind the various ways of using hexadecimal values, as well as the requirements for each method.

The second section of code in the *init()* function generates the blank swatches and positions them. The coding for this is shown in code example 4-1.

Code Example 4-1: Coding for Duplicating and Positioning Color Swatches

```
for (var i = 0; i<30; i++) {
  attachMovie("swatch", "c"+i, i);
  if (i<=9) {
    if (i == 0) {
      c0._y = 30;
    } else {
      eval("c"+i)._y = eval("c"+(i-1)+"._y")+18;
    }
    eval("c"+i)._x = 20;
  } else if (i>9 && i<=19) {
    if (i == 10) {
      eval("c"+i)._y = c0._y;
    } else {
      eval("c"+i)._y = eval("c"+(i-1)+"._y")+18;
    }
    eval("c"+i)._x = c0._x+25;
  } else if (i>19 && i<=29) {
    if (i == 20) {
      eval("c"+i)._y = c0._y;
    } else {
      eval("c"+i)._y = eval("c"+(i-1)+"._y")+18;
    }
    eval("c"+i)._x = c0._x+50;
  }
}
```

 NOTE: *Throughout code example 4-1, note how the* eval() *method is used to get Flash to recognize the concatenated object name as an object rather than as a string. As stated in the last chapter,* eval() *is vital for writing generalized code.*

As shown in code example 4-1, the swatches are built using a *for* loop and are populated from top to bottom and then left to right. Note that the *attachMovie()* method is being used to add the chips based on the movie clip symbol *swatch* in the library. The movie clip contains a class definition (examined in material to follow). Nevertheless, the first column is created from top (*c0*) to bottom (*c9*), and then each subsequent column is created similarly, from top to bottom.

As you begin looking at the *for* loop, you will note that it begins at 0 and proceeds up to and including 29 (or $i < 30$). The second line in the *for* loop reveals that each chip is named per "c" + i. Thus, the counter is important in the naming of each chip, as it is for several other lines in the *for* loop.

The remainder of code example 4-1 takes care of the positioning of each chip on the stage. You can see three major sections in the *if* statement. Each section is related to one of the three columns of chips. As you can see in the first part of the *if* statement, if the duplicated chip is in the first column ($i > 0$ && $i < = 9$)—that is, it is chip name $c1$ to $c9$—only the vertical placement (_y) needs to be set. The vertical position of the newly duplicated chip is based on the previous chip (the one above) plus 18. Figure 4-18 depicts how the chips are positioned and why the vertical spacing is 18.

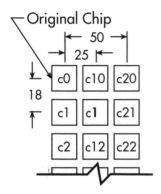

Figure 4-18. The coding of the if *statement is based on the geometrical spacing requirements.*

Concerning the other two columns of swatches, which are defined by the second and third parts of the *if* statement, if the chip is in either of the other two columns, both vertical and horizontal position need to be established. Horizontal position is basically a constant, in that all chips in column 2 are 25 pixels away from swatch $c0$, and all chips in column 3 are 50 pixels away from swatch $c0$. Yet, the vertical position must be treated in a special way. As you saw in the first column, vertical position is based on the last swatch placed. However, when swatch $c10$ is encountered, you want to begin a new column, rather than place it under $c9$. Therefore, swatch $c10$ must be treated singularly.

If you look in the second major part of the *if* statement, you will find a nested *if* statement that looks for $i = = 10$. When i equals 10, you want the vertical position to be equal to the y location of swatch $c0$. If i is 11 to 19, you want to continue making the vertical positioning based on the last chip placed. This is the reason for the nested *if* statement that looks for $i = = 10$. It basically causes it to start a new column.

With vertical position now established, you must also establish horizontal position. When you are dealing with the second column of swatches, the horizontal position of all swatches will be the x location of swatch $c0$, plus 25 (see figure 4-18). Like the second column, generation of the third column begins by looking for $i = = 20$, as it is the first swatch in the third column, and vertical positioning for the other swatches in that column will be based on it. The third part of the *if* statement is congruent to the second part. The only other difference is that the horizontal spacing is 50 pixels away from swatch $c0$, instead of 25.

One of the things you might be wondering as you look at the initialization code is where the chips are colorized. This is actually taken care of by each chip. That is, each chip gets its own color when loaded, as well as a few other details, and it is a function of the Swatch class. Let's look at how the swatches have been made into a class.

The Swatch Class

Chapter 2 talked about the OOP approach and how you can use it in your movies. This chapter involves OOP because it readily and logically applies. If you access the library for file *ch04_03.fla* and access the *swatch* movie clip, located in the *Misc* folder, you will see the definition of the Swatch class in the clip's first frame. Code example 4-2 shows this.

Code Example 4-2: Code That Defines the Swatch Class

```
#initclip
function Swatch() {}

Swatch.prototype = new MovieClip();

Swatch.prototype.onLoad = function() {
    var temp = Number(this._name.substr(1, ¬
    this._name.length));
    new Color(this._name+".myC").setRGB( ¬
    _global.swatchlist[temp]);
    this.bbox._visible = false;
};

Swatch.prototype.onPress = function() {
    this.bbox._visible = true;
    _global.mySound1.start();
};

Swatch.prototype.onRelease = function() {
    new Color(_root.currentC).setRGB(new ¬
    Color(this.myC).getRGB());
    this.bbox._visible = false;
};

Object.registerClass("swatch", Swatch);
#endinitclip
```

The first thing to note in code example 4-2 is the general setup that makes the *swatch* movie clip define the Swatch class. Note the use of the *#initclip* and *#endinitclip* pragmas, definition of the Swatch class (*function Swatch() {}*), the inheritance of the Movie Clip class methods and properties, and the registration of the object. Keep in mind that it is the *registerClass()* method that gets Flash to associate the movie clip (*swatch*) with the class (Swatch).

Let's look at how the swatch colorizes itself. Note the event method defined for the *onLoad* event in code example 4-2. This is what makes the swatch color itself when loaded. The first line within this method function causes the swatch to use its own name to figure out which color it should be. Thus, the first line extracts the number at the end of the swatch's name and places it in the local variable *temp*. It then uses *temp* to extract the color definition from the global variable *swatchlist*, while at the same time assigning that color to itself using the *setRGB()* method. The last line in the *onLoad* event method turns off a small rectangle movie clip used when the swatch is clicked on (more on that in the next section).

 WARNING: *Two things are extremely vital to getting the OOP approach to work in Flash. Not following these is usually the reason for something not working. First, naming (including letter case and spelling) is critical. The name of the class and the name of the movie clip are "connected" using the* registerClass() *method. The names defined in the* registerClass() *method must match exactly the names of the movie clip (first parameter) and the name of the class (second parameter). These must match in case and spelling.*

The second critical thing is to make sure you set the Linkage properties on any movie clip you want to use as a class definition in association with the Export for ActionScript and Export in First Frame options. Remember that you must set the Linkage properties! To do this, right-click on the symbol and select Linkage. Then select Export for ActionScript (Export in First Frame should be automatically selected when you do this).

Transferring the Color from the Small Swatch

Now that you have examined how the color swatches color themselves, let's see how color is transferred from the small swatches to the current color swatch, and from the current color swatch to the image. Transferring the color from the small swatch to the current color swatch in the main timeline is a function of the Swatch class. Transferring the color from the

current color swatch to the image in the main timeline is done another way.

In code listing 4-2, notice the other two event methods within the Swatch class, which define code for the *onPress* and *onRelease* events. When the user presses the swatch, two things happen. First, the small bounding rectangle (instance name *bbox*, which is inside the *swatch* movie clip) is turned on, whereby the user receives visual feedback as a result of clicking on the swatch. The second thing that happens is that the global sound (defined in the *init()* function) plays. Note that these two items are defined in the press, so that if the user clicks and holds the swatch, the bounding box stays "lit" until he or she releases the mouse button. The sound will play only once (even if the user holds the mouse button), because when *attachSound()* was used in the *init()* function no loop value was established.

When the user releases the mouse, two things also happen. The first is that the color of the swatch that was clicked on is transferred (using the *getRGB()* method) to a timeline variable called *currentcolor*. In retrospect, the variable *currentcolor* could have just as easily been defined as a global variable. However, due to the simplicity of this movie, it really does not matter. After setting the *currentcolor* variable, the bounding box that was turned on when the user pressed is turned off.

Make sure you poke around a little in the *swatch* movie clip's timeline. Inside it are four layers. One (*BBox*) contains the bounding box used to show the user the press (instance *bbox*), one (*Lines*) contains some basic lines that bound the area to be filled with color, and the last contains another movie clip (symbol name *s_fill MC*). When the user clicks on one of the swatches at runtime (which are all copies of *swatch* anyway), it is the color of the *s_fill MC* instance (instance name *myC*) that is changed. The bounding lines (on layer *Lines*) are sandwiched between the *bbox* instance and the movie clip that is colorized.

 NOTE: *The movie clip that is colored by the Color object is the instance of* s_fill MC. *Note that the lines that bound the swatch fill are separate from the movie clip actually colored. If the lines were inside* s_fill MC, *they would disappear when the object was colored.*

Passing Color to the Coloring Image

Now that you have examined the Swatch class, the *swatch* movie clip, and how color is passed from the swatches, let's examine how color is passed to the coloring image. The strategy for the rag doll image is a little different from the swatches; that is, it is not OOP oriented. Because the movie

clips for the rag doll are different shapes and sizes, and are placed in unique positions, it does not make sense to go to the trouble of making it OOP. Here, the older technique of attaching code directly to objects is much more straightforward and saves a lot of time.

The *changecolor()* function, defined in frame 1 of the main timeline, is what passes color from the timeline variable *currentcolor* to the rag doll pieces. However, before looking at the *changecolor()* function, you may want to examine the parts that are colorized in the rag doll image. Access the *ragdoll* movie clip. In it you will find three layers. One contains the movie clips that are colored, and the other contains the outlines for the image. The uppermost layer contains some frame actions (the purpose of which is discussed later). Click on one of the movie clips in the rag doll image and look at the scripting associated with it. The following code shows an example from one of the clips (note that the same code is attached to each of the colorable *ragdoll* clips).

```
onClipEvent (mouseUp) {
    if (hitTest(_root._xmouse, _root._ymouse, true)) {
        _global.mySound2.start();
        _root.changecolor(_root.currentC, this);
    }
}
```

Each of the *ragdoll* movie clips includes this code. Note the use of *mouseUp*, which dictates the inclusion and use of the *hitTest()* method. If *hitTest()* were not used, all of the movie clips in the rag doll would react whenever there was a *mouseUp* anywhere in the movie. Using *hitTest()* this way ensures that each movie clip responds only when there is a *mouseUp* while the mouse is over it, and only it.

 NOTE: *You may want to refer to Chapter 13 of* Flash MX: Graphics, Animation & Interactivity *for more information about precedence issues such as* mouseUp *events attached to movie clips.*

In the handler in the previous code, you see two things happen. First, like the Swatch class, a sound is played when the mouse is released. Second, the function *changecolor()* is called and is passed the object name *currentC* (which is the current color swatch in the main timeline), as well as the object reference *this*. Use of *this* passes not only the instance name of the object (rag doll part) but the absolute path to that object.

 NOTE: *Keep in mind the difference between what is returned for* this *and* this._name. *Given a movie clip named* MC1 *in the main timeline, calling* this *would yield* _level0.MC1, *whereas* this._name *would yield* MC1 *only.*

Now let's look at the *changecolor()* function. Click in frame 1 of the *Global* layer of the main timeline and look at the coding located there. What you are interested in is the *changecolor()* function, as follows.

```
function changecolor(source, target) {
    new Color(target).setRGB(new Color ¬
    (source).getRGB());
}
```

Here, you see a function written such that it can receive any *source* or *target* object reference and that will automatically change the color of the target to the source. The important thing to note here is that the passed information is an object reference, not a string. If strings were passed to this function, *eval()* would have to be used around the *source* and *target* in the second line, as shown in the following. This would force the string in *target* and the string in *source* to be evaluated first, allowing Flash to recognize it as an object reference rather than as a string.

```
new Color(eval(target)).setRGB(new ¬
Color(eval(source)).getRGB());
```

Before moving to cursor control, understand one thing about the extra layer (later *MCs*) you saw in the *ragdoll* movie clip. When you use the Color object on a movie clip, the color assigned with it will remain intact until you either change the color to something else using the Color object or until the movie clip is taken off the stage. In the main timeline, you see a Reset button. The Reset button changes all of the movie clips in *ragdoll* back to white—their original, starting color. You could program this "reset" by using the Color object to assign white to every movie clip that is colorable within *ragdoll*. However, a quicker way is just to have all *ragdoll* movie clips momentarily taken off the stage. This will cause all movie clips to go back to white as well (and is less work).

Thus, the extra layer in the *ragdoll* movie clip is for just that. When the Reset button is clicked, the *ragdoll* movie clip is told to go to frame 5. In frame 5, the movie clips that are colored do not exist. Also in frame 5, there is a frame action that sends the playhead in that movie clip directly back to frame 1, where it then stops. This little technique is much quicker (and less work) than using ActionScript to set all *ragdoll* movie clips back to white with the Color object.

Cursor Control

The final thing to look at is the scripting attached directly to the *ragdoll* movie clip. The coding attached to the movie clip causes the mouse to change to the (crude) paint bucket when you roll over the *ragdoll* movie

clip as whole. In Chapter 6, you will return to this (as well as several other examples) to explore the things you can do with the mouse.

 CD-ROM NOTE: *To see a version of the previous file that uses recursion in place of the* for *loops for swatch placement, open the file ch04_04.fla located in the* fmxas/chapter04/ *folder on the companion CD-ROM. Take a look at the* init() *function located in frame 1 of the* Global *layer and compare it to* ch04_03.fla.

A Palette of 228 Colors

The previous coloring example showed the basics of the *setRGB()* and *getRGB()* methods. However, this can be extended much further. To create true coloring applications within Flash, you would probably want a wider range of colors in the palette. As well, you may want to stick with the basic set of browser-safe colors.

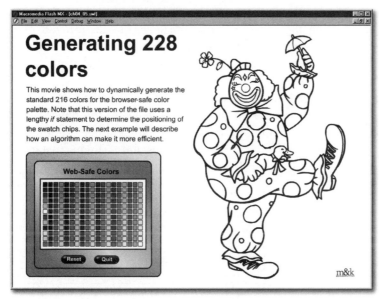

Thus, this example extends the last by providing many more colors—228, to be exact—showing you how to generate the specific set of 216 browser-safe colors using Action-Script coding, as shown in figure 4-19. All you need be concerned with at this point is having the colors in a palette, but the fun part is generating the 216 browser-safe colors in an automated way.

Figure 4-19. This example creates a palette of 228 colors, consisting of a quick-pick list of 12 colors and the 216 browser-safe colors.

 CD-ROM NOTE: *The section that follows examines code and aspects of the file ch04_05.fla located in the* fmxas/chapter04/ *folder on the companion CD-ROM. Open it into Flash and review it throughout the following discussion.*

Like the previous example, there are specific steps this movie goes through as you begin. In essence, most of the action resides in the con-

struction and colorization of the swatches. Most of the rest of this example is a carryover from the last.

Duplicating the Swatches

The first step in this movie is to duplicate and position the color swatches. Like the last movie, the swatches are populated from top to bottom, left to right, and the swatches are named c0, c1, c2, and so forth. Figure 4-20 reveals some important information concerning the positioning of the swatches.

One of the differences in this movie is that instead of creating a function to build the swatches in the main timeline this movie lets the panel itself build the swatches so that it is self-contained. Thus, the panel and the swatches use the OOP approach. The panel's movie clip symbol, which defines the *SwatchArea* class, is named *swatches_area*. The swatches are also defined by a class. *Swatch* is the name of the movie clip for the swatches, and it defines a class named *Swatch*. Both symbols can be found in the library within the *Misc* folder. An instance of the *swatches_area* movie clip exists on the stage from the beginning of the movie, whereas the *swatch* movie clip instances are dynamically attached at runtime (as in the previous example).

If you have the file *ch04-04.fla* open, access the *swatches_area* movie clip's first frame and examine its actions. You will find the typical OOP setup, consisting of one method for the class *(setS)* and three event methods. Look at the *onLoad* event method. It creates and positions instances of the *swatch* movie clip, and colorizes each swatch.

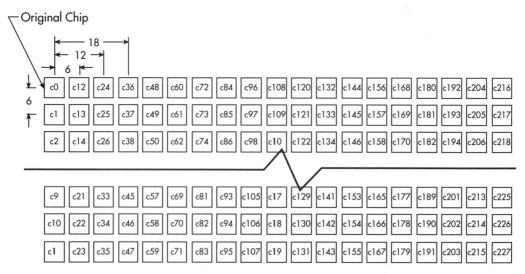

Figure 4-20. The swatch positioning in this example is just a little different.

One of the first things you will notice in the first part of the *onLoad* event method attached to the *swatches area* movie clip is the lengthy *if* statement that handles the duplication and placement of swatches. Because this example includes 19 columns of swatches, the *if* statement used to position them is quite lengthy (as logic would dictate, there are 19 sections to the *if* statement).

 CD-ROM NOTE: *The file* ch04_06.fla *located in the* fmxas/chapter04/ *folder shows an example file that uses an algorithm for chip placement, rather than a lengthy* if *statement with absolute positions. Compare it to* ch04_05.fla *to see the difference.*

Nevertheless, the basic procedure used by the *if* statement is the same as in the previous example. It positions each subsequent chip in a column beneath the last chip. When it finds the first swatch in each column (12, 24, 36, and so on), it treats it uniquely in that it sets the swatch's *y* location equal to that of swatch *c0*, so as to begin a new column. The horizontal spacing is established from *c0*, and vertical spacing from the chip above the chip being placed. In both cases, the offset is 6 pixels. Again, figure 4-20 shows this information (note that the chips in the center have been removed for brevity).

 NOTE: *A key thing you should note is the constant use of the* this *keyword throughout the lengthy* if *statement (compare it to the* if *statement in code example 4-1). The swatches are created within the* swatches_area *instance, and the* if *statement that does the positioning of the swatches is in the* swatches_area onLoad *event method. If the keyword* this *were not used,* swatches_area *would be looking for the swatch instances at the root of the main movie, instead of inside itself.*

Colorizing the Standard Chips

As you saw in the last section, the placement of the chips, although there are more of them, is not really any different than in the last example. Where this example gets fun is in the colorization of the chips. The first chips colorized are the set of "quick-pick" colors; that is, a brief list of frequently accessed colors. These usually include a sampling of grays, as well as the RGB primaries and secondaries. Thus, following the lengthy *if* statement is coding that creates an array and assigns the quick-pick colors to the first column of swatches, as shown in code example 4-3.

Code Example 4-3: Colorizing Quick-pick Color Swatches

```
var standardC = new Array("000000", "333333", ¬
"666666", "999999", "CCCCCC", "FFFFFF", "FF0000", ¬
"00FF00", "0000FF", "FFFF00", "00FFFF", "FF00FF");
for (i=0; i<=11; i++) {
eval("this.c"+i).setMyColor(standardC[i]);
}
```

The first line (which is broken into three for print purposes) creates an array that houses the colors for the quick-pick list. Although you could write an automated means of generating these colors, instead it is simpler to create a 12-item array from which you can simply pull the values. The *for* loop that follows assigns each of the first 12 swatches (swatches *c0* to *c11)* the colors in the array *standardC*. This is no different than in the previous example, in which colors were assigned from a preestablished array. It is the next part, assigning the web-safe colors, where things get fun!

A Strategy for Generating the Colors

Before examining the code for the colorization of the 216 browser-safe swatches, let's explore the basis of what happens. As you will recall from the beginning of the chapter, the 216 web-safe colors are based on a 6 x 6 x 6 RGB cube. The decimal increments to create this cube are increments of 51. In hexadecimal, the colors consist of combinations of 00, 33, 66, 99, CC, and FF. Thus, the colors increment in a series, as shown in table 4-2.

Given this information, and the fact that you want to be able to use a *for* loop to generate these series of numbers (as opposed to having to use an array), you could accomplish this in one of two ways. The first approach would be to use a *for* loop to increment through decimal RGB values (incrementing by 51), and then convert them to hexadecimal for use with the Color object. However, when you consider this more closely, it becomes somewhat complex to keep track of the combinations of RGB

Table 4-2: Progression of Decimal RGB and Hexadecimal Values in the First 18 Colors of the 216 Web-safe Color Palette

Dec.	Hex.	Dec.	Hex.	Dec.	Hex.
0, 0, 0	000000	0, 51, 0	003300	0, 102, 0	006600
0, 0, 51	000033	0, 51, 51	003333	0, 102, 51	006633
0, 0, 102	000066	0, 51, 102	003366	0, 102, 102	006666
0, 0, 153	000099	0, 51, 153	003399	0, 102, 153	006699
0, 0, 204	0000CC	0, 51, 204	0033CC	0, 102, 204	0066CC
0, 0, 255	0000FF	0, 51, 255	0033FF	0, 102, 255	0066FF

values. Although it would be completely valid to work this way, it is much more straightforward to work directly with the hexadecimal combinations.

Thus, the second approach would be to increment the hexadecimal values and use them directly. In that you cannot create a *for* loop that includes CC and FF in its counting mechanism, you need a numerical way of representing these value pairs (and in fact all of the hexadecimal value pairs) that can be incremented with a *for* loop. Thus, you will use a numerical representation for each combination, as shown in table 4-3.

Table 4-3: Hexadecimal Pair Assigned Decimal Numbers

Assigned Number	Hexadecimal Pair
0	00
1	33
2	66
3	99
4	CC
5	FF

If an assigned number is used to represent each hexadecimal pair, each hexadecimal color value (which includes three pairs) can be represented. For example, 000000 would equal 000 (using table 4-3 as a lookup). The representation 001 would yield 000033. Similarly, 025 would yield 0066FF. Note that each digit in the representation represents one pair. In reality, you are using the first number (such as 025) in pieces to represent 0066FF. The first digit, 0, when looked up in the table, yields 00. The second, 2, yields 66. The third, 5, yields FF. Thus, 025 can be made to represent 0066FF, and all of the hexadecimal values can be represented with three digits.

Now you have an easy way of using a *for* loop to generate all 216 of the hexadecimal browser-safe colors. To do so, you are actually using Base6 arithmetic, in which, as you count, you convert the decimal counter value to Base6. Then, each digit in the Base6 number represents one hexadecimal pair, as shown in table 4-4.

As you can see in table 4-4, you now have the means of creating a *for* loop that can be used to generate the hexadecimal colors. The counter will increment from 0 to 215. To arrive at the correct hexadecimal value, the decimal counter is converted to a Base6 number. Then, each digit in the Base6 number is looked up in an array (basically, table 4-3). When the lookup values for all three digits in the Base6 number are put together, you have a hexadecimal value. Let's see how this is implemented in code.

Table 4-4: Relationship Among Decimal Counter (for Loop), Base6 Equivalent, and Resulting Converted Base6 Hexadecimal Value

Dec.	Base6	Hex.	Dec.	Base6	Hex.	Dec.	Base6	Hex.
0	000	000000	6	010	003300	12	020	006600
1	001	000033	7	011	003333	13	021	006633
2	002	000066	8	012	003366	14	022	006666
3	003	000099	9	013	003399	15	023	006699
4	004	0000CC	10	014	0033CC	16	024	0066CC
5	005	0000FF	11	015	0033FF	17	025	0066FF

Colorizing the 216 Web-safe Chips

Assuming you are still looking at the scripting attached to the *swatches_area* movie clip, the coding that colorizes the 216 browser-safe swatches is located toward the bottom of the *onLoad* event method. Code example 4-4 provides the code for this process.

Code Example 4-4: Coding for Coloring the 216 Browser-safe Color Swatches

```
. . .
var hexlist = new Array("00", "33", "66", "99",
"CC", "FF");
 for (i=0; i<216; i++) {
  var temp = i.toString(6);
  if (temp.length == 1) {
   mycolor = "0000"+hexlist[temp.charAt(0)];
  } else if (temp.length == 2) {
   mycolor = "00" + hexlist[temp.charAt(0)] + ¬
hexlist[temp.charAt(1)];
  } else {
   mycolor = hexlist[temp.charAt(0)] + ¬
hexlist[temp.charAt(1)] + hexlist[temp.charAt(2)];
  }
  eval("this.c"+(i+12)).setMyColor(mycolor);
 }
. . .
```

The first thing you will notice in code example 4-4 is the creation of the *hexlist* array. This is basically equivalent to table 4-3 and is used as a lookup table. After each decimal value of the counter in the *for* loop is converted to Base6, each digit in the Base6 representation is looked up to determine its hexadecimal pair equivalent. The *for* loop increments from 0 to 215, and repeats its content a total of 216 times.

Now let's look at how the *for* loop converts to Base6 and generates the hexadecimal value. The first thing that transpires is a conversion of the counter, *i*, to a string, the results of which are placed into a variable called *temp*. The reason for this is explained in material to follow. First, note the line that says:

```
var temp = i.toString(6);
```

This takes care of converting the value in *i* to a Base6 string. Remember that the *toString()* method can be used to convert a number to any base from 2 to 36. Here, the number is being converted to Base6.

Now, you may be wondering why you are converting *i* to a string. Remember that you want to use each digit in the Base6 number as a lookup, as opposed to operating on the Base6 number as a total value. The only real facility needed is the String object's *charAt()* method. It basically allows you to retrieve a character in a certain position in a string. Thus, you can pull out each digit in the Base6 number and look it up.

Once the variable called *temp* has been created, you must take care of one last item. One of the problems you must deal with is that the Base6 data is converted to a string (and this would happen regardless of whether it is a number or a string). The preceding zeros are truncated; that is, 000 is truncated to 0. This would cause you some problems if you tried to look up all three digits, because there is only one.

Thus, the *if* statement is used following the string conversion. Once *temp* is generated, you need to know its *length* property (which tells you how many characters are in its content). If you find that *temp* is one character long, you can assume two zeros have been truncated. Given that, you construct the hexadecimal value by concatenating "0000" and the value retrieved from the *hexlist* lookup array and place it in a variable that will be used in the last line to assign the color. The following line of code does just that.

```
mycolor = "0000" + hexlist[temp.charAt(0)];
```

If you find that *temp* is two characters long (one zero truncated), you generate the hexadecimal value using the following.

```
mycolor = "00" + hexlist[temp.charAt(0)] + ¬
hexlist[temp.charAt(1)];
```

Finally, if you find that *temp* is three characters long (no preceding zeros), you generate the hexadecimal value using the following.

```
mycolor = hexlist[temp.charAt(0)] + ¬
hexlist[temp.charAt(1)] + hexlist[temp.charAt(2)];
```

Once the hexadecimal value has been constructed, the last thing the code in code example 4-4 does is to colorize the current chip based on the current value of *i*. It does so by calling a method called *setMyColor()* that belongs to the instance of the Swatch class. As shown in the following code, you want to begin by colorizing swatch *c12* (the quick-pick colors you have already colored included swatches *c0* to *c11*), which is the reason you use *eval("this.c" + (i + 12))* as the object reference. If you look at the Swatch class definition inside the *swatch* movie clip, you will find that

it expects to receive *mycolor* as the string representation of the hexadecimal value (this the reason *mycolor* is inserted directly into *setMyColor()*). In the *setMyColor()* method you will find that *parseInt(x, 16)* is within the *setRGB()* method to ensure that the *setRGB()* method receives a number, not a string.

```
eval("this.c"+(i+12)).setMyColor(mycolor);
```

The remainder of the *onLoad* event method, as follows, also attaches a movie clip named *s_bounds* to *swatches_area*. This movie clip shows the currently selected color swatch. By default, it is set to black (swatch *c0*), which is the default starting color.

```
this.attachMovie("swatch_s", "s_bounds", 999);
this.s_bounds._xscale = 41;
this.s_bounds._yscale = 41;
this.s_bounds._x = this.c0._x;
this.s_bounds._y = this.c0._y;
```

Color Transfer from Swatches and Cursor Control

One of the other aspects of this example that is different from the previous is the way in which color transfer occurs, as well as the paint brush cursor that is used. (Like the last example, discussion of the cursor is reserved for Chapter 6.) As for the color transfer, this example uses a global variable called *currentcolor* to track the currently selected color. When the user clicks on one of the swatches, this variable is set equal to the color contained in the swatch that was clicked. When one of the clown's movie clips is clicked, the value in *currentcolor* is assigned to the movie clip that was clicked.

Let's take a closer look at passing color from the swatch to the global variable. Examine the event methods defined in the Swatch class. Access the *swatch* movie clip's first frame and look at the event methods associated with the *onPress* and *onRelease* methods, as shown in code example 4-5.

Code Example 4-5: The onPress *and* onRelease *Event Methods in the Swatch Class*

```
Swatch.prototype.onPress = function() {
    this.bbox._visible = true;
    _global.mySound1.start();
};
Swatch.prototype.onRelease = function() {
    eval(this.myParent).setS(this._x, this._y);
```

```
_global.currentcolor = new Color(this+".myC").¬
 getRGB().toString(16);
this.bbox._visible = false;
};
```

In the *onPress*, you see a scenario similar to that of the previous exercise. The bounding box is revealed and a sound plays. There is nothing new about that. However, look at the *onRelease* event method. Note the first line, as follows.

```
eval(this.myParent).setS(this._x, this._y);
```

The latter two lines should be pretty straightforward, but note the first line. This line enables you to move the bounding box (the flashing box that shows which color is the current color) to the location of swatch that was just clicked. It also demonstrates a very important concept. As you read on, make sure you understand this part. The previous line calls a method called *setS()* that belongs to the *SwatchArea* class. It is this method that sets the position of the bounding box. This might appear simple, but there is much more to it.

Thus, each swatch has a property called *myParent* that is set when it is created to keep track of the path back to its parent (in this case, *swatches_area*). This allows the swatch to tell *swatch_area* to move the bounding box (current color identifier) around once a swatch has been clicked. Hypothetically this would allow you to have multiple copies of the Swatches panel in a movie at the same time. If you look at *onLoad* for the Swatch class, you will see that *myParent* starts out as null.

Then (in the *SwatchArea* class's *onLoad*), immediately after attaching the movie clip, that chip's *myParent* property is set equal to the instance of the *SwatchArea* class that instantiated it. This is one way in OOP to set up a hierarchy in which you can refer to the parent from the child. This would allow you to call a method or access properties in the parent from any of the children. In essence, all swatches know they belong to a particular instance of the *SwatchArea* class because of this.

Color Transfer to the Image

As with the previous example file, transferring the color from the *currentcolor* variable to the clown's movie clips is not object oriented. Again, due the differences in shape, size, and position of the clown's internal movie clips, an OOP approach is not needed. If you access the *clown* movie clip and select one of its sub-movie clips, you will find the following code attached to each.

```
onClipEvent (mouseUp) {
    if (hitTest(_root._xmouse, _root._ymouse, true)) {
        _global.mySound2.start();
        _root.applycurrent(this);
    }
}
```

Each piece plays the global sound object *mySound2* and then calls the *applycurrent()* function to transfer the color from the global variable *currentcolor* to the movie clip. Keep in mind the purpose of the *hitTest()* method: it keeps all of the clown's movie clips from reacting when a *mouseUp* occurs in the environment. The *applycurrent()* function, located in frame 1 of the *Global* layer in the main timeline, is shown in the following.

```
function applycurrent(obj) {
    new Color(eval(obj)).setRGB(parseInt( ¬
    _global.currentcolor, 16));
}
```

In the *applycurrent()* function, note the use of *eval()* and *parseInt()*. *Eval()* is used so that the string passed from the clown's movie clip is interpreted as an object reference, rather than as a string. *parseInt()* is used so that the string in the global variable *currentcolor* is interpreted as a Base16 number.

NOTE: *The nice thing about attaching scripting to a movie clip, such as the clown pieces, is that you do not have to name every individual movie clip in the clown. Because* this *is used as the object reference in the* onClipEvent() *handlers, instance naming is not necessary.*

CD-ROM NOTE: *Two more versions of the previous file exist on the companion CD-ROM. The file ch04_06.fla located in the fmxas/chapter04/ folder shows an example file that uses an algorithm for chip placement, rather than a lengthy if statement with absolute positions. The file ch04_07.fla (in the same location) shows an example that uses recursion for chip placement. Compare each to ch04_05.fla to see the difference among them.*

Ordering the Web-safe Colors

In the previous example, you saw how to generate a broader range of colors and how to base those colors on dynamically generated hexadecimal RGB values, rather than on values in an array. The following example

takes this a step further and allows the user to sort the colors in either the linear hexadecimal fashion or based on the 6 x 6 x 6 RGB color planes the colors are actually based on. This example will only sort by slices of red. Later in the book you will dissect an example that can sort by red, green, or blue. Nevertheless, when you sort by red, the palette of colors will look like Flash's Swatch panel.

 NOTE: *To sort the colors in this example, you will simply order the swatches in a different way while creating them (modifying the lengthy* if *statement). Coloring the swatches occurs using the same code as the last example.*

As an alternative, note that you could position the swatches in the same order as the last example, and instead colorize them in a different order. This would require adding a lengthy if *statement to the function that colors the swatches (a little more difficult process than that used here). Nevertheless, with a little planning it could be done either way. You could also take this example further and sort the colors in any fashion, based on hue, lightness, and so on.*

The important thing to see in this example, a continuation of the previous movie, is how you order the colors so that they are arranged by color plane, instead of by linear hexadecimal order. Figure 4-21 shows the file you will be examining.

Figure 4-21. This example demonstrates how to order the colors.

 CD-ROM NOTE: *The section that follows examines code and aspects of the file* ch04_08.fla *located in the* fmxas/chapter04/ *folder on the companion CD-ROM. Open it into Flash and review it throughout the following discussion.*

Swatch Arrangement

The key to understanding this example is to understand how the colors are arranged. You have seen how to order the colors linearly by hexadecimal number from top to bottom, left to right. How are the colors arranged when sorted by color plane? If you can answer this question, you can deduce from what you have already learned how to place the blank swatches so that they are ordered by color plane. Figure 4-22 shows the key to understanding this.

As you can in figure 4-22, the swatches in the first column (the quick-pick list) are simply ordered from top to bottom in the first column. The rest of the swatches are ordered in groups of 36, starting in the second column. The dotted lines reveal the groups of 36 created. Note that for brevity, some rows have been omitted. Only the first three rows, the middle two

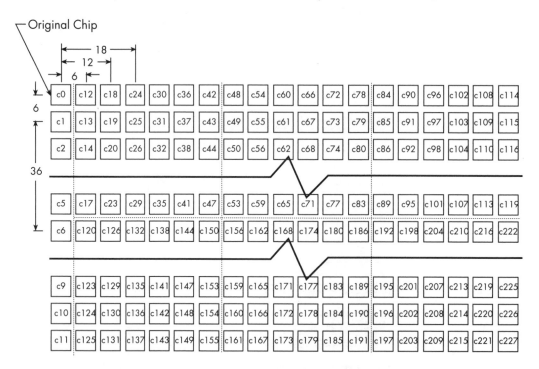

Figure 4-22. The order of the swatches for a sort-by-color plane.

rows and the last three rows, are shown. The rest are irrelevant to the coding.

To order the 216 browser-safe color swatches by slices of red, you need to populate the swatches, beginning in the second column down to swatch *c17*. When swatch *c18* is encountered, you need to start a new column. When swatch *c24* is encountered, you need a new column, and so on.

When you reach swatch *c120*, you need to bump it back over to the second column and beneath swatch *c17*. You then continue population down and to the right. Keep in mind that you are ordering the swatches this way so that you can reuse the colorization code from the last example. You will recall that it simply funnels through the combination of hexadecimal values in a linear fashion using a Base6 representation.

 TIP: *Whenever you are trying to program something like this, take the time to do a quick sketch of what it is you are trying to do, similar to figure 4-22. Inevitably, graphics will help you if you will take the time to draw them.*

Now that you see how to arrange the colors, you really only need look at two parts of the example file. You need to look at how the chips are set up, as well as the drop-down menu that allows the user to switch between the two sorting modes.

Using the ComboBox Component

Let's begin by looking at the drop-down menu. The menu used in this file is one of the standard components installed with the Flash application, called ComboBox. This is located in the Components panel, accessed via Window | Components menu. Generally, components are pretty useful. However, at times it can be challenging to customize them. The nice thing about a component is that once you have dragged it to your file, all you have to do is set up the parameters for it using the Properties panel and then adding the coding to interpret results from it.

Double click on the large *swatch area* movie clip on the stage (you will see that the swatch background, Reset and Quit buttons, drop-down menu, and gray background are all contained in a movie clip called *swatches_area*). As with previous examples, this movie clip is set up to be object oriented and has code within it to create the *SwatchArea* class. Once inside the *swatches_area* movie clip, access the actions in frame 1. One of the last event methods you will find within it is the one used to interpret changes made to the drop-down menu, as shown in code example 4-6.

Code Example 4-6: Event Method for Handling User Interaction with the ComboBox Component

```
SwatchArea.prototype.dropChange = function(component) {
     this.delChips();
     this.createChips(component.getValue());
     this.colorChips();
};
```

The event method shown in code example 4-6 is set up so that when the user chooses an option it calls three methods that belong to the *SwatchArea* class. *DelChips()* deletes all existing swatches, *createChips()* creates a new set of swatches based on the value of the drop-down menu, and *colorChips()* colorizes the newly created swatches. Note the use of the *this* keyword so that the *dropChange()* method knows that it should look in its own instance for these other methods.

Before examining the methods called by the drop-down menu, there is one other thing you should note. Components are nice in that they provide an easy way to create reusable user interface (UI) componentry. However, customizing them can sometimes be difficult. Note in the *onLoad* method associated with the *SwatchArea* class how you modify component properties. Examine the following.

```
...
var myStyleFormat = new FStyleFormat();
myStyleFormat.textSize = 7;
myStyleFormat.addListener(this.myDrop);
...
```

If you need to change the formatting attributes of an individual component, this code provides a quick means of doing so (as described by the *Using Flash MX* reference manual that comes with Flash). This code is designed for modifying the properties of a single, specific component and could be used to modify more than just *textSize* for the *myDrop* instance. There is a complete list of properties (in the *Using Flash MX* reference) that can be modified. The reference also describes how to globally set component properties so that all components in a movie adhere to the same settings. The previous code simply changes one property (*textSize*) of the specific component being used here (instance name *myDrop*).

Creating the Chips Based on Sort

Now let's look at the *createChips()* function method defined in the *SwatchArea* class. If you are still in the *swatches_ area* movie clip, click in

frame 1 and find the *createChips()* function method. Due to the length of the coding, it is not printed in the text of this book, but let's briefly discuss what is going on.

First, the two very long *if* statements are not very efficient. They are the extremely long way of writing the code. However, they are written in longhand because it often helps to see it that way when beginning. Later you will see an example that uses an algorithm to reduce this code to less than 10 lines.

The first thing you will notice in the *createChips()* function method is the *if* statement that determines whether the user requested a sort by linear hex or by RGB plane. When *sortType* = = *"linear"*, the same code from the last example is executed, where the chips are generated from top to bottom, left to right. What you want to look at is where *sortType* = = *"rgb"*. Scroll down until you find the *else if* part of the coding.

When you find the beginning of the section where *sortType* = = *"rgb"*, you may be disappointed (or pleased) to find that the coding is not that much different from the previous example, at least as it relates to each section of the nested *if* statement. Recall that the main difference in what the planar sort does is that instead of creating 19 columns of 12 chips it creates 1 column of 12 chips, then 18 columns of 6 chips, and then another 18 columns of 6 chips positioned beneath the first 18 columns. Thus, the lengthy *if* statement does just that. You will see that the range the nested *if* statement checks for is only an increment of 6, instead of 12, as can be seen in the first *else if*, as follows.

```
} else if (i>11 && i<=17) {
```

In addition, the headings for each column are different from the last example. In this example, you check for 36 separate column headings instead of just 12. If you scroll down far enough, you will also note that in the middle of the *if* statement the coding changes slightly, as shown in code example 4-7.

Code Example 4-7: Slight Change in the *if* Statement for the Planar Sort

```
. . .
1 } else if (i>113 && i<=119) {
2   if (i == 114) {
3     eval("this.c"+i)._y = this.c0._y;
4   } else {
5     eval("this.c"+i)._y = eval("this.c"+(i-1)+"._y")+6;
6   }
7   eval("this.c"+i)._x = this.c0._x+108;
```

```
8 } else if (i>119 && i<=125) {
9  if (i == 120) {
10   eval("this.c"+i)._y = this.c0._y+36;
11  } else {
12   eval("this.c"+i)._y = eval("this.c"+(i-1)+"._y")+6;
13  }
14  eval("this.c"+i)._x = this.c0._x+6;
...
```

In the middle of the *if* statement you will notice that two things change, as shown in code example 4-7. This is the point at which you begin creating the second block of 18 columns. Compare lines 7 and 14 and lines 3 and 10. The difference in lines 7 and 14 is what causes swatch *c120* to be positioned horizontally in line with column 2. The difference between lines 3 and 10 is what causes swatch *c120* to be positioned (vertically) beneath *c17* (see figure 4-22). From line 14 on, 36 is always added to a column heading swatch's vertical positioning. From line 14 on, the horizontal measurement restarts from 6, incrementing by 6 until it reaches 108 (the distance of the last column from swatch *c0*).

Before leaving this script, compare figure 4-22 to the section of the *if* statement that relates to the planar sorting. Recall the importance of sketching out what you are going to create. Note that figure 4-22 is basically a roadmap for the *if* statement. Of particular assistance are the swatch numbers associated with the column headings and endings.

Although using the lengthy *if* statement is not the most efficient route, figure 4-22 is still helpful. Further still, if you are developing equations to handle such things, a graphic such as figure 4-22 is even more important. Take the time to sketch out your ideas, particularly as you begin something new. It will help you visualize the information, data structures, and process you need to employ to accomplish whatever it is you are trying to do. At some point you will likely be able to "see it in your head"—and hopefully you do get to that point as you gather experience programming such things. However, even the most seasoned programmers often create sketches (or at lease crude doodles) to help themselves solve problems. You can save a lot of rework by jotting down your ideas before you sit down to the computer.

The delChips() and colorChips() Methods

Before leaving this example, note two other methods, *delChips()* and *colorChips()*. *colorChips()* is the same code you have seen before, except that the colorization of the standard chips and 216 web-safe chips occurs in a single method.

Turn your attention to the *delChips()* method. Recall that before calling the *createChips()* function method from the *ComboBox* component coding, a method called *delChips()* was called. Because the *createChips()* function can be called multiple times (as the user switches between the two modes of sorting), before you create more chips, you have to make sure all prior chips are gone. Thus, another *delChips()* method is simply designed to delete all existing chips before creating new ones.

 CD-ROM NOTE: *To see the previous code implemented with an algorithm for swatch placement, see the file* ch04_09.fla. *To see it implemented with recursive functions, see the file* ch04_10.fla. *Both are located in the* fmxas/chapter04/ *folder on the companion CD-ROM. Open these into Flash and compare them to file* ch04_08.fla *to see the differences among them.*

Using getTransform() and setTransform()

Before moving on, it seems appropriate to present at least one example that uses the *getTransform()* and *setTransform()* methods, so that you better understand how they function. Although this chapter described these previously, seeing and interacting with an example should help further clarify how they work.

 CD-ROM NOTE: *The section that follows examines code and aspects of the file* ch04_11.fla *located in the* fmxas/chapter04/ *folder on the companion CD-ROM. Open it into Flash and review it throughout the following discussion.*

 NOTE: *To make this example easier and quicker to deal with, it uses the old method of coding, except for the fact that the generic Object object is used to house the properties for the transform.*

To begin this example, use Control | Test Movie to see how it works. Note that the sliders apply a color transform to the movie clip object on the left. The movie clip object has fills that are the RGB primary and secondary colors, as well as white and black. Note that adjusting the red component sliders affects the amount of red in the overall movie clip, as well as the other colors. You will see similar behavior as you adjust the blue and green component sliders. Adjusting the alpha sliders changes overall transparency (or opaqueness).

There are two basic functions used in this movie, both of which are located in frame 1 of the *Global* layer in the main timeline. The code for these functions is shown in code example 4-8.

Code Example 4-8: The Two Functions for the Transforms

```
function init() {
 delete myobj;
 myobj = new Object();
 myobj = {ra:'100', rb:'0', ga:'100', gb:'0', ¬
 ba:'100', bb:'0', aa:'100', ab:'0'};
}
function changecolor() {
 var temp = new Color(colors).setTransform(myobj);
}
```

The *init()* function shown in code example 4-8 initializes the environment by using the generic Object object to create a collection of properties used by the *setTransform()* method. Recall that the *setTransform()* method requires the use of an object for the transformation. If the argument passed to the *setTransform()* method is not an object, the method will not work.

The *changecolor()* function shown code example 4-8 applies the properties in the instance of the generic object (*myobj*) to the movie clip (instance name *colors*). As the user interacts with the sliders on the stage, the property values in *myobj* are modified. A quick look at the code attached to any of the sliders reveals this. Code example 4-9 shows the code attached to the RA slider.

Code Example 4-9: Code Attached to the RA Slider

```
onClipEvent (load) {
 Ball._x=Number(_root.myobj.ra)+100;
}
onClipEvent (mouseMove) {
 if (this.Ball.dragging == true) {
  _root.myobj.ra=String(Math.round(this.Ball._x-100));
  _root.changecolor();
 }
}
```

In the *onClipEvent(mouseMove)* handler in code example 4-9, note that while the slider's ball is being dragged the *ra* property within the object *myobj* is constantly updated. As well, the color in the movie clip colors is constantly updated.

For those who are curious, the *onClipEvent(onLoad)* handler in code example 4-9 is set up such that when the movie loads the slider's ball is placed along its path of travel based on the current value of *ra*. This is done similarly in all sliders, with each slider respective to the particular value it controls. This sets the slider based on the values in *myobj* at the movie's start. Thus, regardless of the starting parameters for the transform properties in *myobj* (as defined in *init()*), the balls in each of the sliders will be in the correct place at the start.

As a final note pertaining to this example, if you examine the code on the sliders, you might wonder how the equations for each slider were derived, particularly where the equations are of the general form:

$y = 20 / 50 x + 100$
$y = 51 / 20 x - 255$

or specific to this example (from the RB slider):

```
this.Ball._x=Number(_root.myobj.rb*20/50+100)
_root.myobj.rb=String(Math.round(51/20*this.Ball._x-255));
```

Chapter 11 explores how you derive these types of linear equations (given what you want to do) and how you apply them in Flash. Being able to reverse engineer such equations is vital for the development and use of UI componentry.

Working with Color Conversion Algorithms

Before leaving this chapter, you need to look at three final examples. The examples here provide ways in which to work with a variety of color specifications using algorithms that convert among RGB decimal, RGB hexadecimal, CMY, HLS, and HSB color modes. The algorithms provided are not new. However, using and implementing them in Flash may well be. The chapter ends with discussion of these so that you will understand how to create basic movies that perform numerically based conversion between color systems.

Hexadecimal and RGB

The first example you will take a look at is a basic RGB-to-hexadecimal converter. In this example, all you need be concerned with are the algorithms for converting hexadecimal colors to their appropriate RGB components. Likewise, in the sections that follow you need be concerned only with the color conversion algorithms. The example is shown in figure 4-23.

 NOTE: *In figure 4-23, you see that fields are presented, with buttons that increment the values in the field. There is code that will*

limit the values when the buttons are clicked, as well as when the user enters data into the fields.

Hexadecimal Converter

This example shows how to work with the color object, and hexadecimal values and decimal RGB values. You can use the up and down arrow buttons, or enter a value and press Enter.

Hex Value	RGB Values
FF3366	Red: 255
Preview	Green: 51
	Blue: 102

m&k

Figure 4-23. Creating a movie that will convert a hexadecimal color specification to a component RGB specification.

Now you may be wondering why you are being presented with hexadecimal conversion when *parseInt()* can be used to convert a hexadecimal number, as you have already seen. What you have seen is how to convert a total hexadecimal number to decimal, not a hexadecimal number to component RGB; that is, where you end up with the red, green, and blue as separate elements. Similarly, you have not seen how to convert decimal RGB values to hexadecimal equivalents using ActionScripting.

CD-ROM NOTE: *The section that follows examines code and aspects of the file* ch04_12.fla *located in the* fmxas/chapter04/ *folder on the companion CD-ROM. Open it into Flash and review it throughout the following discussion.*

Once you have opened the file, you will find that it contains three fields for the RGB color, and one field for the hexadecimal component. Basically, you want to be able to convert back and forth between these two. Conceptually, the beginning of the chapter discussed how this transpires. Let's look at how this is translated into ActionScript.

In the file *ch04_12.fla*, click in frame 1 in the *Global* layer and open the Actions panel. Find the *init()* function, which begins by creating an array called *hexlist*. If you recall from the discussion early in this chapter, this array is needed so that when you are converting decimal RGB values to hexadecimal you can look up the whole number and remainder from the division of the decimal number by 16.

Following the array creation, you will see that there are four variables initialized. These variables coincide with the Hex, Red, Green, and Blue fields on the stage. When the functions that convert the color specifica-

tions are called, they operate directly on these variables (*myhex, myred, mygreen,* and *myblue*), which in turn directly change the values in the fields on the stage. At the end of the *init()* function the preview color box is set to the current color via the *changecolorbox()* function.

Let's begin by looking at the function that converts a hexadecimal value to a decimal value. Find the *hextodec()* and *dectohex()* functions. Code example 4-10 shows the function called *hextodec()*.

Code Example 4-10: Function That Converts a Hexadecimal Value to Component RGB Values

```
function hextodec () {
  myred = parseInt(myhex.substring(0, 2), 16);
  mygreen = parseInt(myhex.substring(2, 4), 16);
  myblue = parseInt(myhex.substring(4, 6), 16);
}
```

As shown in code example 4-10, you find that the function basically supports the process described at the beginning of the chapter. To obtain the hexadecimal representation of the R, G, and B components, you use the string method called *substring()* to extract the first two characters for the R component, the second two characters for the G component, and the last two characters for the B component from the hex value (*myhex*). When you use the *substring()* method, you specify the starting character and ending character you want to extract. Like arrays, string indices begin at 0, not 1. When you use *substring()*, the starting character is included, but the ending character is not. Thus, *substring(0, 2)* yields the first and second characters, not the first, second, and third.

Once you have the characters extracted from the hex value (*myhex*), you use *parseInt()* to convert each to a decimal representation. Note the use of the 16 in the *parseInt()* method. Again, this is so that the value provided to *parseInt()* is recognized as a Base16 value.

 NOTE: *When you use* parseInt() *on a total hexadecimal value, it yields a decimal value of R multiplied by G multiplied by B. By separating the R, G, and B hex pairs and then using* parseInt(), *you are able to get the component RGB values instead of the multiplied value.*

Converting the component RGB values to hexadecimal works in reverse. Code example 4-11 provides the code used to convert the RGB component values to hexadecimal.

Code Example 4-11: Converting Component RGB Values to Hexadecimal String

```
function dectohex () {
 myhex = tohex(myred)+tohex(mygreen)+tohex(myblue);
 function tohex (i) {
  var a1, a2, ihex, idiff, remainder;
  ihex = Math.floor(i/16);
  a1 = Hexarray[ihex];
  remainder = i-(ihex*16);
  a2 = Hexarray[remainder];
  return a1+a2;
 }
}
```

One of the things you will notice in code example 4-11 is the fact that there is an embedded function (*tohex()*). Because the code within the embedded function needs to be called three times (once for each RGB component, as shown in the second line), and because it is not used anywhere else in this movie, you embed the function, rather than write the code in the *dectohex()* function multiple times.

Let's examine the embedded function *tohex()*. The function basically takes the decimal component passed to it and divides it by 16 to obtain a whole number and a remainder. To obtain the whole number from the division operation, *Math.floor()* is used. To obtain the remainder, you use the equation *i-(ihex*16)*.

Once you have the whole number and remainder, each is looked up in the hexlist array created at the beginning of the script. The results of these two lookups are concatenated and returned to the main function, resulting in the hexadecimal pair equivalent of the decimal component. Now that you have seen how to implement hexadecimal to RGB component conversion, let's take this one step further and see how to go between RGB component color and HLS.

 NOTE: *The algorithms shown in the last example, as well as the next two, are inherently linked to fields that exist on the stage. However, this could be easily generalized to accept and return values sent to them, rather than being directly linked to the variables.*

 CD-ROM NOTE: *To examine a recursive example of* ch04_12.fla, *open the file* ch04_13.fla *located in the* fmxas/chapter04/ *folder on the companion CD-ROM. The hexadecimal increment and decrement are recursive, rather than lengthy* if *statements.*

Integrating HLS

Now that you have looked at hex-to-decimal and decimal-to-hex, let's examine how you get from component color to attribute-based color. As you have probably already found, working with component color, especially if you are an artist, is relatively peculiar. Additionally, if you are creating movies for the general public, they too will find that component color is somewhat awkward. Thus, it is important to know how to convert component-based color to attribute-based color, so that you can present easier-to-use color selectors and GUI controls.

Like the last example, all you need be concerned with here are the algorithms needed to convert RGB to the most common attribute-based color model, HLS. Figure 4-24 shows the file with which you will be working.

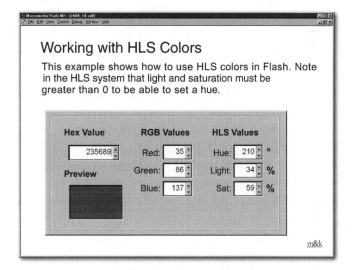

Figure 4-24. Integrating algorithms to convert between RGB and HLS.

 CD-ROM NOTE: *The section that follows examines code and aspects of the file* ch04_14.fla *located in the* fmxas/chapter04/ *folder on the companion CD-ROM. Open it into Flash and review it throughout the following discussion.*

Once you have the file *ch04_14.fla* open, click in frame 1 of the *Global* layer and open the Actions window. Code example 4-12 shows the algorithm, *rgbtohls()*, for converting RGB colors to HLS.

Code Example 4-12: Algorithm for Converting RGB Colors to HLS

```
1 function rgbtohls() {
2  var rr, gg, bb, max, min, H, L, S, delta, myHLS;
3  rr=Number(myred)/255;
4  gg= Number(mygreen)/255;
5  bb= Number(myblue)/255
6  max = Math.max(Math.max(rr,gg),bb);
7  min = Math.min(Math.min(rr,gg),bb);
8  L = (max + min)/2.0
9  if (max==min) {
10    S=H=0
11  } else {
12    delta = max-min;
13    S=(L<=0.5) ? (delta/(max+min)) : (delta/(2.0-(max+min)));
14    if (rr==max) {
15     H=(gg-bb)/delta;
16    } else if (gg==max) {
17     H=2.0 + (bb-rr) / delta;
18    } else if ( bb==max ) {
19     H=4.0 + (rr-gg) / delta;
20    }
21    H*=60.0;
22    if (H<0.0) {
23     H+=360.0;
24    }
25  }
26  myh=Math.round(H);
27  myl=Math.round(L*100);
28  mys=Math.round(S*100);
29 }
```

 NOTE: *The algorithms for converting back and forth among RGB, HLS, and HSB/HSV are adapted from* Computer Graphics: Principles and Practice, *by Foley et al., Addison-Wesley. For further information (and information on other color spaces and their respective conversion algorithms), refer to that text. In addition to the algorithms, the text provides numerous references to the journal publications in which the algorithms were originally published.*

Although space prohibits an exhaustive discussion of the algorithm shown in code example 4-12, the following discusses some of the things

that happen within it. In lines 3, 4, and 5 of code example 4-12, you will notice that the algorithm begins by converting the values of red, green, and blue to percentages, in decimal form. In lines 6 and 7, it records which of the three components is the maximum and which is the minimum.

Once the maximum and minimum intensities are known, the lightness (L) can be calculated. In line 8, you see that L is set equal to the average intensity $((max + min) / 2)$. Following this, the algorithm determines whether the color being converted is a gray (achromatic) or a "color" (chromatic). It does this by comparing the maximum and minimum (line 9). If they are found to be equal, S (saturation) and H (hue) are set to zero (line 10). That is, when a color is achromatic, it has no hue or saturation, only lightness.

If the algorithm is dealing with a chromatic color, it must determine saturation and hue. From line 12 to line 24, hue and saturation are derived, using geometric analysis. Further discussion would require more than can be briefly provided here. The algorithm uses values of maximum and minimum (as well as the existing red, green, and blue components) to derive vectors for hue and saturation.

The final step in code example 4-12 is to transform the values of H, L, and S to rounded values. L and S are also presented as whole numbers between 0 and 100. As the reverse of the previous algorithm, code example 4-13 presents the algorithm for converting HLS values to RGB.

Code Example 4-13: Algorithm for Converting HLS Colors to RGB

```
function hlstorgb() {
  var H, L, S, R, G, B, m1, m2;
  H=Number(myh);
  L=Number(myl)/100;
  S=Number(mys)/100;
  m2=(L<=.5) ? L*(1+S) : L+S-L*S;
  m1=2*L-m2;
  if (S==0) {
    H==0
    myh=0;
    R=G=B=L;
  } else {
    R=calcHue(m1, m2, H+120);
    G=calcHue(m1, m2, H);
    B=calcHue(m1, m2, H-120);
  }
  myred=Math.round(R*255);
  mygreen=Math.round(G*255);
```

```
myblue=Math.round(B*255);
function calcHue(n1, n2, Hue) {
 if (Hue>360) {
  Hue-=360;
 } else if (Hue<0) {
  Hue+=360;
 }
 if (Hue<60) {
  return n1+(n2-n1)*Hue/60;
 } else if (Hue<180) {
  return n2;
 } else if (Hue<240) {
  return n1+(n2-n1)*(240-Hue)/60;
 } else {
  return n1;
 }
 }
}
```

Adding HSB and CMY

As a final example for this chapter, let's pull out all the stops and present a movie that performs color conversion between all of the color models discussed in this chapter, including RGB, HLS, HSB/HSV, and CMY. This movie includes black replacement for CMY, to present CMY(K) calculation (which is an approximation at best). Nevertheless, the following example describes the algorithms added to the last example, to make such a movie possible. Figure 4-25 shows the file you will be examining.

Figure 4-25. Integrating algorithms to convert among RGB, HLS, HSB/HSV, CMY, and CMY(K).

 CD-ROM NOTE: *The section that follows examines code and aspects of the file* ch04_15.fla *located in the* fmxas/chapter04/ *folder on the companion CD-ROM. Open it into Flash and review it throughout the following discussion.*

Once you have the file *ch04_15.fla* open, click in frame 1 of the *Global* layer and open the Actions panel. The first algorithms you will examine are those that convert RGB to CMY, and vice versa. These functions are called *rgbtocmy()* and *cmytorgb()*, which are shown in code example 4-14.

Code Example 4-14: Functions for Converting RGB to CMY, and Vice Versa

```
function rgbtocmy () {
  mycyan = 255-myred;
  mymagenta = 255-mygreen;
  myyellow = 255-myblue;
  correctCMYK();
}

function cmytorgb () {
  myred = 255-mycyan;
  mygreen = 255-mymagenta;
  myblue = 255-myyellow;
  correctCMYK();
}
```

As stated at the beginning of this chapter, the RGB model and the CMY model are inverses of each other. Thus, to obtain CMY values from RGB, you subtract each of the RGB values from 255. To obtain RGB from CMY, you subtract each of the CMY values from 255, as shown in code example 4-14.

In addition to providing basic CMY values, it is helpful to also approximate the CMY(K) values. As you will recall, in CMY(K) the object is to replace equal amounts of cyan, magenta, and yellow to reduce the amount of ink printed on paper, as well as to create true black. By default, this movie assumes 100 percent replacement; that is, it tries to maximize black usage and minimize primary use. The basic algorithm for the CMY(K) values is show in code example 4-15.

Code Example 4-15: Algorithm for CMY(K) Calculation

```
function correctCMYK () {
  if (rep_v != "ERR") {
    var temp = Math.min(Math.min(mycyan, mymagenta), ¬
myyellow);
    if (temp != 0) {
      temp2 = Math.round(rep_v/100*temp);
      rep_k = Math.round(temp2/255*100);
      rep_c = Math.round((mycyan-temp2)/255*100);
      rep_m = Math.round((mymagenta-temp2)/255*100);
      rep_y = Math.round((myyellow-temp2)/255*100);
    } else {
      rep_c = Math.round(mycyan/255*100);
      rep_m = Math.round(mymagenta/255*100);
      rep_y = Math.round(myyellow/255*100);
      rep_k = 0;
    }
  }
}
```

In code example 4-15, you can see how the black replacement is calculated. The opening *if* statement is a safety net to make sure the user enters a number in the Replacement Amount field. If they do not enter a number between 0 and 100, the value in the field is set on ERR (denoting error).

The main thing you want to examine here is the central portion of code example 4-15. Black replacement in CMYK is predominantly based on whichever of the CMY primaries has the lowest value. When replacement occurs, the maximum amount of black cannot be greater than the lowest value of primary. Thus, the local variable *temp* is used. To determine which primary has the lowest value, you use *Math.min (Math.min(mycyan, mymagenta), myyellow)*.

If you find that none of the primaries is zero (if one is zero, there can be no black), you determine the amount of black replacement, based on the Replacement Amount field. Thus, the variable *temp2* is created to hold the true replacement value (*Math.round(rep_v/100*temp)*). Once that value is obtained, you apply it to the each of the existing CMY primary values by subtracting the replacement value. Note that the number is converted to a percentage. CMY(K) values are almost always given as a percentage; that is, a percentage of ink. Thus, this conversion makes sense.

As for the conversion to and from HSB/HSV, code example 4-16 shows the two functions that perform these conversions. If you compare these

conversions with the HLS conversions, you will find that the algorithms work in a similar fashion. Keep in mind that the main different between HLS and HSB/HSV is that HSB/HSV is a single hexacone, where white occurs on the flat, circular top. HLS, on the other hand, is a double hexacone.

Code Example 4-16: Algorithms That Convert HSB/HSV to RGB, and Vice Versa

```
function hsbtorgb() {
 var H, S, V, R, G, B, f, p, q, t, i;
 H=Number(myhue2);
 S=Number(mysat2)/100;
 V=Number(mybright2)/100;
 if (S==0) {
  R=G=B=V;
 } else {
  if (H==360) {
   H=0;
  }
  H/=60
  i=Math.floor(H);
  f=H-i;
  p=V*(1-S);
  q=V*(1-(S*f));
  t=V*(1-(s*(1-f)));
  if (i==0) {
   R=V; G=t; B=p;
  } else if (i==1) {
   R=q; G=V; B=p;
  } else if (i==2) {
   R=p; G=V; B=t;
  } else if (i==3) {
   R=p; G=q; B=V;
  } else if (i==4) {
   R=t; G=p; B=V;
  } else if (i==5) {
   R=V; G=p; B=q;
  }
 }
 myred=Math.round(R*255);
 mygreen=Math.round(G*255);
```

```
 myblue=Math.round(B*255);
}

function rgbtohsb() {
 var rr, gg, bb, max, min, H, S, V, delta;
 rr=Number(myred)/255;
 gg=Number(mygreen)/255;
 bb=Number(myblue)/255
 max=Math.max(Math.max(rr,gg),bb);
 min=Math.min(Math.min(rr,gg),bb);
 V=max;
 S=(max!=0) ? ((max-min)/max) : 0;
 if (s==0) {
  H=0;
 } else {
  delta = max-min;
  if (rr==max) {
   H=(gg-bb)/delta;
  } else if (gg==max) {
   H=2+(bb-rr)/delta;
  } else if (bb==max) {
   H=4+(rr-gg)/delta;
  }
  H*=60;
  if (H<0) {
   H+=360;
  }
 }
 myhue2=Math.round(H);
 mysat2=Math.round(S*100);
 mybright2=Math.round(V*100);
}
```

▪ ▪ ▪ Summary

This chapter has covered a wide range of information. From theoretical color models to applied uses of the Color object, you have covered a lot of ground. It cannot be stressed enough how important an understanding of digital color is, particularly if you want to be an effective programmer. Granted, you may not create an application that converts one color to another, but at some point you will likely have to deal with digital color as you develop your movies.

5

Manipulating Data

▪▪▪ Introduction

In the last chapter you spent a significant amount of time delving into the intricacies of digital color and working with the Color object. Indeed, there are quite a few interesting things you can do with color in Flash. As this chapter progresses, it examines some of the examples from the previous chapter, looking at how data is processed "behind the scenes." The key to creating any movie typically resides in the application of multiple objects, as it is unlikely you will use objects discontinuously. Although for the sake of presentation this book deals with a specific object or group of related objects as discrete topics, in most complex creations you use these objects in concert with one another.

As you begin working with the String, Number, Boolean, and Date objects in this chapter, you will find that they are not particularly interesting as individual topics. Let's be frank: working with raw text or numerical data is not all that exciting to most people. However, the ability to manipulate data is vital to almost every interactive movie you might create. Whether you are creating forms intended to interact with database or text files or creating standalone movies that provide the functionality of a calculator, calendar, guest book, or chat interface, being able to manipulate string and numerical data is important.

In this chapter you will examine String, Number, Date, and Boolean object issues via an object-by-object approach that provides basic explanations of functionality through simple examples. Toward the end of the chapter you will look at applied examples of a more complex nature.

■ ■ ■ Objectives

In this chapter you will:

- Discover the fundamentals of the String, Number, Date, and Boolean objects
- Learn to use the String object to process data input by the user
- Discover how the Number object can be used to ensure compatibility of user input with other object methods

■ ■ ■ Understanding, Using, and Getting the Most Out of the Material

You will see that the first half of this chapter, which deals with the four objects, generally takes the following format: (1) discussion of each object's methods and properties, (2) presentation of the objects' general form for use, and (3) rudimentary code examples. Most of the rudimentary code snippets can be entered directly into a frame in the Actions panel. They are set up so that when you test the movie the results are returned to the Output window, allowing you to see what the method or property does.

When working on real-life projects, most of the time properties and methods are "captured in a variable" or utilized in some other applied fashion. However, in the exercises in this book you set the statement equal to a variable, so as to capture the returned data. You have seen this in previous chapters.

In most of the code snippets found in the early part of this chapter, the *trace()* method is used to output the returned information to the Output window. The applied and more complex examples toward the end of the chapter follow and use various forms—whatever is appropriate to the task at hand.

Note that in some instances a variable is created before the *trace()* method, to give you something with which to work. However, be aware that you can hardwire the methods and properties within a *trace()* method in a frame if you like (just so you can see how they work) and therefore do not have to enter all of the code listed. You can explicitly define strings and numbers to work with the various objects. For example, when working with the String object you can use the following form.

```
trace("I am a String".somemethod());
trace("I am a String".someproperty);
```

These lines negate the need to create a variable to work with before using the method or property. Thus, the following two lines of code

```
var mystring="I am a String";
trace(mystring.length);
```

can be explicitly stated as:

```
trace("I am a String".length);
```

Similar procedures can be used for the Number, Date, and Boolean objects. Throughout, when code snippets are presented, the variable is created and then the methods or properties of the object are used. If you wish to enter the code into a frame, you can use this shorthand method.

Be aware also that in the code examples presented in the first part of this chapter the variables created are preceded by the keyword *var* as a matter of good (or standard) practice. Keep in mind that *var* only truly creates local variables when used within a function. The *var* keyword has no effect in scripts attached to frames or when placed within the *on()* or *onClipEvent()* handlers (buttons and movie clips, respectively). Thus, if you place these snippets in a frame for testing purposes, the variables will be global, even though the *var* keyword is used.

The String Object

Although you have seen the String object in action previously, it has not been examined in depth. Previous chapters left discussion of the String object for this chapter. However, before returning to examples from previous chapters that used the String object, or examining new ones, you need an understanding of the String object and how you can manipulate string data with it using the methods and property that exist for it. This begins with an understanding of string indices and ASCII values.

As you progress through this chapter, keep in mind that there is a difference between the String object and *String()* conversion function, the Number object and the *Number()* conversion function, and the Boolean object and the *Boolean()* conversion function. Do not confuse these entities. Objects give you extended capabilities for working with and manipulating data—most of which provide numerous methods and properties. Functions alone simply convert data from one form to another; that is, they evaluate an argument as a specific data type.

String Indexing

To fully utilize the String object methods, you must understand how strings are indexed; that is, how characters are positioned within a string. As you can probably deduce from your work with arrays in Chapter 3, the characters in a string are indexed starting with 0 and up to the length of the string minus 1, very much like the indices within an array.

Thus, if you had a variable that contained the string *fishing*, the character at index position 0 is *f*. The length of the string in this variable is 7, whereas the last character index is 6. If you tried to retrieve a character outside the range of the indices in the string (that is, outside indices 0 to 6), Flash would return a −1, indicating that the character does not exist because the index is outside the range of the specified string. This topic is explored in more detail later in the chapter.

Understanding ASCII Values

As you begin working with text and strings, you must also understand how ASCII values are related to ActionScripting. Two of the String object's methods, *fromCharCode()* and *charCodeAt()*, are designed to work with raw ASCII values. The former generates a string based on the specified ASCII character values, and the latter performs the inverse, yielding the ASCII value of the character specified. For the creation of basic movies, the likelihood of using these methods may be slim. However, for more advanced creations (in which you need to parse, analyze, or compose string components), these methods become highly relevant.

NOTE: *Appendix C provides the 128 standard ASCII code values and the respective characters they generate in Flash. The appendix also provides 127 nonstandard ASCII code values and the characters they generate on the Windows and Macintosh platforms.*

ASCII values are simply the de facto standard for numerically representing all uppercase and lowercase Latin letters, numbers, punctuation, and the like on the computer. ASCII uses an 8-bit numerical representation and is generally limited to the characters that were common to the English language at the time of its adoption. Sometimes this standard is called UTF-8.

Even with its limited set of characters, ASCII has been adopted internationally as ISO 9959-1 or Latin 1. (ISO stands for International Standards Organization.) However, due to the limits of the characters that can be represented in ASCII, a newer standard, Unicode (short for Universal Character Code), exists. Unicode uses a 16-bit sequence and is much more stable and extensive than ASCII. However, at this time Flash does not support Unicode characters within the String object methods.

Even though you cannot use Unicode specifications directly in the *fromCharCode()* and *charCodeAt()* methods, you can use the Unicode representation of the first 256 characters using a string escape sequence. Here, you precede the string entry with \u, followed by a 16-bit hexadecimal number, such as \u00a2 for the cents (¢).

NOTE: *For more information on Unicode, see* http:www.unicode. org/. *The code charts section of the site* (www.unicode.org/charts/) *provides Unicode hexadecimal entries.*

Although a detailed analysis of ASCII is unnecessary, akin to browser-safe colors there is a binary and hexadecimal relationship that could be reviewed to help you understand how the values are assigned. This text does not delve that deeply, but you do need to understand that the first 128 characters are fairly standardized across platforms; only a few vary between the Macintosh and Windows platforms. The latter 127 do vary quite a bit, and thus you have to be careful in their use.

NOTE: *For more information on ASCII (ISO 8859), see* www. czyborra.com/charsets/iso8859.html *or* www.bbsinc.com/ iso8859.html.

You may wish to refer to Appendix C to see the 128 standardized characters and the 127 nonstandard characters. Later in this chapter you will see why ASCII representations are important. Generally, for cases in which you want to format data in a special way, such as adding a dollar sign to a number, you need to be able to employ ASCII codes and the String methods that utilize them.

You can also check the ASCII value of a character using either the Windows | Accessories | Character Map application or the Key Caps application on the Macintosh. Just keep in mind that if you are using Character Map on the Windows platform only the Windows Characters section is valid.

NOTE: *For more information on Unicode support in Flash, see the following TechNotes on Macromedia's support site:*

www.macromedia.com/support/flash/ts/documents/ unicode.htm

www.macromedia.com/support/flash/ts/documents/ unicode_support_in_flash.htm

Methods and Property

Now that the preliminaries are out of the way, let's get down to business. As in Chapter 3, let's begin with a holistic view of the methods available for the String object. The String methods fall into one of five categories: creation, single-character extraction, multiple-character extraction, formatting, and searching. Table 5-1 summarizes the methods available for the String object. The material that follows examines each of these methods, including explanations and examples.

Table 5-1: String Method Categories

Category	Method	Description
Creation	*concat()*	Returns a new string by adding the text of one string to another.
	split()	Examines a string for a certain character (a delimiter) and then splits the string wherever the character is found. The split results are returned as indices in an array.
	fromCharCode()	Returns a new string from a list of ASCII values representing that string.
Single-character Extraction	*charCodeAt()*	Returns the ASCII code of a character at a particular index in the string.
	charAt()	Returns the character at a particular index in the string.
Multiple-character Extraction	*slice()*	Returns a section of a string defined by a starting and ending index. Does not include character at ending index.
	substr()	Returns a section of a string defined by a starting index and a length.
	substring()	Returns a section of a string defined by a "from" and "to" index Does include character at the "to" index.
Formatting	*toLowerCase()*	Converts all characters in the string to lowercase.
	toUpperCase()	Converts all characters in the string to uppercase.
Searching	*indexOf()*	Searches a string and returns the index position of the first occurrence of the character or characters being searched for; starts from the beginning of the string.
	lastIndexOf()	Searches a string and returns the index position of the last occurrence of the character or characters being searched for; generally starts at the end of the string.

> **NOTE:** *The String object does not require instantiation for use of its methods or property. All you do is append the method on the end of a variable that contains a string.*

In addition to the various methods available, the String object provides one very important property, the *length* property. With it you can determine the number of characters in any given string, much like using the *length* property on an array to determine the number entries in the array. The general form for using the String object's *length* property or its methods follows.

```
mystring.length;
mystring.method();
```

Here, *mystring* is a variable containing a string. Note, however, that often when you retrieve the length of a string you capture the returned value in a variable so that you can do something with that value. The first of the previous lines would retrieve the length of *mystring*, but it is not doing anything with it. Commonly you will use the *length* property directly within a *for* loop, or will place the value in a variable. Examples in previous chapters make use of both of these techniques frequently, as you will see in further material regarding them.

String Creation

You have seen the basics of creating strings and placing them in variables. By using double quote marks around a value inserted into a variable, the data is defined as a string; that is, a *string variable* is created. In addition to this "direct" method of string creation, you can use the String methods *concat()*, *split()*, and *fromCharCode()*. The next three sections examine these more closely.

concat()

Like the array method of the same name, *concat()* allows you to concatenate two strings into a new string. The general form for its use is:

```
var mystring4 = mystring1.concat(mystring2, mystring3);
```

Here, *mystring4* contains the concatenated string consisting of *mystring1*, *mystring2*, and *mystring3*. Note that the concatenation occurs in the order the strings are coded (i.e., *mystring1*, *mystring2*, and *mystring3*), and that the original value in *mystring1* is not affected by the *concat()* method. Note also that you can have as many values as you want in the arguments passed to the *concat()* method. Only two are shown in the previous line of code, but you could concatenate as many as you wanted.

For example, given the following code, the result of the *trace()* method on the variable *mystring7* yields *Professor James Mohler from Purdue University*. Also note that each of the strings in the variables has a space appended to the end of it. You will see a better way to do this a little later. If you enter this code into a frame and use Test Movie, you will see the concatenated results in the Output window.

```
var mystring1 = "Professor ";
var mystring2 = "James ";
var mystring3 = "Mohler ";
var mystring4 = "from ";
var mystring5 = "Purdue ";
```

```
var mystring6 = "University";
var mystring7 = mystring1.concat(mystring2, ¬
mystring3, mystring4, mystring5, mystring6);
trace(mystring7);
```

 NOTE: *Keep in mind that you can also concatenate strings direct-ly using the mathematical operator for addition (+). For exam-ple, using the previous code, you could concatenate the string using* var mystring7 = string1 + string2 + string3 + string3 + string4 + string5 + string6.

fromCharCode()

As noted earlier in this chapter, often when you are working with string data you will want to format text and quite possibly add specific characters to a string. For example, you might want to add a dollar sign to a value, so that it is displayed as currency. Or you may want to add a degree symbol at the end of a value so that it is perceived as a radial measurement. For doing either of these, the *fromCharCode()* method is quite useful.

The *fromCharCode()* method allows you to deal with strings at the character level. To do so requires the use of ASCII codes, which may be found in Appendix C. However, the *fromCharCode()* method is different from the other String object methods in that the word preceding the method must be *String*, as in *String.fromCharCode()*. Thus, the general form for its use is:

```
var mystring1 = String.fromCharCode(value_1, ..., value_n);
```

Here, *mystring1* is a local variable into which are placed the charac-ters represented by the ASCII values *value_1* to *value_n*. The code for a case in which you want to place a dollar sign at the beginning of a num-ber follows.

```
var string1 = "125";
var string2 = String.fromCharCode(36)+string1;
trace(string2);
```

Note that the ASCII code for the dollar sign ($) is 36. Thus, when *string2* is traced, the result is $125. In general, any character can be added to a string using the *fromCharCode()* method, if you know the ASCII char-acter representation for that character. In fact, you could add an entire set of characters to a string by simply specifying the characters within the *fromCharCode()* method.

One caution must be made concerning ASCII character values. The first 128 characters in the ASCII code values are relatively stable across platforms, meaning that standard characters (such as numerals, alphabet-

ical characters, and standard symbols such as the dollar sign, asterisk, and so forth) will display the same way on both platforms. However, many of the 127 characters following the first 128 (see Appendix C) are inconsistent across platforms.

For example, ASCII value 169, which is the copyright symbol, is the same across platforms. Yet ASCII value 144 yields no representation on the Windows platform, but on the Macintosh it is the infinity symbol. If you are going to use the *fromCharCode()* method to dynamically generate symbols or add things to strings, be cautious with the 127 ASCII values following the first 128, as these are not standard.

 NOTE: *Keep in mind that the* fromCharCode() *method is different from the other String object methods in that the method cannot be appended to all variable names. It must be preceded by the object name* String, *as in* String.fromCharCode(ASCII_code).

split()

The *split()* method is rather unique in that it allows you to split a string into individual string components. The string is split based on a specified delimiter, and the substrings are placed into an array. The general form for its use is:

```
mystringarray = mystring.split(delimiter);
```

Here, *delimiter* is the character that defines where the string will be split. For example, imagine you had a string that contained the names of individuals and you wanted to "parse" that string, placing each name in a unique position of an array. Code such as the following would accomplish this.

```
var string1 = "John,James,Barry,Michael,Ruben";
var myarray = string1.split(",");
for (var i = 0; i<myarray.length; i++) {
    trace(myarray[i]);
}
```

 NOTE: *Delimiters for the* split() *method must be a single character. You cannot split the string based on pairs or combinations of characters. The delimiter must be a single character, which is omitted from the substring results placed in the array.*

If you were to enter the previous code into a frame in Flash and test the movie, you would find that the variable *myarray* is created and each name is inserted into a unique index in that array. If you need to quickly divide a string into components based on some unique (single) separator character, use the *split()* method.

Single-character Extraction

Now that you have seen how to create strings, let's examine how to extract information from them. The first of the following sections deals with extracting single characters. Subsequent sections deal with extracting sets of characters. Two methods exist for extracting data about a single character: *charAt()* and *charCodeAt()*.

charAt()

The *charAt()* method allows you to extract a character from a particular string index location in a string. This is akin to accessing a particular array value using the array index number. The general form for using this method is as follows.

```
mystring.charAt(index);
```

Here, *mystring* is a string and *index* is a number specifying the location of the character you want to extract. As always, keep in mind that, like array indices, string indices start at 0. If you want to retrieve the third character in a string, you use 2 as the index. In addition, because the *charAt()* method is designed to return a value, you will generally capture the returned value in a variable or paste it to the Output window using *trace()*, as in either of the following two lines of code.

```
var mychar = mystring.charAt(3);
trace(mystring.charAt(3));
```

 NOTE: *If the index specified in the* charAt() *method is anything other than 0 to the string's length minus 1, the method will return a null string. Null strings traced to the Output window show up as a blank line.*

charCodeAt()

The *charCodeAt()* method is similar to the *charAt()* method except that instead of returning the actual Latin character at a particular index position it returns the ASCII character code for that character. The general form for using this method is:

```
mystring.charCodeAt(index);
```

Here, *mystring* is a string and *index* is a number between 0 and *mystring.length-1*. Like *charAt()*, if the index is greater than the length of the string minus 1 or is less than zero, a null string is returned. The ActionScript reference states that *charCodeAt()* returns a number between 0 and 65535. However, this is only true (and beneficial) when using the Shift-JIS character set, which is a Japanese encoding scheme for the Macintosh.

 NOTE: *The Shift-JIS character set can be found at* www. microsoft.com/globaldev/reference/dbcs/932.htm.

Even though the *fromCharCode()* and *charCodeAt()* methods will accept values between 0 and 65535, only the values between 0 and 255 (respective to the ASCII character code values) are of any use. As previously noted, Flash does not support Unicode or UTF-8 character values within String methods.

Multiple-character Extraction

Now that you have examined single-character extraction, let's look at how you can retrieve a range of characters from a string. There are three methods for accomplishing this: *slice()*, *substr()*, and *substring()*. These methods all basically do the same thing: retrieve subsets of characters from a string. However, each does it a little differently, as examined in the sections that follow.

slice()

The *slice()* method allows you to extract a subset of characters from a string by specifying an absolute starting index and an absolute ending index. The general form for its use is:

```
mystring.slice(start, end);
```

Here, *mystring* is a variable or object containing a string, and *start* and *end* are numbers that define the beginning and ending indices for the extraction. There are three important things to note about this method. When you use this method, the returned substring includes the character at the starting position, but not the character represented by the ending position. Second, you can make the method operate from the end of the string, rather than the beginning, by using negative numbers for the start and end (an example is shown later in this section). Third, using *slice()* on a string does not modify the original string.

As with previous examples, because *slice()* returns data, you generally capture that data in a variable or use it directly in a *trace()* method. You could also embed it within another method. The following are examples of these three uses, each of which would be used under its own set of circumstances.

```
var mysubstring = mystring.slice(0, 3);
trace(mystring.slice(0, 3));
mc1.gotoAndPlay(mystring.slice(0, 3));
```

There are myriad ways of using the *slice()* method. For example, given a string, let's say you want to extract the first character to the third character. This would be done as follows.

```
var mystring = "Purdue University";
trace(mystring.slice(0,3));
```

The results in the Output window from this code would be *Pur*. The important thing to note is that this code specifies the start of the slice at 0 (the first character), and the end at 3 (character four). Remember, *slice()* does not include the character represented by the ending index in the extracted substring. This is where most people get confused.

Another way to use the *slice()* method is to define a starting point and then grab the remainder of the string. Let's say for a series of string variables you always want to extract from the third character to the end of the string. If all of the strings are the same length, you could use the previous technique, in which you specify an absolute starting point and ending point. However, what if all of the strings vary in length? How will you know what the last character is? Of course, you could use the *length* property, but with *slice()* there is an easier way.

When you use the *slice()* method, if you do not define an ending index, the method will automatically extract from the starting point to the ending point, regardless of the length of the string. Thus, the following code would return *University*.

```
var mystring="Purdue University";
trace(mystring.slice(7));
```

Thus, when no end index is specified within the *slice()* method, it returns from the start (including the character at the start) to the end of the string, regardless of the length of the string. The following example concerns what happens when negative numbers are used. As you think about the positions in a string, and when dealing with negative numbers, keep in mind that the indices you specify are absolute positions in the string. Thus, −1 is associated with the last character, −2 with the next to last character, and so on.

 NOTE: *You cannot combine negative and positive starting and ending numbers to create a reversed substring extraction.*

Let's say that given a string you simply want to capture the next-to-last character and the one before it. The code for this extraction would be the following.

```
var mystring = "Purdue University";
trace(mystring.slice(-3, -1));
```

If you placed this code into a frame and tested the movie, the output result would be *it*. Note again that the character defined by the end (−1) is not included. If you wanted to extract the last three characters, regardless of string length, you could use the following.

```
var mystring = "Purdue University";
trace(mystring.slice(-3));
```

Here, the output result would be *ity*.

 NOTE: *When using positive numbers, the ending index must be greater than the starting index. When using negative numbers, the starting index must be less than the ending index. Otherwise, a null string will be returned, indicating an error.*

substr()

When using the *substr()* method, instead of defining a starting index and an ending index, as you do with *slice()*, you define a starting index and a length. The general form for using the *substr()* method is:

```
mystring.substr(start, length);
```

This method is pretty straightforward, at least more so than *slice()* for most people. The following is a basic example.

```
var mystring = "Purdue University";
trace(mystring.substr(0, 6));
```

In this example, you are extracting six characters, starting from the first character. Thus, the output is *Purdue*. Like the *slice()* method, if you define no length, *substr()* extracts to the end of the string. Thus, the following code yields *University*.

```
var mystring = "Purdue University";
trace(mystring.substr(7));
```

In addition, like the *slice()* method, you can use the *substr()* method to extract from the end of a string. However, when using *substr()*, you cannot have a negative length. Only the starting index can be negative. For example, let's extract the next-to-last character from this string, as follows.

```
var mystring = "Purdue University";
trace(mystring.substr(-2, 1));
```

The result of this code would be the output *t*. Similarly, if you simply wanted to extract the last three characters, you could use the following.

```
var mystring = "Purdue University";
trace(mystring.substr(-3));
```

When you use a negative number for the starting index, the length cannot be negative. If it is, a null string will be returned. In cases in which the starting index is negative, the length is usually between 1 and the absolute value of the starting index. If the length is greater than the number of available characters (regardless of the sign of the starting index), the

totality of the string will be returned. That is, it will *not* return a null string. Logically, a length of zero will return a null string.

substring()

Like the previously discussed methods, the *substring()* method will return a portion of a string. Yet it uses a "from" and "to" value to determine the points of extraction. The general form for its use is:

```
mystring.substring(from, to);
```

Here, *mystring* is a string and *from* is a number from 0 (the first character index) to the length of the string minus 1 (the last character index). Let's deal with the *to* value for a moment. Because the *from* value is based on the string index, you would think that *to* also represents an index. However, it does not. It actually represents the character itself. Thus, the number you should use for it is the character's index plus 1.

Valid values for *to* range from 1 to the length of the string, not 0 to the length of the string minus 1. Table 5-2 summarizes some of the possible implementations and their results. It is the fact that the *to* value is a character representation that makes the *substring()* method somewhat tricky (see the following Tip).

 TIP: *To keep this straight, remember the following: The* from *value is an index; the* to *value is the last character you want in the substring (the character's index plus 1).*

As you can see in table 5-2, when the *from* and *to* values equal one another, a null string is returned, as shown in the first, fifth, and eighth examples. The remainder of the examples demonstrate that the *from* value is an index, whereas the *to* value is a character reference. Note that the last example could also be written as *trace(string1.substring(0));*. The reason it is written as shown in the table is to demonstrate that the *to* value is counting characters, not string indices.

One final thing that is peculiar about the *substring()* method is that you cannot use negative numbers in it. If you use a negative number for the *from* value, it is automatically evaluated as 0. If you use negative number for the *to* value, a null string is returned. In addition, when the *substring()* method is executed, if the *from* value is greater than the *to* value the arguments are automatically swapped prior to execution of the function.

Generally you will find that the *slice()* and *substr()* methods are much more straightforward to use. For those that like a challenge, use the *substring()* method. Now let's turn our attention to the rudimentary formatting available for string data.

Table 5-2: Results of Using the substring() *Method*

Given: var string1 = "Purdue University"	
Code	**Output**
trace(string1.substring(0,0));	A Null string ("")
trace(string1.substring(0,2));	Pu
trace(string1.substring(0,4));	Purd
trace(string1.substring(2,4));	rd
trace(string1.substring(4,4));	A Null string ("")
trace(string1.substring(2,8));	rdue U
trace(string1.substring(4,8));	ue U
trace(string1.substring(8,8));	A Null string ("")
trace(string1.substring(0,17));	Purdue University

Formatting

If you are familiar with other programming languages, you realize that many of them provide a wide range of formatting capabilities for strings and numbers. However, as it relates to strings, ActionScript provides only the ability to convert to all uppercase or all lowercase letters. It does not give the ability to format strings into proper case (that is, making the first letter of every word in a string uppercase) or reverse strings, nor does it directly provide the ability to format strings as currency or other formats. For the moment, let's look at the two methods that are available in the current version.

 NOTE: *Although it is not covered in this section, later in this chapter you will look at an example that demonstrates how to convert a string to proper case, as well as how to reverse a string, using a user-defined function.*

toLowerCase() and toUpperCase()

As their names imply, the *toLowerCase()* method and the *toUpperCase()* method return a string converted to, respectively, all lowercase or all uppercase letters. Thus, the general form for their use is:

```
mystring.toLowerCase();
mystring.toUpperCase();
```

Here, *mystring* is a string variable. As with prior methods that return values, these methods are typically captured in a variable or used in a *trace()* method. The original string is left intact; that is, it remains in its original case, whereas the returned results are either upper- or lowercase.

Appending Methods to Methods

Note that you can use these two methods (as well as others) in conjunction with other methods that return a string value. For example, in Chapter 4 you saw how the *getRGB()* method could be used to retrieve an assigned RGB value from a movie clip. Recall that you used *.toString(16)* to convert it to a Base16 string, using code such as the following.

```
new Color(this.myC).getRGB().toString(16);
```

 NOTE: *Remember that in the* .toString(16) *conversion preceding zeros are eliminated.*

Using *getRGB().toString(16)* on an object that had previously been assigned a color with the Color object would return a hexadecimal value such as *ccff66*. As simply an acknowledgment, realize that you could tack on *.toUpperCase()* at the end of the previous line of code to convert the hex value to an uppercase representation, as in the following.

```
new Color(this.myC).getRGB().toString(16).toUpperCase();
```

By doing this, the returned color specification would be *CCFF66* instead of *ccff66*. Without a solid context, this may seem irrelevant, but it is far from it. You can append the *toUpperCase()* or *toLowerCase()* method to the end of any other method that returns a string.

This technique might be useful for comparing a retrieved color to a lookup to see if the item is the right color. It might also be useful for any scenario in which you need to perform comparisons that might otherwise be affected by the case of the characters. You saw an example of this in Chapter 3 when you dealt with order functions in which you wanted to ignore letter case when the array sorted (see table 3-5).

Searching

The last "set" of methods related to the String object are those designed to search a string for the string index position of a particular character or set of characters. This set of methods consists of two types: *indexOf()* searches for the first occurrence, and *last IndexOf()* searches for the last occurrence. The difference between these two methods is that they start their search from different ends of the string. However, regardless of which end you start searching from, both methods return the absolute string index position.

indexOf()

The *indexOf()* method looks for the index position where a match to the search string is found. By default, it starts from index 0 and proceeds to

the length of the string minus 1, looking for the search string. When the method finds the search string, it returns the string index where it found the value. Note that you can define either a single character as the search string or multiple characters. The general form for the method's use is as follows.

```
mystring.indexOf(searchstring, start);
```

Here, *mystring* is a string variable, *searchstring* is the character or characters you are trying to find in the string, and *start* is the index position with which you want the method to begin. Note that the *start* argument is not required. If no starting index is given, the search begins at index 0 (the default). If the *searchstring* is a set of characters, the index returned is the position at which the first character in *searchstring* occurs. For example, given the following code, the result of the *trace()* method would be 2 because the first occurrence of the search string *"34"* occurs at string index positions 2 and 3 (the *3* is at position 2, and the *4* is at position 3).

```
var mystring = "123412341234"
trace(mystring.indexOf("34"));
```

If you were to revise this code and add a starting index, as in the following, the result of the *trace()* method would be 6 because the first occurrence of the search string *"34"* (starting at index 3) occurs at string index positions 6 and 7 (the *3* is at position 6, and the *4* is at position 7).

```
var mystring = "123412341234"
trace(mystring.indexOf("34", 3));
```

If *searchstring* is not found in the string, the method returns –1, indicating that the character or combination of characters was not found in the string.

lastIndexOf()

The *lastIndexOf()* method is similar to the *indexOf()* method, except that instead of searching from the beginning of the string it starts at the end of the string. The general form for its use is:

```
mystring.lastIndexOf(searchstring, start);
```

Here, *mystring* is a string variable or object, *searchstring* is a character or set of characters for which to search, and *start* is the index with which to begin. For example, the following code yields 11 in the Output window because the first occurrence of *4* (starting from the end of the string) is at index 11, consequently the last character in the string.

```
var mystring = "123412341234"
trace(mystring.lastIndexOf("4"));
```

Note that if you specify a starting index, the method still works backward from the end of the string to the beginning. However, it works backward from whatever starting index you give it. For example, the following code yields 7.

```
var mystring = "123412341234"
trace(mystring.lastIndexOf("4", 10));
```

By adding a starting index, the method skips the trailing 4 on the string, finding the next available match from the specified *start* value. As with the *indexOf()* method, if the search string contains a set of characters, rather than a single character, the index defining the beginning of the last instance of the search string is returned. Thus, the following code returns 10 because the first character of the search string found in the string is at position 10 (the *3* is at index 10). A −1 is returned from the method when the search string is not found in the string.

```
var mystring = "123412341234"
trace(mystring.lastIndexOf("34"));
```

▪ ▪ ▪ The Number Object

Now that you have looked at strings, let's explore the Number object. The Number object does not have as many methods associated with it as the String object. However, the Number object provides several properties. Unlike the String object, you must instantiate the Number object to be able to use its methods. Yet, to use its properties, you do not need to instantiate the object.

Methods

There are two methods for the Number object: *toString()* and *valueOf()*. Of the two, *toString()* is the most useful because it allows you to convert a number to a string using a variety of numbering systems. The *valueOf()* method is a little less useful. Nevertheless, the following two sections describe these methods in more detail.

toString()

The *toString()* method allows you to convert a number to a string. However, the important thing to note is that you can use the method to interpret the number using a specific numeric base. The general form for using the *toString()* method is:

```
mynumber.toString(radix);
```

Here, *mynumber* is a variable or instance of the Number object, and *radix* is the base you want the number to be interpreted as. Note that if no *radix* value is given the conversion occurs using Base10.

As mentioned in the last chapter, the binary numbering system is typically referred to as *Base2*. However, you can also say *Radix2* or *Modulo2*. Any of these terms refers to the binary numbering system. Similarly, hexadecimal may be called Base16, Radix16, or Modulo16, and octal may be called Base8, Radix8, or Modulo8. The following code converts a single decimal number (Base10) to a Base2, Base10, Base8, and Base16 string.

```
var mynum = 1111
trace("Base2 = "+mynum.toString(2));
trace("Base8 = "+mynum.toString(8));
trace("Base10 = "+mynum.toString());
trace("Base16 = "+mynum.toString(16));
```

If you plug this code into a frame and test the movie, you will find that the output is:

```
Base2 = 10001010111
Base8 = 2127
Base10 = 1111
Base16 = 457
```

Note that the single value can be interpreted in various ways, depending on the base or radix you provide. In regard to the *toString()* method, note that the Number object's *toString()* method and *parseInt()* function can be used as ways of converting data back and forth. You can basically think of these two as "opposites" of each other. Thus, given the number 1000, you can convert it to binary using:

```
var mystring = (1000).toString(2)
```

The content of *mystring* would be the string *10001010111*. You can convert that string back to a Base10 number using:

```
mystring = parseInt(mystring, 2);
```

Thus, *toString()* and *parseInt()* complement each other by allowing you to convert a number of any base to a string, or to convert a string to a number of any base.

valueOf()

The *valueOf()* method, which has few uses when appended to a Number instance, basically returns the numeric value inside the instance of the Number object.

Properties

The Number object includes five properties, which are constants (values that never change) that are fairly straightforward. Rarely will you encounter a situation in which you would need to use them. Thus, this section reviews these properties briefly. You access the Number object property values using the form:

```
Number.property
```

Here, *Number* is used as the object reference and *property* is the name of the property you want to retrieve. For example, imagine you wanted to set a variable equal to positive infinity. You would do so as follows.

```
var myvar=Number.POSITIVE_INFINITY;
trace(myvar);
```

Recall that when you examined the String object earlier in this chapter you saw that when you use the *fromCharCode()* method you have to use the word *String* in front of it (e.g., *String.fromCharCode(36)*) instead of an actual object instance. Similarly, when you access the Number object's properties, you must use the word *Number* before the property.

As for the properties, the first two (*MAX_VALUE* and *MIN_VALUE*) are the maximum and minimum values that can be represented in Action-Script. The *MAX_VALUE* is 1.79e + 308 (1.79 x 10^{308}) and the *MIN_VALUE* is 4.94e – 324 (4.94 x 10^{-324}). Although it is unlikely you will need to calculate to the maximum or minimum values available in Flash, these two constants are the limits of the numerical system in Flash (which, for those who are interested, is based on the IEEE standard 754 for binary floating-point arithmetic).

The other three properties are constants that represent "theoretical" values. They are *POSITIVE_INFINITY*, *NEGATIVE_INFINITY*, and *NaN* (not a number). The first two are the maximum theoretical limits of any numbering system. *NaN* is the representation of anything that is "Not a Number". Generally, *NaN* is used for errors. For example, if you try to perform certain mathematical operations on something that is not a number, the result is frequently *NaN*, meaning that the operation cannot be performed. As previously mentioned, it is not likely you will need the Number properties for 99 percent of what you do, but you should be aware of their existence.

▪ ▪ ▪ The Boolean Object

Like the Number object's properties, the Boolean object is not heavily used, even though Boolean values typically play a role in scripting. For

example, you may want to create a variable to track the on and off (or *true* and *false*) state of something, such as a checkbox or property. By doing so, you can construct an *if* statement to test against that binary variable or property. When you start creating your objects, using the Object object, creating binary properties becomes more important.

> **NOTE:** *Keep in mind that binary variables may contain the values 0 or 1 or the keywords* true *or* false. *In Flash,* true *and* false *are keywords, not strings. Like the keyword* _root *or* _parent, true *and* false *are reserved words that turn blue in the ActionScript window, indicating that they are treated specially.*

When you use Boolean variables (i.e., variables that track the current of two states), most of the time you deal with the numerical values 0 and 1. If you deal with properties, such as the *_visible* property, you may be dealing with *false* (invisible) or *true* (visible) values. In any event, the Boolean object exists so that there is continuity or relationship between the values 0 and 1 and the values *false* and *true*.

This continuity exists without you having to instantiate the Boolean object. This means that you can take a Boolean variable you have created and extract a numerical representation of the on and off state by using the Boolean object's *valueOf()* method, or use the Boolean object's *toString()* method to generate the string "true" or "false".

▪▪▪ The Date Object

Before delving deeply into the Date object, one of the first things you must understand—if you want to use this object effectively—is how the date is stored inside the computer, what data the Date object yields, and how you set up the Date object to output your local date and time (as well as other secrets you may want it to reveal). These issues are explored in the sections that follow.

How Are Dates Stored?

You are likely aware of the various time zones that exist across the continental United States, or wherever your part of the world is located. Although many pages of this book might be devoted to the background and intricacies of tracking date and time around the world and its history, the following is intended as a concise, practical summary of this area as it relates to the use of Flash.

The one "zone" you may or may not be familiar with is the GMT zone, or Greenwich Mean Time. GMT is basically the reference point for all time zones across the world, which is located directly in the middle (or mean) of all other time zones. Geographically, this longitudinal line runs through

Greenwich, England. Thus, on the opposite side of the world to the GMT zone is the International Date Line, the longitudinal line on either side of which is a different day. Ranging between these two demarcations are all other time zones, including those native to the continental United States, including PST, MST, CST, and EST.

In the United States, we use Standard Time (ST) instead of Mean Time (MT) in the abbreviation. Thus, Pacific, Mountain, Central, and Eastern Standard Times all have some relative position to GMT. For example, EST is GMT-5 (or 5 hours behind GMT).

UTC, Universal Time (Coordinated), is synonymous with GMT. UTC differs from GMT in that it is based on atomic measurement rather than the earth's rotation, which is subject to slight irregularities. Where GMT comes into play in the computer is that behind the scenes all computers track time based on the GMT, not the local time in the user's time zone. Fortunately for computer users, all output to the user, such as the PC's clock and so forth, present the time as the true local time, based on GMT plus or minus some value relative to GMT. Thus, local time is dynamically derived from GMT for output to the user.

Also fortunate for us, Flash provides the ability to work with either UTC (GMT) or the user's local time. Later you will find that the methods for the Date object are specifically designed to report or use one or the other of the date and time formats; that is, there are specific methods for UTC specifications, and others for the local date and time specification. The drawback of working with UTC is that you have to calculate local time (if that is what you need), and you have to assume the user's BIOS clock is the correct time.

The only drawback of working with the local user's time is that you have to assume that the user's computer clock is correct and you have to assume that the "regional" or "time-zone" settings in the operating system are also correct. (These issues are explored further in material to follow.) For now, simply note that ActionScript is pretty diverse in the methods it provides for working with the Date object, as it provides access to either UTC or local time.

What Is Date Data?

The Date object provides much more information than you might think at first glance. Many think it is just the "the computer's clock" ticking away. As previously explained, to some extent it does relate to the computer's internal clock. However, it is really much more, and it is much more powerful. The Date object can be used in one of three ways. You can get data (find out information) about today's date, get/set information about a past

date, or get/set information pertaining to a future date. When you talk about the "date" on the computer, it includes the day, month, and year, as well as more detailed components of time, such as hour, minutes, seconds, and even milliseconds.

In addition to these general ways of working with dates (that is, aside from working with past, present, or future information in general), the Date object can work with or yield three types of data. This distinction has to do with the type of data your are transferring about the past, present, or future date. The first way the Date object can be used is to make it yield straightforward and complete information about the time and date.

When used this way, the Date object provides a string of information, such as *Tue Jul 3 10:15:13 GMT-0400 2002*. Note that this string is relative to GMT, and gives the local time setting at the end. For example, Indiana is currently on CST, 4 hours behind GMT. (Indiana is one of two states that do not change the clock. However, because the rest of the United States does change, Indiana fluctuates between CST and EST, depending on the rest of the nation.) This is the simplest way of working with the date object.

The second way to work with the Date object, a somewhat obtuse method, is to work in milliseconds (where 1 second equals 1,000 milliseconds, 1 minute equals 60,000 milliseconds, 1 hour equals 3,600,000 milliseconds, and 1 day equals 86,400,000 milliseconds). In this "mode," everything is measured in milliseconds. The first question that should come to mind is, if the Date object returns (or receives) a millisecond measurement of 994170065625, what does this mean? Where is the starting point (the number is relative to what)?

The "zero point" for the Date object used this way is January 1, 1970. Thus, if you ask for a "millisecond" measurement, it will provide a value relative to 1/1/1970. If the resulting number is positive, it is after 1/1/1970, and if it is negative, it is before. Working with the Date object is a little more difficult when dealing with this type of measurement, and it is not broadly used, but it is another possibility.

The last way to work with the Date object is to deal with each of the individual components of the Date object (including year, month, day, hours, minutes, seconds, and milliseconds) at any given point in time. With this facility you can retrieve any one of these components (you will find that there is a lengthy list of methods for the Date object, generally one for each of these) or create a Date object relative to a past or future date, and then retrieve information about it. For example, you could create an instance of the Date object associated with June 18, 1971, and find out what day of the week that was.

Setting Up the Object for Use

To use the Date object's methods and properties, you must instantiate the object. As you saw in the last section, there are three ways to use the Date object (and the way you instantiate the Date object is based on the method in which you intend to use it). As a result, there are three general forms for using the Date object. Let's examine each. If you simply intend on working with the current date and time, you instantiate the object in the following way.

```
var today=new Date();
trace("This year is " + today.getFullYear());
```

The important thing to note in this code is that no argument is passed to the Date object. When no argument is passed to the Date object, it assumes you want to instantiate the object using today's date. Once you have the date object associated with the current day, you can extract any portion of the date or time and do something with it. The second line in the previous code simply pulls out the current year.

The second means of instantiating the Date object is to specify a past or future date you want to work with, and provide that number, in milliseconds, to the Date object. As mentioned previously, the number provided to the Date object is given relative to January 1, 1970; positive is a date after and negative is a date before. Thus, the general form for this is:

```
new Date(milliseconds);
```

Here, *milliseconds* is provided as the number of milliseconds before or after January 1, 1970. Let's look at a specific example. Given the following code, the results from the *trace()* method would yield *2002,* as the argument passed to the Date object is representative of the number of milliseconds after January 1, 1970.

```
var today=new Date(1025706065625);
trace("The year is "+today.getFullYear());
```

Consequently, the number represents the date as of July 3, 2002. As you can see, working with millisecond measurements for dates can be unwieldy, and it is unlikely you would be using it in everyday ActionScripting. However, there are specific instances in which you may find it the only means of obtaining the results you need. The last method for instantiating the Date object is to provide the object with a specific year, month, day, and so on. The general form for its use is:

```
new Date(year, month, day, hours, minutes, seconds, milliseconds);
```

Here, the arguments are presented in the order shown. Note that the only two arguments required are the *year* and *month*. All other elements

default to 0 or 1 if they are not provided as arguments, as explained in material to follow. When you specify each of these arguments, there are some requirements and things you need to know. Let's take a look.

Specifying Year, Month, and Day

The *year* specification is presented as an integer. Any number over 100 is interpreted as that specific year. For example, 100 is interpreted as 100 AD, 500 is interpreted as 500 AD, 1910 is interpreted as 1910 AD, and 2010 is interpreted as 2010 AD. If you specify only two digits (that is, a number between 0 and 99), it is added to 1900 to create the year. Thus, 20 is interpreted as 1920, and 50 is interpreted as 1950. Consequently, 0 is interpreted as 1899.

For the years between 1900 and 0, you can use a negative number. For example, if you use –1899, you get 0 AD; if you use –1499, you get 400 AD; and if you use –999, you get 900 AD. However, if you attempt to use a number less than or equal to negative1900, the results provided are unreliable (they result in negative years). To specify a date prior to 0 AD, specify the date in milliseconds instead.

The *month* specification works a little differently as well. It is provided as a number between 0 and 11 (not 1 and 12). Much like string and array indices, the *month* specification begins counting at zero. Thus, January is 0, February is 1, and so on. If you specify a month outside the range of 1 to 12, the year is incremented and you are automatically "forwarded" to the next year. For example, if the *year* argument is 99 (interpreted as 1999) and you specify 16 as the *month* argument, the *year* is incremented to 2000 and the *month* is set on June (16 – 11 = 5 = June).

 NOTE: *A year and month specification must always be provided. The other arguments are optional.*

Like *year* and *month*, the *day* specification is different still. Rather than starting at 0, the day specification starts at 1 and progresses through 31. However, like the *month* specification, if you specify a day outside the range allowable in the current month, the *month* is incremented. For example, if you specify 31 for the *day* argument, and the *month* argument is currently 1 (February), the *month* is incremented to March and the day is set to the third day of the month (31 – 28 = 3)—unless of course it is a leap year!

Specifying Hours, Minutes, Seconds, and Milliseconds

Like the *day* argument, the *hours*, *minutes*, *seconds*, and *milliseconds* (abbreviated ms) are optional. To specify an hour, you do so using "military" time; that is, a number between 0 (midnight) and 23 (11 PM). If you specify a number greater than 23, it is carried over to the next day. Thus,

if you used the following, the data would yield June 19, 2002, and the time would be 1:00 AM.

```
mydate=new Date(2002, 5, 18, 24);
```

Note that you cannot use negative numbers for the hour argument. If you do, it will "zero out" the day argument.

 NOTE: *The* day, hour, minute, second, *and* millisecond *arguments are optional. In previous code, only* year, month, day, *and* hour *are presented. You can use any combination of the additional arguments for the time component.*

As for the *minutes* and *seconds* arguments, both are specified as a number between 0 and 59. If you specify a number outside this range, the date is either progressed or regressed. For example, a *minute* specification of 75 would be 16 minutes into the next hour; that is, 75 – 59 equals 16 plus one hour. Similarly, if you specify a *minute* setting of –11, it would yield the 49th minute of the previous hour. The *seconds* specification works exactly the same way.

As for the *milliseconds* argument, if you need that level of detail, you can specify a number between 0 and 999. If no argument is presented, the *milliseconds* defaults to 0. Like the *minutes* and *seconds* specifications, if you specify a number outside the range, the *seconds* are incremented or decremented. For example, if you provide a specification for *milliseconds* of 1025, it is treated as 26 milliseconds into the next second.

Methods

As previously mentioned, the methods for the Date object can be divided into two main groups: those designed to get information about a Date instance and those designed to set information concerning a Date instance. There is also a third group of what the author calls "utility" methods. Each of the two main method groups can be further divided into methods designed to work with the local date and those designed to work with UTC.

An exhaustive examination of each individual method is not necessary—using them is quite simple. If there is a complex part of using dates, it is instantiating the Date object itself. Instead of an extensive and complicated review of the methods, the material that follows provides tables of the methods that get data and those that set data, as well as the detailed information you really need to know.

Methods That Get Data

Table 5-3 outlines the methods designed to return information from a Date instance. The value range for each method is provided.

Table 5-3: Date Object Methods That Return Specific Information

Method	Value Range	Description
getDate()	1 – 31	Gets the day of the month
getDay()	0 – 6	Gets the numerical day of the week (0 is Sunday)
getFullYear()	0 – 999 or 1000 – ∞	Gets the full, four-digit year (if year >= 1000)
getHours	0 – 23	Gets the hour of the day in military time
getMilliseconds()	0 – 999	Gets the milliseconds
getMinutes()	0 – 59	Gets the minutes
getMonth()	0 – 11	Gets the numerical representation of the month (0 is January)
getSeconds()	0 – 59	Gets the seconds
getTime()	–∞ – ∞	Gets milliseconds before or since 1/1/1970
getTimezoneOffset()	−43.2 million – 43.2 million	Gets the difference between UTC and local time in milliseconds
getUTCDate()	1 – 31	Gets the UTC day of the month
getUTCDay()	0 – 6	Gets the numerical day of the week (0 is Sunday) in UTC
getUTCFullYear()	0 – 999 or 1000 – ∞	Gets the full, four-digit year in UTC (if year >= 1000)
getUTCHours()	0 – 23	Gets the hour of the day in military time in UTC
getUTCMilliseconds()	0 – 999	Gets the milliseconds in UTC
getUTCMinutes()	0 – 59	Gets the minutes in UTC
getUTCMonth()	0 – 11	Gets the numerical representation of the month in UTC (0 is January)
getUTCSeconds()	00 – 59	Gets the seconds in UTC
getYear()	–∞ – ∞	Gets the year as a relative numerical value from 1/1/1970 (not in milliseconds)

Methods That Set Data

Table 5-4 outlines the methods designed to set various aspects of a Date instance. The value range for each method is provided.

Table 5-4: Date Object Methods That Set Date Instance Information

Method	Value Range	Description
setDate()	1 – 31	Sets the day of the specified month
setFullYear()	1000 – ∞	Sets the year as a four-digit format
setHours()	0 – 23	Sets the hour of the specified day
setMilliseconds()	0 – 999	Sets the milliseconds of the specified second
setMinutes()	0 – 59	Sets the minute of the specified hour
setMonth()	0 – 11	Sets the month of the specified year
setSeconds()	0 – 59	Sets the second of the specified minute
setTime()	-∞ – ∞	Sets the time using milliseconds before or since 1/1/1970
setUTCDate()	1 – 31	Sets the day of the specified month in UTC
setFullYear()	1000 – ∞	Sets the year as a four-digit format in UTC
setUTCHours()	0 – 23	Sets the hour of the specified day in UTC
setUTCMilliseconds()	0 – 999	Sets the milliseconds of the specified second in UTC
setUTCMinutes()	0 – 59	Sets the minute of the specified hour in UTC
setUTCMonth()	0 – 11	Sets the month of the specified year in UTC
setUTCSeconds()	0 – 59	Sets the second of the specified minute in UTC
setYear()	-∞ – ∞	Sets the year as a relative numerical value from 1/1/1970 (not in milliseconds)

Utility Methods

As with other objects you have read about, the Date object provides two utility methods, *toString()* and *valueOf()*, that allow you to extract a specified string or numerical value from any Date instance. As with any object, the *toString()* method returns the string representation of a value (in essence, converts whatever precedes it to a string). For example:

```
mydate = new Date(2002, 5, 18);
trace("Today's date is " + (mydate.getMonth()+ 1) ¬
.toString() + "/" + (mydate.getDay()+ 1).toString()
¬ + "/" + mydate.getFullYear().toString());
```

will output the following to the Output window.

```
Today's date is 6/2/2002
```

Note that when the month and day are returned, you must increment it by one before using the *toString()* method, as in the following.

```
(mydate.getMonth()+ 1).toString()
(mydate.getDay()+ 1).toString()
```

In these two cases you are actually "using" the String object's *toString()* method, not the Date object's. Previously, in the case of *mydate.getFullYear().toString()*, you are using the Date object's *toString()* method. Nevertheless, in all three cases the *toString()* method converts the returned results to a string so that they can be concatenated. If you did not use the *toString()* method, Flash would likely try to add the numerical results, rather than concatenate the string results. As for the *valueOf()* method, when used on any Date object it returns a numerical value of the milliseconds between the date instance and "hour zero" (midnight) of 1/1/1970.

▪ ▪ ▪ Applications of the Objects

In previous sections you have examined the fundamentals of the String, Number, Boolean, and Date objects. The remainder of this chapter examines applied examples and the code that makes them work.

Parsing and Manipulating String Data

This section examines "parsing" scenarios; that is, situations in which you might need to parse a string of data, and manipulate or use it in some way. This section also examines scenarios for comparing strings.

Simple Word Search

The first example examined in this section involves a simple word search, such as might be used to evaluate answers to questions a user might type in as responses to an on-line quiz or exam. This example looks for a single word or phrase in the input.

 CD-ROM NOTE: *The example discussed in this section can be found on the companion CD-ROM. The file is named* ch05_01.fla *and is located in the* fmxas/chapter05/ *folder. You may want to use Test Movie to see how it works.*

Once you have the file *ch05_01.fla* open, you will find four fields and two buttons that check the answer, as shown in figure 5-1. The determination of whether the user entered the correct answer is written in a function in frame 1, which is discussed in material to follow. The two upper fields are named *q1* and *q2*. The other two fields are named *out1* and *out2*.

Figure 5-1. This first example does a simple word search to determine if the user entered the correct answer.

They are used to tell the user whether or not the question was answered correctly.

Note that the naming of the fields is important; that is, if you want to be able to write a single generalized function that will work for all questions. The way this example is set up, you could easily include hundreds of questions and use a single function to check the answer for all of them. Let's begin by looking at the event methods associated with the two Check Answer buttons, as shown in code example 5-1. All code for this example is contained in frame 1 of the *Global* layer.

Code Example 5-1: Event Methods for the Check Answer Buttons

```
check1.onRelease = function() {
  answercheck(1, "animator");
};
check2.onRelease = function() {
  answercheck(2, "futurewave");
};
```

Both buttons call the function *answercheck()* and pass two arguments to the function. The first argument is a number, related to the question number. The second argument is the answer (or word) you are looking for in the user's response. In this example, all you want to do is make sure the user entered the word in his answer. Now let's look at the *answercheck()* function, which is above the event methods for the buttons. The code is shown in code example 5-2.

Code Example 5-2: The Function That Checks the Answer

```
function answercheck (q, answer) {
 if (findword(eval("q"+q), answer) == true) {
 set("out"+q, "That is correct!");
 } else {
 set("out"+q, "That is incorrect. Please try again.");
 }
 function findword (input, answer) {
 var input = input.toLowerCase();
 return input.indexOf(answer) != -1;
 }
}
```

You will see that the function actually consists of two functions, one inside the other. Because the *findword()* function is only used by the *answercheck()* function, one is embedded in the other. This makes the code more portable, in that if you wanted to use it in another file you would not have to worry about making sure you had both functions (as one is contained in the other). Make sure you are always thinking about portability in your code.

The first thing you will note in code example 5-2 is that when the data is received by the *answercheck()* function it immediately assigns it to the local variables *q* (the question number) and *answer*. In essence, the first half of the function calls the secondary function (*findword()*) to determine if the answer is found in the user's response. It then responds accordingly, as shown by the preceding *if* statement.

NOTE: *The feedback given by the* answercheck() *function is rudimentary. You could set up an array of correct answers and an array of wrong answers so that the same response is not given every time.*

The key to understanding how the *answercheck()* function works is to examine the *findword()* function. In the *if* statement in *answercheck()*, you see *findword(eval("q" + q), answer) = = true* being used as the condition. Thus, you can deduce that *findword()* is going to return a *true* or *false* Boolean response based on whether or not the user answered correctly.

When *findword()* is called, you see two arguments passed to it: which question is being checked (*eval("q" + q)*) and *answer* (*answer* was originally passed to *checkanswer()*). Note the use of the *eval()* method. As mentioned in previous chapters, the ability to write generalized code is fundamentally based on understanding how to use the *eval()* method. Here, *eval()* is used so that "*q*" + *q* is evaluated as the variable associated

with one of the two fields, *q1* or *q2*. Without the *eval()* method, the function will not work.

TIP: *Keep in mind that* eval() *can no longer be used on variable names, only on objects. Alternatives include the use of the* set() *method (as shown in code example 5-2), as well as the array access brackets.*

Within the *findword()* function, the first thing done is to convert the user's response to lowercase. The program then checks to see if *answer* can be found in *input (input.indexOf(answer))*. Remember that if *answer* is not found in *input*, the result is –1. Note that you are returning the evaluation of a statement, not just the result of *indexOf()*. In essence, the last line is returning a Boolean result. If the result of the *indexOf()* method is not –1, *true* is returned (the user's answer was correct). Otherwise, *false* is returned because *indexOf()* would return –1.

NOTE: *The use of the not equals (! =) operator is important here. This indirectly invokes a Boolean response.*

Multiple Word Search

In the previous example you learned how to search for a single word in a field. However, often you may wish to search for a series of words or phrases within a user's input. The example that follows examines a generalized function that searches for multiple words or phrases in a user's input. The function is set up so that it can look for a varying number of words or phrases.

CD-ROM NOTE: *The example discussed in this section can be found on the companion CD-ROM. The file is named* ch05_02.fla *and is located in the* fmxas/chapter05/ *folder. You may want to use Test Movie to see how it works.*

The example file for the multiple word search is basically set up the same way as the previous example, as shown in figure 5-2. There are two questions and four input text boxes. Two of the text boxes are for the user's input, and the other two are for output to the user. The text boxes in this example are named the same way as well.

As you can see in figure 5-2, the first question requires three words or phrases in the response, and the second question requires two words or phrases. Both are handled by a single function. As a matter of fact, the function you will look at could handle a question with as many words or phrases as necessary. As with the previous example, let's begin by looking at the code associated with "check answer" buttons. The code is shown in code example 5-3.

Figure 5-2. This example uses a generalized function to search for multiple words or phrases within a user's input

Code Example 5-3: Event Methods for the Check Answer Buttons

```
check1.onRelease = function() {
 var answer=["button", "movie clip", "graphic"]
 answercheck(1, answer);
};
check2.onRelease = function() {
 var answer=["mask", "guide"]
 answercheck(2, answer);
};
```

Note that in this code, as in the previous example, the *answercheck()* function is executed. However, the difference you see is that prior to calling the function an array is set up that contains the correct answers to the question. That array is then passed to the *answercheck()* function. Note also that because the *answer* array is created within a function, the *var* keyword can be used to establish *answer* as a local variable. Now let's look at the *answercheck()* function, shown in code example 5-4.

Code Example 5-4: The answerCheck() Function

```
function answercheck (q, answer) {
 var temp=true;
```

```
for (var i=0; i<answer.length; i++) {
  if (findword(eval("q"+q), answer[i])!=true) {
    temp=false;
    break;
  }
}
if (temp==true) {
 set("out"+q, "That is correct!");
} else {
  set("out"+q, "That is incorrect. Please try ¬
  again.");
}
function findword (input, s_word) {
  var input=input.toLowerCase();
  return input.indexOf(s_word) != -1;
}
}
```

 NOTE: *Keep in mind that the* answer *variable is an array. This is imperative for the* answercheck() *function to work on any question with multiple answers, regardless of the number of answers you are looking for in the user's response.*

The first thing you will note in code example 5-4 is that the function receives two pieces of data. One is assigned to a local variable, *q* (the question being checked), and the other to a local variable, *answer* (which is an array). The local variable *q* is used so that the correct input text box and output text box are used when the answer is checked (as in the previous example). The variable *answer*, now local, contains the answers you want to look for within the user's response.

In general, the *answercheck()* function must look for all values in the *answer* array, within the user's response. The answer is correct only if all values are found. In the previous example, where only a single word or phrase was being searched for, the embedded *findword()* function was used directly as a condition within an *if* statement, and then an appropriate response was output. In this example, because the number of answers is going to vary from question to question, you cannot use an *if* statement like you did in the prior example. The conditions for the *if* statement would have to vary dynamically as the number of answers varied. This is something you cannot do in code. Therefore, a different technique must be employed.

The simplest method of checking for all answers is to first assume that all answers are going to be in the user's response—that the user's response is correct. Then, if one of the answers is not found in the response, the answer is flagged as incorrect and a response is made accordingly. To do this, the code begins by creating a local variable and setting it to *true* (*var temp = true;*). Later in the code you can see that the value in *temp* will be used to determine the response output to the user. If *temp* is *true*, the user's answer is correct. If *temp* is *false*, the user's answer is incorrect.

To check for all words or phrases in the user's answer, a *for* loop is used. The number of repetitions of the *for* loop is based on the number of items (answers) in the *answer* array. This is the key that will make the *answercheck()* function work for any question, regardless of the number of words or phrases required for the answer to be correct. In fact, you could also use this to search for a single answer.

Within the *for* loop you see an *if* statement. For each iteration of the *for* loop, one of the items in the answer array is looked for in the user's response (*findword(eval("q" + q), answer[i])! = true*). Note the use of *eval()* to refer to the correct input text box, and the use of the counter *i* to pull an item from the *answer* array. If the item from the *answer* array is found in the user's entry, the *for* loop continues with the next value of *i*, which is the next item in the *answer* array. If all items in the answer array are found in the user's response, the value of *temp* remains *true* and the user is given the response "That is correct!"

However, within the *for* loop, if an item from the *answer* array is not found in the user's response, the *if* statement within the *for* loop executes its statements. When this happens, the value of *temp* is set to *false*, the *for* loop is stopped by the *break* command, and the subsequent *if* statement returns the response "That is incorrect. Please try again."

In summary of this example, there are two "keys" you should garner from this example. First, to make this function generalized—able to be used with questions with myriad answers—the array was needed. This goes back to what you learned in Chapter 3 about arrays and provides yet another example of their usefulness. One of the foundational programming techniques is the use of an array that varies in length with a *for* loop. Here you see an application of it, which is what makes this function generalized.

A second key you should note is the assumption that the user's answer was correct (*var temp = true*). This is an example of a "logic" solution to a problem. When first considering how you might write a function to check for multiple answers, you might immediately think you should assume that the user's answer is false and then see if it was true with the *for* loop. However, this approach would be much more difficult in this example. By

thinking in the reverse—assume the user's answer is true and then check for a false answer—the solution was much easier.

 TIP: *The previously discussed logic is a classic problem. When trying to solve a programming problem, do not get stuck thinking in one "direction."*

Search and Replace

As a continuation of searching for words or phrases, a common capability is the ability to perform a search and replace. The following example demonstrates a function that searches and replaces words in a text box.

 CD-ROM NOTE: *The example discussed in this section can be found on the companion CD-ROM. The file is named* ch05_03.fla *and is located in the* fmxas/chapter05/ *folder. You may want to use Test Movie to see how it works.*

This search-and-replace example, shown in figure 5-3, provides four text boxes. The upper-most text box, named *myinput*, provides the string that will be used as the basis for the search and replace. The word or phrase being searched for is associated with the text box named *find*, and the word or phrase used as the replacement is associated with the text box named *replace*. The lower-most text box, which is where the modified string will be output, is named

> **A Find and Replace Function**
>
> This example demonstrates a function that searches and replaces text. It is case sensitive.
>
> **Entry String:**
>
> The quick brown fox jumped over the lazy white dog.
>
> **Find:** the **Replace with:** a
>
> ⬇ Do it!
>
> **Output String:**
>
> The quick brown fox jumped over a lazy white dog.
>
> m&k

Figure 5-3. This example uses a generalized function to perform a search and replace on a string.

myout. The *myinput*, *find*, and *replace* text boxes are editable by the user.

If you begin by looking at the code-attached frame 1 of the *Global* layer, you will find the reference to the function that performs the search and replace, as shown in the following event method.

```
mybutton.onRelease = function() {
  myout = findAndReplace(myinput, find, replace);
};
```

As you can see, the results of the *findAndReplace()* function are automatically inserted into the *myout* variable (associated with the output field). Note that when the *findAndReplace()* function is called the values of the three other fields are passed to the function. The *findAndReplace()* function, shown in code example 5-5, is located above the prior event method.

Code Example 5-5: The findAndReplace() Function

```
function findAndReplace(input, findstr, replacestr) {
  if (findstr == replacestr) {
  return "Error! The Find and Replace strings are ¬
  the same!";
  } else {
  while (input.indexOf(findstr) != -1) {
    var index = input.indexOf(findstr);
    input = input.substring(0, index) + replacestr + ¬
    input.substring(index + findstr.length);
  }
    return input;
  }
}
```

In this code, you see that once the function is initiated it stores the data passed to it in three local variables: *input* (the original string), *findstr* (the find string), and *replacestr* (the replace string). The function begins by checking to make sure that the "find" (search) and "replace" strings are not equal. If they are, the user is prompted via the *output* text box. Assuming the find and replace strings are different, the function works on the replacement. One of the keys to this example is the condition used for the *while()* command. When doing the replacement, you simply want to keep searching the input string until there are no more instances of *findstr* in *input*.

Recall that *while()* will loop until its condition is no longer *true*. Also recall that the *indexOf()* string method will return –1 when it cannot find a search string in a string. Thus, you can use these two pieces of information to create a *while()* loop that will continue to replace instances of a search string until there are no more instances to replace (as in *while (input.indexOf(findstr)! = -1)*). The moment *findstr* is no longer found in *input*, the *while()* condition will evaluate as *false* and cease its loop.

NOTE: *Make sure you understand how the* while() *statement is working here. Because you are using a Boolean—checking for something not being equal to something else—it can sometimes be confusing. This is a frequently used technique in programming.*

Now that you have examined what makes the *while()* operate, let's look at what it does while *indexOf()* is not returning –1 (that is, while it is finding an instance of *findstr* in *input*). What you want to do is find the place where *findstr* begins, remove *findstr*, and insert *replacestr*. Thus, the first step is to find the point of insertion (or where *findstr* starts in *input*). You will then merge the front part of the string, the replace string, and then the last part of the string. In some programming languages there is a string method that will automatically perform a search and replace. Currently, Flash does not have a search-and-replace method. Therefore, you have to manually find, split, and the rejoin a string to execute a search and replace.

Let's begin with finding the point at which you need to "break" the string. That point will be where the first character of *findstr* occurs in *input*. Recall from earlier in this chapter that if *indexOf()* finds an instance of *findstr* in *input* it returns the string index number where *findstr* begins. For example, if *input* contained "the dog is lazy" and *findstr* was "dog," the statement *input.indexOf(findstr)* would return 4 because the *d* in dog (in *findstr*) occurs at string index position 4 in *input*. Thus, the insertion point for *replacestr* is found by using *var index = input.indexOf(findstr)*.

Once the insertion point is found, it is used in the subsequent line of code to modify the text in *input*. It creates the new string by concatenating the substring from the beginning of the string to the insertion point (*input.substring(0, index)*), the text in *replacestr*, and the end of the string in *input* from the last character in *findstr* to the end of the string (*input.substring(index + findstr.length)*). Remember that if provided only one argument, the *substring()* method will return the portion of the string from that character index to the end of the string. Thus, when *index + findstr.length* is used in *substring()*, the tail end of the string excluding *findstr* is returned.

Once the first occurrence of *findstr* has been replaced, the *while()* statement continues examining input for occurrences of *findstr*. When no more are available (when *input.indexOf(findstr)! = -1* evaluates as *false*), the final content of *input* is returned to where the function was called. In this case, the content of *input* is passed to *myout*. Note that at the very beginning of the *findAndReplace()* function you prompted the user that there is an error if *findstr* and *replacestr* were equal. Having now looked at the function, note that if you allowed the user to execute the function

with *findstr* equal to *replacestr*, because of the way you are executing the replacement, the *while()* would loop infinitely.

This example is case sensitive. If you use the default sentence ("The quick brown fox jumped over the lazy white dog"), the beginning *The* will not be replaced if the *findstr* is *the* (i.e., due to capitalization). You could make the function case insensitive by using *toLowerCase()* on the *findstr* variable and within the *findAndReplace()* function. You would need to edit the first line in the *while()* statement to *var index = input. toLowerCase() .indexOf(findstr)*. Here, the methods are appended to each other and operate from left to right (that is, input is converted to lowercase and then the *indexOf()* method is executed). Compounding methods does not always work, but here it does. If you want to compound methods, give it a try. You can often shorten your code by employing this technique.

Making a String Proper Case

As stated previously, the String object provides the ability to make an entire string uppercase or lowercase. There may be times when you want to have a string in which the beginning of every word is capitalized (often called *proper case*). As such, this example builds upon the last and shows a function that converts a string to proper case.

CD-ROM NOTE: *The example discussed in this section can be found on the companion CD-ROM. The file is named ch05_04.fla and is located in the* fmxas/chapter05/ *folder. You may want to use Test Movie to see how it works.*

Figure 5-4 shows the example you will be looking at. The file has two text boxes that are used. The upper text box uses the Input text type (as set in the Properties panel) and is named *myinput*. The lower text box uses the Dynamic text type and is named *myoutput*.

As with previous examples, the first thing to look at is the event method associated with the button, as shown in the following.

Changing a String to Propercase

This example demonstrates a function that converts a string to propercase.

Entry String:

The quick brown fox jumped over the lazy white dog.

Convert to propercase

Output String:

The Quick Brown Fox Jumped Over The Lazy White Dog.

m&k

Figure 5-4. A function can be written to convert a string to proper case.

All of the code is located in frame 1 of the *Global* layer.

```
mybutton.onRelease = function() {
  myoutput = propcase(0, myinput);
};
```

The function that does the conversion is called *propcase()*, which receives two values: the numerical value 0 (explained in material to follow) and the current text in the input text box (in the variable *myinput*). The *propcase()* function is shown in code example 5-6.

Code Example 5-6: The propcase() Function

```
function propcase(space, input) {
  input = capword(space, input);
  while (space != -1) {
  space = input.indexOf(" ", space+1);
  input = capword(space+1, input);
  }
  return input;
  function capword(index, mystring) {
      return mystring.substring(0, index) + ¬
      mystring.charAt(index).toUpperCase() + ¬
      mystring.substring(index+1);
  }
}
```

In this code, the data the *propcase()* function receives is inserted into two local variables, *space* and *input*. To capitalize the first letter of each word in the string, you will search for the space character that occurs between the words in the string and then capitalize the very next character. Thus, the *space* variable is used to find the index position of each space from the beginning of the string *input* to its end. Then the letter following each space will be capitalized using the embedded function *capword()*.

In examining this code, ignore for a moment the first line of the *propcase()* function (that is, *input = capword(space, input)*). Focus your attention on the *while()* loop itself. Like the last example, the condition for the *while()* loop is "while *space* is not equal to −1" (i.e., while *space! = -1* is *true*). As long as there is a subsequent space character found (*space* is constantly updated within the *while()* loop), space will not be equal to −1 and the statements in the *while()* loop will continue to execute.

Let's look at what happens inside the *while()* loop. Basically, it searches for a space character in *input* (using *indexOf()*). It does this by search-

ing from the last value in *space* plus 1. The first line in the *while()* loop finds the next space. The second line then uses the new value in the *space* variable to capitalize the next character. The variable *input* is set equal to the data returned from the embedded function *capword()*. When *capword()* is called, it is sent the position of the character to be capitalized (*space + 1*) and the current value in the string *input*.

The final aspect of the proper-case conversion is to look at the *capword()* function. It is really not that much different than the concatenation line used in the *findAndReplace()* function of the previous example. The string it receives is split into two pieces, using *substring())* at the point of capitalization and then reassembling around the capitalized letter (using *charAt()* and *toUpperCase()*). The uncapitalized letter is omitted due to the use of *index + 1* in the last piece of the concatenation (*mystring.substring(index + 1)*).

 NOTE: *See what happens if you modify the last part of the concatenation in the* capword() *function, so that it says* index *instead of* index + 1.

Let's return to the line intentionally skipped (*input = capword(space, input)*). Omitting this line creates a problem. The very first word in the string will not be capitalized. Thus, the first line in the function capitalizes the very first word. Recall that when the *propcase()* function is called, you send it a starting value of 0 for the *space* variable. Therefore, the first line in *propcase()* modifies the string in *input*, by calling *capword()* and passing the current value of *space* and *input* to it. Because the value of space is 0 when the first line is encountered, the very first word in the string is capitalized.

 NOTE: *See what happens if you comment out the first line in the* capword() *function.*

 CD-ROM NOTE: *This example provides a good opportunity to use recursion. To see a recursive example of the proper-case conversion, open the file* ch05_05.fla, *located in the* fmxas/chapter05/ *folder on the companion CD-ROM. Compare the file to* ch05_04.fla *to see the difference.*

Reversing Character Order

Another relatively simple example is the ability to reverse the character order of a particular string. Again, some languages provide this capability via a built-in method associated with the String object. Unfortunately, Flash does not. In the following example you will see a general function that will reverse the characters in a string.

 CD-ROM NOTE: *The example discussed in this section can be found on the companion CD-ROM. The file is named* ch05_06.fla *and is located in the* fmxas/chapter05/ *folder. You may want to use Test Movie to see how it works.*

As shown in figure 5-5, this example again provides two text boxes, named *myinput* and *myoutput*. An event method for the button calls a function named *reversechar()*, which is located in frame 1 in the *Global* layer.

> **Reversing the Content of a String**
>
> This example demonstrates a function that reverses the character order of a string.
>
> **Entry String:**
>
> The quick brown fox jumped over the lazy white dog.
>
> 🔽 **Reverse Characters**
>
> **Output String:**
>
> .god etihw yzal eht revo depmuj xof nworb kciuq ehT
>
> m&k

If you examine the code in frame 1 of the *Global* layer, you will find that the function for reversing the characters in a string is relatively simple. The code for the function is shown in code example 5-7.

Figure 5-5. In this example a general function is used to reverse the character order of a string.

Code Example 5-7: The **reversechar()** *Function*

```
function reversechar(input) {
  var myout = "";
  for (var i = input.length-1; i>=0; i--) {
    myout += input.charAt(i);
  }
  return myout;
}
```

The heart of the character reversal is the *for* loop in the center of the previous code. In essence, the *for* loop progresses backward (decrements) and pulls characters from the end of the string *input* using the *charAt()* method. Note that each character is appended to the end of the content stored in the local variable *myout*, using the addition and assignment operator (+ =). Once the results have been assembled within the *myout* variable, the variable itself is returned.

Note that the first line appears to have no relevance, but it is important. Because the addition and assignment operator is used inside the *for* loop, each time the *reversechar()* function is called, the *myout* variable must be local. If it were a timeline variable, each subsequent call to the *reversechar()* function would begin appending characters to the end of the content already in the *myout* variable.

 NOTE: *Try commenting out the line that says* var output = "" *and use Test Movie to see the results. What happens and why?*

 CD-ROM NOTE: *As with the preceding example, this example provides another opportunity to examine recursion. To see a recursive example of the file, open the file* ch05_07.fla *located in the* fmxas/chapter05/ *folder on the companion CD-ROM. Compare the file to* ch05_06.fla *to see the difference.*

Removing End Spaces

This section on parsing closes with an examination of two more examples that focus on removing spaces from strings. This process is similar to functionality in the proper-case example. Recall that in that process a lowercase letter was replaced by a capital letter using deletion. Here, you will see how to remove beginning and trailing spaces. In the next section, you will see how to remove all spaces in a string. For brevity, these examples focus on the functions themselves, as the remainder of the items in the movie should be self-explanatory at this point.

 CD-ROM NOTE: *The example discussed in this section can be found on the companion CD-ROM. The file is named* ch05_08.fla *and is located in the* fmxas/chapter05/ *folder. You may want to use Test Movie to see how it works.*

Access frame 1 of the *Global* layer, which will reveal the *removespaces()* function, shown in code example 5-8.

Code Example 5-8: The **removespaces()** *Function*

```
function removespaces(input) {
 while (input.indexOf(" ") == 0) {
   input = input.substring(1);
 }
 while (input.lastIndexOf(" ") == input.length-1) {
   input = input.slice(0, input.length-1);
 }
 return input;
}
```

In this code, the process of removing spaces at the beginning and end of a string is performed by two separate *while()* commands. The first deals with the spaces at the beginning of the string. It removes them by continually "chopping off" the first character (*input = input.substring(1)*) as long as the first character is a space (*input.indexOf(" ") = = 0*). In a similar manner, the second *while()* command "slices off" the last character (*input = input.slice(0, input.length-1)*) as long as the last character is a space (*input.lastIndexOf(" ") = = input.length-1*). Once any spaces at the beginning or end of the string have been removed, the remaining value in the local variable *input* is returned to where the function was called.

 CD-ROM NOTE: *This example can be extended to remove all spaces in a string by adding a straightforward for loop to the function. To see how, open the example file* ch05_09.fla *located in the* fmxas/chapter05/ *folder on the companion CD-ROM. The code is commented to explain what it does.*

Basic Form Validation Elements

One of the keys to creating effective applications that use string data is field validation, often called form validation. In essence, when you write functions based on data the user enters, you cannot assume that the user will always enter the data you think she should. So that your functions are not executed with erroneous data entered by the user, you must always integrate validation when you present the end user with a field. The following section describes some basic validation methods, most of which are based on evaluating the data contained in a variable.

There are generally two aspects to utilizing form validation. The first is the code that actually checks the user's input, and the second is the event, which causes the validation code to execute. In this section, you will examine the former. In the next chapter, you will apply what you learn here by attaching the scripting explored here to events. In this way you will be able to see how form validation works in applied examples.

Checking for Empty Fields

The foremost thing you must check for when trying to utilize data from an input field is whether or not the user has actually entered data. Once you know that the user has entered data, you can use various validation functions to see if it is a number, word, or other type of user input you were expecting. As it relates to empty fields, in Flash you do not have a method that does this automatically. You must therefore manually check the field to see if the user actually entered any data. Usually what you want to do is make sure the user did not enter a space or no value at all. However,

this is a little trickier than it sounds, due to the way input text variables are created behind the scenes.

As you know, when you set a text element to Input (text type) in the Properties Options panel, a variable is used to contain the text for that field. The thing you must keep in mind is that the variable associated with the field does not exist in the environment until there is data within it. If you traced a variable name associated with an Input text box that contained no value, *undefined* would be returned, meaning that the variable does not exist in the environment.

As such, if you create a field for the user to enter data into, and it has no starting value, there is no way to find out whether the user has entered anything (i.e., because the variable is not created unless there is a starting value for the field). Thus, rule number one when working with input fields is to make sure the field has a default starting value. Otherwise, you will not be able to determine if the user has entered anything in the field.

Given that you follow the rule concerning starting values for input fields, detecting whether a value has been entered is pretty easy. Generally you will examine the field to see if it contains no data (that is, a null string, identified by "") or if it contains only space characters. To determine if a field is "empty" when you are expecting nonnumerical data, you could use a function such as that shown in code example 5-9. If the data sent to the function is empty, the function returns *true* (the data is a null or an empty value). Otherwise, it returns *false*.

 NOTE: *For this example, you could also check to see if the value returned was* undefined, *which would signify the same thing performed via code example 5-9. However, it is preferable to check for empty strings to signify empty fields, as opposed to undefined— predominantly because most fields have to be evaluated for individual space characters anyway.*

Code Example 5-9: The **empty()** *Function*

```
function empty(mytext) {
  if (mytext != "") {
    var temp = true;
  for (var i = 0; i<mytext.length; i++) {
   if (mytext.charAt(i) != " ") {
   temp = false;
   break;
   }
 }
```

```
return temp;
} else {
return true;
}
}
```

This function begins by making sure that the value in the variable *mytext* is not a null string. Assuming it is not, it looks through the variable *mytext* to determine if a character other than a space can be found. Note that when it is searching for a character it assumes the variable is empty (*mytemp = false*) until it finds something other than a space character in the variable *text*.

Although rudimentary, this function performs the basic analysis of whether a variable associated with an input field is empty or not. By adding to the innermost *if* statement and using logical operators, you can customize this function to ignore other non word-forming characters, such as mathematical operators. You could also have it ignore numerical values by using the *isNaN()* method, described in the next section.

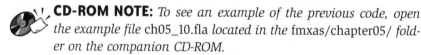 **CD-ROM NOTE:** *To see an example of the previous code, open the example file* ch05_10.fla *located in the* fmxas/chapter05/ *folder on the companion CD-ROM.*

Keep in mind when you are checking for a null string that there must be a starting value in the input text for it to work. If the field is *undefined* from the start, the function described in this section will not work because there is no way to determine if the user entered anything; that is, because the variable associated with the input field was never created and is thus *undefined*.

Is It a Number?

Determining whether an entry is a number is a little easier due to the *isNaN()* method. This method receives a value and then returns *true* if the supplied value is not a number (NaN) and *false* if the value is a number.

 CD-ROM NOTE: *To see an example, open the example file* ch05_11.fla *located in the* fmxas/chapter05/ *folder on the companion CD-ROM.*

Positive or Negative Numbers

In addition to determining whether an entry is a number, you may wish to determine if the entry is a positive or negative integer. The function

shown in code example 5-10 determines if the entry is an integer, and then whether it is positive or negative.

Code Example 5-10: The whatis() Function

```
function whatis(mytext) {
  if (isNaN(mytext) != true) {
    if (mytext.charAt(0) == "-") {
      return 1;
    } else {
      return 2;
    }
  } else {
    return 3;
  }
}
```

 CD-ROM NOTE: *To see an example, open the example file* ch05_12.fla *located in the* fmxas/chapter05/ *folder on the companion CD-ROM.*

Extended Examples

In the previous section you saw a few basic examples of parsing or string-related functions. Now let's turn to two final examples that show string-related manipulation in context.

Making Arrays from Strings

One of the things that is indeed important to know is how to dynamically generate arrays. Although the following example may seem trivial, it is actually quite important because the technique is used in many of the emerging Internet-based game sites across the Web. The fundamental idea is to be able to receive two strings and convert one to an array name and the other to the values in the array. This allows you to extend Flash by utilizing other technologies. The fundamental idea of this example was to use ASP to determine the files that exist in a directory and inform Flash of those files so that they could be used to dynamically generate an array. The array became a listing of movies that Flash could load. The file you will be examining is shown in figure 5-6.

 CD-ROM NOTE: *Open the file* ch05_13.fla *located in the* fmxas/chapter05/ *folder on the companion CD-ROM. Use Test Movie to see how it works.*

Creating an Array from a String

This little example shows how to take a string for an array name and a string of values and make them into an array.

Array Name: `myarray`

Item 1: `potatoes`
Item 2: `tomatoes`
Item 3: `beans`
Item 4: `corn`
Item 5: `sprouts`

Create Array

Output:

```
The array myarray has been
built.
It contains:
myarray0=potatoes
myarray1=tomatoes
myarray2=beans
myarray3=corn
myarray4=sprouts
```

m&k

Figure 5-6. This example demonstrates how to dynamically generate an array based on two strings.

The first things you will notice in this example are the fields. The first field will be used as the array's name, whereas the remaining fields will be used as the values in the array. Access the actions in frame 1 of the *Global* layer and scroll to the bottom to examine the event method associated with the Create Array button (instance name *mybutton*). The event method is shown in code example 5-11.

Code Example 5-11: The Event Method for the Button

```
mybutton.onRelease = function() {
  buildArray(arrayname, String.fromCharCode(34) + item1 ¬
String.fromCharCode(34) + String.fromCharCode(44) + ¬
String.fromCharCode(34) + item2 + String.fromCharCode(34) ¬
+ String.fromCharCode(44) + String.fromCharCode(34) + ¬
item3+String.fromCharCode(34) + String.fromCharCode(44) ¬
+ String.fromCharCode(34) + item4 + ¬
String.fromCharCode(34) + String.fromCharCode(44) + ¬
String.fromCharCode(34) + item5);
};
```

In this code, you see that the function *buildArray()* is called and is sent two pieces of information. The first is the value in the variable *arrayname*. This will become the name of the array that is generated. The second part, consisting of the very long concatenated string, takes all values of the remaining variables and combines them with quote marks

(*String.fromCharCode(34)*) and commas (*String.fromCharCode(44)*). What this is essentially doing is simulating what you would get if data were actually coming from ASP, JSP, or some other server-side technology. Now let's examine the *buildArray()* function, shown in code example 5-12.

Code Example 5-12: The buildArray() Function

```
function buildArray(arrayname, mystring) {
  var temp = 1;
  var temp2 = "";
  var temp3 = 0;
  for (var i = 0; i<mystring.length; i++) {
    temp2 = mystring.charAt(i);
    if (temp2 != String.fromCharCode(44) && temp2 != ¬
    String.fromCharCode(34)) {
      set("myvar"+temp, eval("myvar"+temp)+temp2);
    } else if (temp2 == String.fromCharCode(44)) {
      temp++;
    }
  }
  set(arrayname, new Array());
  for (var j = 0; j<=temp; j++) {
    temp3 = j+1;
    eval(arrayname)[j] = eval("myvar"+temp3);
  }
  for (var k = 0; k<=temp; k++) {
    temp3 = k+1;
    delete eval("myvar"+temp3);
  }
  output = "The array "+arrayname+" has been built.\n";
  output += "It contains:\n";
  output += arrayname+"0="+eval(arrayname)[0]+"\n";
  output += arrayname+"1="+eval(arrayname)[1]+"\n";
  output += arrayname+"2="+eval(arrayname)[2]+"\n";
  output += arrayname+"3="+eval(arrayname)[3]+"\n";
  output += arrayname+"4="+eval(arrayname)[4]+"\n";
}
```

There are four major sections to this code. Like most scripts, it begins with an initialization of local variables to be used. Following this, the first major *for* loop parses the string that will be used for the array values.

Using the comma as a separator, it places each array value in a variable called *myvar1*, *myvar2*, and so on. The number at the end of *myvar* is based on the temporary variable *temp*. The number of *myvar* variables will fluctuate depending on the number of entries in the string sent to the function. The second major portion of this code takes the *myvar* variables generated in the first part and inserts them into the array. The name of the array is based on the local variable *arrayname*. Pay particular attention to the following line.

```
eval(arrayname)[j] = eval("myvar"+temp3);
```

Recall from Chapter 3 how you dynamically name an array's entries (the direct method) using *eval()*. For the entire function to work, knowing how to use the *eval()* method is critical. Once this center section of code is completed, the dynamically generated array and its values are defined in memory.

The last *for* loop in this code is for cleanup. In the first *for* loop, you create a series of *myvar* variables. In the last section, you delete them so that unused variables are not floating around in memory. You may wonder why the *var* keyword is not used when the *myvar* variables are created. This is because you cannot precede *eval()* with *var*. For example, the following line of code will generate an error.

```
var eval("myvar"+temp)
```

 NOTE: *The* set() *method can be made to create global or timeline variables, but not local variables.*

Thus, the only option is to create the variables dynamically as timeline variables and then delete them. The last part of the code is for display purposes only. It outputs the name of the array and its value to the text box.

Incrementing and Limiting Data in Fields

The following final example makes use of a file you looked at in the last chapter. Figure 5-7 shows the example, which involves incrementing and limiting data in fields.

 CD-ROM NOTE: *Open the file ch05_14.fla located in the fmxas/chapter05/ folder on the companion CD-ROM. Use Test Movie to see how it works. In this example, you will look at the code that increments the numbers in the fields when you click on the Up and Down arrow buttons.*

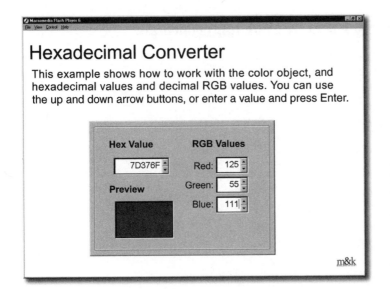

Figure 5-7. This example demonstrates how to increment and limit data in input text boxes.

Decimal-based Incrementing

As you will recall, the Hexadecimal Converter allows you to compare values and the color of those values, between RGB and hexadecimal. This section explores the scripting associated with the Up and Down arrow buttons next to each field. The incrementing and limiting of values (represented functionally by these buttons) requires the use of String and Number methods. Because two different numbering systems are used for each field (decimal for RGB and hexadecimal for the Hexadecimal field), there are two main scripts used to limit and increment the fields. Incrementing decimal numbers is quite easy, and therefore that is explored first.

If you double click on any of the movie clips that contain the fields (to the right of the Static text objects *Red*, *Green*, or *Blue*), you will be able to click on either the Up or Down arrow in that movie clip to reveal its actions. If you do so, you will see that all of the arrows associated with the Red, Green, and Blue fields call the *modrgb()* function and pass two arguments to the function.

In all cases (regardless of the field or the type of arrow), the name of the parent movie clip is passed to the function so that the function knows which field needs to be changed (Red, Green, or Blue). The second argument describes whether the Up or Down arrow was pressed. If it is an Up arrow, it passes the string *"inc"* (for increment). If it is a Down arrow, it passes the string *"dec"* (for decrement). Let's examine the *modrgb()* function. Click in frame 1 of the *Global* layer in the main movie timeline and scroll down until you find the *modrgb()* function. The code for this function is shown in code example 5-13.

Code Example 5-13: The modrgb() Function

```
1 function modrgb(which, type) {
2   if (eval("_root.my"+which) != "ERR" && ¬
isNaN(eval("_root.my"+which)) == false) {
3   if (type == "inc" && ¬
Number(eval("_root.my"+which))+1<=255) {
4     set("_root.my"+which, ¬
Number(eval("_root.my"+which))+1);
5   } else if (type == "dec" && ¬
Number(eval("_root.my"+which))-1>=0) {
6     set("_root.my"+which, ¬
Number(eval("_root.my"+which))-1);
7   }
8   } else {
9   set("_root.my"+which, "0");
10  }
11 }
```

 NOTE: *Line numbers have been added to the previous code for reference purposes.*

Let's examine this code. When you tested this movie, you might have noticed that you can actually enter data into the fields with the keyboard, as opposed to using the Up and Down arrows. The details of how this is done are explored in the next chapter. For purposes here, suffice it to say that line 2 of the previous code ensures that the field contains numerical data only, which is applicable only if the user enters data and then presses one of the arrow keys before pressing the Enter key.

Line 3 is the starting point of an examination of limiting and incrementing. In line 3, if the user has clicked on the Up arrow and the current value of the field plus 1 is less than 255 (which is the upper limit for the field), you want to increment the value in the field. Line 4 increments the value in the field. Note that *set()* is used here because *eval()* can no longer be used on the left side of the equals sign. This is what makes the function work, independent of whether it is dealing with the Red, Green, or Blue field value.

 NOTE: *The fact that you could use eval() on variable names on the left side of an equation was a misnomer in Flash 5. This ability actually conflicted with the EMCA-262 standard. Although it may be frustrating to get used to, this change is in line with the*

ECMA-262 standard and can be easily accommodated using the
set() *method.*

Also note that when the value is incremented (as in
Number(eval("_root.my" + which)) + 1), the *Number()* method is used on
the value from the field to make sure the retrieved value is a number and
not a string. When you pull a value from an input text field variable and
you want to perform a mathematical operation on it, it is good practice to
use the *Number()* method on the value to make sure you do not acciden-
tally end up with a concatenated string instead of a resulting mathemati-
cal value. Lines 5 and 6 work very much like lines 3 and 4. The only dif-
ference is that lines 5 and 6 are checking for the lower limit of 0, the least
value that can be used within the Red, Green, or Blue field.

 NOTE: *Anytime you are working with input text boxes and you
want to perform a mathematical operation of the value entered by
the user, make sure you use the* Number() *method on the retrieved
value.*

Hexadecimal-based Incrementing

As you saw in the last example, setting up the increment and limit for the
decimal fields was relatively painless. Now let's turn our attention to deal-
ing with the hexadecimal (Hex Value) field, which is a little more involved.
The thing that makes the hexadecimal increment more difficult is the fact
that the numbers must vary from 0 to 9 and A to F. To increment this six-
teen-digit value requires more effort and thought. In the following exam-
ple, you will again rely on an array to look up the hexadecimal values
based on decimal values, as in Chapter 2.

As for the Up and Down arrows associated with the Hex Value field
(see figure 5-7), you will find that like the Red, Green, and Blue fields the
arrows call a function located in the *Global* layer. The function that han-
dles this is called *dohex()*. Access frame 1 of the *Global* layer and find the
dohex() function. You will notice that this is an extremely long function
due to the series of nested *if* statements. As such, to begin with you will
deal with only the first half of the function, which follows.

Code Example 5-14: The First Half of the dohex() *Function*

```
1  function dohex(type) {
2    if (myhex != "ERR") {
3      var char0, char1, char2, char3, char4, char5;
4      for (var i = 0; i<=myhex.length-1; i++) {
5        set("char"+i, myhex.charAt(i));
```

```
6   }
7   if (type == "increment") {
8    var temp5 = returnindex(char5, hexarray);
9    temp5 += 1;
10   if (temp5 != 16) {
11    char5 = hexarray[temp5];
12   } else {
13    char5 = "0";
14    var temp4 = returnindex(char4, hexarray);
15    temp4 += 1;
16    if (temp4 != 16) {
17      char4 = hexarray[temp4];
18    } else {
19      char4 = "0";
20      var temp3 = returnindex(char3, hexarray);
21      temp3 += 1;
22      if (temp3 != 16) {
23       char3 = hexarray[temp3];
24      } else {
25       char3 = "0";
26    var temp2 = returnindex(char2, hexarray);
27    temp2 += 1;
28    if (temp2 != 16) {
29      char2 = hexarray[temp2];
30    } else {
31      char2 = "0";
32      var temp1 = returnindex(char1, hexarray);
33      temp1 += 1;
34      if (temp1 != 16) {
35       char1 = hexarray[temp1];
36      } else {
37       char1 = "0";
38       var temp0 = returnindex(char0, hexarray);
39    temp0 += 1;
40    if (temp0 != 16) {
41       char0 = hexarray[temp0];
42    } else {
43       for (var i = 0; i<=5; i++) {
44        set("char"+i, "F");
45       }
46       }
```

```
47      }
48       }
49      }
50      }
51     }
. . .
```

Like the function for the Red, Green, and Blue fields, line 1 of this code is designed to make sure that what the user has entered is a valid hexadecimal value. Recall that it is only applicable if the user enters a value and clicks on the Up or Down arrow before pressing the Enter key. Because the hexadecimal digits must be incremented individually (that is, each digit incremented separately because you cannot simply count from 000000 to FFFFFF by "adding 1 to it"), lines 3 through 6 take the values at each position in the six-digit hex value and place them into separate local variables called *char0, char1*, and so on. The variable *char5* is the furthest digit to the right, and *char0* is the furthest digit to the left.

The remainder of the code is designed to increment the Hex Value field. If indeed the user pressed the Up arrow button to increment the value (line 7), you begin figuring out what the hex value should be, starting with *char5*, the digit (and smallest placeholder) furthest to the left. Line 8 finds the index position of the value in *char5* in the array *hexarray* and places it in a temporary variable called *temp5*. Remember that the *hexarray* variable is an array that matches the hex representation (the array values) with the decimal representation (represented by the array indices). The *returnindex()* function finds the current index position of the value sent to it (the first argument) in the array provided it (the second argument). If you forget how this works, you may want to revisit chapters 3 and 4.

Once the current decimal representation of the first digit (*temp5*) is obtained, line 9 increments it. Line 10 is where the logic part comes in. If, after incrementing *temp5*, you find that *temp5* does not equal 16 (that is, *temp5* is still referencing a valid hexadecimal digit, 0-9, A-F), you look up the new value of *temp5* in *hexarray* and set *char5* to it (line 11). However, if *temp5* is equal to 16, you know before incrementing it (line 9) that it was already at F (the highest value for any hex digit). Thus, if *temp5 = 16*, you need to reset the value in the first digit (*char5*) to 0 and go to the second digit and increment it by 1. Lines 13 through 15 do just that.

From line 13 to line 39, the process of incrementing each character (from left to right) based on the adjacent value to the right repeats. When you get to the last character, *char0*, you terminate this recurrent logic. If *char0* is found to already be at the hex value of F (line 42), you use a *for*

loop to set the value of all *char* variables to F. This prohibits the user from trying to increment beyond FFFFFF.

If you return to the rest of the code in the *dohex()* function, you will find that decrementing the hexadecimal counter works in very much the same way as incrementing, except that when checking the value following the decrement you look for –1. Given the previous explanation, you should be able to decipher this part of the code. However, note the line that takes all *char* variables, regardless of whether they have been incremented or decremented, and puts them back together to form the hexadecimal value. The line that does this follows.

```
myhex = String(char0) + String(char1) + String(char2) + ¬
String(char3) + String(char4) + String(char5);
```

In this code, note that the *String()* method is used on each of the *char* variables because they are being concatenated. This is done because otherwise the variables would be mathematically added (when the *char* variables contain numbers) and sometimes concatenated. By forcibly using the *String()* method, you ensure that these are concatenated all of the time.

Hexadecimal Recursion

In the previous example, you saw how you could use ActionScript code to increment and decrement the hexadecimal value. Recall the very lengthy series of nested *if* statements that were used. In the final example for this chapter, you will return to the previous example and replace the lengthy *if* statements with much more efficient code. To do so, you will use recursion.

 TIP: *As you begin working with recursion, or even writing your own recursive functions, try writing out the code in long form and then replacing it with a recursive function (as you are doing here). One of the best ways to write a recursive function is to begin writing it out and then "reverse engineering" the recursive function.*

 CD-ROM NOTE: *Open the file ch05_15.fla located in the fmxas/chapter05/ folder on the companion CD-ROM. You will find that the lengthy if statements in the dohex() function have been replaced with recursive functions.*

Once you have the file *ch05_15.fla* open, return to the scripting attached in frame 1 of the *Global* layer. Let's begin by looking at the modified *dohex()* function, shown in code example 5-15.

Code Example 5-15: The Revised dohex() *Function*

```
function dohex (type) {
 if (myhex != "ERR") {
 char0, char1, char2, char3, char4, char5;
 for (var i = 0; i<=myhex.length-1; i++) {
  set("char"+i, myhex.charAt(i));
 }
 if (type == "increment") {
  myhex = recurseinc(5);
 } else {
  myhex = recursedec(5);
 }
 myhex = String(char0) + String(char1) + ¬
 String(char2) + String(char3) + String(char4) ¬
 + String(char5);
 } else {
   myhex = "000000";
 }
 for (var i=0; i<6; i++) {
   delete eval("char"+i);
   delete eval("temp"+i);
 }
}
```

In this code you will note that the large *if* statements have been replaced by calls to recursive functions that are a little farther down in the script. Note in both cases that the value 5 is sent to both recursive scripts. You will also note that the following *for* loop has been added.

```
for (var i=0; i<6; i++) {
 delete eval("char"+i);
 delete eval("temp"+i);
}
```

When using the recursive functions, two sets of global variables are created. One set (char0, char1, and so on) is created in the function shown previously, whereas the other is generated within the recursive functions (temp0, temp1, and so on). Because there are three functions involved in this process (the dohex() function and the two recursive functions), the data for each digit of the hex value must be stored globally so that all three functions can access the data. You could pass them as arguments from one

function to another, but it is easier to create "temporary global variables" that can be used while recursively incrementing or decrementing the values. These are then simply deleted.

In a similar manner, the series of *temp* variables created in the recursive functions are also required. What these do is explained following discussion of the recursive functions, the first of which follows. The code for the recursive "incrementer" is shown in code example 5-16.

Code Example 5-16: The Recursive "Incrementer"

```
1 function recurseinc (z) {
2   set("temp"+z, returnindex(eval("char"+z), hexarray));
3   set("temp"+z, eval("temp"+z)+1);
4   if (eval("temp"+z) != 16) {
5     set("char"+z, hexarray[eval("temp"+z)]);
6   } else {
7     if (z != 0) {
8       set("char"+z, "0");
9       recurseinc(z-1);
10    } else {
11      for (var i = 0; i<=5; i++) {
12        set("char"+i, "F");
13      }
14    }
15  }
16 }
```

Although this code may look complex, given the previous example (in which you saw the nested *if* statements), it should look relatively familiar. Note that in line 1 the value sent to the function (5 in both cases) is put into the variable z. This value will be used to make the function recur, and is the value used in the base case. As for the guts of the function, in line 2 you obtain (using the *returnindex()* function) the decimal representation of the current digit's hex value, just as you did in using the lengthy *if* statements. In like manner, once you have the decimal value, you increment it (line 3) and then check to see if the incremented decimal value is 16 (line 4). If the incremented decimal value is not 16 (that is, the hex digit is still below its maximum value of F), you place the new hex value into the appropriate *char* variable.

If you find that the returned decimal value from line 2 is 16 (that is, the hex digit was already at its maximum value of F before you incremented, in line 3, the value), you check to see if you are working with the

leftmost digit. If you are not, you must reset the current hex value to 0 and increment the next left-hand digit. Line 8 resets the current hex digit to zero, whereas line 9 restarts the prior process with the next left-hand digit by recursively handling the function with *z-1*. You could say that *z* is basically the variable that represents which of the hex digits you are working on at any given time. If *z* equals 5, because you are in the first iteration of this function you know that you are working with the rightmost digit. If *z* equals 0, you are working with the leftmost digit.

As you can see, the recursive function will continue to repeat itself until at some iteration *z* equals 0 (the point at which the leftmost digit is F and you can increment no more). When this is true, lines 11 through 13 will be encountered. At that point, the recursive function will reset all *char* values to F and the counter will not increment any higher. Let's examine in the previous code what the series of *temp* variables does. In the nonrecursive version of this script, recall that the *temp* variables (as well as the *char* variables) were created. You know that the *char* variables are timeline in this case and that you therefore do not have to pass the data in them as arguments as you go back and forth between the *dohex()* function and the two recursive functions. That is, by making them timeline, you do not have to pass so many arguments between functions.

Concerning the *temp* variables, each time a new instance of the *recurseinc()* function is initiated, if the series of *temp* variables were created local to each instance of the function, only the first instance of the *temp* variable would be "trackable." This is because each *temp* variable would be owned by the respective function that generated it. Each time each subsequent function ceased to exist, so would its *temp* variable. Thus, the *temp* variables must be timeline (they could also be global) so that they are not deleted when each instance of the function is deleted. Yet, because you do not use the *temp* (or *char*) variables beyond the *dohex()* function, you delete them at the end of the *dohex()* function so that you do not have unused variables floating around in memory.

You may wish to continue your examination of the example by looking at the *recursedec()* function. It follows a process similar to that of the *recurseinc()* function. The only difference you will find is in lines 3 and 4 of the previous code. In the *recursedec()* function, you subtract 1 instead of adding 1 (line 3), and you check for a value of –1 (line 4) instead of 16.

■ ■ ■ Summary

In this chapter you have examined the fundamentals of the String, Number, Boolean, and Date objects. Although typically used as utility objects (that is, objects that assist with more complex creations), the pri-

mary focus in this chapter has been to familiarize you with how these objects work. You have also examined examples that demonstrate more advanced operations you can perform using these objects. The next chapter builds on what you know about data manipulation and focuses on controlling user input via the keyboard and mouse.

6

User Input and Interaction

▪▪▪ **Introduction**

Being able to manipulate user-supplied data in a Flash movie is a key to being able to create web sites that are more than just animations. The process of receiving user input and putting it to work is twofold. One part is being able to manipulate that data in its various forms. That is what Chapter 5 was all about. The other part of this process is the event that causes data to be captured or that spawns the processing of data, which is the focus of this chapter.

Being able to control the mouse and keyboard is important when you are attempting to create Flash applications in which you expect the user to interact. Granted, at this point, Flash is still relatively immature compared to other applications in regard to overall development. You will find, for example, that control of the mouse is somewhat basic compared to applications such as Director, because the Mouse object provides just two basic methods for hiding and showing the mouse. Nevertheless, the basic mouse-control capability is there, and we will undoubtedly see much improvement of mouse and keyboard features in future versions.

▪▪▪ **Objectives**

In this chapter you will:

- Find out about listeners and how they can be used
- Learn to use the Mouse object and its related methods to control the cursor on the screen

- Learn to use the Key object to detect specific keys and the state of those keys

- Find out about the Selection object and how you can use it to make and control text selections

- Discover the Button object and how it differs from buttons in Flash 5

∎ ∎ ∎ Understanding Listeners in Flash MX

As you know, several objects in Flash can generate events; that is, when the user interacts with the object, an event message is sent out into the environment. If code is established for the object and the event, something happens in the environment. However, until Flash MX, you were somewhat limited in what you could do and where you could do it. If you wanted several movie clips to respond simultaneously to a certain event, you had to attach code to each one—often creating redundant code on a series of objects. Similarly, creating global responses to events, independent of other things in the environment, required peculiar workarounds and sometimes lengthy or complex code snippets.

Listeners provide a lot of flexibility and a more straightforward approach to coding events in Flash, allowing to you centralize your code. Listeners allow you to enable objects so that they become aware of (or "listen for") events that occur in the environment. They even allow objects to listen for events those objects would not commonly respond to or be aware of. Listeners allow you to communicate one-to-one (where only a single object responds to another object's events) or one-to-many (where several objects respond to the same occurrence of an event). The single greatest advantage of using listeners in Flash is the effect they have on code location. With them you can make code management easier by keeping all event-handling code in one or two locations in the movie, as opposed to attaching code to myriad objects in the environment.

Listeners are in actuality a carryover from other languages, such as Java, where all event-driven programming is constructed by coding listeners that tune into things the user does in the environment. These types of languages do not have "prebuilt" event structures, such as the *on()* handler or the *onClipEvent()* handler found in Flash. Instead, you must manually establish the code to handle events. As you know, Flash has historically provided prebuilt handlers, which are used in the pre-Flash MX coding strategy. Flash now borrows from these other languages by implementing the listener concept as well.

Objects as Event Sources

Flash MX currently provides five objects that can be used as event sources. An event source is an object that can notify other objects of an event occurrence. For example, an object (such as a movie clip, button, or any other object) can "register" itself with an event source and then be notified when a particular event happens in relation to the event source. Any object, then, can be a listener, but only five specific objects can be event sources.

 NOTE: *Some objects, by default, are listeners of certain events and therefore do not need listeners established for certain events. For example, by default the movie clip object is a listener of mouse, button, and frame events, but not of key events. Thus, you need not make a movie clip listen for mouse, button, or frame events, as it does so already by default.*

Objects register themselves with an event source using the *addListener()* method. Objects can also "unregister" themselves using *removeListener()*. Table 6-1 shows the objects in Flash that can be used as event sources. Note that each has *addListener()* and *removeListener()* methods.

Table 6-1: Flash Objects That Can Be Used as Event Sources

Object	Description
Key	Allows notification of the *onkeyDown* and *onkeyUp* events.
Mouse	Allows notification of the *onmouseDown, onmouseUp,* and *onmouseMove* events.
Selection	Allows notification of the *onSetFocus* event.
Stage	Allows notification of the *onResize* event.
Text Field	Allows notification of the *onChanged* and *onScroller* events associated with a specific text field.

In addition to the objects listed in table 6-1, there is an additional special use. The *addListener()* method is used to apply style format changes to components used in Flash MX. In essence, this use allows components on the stage to listen (and in reality, subscribe to) specific formats (font size, font face, color, and so on) for components. Using this you can create format groups, in which certain components share format attributes. Let's take a closer look.

To change the formatting of a component, you use the *FStyleFormat* object by establishing an instance of it. The instance of the object is used

to hold a collection of properties (for a listing of available properties, see Chapter 11 of the *Using Flash MX* reference that comes with the software) that pertain to the formatting details for the component, such as *textSize*, *face*, and so on.

Once you have established an instance of the *FStyleFormat* object, you then register an instance of a component that exists on the stage with the instance of *FStyleFormat* using *addListener()*. This applies the formatting properties in the *FStyleFormat* instance to the component. By registering a component with the *FStyleFormat* instance, changes made to the *FStyleFormat* instance later in the movie are automatically applied to the component because the component is listening to (and registered with) the *FStyleFormat* instance.

 NOTE: *Chapter 11 of the* Using Flash MX *reference does a pretty good job explaining component use and formatting. Make sure you take the time to read it. Note that a PDF version of the reference can be downloaded from Macromedia's web site in case you obtained the software electronically.*

Basic Listener Use

To better understand listeners, let's examine a simple example that demonstrates how to set up a listener, as well as some specific things you should be aware of. The basic code required to set up listeners is pretty simple once you know what goes where. Anytime you want to establish a listener you must first establish an event handler for the event for which the object will be listening.

This event handler is in the form of an event method and has code for what you want the object to do when the event happens. Note that it may seem odd at first—establishing a nonstandard event for an object. For example, let's say you want a movie clip to listen for changes a user makes to a text field. In this case, you would set up an event method for the *onChanged* event for the movie clip. Note that the movie clip does not normally have an *onChanged* event method. This is how listeners allow you to establish event handlers for events that objects do not normally respond to (in essence extending the functionality of objects).

The next step is to register the object with the event source. In essence, you use *addListener()* to tell the event object to notify and use the event handler for the listening object when the event occurs. Using our example, the second step would be to tell the text field (to which the movie clip is to listen) that it should notify the movie clip when *onChanged* has occurred. This is achieved using the *addListener()* method. Let's look at the basics of this using a simple example.

 CD-ROM NOTE: *Open the file* ch06_01.fla *located in the* fmxas/ chapter06/ *directory installed from the companion CD-ROM. Use Test Movie to see how it works. As you click on the stage with the mouse or press keys on the keyboard, information is output to the Output window.*

Although quite rudimentary, the CD-ROM example *ch06_01.fla* shows the basic idea of listeners, and points out some important things. If you access frame 1 of the *Global* layer, you will see that listeners are established for the field, button, and movie clip that reside on the stage. Let's examine the listeners for the field first, as shown in code example 6-1.

Code Example 6-1: Setting Up Listeners for the Field

```
1   myfield.onMouseDown = function() {
2    trace("Field: I heard the mouseDown");
3   };
4   myfield.onMouseUp = function() {
5    trace("Field: I heard the mouseUp");
6   };
7   Mouse.addListener(myfield);
8   myfield.onKeyDown = function() {
9    trace("Field: I heard the KeyDown");
10  };
11  myfield.onKeyUp = function() {
12   trace("Field: I heard the KeyUp");
13  };
14  Key.addListener(myfield);
15  myfield.onChanged = function() {
16   trace("Field: I was changed.");
17  };
. . .
```

As explained previously, to use listeners you must establish event methods for objects and then register the object with the event source. Thus, lines 1 through 6, 8 through 13, and 15 through 17 set up the event methods for the field *myfield*. Note that lines 7 and 14 register *myfield* with the Mouse and Key objects. Thus, anytime the Mouse or Key object spawns a *mouseUp, mouseDown, keyUp,* or *keyDown* event, the field *myfield* is notified of the event, and the event methods shown in code example 6-1 are executed.

One curious note about code example 6-1: the last event method is not registered with anything (i.e., there is no *addListener()* following it). The

reason for this is that the field *myfield* is the event source for the *onChanged* event (as well as *onScroller,* although not used here). You do not have to register an object with itself—and problems would likely ensue if you did. Thus, as it relates to the *onChanged* event, all you need do is establish an event method for what to do when the field is changed. You do not need to establish a listener.

In the middle section of code in the example you have open in Flash, you will find the listeners and event method for the button. These are fairly straightforward (i.e., there are no "gotchas" known to the authors concerning this). You will note that the button does register itself with the field (see the example file). In essence, the button tells the field *myfield* to let it know when its *onChanged* event has been triggered (see the line *myfield.addListener(mybutton);).*

Following the code for the button is the code for the movie clip, which bears discussion. Like the text field, there is one important thing to realize about movie clips and listeners. Examine code example 6-2, which shows the listener setup for the movie clip.

Code Example 6-2: Setting Up Listeners for the Movie Clip

```
1   myMC.onMouseDown = function() {
2     trace("MC: I heard the mouseDown");
3   };
4   myMC.onMouseUp = function() {
5     trace("MC: I heard the mouseUp");
6   };
7   myMC.onKeyDown = function() {
8     trace("MC: I heard the KeyDown");
9   };
10  myMC.onKeyUp = function() {
11    trace("MC: I heard the KeyUp");
12  };
13  Key.addListener(myMC);
14  myMC.onChanged = function() {
15    trace("MC: The field changed.");
16  };
17  myfield.addListener(myMC);
```

Like the other listeners, note that lines 1 through 12 and 14 through 16 establish the event methods for the movie clip. Lines 13 and 17 register the movie clip with the Key object and the field *myfield.* Yet notice that the movie clip is not registered with the Mouse object. Just as fields are

automatically aware of *onChanged* events, movie clips are automatically notified of mouse events. Movie clips are not necessarily the event object (as is the case with the field)—the Mouse object is the event source—but movie clips are automatically within the event chain of mouse events and are therefore automatically aware of mouse events.

 NOTE: *Actually, movie clips are already listeners for not only mouse events but* enterFrame *and button events, such as* onPress *and* onRelease.

Unlike attempting to register a field with itself (which is problematic), if you use *addListener()* to subscribe a movie clip to mouse events, the movie clip will actually encounter its mouse event methods twice—and they will execute twice. In the example file, there is a line commented out within the code (this line is not shown in code example 6-2). If you uncomment the line and test the movie, you will see that the movie clip responds twice to the *mouseUp* and *mouseDown* events.

Precedence

Another issue is that of precedence as it relates to listeners and events. As you saw in the previous example, movie clips automatically respond to mouse events. Thus, if you add a listener to a movie clip to listen to mouse events, its associated code will execute twice. (See code example 6-2.)

As it relates to precedence, table 6-2 shows the order of precedence given the different types of events. The Order of Precedence column shows the order in which the objects react. Keep this order in mind if you are using multiple event listeners.

Table 6-2: Order of Precedence Related to Listeners

Event	Order of Precedence
Mouse	Movie clips > fields > buttons
Key	Fields > buttons > movie clips
Text Field	Fields > buttons > movie clips

Integrating Listeners in OOP

Before leaving the topic of listeners it would be good to return to a previous example and examine listeners in the context of their use in a class. The following explores how listeners can be integrated into OOP.

 CD-ROM NOTE: *Open the file ch06_02.fla located in the fmxas/chapter06/ directory installed from the companion CD-ROM. Use Test Movie to see how it works. You will recall that this example was discussed in Chapter 3. A listener has been added to the Ball class such that when you press the space bar all balls stop. Test the movie and press the space bar to see how it works.*

Once you have opened *ch06_02.fla*, try using the space bar once you have a few balls bouncing around. Also, try clicking on one of the balls as it is moving. These two "features" have been added to highlight when (and when not) to use listeners.

To make all balls stop when the space bar is pressed, code for a listener has been added to the Ball class. Access the *Ball* movie clip and access its frame 1 actions. Code example 6-3 shows the *onLoad* event method (where *addListener()* is called) and the event method for the *onkeyUp* event. Portions of the code for the *onLoad* event method have been omitted for brevity (return to Chapter 3 if you need refreshing on what this code does).

Code Example 6-3: Modified Ball Class Code

```
Ball.prototype.onLoad = function() {
    . . .
    //set ball's selection border
    this.flag = 1;
    this.myborder._visible = false;
    . . .
    //add listener for the key events
    Key.addListener(this);
};
Ball.prototype.onKeyUp = function() {
    if (Key.getCode() == 32) {
        this.flag = -(this.flag);
    }
};
```

In code example 6-3, you see the elements that have been added to this example. Note the event method established for the *onKeyUp* event at the bottom of the code example. In essence, the event method detects whether or not the space bar has been pressed, and then toggles a variable named *flag*. The variable *flag* toggles between a value of 1 and negative 1. You will learn more about the Key object and its methods later in this chapter.

In the upper part of the code you see that when the *Ball* instance is loaded it first hides a movie clip named *myborder* and initializes and sets the variable *flag* to 1 (more on this in material to follow). Note that later in the *onLoad*, *addListener()* is used to let the *Ball* instance listen to key events; specifically, the *onKeyUp* event. Thus, listeners provide a quick means of establishing that all balls generated—whether 1 or 50 of them—detect the *onkeyUp* event and stop. "So, how do they stop?" you might wonder. It is actually due to the *flag* variable. Examine code example 6-4, which shows the *onEnterframe* event method for the Ball class.

Code Example 6-4: The onEnterFrame *Event Method for the Ball Class*

```
Ball.prototype.onEnterFrame = function() {
  if (this.flag == 1) {
   if (this._x - this.radius + this.deltax < 13 || ¬
this._x + this.radius + this.deltax > 261) {
    this.deltax = -this.deltax;
   }
   if (this._y - this.radius + this.deltay < 100 || ¬
this._y + this.radius + this.deltay > 280) {
    this.deltay = -this.deltay;
   }
   this._x += this.deltax;
   this._y += this.deltay;
  }
};
```

The only difference you will note in the code shown in code example 6-4 (compared to the version in Chapter 3) is the opening *if* statement, which detects the value of the variable *flag*. This *onEnterFrame* event is applied to all balls (movie clips are automatically listeners of frames), and therefore this code causes each ball to move itself each time a frame is encountered. Thus, the easiest way to make all balls stop is to disallow them from executing their "movement code," based on the state of the variable *flag*. Thus, if *flag* equals 1, the balls move, and if *flag* equals negative 1, the balls do not move. Keep in mind that movie clips automatically "hear" the movement of the playhead; no listener is required.

Now let's turn our attention what happens when you click on one of the moving balls. If you clicked on one of the balls when you tested the movie, you should have noticed that when you successfully click on one of them a border appears around the ball. When you click a second time,

the border disappears. Remember that the ball border is turned off (*myborder._visible = false*) when the ball is loaded.

You might assume that this functionality is also constructed using listeners, but in actuality they are not needed for this. Recall that the movie clip object is automatically in the scope of the Mouse object; that is, movie clips are automatically listeners of mouse events, just as they are of frame events. Thus, the functionality of the border is simply an event method defined in the Ball class; no listener is needed, as shown in code example 6-5.

Code Example 6-5: The onEnterFrame *Event Method for the Ball Class*

```
Ball.prototype.onMouseUp = function() {
  if (this.hitTest(_root._xmouse, _root._ymouse,
false)) {
    if (this.myborder._visible == false) {
    this.myborder._visible = true;
    } else {
    this.myborder._visible = false;
    }
  }
};
```

When to Use Listeners

Listeners are a nifty new feature of Flash MX and indeed they will let you do a lot of things. The primary thing they give you in Flash MX is the ability to centralize your code into a single frame, or at the maximum a few selected places (such as in frame 1 of the main movie and frame 1 of a movie clip, and so on). Rather than attaching code directly to objects— which makes finding code snippets very difficult—the use of event methods, the OOP approach, and listeners allows you to more concisely write your code, making code management much easier.

▪ ▪ ▪ Objects for Interaction

Now that you are aware of the role of listeners and related concepts, let's move on to the objects that are central to this chapter; namely, the Mouse, Key, Selection, and Button objects. The following section begins with the Mouse object.

The Mouse Object

The Mouse object is relatively simple, in that currently it has just two basic methods associated with it and no real properties. The following sections explore the *hide()* and *show()* methods associated with the Mouse object, the general properties for tracking the mouse position (which are not part of the Mouse object), and strategies for controlling the mouse.

Mouse Methods

Mouse methods provide the basic ability to turn the standard cursor, normally the arrow, on and off. This allows the developer to replace the standard mouse cursor with just about anything she desires. You may use a movie clip (animated or static) as the cursor to provide a more customized experience for the end user. You can also use a movie clip in combination with the *duplicateMovieClip()* or *attachMovie()* method to create a trailing cursor or a cursor with some sort of special effect. In other cases, you may wish to turn the mouse off entirely if you are creating a kiosk or full-screen presentation in which everything is controlled via a touch screen or keystrokes on a keyboard. Let's examine these two methods.

hide()

When the *hide()* method is used, the graphic representation of the mouse cursor is simply hidden from the user. Note that even when the mouse is hidden you are still able to track the position of the mouse, even though it is not visible. This is what allows the developer to replace the normal cursor with a movie clip or other entity. While the mouse is hidden, the location of the desired "movie clip cursor" is set equal to the current position of the mouse.

 NOTE: *The Mouse object does not require instantiation prior to use.*

To hide the mouse, the following code is used.

```
Mouse.hide();
```

Note that unlike many methods you need not instantiate the Mouse object in a variable for use. You simply use the keyword *Mouse*, followed by the method. With the mouse hidden, you can immediately associate a movie clip with the current mouse position, which you will see an example of in the section "Strategies for Custom Cursors."

When the mouse is hidden, there are two special cases in which it will be revealed, even though Flash is supposed to be hiding it. The first case is if the mouse moves outside the Flash Player. In this case, the moment the user moves the cursor to a location outside the Flash Player, the stan-

dard system cursor will reappear. The second special case is if the user moves the mouse of a text field that is either editable or selectable. In this case, the traditional I-beam cursor will appear while over the respective text element on the Flash stage.

show ()

Using the *show()* method, which follows, is very similar to the *hide()* method.

```
Mouse.show();
```

This code would basically turn the Flash cursor back on if it had been previously hidden. The thing to keep in mind is that if a movie clip is being used as the cursor prior to using the *show()* method, you must ensure that you first get rid of the custom cursor (movie clip) by either changing its *_visible* property or by moving it off the visible portion of the stage. Otherwise, you end up with the standard cursor on top of the custom cursor. Again, you will see an applied example of this in material to follow.

Mouse Properties?

As we have alluded to already, the Mouse object has no inherent properties. Strange as it may seem, the properties you would think would be "owned" by the Mouse object, the *_xmouse* and *_ymouse* properties, are actually global properties. This is likely due to carryover from Flash 5, but for those not familiar with the previous version, this may seem strange nonetheless.

_xmouse and _ymouse

The *_xmouse* and *_ymouse* properties are global properties that yield the current *x* and *y* location of the mouse. As such, when you are working with the Mouse object to create your own custom cursor in a movie, you use the *_xmouse* and *_ymouse* properties as the location where the "custom cursor" movie clip is to be placed. Simply put, you set the *_x* and *_y* properties of a movie clip to the *_xmouse* and *_ymouse* repeatedly in each frame of the movie. This gives the perception that the movie clip is the cursor.

Except in cases in which the clip being used is physically large or where *duplicateMovieClip()* or *attachMovie()* is used to create trailing mouse effects, the user will not generally realize that you have replaced the standard cursor with a movie clip of your choosing. For those familiar with Director, in which you can set the cursor to not only custom cursors but also to other standard cursors (such as the hourglass and so forth), Flash may seem limiting. Again, this is one area in which we will likely see improvement in the future.

Stage Versus Clip Coordinates

The results of _xmouse_ and _ymouse_ can vary depending on whether they are accessed inside a movie clip or within the main movie. Fundamentally, these results vary because of the difference between the origin of a movie clip and the origin of the stage.

The origin for the stage or main movie timeline is always the upper left-hand corner, whereas the origin for a movie clip is based on its registration point. When movie clip symbols are created using the Insert | Convert to Symbol menu option, the origin is in the center of the selected elements. If you create a new movie clip symbol using the Insert | New Symbol menu option, the registration will depend on where you start drawing or placing stage elements within that symbol. Remember that the origin for a movie clip symbol is shown as a small plus sign (+) on the movie clip's stage.

Given the difference in origins, where you access the _xmouse_ or _ymouse_ properties will be based on that entity's origin. If accessed in the main movie timeline, these properties will be in relation to the stage's origin. If accessed in a movie clip, these properties will be in relation to the movie clip's origin. This is both a positive and negative characteristic.

It is positive in that you can access the position of the mouse relative to either the main movie timeline or a movie clip, but it is negative in that developers frequently forget that it works this way. They suddenly get mouse coordinates that are not what they thought they should be, and face no end of frustration until they figure out what is going on! To keep things simple, it is suggested that you always precede the _xmouse_ and _ymouse_ properties with _root, as in the following.

```
_root._xmouse;
_root._ymouse;
```

These two lines of code will force Flash to interpret the mouse coordinates in relation to the main movie timeline (stage). If you want to interpret the mouse coordinates in relation to a movie clip, you may precede the properties with the specific instance name of a movie clip, which will yield the mouse positions in relation to the movie clip's origin. It is important to remember this issue concerning the _xmouse_ and _ymouse_ properties, as it will reduce much frustration during development.

 NOTE: *The next chapter deals with the* globalToLocal() *and* localToGlobal() *methods that belong to the Movie Clip object. These methods can be used to convert stage and movie clip points back and forth between the local and global coordinate systems.*

A Note About updateAfterEvent()

There seems to be a lot of confusion within the development community concerning the *updateAfterEvent()* method. This method directly relates to and is commonly used with the Mouse object, and can also be used with keyboard interaction.

The fundamental reason for this method's existence is so that you can control when certain screen elements are redrawn or refreshed. Unlike programs such as Director, which has the *updateStage* command, ActionScript lacks the ability to redraw or refresh the screen directly. Instead, the screen is only refreshed in Flash when the playhead moves from one frame to another. When the user interacts with input components via the mouse or keyboard, the interaction may occur between refreshing of the screen (while the playhead is between frames). In the case of the Mouse object, this causes the cursor to flicker. In the case of text fields, text entries update slowly.

The *updateAfterEvent()* method was created to overcome these problems. However, it only partially provides the ability to control screen redrawing, as it only works in relation to code that appears in an *onClipEvent()* handler (scripts attached to movie clips). The method is only valid when specifically linked to the mouse events (*mouseUp*, *mouseDown*, and *mouseMove*) and keyboard events (*keyUp* and *keyDown*) within the *onClipEvent()* handler.

To use the *updateAfterEvent()* method with the mouse object, you generally end the *onClipEvent()* method with it. Again, this is to solve the flickering mouse problem. In the examples shown in the next section, you will see it used to solve this problem.

Strategies for Custom Cursors

The sections that follow explore common mouse operations involving the Mouse object or mouse cursor. In the first example, you will see the basics of replacing the standard arrow cursor with a movie clip. The second example involves the difference between tracking mouse coordinates in a movie clip versus tracking them in the main movie. The third example demonstrates how to change the cursor over a specified area.

Creating a Custom Cursor

This first example demonstrates the basics of creating a custom cursor. Within it you will see the basic use of the *hide()* and *show()* methods and how you can replace the standard cursor with a movie clip.

CD-ROM NOTE: *Open the file ch06_03.fla from the companion CD-ROM and use Test Movie to see how it works.*

The first thing you will note in the example file is the use of the standard radio button components that are prepackaged with Flash. At runtime, as you click on each of these radio buttons—which are designed to automatically work in conjunction with one another—the cursor is changed. Use of the radio button components is relatively easy. Once you drag them from the Components library, you set their parameters using the Properties panel.

The most important parameters to set are Group Name and Change Handler. If a set of radio buttons shares the same name, they function as a set of radio buttons, where only one in the set can be active at a time. The "change handler" is the code designed to interpret what should happen when the user interacts with the component. (This is discussed further in material to follow.)

Another thing you should note are the three movie clips that will be used as the cursors, which are located in the library. Each of these is attached when a respective radio button is selected. Note that each cursor movie clip is object-oriented and has a class defined for itself.

To begin examining the code, the first thing to look at is the code associated with the cursor movie clips. Select any of the cursor movie clips from the library and access the actions contained in the movie clip's first frame. Code example 6-6 shows the code for the arrow movie clip.

Code Example 6-6: Code for the **arrowcursor** *Class*

```
#initclip
function arrowcursor() {}
arrowcursor.prototype = new MovieClip();
arrowcursor.prototype.onEnterFrame = function() {
  this._x = _root._xmouse;
  this._y = _root._ymouse;
  updateAfterEvent();
};
arrowcursor.prototype.onLoad = function() {
  _global.laststate="arrow";
  this._x = _root._xmouse;
  this._y = _root._ymouse;
  updateAfterEvent();
};
Object.registerClass("arrow", arrowcursor);
#endinitclip
```

The code contained in each of the movie clips used as cursors (*arrow*, *bucket*, and *hand*) is similar to that shown for the *arrow* in code example 6-6. Note that it begins by defining a class for the movie clip, with the class inheriting the Movie Clip object's methods and properties. Then two event methods are defined: one for *onEnterFrame* and one for *onLoad*.

When the clip loads (the *onLoad* event method), the code first stores the cursor type (the name of the cursor) in a global variable called *laststate*. You will see the relevance of this variable a little later. Then the movie clip is immediately placed at the current location of the mouse coordinates. The *updateAfterEvent()* method is called to try to keep cursor flicker to a minimum. In the *onEnterFrame* event method, each time a frame is encountered the movie clip location is updated.

Even when you use the *updateAfterEvent()* method, you may notice some mouse flicker. This is not as bad as the flicker that occurs when the method is not used, but it does flicker some nonetheless. If smoother cursor performance is critical, you can increase the frame rate to get a smoother mouse (Modify | Document). However, changing frame rate may affect other things in your movie, particularly as it relates to timing. The key is to find a frame rate that satisfies you.

Generally, a frame rate of 30 (as opposed to the default of 12) will yield a relatively stable mouse, but other things in the movie may dictate a lower setting. In addition, it is best to set this from the start of creation, as changing it midstream in the development process may affect the timing of other things in your movie. Now let's examine the code located in frame 1 of the main movie timeline, as shown in code example 6-7.

Code Example 6-7: Code Located in Frame 1 of the Main Movie Timeline

```
Mouse.Hide();
attachMovie("arrow", "arrowMC", 999);
stop();

function setCursor(component) {
  switch (_global.laststate) {
  case "arrow" :
   arrowMC.removeMovieClip();
   break;
  case "hand" :
   handMC.removeMovieClip();
   break;
  case "bucket" :
```

```
    bucketMC.removeMovieClip();
   }
  switch (component.getValue()) {
  case "arrow" :
   attachMovie("arrow", "arrowMC", 999);
   break;
  case "bucket" :
   attachMovie("bucket", "bucketMC", 999);
   break;
  case "hand" :
   attachMovie("hand", "handMC", 999);
   }
  }
```

The code shown in code example 6-7 includes some initialization code, as well as the handler used when the component (radio button group) is changed. When the movie starts, the standard mouse cursor is hidden and the *arrow* movie clip is then attached. Once attached, the *arrow* movie clip contains all intelligence required to make it function as a cursor, as you saw in code example 6-6.

The *setCursor()* function is used as the change handler for the radio button components. If you click on any of the radio buttons on the stage and examine the Properties panel, you will see that each references the *setCursor()* function in its Change Handler parameter.

When the user clicks on one of the radio buttons, the *setCursor()* function executes and does two things: it turns off whatever is the current cursor, and then sets up the new cursor by attaching a movie clip from the library. Thus, each *switch* statement takes care of one of these procedures. The first *switch* statement resets the environment based on the value in the global variable *laststate*. Recall that *laststate* is set when the various cursor movie clips are loaded.

The second *switch* statement sets up the new cursor, based on the user's selection. To find out which of the radio buttons has been selected, *component.getValue()* is used. Note that components automatically identify themselves to their defined change handler. By including a *component* argument in whatever change handler you write, you can detect the value of the component using *component.getValue()*.

 NOTE: *You are encouraged to try removing the* updateAfterEvent(); *methods from the code in the cursor movie clips, and to test the movie so that you can see the effect of not including it. As a result, you should see the mouse cursor flicker sporadically when you move the mouse.*

Tracking the Mouse

This second example is not designed to show some complex movie but to explore one of the things that causes no end of frustration to those unfamiliar with tracking the mouse. In this exercise you will see the difference between tracking the mouse relative to the stage or main movie and tracking the mouse relative to a movie clip.

 CD-ROM NOTE: *Open the file* ch06_04.fla *from the companion CD-ROM and use Test Movie to see how it works.*

In this example you see two sets of coordinates tracked at the same time. One is the mouse in relation to the main movie, and the other is the mouse in relation to the movie clip. The origin used for _xmouse and _ymouse depends on the path used to get these properties.

When the _xmouse and _ymouse properties are called within the main movie timeline (in a frame or attached to a button), the mouse will be tracked relative to the stage origin, which is the upper left-hand corner of the stage. Similarly, if the properties are preceded by the keyword _root, regardless of the location of the code, the mouse will be tracked relative to the main movie origin.

If _xmouse and _ymouse are called from inside a movie clip, attached to a movie clip (with *onClipEvent()*), or preceded with the *this* keyword in an event method, the mouse will be tracked according to the movie clip's origin, unless it is preceded with _root. Access the actions located in the main movie timeline, which are shown in code example 6-8.

Code Example 6-8: Event Methods for the Movie

```
g_mouseloc.onEnterFrame = function() {
  this.my_x=_root._xmouse;
  this.my_y=_root._ymouse;
}
mc_mouseloc.onEnterFrame = function() {
  this.MC_coord.my_x = this._xmouse;
  this.MC_coord.my_y = this._ymouse;
}
```

Code example 6-8 shows the two event methods for this movie. The first event method is associated with the global mouse coordinate fields, which are located inside the movie clip instance named *g_mouseloc*. Note the use of the *this* keyword, meaning that the *my_x* and *my_y* variables are inside the movie clip *g_mouseloc*. If the *this* keyword were not used, Flash would assume that these variables were owned by the main timeline.

In this first event method, also note the use of _root to precede the _xmouse and _ymouse properties. This makes Flash get the location of _xmouse and _ymouse using the stage origin (upper left-hand corner of the stage) as the point of reference.

In the second event method, you see that the code is associated with the movie clip mc_mouseloc. Again, note the use of the *this* keyword on the left-hand side of the statements. This acknowledges that *my_x* and *my_y* are inside *MC_coord*, which is inside *mc_mouseloc*. If *this* were not used, Flash would assume that the two variables belonged to a movie clip named *MC_coord* located in the main timeline.

Of greater importance, note the use of the keyword *this* in front of the _xmouse and _ymouse properties on the right-hand side of the statement. This tells Flash to use the origin of the movie clip *mc_mouseloc* as the point of reference for _xmouse and _ymouse.

As shown in this simple example, what you precede the _xmouse and _ymouse with is very important, as it determines the resulting coordinate system used for measurement. If preceded with _root, these properties are based on the stage origin. If preceded with *this*, these properties are based on the item to which the script is attached. You can actually get the _xmouse and _ymouse to measure against the origin of any movie clip simply by including a valid reference to the movie clip name in front of _xmouse and _ymouse. This offers tremendous flexibility when tracking the mouse.

Changing Cursors over Areas

Although this example employs the use of the Movie Clip object's *hitTest()* method, it is desirable to show it here as another implementation of cursor control. The *hitTest()* method allows you to compare the location of one movie clip to another to determine if the two intersect (collide). Here, however, you will see how to use it to determine if the mouse intersects with a movie clip.

 CD ROM NOTE: *Open the file* ch06_05.fla *from the companion CD-ROM and use Test Movie to see how it works.*

Once you have the file open, access the actions in frame 1 of the *State* layer in the main timeline. Note the event methods that set up the *onRollOver* and *onRollOut* events for the *ragdoll* movie clip, shown in code example 6-9.

Code Example 6-9: Event Methods for the ragdoll *Movie Clip*

```
ragdoll.onRollOver = function() {
  if (this.hitTest(_root._xmouse, _root._ymouse, ¬
  true)) {
```

```
    Mouse.hide();
    _root.attachMovie("bucket", "bucketMC", 999);
    updateAfterEvent();
  }
};
ragdoll.onRollOut = function() {
  removeMovieClip("bucketMC");
  Mouse.show();
  updateAfterEvent();
};
```

Chapter 4 of this book presented this example to demonstrate the Color object. However, it used a non object-oriented approach to the cursor change. Here, it is revised using the cursor from example file *ch06_03.fla*. With the OOP cursor, event methods are established as shown in code example 6-9. In the *onRollOver* event method, note that the *hitTest()* method is being used to determine if the mouse intersects the "true shape" of the *ragdoll* movie clip. True shape means that *hitTest()* will only evaluate as *true* if the cursor is over a portion of the *ragdoll* clip that has content.

If the last argument were *false*, *hitTest()* would evaluate as *true* if the mouse were over any part of the bounding box for the *ragdoll* movie clip. Here, you want the cursor to change only if it is over a colorable part of *ragdoll*.

Beyond the use of *hitTest()* and the fact that you are using *onRollOver* and *onRollOut* events, there is nothing more that is special about this example. Recall that most of the intelligence lies within the *bucket* movie clip, where the Bucket Cursor class is established.

The Key Object

Now that you have taken a look at the Mouse object, let's examine the Key object. The Key object exists so that you can enable keyboard interaction within your movies, well beyond the *on(keyPress)* handler typically associated with button instances. Thus, the Key object provides ways in which to track and decipher which keys are pressed during a movie.

 TIP: *Like the Mouse object, the Key object does not require a constructor function to use its methods or to access its properties.*

Methods

Aside from the listener methods discussed earlier in the chapter, the Key object provides four methods you can use to determine which keys are

pressed or characters entered at runtime. The sections that follow describe these methods.

getAscii() and getCode()

The *getAscii()* method allows you to get the exact ASCII code representation for the last keyboard key pressed, and the *getCode()* method retrieves the virtual key code value of the key pressed. ASCII (American Standard Code for Information Exchange) code representations are numerical representations of characters—consisting of 96 uppercase and lowercase letters, as well as 32 non-printing control characters. Generally a number from 0 to 255 is used to represent each character. For example, the uppercase letter J is ASCII value 74, whereas the lowercase j is 106.

Because it was devised in the 1960s, ASCII character sets are generally incapable of representing non-English languages. More modern character representations, such as Unicode or ISO Latin-1, provide a broader range of characters and are more reliable across platforms and spoken languages. The primary thing you must watch out for when using ASCII values are the character representations above 127. The first 127 characters are relatively consistent across platforms, whereas the later 128, called extended characters, vary from platform to platform.

 NOTE: *Appendix B provides Flash key code values. Appendix C provides ASCII code values and their characters.*

Aside from ASCII values, Flash also provides something called virtual key codes to help combat some of the problems associated with the use of raw ASCII values. This is an internal numerical key assignment made within Flash. Use of Flash's virtual key codes, as opposed to ASCII values, allows you to ensure that your movie controls remain constant across platforms and independent of the spoken language of the end user.

 CD-ROM NOTE: *To see an example of* getASCII() *and* getCode() *in use, open the file* ch06_06.fla, *located in the* fmxas/chapter06/ *folder on the companion CD-ROM.*

isDown() and isToggled()

The *isDown()* and *isToggled()* methods are what the authors would deem "utility" methods. The *isDown()* method allows you to determine if a specific key is being held down at the time it is called. You typically use it in the following form.

```
Key.isDown(keycode);
```

Here, *keycode* is the key you want to detect. Note that the *isDown()* method returns *true* of the key is currently being pressed, and *false* if it is

not being pressed. Generally you will use the previous code in an *if* statement or capture the value in a variable and then use the variable in some fashion. If you use it in association with key events, it should be used within the *onmouseDown* or *onPress* for it to work properly. Where this method becomes quite handy is when you are trying to capture data entered with the keyboard via ActionScript. With it, you can determine the status of the Ctrl, Alt, or Shift key in combination with other key presses.

In a similar vein, *isToggled()* is used to specifically determine if the Caps Lock or Num Lock key is toggled on or off. Because most, if not all, keys result in different characters when these two keys are toggled on or off, *isToggled()* can be used to check this status so that the proper character can be interpreted based on a key press.

Properties

The Key object provides several properties that basically serve as constants referenced to specific utility keys, such as the Enter, Escape, and Home keys. Lengthy description of these properties is not necessary, as they are all documented quite well in the reference section of the software. Simply note that you can use these properties directly as a way of referring to specific keys on the keyboard.

Strategies for Capturing Keys

Before examining the Selection object, let's examine a couple of examples of use of the Key object.

Determining Specific Keys

In Chapter 4 you took a look at an example that used keyboard interaction. Discussion of the Key object was reserved for this chapter. Let's quickly return to that example so that you can see how the Key object is used.

 CD-ROM NOTE: *Open the file* ch06_07.fla, *located in the* fmxas/ chapter06/ *folder installed from the companion CD-ROM. Use Test Movie to refresh your memory about how this example works.*

Recall that the Key object performs basic color conversion between hexadecimal RGB, decimal RGB, and HLS color values. In Chapter 4 you examined how most of this example works. In Chapter 5 you examined how the Up and Down arrows in the movie clips associated with each value increment and decrement. Of particular interest was the hexadecimal control, which is more than just adding or subtracting a value of 1 from the field. The following examines how a user can directly enter data into various fields such that when the Enter key is pressed the data is validated and then used.

Click on the movie clip beneath the text Hex Value. Recall that each of the fields is actually an input text field within a movie clip. The code you will examine is attached to the hexadecimal control (instance name hexctrl). Code example 6-10 shows the code attached to this control. Remember that this particular example uses the older style of coding, as the OOP approach was really unnecessary.

Code Example 6-10: Code Attached to the **hexctrl** *Instance*

```
onClipEvent (keyUp) {
 if (Key.getCode()==13 && String(Selection.getFocus()) ¬
== "_level0.hexctrl.hex_field") {
 _root.myhex=_root.myhex.toUpperCase();
 flag=0
 for (k=0; k<6; k++) {
 temp = _root.returnindex(_root.myhex.charAt(i), ¬
 _root.hexarray);
 if ( temp==null ) {
  flag=1
  break;
  }
 }
 if (flag==1 || _root.myhex.length>6) {
 _root.myhex="ERR"
 } else {
 _root.hextodec();
 _root.rgbtohls();
 _root.changecolorbox();
 }
 delete temp;
 delete k;
 delete flag;
 }
}
```

The code shown in listing 6-10 is set up such that once a user enters a value in the field contained in the movie clip and presses the Enter key, the entered value is examined to make sure it is a *value* hexadecimal value. If it is *value*, the color conversion occurs. If not, the value in the hexadecimal field is changed to ERR, meaning *error* (similar to basic calculators).

The first thing you will note in code example 6-10 is that it is using the movie clip's *keyup* event. Actually, all the movie clip controls for the color

component values are set up this way. Thus, you must use an *if* structure to set it up so that all of the movie clips do not try to respond on every key press. The opening *if* statement within the handler does this.

In the *if* statement, note the use of the Key object (*Key. getCode() = = 13*). The Key object is used to see if the Enter key was pressed. However, note in the *if* statement that it is not just the Enter key that allows the rest of the code to execute. If you check for the Enter key only, anytime the Enter key is pressed all of the controls on the stage (including those for the decimal RGB fields and the HLS fields) will execute.

Thus, you use the logical operator && (and) to see if the Enter key is pressed and whether or not the field contained inside the movie clip is currently focused (focus basically means that the item has the attention of the user). Later in this chapter you will learn more about the Selection object, to which the *getFocus()* method belongs. Suffice to say here, however, that it determines if the user pressed the Enter key in relation to the field contained in the movie clip. This is what enables keyboard functionality in this and all other controls in the movie.

The remainder of the code in code example 6-10 takes care of validating the user's entry. Validation of the hex value is a little more complex than validating the decimal RGB or HLS values. It basically compares the digit values in *myhex* (the variable associated with the movie clip's text field) to the array *hexarray*. It also checks to make sure that *myhex* is not greater than six digits. If you examine the code attached to each of the field movie clips, you will see similar code attached to each.

Creating Keyboard Interaction

Let's examine one more keyboard example before moving on. The example pointed to by the following CD-ROM Note shows how to interactively control a movie using key presses and mouse clicks.

 CD-ROM NOTE: *Open the* file ch06_08.fla, *located in the* fmxas/ chapter06/ *folder installed from the companion CD-ROM. Use Test Movie to refresh your memory about how this example works.*

If you have not done so already, use Control | Test Movie to see how the movie works. Try pressing keyboard keys, as well as clicking the keyboard on the stage with the mouse, to see what happens. In some cases you may find that certain keys do not appear to work when you test the movie. Additionally, certain keys may do some things you may not expect. For example, pressing the F1 key on the keyboard will open the Flash Help file, but the movie will still react. Such keyboard functionality is explored following examination of the example.

Let's begin by taking a look at the keys in our keyboard and how they are set up. All of the keys are movie clips contained within the *keyboard* movie clip. As much as possible, the movie clips of the keyboard keys have been shared. That is, where keys are the same size and shape, they are all instances of the same movie clip. However, where keys are of different sizes (such as the Backspace and Enter keys and the space bar), each is represented as a unique movie clip.

Access the *key bkrds* folder in the library. In it you will find all movie clips that are the backgrounds for the keys. The symbols named *gray_bkrd* and *white_bkrd* are used for the majority of the keys. The other key backgrounds are used as needed.

Find the *gray_bkrd* movie clip in the library and double click on it to access its timeline. When you do so, you will find that there is no text in the movie clip. In actuality, the text for each key is layered above the instance of the movie clip within the keyboard movie clip. You can verify this by accessing the keyboard movie clip in the library and examining its layers. In the *gray_bkrd* movie clip, access the actions in frame 1 of the *Global* layer. The code located there is shown in code example 6-11.

Code Example 6-11: Code in Frame 1 of the gray_bkrd *Movie Clip*

```
#initclip
function GrayKey() {
  this.b_shadow._visible = false;
  this.tabEnabled=false;
}
GrayKey.prototype = new MovieClip();
GrayKey.prototype.onRollOver = function() {
  this.useHandCursor = true;
};
GrayKey.prototype.onPress = function() {
  if (this.hitTest(_root._xmouse, _root._ymouse, ¬
  false)) {
    this.b_shadow._visible = true;
    this.clicked = true;
    _global.mySound1.start();
  }
};
GrayKey.prototype.onRelease = function() {
  if (this.clicked == true) {
    this.b_shadow._visible = false;
```

```
    this.clicked = false;
    _root.myCode=this._name.substr(1);
    _root.myAscii="—-"
  }
};
Object.registerClass("gray_bkrd", GrayKey);
#endinitclip
```

In code example 6-11 you can see that the key background sets up its own class (as do all backgrounds). When the class is initialized, it sets the visibility of an object named *b_shadow* to *false* and sets the *useHandCursor* property so that when the cursor rolls over the object the hand cursor is used. The *b_shadow* object is a movie clip instance inside the *gray_bkrd* movie clip that is turned on and off when the user clicks on the key with the mouse. If you examine the *onPress* and *onRelease* event methods, you see that the visibility of the *b_shadow* object is toggled when the movie clip is pressed and released.

Note the use of *hitTest()* in the *onPress* event method. Because all backgrounds are set up to catch *onPress* events, it is *hitTest()* that makes it so that only the current movie clip under the cursor responds to the press. A similar scenario is used so that the *onRelease* event is not acted upon by all movie clips. The only difference is that the variable *clicked* is used to control this. Also note that a global sound is called in *onPress*. This global sound is established in the main movie timeline.

In the *onRelease* event method, note that aside from setting the *b_shadow* object's visibility, two variables are set. The first, *_root.myCode*, is a variable associated with the Key Code field on the main timeline's stage. Note that this field is set equal to a portion of the movie clip's name. Each of the key movie clips within the keyboard movie clip is named *kXXX*, where *XXX* is the key code the key represents. Thus, when the user clicks on the keyboard movie clip's keys with the mouse, the key code is derived from the movie clip's name. Note that for brevity in this example, when the user clicks on the graphical keyboard on the stage, the ASCII value is not determined.

 NOTE: *All of the key background movie clips contain similar code. The only difference between them is the name of their class and the size and/or shape of the graphical components.*

Now that you have examined how mouse interaction is established, let's look at how user key presses are coded. Access frame 1 of the *Global* layer in the main timeline. Code example 6-12 shows the code that sets up

the global sound object, as well as the listener that permits keyboard inter-action.

Code Example 6-12: Code Located in Frame 1 of the Global Layer in the Main Timeline

```
global.mySound1 = new Sound();
mySound1.attachSound("typing");
myLnr = new Object();
myLnr.onKeyDown = function() {
 var temp = Key.getCode();
 if (temp == 16 || temp == 17 || temp == 18) {
  eval("keyboard."+"k"+temp+".b_shadow")._visible = ¬
  true;
  eval("keyboard."+"k"+temp+"_2.b_shadow")._visible ¬
  = true;
 } else {
  eval("keyboard."+"k"+temp+".b_shadow")._visible = ¬
  true;
 }
 _global.mySound1.start();
};
myLnr.onKeyUp = function() {
 var temp = Key.getCode();
 if (temp == 16 || temp == 17 || temp == 18) {
  eval("keyboard."+"k"+Key.getCode()+".b_shadow").¬
  _visible = false;
  eval("keyboard."+"k"+Key.getCode()+"_2.b_shadow").¬
  _visible = false;
 } else {
  eval("keyboard."+"k"+Key.getCode()+".b_shadow").¬
  _visible = false;
 }
 myCode = Key.getCode();
 myAscii = Key.getAscii();
};
Key.addListener(myLnr);
```

Code example 6-12 begins by setting up a global sound object used by the key movie clips, as well as by the listener. Next, an object named *myLnr* is set up and assigned an *onKeyDown* and *onKeyUp* event method.

These are what make the graphic representation of the keyboard keys on the stage react when you press keys at runtime. Let's take a closer look.

In the *onKeyDown* note that the code first captures the key code of the last key pressed, in the local variable *temp*. You do this so that you do not have to repetitively call *Key.getCode()*. Next, you check to see if the user has pressed the Alt, Ctrl, or Shift key. Because there are two of each of these keys on the stage (as movie clips inside the *keyboard* movie clip), you want to make it so that if one is pressed they both react (show their *b_shadow* element) on the stage. Thus, if the user has pressed any one of these, the *if* statement makes it so that both will respond. If any other key is pressed, you simply tell that key to respond. In either case, note how *eval()* is being used to use the value in *temp* to refer to the appropriate object within the *keyboard* movie clip instance.

The code for the *onKeyUp* event method is similar to the *onKeyDown*. Again, you must check to see if Shift, Alt, or Ctrl was pressed. If so, you must make two instances hide their *b_shadow* object. At the end of the *onKeyUp*, you see that *Key.getCode()* and *Key.getAscii()* are used to place values in the variables *myCode* and *myAscii*, which are scoped to the main timeline and are associated with the respective fields on the stage.

Runtime Versus Authoring

In regard to the Key object, if you press and hold a key for a certain amount of time, the actions established in a listener (or on a movie clip) will execute multiple times. What happens when you are in a word processor and press and hold a keyboard key? If you press a letter key, the letter is entered once and (if you hold the key long enough) the letter continues to be entered until you let up on the key. This functionality is inherent in the operating system, and Flash behaves the same way.

If you establish a listener associated with an *onKeyDown* and/or *onKeyUp*, if the user presses and holds the key for an appropriate length of time, the associated actions will repeat themselves unless you program it to do otherwise. The speed of the repetition will depend on the settings in the operating system, but they will nevertheless repeat themselves. Try it with the previous example. Test the movie and hold down one of the keyboard keys (on your physical keyboard, not the graphical keyboard in the file) and see what happens.

Also in regard to the Key object and the previous example, keys that are predefined in Flash affect the file during testing in the Flash application. Similarly, specific keys that are assigned tasks by the operating system will affect files played in the player or in the browser.

For example, if you open the previous example, use Test Movie in Flash (such that the player is playing inside the Flash application), and

then try to press the Enter, Escape, or Alt keys on the keyboard (again, the physical keyboard), the Flash movie will do nothing because these keys are "locked out" by Flash. Because these keys are preassigned in Flash, you cannot "reprogram" them. You will find that some of the keys will do something else prior to performing what you have programmed (the F1 key is a good example). If you press F1 while testing the previous example, you will find that it opens the Flash Help file, but it still reacts afterward in the Flash file. Keys such as Enter, Alt, and Escape behave differently; that is, they do not allow the example file to do anything.

In a similar manner, if you open an SWF version of the file into the Flash Player (apart from the Flash application) and try to press the Alt key, it appears disabled, as will several others. Some keys may or may not respond (for example, the function keys), depending on whether or not you have set them for specific tasks in the operating system.

In summary, when programming keys in Flash, remember that you do not have absolute control over all keys. Where Flash or the operating system have predefined tasks for keys, Flash or the OS may take precedence over the Flash movie being played. In addition, Flash or the OS may completely override or disable the use of certain keys in your authored Flash files. You can be sure that most letter keys and the like can be programmed, but function keys and utility keys (such as Enter, Backspace, and so on) are unreliable at best. If you plan on using the Key object in this way, make sure you test early and test often, to make sure you make proper key choices in your applications.

The Selection Object

In general, the Selection object allows you to control which text field or button has the current focus of the user (that is, which is currently the "active" field or button). Additionally, in regard to text fields, the Selection object can be used to determine the currently selected text within a field or to set a selection within a field. The Selection object currently has no accessible properties. The following section explores the methods available for the Selection object and how they can be used.

getFocus() and setFocus()

The *getFocus()* and *setFocus()* methods are used to get and set the focus as it relates to fields and buttons within a Flash movie. Typically, when a field becomes active in a graphical user interface (GUI)—such that if you begin to type, text is entered in the field—it is said to "have the focus." Thus, the term *focus* refers to which graphical item or component is currently active and has the attention of the user.

In Flash, text fields (Input, as well as Dynamic if set to Selectable) and buttons are items that can receive focus in Flash. Granted, buttons typically do not receive text input as a result of the keyboard (unless you build them to do so). Nevertheless, buttons can be focused so that you can create forms in which you can "tab" between buttons and fields, similar to other technologies, such as HTML forms. To use the *getFocus()* method, you use the following form.

```
Selection.getFocus();
```

Note that the Selection object does not require a constructor function. In addition, like the *String.fromCharCode()* method, you precede the *getFocus()* method with the keyword *Selection*.

When you use the *getFocus()* method, the absolute path and instance name of the currently selected field or button is returned. For example, if a text field in the main timeline with the instance name *myfield1* has the focus when *getFocus()* is called, *_level0.myfield1* is returned. If no field or button has the focus when the method is called, *null* is returned.

 NOTE: *The ActionScript reference states that if a text field has no instance name, the variable associated with text field is returned. This is incorrect. If a text field has no instance name, the absolute path and a generic name assigned by Flash is returned (if you do not name instances of buttons, movie clips, or text fields, Flash automatically assigns a generic instance name to the item, in the form of* instance1, instance2, *and so on). Thus, it is important to give instance names to fields you wish to use with the Selection object.*

The *setFocus()* method is used to set the cursor focus to a field or button. The general form for its use is:

```
Selection.setFocus(instancename):
```

Here, *instancename* is a path and instance name of a button or field.

 NOTE: *Again, the ActionScript reference states that variable names are used with the* setFocus() *method. This appears to be incorrect.*

When you use the *setFocus()* method on an Input text field, the entirety of the text in the field is selected. If you use *setFocus()* on a Dynamic text field that is selectable, the entirety of the text in the field is also selected. When you use the *setFocus()* method on a button, a yellow selection border briefly appears over the top of the button.

CD-ROM NOTE: *To get a better understanding of* getFocus() *and* setFocus(), *open the file* ch06_09.fla located in the fmxas/chapter06/ *folder on the companion CD-ROM.*

getBeginIndex(), getCaretIndex(), and getEndIndex()

These methods are designed to work with Input and Dynamic text field selections. Like strings and arrays, text fields are zero based, meaning that the first character in the field is at index 0. The *getBeginIndex()* and *getEndIndex()* methods get the beginning and ending indices of a selection, when multiple characters have been selected by the end user. The *getCaretIndex()* method gets the current index of the cursor within the text field. If there is no selection but a field has the focus, all three methods will return the same index value. If no field has the focus, negative 1 is returned by the methods.

CD-ROM NOTE: *To see an example of these methods in use, open the file* ch06_10.fla *located in the* fmxas/chapter06/ *folder on the companion CD-ROM.*

setSelection()

The *setSelection()* method, as its name implies, allows you to set the selection within an Input or Dynamic text field. The general form for its use is:

```
Selection.setSelection(start, end);
```

Here, *start* is the starting index for the selection and *end* is the ending index for the selection. If no field has the focus when the method is called, the method does nothing. Thus, prior to using *setSelection()* you should ensure that the appropriate field has the focus by using *Selection. setFocus()*.

CD-ROM NOTE: *To see an example of this method in use, open the file* ch06_11.fla *located in the* fmxas/chapter06/ *folder on the companion CD-ROM.*

The Button Object

Although button symbols were available in Flash 5, they were not accessible with ActionScripting. If you used Flash 5, you will recall that you could not target buttons, predominantly because their instances could not be named. To support further functionality in Flash MX (as well as in the future), the built-in Button object has been added. Granted, unlike the Move Clip object, the Button object does not provide an extensive set of

methods, but it is a step in the right direction. Note the following in regard to the Button object.

- The Button object has one method: *getDepth()*. The *getDepth()* method can be used to determine the current z level of buttons, enabling you to arrange the visual layering of other elements around the current depth of a button.

- Many of the Button object properties are consistent with those permitted as it relates to the Movie Clip object.

- With Flash MX, you can now program events associated with buttons receiving and losing focus, via *onSetFocus()* and *onKillFocus()*, respectively.

▪ ▪ ▪ Summary

In this chapter you have examined the Mouse, Key, Selection, and Button objects. In subsequent chapters you will see further techniques and examples demonstrating use of these objects in various contexts. In the next chapter, you will dive into using movie clips. Methods and properties associated with movie clips are covered in further chapters in the context of other sources you have at your disposal.

7

Movie Clip Essentials

▪ ▪ ▪ Introduction

This chapter will always be a "work in progress." A movie clip is much like Flash itself, a blank canvas. Every day a new painter comes along and adds some more color to its ever-growing spectrum of ingenious uses. Essentially, one could write an entire book on the various uses of movie clips, or even a series. That is the beauty and elegance that make movie clips so essential to Flash creation.

This chapter picks up where the discussion left off in *Flash MX: Graphics, Animation & Interactivity*. If you do not have access to that book, it is recommended that you research movie clips in the *ActionScript Reference*. This chapter quickly revisits basic concepts, and then moves on to highlighting a few methods and properties of the Movie Clip object. Due to the nature of the Movie Clip object, as well as the fact that the ActionScript reference provides adequate explanation of some things, not all aspects of the Movie Clip object are covered here. This chapter examines issues not covered by other resources.

It is recommended that you understand the concepts in this chapter quite well. Movie clips are undeniably the most powerful tools Flash provides. Not only do they allow us to nest timelines within Flash but serve as extremely accessible objects with a wide array of programmatically controllable attributes. Movie clips are central to most Flash arenas, including web design, multimedia, gaming, and application development.

■ ■ ■ Objectives

In this chapter you will:

- Learn about movie clips, how Flash interacts with them, and their overall structure
- Learn different ways to instantiate and reference movie clips
- Get an overview of a few methods and properties that belong to the Movie Clip object, with examples as needed
- Learn an advanced approach to using movie clips in your applications
- Deconstruct an advanced example that uses movie clips effectively

■ ■ ■ What Are Movie Clips?

You are probably tired of hearing this over and over, but Macromedia really extended the Movie Clip object and what it can do in Flash MX. As well as adding a large repertoire of really great methods and properties, Macromedia changed the basic nature of the Movie Clip object and how it behaves. The Movie Clip object is now very closely bound into the new object-oriented methodology. Let's begin by reviewing the basics of what movie clips are from the ActionScript point of view.

Independent Timelines

Movie clips are mini-Flash movies available as symbols. In essence, they are just like nested Flash movies within Flash movies, only much more powerful and flexible. They are distinctly different from, and provide several advantages over, loaded movies. A movie clip has its own timeline, with both movie independence and programmatic control.

Movie Independence

The timeline of a movie clip is completely independent of the main Flash timeline. That is, if you had a movie clip named *animationClip* with 100 frames in a single-frame Flash movie, *animationClip* would play all 100 frames despite the main movie ending or stopping at frame 1.

 CD-ROM NOTE: *To see an example that demonstrates this, open the file* ch07_01.fla *located in the* fmxas/chapter07/ *folder on the companion CD-ROM. Note that even though the main timeline is one frame long, the inserted movie clip plays completely independently of the main timeline.*

Programmatic Control

The timeline of a movie clip is completely exposed and at the mercy of the programmer. It is prone to event handling, navigation, play controls, and so on. With appropriate knowledge of available methods and properties, movie clips can be used with a great deal of power due to their completely programmable nature. You can essentially apply most of the basic actions to a movie clip, allowing it to behave as an independent element.

 CD-ROM NOTE: *To see an example that demonstrates basic programmatic control of a movie clip, open the file* ch07_02.fla *located in the* fmxas/chapter07/ *folder on the companion CD-ROM. Use the Click Me button to start and stop the movie clip.*

Object-oriented

As you have read, movie clips are object-oriented. You can think of them as a hierarchy of containers within which you may nest other containers—with absolute control over the entire hierarchy at all levels. The Movie Clip object comes armed with a wide array of methods and properties that may be manipulated with ActionScript.

Fortunately, you are not limited to what Macromedia has provided. Flash MX has made provisions for some serious customization and expansion of movie clips with the introduction of components and the *registerClass()* method. Whereas *registerClass()* was covered in Chapter 2, the creation of components will not be covered in this discussion. However, you will be informed about the uses, implementation, and customization of existing components over the span of the discussion.

Masks

Flash MX allows you to create scriptable masks with the *setMask()* method. This method utilizes a movie clip to function as the mask for another movie clip. The mask clips themselves are nothing more than movie clips and may be animated and controlled via ActionScript.

 NOTE: *Select Help | Samples and click on* Feature *highlight:* Scriptable masks *to see a basic example of this feature.*

Although scriptable masks are extremely powerful, they have several weaknesses. There are several features you would expect to find with regard to scriptable masks, such as multiple clips functioning as a mask simultaneously, dynamic text as a mask, and others. Unfortunately, this is not the case. The sections that follow delve into these shortcomings and how to work around them in the course of highlighting the capabilities these features currently provide.

Drawing Objects

The new functionality of the Movie Clip object is creating quite a buzz in the Flash community. Movie clips can now function as vertices and points, enabling the programmatic creation of lines, curves, fills, and gradients. Although this is an extremely powerful new feature, do not expect it to enable you to create traditional 3D games, such as *Quake*. There are limits on this new feature set—limits imposed by player size. The very essence of Flash is to enable fast-loading, immersive web content, while keeping the Flash player size to a minimum.

We all know what *Quake*-level 3D need—loads of memory! Although the Flash MX drawing API will facilitate some great intermediate-level 3D development, you should not expect to see any high-quality, photorealistic 3D. Sure, a few developers will push the player to its limits, but on the whole it is still easier to do that sort of development in languages such as C++ and Java.

▪▪▪ Structure of Movie Clips

Now that you understand how movie clips have evolved from Flash 5 to Flash MX, it is important to understand the structure of movie clips from the object-oriented point of view so that you can manipulate their methods and properties. The following sections elaborate on this concept.

Objects

Movie clips may be treated like any other object in the Flash environment. This gives you the luxury of using the dot syntax efficiently, while still having access to the functionality you need. A movie clip may be referred to directly using its instance name, as follows.

```
myBall._x = 50;
```

Here, an instance called *myBall* exists in the same timeline as the code. Note that you may also reference movie clips nested inside other movie clips in the same fashion, as in the following.

```
myBall.myShadow._alpha = 20;
```

Here, *myShadow* is nested within the *myBall* movie clip, and it is assumed that *myBall* resides at the same hierarchical level as this line of ActionScript code. In a similar manner, movie clips nested inside other movie clips may reference their parents (that is, the movie clip into which they are placed), as in the following.

```
trace (myShadow._parent._name);
```

Here, the *trace()* method would return the name of the movie clip in which the *myShadow* movie clip is nested. The *_parent* property is a direct reference to the movie clip object that contains the current movie clip. It follows that you may also use *_parent* in a nesting chain. ActionScript also offers the functionality of absolute references, using *_root* and *_leveln*. For instance, you could write the following.

```
_root.myBall.myShadow._x += 5;
```

This line would work from anywhere in a nesting hierarchy. However, use this methodology only when absolutely necessary, because hierarchical changes in the movie nullify absolute references and require rewriting of code in such scenarios. Instead, it is recommended that you use the *_parent* property wherever possible, as it makes your code much more portable. For instance, if you used absolute references and changed the nesting order of movie clips within your movie, you would have to change all absolute references within the movie to accommodate the change in hierarchy (that is, the new location of the movie clip in the movie hierarchy).

Variables

You might wonder how you access variables defined in a movie clip. Recall that it is as simple as referring to other movie clip attributes. In this regard, let's review code example 7-1.

Code Example 7-1: Retrieving Variables for a Movie Clip Instance

Attached to *myBall* movie clip:

```
onClipEvent (load) {
      x = _x;
      y = _y;
}
```

In the main timeline:

```
//Traces position of the myBall movie clip
myBall.getPosition = function() {
      trace ("x: " + this.x + " " + "y: " + this.y);
}
myBall.getPosition(); // x: 217 y: 161.85
stop();
```

As you can see in code example 7-1, retrieving the variables that exist in a movie clip is no different than retrieving the variables of an object. In

essence, the variables of a movie clip become just like properties, and may be accessed in a manner similar to that of accessing properties of the movie clip.

 WARNING: *You might have noticed that the sample code is in frame 2. This is because of the way Flash streams content. Place the same code in frame 1 of the main timeline to see what happens. It does not work because the function executes before Flash gets a chance to load the movie clip onto the stage and give it an instance name. You can get around this mess by using the #init-clip and #endinitclip pragmas (discussed in Chapter 2).*

 CD-ROM NOTE: *To see an example that demonstrates variable access, open the file ch07_03.fla located in the fmxas/chapter07/ folder on the companion CD-ROM. Access the actions attached to the ball to see how its variables may be tracked.*

Properties

The Movie Clip object comes with several properties that can be manipulated using ActionScript. Whereas some are read-only, others are readable, as well as writable. Accessing movie clip properties is similar to referencing variables of a movie clip. For instance, to change the *_alpha* of a movie clip, you might write the following.

```
myBall._alpha = 50;
```

 NOTE: *As most of the information pertaining to movie clip properties is extremely basic, this chapter does not examine in greater detail the structure and syntax associated with the Movie Clip object. If you are feeling uncomfortable about proceeding without more syntactical knowledge, we strongly recommend another visit to the* ActionScript Reference. *The descriptions provided there are straightforward and negate the need for further discussion of movie clip properties.*

∎ ∎ ∎ Method and Property Summary

The following discussion assumes you have worked enough with movie clips to know most of the basic methods available in Flash 5. Whereas some methods are rather straightforward in implementation, others are not as easy to use. The *ActionScript Reference* represents just the tip of the iceberg when it comes to utilizing the full potential of scripting in Flash MX.

 NOTE: *To learn about Flash MX's new event model, see Appendix A. In fact, it is recommended that you read about the new event model before you continue reading this chapter. The new event model has very important implications to the current discussion.*

This text does not discuss in detail every method the Movie Clip object comes with. Rather, it focuses on the few that might need some elaboration beyond is the information provided in the *ActionScript Reference* and the text *Flash MX: Graphics, Animation & Interactivity*. The basics of methods discussed briefly here are dealt with in greater detail in these other two sources. The methods discussed in this chapter are outlined in table 7-1.

Table 7-1. Method Summary

Method	Summary
attachMovie()	Attaches a movie from the library
createEmptyMovieClip()	Creates an empty movie clip
duplicateMovieClip()	Duplicates the specified movie clip
getBounds()	Returns the maximum and minimum *x* and *y* coordinates for a movie clip in a given coordinate space
localToGlobal()	Converts the point object from local coordinates to the stage coordinates of the specified movie clip.
globalToLocal()	Converts the point object from stage coordinates to the local coordinates of the specified movie clip
removeMovieClip()	Removes the movie clip from the timeline if it was created with a *duplicateMovieClip* action or method or with the *attachMovie* method
setMask()	Specifies a movie clip as a mask for another movie clip
swapDepths()	Swaps the depth level of two movies

attachMovie()

The *attachMovie()* method is one of the methods you should expect to use a great deal. It is recommended that you familiarize yourself with its syntax and implementation. *attachMovie()* was also available in Flash 5. Flash MX has extended this method to include another parameter, called *initObject*. The general syntax for using this method is:

```
myMovieClip.attachMovie( idName, newName, depth ¬
[, initObject] )
```

Here, *myMovieClip* is the movie clip you want to attach a new movie clip to, *idName* is the linkage name (as defined in the library's Linkage dialog box) of the movie clip symbol you want to attach to *myMovieClip*, *newName* is a unique instance name for the new movie clip being attached, *depth* is the integer specifying the depth level where the movie clip is placed (every depth level can accommodate only a single movie clip), and *initObject* is an object that contains properties with which to populate the newly attached movie clip. Note that *initObject* must be of type Object for the methods and properties to be inherited. As well, this parameter is optional.

The *attachMovie()* method enables the dynamic creation of movie clips on the stage from those that exist in the library. It takes the movie clip symbol specified by the *idName* argument and attaches it to *myMovieClip*. The movie clip represented by *myMovieClip* may be preceded by *_leveln*, *_root*, or *_parent*. To remove a movie attached with *attachMovie()*, you use the *removeMovieClip()* or *unloadMovie()* method. Code example 7-2 demonstrates the basic use of the *attachMovie()* method.

Code Example 7-2: Attaching a Movie Clip to the Stage

```
i = 10;
temp = attachMovie ("tile", "tile"+i, i);
```

If the code shown in code example 7-2 were attached to a frame in the main movie timeline, the movie clip *tile* would be attached to the *_root* level of the main movie. The same effect could be achieved by simply writing the following.

```
attachMovie ("tile", "tile"+i, i);
```

 NOTE: *Note the form of code listing 7-2, in which the* attachMovie() *method is stored in a variable called* temp. *This syntax is new to Flash MX. Essentially, it stores a reference to the movie clip that was just created so that you do not have to use the form* _root ["tile" + i] *to reference it. It is recommended that you use the new methodology.*

 CD-ROM NOTE: *To see an example of attachMovie() in use, open the file* ch07_04.fla *located in the* fmxas/chapter07/ *folder on the companion CD-ROM.*

Understanding the initObject Argument

You have to dig quite deep to understand how to use the optional *initObject* argument for the *attachMovie()* method efficiently. The *initObject* argument is quite peculiar. One might wonder why it does not work with classes within a movie clip symbol, or why it works only with an object of type Object. Despite its nature and peculiarities, it is an extremely useful addition to Flash MX, as it allows a developer to separate data and behaviors from actual objects.

Using this new argument is hardly intuitive. Let's examine one way of implementing it. First, you must instantiate your *initObject*. You can attach any number of desired methods and properties to it. In the example file *ch07_04.fla*, we declared an *onPress* method that traces the name of the object, as follows.

```
initObj = new Object()
//onPress event handler
initObj.onPress = function(){
  trace (this._name);
}
```

This permits you to use *attachMovie()* in the following manner.

```
attachMovie ("tile", "tile", 1, initObj);
```

The *initObj* basically lets you populate the *tile* movie clip with all properties and methods that exist for *initObj*. Sure enough, if you clicked on the *tile* movie clip in the example file, it would trace the name of the movie clip in the Output window. As you can see, this new functionality enables some nifty pseudo-inheritance.

duplicateMovieClip()

The *duplicateMovieClip()* method is another method you should expect to use a great deal. Flash MX has extended this method to include a parameter called *initObject,* similar to that of the *attachMovie()* method. The general syntax for the *duplicateMovieClip()* method is:

```
myMovieClip.duplicateMovieClip ( newName, depth ¬
[, initObject] )
```

Here, *myMovieClip* is the movie clip on stage that is being duplicated, *newName* is a unique instance name for the duplicate movie clip, *depth* is the integer specifying the depth level (or movie clip) where the duplicated movie clip is to be placed (every depth level can accommodate only a single movie clip), and *initObject* is an object that contains properties with which to populate the newly attached movie clip. *initObject* must be of type Object for the methods and properties to be inherited. Again, it is optional.

The *duplicateMovieClip()* method enables the dynamic duplication of movie clips while the movie is playing. It takes the movie clip symbol

specified by the *myMovieClip* and makes a duplicate of it. The primary difference between *attachMovie()* and *duplicateMovieClip()* is the fact that *duplicateMovieClip()* creates a duplicate instance of an already-existing movie clip instance that is on the stage, whereas *attachMovie()* is used to create an new instance of a movie clip on the stage from the library symbol.

 WARNING: *When* duplicateMovieClip() *is used, variables from the original movie clip instance are not copied into the duplicated one. For more detailed information about some other things to be wary of, look at the ActionScript Reference discussion of the* MovieClip.duplicateMovieClip() *method.*

Examine the following code.

```
i = 10;
temp = myTile.duplicateMovieClip ("tile"+i, i);
```

In this code, the movie clip *myTile* that exists on the stage is duplicated with a new instance name. Again, note the use of *temp*, which provides a shorthand method of referring to the instance. The *duplicateMovieClip()* method can take an optional argument *initObject*, as indicated earlier. The implementation for this is exactly the same as for *attachMovie()*.

 CD-ROM NOTE: *To see an example of* duplicateMovieClip() *in use, open the file* ch07_05.fla *located in the* fmxas/chapter07/ *folder on the companion CD-ROM.*

createEmptyMovieClip()

This new method proves that Macromedia has in fact heeded the suggestions of Flash developers in the development of Flash MX. It is extremely straightforward to use, and allows you to do away with the prehistoric practice of using real movie clip instances with nothing inside them to serve as containers for other objects. In the past, if you wanted to dynamically generate a new blank movie clip you had to have already-existing blank movie clips on the stage. Now you can use the *createEmptyMovieClip()* method. The basic syntax for this method is:

```
myMovieClip.createEmptyMovieClip (instanceName, depth)
```

Here, *myMovieClip* is the movie clip you want to attach the newly empty movie clip to, *instanceName* is a unique instance name for the movie clip being created, and *depth* is the integer specifying the depth level where the movie clip is placed. Note that each depth level can accommodate only a single movie clip.

When you use this method, it creates an empty movie clip as the child of the clip specified by *myMovieClip*. By default, it places the newly created empty movie clip at the *_root* or main timeline. Note that the registration point of the new movie clip is the upper left-hand corner. As an example, the following code would create an empty movie clip called *myEmptyClip* on the stage.

```
_root.createEmptyMovieClip ("myEmptyClip", 1);
```

getBounds()

The *getBounds()* method is a carryover from Flash 5. Yet it is very useful when dealing with movies for which screen real estate and coordinate positions are important. In essence, *getBounds()* provides coordinates for the bounding box of an instance. The general form for using this method is:

```
myMovieClip.getBounds(targetCoordinateSpace)
```

Here, *myMovieClip* is the name of the instance for which you would like to find bounds, and *targetCoordinateSpace* is the target path of the timeline that should be used as a reference point (e.g., *_root*, *this*, *_leveln*, and so on). When you use this method, keep in mind the differences between the coordinate systems of the main movie (whose origin is the upper left-hand corner) and movie clips (whose origin may be in a variety of locations, depending on how the clip was constructed). The *getBounds()* method returns an object with the following four properties.

- *xMin*: The minimum *x* coordinate value of instance *(left)*
- *xMax*: The maximum *x* coordinate value of instance *(right)*
- *yMin*: The minimum *y* coordinate value of instance *(top)*
- *yMax*: The maximum *y* coordinate value of instance *(bottom)*

For example, consider the following code.

```
myGlobalBounds = myBall.getBounds (_root)
```

In this code, if a movie clip called *myBall* existed on the stage, the object *myGlobalBounds* would return *xMin*, *xMax*, *yMin*, and *yMax* calculated from the registration point of the stage (0, 0 of *_root*), as shown in figure 7-1. These are typically called the "global bounds" of *myBall*, because they report the bounding coordinates for the ball in relation to the stage coordinate system (the global coordinates).

Similarly, let's examine what would happen with the following code.

```
myLocalBounds = myBall.getBounds (this)
```

In this code, if *this* is a reference to the *myBall* object itself, the object *myLocalBounds* would return *xMin*, *xMax*, *yMin*, and *yMax* calculated from the registration point of *myBall* (0, 0 of the *myBall* movie clip), as shown in figure 7-2. It follows that these are typically called the "local bounds" of *myBall*, because they report the bounding coordinates for the ball in relation to its own coordinate system (the local environment).

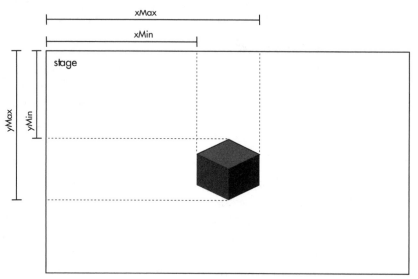

Figure 7-1. Coordinates of a movie clip instance in relation to the _root level (global bounds).

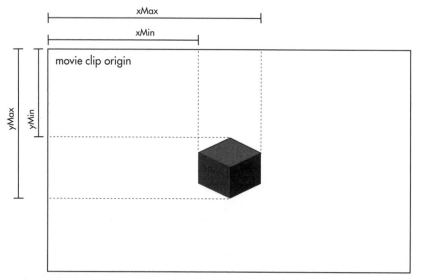

Figure 7-2. Bounds of a movie clip instance with relation to self (local bounds).

As you work with coordinate positioning with ActionScript, always be aware of which set of coordinates you need. Often it is global bounds that are important. However, there are times when you may be working with local coordinates.

 CD-ROM NOTE: *To see a related example, open the file* ch07_06.fla *located in the* fmxas/chapter07/ *folder on the companion CD-ROM.*

localToGlobal() and globalToLocal()

These two methods are simply inverses of each other that provide a means of toggling a point object from local coordinates to global coordinates, and vice versa. As mentioned, dealing with the difference between the main movie coordinate system and the local coordinate systems of movie clips can be troublesome until you get used to it. Thus, the *localToGlobal()* and *globalToLocal()* methods are designed to make traversing these coordinate systems easier. They essentially let you convert points back and forth between them. The basic syntax for using these methods is:

```
myMovieClip.localToGlobal(point)
myMovieClip.globalToLocal(point)
```

Here, *myMovieClip* is the target path of the timeline to be used as a reference point (e.g., *_root*, *this*, *_leveln*, and so on), and *point* is the name of an object of type Object, with the *x* and *y* coordinates as properties.

At first glance these methods appear to be quite simple in theory, but they are slightly tricky to implement. The best way to understand how they work is by examining the related example file. Essentially, the methods convert the point object from one coordinate system to another.

 CD-ROM NOTE: *Open the file* ch07_07.fla *located in the* fmxas/chapter07/ *folder on the companion CD-ROM.*

If you double click on the instance of *myParent* on the stage of the example file, you will find the code shown in code example 7-3 attached to the instance inside it.

Code Example 7-3: Converting from Local to Global Coordinates

```
onClipEvent (enterFrame){
    //Coordinate object
    point = new Object();
    point.x = _x;
    point.y = _y;
```

```
localToGlobal (point);
//Call updateField with parameters
updateField (_x, _y, point.x, point.y);
}
```

In code example 7-3, an *enterFrame* clip event has been attached to a movie clip nested within another movie clip. An object called *point* is assigned the current local *x* and *y* coordinates of the movie clip. This *point* object is then converted to global coordinates, and all coordinates are passed to a function that displays them in a text field.

 NOTE: *The file ch07_07.fla located in the* fmxas/chapter07/ *folder also uses a dynamically created text field. It is fairly simple to use, but it is recommended you check it out nonetheless.*

removeMovieClip()

This method is used in conjunction with movie clips that have been instantiated with the *attachMovie()* and *duplicateMovieClip()* methods. The basic syntax for its use is:

```
myMovieClip.removeMovieClip()
```

Here, *myMovieClip* is the name of the movie clip instance you want to remove. In essence, all this method does is remove a movie clip instance created with the *attachMovie()* or *duplcateMovieClip()* method. The following code would remove a movie clip instance called *myBall* from the stage.

```
myBall.removeMovieClip();
```

 CD-ROM NOTE: *To see the related example, open the file ch07_08.fla located in the* fmxas/chapter07/ *folder on the companion CD-ROM.*

setMask()

The *setMask()* method is a very unique and interesting addition to ActionScript. It allows you to create a mask dynamically by using movie clip instances, both as masks, as well as "maskees" (maskees are the objects that are masked). Although it has several neat features, it also has some shortcomings. Let's examine both its pros and cons. The basic syntax for the setMask method is:

```
myMovieClip.setMask(maskMovieClip)
```

Here, *myMovieClip* is the name of the movie clip instance to be masked, and *maskMovieClip* is the name of the movie clip acting as the mask (maskee). This method designates the movie clip in the parameter *maskMovieClip* as the mask that reveals the movie clip specified by the *myMovieClip* parameter. The following are several important things to note about this method.

- You may use multiple-frame movie clips (animations, movie clips with frame labels, and so on) as masks. Furthermore, these multiple-frame movie clips may contain complex layered content.

- Only static text may be used as a mask. If your mask contains device fonts (dynamic or input text), the font must be embedded.

- Movie clips instantiated dynamically may be used as masks, provided they meet the necessary requirements for masks.

- Mask movie clips may be controlled programmatically. For instance, if a movie clip is set as the mask, you may apply *x* and *y* transformations to produce a desired animated effect, and so on.

The following code would set the movie clip *myMask* as the mask for the movie clip *myMaskee*.

```
myMaskee.setMask (myMask);
```

 TIP: *To clear or cancel a mask that has been assigned with ActionScript, you use* setMask(null).

 CD-ROM NOTE: *To see the related example, open the file* ch07_09.fla *located in the* fmxas/chapter07/ *folder on the companion CD-ROM. In particular, pay attention to the use of dynamic text for setting multiple-character text fields as a single mask for a picture. To enable this process, you must manually embed the font face you intend to use. This option is available from Library | New Font. To learn more about embedding fonts, see* Flash MX: Graphics, Animation & Interactivity.

swapDepths()

The *swapDepths()* method is a carryover from Flash 5 and is frequently used in scenarios in which dynamic z-sorting is necessary. With it you can dynamically change the depth assigned to a movie clip, allowing one clip to pass in front of another. The basic syntax for its use is:

```
myMovieClip.swapDepths(depth)
```

or

```
myMovieClip.swapDepths(target)
```

Here, *myMovieClip* is the name of the movie clip instance to be depth swapped, and *depth* is the target depth level of the movie clip instance specified by *myMovieClip*. You can alternatively use a *target* specification instead of depth. In such cases, *target* is the *_name* of the movie clip instance whose depth is swapped by the depth of the movie clip instance specified by *myMovieClip*. Note that when using this form both the *target* and *myMovieClip* instances must exist in the same timeline.

This method swaps the stacking order (z-order) of movie clip instances on stage. The first form is typically used to place a movie clip element above others. The second form is generally used to swap the depth levels of two movie clip elements that are overlapping on stage, to give the "active" one precedence (much like stacking multiple browser windows on your desktop, wherein the one you clicked on last remains uppermost in the stack). The following code would swap the depth of the movie clip instance *myTile* with that of *myTileToSwap*.

```
myTile.swapDepths (myTileToSwap);
```

 CD-ROM NOTE: *To see the related example, open the file* ch07_10.fla *located in the* fmxas/chapter07/ *folder on the companion CD-ROM.*

▪ ▪ ▪ **Properties**

The Movie Clip object for Flash MX boasts a wider selection of quite useful properties as compared to Flash 5. The *ActionScript Reference* does a fairly decent job of documenting all properties, and it is recommended that you consult it. This discussion does not cover the same ground. However, two of the properties would be advantageous to explore in more depth: *enabled*, which indicates whether a button movie clip is enabled, and *hitArea*, which designates another movie clip to serve as the hit area for a button movie clip.

enabled

The *enabled* property is a welcome addition to the Movie Clip object property list. It allows you to circumvent equivalent, yet hacked, workarounds that were performed in Flash 5. As with most properties, you access it using the general form:

```
myMovieClip.enabled
```

Here, *myMovieClip* is the instance name of the movie clip you would like to set the *enabled* property for. This property uses a Boolean value to indicate whether a movie clip is enabled or not. An enabled movie clip is one that allows its button-like properties to function.

By default, the *enabled* property is set to *true*. If *enabled* is set to *false*, the button movie clip's callback methods and *on* action events are no longer invoked and the *over*, *down*, and *up* states are disabled. However, a disabled movie clip may still react to movie clip events. Note that the *enabled* property is both settable and gettable. Thus, the following code could be used to set the *enabled* property of the movie clip *myTile*.

```
myTile.enabled = true;
```

hitArea

hitArea is a new property available in Flash MX. Again, like several other methods and properties new to Flash MX, *hitArea* is extremely useful, but its use extends to only a few scenarios. To access the *hitArea* property, use the following form.

```
myMovieClip.hitArea
```

Here, *myMovieClip* is the instance name of the movie clip you want to set the hit area for. Note that this property allows you to designate a movie clip to serve as the hit area for another movie clip. However, the usage extends only to button movie clips (i.e., the new hit area responds only to button events on that particular movie clip).

Unfortunately, this property cannot be used to help in better collision detection scenarios (for irregular shapes). In the absence of the *hitArea* property, the button movie clip itself acts as the hit area. For example, the following code would set the movie clip instance *myHit* as the hit area for movie clip instance *myTile*. The *myHit* movie clip instance is nested within the *myTile* movie clip.

```
myTile.hitArea = myTile.myHit;
```

▪ ▪ ▪ Deconstructing the isoMemory Game

It is time to get into some advanced Flash development. The remainder of this discussion leads you through the production and implementation of a pseudo 3D game created specifically to harness and showcase the power of the Movie Clip object and Flash's new event model. At this point, it is critical that you are extremely familiar with the methods, properties, and event handlers available to the Movie Clip object.

In addition, it is also assumed that you can navigate the Flash environment with sufficient ease, as well as perform tasks such as setting linkage properties for library symbols, and so on. Because this is an *advanced* discussion, the text does not go into a step-by-step tutorial on creating the game. Rather, focus is placed on the "big picture," including class implementation, process flow design, and so forth.

CD-ROM NOTE: *Before you proceed, it is recommended that you run the file* ch07_11.swf *located in the* fmxas/chapter07/ *folder on the companion CD-ROM and play the game a few times. Pay special attention to events taking place in the environment, such as text field updating, tile events, and button events. Once you are familiar with the game, open the file* ch07_10.fla *in the same folder and continue reading.*

Creating Isometric Graphical Assets

If you played *isoMemory*, you may have noticed that the game itself is not very complicated. It is similar to several other popular memory games. Even though the game appears 3D, you will soon find out that there is no 3D math involved (aside from a logical z-sorting *attachMovie()* algorithm, a common characteristic among tile-based isometric games).

The first question that probably came to mind when you viewed the game was how the graphics were so accurate and crisp. Most developers, at one point or another, have struggled with the fuzzy anti-aliasing effect Flash adds to everything on stage. Again, most developers have probably also visited web sites and played Flash games on the Internet that appeared extremely clean, much like the game you are about to dissect. Creating crisp, clean, and elegant graphics is simply a matter of following some rules of thumb during graphical asset development, as explored in the material that follows.

Creating the Tile Base

For the benefit of those who would like an introduction to isometric graphic creation, let's run through a simple procedure for creating the *tile* movie clip. Although this task would be a lot simpler and accurate if performed in a vector program such as Macromedia FreeHand or Adobe Illustrator, it can be done quite successfully within Flash itself. To create the clip, perform the following steps.

1. Open a new Flash document and set the background to a color such as #CCCCCC to achieve a balanced contrast between the foreground elements and the background. Select View | Fast. This view disables anti-aliasing.

2. Select the Rectangle tool and create a square on stage. Make sure your square's border width is set to *hairline*. It is also important to set the W (width) and H (height) of the square in the Properties panel to a number in the form *nn.5* (for example, 92.5, 42.5, 35.5, and so on). This ensures that Flash does not perform any rounding (anti-aliasing) on the square's width and

height that may prove degradative to the graphic (see figure 7-3a).

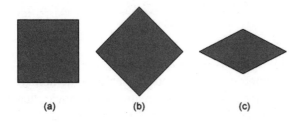

(a) (b) (c)

Figure 7-3. Creating the base of the isometric tile.

3. Rotate the square by 45 degrees using the Transform panel, and deselect it (see figure 7-3b).

4. Select the square again and then vertically scale it by 50% using the Transform panel. To be able to do vertical scaling only, deselect the Constrain checkbox. You should get something that looks similar to that shown in figure 7-3c.

 NOTE: *If you do not deselect the square between steps 3 and 4, the scaling will not work properly. This appears to be a bug, but this is unconfirmed. By deselecting the square, you force scaling and rotation to be applied independently of each other.*

5. Select the isometric tile you just created and then select Insert | *Convert to symbol*. Select *movie clip* as the behavior. In the Linkage section, select Export for ActionScript and *Export in first frame*. Recall that these must be set for objects to be used under the OOP approach.

6. You may now use this base from which to create any sort of isometric tile. For the game, a simple cubic tile was created using the drawing tools in Flash.

 WARNING: *You must make sure your isometric tile base is aligned by selecting the* Align horizontal center *and* Align top edge *options in the Align properties panel. This means that the top edge of the tile base must coincide with the origin of the movie clip symbol. Examine the* tile movie clip in ch07_11.fla *located in the* fmxas/chapter07/ *folder on the companion CD-ROM to get a clearer idea of the position of the base.*

 NOTE: *The text* Flash MX: Graphics, Animation & Interactivity *(OnWord Press) provides an alternative method for constructing isometrics (as well as other classes of axonometric drawings) using skew angles. It pro-*

vides an appendix with skew angles appropriate for every 10 degrees of object rotation, allowing almost any dimetric or trimetric drawing to be easily constructed.

Other Assets

The other graphic symbols in the library of the *isoMemory* game are derived from the *Tile* base. Several isometric text elements also exist in the library. The only other assets that may seem confusing to create are the movie clips in the *Number Clips* folder. These were created in Freehand 10 using the method previously described. They were then converted into symbols within Freehand and dragged into Flash MX (the simplest way to import graphics from Freehand into Flash). At this point, their linkage properties were modified and their origins were adjusted using the Align panel.

In the example file's main timeline, you will see that there is a layer folder called *Screen Elements*. One of the layers within it contains a movie clip called *overLay*. This movie clip covers the entire stage, and is called each time a new game is initialized, so as to provide the player with some feedback. Aside from that, the rest should be self-explanatory. Now, with the graphic assets out of the way, it is time to examine the overall implementation process for the game.

▪ ▪ ▪ Implementation and Processes

This section explores the run cycle of the game, examining it at two different levels:

- Initialization and main movie functions
- The Tile class, methods, and properties

Initialization and Main Movie Functions

Initialization is the process of setting up the interface, resetting global variables and arrays, and starting the game. Whereas the game buttons (Reset and Give Up), and text fields are hard-wired into the interface along with background and foreground elements, the game board itself is generated dynamically using multiple instances of the *Tile* movie clip symbol. This game uses both the old Flash ActionScript methodology and the new object-oriented design paradigm where appropriate.

Data Flow Overview

Projects are best understood when you have a holistic view of what transpires. The details have greater relevance when you can "get your brain around" the solution as a whole. Therefore, let's look at the overall picture

of what happens when you run the *isoMemory* game. Examine figure 7-4, which provides a combined graphical and procedural look at what happens. Let's begin by examining sequentially what happens in the background.

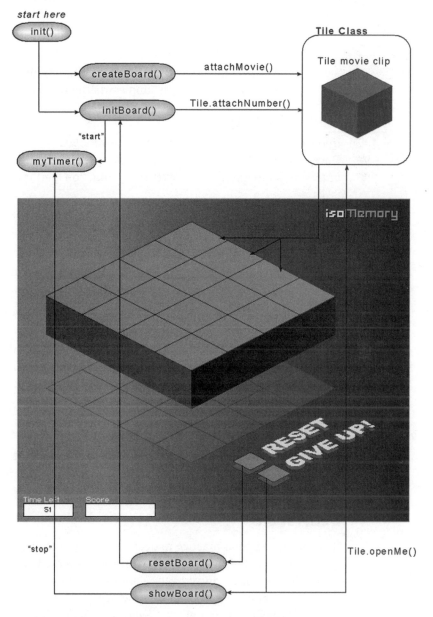

Figure 7-4. Data flowchart for the isoMemory *game.*

Game Board Initialization

When the game starts, and once all the variables have been declared, the *init()* function is called. The *init()* function calls the *createBoard()* and *initBoard()* functions, in that order. Each of these functions is examined later in this discussion, but at this point it is important to simply understand what each does, explained in the following.

- *createBoard()* physically creates the game board on stage with appropriate positioning.
- *initBoard()* initializes a new board by calling the *attachNumber()* method of the Tile class, and starts the timer.

Control Buttons

Upon clicking on the Reset button, the *resetBoard()* function is called. Once the *resetBoard()* function is completely executed, it calls the *initBoard()* function. The *resetBoard()* function performs the following tasks.

- It calls the *removeNumber()* method for all *Tile* instances and closes them.
- It returns *true* upon completion.

When the user clicks on the Give Up button, it performs the following.

- It calls the *myTimer()* function and stops the timer.
- It calls the *openMe()* method for all *Tile* instances to reveal all *Tile* numbers.

The actual intelligence for the *Tile* instances is embedded in the Tile class and inherited by each *Tile* instance. This makes the global initialization code very flexible, and independent of tile instance behavior. Let's examine the actual initialization and main movie code.

Main Methods and Functions

Let's examine the main program elements of the game. It is recommended that you follow along with the file *ch07_10.fla* located in the *fmxas/chapter07/* folder on the companion CD-ROM.

Declarations

It is considered good practice to declare all variables and constants before any of the methods and functions are encountered. In the *isoMemory* game, the variables critical to the entire game are declared at the start of the code. Examine its declarations, which are located at the top of the script attached to frame 1 of the *Global* layer. The following constants store the origin for the game board.

```
//Origin
Xo = 220;
Yo = 30;
```

The following variables store the width and height of the base tile. The dynamic placement of the tiles is dependent on these variables.

```
// Dimensions of base tile
baseWidth = 92;
baseHeight = 46;
```

The following constants define the number of rows and columns the game board will consist of.

```
// ROW?COLS
ROWS = 4;
COLS = 4;
```

The following *myDepth* variable defines a starting depth level for the game board *Tile* instances.

```
//Depths
myDepth = 100;
```

The following variable stores the player score as a timeline variable.

```
//Variables
myScore = 0;
```

Initialization

The *init()* function simply gets the ball rolling. It initializes all dynamically created portions of the game. Typically, *init()* functions in applications do not perform a task in themselves. They simply act as catalysts in starting up applications. Examine the *init()* function shown in code example 7-4.

Code Example 7-4: The init() Function

```
function init() {
 _root.createEmptyMovieClip ("origin", 50);
 origin._x = Xo;
 origin._y = Yo;
 createBoard();
 initBoard();
}
```

As shown in code example 7-4, the *init()* function performs simple initialization tasks. It firsts creates an empty movie clip called *origin* and sets

its *x* and *y* coordinates to the constants declared earlier in the game code. It then calls the *createBoard()* and *initBoard()* functions.

Board Interaction Functions

There are several functions that actually create the board elements, and communication with them occurs throughout the life of the game. Each one plays a specific role and attempts to encapsulate a complete task so as to make that task reusable.

createBoard()

The *createBoard()* function creates the board dynamically by instantiating *Tile* movie clips and assembling them using a simple isometric tile arrangement algorithm. Because this chapter is primarily focused on the Movie Clip object, it does not explicate the math behind the arrangement algorithm. For those who are really curious, it is recommended you try to draw a few iterations of the function on paper. This should make it extremely clear to you. Code example 7-5 shows the *createBoard()* function.

Code Example 7-5: The createBoard() Function

```
createBoard = function() {
  for (var i=1; i<ROWS+1; ++i) {
   for (var j=1; j<COLS+1; ++j) {
    temp = origin.attachMovie("Tile", "t_"+i+"_"+j, ¬
myDepth);
    temp._x = (baseWidth/2)*(j-i);
    temp._y = (baseHeight/2)*(j+i);
    myDepth++;
   }
  }
};
```

As shown in code example 7-5, the *createBoard()* function uses two nested *for* loops to attach *Tile* movie clips to the *origin* movie clip created in the *init()* function. These *Tile* instances are named according to their positions in the game board grid and then positioned such that they align to each other's edges. Attaching the game board to the *origin* clip allows you to make the positioning of the game board extremely flexible. For instance, at a later point, if you decide to add some more buttons and graphics on stage or want to relocate the entire board, all you would have

to change are the constants that define the *origin* movie clip's *x* and *y* coordinates *(Xo* and *Yo)*.

initBoard()

This *initBoard()* function initializes new numbers for each *Tile* instance. This function is called each time a new game is to be started. In essence, it facilitates shuffling of the *Tile* instances by interfacing with the Tile class. In addition, it also restarts the timer by calling *myTimer()*. The code for the *initBoard()* function is shown in code example 7-6.

Code Example 7-6: The initBoard() *Function*

```
initBoard = function() {
 timeLeft = 60;
 myTimer("stop");
 for (var i=1; i<ROWS+1; ++i) {
  for (var j=1; j<COLS+1; ++j) {
   origin ["t_"+i+"_"+j].attachNumber();
   origin ["t_"+i+"_"+j].enabled = true;
  }
 }
 myTimer ("start");
};
```

As shown in code example 7-6, the first thing the *initBoard()* function does is set the timer clock to read *60*. It then stops the timer so as to ensure that the timer is not ticking while the board is being shuffled. The nested *for* loops help in creating the instance names of the *Tile* instances attached to the *origin* movie clip.

Each *Tile* instance uses its own *attachNumber()* method (contained in the prototype of its parent Tile class) to initialize a new random number clip. (These methods are discussed in material to follow.) At this point, all the *Tile* instances are enabled to allow button events that may have been disabled due to found pairs. Finally, once all the *Tile* instances have their random number clips attached, the timer is started.

 TIP: *Another way to reference all Tile instances would be to store them in a lookup array the moment they are created. You may then use this array to iterate through each instance whenever needed. The "nested for loop" method was chosen for this particular example to help familiarize you with dynamic instance name creation, which is very tricky at times.*

resetBoard()

The *resetBoard()* function is called when the Reset button is released. It performs two critical tasks:

- Removes all current numbers attached to the *Tile* instances
- Closes all *Tile* instances

The code for the *resetBoard()* function is shown in code example 7-7.

Code Example 7-7: The resetBoard() *Function*

```
resetBoard = function() {
  for (var i=1; i<ROWS+1; ++i) {
    for (var j=1; j<COLS+1; ++j) {
      origin["t_"+i+"_"+j].removeNumber();
      origin["t_"+i+"_"+j].gotoAndStop(35);
    }
  }
  return true;
};
```

As shown in code example 7-7, the *resetBoard()* function is very similar to the *initBoard()* function. It simply calls the *removeNumber()* method for each *Tile* instance. Once this is done, it tells every *Tile* instance to stop at the final frame of its "close" state (examine the timeline of the *Tile* movie clip to see this). Finally, the function itself returns *true* to indicate that all *Tile* instances have been reset.

showBoard()

The *showBoard()* function is called when the Give Up button is released. It simply "opens" all *Tile* instances and then disables them from receiving button events. Code example 7-8 shows the code.

Code Example 7-8: The showBoard() *Function*

```
showBoard = function() {
  myTimer("stop");
  for (var i=1; i<ROWS+1; ++i) {
    for (var j=1; j<COLS+1; ++j) {
      origin["t_"+i+"_"+j].openMe();
      origin["t_"+i+"_"+j].enabled = false;
    }
  }
};
```

As shown in code example 7-8, this function calls the *openMe()* method for every *Tile* instance. It then sets the *enabled* property for each instance to *false*, so that even if the user attempts to click on any *Tile* instance no action occurs.

Task Functions

Each task function, described in the sections that follow, performs a specific task for the game. Each of these functions has a high frequency of calls made to it through the span of game play.

myTimer()

The *myTimer()* function handles the timing display for the game. It uses a method mechanism available in Flash MX called *setInterval()*, which allows a function to be called repeatedly at specific time intervals. Code example 7-9 reveals how it works.

Code Example 7-9: The myTime() *Function*

```
myTimer = function (myAction) {
  if (myAction == "start") {
    timeRemaining = 60;
    timer = setInterval(function () { ¬
if (timeRemaining<=0) ¬
{showBoard();clearInterval(timer);} ¬
else {timeRemaining—;timeLeft = timeRemaining;}}, ¬
1000);
  }
  if (myAction == "stop") {
    clearInterval(timer);
  }
};
```

 NOTE: *It is recommended that you read about the* setInterval() *action in the* ActionScript Reference *to get a clear understanding of its syntax and usage. Although it is a bit tricky, it is an extremely useful addition to ActionScript in Flash MX.*

Examine code listing 7-9. The *myTimer()* function accepts a string argument (either *"start"* or *"stop"*) used to evaluate what action must be taken (whether to start the timer or to stop it). Note the syntax of the *setInterval()* action. Being an action, it must be defined in a single line of code. However, you can still include a function as its first argument.

The first argument is essentially a function that performs the required task at every interval specified by the second argument. In this case, the function checks whether the time is up. If it is, the function stops the timer by calling the *clearInterval()* action. Otherwise, it decrements the counter and updates the text field. This is a really nifty way of handling a timing mechanism and is quite CPU friendly. The second argument in the *setInterval()* action simply defines the interval time, which in this case is every second (specified in milliseconds, and 1000 milliseconds equals 1 second).

calculateScore()

The *calculateScore()* function is a very straightforward function and does exactly what its name indicates: it calculates the score for each game. Code example 7-10 shows this function.

Code Example 7-10: The calculateScore() *Function*

```
calculateScore = function() {
  myScore += (timeRemaining)*100;
  score = myScore;
};
```

As shown in code example 7-10, the *calculateScore()* function simply calculates the score based on the time remaining once all number pairs have been found. It then updates the *score* text field with the new score.

fadeOverLay()

The *fadeOverLay()* function fades out the *overLay* movie clip once initialization for a new game has occurred. Code example 7-11 shows how this works.

Code Example 7-11: The fadeOverLay() *Function*

```
fadeOverLay = function() {
  _root.onEnterFrame = function() {
    overLay._alpha -= 5;
    if (overLay._alpha<=0) {
      overLay.messageField = "";
      delete _root.onEnterFrame;
    }
  };
};
```

Examine code example 7-11. Instead of having to manually create a movie clip with a tweened fade-out graphic animation, you can simply script the fade procedure using an *enterFrame()* event method attached to *_root*. This event method is triggered every time the playhead enters the first frame of the main-level timeline.

When the *fadeOverLay()* function is called, it creates a new *enterFrame()* event method for *_root*. This fades the *overLay* movie clip each time the frame is entered. Each time, it also checks to see if the *overLay* movie clip is already invisible. Once this condition becomes *true*, the function sets the *messageField* text field in the *overLay* clip to nothing. It also deletes the *_root.enterFrame()* event method and forces the function to break out of it. Hence, the fading procedure stops.

 WARNING: *At first glance you would wonder why you could not simply break out of the _root.enterFrame() event method. That would be a solution, but the approach involves a serious problem. Even if you use a break to get out of the* enterFrame() *event method, it still continues to persist in memory. This uses up valuable CPU resources. Take several hundred* enterFrame() *event methods and leave them instantiated, and the Flash player will definitely start complaining. It is good practice to clean up after yourself, and the* delete *command does exactly that, freeing up valuable CPU resources for the rest of the application.*

gameOver()

The *gameOver()* function's duties are very straightforward as well. It is called when a game is legitimately finished (i.e., all matching pairs have been found). Code example 7-12 shows its code.

Code Example 7-12: The gameOver() Function

```
gameOver = function() {
  showBoard();
  calculateScore();
};
```

As shown in code example 7-12, the *gameOver()* function simply delegates responsibilities to other functions by calling them. It calls the *showBoard()* and the *calculateScore()* functions to end a game.

Event Methods

The remainder of the main movie code consists of event methods for the movie clip buttons on stage. Each movie clip button object has three event

methods associated with it: *onRelease()*, *onRollOver()*, and *onRollOut()*. The following sections describe the code related to each.

resetButton Event Methods

You will recall that the Reset button allows the user to reset the game. Code example 7-13 shows the three event methods associated with the Reset button.

Code Example 7-13: resetButton *Event Methods*

```
resetButton.onRelease = function() {
      overLay._visible = true;
      overLay._alpha = 100;
      overLay.messageField = "Initializing";
      if (resetBoard()) {
            initBoard();
      }
      fadeOverLay();
};
resetButton.onRollOver = function() {
      this._y += 2;
};
resetButton.onRollOut = function() {
      this._y -= 2;
};
```

In code example 7-13, the first event method assigned to the *resetButton* button movie clip is the *onRelease()* event method. It simply makes sure that the *overLay* movie clip becomes visible to show the reset status to the user. It then calls the *resetBoard()* function to reset the board elements, and once this function returns *true*, the *initBoard()* function is called to initialize a new game board. This marks the end of the initialization process, and hence the *fadeOverLay()* function is called to fade out the *overLay* movie clip. The *onRollOver()* and *onRollOut()* event methods simulate a button click by using the *_y* setter of the movie clip button instance to shift its position.

The giveupButton Methods

The Give Up button allows the user to immediately end the game by revealing the matched pairs. Code example 7-14 shows the event methods associated with the Give Up button.

Code Example 7-14: **giveUpButton** *Event Methods*

```
giveupButton.onRelease = function() {
     showBoard();
};
giveupButton.onRollOver = function() {
     this._y += 2;
};
giveupButton.onRollOut = function() {
     this._y -= 2;
};
```

As shown in code example 7-14, the *giveupButton* button movie clip's event methods are fairly straightforward. The *onRelease()* event method triggers the *showBoard()* function, whereas the remaining event methods are similar to those for the *resetButton()* button movie clip.

Tile Class, Properties, and Methods

Let's turn our attention to the Tile class. The Tile class is attached to the *Tile* movie clip in a fashion similar to that described in Chapter 2. The Tile class encapsulates several methods and properties with which each *Tile* movie clip instance is populated. This is not true encapsulation, however, as none of the methods bears a realistic *public* or *private* classification. This text does not deal with *public* and *private* methods simply because their implementation in Flash is weak at best.

Nevertheless, the *Tile* movie clip is extremely intelligent. Every instance of the *Tile* movie clip exists independent of another, yet references master variables and arrays common to the class itself. The *Tile* instances interact with each other to ensure a reliable shuffling process, seamless pair tracking, and intelligent event handling.

Each *Tile* movie clip instance is also a button movie clip, giving it interaction capabilities of its own. Most of the intelligence for the Tile class is attached to its prototype object. This enables efficient CPU resource allocation. Before you begin dissecting the scripting associated with the Tile class, you need to familiarize yourself with the *Tile* movie clip itself. Let's examine it.

Anatomy of a Tile

The *Tile* movie clip has four main graphics layers, as shown in figure 7-5.

The layers shown in figure 7-5 are arranged bottommost to topmost. For instance, the layer *Box back* is the bottommost layer, and *Box front* is

Figure 7-5. Layer structure for Tile *movie clip.*

the topmost. The middle layers contain movie clip instances. The *nContainer* layer contains an instance of the *numberContainer* movie clip symbol, which will act as a container for a number of movie clips. The *Box lid* layer contains an instance of the *lid* movie clip symbol. This movie clip will be tweened to produce the effect of the lid closing, as well as the lid being flipped when a pair is found.

NOTE: *It is recommended that you examine the* Tile *movie clip symbol's timeline to get an idea of how the various Tile states (*init, open, close, found*) are established.*

Data Flow Overview

Examine figure 7-6, which shows the data flow for the Tile objects. As you read further, figure 7-6 will start to make more sense. At this point, simply note the following.

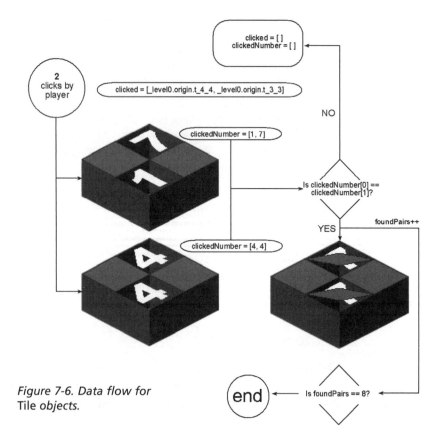

Figure 7-6. Data flow for Tile *objects.*

- When the player clicks on a *Tile* instance, aside from the properties of that instance, a few Tile class variables (common to all *Tile* instances) are updated. These are as follows.

 — *clicked:* Array that stores a reference to the Tile instance just clicked. Each time a pair of Tile instances is clicked, this array is reinitialized and awaits more player clicks.

 — *clickedNumber:* Array that stores the actual number just clicked as a string literal. This is used to check if two consecutive clicks make a like pair. Each time a pair of Tile instances is clicked, this array is reinitialized and awaits more player clicks.

 — *foundPairs:* Variable that stores the number of pairs already found.

- The game continues if any of the following conditions is *true*.

 — There is time remaining.

 — The Give Up or Reset button has not been clicked.

 — All eight pairs have not been found.

Variables, Methods, and Properties

Let's examine the Tile class. If you have not already done so, open the file *ch07_10.fla* located in the *fmxas/chapter07/* folder on the companion CD-ROM, to the code on the first frame of the *Tile* movie clip, and follow along.

Declarations

The first thing you need to examine is the variable declarations section. It is important to know what each variable tracks and how the various methods interact with them. Let's examine them, beginning with *totalElements*, shown in the following.

```
totalElements = ["0", "0", "0", "0", "0", "0", "0", "0"];
```

This array is used in the number initialization process. It is accessed by the *attachNumber()* method. Each time a valid random number is generated for a *Tile* instance, the corresponding index for that number in this array is incremented. For example, when a 1 is attached to a *Tile* instance's *numberContainer*, the previously shown array would look as follows.

```
totalElements = ["1", "0", "0", "0", "0", "0", "0", "0"];
```

When a second 1 is attached, the array would look as follows.

```
totalElements = ["2", "0", "0", "0", "0", "0", "0", "0"];
```

 NOTE: *The corresponding index in the array for a number is one less than the value of the number.*

The next item initialized is the clicked array, as follows.

```
clicked = [];
```

As mentioned, the *clicked* array stores a reference to the *Tile* instance just clicked on. Each time a pair (like or unlike) of *Tile* instances is clicked, this array is reinitialized and awaits more player clicks. Following *clicked* is the *clickedNumber* array, as follows.

```
clickedNumber = [];
```

This array stores as a string literal the actual number just clicked. It is used to check if two consecutive clicks make a like pair. Each time a pair of *Tile* instances is clicked, this array is reinitialized and awaits more player clicks. The last item is *foundPairs*, written as follows.

```
var foundPairs = 0;
```

This variable stores the number of like pairs already found.

Constructor

The constructor function for the Tile class simply initializes the *state* instance variable. This tracks the current state of any *Tile* instance. Possible states are *open*, *closed*, and *found*. Code example 7-15 shows the constructor.

Code Example 7-15: Tile *Constructor Function*

```
function Tile() {
  this.state = "closed";
}
```

Initialization and Reset Methods

The initialization methods primarily deal with generating, validating, and attaching random number movie clips to the *Tile* instance's *numberContainer* movie clip. The reset methods clear up *numberContainers* for reuse.

randomNumber()

The *randomNumber()* method generates a random number between 1 and 8 and returns it to the calling function, as shown in code example 7-16.

Code Example 7-16: The randomNumber() Method

```
Tile.prototype.randomNumber = function() {
  this.myRandom = Math.round (Math.random()*10) +1;
  if (this.myRandom > 8) {
   this.myRandom = 8;
  }
  return this.myRandom;
};
```

As shown in code example 7-16, the random number function method generates a variable called *myRandom* while it stores a random number between 1 and 11. The *if* condition that follows reverts all numbers greater than 8 to 8.

attachNumber()

The *attachNumber()* method is recursive. It evaluates a generated random number using the lookup array *totalElements* to make sure that more than two instances of the same number movie clip are never attached on stage during any game. The method simply takes a random number between 1 and 8 (inclusive), and checks how many instances of the number movie clip, corresponding with that number, have been created this far. If no more than one is present, it attaches the number clip corresponding to that random number to the *numberContainer* movie clip for the *Tile* instance and names it accordingly. In addition, it updates the *totalElements* array to reflect the newly added number movie clip.

In case two number movie clips have already been used, the method calls itself. Therefore, this recursive method has two base cases. One checks whether no instances of the respective number movie clip are already present, and the other checks if one instance is present on stage. In either case, the method carries out its required actions and returns, as shown in code example 7-17.

Code Example 7-17: The attachNumber() Method

```
Tile.prototype.attachNumber = function() {
 this.myRandom = this.randomNumber();
 this.myRandomString = this.myRandom.toString();
 if (totalElements [this.myRandom-1] == "0") {
  this.numberContainer.attachMovie(this.myRandomString, ¬
  this.myRandom, this.myRandom);
  totalElements[this.myRandom-1] = "1";
```

```
} else if (totalElements [this.myRandom-1] == "1") {
 this.numberContainer.attachMovie(this.myRandomString, ¬
 "d"+this.myRandom, this.myRandom+8);
 totalElements[this.myRandom-1] = "2";
} else if (totalElements[this.myRandom-1] == "2") {
 this.attachNumber();
 }
};
```

As shown in code example 7-17, the first line calls the *randomNumber()* method and stores the random number in the variable *myRandom*. The second line converts this number to a string literal and stores it in the *myRandomString* variable. Keep in mind that this method is being called simultaneously by 16 *Tile* instances. Hence, it is pointless to keep track of which number clip has already been attached to which *Tile* instance, as this could get confusing. Instead, you simply keep track of the number of instances of already-attached number movie clips and make sure that no more than one like pair of each number movie clip is instantiated.

The first condition attaches a number movie clip to the current *Tile* instance's *numberContainer* only if no instances of this number movie clip exist in the game. Once it does this, it updates the *totalElements* array to "*1*", indicating that one instance of a particular number is now on stage. Similarly, the next condition repeats this process if only one instance of the particular number movie clip already exists on stage.

The final condition checks if two instances of this particular number clip exist on stage. If this condition returns *true*, the entire process is restarted. Essentially, this process has a completely random nature. Often it takes only one recursive call to attach a valid number movie clip. It follows that often it takes more than one recursive call. Typically, the first few number movie clip instances get attached within the first call.

removeNumber()

The *removeNumber()* method does exactly what its name indicates: it removes a number movie clip already attached to a *Tile* instance's *numberContainer,* as shown in code example 7-18.

Code Example 7-18: The removeNumber() *Method*

```
Tile.prototype.removeNumber = function() {
 for (var property in this.numberContainer) {
  if (typeof this.numberContainer [property] == ¬
```

```
"movieclip") {
    this.numberContainer[property].removeMovieClip();
  }
 }
 this.resetVariables();
};
```

If you look at code example 7-18, you will note that the process seems quite strange. The *for...in* loop structure has been used to traverse through all movie clip instances attached to the *numberContainer* instance of the *Tile* instance. All instances found within it are removed using the *removeMovieClip()* method. This has the effect of removing any movie clip attached to *numberContainer*. Finally, this method calls the *resetVariables()* method.

resetVariables()

The *resetVariables()* method resets all Tile class variables. It is called when a new game is to be started, as shown in code example 7-19.

Code Example 7-19: The resetVariables() Method

```
Tile.prototype.resetVariables = function() {
  totalElements = ["0", "0", "0", "0", "0", "0", "0", "0"];
  clicked = [];
  clickedNumber = [];
  this.state = "closed";
  this.closeMe();
  foundPairs = 0;
};
```

As shown in code example 7-19, this method simply resets all class variables and arrays.

State Methods

The following methods deal with tracking and toggling the state variable of *Tile* instances.

openMe()

The *openMe()* method opens a *Tile* instance to reveal its associated number, as shown in code example 7-20.

Code Example 7-20: The **openMe()** *Method*

```
Tile.prototype.openMe = function() {
  if (this.state != "opened") {
    this.gotoAndPlay ('open');
    this.state = "opened";
  }
};
```

 As you can see in code example 7-20, this method opens a *Tile* instance if its *state* is not already equal to "open." It does this by sending the playhead of the movie clip to the frame with the label named *open*. It then updates the state of the *Tile* instance.

closeMe()

The *closeMe()* method closes a *Tile* instance to conceal its associated number, as shown in code example 7-21.

Code Example 7-21: The **closeMe()** *Method*

```
Tile.prototype.closeMe = function() {
  if (this.state != "closed") {
    this.gotoAndPlay ('close');
    this.state = "closed";
  }
};
```

 As you can see in code example 7-21, this method closes a *Tile* instance if its *state* is not already equal to "closed." It does this by sending the playhead of the movie clip to the frame with the label named *close*. It then updates the state of the *Tile* instance.

foundMe()

The *foundMe()* method indicates that the *Tile* instance is one of a found like pair, and performs the associated actions, as shown in code example 7-22.

Code Example 7-22: The **foundMe()** *Method*

```
Tile.prototype.foundMe = function() {
  this.gotoAndPlay ('found');
  this.state = "found";
```

```
 this.enabled = false;
};
```

As you can see in code example 7-22, this method indicates that the *Tile* instance is one of a found like pair. It does this by sending the play-head of the movie clip to the frame with the label named *found*. It then updates the state of the *Tile* instance and sets its *enable* property to *false*, so that a user may not click on it anymore.

foundPair()

The *foundPair()* method returns *true* if the two elements of the *clickedNumber* array are equal, as shown in code example 7-23.

Code Example 7-23: The foundPair() Method

```
Tile.prototype.foundPair = function() {
 if (clickedNumber[0] == clickedNumber[1]) {
  return true;
 } else {
  return false;
 }
};
```

foundAll()

This method is called when all eight like pairs have been found. It invokes the *_root* level function *gameOver()*, as shown in code example 7-24.

Code Example 7-24: The foundAll() Method

```
Tile.prototype.foundAll = function() {
 _root.gameOver();
};
```

toggleState()

The *toggleState()* method is called each time a *Tile* instance is clicked. It decides whether the *Tile* instance needs to be opened, closed, or marked as found, and carries out the necessary actions, as shown in code example 7-25.

Code Example 7-25: The toggleState() *Method*

```
Tile.prototype.toggleState = function() {
 clicked.push (this);
 clickedNumber.push (this.myRandomString);
 if (!this.foundPair()) {
  if (clicked.length < 2) {
   this.openMe();
  } else {
   this.openMe();
   this.closeMe();
   clicked[0].closeMe();
   clicked = [];
   clickedNumber = [];
  }
 } else {
  this.foundMe();
  clicked[0].foundMe();
  foundPairs++;
  clicked = [];
  clickedNumber = [];
  if (foundPairs == 8) {
   this.foundAll();
  }
 }
};
```

Examine code example 7-25. First, this method adds a reference to the current *Tile* instance to the *clicked* array. It then adds the actual number value of the current *Tile* instance to the *clickedNumber* array. The first condition calls the *foundPair()* method. If this returns *false*, it confirms that only one *Tile* instance is already open on stage. If this returns *true*, it calls the *openMe()* method to open the current *Tile* instance. Otherwise, it calls the *openMe()* method to open the current *Tile* instance, and then closes both open *Tile* instances by calling the *closeMe()* method for each. It then resets both *clicked* and *clickedNumber*.

In case the *foundPair()* method returns *true*, the *foundMe()* method is called for each instance of the like pair. The *foundPairs* class variable is then incremented and the arrays *clicked* and *clickedNumber* are reset. Finally, an *if* condition checks if all the pairs have been found. If this returns *true*, the *foundAll()* method is invoked.

Event Methods

These methods handle events for *Tile* instances. Only one event method has been declared for the Tile class, as shown in code example 7-26.

Code Example 7-26: The onRelease() event *Method*

```
Tile.prototype.onRelease = function() {
  if (this.state != "opened") {
    this.toggleState();
  }
};
```

Code example 7-26 shows that the *onRelease()* event method simply calls the *toggleState()* method to change the state on the *Tile* instance just clicked.

■ ■ ■ **Summary**

This chapter showed you the power of movie clips. Of course, this chapter did not cover every use of a movie clip method, but simply gave you a detailed picture of how they may be used in various scenarios. You have probably already realized that movie clips are central to any application in Flash. As you proceed to deconstruct more advanced examples, this will become increasingly clear to you. It is imperative that you become extremely comfortable with all aspects of the Movie Clip object.

8

Dynamic Data Exchange in Flash MX

▪ ▪ ▪ **Introduction**

Most newcomers to Flash are not aware that Flash can display extremely dynamic content. In fact, once you get the hang of it, it is simpler to display dynamic content using Flash MX than it is, for example, using an HTML page. Why? There are two very good reasons. First, applications created using Flash MX can have a rich, predefined interface—much more so than can be provided with most other technologies, most notably HTML. Displaying dynamic content in Flash MX is simply a matter of developing a seamless mechanism for exchanging data or content between client and server, and there are many technologies that can be used as the bridge. Regardless, Flash provides an extremely rich way of putting a front end on dynamic web content.

The second reason is that Flash MX makes it possible to separate content from appearance. Whereas appearance is predefined, static, and constant (the interface), content can be changed as necessary. The great thing about such a paradigm is increased efficiency and speed in regard to exchange of data between client and server.

The bottom line is that at some point in your career you will come across a situation in which manually updating content will be impossible. For instance, if you were running a game on your web site and wanted to

keep track of the top scores, it would be virtually impossible to update the scores manually from a text file every day. Also for example, if you displayed a new "thought for the day" every day, it would be silly for you to open up the FLA file and change the content of a text field manually each day.

This chapter explores creating dynamic content. Flash MX comes with a new client/server object group that eliminates several inconsistencies associated with using dynamic content in Flash 5. A single chapter cannot cover every development possibility using client/server objects, but the chapter does cover the fundamental principles and techniques involved.

It is beyond the scope of this book to delve deeply into the issues of database design, normalization, and server-side scripting languages. It is left to you to get up to speed with these topics. Wherever possible, guidelines and tips on these issues are provided. However, it is in your interest to research sources on database design and normalization, as well as to learn a server-side scripting language. Microsoft Active Server Pages (ASP) and Microsoft Access are used for the examples related to this discussion. Note, however, that the solutions provided, with some modification, could be applied to any combination of database and server-side technology. Before continuing, the following are prerequisites to making the best use of the information provided here.

- Microsoft Access 2000

- Access to a web server that can host ASP written in VBScript (that is, ASP support)

- A working knowledge of uploading/downloading via an FTP client

Objectives

In this chapter you will:

- Examine client/server data exchange scenarios between Flash and a server.

- Learn the methods and properties associated with the *LoadVars* object and how to apply them.

- Examine methods of sending/receiving data between Flash and a server

- Examine methods of retrieving content from a database using *LoadVars*

- Dissect an advanced example using the concepts introduced in this chapter

■ ■ ■ The Power of Server-side Scripting

Why use server-side scripting or dynamic content? Developers often over-look this fundamental question. Today, making a "database-driven" web site has become sort of a cliche. Although dynamic content is extremely powerful, there are several scenarios in which you do not need to employ it. In fact, if used in the wrong scenario, dynamic content can reduce the functionality and manageability of your project.

So, how do you decide what approach is best suited for a project? If you answer yes to any of the following questions, chances are you need some sort of a data store to serve content dynamically to your clients.

- Is the content in my Flash movie going to change frequently?
- Do I need to provide different clients with different content (i.e., will the content be user specific)?
- Do I need to validate clients before I can show them content?
- Do I want clients to be able to communicate with me interactive-ly and quickly?
- Do I need to store a client's input or display a client's input to another user or page?

It is critical that you analyze your audience, the infrastructure available to you, and tasks you wish to accomplish before you dive into creating a dynamic application or web site. Keep in mind the following trade-offs associated with the use of dynamic content.

- Increased download times
- Possibility of server being down (less common these days)
- Any number of execution errors
- Unforeseen human-induced errors, such as insertion anomalies in the database, faulty SQL queries, and so on

Fortunately, database packages and other development tools have come a long way in the past few years. Today, virtually anybody can put together fairly simple web applications using wizards and other user-friendly mechanisms. It essentially comes down to two things: form and function. Does the form of your application dictate the use of dynamic content, and more important, does it make provisions to display such content? Does the introduction of dynamic content enhance the function of the application itself? If you can answer yes to these two questions, you need to employ a dynamic mechanism. This could mean simply using an ASP file, or it could mean using a complex, full-blown SQL Server Enterprise-driven front end.

Flash MX Versus Flash 5

From a client/server point of view, Flash MX represents a significant advance over Flash 5. Flash 5 incorporated the following primary actions that enabled data exchange between Flash and a server-side page.

- *loadVariablesNum()*
- *loadVariables()*

These two actions are not discussed here, simply because their uses are too limited to achieve anything substantial. Instead, the focus here is on use of the *LoadVars* object. If you have had any experience with the XML object in Flash 5, this chapter should be a cinch for you to pick up. If you have not had any XML experience in Flash 5, this chapter is a must read for you. Although the ActionScript reference does a fairly decent job of documenting this object, it does not explore in depth its wider implications and implementations.

Let's explore Flash MX's new *LoadVars* object. The best feature of this object is its similarity to the XML object. In fact, its methods use an implementation procedure identical to that of the XML object. What does this mean to you as a developer used to the looping, procedural *gotoAndPlay()* methodology? Flash MX simply marks the end of those types of solutions. The *LoadVars* object can use callback functions, eliminating the need for loops that constantly check to see if the server's response has arrived yet.

The *LoadVars* object is examined closely in the sections that follow, including examples as needed. It is true that the *LoadVars* object cannot do as much as the XML object, but again, it comes down to the question of preference and need. It makes no sense to use the XML object and an XML-based back end if you do not plan on sharing the same content with other applications, or if you simply want to perform some rudimentary remote tasks. There is no question that an XML-based solution will prove to be extremely portable and scalable, but if you simply want to implement something with considerable ease and promptness, *LoadVars* is the way to go.

Data Exchange Model

The data exchange process between Flash and a data store is similar to that between an HTML form and a data store. However, there are some subtle differences between the two. This section describes the respective data exchange processes and explores the differences between them.

You have probably dealt with sending and receiving data from HTML forms. If not, you have probably filled out a form online at some point in time. It is crucial to understand what happens when your browser

requests a form document and you subsequently fill it out and send it. To illustrate this process, let's create a hypothetical message board application. Let's first do this using HTML for the front end (often called the *presentation layer*), and then duplicate the process using Flash MX.

HTML

First, let's define the tasks at hand and the structure of the application. For the sake of clarity, let's keep it simple. The goal of the message board is to allow clients to fill out a simple feedback form and submit it. There should also be a viewing section in which a client may view posted messages. To wrap up our message board, let's provide a security mechanism for logging in and registering. That should be enough to get the application up and running.

Now that the tasks are defined, let's make a tentative list of documents needed to make these happen. In an attempt to keep this simple, let's assume that each form page will have a corresponding action page. (Technically, this entire application could be made with one massive ASP document, but for obvious reasons this is discouraged.) The document structure is better explained with a diagram, as shown in figure 8-1.

As you can see in figure 8-1, the application would need nine documents at the very least. You might divide the documents into three categories or sections, as shown in the figure. The Login section handles the display and actions related to the log-in page. The Registration section handles the registration process for new users. The Message Board section is the application itself. Next, you need to examine how the data flow would occur, as depicted in figure 8-2.

Figure 8-1. Message board HTML example showing necessary documents.

Figure 8-2. Message board HTML example showing data flow.

For the sake of simplicity, let's assume that a client is first sent to *login.asp*. If the client cannot log in successfully, it is assumed the client is not a registered member and is therefore sent to *register.asp*. Once the client has registered successfully, he is directed to *menu.asp*. Here, he may choose to post or view messages. Based on what he selects, he is sent to the applicable page. With this basic idea laid out, let's examine what happens right from the start, when a new client requests the log-in page.

When a client initially hits the application, the server sends him *login.asp* (because this is the default page), which contains a log-in form. The client fills out the required fields and submits the form to *login_a.asp* (the action page that carries out the validation). *login_a.asp* retrieves the form information and validates it against a database. Because the client is not a registered member, no match is returned and *login_a.asp* redirects him to *register.asp*. Once the client has filled out the registration form, he submits the page to *register_a.asp*. If there are no errors, the client is logged in with his new user name and password and is redirected to *menu.asp*.

Let's say the client decides to post a message and clicks on the "post message" link. This page requests the post form page, *post.asp*. The client types out a message and submits the form to *post_a.asp*. This document contains the actions for inserting the new message into the database and then reporting the outcome to the user. With this successfully completed, the client is redirected to *menu.asp*. Now, let's assume the client decides to view messages and clicks on the "view messages" link. He is now served *view.asp*. This page gives him search features. It is submitted to *view_a.asp*, which contains the necessary information for retrieving the search query and displaying it to the client.

As you just saw, it required eight pages to perform four simple tasks: log-in, registration, post, and view. In addition to carrying out necessary tasks, each action page (such as *login_a.asp*) returns not only dynamic content, but also the code for presenting it (i.e., integrated HTML tags in the returned data). This is terribly inefficient, because the actual data is mixed with the presentation tags. Basically, with this ideology, each task requires a trip to the database to retrieve the data and then custom "assembly instructions" to display this data by wrapping the content in HTML.

Even less efficient is the fact that the data and the presentation layer get interspersed and may not be reused. Imagine yourself having to drop your car off at the mechanic's to get your oil changed. If you compared it to the classic dynamic application development process just examined, your mechanic would completely take the car apart, change the oil, put it back together, and deliver it to you! That is quite a lot of hassle for such a small task. Enter Flash MX.

Flash MX

CLIENT-SIDE

SERVER-SIDE

Figure 8-3. Message board Flash MX example showing document structure.

Let's examine how this task would be undertaken in Flash MX. Again, let's first define the document structure and data flow. Let's assume that the entire message board application exists in a single SWF file. Examine figure 8-3.

You probably instantly noticed the great difference in document structure between the HTML version and Flash MX version. The application can be broken up into two intuitive sections: client side and server side. Flash MX enables complete separation between the two layers of a dynamic application; that is, presentation and data. On the presentation side (client side) there are only two files. *index.html* is simply the container for the Flash movie. The guts of the application (forms and menus) exist within *board.swf*, the solitary SWF file. If you wanted, you could use multiple SWF files and load them into a single container. (Such scenarios are discussed in material to follow.)

The server-side section includes one document, *index_a.asp*. This is the action page that will be called by *board.swf* to execute server-side actions. In this case, all action pages are consolidated into a single page that will receive a custom query string to execute any required task. The neat thing about this methodology is that the presentation and data layers exist in symbiosis (i.e., do not conflict).

So what happens when a client browser requests the default page of the application? As shown in figure 8-4, the server sends it *index.html*. This document contains the embedded SWF file, *board.swf*. Within *board.swf* exists a user interface for the log-in, registration, post, and view forms. Each of these forms communicates with *index_a.asp* using custom query strings. For instance, when a client clicks on the submit button for the registration process, Flash performs a *sendAndLoad()* post using the following query string: *index_a.asp?mode = register*. Using this technique, you can centralize all of your code efficiently in a single server-side script and reduce file management issues.

Note that there is also a database entity present that is not shown in figure 8-4. The document *index_a.asp* uses subroutines to query and update the database based on the requests it receives from *board.swf*. The most powerful characteristics of this approach are scalability and portability. Because the presentation and data layers remain very distinct from each other, each may be manipulated extensively to customize overall out-

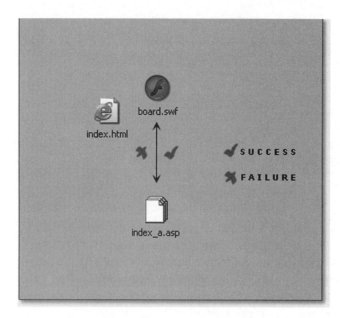

comes without affecting the other. This proves very useful for an *n-tier* approach, in which each tier is responsible for implementing a specific topic. This tiered approach enables designers to concentrate on designing, programmers to concentrate on programming, and database experts to concentrate on database development. In essence, it facilitates an object-oriented development environment.

Figure 8-4. Message board Flash MX example showing data flow.

Client/Server Objects

Flash MX lists the following objects under the Client/Server grouping in the Actions panel.

- LoadVars
- XML
- XML Socket

This chapter primarily deals with the *LoadVars* object. Although this object comes with only a few methods and properties, it is nonetheless an extremely powerful object. Essentially, it fixes the problems of its predecessors, the *loadVariables()* and *loadVariablesNum()* actions. Let's examine the *LoadVars* object.

The LoadVars Object

This section explores the *LoadVars* object without comparison to the XML object for the benefit of those who have never dealt with the XML object. However, it is expected that you know the general workings of the *loadVariables()* action. The *LoadVars* object is an elegant solution for transferring variables between client and server (i.e., the Flash movie and the server). *LoadVars* has numerous uses, including the following. These are highlighted in the sections that follow so that you can get a clear picture of how this object is used.

- Send variables to a server from Flash to update a database
- Receive variables from the server to display within a Flash movie
- Receive error information about variable transfer failures (i.e., feedback from the server)
- Receive progress indicators for display in a Flash movie
- Request custom records from a database

These are but a few of the potential uses of the *LoadVars* object, but there are a few things you need to know before you can begin using the *LoadVars* object extensively. Unlike several other objects, *LoadVars* has some peculiarities with regard to syntax and implementation. Among these are the following.

- The *LoadVars* object must be instantiated using the constructor *new LoadVars()*. Without this statement, you will not be able to use the object. The object is instantiated as follows.

```
myVars = new LoadVars();
```

- The *LoadVars* object transfers name and value pairs of variables.

Aside from this, there is not much to the *LoadVars* object constructor. Once you have instantiated the object, you many use it to perform various tasks. You may also have multiple *LoadVars* instances on stage. With the basics out of the way, you are now ready to examine the methods and properties of the *LoadVars* object.

■ ■ ■ **Method and Property Summary**

This section explores the methods and properties of the *LoadVars* object. Discussion of relevant concepts are supported by numerous examples. It is recommended that you have access to a server for testing the examples in this chapter. Typically, almost all server-side development is quite easy to understand in theory. However, due to the lack of debugging facilities within Flash, many things can go wrong. Some problems simply require some experience to resolve, in combination with testing on a live server.

 WARNING: *It is recommended that you try to improvise on each example and build some of your own from scratch. Working with server-side scripts and Flash is like doing a math: it all seems perfectly fine in theory, but when you are thrown a pen and a piece of paper, you often do not know where to start solving the problem. You need to do three things to become an effective developer of dynamic applications in Flash: practice, practice, and more practice!*

Methods

The *LoadVars* object has very few methods. However, they are all very useful and it would benefit you to know them well. Each method is discussed in detail in the material that follows, including appropriate examples. It is also recommended that you review the *ActionScript Reference* for further information about this object. Table 8-1 outlines methods associated with the *LoadVars* object.

Table 8-1: LoadVars *Object Method Summary*

Method	Summary
load()	Downloads a set of variables from a specified URL
getBytesLoaded()	Returns the total number of bytes loaded from a *load()* or *sendAndLoad()* method
getBytesTotal()	Returns the total number of bytes that will be downloaded by a *load()* or *sendAndLoad()* method
send()	Sends variables from a *LoadVars* object to a URL
sendAndLoad()	Sends variables from a *LoadVars* object to a URL, and downloads the server's response to another *LoadVars* object
toString()	Returns a string containing all name and value variable pairs for a particular *LoadVars* instance

For the sake of convenience, the following material examines the *LoadVars* object's only event handler, outlined in table 8-2.

Table 8-2: LoadVars *Object Event Summary*

Event	Summary
onLoad()	Invoked when a *load()* or *sendAndLoad()* operation has completed

load()

The first method you will probably come across for the *LoadVars* object is *load()*. Essentially, this method allows a Flash movie to download variables from a text file or a server-side script. The variables must be in *application/x-www-urlform-encoded* format for Flash to recognize them.

 NOTE: *Most server-side scripting languages provide a function for URL-encoding data, similar to Flash's* escape() *function. Before a script passes data to Flash, you must ensure that it is URL encoded.*

One thing to keep in mind about the *load()* method is that the variables that are being received must be in the form of a string of name and value pairs, separated by the ampersand (&) character, an example of which follows.

```
subject=Hello&message=world
```

When such a string is received in response to a *load()* call, the variables therein become available as properties of the *LoadVars* instance. Let's examine the syntax in detail to get a better idea. The basic syntax for this method is as follows.

```
myLoadVars.load(url)
```

Here, *myLoadVars* is the object in which the received variables are stored, and *url* is the URL from which the variables should be downloaded (this may be a text file or a server-side script). Assuming you have instantiated an object called *myLoadVars*, when this method is called, it requests the *url* in question for a set of variables in the string format examined earlier. It should be noted that if *myLoadVars* has any properties with the same name as one of the variables being loaded, the properties get overwritten. However, *myLoadVars* will retain all properties that belong to it and that have different names than the downloaded variables.

Let's take a look at a few examples. In the following example, the *load()* method downloads a string containing a variable name and value pair from the file in the same folder called *my_variables.asp*, and then parses this string and stores the variables as properties in *myVars*.

```
myVars.load("my_variables.asp");
```

Let's see what this means. If the following string were passed back to the Flash movie, *myVars* would contain two properties, *var1* and *var2* (with the values *Hello* and *World*, respectively).

```
var1=Hello&var2=World
```

There is one very important thing to note when using the methods for the *LoadVars* object. All of this exchange of information does not occur instantaneously. Due to this problem, you have to establish a means of catching the loaded variables after an indefinite delay (the delay depends on the size of the string, server traffic, net traffic, and so on).

In Flash 5, these scenarios were handled by making looping segments within the timeline. For instance, a *loadVariables* action could be called in frame 1, and frame 3 would contain some mechanism to detect whether the variables had arrived yet. If they had not, the playhead would be sent back to frame 2 and this process would repeat until the variables arrived or until some alternative action was called. This was a very clumsy way of

handling such scenarios, but due to the lack of any built-in method Flash 5 developers had no alternative but to resort to it.

Fortunately, Flash MX does away with these inconveniences. Flash MX now comes with the following primary event handlers for catching loaded data/variables from external files.

- *MovieClip.onData()*
- *LoadVars.onLoad()*

Both methods are fairly straightforward to use. We recommend that you take a look at the *ActionScript Reference* for syntactical details. Although examples have been provided using both approaches to catching loaded variables, this chapter explores only the *onLoad()* handler.

 CD-ROM NOTE: *To follow along with the description of the* onLoad() *handler, open the file* 1.fla *located in the* fmxas/chapter08/ch08_01/ *folder on the companion CD-ROM.*

onLoad()

The *onLoad()* handler is used in conjunction with the send and load methods to actually receive variables. It is crucial to understand this event method early in this discussion, as it is used as the primary handler for the *LoadVars* object.

The previous section discussed the *load()* method. You saw that when a *load()* method is invoked, it requests variables from a given URL. These variables can originate from anywhere. For instance, they may be dynamically generated from a server-side calculation or pulled from a record set of a database. Essentially, the request could take an indefinite amount of time to be fulfilled, within which the requesting Flash movie may have already moved on to another frame.

To prevent this from happening, the *onLoad()* handler may be invoked. Once a *load()* procedure has been called for an object, you may assign an *onLoad()* handler to check for the arrival of the requested data. You might think of this as some sort of a listener working in the background, constantly checking if the variables have arrived. The exact syntax of the *onLoad()* handler is as follows.

```
myLoadVars.onLoad(success)
```

Here, *myLoadVars* is the instance name of the *LoadVars* object, and *success* is a parameter that indicates whether the load operation was successful or not. As you will notice after working through the examples in this section, *success* is not really required. There are several ways to call the *onLoad()* handler. The following sections describe two of the ways this can transpire.

Using an Anonymous Function

The approach of using an anonymous function directly assigns a user-defined function to the *onLoad()* handler. You should use this approach when performing single-load procedures (i.e., when you do not plan on using the same load procedure more than once). Examine code example 8-1, which demonstrates this approach.

Code Example 8-1: Assigning an Anonymous Function to Handle an onLoad()

```
myVars = new LoadVars();
myVars.onLoad = function () {
  for (var i in this) {
    trace (i + ". " + this[i]);
  }
};
myVars.load("foobar.asp");
```

As shown in code example 8-1, an object *myVars* is instantiated and its *load()* method is invoked. Before that, an anonymous function is declared, which handles the *onLoad()* event for *myVars*. The following Note points out one important thing to keep in mind.

 NOTE: *The* this *keyword refers to the object* myVars. *Because all variables loaded become properties of the* myVars *object, they may be retrieved with the customary for...in loop.*

Using an Assigned Function

In the approach of using an assigned function, you must declare a function in the customary way and then assign this function's name to the *onLoad()* handler. This approach is preferred when you anticipate calling the *load()* method several times over the life of the movie. Examine code example 8-2.

Code Example 8-2: Assigning a Named Function to Handle an onLoad()

```
myVars = new LoadVars();
myVars.onLoad = checkLoaded;
checkLoaded = function () {
  for (var i in this) {
    trace (i + ". " + this[i]);
```

```
   }
};
myVars.load("foobar.asp");
```

In code example 8-2, the named function is assigned to the *onLoad()* handler for the *myVars* object. Note that no parentheses are required after the name of the function.

 CD-ROM NOTE: *To see a further example of use of an assigned and named function, open the file* 2.fla *located in the* fmxas/ chapter08/ch08_02/ *folder on the companion CD-ROM.*

send()

The previous sections taught you how to use *load()* and *onLoad()* to load and catch variables from an external file or a server-side script. As the need to retrieve data is great, so is the need to send data, either for some sort of server-side processing or to insert into a database. The *send()* method does exactly this. It allows you to send a set of name and value pairs to a script. Let's examine the exact syntax of the *send()* method, which follows.

```
loadVarsObject.send(url [,target, method] )
```

Here, *loadVarsObject* is the instance name of the *LoadVars* object that holds the variables to be sent, *url* is the URL to upload the variables to, *target* is the browser frame window in which the response from the script is displayed, and *method* is the request/response HTTP protocol (i.e., *GET* or *POST*). Because this method is not really documented well in the *ActionScript Reference*, let's examine more closely how it may be used.

Sending Variables to a URL

Simply put, the *send* method needs only two arguments, as shown in the following code.

```
myVars.send("myScript.asp", "POST")
```

This line would post all variables in *myVars* to the given URL. In some cases, you would use the *target* parameter as well. This is similar to frame/window targeting in HTML using *_blank*, *_self*, and so on. Examine the following syntax.

```
myVars.send("myScript.asp", "_self", "POST")
```

This code would post the variables exactly like the previous code, except for the fact that it would post the results (response) of the server to the same window. Similarly, if you switched the *_self* with *_blank*, it

would post the response to a new browser window. As you might have guessed, this becomes extremely handy when debugging applications. (Debugging tactics are discussed later in the chapter.)

 CD-ROM NOTE: *To see an example of use of the send method, open the file* 3.fla *located in the* fmxas/chapter08/ch08_03/ *folder on the companion CD-ROM.*

sendAndLoad()

Now that you have reviewed loading and sending variables individually, let's look at the *sendAndLoad()* method. Simply put, this method is the workhorse of the *LoadVars* object. As its name indicates, you may use this method to send variables to a server-side script and to receive response variables from the server.

A typical scenario in which *sendAndLoad()* is used is for user authentication. A client may type her user name and password into a Flash movie. Using a *sendAndLoad()*, the client's user name and password pair may be passed to a server-side script, which would perform the customary validation against a database. Based on the success of the authentication, the script would respond with a variable string that reports the result. This variable is loaded into a target object in the Flash movie and may be printed to the screen to give the user feedback. This is the simplest example of a typical use of *sendAndLoad()*. This method can, however, handle some complicated scenarios, examined in material to follow. First, let's examine the basic syntax of this method, which follows.

```
myLoadVars.sendAndLoad(url, targetObject[,method])
```

Here, *myLoadVars* is the instance name of the *LoadVars* object that holds the variables to be sent, *url* is the URL to upload the variables to, *targetObject* is the *LoadVars* instance that receives the downloaded variables, and *method* is the request/response HTTP protocol (i.e., *GET* or *POST*).

As you might have already noticed, the syntax is not much different from that of the *send()* method. In fact, the only difference is the *targetObject* parameter. As you might recall, *sendAndLoad()* performs two tasks: sending variables and receiving variables. Whereas *myLoadVars* already contains the variables to be sent, you need a similar instance to store the variables sent back by the server. Depending on what approach you choose, you may store the received variables in the same object (i.e., *myLoadVars*) or store them in another instance of the *LoadVars* object. Let's examine some example code for this method, shown in code example 8-3.

Code Example 8-3: Using **sendAndLoad()**

```
myVars = new LoadVars();
myVars.foo = "bar";
myVars.onLoad = checkLoaded;
checkLoaded = function () {
  for (var i in this) {
   trace (i + ". " + this[i]);
  };
myVars.sendAndLoad("foobar.asp", myVars, "POST");
```

Code example 8-3 is very similar to code example 8-2, with one major difference: the *targetObject* parameter (i.e., in this case, the *myVars* object itself). When this method is executed, the name and value pair *foo = bar* is sent to *foobar.asp*. At some point, *foobar.asp* returns some variables to the Flash movie. These variables are loaded as properties of the *myVars* object itself.

 CD-ROM NOTE: *To see an example of use of the* targetObject *parameter, open the file* 4.fla *located in the* fmxas/chapter08/ ch08_04/ *folder on the companion CD-ROM.*

toString()

This method is fairly easy to implement, and is therefore not examined in great detail. This method takes all variables of a given object, and outputs them as a URL-encoded string of name and value pairs separated by the ampersand. Let's examine the syntax of this method, which follows.

```
loadVarsObject.toString()
```

Here, *loadVarsObject* is the instance name of the *LoadVars* object that holds the variables. Consider code example 8-4.

Code Example 8-4: Using **toString()**

```
myVars = new LoadVars();
myVars.foo = "bar";
myVars.hello = "world";
trace(myVars.toString());
//hello=world&foo=bar
```

As shown in code example 8-4, the last variable name and value pair attached to the *myVars* object is the first one out.

getBytesTotal() and getBytesLoaded()

These two methods are welcome additions to Flash MX and are particularly useful in one primary scenario: preloading. At some point in time, you have probably used a preloader in your movies. These two methods are very similar to the *getBytesLoaded()* and *getBytesTotal()* methods for the Movie Clip object available in Flash 5. Let's examine the syntax of each of these methods, which follow.

```
myLoadVars.getBytesLoaded()
myLoadVars.getBytesTotal()
```

Here, *myLoadVars* is the name of the object into which the variables are being loaded in each case. It is important to note that these methods return *undefined* if no load operation is in progress or if a load operation has not yet begun. If *undefined* is returned as the outcome for one of these methods and you are sure that load operations have been initiated, the server has probably not sent the variables across. Examine code example 8-5.

Code Example 8-5: The getBytesLoaded() and getBytesTotal() Methods

```
//**********CODE FOR FRAME 1*************//

myLoad = function() {
 myVars = new LoadVars();
 myVars.a = "Hello!!";
 myVars.onLoad = function(success) {
   if (success) {
    trace("Variables Loaded");
   } else {
    trace("Something went wrong");
   }
 }
 myVars.sendAndLoad("http://LocalHost/test.asp", ¬
myVars, "POST");

//************CODE FOR FRAME 2*************//
_root.onEnterFrame = function() {
 trace (myVars.getBytesLoaded());
 trace (myVars.getBytesTotal());
 if (myVars.getBytesLoaded() == ¬
myVars.getBytesTotal()) {
```

```
    delete _root.onEnterFrame;
    }
};
```

As shown in code example 8-5, there is no straightforward way to get *getBytesLoaded()* to work other than using the second-frame approach. If you try to start a *_root.onEnterFrame* event method once the *sendAndLoad()* has been executed, Flash will simply wait until the variables have been returned completely and then display the total bytes loaded. Currently, there seems to be no better solution than that provided in code example 8-5 for solving the problem of displaying some preloading feedback using *getBytesLoaded()* in Flash MX. The code should be self-explanatory in this example.

 CD-ROM NOTE: *To see an example that uses* getBytesLoaded() *and* getBytesTotal(), *open the file* 5.fla *located in the* fmxas/chapter08/ ch08_05 *folder on the companion CD-ROM.*

Properties

The *LoadVars* object has two primary properties. Both are extremely simple to implement, and you are encouraged to consult the *ActionScript Reference* to learn about them. Table 8-3 summarizes the two available properties.

Table 8-3: LoadVars *Object Property Summary*

Property	Summary
loaded	This returns a Boolean value indicating whether a *load()* or *sendAndLoad()* operation has reached completion.
contentType	This property specifies the MIME type of the data being passed.

Note that the *contentType* property specifies the MIME type of the data being sent to the server. By default it is *application/x-www-urlform* encoded. This wraps up discussion of the *LoadVars* object. The remainder of this chapter deals with connecting your Flash movies to databases for inserting, retrieving, and updating records.

▪ ▪ ▪ Databases and ASP

From this point, it is assumed you have had traditional database development experience (creating forms that interact with databases). This chapter does not deal with database theory, but does examine some techniques

in database design related to Flash MX. Examples use Microsoft Access 2000 for database needs. Although this may not represent the best data store solution, the authors understand that due to its simplicity it is one of the most widely used among Flash developers. At this point, it is important for you to familiarize yourself with the data exchange process in Flash MX, and Access represents a starting point for doing so.

As for the server-side technology used here, the authors have chosen Active Server Pages (ASP). ASPs are server-side scripts written in a variety of scripting languages (VBScript is the most common) that give you some powerful features to make your web applications dynamic. As related to Flash, ASP pages are typically used as middleware to access a database. This book will primarily use ASP pages written in VBScript, in that the published support for ASP-driven Flash examples is quite scarce on bookshelves today.

The concepts used to develop the examples may be applied to any other server-side scripting language. However, the authors do recognize the growing popularity of the NET platform and Flash Remoting, and encourage readers to start examining these technologies because future versions of Flash are likely to include integrated support for these platforms. With these assumptions laid out, let's create a dynamic Flash movie, a simple authentication system.

▪ ▪ ▪ **Authentication with Flash MX**

Authentication deals with introducing security to Flash applications. Although most areas of your web site will be open to public access, you might want to limit access to certain areas. For instance, say you want to offer some files for download to your clients, but also want to seal off the download location from other visitors. To do this, you could set up an authentication system by verifying user names and passwords (either predefined or dynamically registered). The *sendAndLoad()* method makes this a piece of cake, as explored in material to follow.

Authentication scenarios are great examples for learning about data exchange, not only because they are very familiar to most people but because they demonstrate most of the critical aspects of data exchange, including validation, update of records, and record retrieval. Although this example is not necessarily the most elegant solution to this problem, it is nevertheless a very effective demonstration application. One of the toughest hurdles when it comes to dynamic data delivery in Flash MX is debugging tactics. This example should also provide you with some practice in debugging dynamic Flash applications.

Screen Elements

 CD-ROM NOTE: *Open the file* authentication..fla *located in the* fmxas/chapter08/authentication/ *folder on the companion CD-ROM. We recommend that you deploy this application on your test server before proceeding from this point in the discussion. You will have to refer to this example file quite frequently for the next few sections.*

This example has three main elements or display screens: log-in, registration, and action. The sections that follow tell a little more about them.

Log-in

Figure 8-5. Log-in screen.

This is the initial screen a user is sent to. It contains a user name field and a password field in addition to two buttons, Log-in and Register. The Log-in button submits the form inputs, whereas the Register button takes the user to the second screen (registration). Note that users must fill in both fields before submitting the form. (The log-in screen is shown in figure 8-5.) Once the server sends back the log-in results, the user is transferred to the action screen, where the results are displayed.

Registration

The registration screen, shown in figure 8-6, is the second screen on which a user enters information to create a new account. The user must provide the following information: user name, password, first name, last name, and e-mail address. The form will not submit if any input field is missing user data. The results of the registration process are displayed on the action screen, where the user is automatically transferred.

Action

The action screen, shown in figure 8-7, is the final screen in which server response is displayed to the user. Our example uses several custom error messages based on server-side validation anomalies. Each error message is displayed in the text field of this screen. A Back button is provided to allow the user to go back to the log-in screen.

Figure 8-6. Registration screen.

Figure 8-7. Action screen.

Table 8-4: Error Codes

Error Code	Error String
0	Successful log-in
1	User not found
2	Incorrect password
3	User already exists
4	Unknown error

Dealing with Errors

As stated, several custom errors may be returned by the server-side ASP page. In fact, the only variable sent back by ASP is *myError* = *n*, where *n* is the error code generated. The actual error strings are stored within the Flash movie in an array. The error codes sent back share a one-to-one relationship with the indices of the array elements. For example, if the error code sent back is 0, the corresponding error in the array *errorArray* is the string element at *errorArray[0]*. Using this methodology, you can decrease the physical data size being sent back, possibly leading to faster processing. At this point, it would probably help to know what each error code means. Examine table 8-4.

The sections that follow examine how each error is generated by the server-side script. First, however, let's examine the database for this application.

Database

This application uses something called a *flat-file database*. This simply means that the database has only one table with several fields, much like an Excel spreadsheet. The important thing to remember is that you may start adding to the complexity of this database quite easily from this point, should you decide to implement this example in your web site. This database is essentially the lowest common denominator for any authentication system.

Creation of the database is not examined here. It is assumed you are sufficiently versed in database design. Therefore, instead of running through a step-by-step procedure on how to create the database, let's examine the table and field structures,

as well as the logic behind the choices made. Despite being a single-table database, the possibility of running into an insertion anomaly is still present. You will also examine what provisions have been made to avoid this. The database has one table, called *users*, which stores all vital information about users. The *users* table contains the fields shown in table 8-5.

Table 8-5: The users *Table*

Field Name	Description
userID	Unique ID for every registered user (primary key)
userName	Log-in name chosen by user
passWord	Password chosen by user
firstName	User's first name
lastName	User's last name
emailAdd	User's e-mail address

CD-ROM NOTE: *For details about the database design, open the file* db.mdb *located in the* fmxas/chapter08/authentication/db *folder on the companion CD-ROM.*

Field Name	Data Type
userID	AutoNumber
userName	Text
passWord	Text
firstName	Text
lastName	Text
emailAdd	Text

Figure 8-8. The users *table.*

As you can see, the structure of the database is anything but complex. For those who have had sufficient experience with databases, this will seem quite rudimentary. However, the debugging issues associated with dynamic data in Flash MX entail peculiarities associated with the database design that require an understanding of it. The *users* table located in the file *db.mdb* should look similar to that shown in figure 8-8.

Movie Timeline

Before examining the middleware script, it will help to examine the timeline of the movie. You should note that this is simply one way to accomplish the task at hand. A more elegant solution would involve multiple SWF files (each with a form) loaded onto different levels within the main movie. However, to keep this example simple, the traditional Flash 5 methodology with frame labels and *gotoAndStop()* actions has been used. Remember that the goal is to accomplish data exchange in a neat and tidy

manner using the *LoadVars* object. Examine figure 8-9, which shows the timeline for this example.

Figure 8-9. Timeline for the authentication example.

As you may have noticed, there are three distinct frame sections in this example. Each section spans 10 frames (this is not necessary, but done so that frame labels are immediately readable) to keep the timeline neat and comprehensible. It follows that each section is basically a different screen; that is, log-in, registration, or action. Navigation in this type of scenario is a bit procedural, and hence it is recommended that you use this methodology only where apt. For instance, an authentication system is pretty simple to visualize, so this methodology is not really a bad choice for implementing such a system.

You may notice that there are two layers that contain actions. The first (*Global*) contains the variables and functions you want to keep global to the movie, and the second (*Actions*) contains screen-specific actions. With all the housework out of the way, let's examine the client-side ActionScript used to facilitate the data exchange.

Screen-specific Actions

This section examines the ActionScript that makes the data transfer happen. If you have not already done so, we suggest that you open the related example file and follow along.

Log-in Screen

The first screen the user sees is the log-in screen. As you have already seen, this screen is very similar to most authentication screens, sporting a few input fields and buttons. Let's examine the actions for this frame to get a clearer idea of what is going on. Click in frame 1 of the *Actions* layer, which will reveal the code shown in code example 8-6.

Code Example 8-6: Log-in Screen Actions

```
userName = "";
passWord = "";
loginButton.onRelease = function() {
  if (userName != "" && passWord != "") {
    myLoadVars();
```

```
    myVars.mode = 1;
    myVars.userName = userName;
    myVars.passWord = passWord;
    myVars.sendAndLoad(URL, myVars, "POST");
    } else {
    return;
  }
};
registerButton.onRelease = function() {
 gotoAndStop("Register");
};
stop();
```

Essentially, code example 8-6 should be pretty easy for you to understand at this point. Nevertheless, let's examine what is going on. The first two lines of code set the input fields to blank, as follows.

```
userName = "";
passWord = "";
```

Then an event method is declared for *loginButton*. Note that the *if* condition simply ensures that this method will execute only when both input fields have user input in them. If the user has entered data in both fields, the *myLoadVars()* function is called. This function exists in the *Global Actions* layer in the first frame (examined in material to follow). For now, simply note that it creates an instance (called *myVars*) of the *LoadVars* object and assigns an anonymous callback function to its *onLoad()* method. Once the *myLoadVars()* function has executed, the remaining lines of the event method attach the various variables (*userName*, *passWord*, and *mode*) to it, as follows.

```
myVars.mode = 1;
myVars.userName = userName;
myVars.passWord = passWord;
```

Note that the ASP script recognizes two modes at this point: 1 is login and 2 is registration. Sending this variable is equivalent to writing the following.

```
http://www.myURL.com?mode=1
```

Fortunately, *LoadVars* makes it easy to send even the *mode* variable via the regular *POST* method. The next line of code executes a *sendAndLoad()* for *myVars*, as follows.

```
myVars.sendAndLoad(URL, myVars, "POST");
```

Note that the first parameter is simply a variable called *URL*. If you examine the actions in the *Global* layer, you will actually see the URL string used. This adds some portability to the code, allowing you the freedom of easily changing the URL in one location and have it reflect throughout the movie. In essence, all code would refer to this string-based path for the URL.

The second variable is the target object, *myVars*. Memory is saved here by not instantiating a new object to receive the variables. Essentially, the variables returned by the ASP script are loaded back into the same object from which they were sent. The last parameter is simply the HTTP protocol for sending the data.

Note that the *onLoad()* event for this object has already been declared. Therefore, once the previous line executes, the *onLoad()* method declared in *myLoadVars()* is called after the server-side script responds. This wraps up the main event method for the log-in screen. At the end of code example 8-6, note the event method for the *registerButton*, which simply sends the playhead to the register screen if the button is clicked.

Register Screen

The register screen contains some form fields used to collect user information, as well as the customary Submit and Back buttons. Aside from that, it functions exactly the way the log-in screen functions. It would be redundant to examine the ActionScript related to this screen in as great detail as for the log-in screen, because the register screen is identical in implementation to the log-in screen. The only difference you will notice is the set of variables attached to the *LoadVars* instance, *myVars*. In this case, the *mode* variable is set to 2, so that the ASP code can identify what needs to be done. Examine code example 8-7 to get a better idea of the differences related to the register screen.

Code Example 8-7: Register Screen Actions

```
userName = "";
passWord = "";
firstName = "";
lastName = "";
emailAdd = "";
registerButton.onRelease = function() {
  if (userName != "" && passWord != "" && firstName ¬
!= "" && lastName != "" && emailAdd != "") {
    myLoadVars();
    myVars.mode = 2;
```

```
    myVars.userName = userName;
    myVars.passWord = passWord;
    myVars.firstName = firstName;
    myVars.lastName = lastName;
    myVars.emailAdd = emailAdd;
    myVars.sendAndLoad(URL, myVars, "POST");
    } else {
    return;
  }
};
stop();
```

Action Screen

The action screen has a dynamic text field that returns the various error or success messages sent back to Flash from the server-side script. This incorporates an efficient mechanism for providing feedback to the user. As you have already seen, the server-side script responds with simple error codes. These error codes are used as indices for looking up the corresponding error messages stored in the *errorArray* array (declared on the *Global* layer, discussed in material to follow). Once the error string is extracted from the array, it is stored in a variable called *error*, used to update the text field *myError*, as shown in the following line of code.

```
myError = error;
```

Now let's take a look at the actions attached to the first frame of the *Global* layer.

Global Layer Actions

As noted previously, the first frame of the *Global* simply contains variables and methods common to the entire movie. These may be accessed by any screen or any function in the movie, making it easy to reuse code. Let's examine the code shown in code example 8-8.

Code Example 8-8: Global *Layer Frame 1 Actions*

```
URL = "authenticate.asp";
errorArray = ["Successful Login!", "User not ¬
found", "Incorrect password", "User already exists",¬
"Unknown Error"];
myLoadVars = function () {
  myVars = new LoadVars();
```

```
myVars.onLoad = function() {
  error = errorArray[this["myError"]];
  gotoAndStop("Action");
};
};
```

The first few lines of code example 8-8 declare common variables for the application. *URL* stores the connection string for the ASP script, and *errorArray* is an array that stores all possible error messages. Note that an error code sent back from the server corresponds to the appropriate error message index in the array. Next, the *myLoadVars()* function is declared. This function creates an instance of the *LoadVars* object and then assigns it an *onLoad()* callback function. The server sends back a string that looks similar to the following.

```
myError=0
```

As you can see, the next line in the code uses this returned error code as an index to look up the appropriate error message. The *this* keyword refers to the *myVars* object. Once the error is assigned to the variable *error*, the playhead is sent to the action screen to display the result of the data exchange to the user. All in all, this is quite a seamless process, especially when compared to its Flash 5 equivalent. Let's examine the server-side ASP script that does all the work in this example.

Server-side Script

The ASP script Flash calls acts as an interface to the database. It performs several important functions, the most important being the following.

- Validating that user input is unique and valid
- Inserting new users and retrieving current user info from the database
- Sending feedback to the Flash movie

The ASP page performs these functions with just a few lines of code. The great thing about the methodology used in this example is that it centralizes all code in one script and minimizes data exchanged by using error codes. Programming this way allows you more flexibility and portability. The same script could be used, for example, for a wide array of similar applications. Let's examine the script a bit further.

 NOTE: *The ASP script, usable as it may be, is not very elegant. For all practical purposes, it has been kept simple and clean. When you create such an application in the real world, however, you would*

have to make provisions for error checking, caching, forcing variable declarations, and so on.

The first few lines of the ASP script should look familiar, as they are simply variable requests. Flash sends the variables just like any HTML form would, and therefore you can use the *Request* object in ASP to catch these variables. The script catches all possible variables every time it is called. (Why this is so is examined in material to follow.) Examine the first few lines, which follow (comments have been left out for brevity).

```
myMode = Request("mode")
userName = Request("userName")
passWord = Request("passWord")
firstName = Request("firstName")
lastName = Request("lastName")
emailAdd = Request("emailAdd")
```

At this point, a DSN-less connection is opened to the authentication database (previously examined). DSN-less connections are less taxing on the server, and provide ease of use when connecting to a database. We recommend that you use these types of connections for applications that are not very large. Examine the following code.

```
set db = Server.CreateObject("ADODB.Connection")
db.Open "DRIVER={Microsoft Access Driver (*.mdb)}; ¬
DBQ=F:\fmxas\authentication\db\db.mdb"
```

The first two of the previous lines of code create a record set of all fields for the row that has a matching user name as the one sent by the user. The way the logic of the script works, if a user does not exist, the record set returned will have no rows. Therefore, you will know that either the user does not exist in the database or that the user has made a typographical error when he filled in the log-in form fields. Examine how the record set is created and the necessary SQL that facilitates this, as shown in the following code.

```
theSQL = "SELECT * FROM users WHERE userName = '" & ¬
userName & "'"
set rs = db.Execute(theSQL)
```

This segment of code is where the validation and updating occurs. A *SELECT* structure is used to trigger the events for each mode, log-in and registration. *Select* statements in VBScript are akin to *Switch* statements in ActionScript or JavaScript. Let's examine the log-in scenario first, and then the registration.

Case 1: Log-in

The log-in case simply needs to perform some logical error checking and send feedback to the Flash movie. The following are typical scenarios our script supports.

- Successful log-in
- User not found
- Incorrect password entered
- User already exists
- Unknown error

We recommend that you examine this case of the *Select* condition to understand the logic behind the conditions. Essentially, if the *username* and *password* make a valid pair, the user is logged in. In all cases, an error code is generated and sent back to the Flash movie, where it is displayed, as you have already seen.

Case 2: Registration

The case of registration is also pretty straightforward. In simple English, this case first checks if *username* already exists in the database. If it does, it generates the appropriate error and terminates any insertion. If not, it simply inserts all retrieved variables into the appropriate fields in the database.

Ending the Script

Once the *Select* condition has been completely executed, what remains is a variable called *myError*, which contains the outcome of the transaction (the term *transaction* is used loosely here). This variable is the only item sent back to the Flash movie. Once this is done, all objects created are eliminated, in that ASP does not perform automatic "garbage collection."

You have just learned a lot of very useful techniques for integrating dynamic content into your Flash applications. We recommend that you play with these concepts some more, because in the next few years it will become imperative for you to know how to handle dynamic data with Flash. To round out this chapter, let's address one final issue, debugging.

▪ ▪ ▪ Debugging Tactics

Unfortunately, debugging dynamic applications in Flash MX leaves a lot to be desired. Although there is no generalized, single-solution methodology for debugging applications, each developer generally has her own technique. The sections that follow examine practical debugging tactics using

the tools available in Flash MX. The following material also explores useful strategies for creating Flash applications. At this point, it is assumed you are pretty familiar with all of the methods available to the *LoadVars* object, in particular *load()*, *send()*, and *sendAndLoad()*.

Project Development

Ideally when working with a dynamic Flash application, the best way to avoid potholes later in the process is to ensure that the server side of the application works seamlessly. It usually helps to draw a rough flowchart of the process occurring on the server side. Familiarity with HTML for rapid prototyping is of great benefit during debugging. Let's use the previous example to examine how it was designed and tested from the start.

Once the required tasks and features were laid out, the first thing created was the server-side script and the database. Simple inserts and selects were performed to ensure that the connection to the database was stable and responsive. Often the entire process gets foggy simply because the database connection is faulty. This is an error you want to avoid at all costs. The simplest way to avoid it is by creating the database connection and executing SQL statements against it to perform a *select and* an *insert*. The authentication example, for instance, was checked for integrity using a query string similar to the following.

```
http://www.nishantkothary.com/fmxas/authentication/ ¬
authenticate.asp?userName=kothary&passWord=boiler
```

The ASP script at this point simply performed a *select* statement and wrote the results to the browser window. When you work this way, you start eliminating simple bugs as they occur, making it simple to debug larger problems with greater ease. Essentially, the bottom-up approach for such development scenarios is preferred to the top-down approach.

Tricks in Flash MX

You can use certain tricks to actually view the dynamic data in test mode while authoring in Flash. It involves a simple change in the URL string you use to call the server-side script. Typically, if your script is in the same folder as the compiled SWF application file, you would use a local path to it, as follows.

```
myVars.sendAndLoad("foobar.asp", myVars, "POST");
```

With this code in place, if you select Control | Test movie, Flash will not really carry out the data exchange because it needs a web server to do so. You would be able to test the movie only through a web browser and

live connection. This may take up too much time just to make simple checks. However, if you manipulate the URL string as follows, you can actually test from within the Flash authoring tool.

```
myVars.sendAndLoad("http://LocalHost/foobar.asp", myVars, "POST");
```

Here, *LocalHost* is the name of your server's root folder.

 NOTE: *For an example of data transfer with Flash, see the file* authentication.fla *located in the* fmxas/chapter08/authentication *folder on the companion CD-ROM.*

This code acts very similarly to HTML. With a little common sense and careful testing, you could save yourself hours of wasteful debugging time.

Trace

You could also use the previously described methods to *trace()* the response of the server to the Output window. At times, this is very useful while you are authoring. Instead of creating text fields, you can simply use *trace()* methods to quickly check the results of individual items. In the authentication example, *trace()* actions have been commented out. If you want to see the results, uncomment them, making sure you are using the URL string with the *LocalHost* path.

■ ■ ■ **Summary**

This chapter taught you everything you need to know to use the *LoadVars* object, including what is possible with Flash MX and server-side technologies. Flash MX has moved Flash development to a new plateau, where serious programmers are now starting to realize the potential of Flash as a dynamic front end for large-scale application development. It appears that Macromedia is investing in tying Flash MX and future versions of it to back-end technologies such as ColdFusion, .NET, and so on to provide robust solutions utilizing the latest paradigms in dynamic data exchange, such as SOAP, XML-RPC, and others.

Although it is beyond the scope of this book to explore these technologies and concepts in detail, it is instructive to examine an application using such technologies. In fact, the final chapter deals with XML-RPC, as well as some pseudo-SOAP scenarios. With the *LoadVars* object out of the way, the next natural step is to examine XML, the focus of the next chapter.

9

XML and Flash MX

▪▪▪ Introduction

Flash MX and XML make a promising pair and should get almost any developer excited. Why? Simply because XML is a wonderful data exchange model that is extremely easy to understand. XML has been around for a few years, but it has only been within the past year or so that it has gained immense popularity among intermediate-level developers. The reason for this can be summed up in one word: *reusability*.

This chapter is intended to get you up and running with XML and its uses in Flash MX applications, as well as on the Web. Whereas the last chapter dealt with dynamic data exchange using a traditional scenario, this chapter changes that paradigm and shows you how XML makes the tasks covered in Chapter 8 simpler, more object-oriented, and extremely robust. The *LoadVars* object discussed in the previous chapter is great for completing simple tasks, but the moment you need to deal with large amounts of data, or data that must be shared between different services and applications, you should immediately see a flashing neon sign with the letters *XML*. If you are simply someone who likes a great deal of organization and logic, XML is your free ride to data perfection.

Although Flash MX has solved several issues with the XML object from Flash 5, the XML object still leaves a lot to be desired. Fortunately, it seems that the folks at Macromedia have good heads on their shoulders, so we can expect some great improvements in the next version of Flash, similar to those we saw in this one. If you are completely new to XML, do not worry. Unlike Chapter 8, this chapter will actually concentrate on

material that is not really Flash-related, such as well-formed XML, DOM, and so on. This chapter discusses XML from a global standpoint, and then explores it as it is used with Flash MX. There are two key things you need to understand before you begin working with XML in Flash.

- XML structure
- XML rules

The *structure* of XML refers to the XML tree. It is important for you to be fluent in navigating an XML tree. This is much like driving a car: you cannot drive a car until you know where all of the controls are, what each one does, and most importantly in what order you must use the controls. The *rules* of XML deal with knowing what is legal and what is not. Again, with the car analogy, this is the knowledge of what each of the road signs indicates, the speed limit on a particular street, and so forth. Much like on the road, if you break a rule in XML, you are in trouble. So, without further ado, let's start up our cars and race off onto the XML highway!

■ ■ ■ Objectives

In this chapter you will:

- Get an overview of XML and its vast implications on the future of the Internet
- Learn about the structure of XML documents and rules for writing well-formed documents
- Examine the Flash XML model, and learn how to devise XML documents for use in Flash
- Learn about the built-in XML object and its methods and properties, and examine examples of each
- Examine an example using some advanced XML integration techniques

■ ■ ■ XML: A Comprehensive Overview

Before you can begin using XML in Flash applications you need to understand XML thoroughly. A large part of this chapter deals with XML and its intricacies. For developers well versed with XML, we recommend that you simply skim through these sections. However, references to Flash MX point out peculiarities related to Flash's handling of XML. Even the experienced XML user will want to note these.

 NOTE: *Everything you ever wanted to know about XML is available at the W3C XML Web site at* www.w3.org/XML/. *Most of the*

material in this section has been compiled from this source and is available freely over the World Wide Web.

Extensible Markup Language, or XML for short, is a tagging language, much like HTML. However, there is one enormous difference between these two languages: whereas HTML tags describe the structure (the "look") of the page, XML tags describe the data contained in a page. Furthermore, XML allows you to define your own tags, enabling you to define your own language. Although XML is extremely powerful, it is in no way a substitute for HTML. In fact, HTML and XML complement each other (i.e., whereas the former displays the data, the latter gives the data a defined structure). To better understand this, examine code example 9-1.

Code Example 9-1: An HTML Code Snippet for Formatting a CD Collection

```
<h1>A Brand New Day</h1>
<h2>by Sting</h2>
<p><b>1. </b>A Thousand Years</p>
<p><b>2. </b>Desert Rose</p>
<p><b>3. </b>Big Lie Small World</p>
<p><b>4. </b>After The Rain Has Fallen</p>
```

As shown in code example 9-1, you can use generic tags such as <h1>, <h2>, <p>, and so on in HTML to format data. Unfortunately, these tags tell you nothing about the data itself. To someone who does not know HTML, this would be extremely difficult to read. Examine code example 9-2 to see how the same task is achieved in XML.

Code Example 9-2: An XML Code Equivalent of Code Example 9-1

```
<album>
 <title>A Brand New Day</title>
 <artist>Sting</title>
 <songs>
  <song>
   <track>1</track>
   <name>A Thousand Years</name>
  </song>
  <song>
   <track>2</track>
   <name>Desert Rose</name>
```

```
</song>
<song>
 <track>3</track>
 <name>Big Lie Small World</name>
</song>
<song>
 <track>4</track>
 <name>After The Rain Has Fallen</name>
</song>
</songs>
</album>
```

As shown in code example 9-2, the same data is given much more meaning when wrapped in XML. Aside from being human readable, this approach isolates the *structure* of the data from its *presentation*. Whereas HTML has quite a low reusability rating, XML can be exchanged among different applications, where each one would use the same data in a different way. It is this aspect of XML that makes it an excellent choice for application migration. So, let's start writing some XML!

The Basics of XML

You have seen a simple example of an XML document. Now let's examine how XML documents are written. Because the nature of XML dictates that a developer must make up his own tags, when you get into advanced development and integration using XML for your dynamic pages it is essential that you know exactly what your goals and needs are prior to beginning. Let's write our first XML document by first examining code example 9-3.

 CD-ROM NOTE: *To see the related example, open the file* ch09_01.xml *located in the* fmxas/chapter09/ *folder on the companion CD-ROM, in a browser capable of viewing XML.*

Code Example 9-3: An XML Document

```
<name>
 <first>Nishant</first>
 <last>Kothary</last>
</name>
```

XML is extensible, as you can see in listing 9-3. This means that XML is intended to be human-readable, and likely you can determine what the

data in code example 9-3 is for without much more explanation. XML was born out of the shortcomings of SGML and HTML, both languages characterized by rigid, incomprehensible structures. With XML, a server can perform qualitative analysis on data, as the data is self-describing.

XML also facilitates the creation of your own attributes. You see now how powerful XML is. It is like having the ability to make your own language, and the best part is that you can do this using English (or any other language XML supports). Let's see how you could rewrite the previous document using attributes, as shown in code example 9-4.

 CD-ROM NOTE: *To see the related example, open the file* ch09_02.xml *located in the* fmxas/chapter09/ *folder on the companion CD-ROM, in a browser capable of viewing XML.*

Code Example 9-4: An XML Document Utilizing Attributes

```
<name first="Nishant" last="Kothary"/>
```

As code example 9-4 shows, you can achieve the same effect as in code example 9-3 by creating the XML document with only attributes. Note that the XML document does not have a closing tag. Instead, it ends with the forward slash (/). Often you need to create XML tags that have no content between the tags (i.e., the tag itself is sufficient to accomplish a task). XML is thankfully very strict about coding standards (unlike its sloppy friend, HTML) and requires all tags to be closed. In fact, there are several standards and rules that every XML document must follow. On fulfillment of these the XML document is said to be *well formed*. These rules are discussed in material to follow.

Terminology

XML is fortunately not terminology heavy. In fact, there are very few terms you need to know in regard to XML development.

Elements or Nodes

Elements were used in the XML documents created this far (called *tags* to this point). In fact, XML documents *must* contain elements. Examine the XML document in code example 9-3. An element (more popularly referred to as a *node*) from this example looks as follows.

```
<first>Nishant</first>
```

Another element from the same example is:

```
<last>Kothary</last>
```

You have probably noted that an element consists of the following three parts.

- Start tag, such as *< first >*.
- End tag, such as *< /first >*.
- Text between tags, such as *Nishant*. This is also known as PC data (parsed character data).

In addition, elements may contain text and other elements. This is known as *nesting*. Code example 9-3 is an example of a nested XML structure.

Attributes

Again, you have already used these, but let's define them. *Attributes* are name-value pairs associated with elements. XML requires that both name and value be strings. Further, no element may contain two attributes with the same name. Attributes have to fulfill certain requirements before they become contributors to making an XML document well formed. (This is explored later in the chapter.)

Attributes Versus Elements

This is a debate that is yet to reach some conclusion. Whereas hardcore Flash developers (from the Flash 5 development environment) will tell you to minimize the use of tags and maximize the use of attributes, hardcore XML developers will advise against doing the same. Each side has its reasons, which are justified to a great extent. What are their reasons?

Let's see what the XML community has to say about this. If you asked an XML developer why elements are better than attributes, you would probably get the following reasons.

- Elements are more extensible for future changes to the XML standard
- Attributes are loose in structure and cannot describe structures
- Attribute values are not easy to check against DTDs (largely does not apply here)
- Attributes cannot contain multiple values

And sure enough, the XML gurus are quite right about this. Writing an XML document using empty tags filled with attributes, and no nested elements, could amount to the massacre of the very essence of XML; that is, organization and readability. However, do not make up your mind yet, because the Flash community has a pretty valid rebuttal to the XML gurus' argument. Ask the Flash community why attributes are better than elements, and you will probably get the following response.

- Attributes are parsed faster by the Flash parser

It is as simple as that! Sure enough, this was very true of Flash 5. In fact, many

developers shied away from using XML in their applications, because of how poorly Flash 5 parsed it. Others wrote their own XML parsers to improve parsing performance. Overall, the Flash community was never too happy about letting Flash parse large amounts of XML simply because the Flash player would come to its knees. So why was the XML parser so bad in Flash 5?

The plain and simple reason for this was the fact that it was written in ActionScript! When you parsed an XML document in Flash 5, you were simply using some functions that were invisible to you. The worst part was that the parsing algorithm written by Macromedia was not really that great. This is why parsers such as *XMLNitro* that were written in ActionScript managed to perform better than the native *parseXML()* method.

XML and Flash MX

So now you are probably wondering if you need to worry about the same problems that were associated with Flash 5. To a great extent, the answer to this question is an emphatic "no." The Flash engineers cleaned up the mess by writing most of the functions in native code. If you visit forums such as *FlashKit.com* or *Were-here.com*, you will see a collection of test results comparing the Flash 5 and Flash MX XML parsers. In a nutshell, Flash MX parses about 25 to 30 times faster than its predecessor!

Final Take

Unfortunately, the issue of attributes versus elements is still an inconclusive one. Although Flash MX has better XML capabilities built into it, simple tests will immediately show you that attributes often work faster than elements. However, the overhead of using elements over attributes has decreased tremendously and issues that existed with Flash 5 are no more. Often, the problem lies with the parsing algorithm and not the Flash parser. We recommend that whenever you plan on parsing large amounts of data, devise a simple parsing test to see whether the element or the attribute approach works better. Like they say, sometimes to get something done you just need to do it yourself!

Well-formed XML

This is a term you will hear over and over in the world of XML. A *well-formed* XML document is one that adheres to all grammatical rules outlined by the XML 1.0 specification. Currently, to be well formed, an XML document must meet the following requirements.

- An XML document may have only one root element
- Every start tag must have a matching end tag
- Tags may not overlap and must be nested correctly

- Element names must adhere to XML naming conventions
- XML is case sensitive and hence tags must have matching case
- All attributes must be quoted
- Reserved characters must be escaped

 NOTE: *All examples in this section are not really complete, as they lack the XML declaration. We have not discussed this as yet, so for the time being, ignore it.*

Only One Root Element

XML documents may have only one root element; meaning that as a whole an XML document must syntactically appear as a single element. What does this mean? Examine the following XML document.

```
<Cat>Bonzo</Cat>
<Mouse>Oliver</Mouse>
```

Although this might appear well formed, it actually is not. This is because there is no root element present for this document. Correcting this code would result in the following XML document.

```
<Animal>
 <Cat>Bonzo</Cat>
 <Mouse>Oliver</Mouse>
</Animal>
```

If you now consider the complete document, it may be considered a single element (with nested elements). A good rule of thumb in naming a root node is to ask yourself what the entire document describes. Usually you will end up with a few words, of which you pick the most appropriate. For the previous example, alternate root node names might be *Cartoon*, *Pet*, and so on.

Matching Closing Tags

Gone are the days of sloppy HTML-style tagging. Unlike HTML, XML requires that all tags be closed. So, what if you need to use empty tags? As shown in code example 9-4, you can save yourself some space by using the forward slash (/) character at the end of an empty tag to close it. Examine the following code.

```
<Dog Name="Bonzo"/>
```

This code would be equivalent to the following.

```
<Dog Name="Bonzo"></Dog>
```

 TIP: *The former method is preferred simply because it saves the Flash parser some time, and because it requires a smaller amount of memory.*

Proper Nesting

HTML also requires proper nesting of tags. However, if HTML tags are not nested properly in a document, you will probably see some weird formatting when you view it. In the case of XML, you will get an error. Nesting refers to closing tags in the order in which they were opened. In other words, the last tag opened must always be the first one closed. As shown in code example 9-5, the following document illustrates a nesting error. Although this will display in a browser, Flash will probably not parse it correctly.

Code Example 9-5: Incorrect Nesting

```
<Animal>
 <Cat>Tom
  <Mouse>Jerry</Mouse>
 </Cat>
</Animal>
```

Naming Conventions

XML, like any other language, has strict naming conventions. Several characters are considered *reserved* in XML (i.e., used by the native XML format internally). In addition, XML elements and attributes must adhere to the following rules to be classified as well formed.

- Tag names may not contain spaces
- Tag names may not begin with the text *XML* (in any case)
- Tag names must start with a letter or hyphen (-)

If you fail to follow these rules, chances are that Flash will not parse your data correctly even if the XML document loads up properly in a browser.

Case Sensitivity

XML is a case-sensitive language (unlike HTML). Although you may define your opening tags using any case, a closing tag must follow the same case as its corresponding opening tag. The following would generate an error, both in a browser and in Flash.

```
<Name>Nishant</name>
```

It is recommended that you use case consistently throughout your XML documents.

Quotes Around Attributes

Whereas HTML is not really sensitive about punctuation, XML gets very picky when you forget the required punctuation. In XML, the following element would be considered well formed.

```
<Name First="Nishant"/>

<Name First='Nishant'/>
```

On the other hand, the following would generate an error.

```
<Name First="Nishant'/>
```

Again, it is advised that you use double quote marks.

Reserved Characters

XML requires you to leave some characters alone. Several characters are reserved for internal use by XML. Therefore, if you insert these characters in your data, XML will get confused about what to do with them, and break. Many a great developer has fallen off his steed while trying to fight this XML law. But what if you want to use the reserved characters in your PCDATA, or even your attributes? XML has made provisions for this. Before you learn various ways to *escape* reserved characters, let's examine them, and their corresponding escape codes. Examine table 9-1.

As you might have already noticed, the characters outlined in table 9-1 are used quite frequently.

Table 9-1: Reserved Characters and Escape Codes

Reserved Character	Escape Code
<	<
>	>
"	"
'	'
&	&

You can still use them in your XML data, but you have to substitute the character with its corresponding escape code. *Escaping* a character simply means that you substitute it with another character or symbol so that XML does not parse it, but simply displays it. Examine the following code.

```
<rant>a>b & b<c</rant>
```

 CD-ROM NOTE: *To see the related example, open (in a browser capable of viewing XML) the file ch09_03.xml located in the* fmxas/chapter09/ *folder on the companion CD-ROM.*

By itself, this would generate an error when viewed in an XML-capable browser. This is because XML tries to close a tag when it gets to the > sign after *a*. The previous code can be made workable by simply substituting the reserved characters with their escape codes, as follows.

```
<rant>a&lt;b & b&gt;c</rant>
```

This code would actually work great when viewed. Now, what if you had large amounts of data, being loaded dynamically from a database and being written out as an XML file? Would you have to escape every character? This would be too tedious, and if you have not guessed already, there is a much simpler solution. You can use a *CDATA* (character data) section. Let's examine another example. Consider the following code.

```
<rant id="This is just not possible">"if you do it
<i>without</i> escaping the 'reserved' characters."</rant>
```

 CD-ROM NOTE: *To see the related example, open (in a browser capable of viewing XML) the file* ch09_04.xml *located in the* fmxas/chapter09/ *folder on the companion CD-ROM.*

Without any explanation, you should immediately notice that this code would make the XML parser really mad, and the parser would immediately throw an error at you. What you need is a simple way of escaping all reserved characters without having to manually substitute each one. Using *CDATA*, the previous code can be corrected in the following manner (changes are reflected in the code via italicized bold code).

```
<rant id="This is just not possible"><![CDATA["if you do it
<i>without</i> escaping the 'reserved' characters."]]></rant>
```

This code would eliminate all parsing errors and would appear in the browser as shown in figure 9-1.

Figure 9-1. Escaping reserved characters using CDATA.

The previous examples should tell you that it is simply a matter of convenience when choosing a method of escaping characters. However, it is important for you to make sure that any data you do not have control over should be escaped, so as to not generate a parsing error.

Related Technologies

Usually XML is quite worthless by itself. XML documents are data containers, and by themselves simply appear as trees of nodes when viewed in a browser. Although XML is meant to be human-readable, often you need an external technology to give XML some form. Whereas some technologies simply use XML to output the data in a presentable fashion, others use it to carry out tasks remotely. Although several of these do not really apply to Flash at this point in time, it would still be a good idea to familiarize yourself with them. The future versions of Flash may make one or more of them an integral part of the software.

Cascading Style Sheets (CSS)

You are probably familiar with cascading style sheets as related to formatting HTML pages. XML simply consists of arbitrary tags, and the browser does not really know what to do with an XML document aside from just writing it to the screen. As an analogy, consider the case in which the only content in your HTML page is as follows.

```
Hello World! My name is Foo Bar!
```

What you would end up with upon loading up the HTML page in a browser would be simple text with no formatting. However, if you added some tags around this text (e.g., < *h1* > and < *font* >), the HTML page would use the formatting rules of those tags in displaying the content. Cascading style sheets provide a way of formatting XML tags, giving an XML document more meaningful formatting instructions.

Hypertext Markup Language (HTML)

Why on earth would you need HTML with XML? One reason: XML is not supported by any of the older browsers (older than Internet Explorer 5.0 and Mozilla 5.0). Without formatting instructions, XML simply appears as plain text in XML-ready browsers. However, if your browser is not XML-capable, you would have a greater problem (you better believe that not everyone has the latest browser). The only way to serve your XML content to an older browser would be to reformat it as HTML content before sending it to a client. Again, as time has progressed, this has become a concern of lesser importance.

Extensible Style Language (XSL)

XSL is the "holy grail" of formatting XML documents. It was designed specifically for use with XML documents, and peculiarly enough, XSL documents are simply well-formed XML documents. A lot of developers argue that XSL and CSS are one and the same. Shame on them! XSL is sheer genius compared to CSS. Whereas CSS only allows formatting of every occurrence of an element, XSL is not that restricting. XSL has logic built into it, so that you can write XSL styles to format only a particular number of elements, or rearrange elements, and so on. Essentially, XSL can apply *qualitative* formatting to an XML document.

How XSL works is quite simple. An XSL processor reads an XML document and searches for patterns and conditions in it. Once it finds these patterns, it uses the formatting rules defined in it to output formatted XML. In addition, XSL can easily take an XML document and output HTML. Although the XSL standard is still not as defined as one would like it to be, if you are someone who plans for the future, XSL is the way to go.

 NOTE: *For those of you thinking about using XML beyond Flash,* XML Bible, *second edition, by Elliotte Rusty Harold is a great resource (Wiley, ISBN 0764547607). It sums up almost everything you need to know about XML. We strongly recommend this book as a reference.*

▪ ▪ ▪ Traversing the Tree

Now that you know everything you need to know about XML basics as applied to Flash, let's see what Flash can actually do with it. The structure of the remainder of this chapter should seem familiar to you. Like several of the previous chapters, in the following you will delve deeper into the XML object's built-in methods, properties, and event handlers. You will examine how each is used, making use of applicable examples. This section doubles as a great reference during development, but we also recommend that you give it a complete read at least once.

XML, by nature, is an *ancestral* (or *parent-child*) modeled language. The two most basic relationships a node may have with another are *parent* and *child*. As you can see, this is derived from a real-world model, making it easy to visualize. The key to using XML effectively with Flash is to be able to "follow the nodes and branches" of this ancestral tree. Let's elaborate with an illustration. Examine the XML document shown in figure 9-2.

```
attributes ◄─────────────────────────────────┐
xml declaration ◄──────── <?xml version="1.0" encoding="iso-8859-1"?>
level 1 / root ◄──────── <addressbook>
    level 2 ◄──────────── <address id="1" order="a">
    level 3 ◄──────────────── <entry>
    level 4 ◄───────────────────── <name> Joe Bob </name>
    level 5 ◄───────────────────── <bday> 12/12/1939</bday>
                            </entry>
                            <line1>999 Chauncey Street</line1>
                            <line2>Apt. 8</line2>
                            <city>Lafayette</city>
                            <state>IN</state>
                            <zip>47909</zip>
                            <country>USA</country>
                            <phone>765-722-7585</phone>
                            <email>joebob@unemployed.com</email>
                        </address>
                    </addressbook>
```

Figure 9-2. An XML document.

Let's first traverse the document as if it were a tree, each new level serving as a new layer (branch) of the tree. As you can see from figure 9-2, the XML declaration is simply ignored by Flash. In a typical scenario, you would add this declaration only if you were planning on serving the same XML file to other services or applications. For our purposes, however, this is quite unnecessary. As you can see, the first node Flash acknowledges is what we have called the *level 1* node. This is simply the root node of the document. Typically, once your XML file is loaded, it is customary to reference all other nodes from the root node. As far as Flash is concerned, however, it is just another node.

 NOTE: *Our discussion is intended to throw some light on how to conceptualize XML families. Our terminology (level 1, and so on) is not to be confused with actual syntax. It is simply a classification mechanism to help you visualize the XML document.*

It is evident from the code in figure 9-2 that one unique characteristic of every level is that it is the *child* of another level. (You will examine the same document from a parent-child perspective in material to follow.) Right now it is important for you to be able to see the XML document as a collection of interrelated levels. Thinking this way is less abstract, and allows you to quantify the nodes in an XML document. Another peculiarity of the manner in which Flash MX handles XML is the fact that element

text is also considered a level. This is the reason indents in your code cause problems (Flash sees them as nodes).

Looking at the same example from a parent-child perspective is often useful. Let's traverse through the document shown in figure 9-2 using this methodology. The parent of all parents, also known as the root node (or level 1), is the *< addressbook >* element. The element *< address >* is its first child. Conversely, *< addressbook >* is the parent of the *< address >* element. The *< address >* element has two attributes: *id* and *order*. As you might have already guessed, attributes are not considered child elements. They simply serve as *collections*, better known as name/value pairs.

Moving on, the *< address >* element has several children: *< entry >*, *< line1 >*, *< line2 >*, *< city >*, *< state >*, *< zip >*, *< country >*, *< phone >*, and *< email >*. The *< entry >* element has two children: *< name >* and *< bday >*. How are these children related to each other? Think of it as a real-world scenario and you will answer this question yourself. Sure enough, they are called *siblings* of each other. Similarly, *< entry >* has siblings *< line1 >*, *< line2 >*, *< city >*, *< state >*, *< zip >*, *< country >*, *< phone >*, and *< email >*. As you saw previously, the PCDATA (text between the tags) are children of their container elements. For instance, *Joe Bob* is the child of *< name >*. The following summarize the main points of this section.

- Nodes are related to each other using a parent-child-sibling ancestral methodology.
- Nodes may also be thought of as individual levels, each level sharing a parent-child relationship with its predecessor level.
- PCDATA is simply the child node of its container element.
- Attributes are not a part of the ancestral model. They may be thought of as characteristics of the family.
- Parents, children, and siblings may have other parents, children, and siblings, and so on.

Following the construct of an XML document in Flash MX is quite simple, and if you are a sucker for *for* loops, it can often be absolutely delightful. This is simply because Flash comes packed with extremely useful methods and properties to help you traverse the tree with style. There is room for improvement, but on the whole the XML object probably has some of the most useful and logical methods. If you have worked with other parsers, this should be a piece of cake.

Similar to previous chapters, let's now dissect the XML object, method by method, and property by property. Again, the following concentrates on that which requires a little more elaboration. Without further ado, let's get into the XML object.

▪ ▪ ▪ The XML Object

The XML object allows you to parse, load, send, build, manipulate, and traverse an XML document in Flash. The folks at Macromedia integrated the XML object as a native object in Flash MX, accounting for dramatic performance increases from Flash 5. The XML object itself must be instantiated before it may be used. One way of doing this is:

```
myXML = new XML();
```

Alternatively, you could pass it a *source* parameter as follows.

```
myXML = new XML(mySource);
```

Here, *mySource* would point to an XML document. There is also a third way to instantiate the object, as follows.

```
myXML = new XML("<name>foobar</name>");
```

This method is usually not encouraged for documents containing more than one node. Regardless of the approach you choose, the XML object must be instantiated before it is used.

Once the XML object has been instantiated, you have a wide array of methods and properties at your disposal. Again, the following explores only a few methods and properties that need some elaboration. You are encouraged to visit the *ActionScript Reference* to learn about the remaining. It is essential that you know what is possible before you get into development, and it would be worth your while to read the method and property descriptions in the *ActionScript Reference*. After an exploration of our select choice of methods and properties, you will examine a few scenarios in which XML is used, to give you a start on this extremely wonderful technology.

Methods

Discussion of methods of the XML object in the following highlights a few methods that need a little elaboration beyond the information available in the *ActionScript Reference*. Along the way, other methods and properties are examined. We recommend that you keep the *ActionScript Reference* handy. The methods outlined in table 9-2 are discussed in the material that follows.

createElement()

The most basic XML method, *createElement()* allows you to create a new node. You use it primarily for constructing XML documents in Flash MX, typically to enable XML RPC (remote procedure calls) or simply to send data to a server. This method creates a new XML element in memory and returns a reference to it. This element may be appended to an existing doc-

Table 9-2: Method Summary

Building/Communication Methods	
Method	**Summary**
createElement()	Creates a new XML element
createTextNode()	Creates a new XML text node
appendChild()	Appends a node to the end of the object's children
Reading Methods	
Method	**Summary**
load()	Loads an XML document from a specified URL
hasChildNodes()	Returns a Boolean result indicating whether or not the current node has child nodes

ument and saved for future use. The basic syntax for this method is as follows.

```
myXML.createElement(name)
```

Here, *myXML* is the name of the XML object, and *name* is the name you would like to give to the new element/node. Simply put, this is one of the most important methods for creating XML documents on the fly within Flash MX. An alternative would be to use some sort of string construction, but this can be quite limiting in certain scenarios. The following line of code would create an element named *message* in the object *myXML*.

```
messageElement = myXML.createElement("message");
```

Note that this code simply creates the node, and does not insert it into an XML document's hierarchy. To do this, you would use the *appendChild()* method, discussed in material to follow.

createTextNode()

As you may have already guessed, this method creates a simple XML text node. It is very similar to the *createElement()* method, in that it creates a reference to a new XML text node but does not really insert it in an XML document. You may use this method to insert text within your XML elements. Syntactically, the method's usage is as follows.

```
myXML.createTextNode(text)
```

Here, *myXML* is the name of the XML object, and *text* is the textual content. Once created, this node may be inserted into any part of an XML document. The following line of code would create a text node with the text string *"Send a message in a bottle"*.

```
messageText = myXML.createTextNode ¬
("Send a message in a bottle");
```

Now *messageText* may be used as a text element in an XML document.

 NOTE: *The attribute property is discussed in the section on properties. It is simply a getter/setter that may be used to get/set attributes for XML nodes.*

appendChild()

The *appendChild()* method actually gives some meaning to the methods discussed earlier. Whereas the *createElement()* and *createTextNode()* methods create different types of nodes, the *appendChild()* allows you to connect nodes via parent-child relationships. The *appendChild()* method appends the specified node to a specified XML object's child list. In essence, when you append node A to node B, you make A the child node of B. The syntax of the *appendChild()* method is straightforward, as follows.

```
myXML.appendChild(childNode)
```

Here, *myXML* is the name of the XML node/object you want to append to, and *childNode* is the node to be added to the *myXML* object's child list. Building on the examples from the previous sections, examine code example 9-6.

Code Example 9-6: Building a Simple XML Document

```
myXML = new XML();
myNode = myXML.createElement("name");
myNodeValue = myXML.createTextNode("My name is ¬
foobar");
myNode.appendChild(myNodeValue);
myXML.appendChild(myNode);
trace(myXML)// <name>My name is foobar</name>
```

As shown in code example 9-6, it is very easy to create XML documents in Flash. You first create an element called *name* and store a reference to it using *myNode*. You then create a text node with the value *My name is foobar*, and store a reference to it using *myNodeValue*. Because the text node is simply considered a child of its parent element node, you use *appendChild()* to establish this relationship. Finally, the parent node is attached to the root XML document, which in this case is *myXML*. All in all, you can see that this is a very simple process to visualize.

load()

The *load()* method should be familiar. If you have read the previous chapter, you will easily see that the *load()* method functions similarly for both the *LoadVars* and XML objects. This method loads an XML document from the specified URL. (There is one catch, however, discussed in material to follow.) The syntax for the *load()* method is as follows.

```
myXML.load(url);
```

Here, *myXML* is the target XML object into which the XML document should be loaded, and *url* is the location of the XML document. The *url* parameter has a catch, though. Due to security reasons, your *url* must exist in the same domain in which the SWF file resides. However, where there's a will, there's a way, and if you feel compelled to load your XML files from a different domain, you can easily do so by setting up a proxy, or by using a simple server-side script on your local subdomain to get an XML file from a different domain.

 NOTE: *If you are interested in finding out more about loading XML files across domains, register at* www.were-here.com *and search the XML Discussion Forum. There are several discussion threads on this forum that show you exactly how to solve the problem.*

The *load()* method is asynchronous, which means that once it is called the action may or may not occur instantaneously. It follows that Flash needs some mechanism to catch the loaded file. Similar to the *LoadVars* approach, you can do one of two things with the XML object.

- Specify a callback function for the *onLoad()* method
- Override the *onData()* handler

Typically, most developers use the first approach, but what you choose is simply a matter of personal choice. To wrap up this discussion, let's examine code example 9-7.

Code Example 9-7: Typical Load Procedure for the XML Object

```
myXML = new XML();
myXML.ignoreWhite = true;
myXML.onLoad = xmlLoaded;
myXML.load("myXMLFile.xml");
function xmlLoaded {
  trace(this);
}
```

Let's quickly dissect code example 9-7. A couple of aspects of this code are not very intuitive, or well documented in the Flash MX Help. In the second line of the code, you see the following.

```
myXML.ignoreWhite = true;
```

This is a very important step for any XML load procedure (read about the *ignoreWhite* property in the "Properties" section of this chapter). Then the *load()* method is invoked for the *myXML* object. Immediately after this, the callback function *xmlLoaded()* is assigned to the *onLoad* property of *myXML*. Note that the assignment does not end with a parenthetical (*()*) after the callback function's name. Note also the line *trace(this)* within the callback function. In this case, *this* refers to *myXML*. This trace action would write your entire XML document to the Output window.

hasChildNodes()

The method *hasChildNodes()* is one you should expect to be using a lot. It simply returns a Boolean indicating whether an XML object/node has children or not. This method is read-only, and returns either *true* or *false*. The syntax of this method is as follows.

```
myXML.hasChildNodes();
```

Here, *myXML* is the XML object you want to check for children. One of the most common uses of this method is to check an object for children before beginning to traverse through it. As you can see, such a technique could save a lot of time and memory when dealing with several hundred XML documents with complex node structures, as it would allow you to traverse only those nodes that had children. The following line of code would return *true* if the first child of *myXML* had any children.

```
myXML.firstChild.hasChildNodes();
```

Properties

Most of the functionality attached to the XML object comes from its library of getter/setter properties that belong to it. The XML object comes bundled with a comprehensive list of the most useful properties, used to traverse a document and to create one. Table 9-3 outlines the properties examined in detail in this section. Again, it is recommended that you use the *Actionscript Reference* to figure out the rest.

attributes

In the methods discussion, you learned how to create elements and text nodes. Another important aspect of XML documents is the *attributes* prop-

Table 9-3: Property Summary

Collections	
Property	**Summary**
attributes	Returns an associative array of all attributes for a specified node
childNodes	Returns an array containing references to child nodes of specified node
Traversing	
Property	**Summary**
firstChild	References the first child for a specified node
nextSibling	References the next sibling in the parent node's child list
nodeName	Returns the name (tag) of an XML node
nodeValue	Returns the text of a specified node
nodeType	Returns the type of the specified node (1 or 3)
ignoreWhite	Discards all text nodes that contain only white space when parsing an XML document

erty. This property is a read/write property that returns an array of node attributes and helps you assign attributes to specified nodes.

Reading attributes

Let's examine the read aspect of this property first. It is important to know how the returned array may be manipulated. Examine code example 9-8.

Code Example 9-8: Working with the attributes *Property*

*XML document (*myXMLDoc.xml*):*
```
<user id="1">
 <name first="foo" last="bar"/>
 <email>foo@bar.com</email>
</user>
```
Actionscript for retrieving attributes:
```
myXML = new XML();
myXML.ignoreWhite = true;
myXML.load("myXMLDoc.xml");
myXML.onLoad = getAttributes;
function getAttributes() {
```

```
rootNode = this.childNodes;
var myAtts = rootNode[0].attributes;
  for (var i in myAtts) {
   trace(i + ": " + myAtts[i]);
   }
}
```

As shown in code example 9-8, the *getAttributes()* function effectively extracts the attributes for the root node in the given XML document. The property *childNodes* returns an array of all children for the specified node. The line *this.childNodes* effectively returns all child nodes of the XML object *myXML* as an array, making it easily manipulated. The next line returns an array of attributes for the first element in *rootNode* (i.e., the actual root node, *<user>*). Again, note that you simply use an array index to reference the root node. When you have a reference to the attributes array of the root node, it is a simple matter of extracting the data within in the array.

Remember that arrays, like conventional objects, can be easily manipulated. That is, you may effectively use a *for...in* loop to traverse an array's elements. The next lines of code simply extract the attribute name and value pairs from the attribute array reference *myAtts*. If the root node were to have more than one attribute, all attributes would be traced to the Output window.

 CD-ROM NOTE: *To see the related example, open the files ch09_05.fla and ch09_05.xml located in the fmxas/chapter09/ folder on the companion CD-ROM. This example also provides an alternative method of extracting attributes from an element.*

Writing

You can also use the *attributes* property for adding attributes to XML elements. This can be rather useful, for example, when you are constructing an XML document on the fly to send to a server. Examine code example 9-9.

Code Example 9-9: Adding Attributes to XML Elements

```
myXML = new XML();
myNode = myXML.createElement("name");
myNode.attributes.last = "bar";
myNode.attributes.first = "foo";
myXML.appendChild(myNode);
trace(myXML)// <name first="foo" last="bar" />
```

As shown in code example 9-10, you can add attributes to element nodes with a simple implementation of the *attributes* property. The following line of code actually sets the name of the attribute as *first* and the value as *foo*.

```
myNode.attributes.first = "foo";
```

Note that the last attribute appended is the first one when the element is traced.

childNodes

This is the second *collections* property available to the XML object. It returns an array of all child nodes for the specified node. Unfortunately, this is a read-only property and may not be used to manipulate child nodes. However, this property is extremely useful for generating a rough node map of an XML document before you begin traversing it. The syntax for this property is as follows.

```
myXML.childNodes
```

Here, *myXML* is the node/object for which you would like to find all children. As you can see, this property is not very complicated. However, it often enables quite complicated node traversals due to the fact that it returns an array of child nodes. Let's examine code example 9-10 to get a better idea of this.

Code Example 9-10: Adding Attributes to XML Elements

XML document *(myXMLDoc.xml):*
```
<user>
 <name>Foobar</name>
 <email>foo@bar.com</email>
</user>
```

Actionscript for retrieving child nodes:
```
myXML = new XML();
myXML.ignoreWhite = true;
myXML.onLoad = xmlLoaded;
myXML.load("myXMLDoc.xml");
function xmlLoaded () {
  trace(this.childNodes); //1st trace
  trace(this.childNodes[0].childNodes); //2nd trace
};
//1st Trace results
//<user><name>Foobar</name><email>foo@bar.com ¬
```

```
</email></user>
//2nd trace results
//<name>Foobar</name>,<email>foo@bar.com</email>
```

As shown in code example 9-10, traversing through an XML document using the *childNodes* property is just like traversing through an array. You could visualize an XML document as a multidimensional array of nodes, in which each index could have n number of multidimensional node arrays. Technically, it is possible to traverse through an XML document to infinite depths (such is the power of XML). Examine figure 9-3, which depicts XML documents as arrays.

myXML.xml:

```
<user>
    <name>
        <first>Foo</first>
        <last>Foo</last>
    </name>
    <email>foo@bar.com</email>
</user>
```

myXML as an array of child nodes:

```
myXML.childNodes ==
["<user><name><first>Foo</first><last>Foo</last> ¬
        </name><email>foo@bar.com</email></user>"]

myXML.childNodes[0].childNodes ==
["<name><first>Foo</first><last>Foo</last> ¬
        </name>", "<email>foo@bar.com</email>"]

        myXML.childNodes[0].childNodes[0] ==
        ["<name><first>Foo</first><last>Foo</last></name>"]

        myXML.childNodes[0].childNodes[1] ==
        ["<email>foo@bar.com</email>"]

        and so on....
```

Figure 9-3. Visualizing an XML document as an n-dimensional array.

 CD-ROM NOTE: *To see the related example, open the files* ch09_06.fla *and* ch09_06.xml *located in the* fmxas/chapter09/ *folder on the companion CD-ROM. This is a slightly advanced example that uses a recursive function to traverse through an XML document.*

firstChild

 NOTE: *The next section includes a comprehensive example using some of the remaining properties.*

The *firstChild* property is a shorthand way of referencing the first child of the specified parent node's child list. This is a read-only property only, but is useful nevertheless when you do not really need to use the *childNodes* approach using a collections array. The syntax of the *childNodes* property is as follows.

```
myXML.firstChild;
```

Here, *myXML* is the parent XML node whose first child you wish to find. Referring to the example XML document from code example 9-10, examine the following trace action.

```
trace(myXML.firstChild.firstChild.firstChild);
//<first>Foo</first>
```

This code makes it clear that traversing an XML document using only the child property can be quite cumbersome, as it uses a *relative* addressing methodology using only the first children. Although this is great methodology for documents that have a defined and known structure, it involves some thought when used with XML documents whose tree structures are unknown to you. In addition, it imposes the restriction of having only the first index to work with. An equivalent operation for the previous code is as follows.

```
trace(myXML.childNodes[0].childNodes[0].childNodes[0]);
```

nextSibling

The *nextSibling* property actually gives more meaning to the *firstChild* property. If you are looking for an iterative way of traversing XML nodes, this property would play an important role in it. So far, you have not really looked at siblings in much detail. Based on previous discussion, you know that siblings are simply elements of a parent node's child list that are at the same level/depth. Think of siblings as brothers and sisters.

Expanding on this analogy, think of how your family works. Whereas your brothers and sisters are your siblings, all of you are collectively children of your parents. Similarly, your parents have their own siblings and in turn their own parents. It follows that you may have your own children, who may in turn have siblings. The *nextSibling* property simply references the next sibling in the parent node's children list. Its syntax is as follows.

```
myXML.nextSibling;
```

Here, *myXML* is the parent XML node whose next sibling child you wish to find. Referring to the example XML document from code example 9-10, examine the following trace action.

```
trace(myXML.firstChild.firstChild.nextSibling);
// <email>foo@bar.com</email>
```

As you can see from this code, using a combination of *firstChild* and *nextSibling*, you could easily traverse through a complete XML document.

nodeName, nodeType, and nodeValue

The properties *nodeName*, *nodeType*, and *nodeValue* are extremely useful in helping you iterate through a series of nodes and retrieve all critical data from them. While they are all read-only, they may be used quite effectively to pull data from an XML document before you begin working with it. This data may be used to provide feedback to the user, for comparison purposes, and so on.

nodeName

The *nodeName* property, which is read-only, is extremely useful for output purposes, or simple lookup purposes. It returns the name of an XML element's tag. In the case of text nodes (*type* = = *3*), this property returns *null*. The syntax for the *nodeName* property is as follows.

```
myXML.nodeName;
```

Here, *myXML* is the parent XML node whose name you wish to find. Referring to the example XML document from code example 9-10, examine the following trace action.

```
trace(myXML.firstChild.firstChild.nextSibling.nodeName);
// email
```

However, if you tried to find the node name of the *email* text, the property would return *null*, as follows.

```
trace(myXML.firstChild.firstChild.nextSibling.firstChild.nodeName);
//null
```

nodeType

This property returns the type of node for a specified node. Flash MX incorporates two types of nodes, outlined in table 9-4. The syntax for the *nodeType* property is as follows.

```
myXML.nodeType;
```

Here, *myXML* is the parent XML node whose node type you want to find. Consider the following XML node.

```
<name>Foo Bar</name>
```

Table 9-4: Node Types

Type	Summary	Example
1	Element node	*<name>, <user>, <deer>*
3	Text node	*Foo, Bar, Bambi*

If this XML node were referenced by the instance *myXML*, the following trace actions would yield each node's type for *myXML*.

```
trace(myXML.nodeType); //1
trace(myXML.firstChild.firstChild.nodeType); //3
```

nodeValue

The *nodeValue* property returns the actual value (text) for the specified node, provided it is a text node. In the case of an element node (*type = = 1*), this property returns *null*. The *nodeValue* property is used extensively, and often exclusively, to retrieve text node values for XML documents. Its uses are obvious, considering that text nodes are extremely useful containers of data in XML documents. The syntax for the *nodeType* property is as follows.

```
myXML.nodeValue;
```

Here, *myXML* is the parent XML node whose node value you want to find. Consider the XML node from the previous example, as follows.

```
<name>Foo Bar</name>
```

If this XML node were referenced by the instance *myXML*, the following trace actions would yield each node's value for *myXML*.

```
trace(myXML.nodeValue); //null
trace(myXML.firstChild.firstChild.nodeValue); //Foo Bar
```

The ignoreWhite Dilemma

For experienced XML users coming from Flash 5, the *ignoreWhite* property should bring back memories of parsing nightmares that most of you have probably had. A little flashback is in order for newcomers. When Flash 5 came out (packed with the new XML object), several developers dove straight into the well of XML development using Flash. However, most developers found out soon enough that because of the way Flash parses XML it considers all empty nodes (blank spaces, indents, and so on) text nodes. This posed a serious problem for those developers who had to work with XML documents that were indented, or that had tabbed sections.

Several solutions to the problem were advanced. The least elegant was to write XML documents as single line strings with no spaces, indents, or carriage returns. You can easily see this turning into a cruel mind game when dealing with large XML documents. The second solution was a lot more elegant. Some developers came up with their own prototype functions that you would pass your XML document to, and have them returned without blank nodes.

These functions in effect simply stripped the XML of white space. At the same time developers were devising these workarounds, Macromedia decided to throw in its two cents. Macromedia's solution was to add the *ignoreWhite* property. When this property is set to *true* for an XML document, it simply tells the Flash parser to ignore all white space when it parses the document.

You are probably wondering how Macromedia implemented this sort of mid-semester modification. Quite simply, they released a new version of the Flash Player. However, at that point in time, way too many people already had the previous Flash Player installed on their machines. They had no reason to upgrade their Flash players, simply because those worked quite well.

Essentially, the problem with this solution was that now there were two versions of the Flash Player in circulation: one that recognized the *ignoreWhite* property and another that did not. Hence, simply adding the property to Flash documents was not a comprehensive solution to the problem, because to translate the property the end user was required to have the new Flash Player. The only foolproof method was to use a prototype function to strip white space.

ignoreWhite

The *ignoreWhite* property is fully implemented in the Flash MX Player, and eradicates one of the largest problems with parsing XML in Flash: white space. When the *ignoreWhite* property is set to *true* for an XML object, the Flash parser discards all text nodes with only white space during the parsing process. This property may be set for entire XML objects or individual nodes. By default, this property is set to *false*. The syntax for this property is as follows.

```
myXML.ignoreWhite = true;
```

Here, *myXML* is the XML object for which you would like the parser to discard white space. We have already used *ignoreWhite* extensively, so we recommend that you examine any of the XML example files included for this chapter.

▪▪▪ Case Study: Address Book Application

Now that you are an XML guru, it is time to put this knowledge to the test. Although this example is simplistic, it is nevertheless an effective one. It demonstrates how you should, and could, use XML. XML is a wonderful tool when integrated with a database, but a lot of developers do not really want to use a database, or simply do not have the server skills to implement one. In fact, some tasks could be easily handled with the help of a simple XML file you can manually update.

Although the application discussed here does not claim to be something you might use on your own web site, it is nevertheless something that shows you how to effectively harness the power of XML. The concepts used here could very well be translated into a daily log, a menu system, a simple message board, and so on. The goal of this application is to show you how to design application-specific XML documents, parse them, and in turn display the data in a useful and graphical manner.

Overview

 CD-ROM NOTE: *Open the files* addressbook.fla *and* addressbook.xml *located in the* fmxas/chapter09/addressbook *folder on the companion CD-ROM. Play around with this example until you are familiar with it (activated letters are a, f, j, and r). We recommend that you leave this example open to follow along with the remaining sections.*

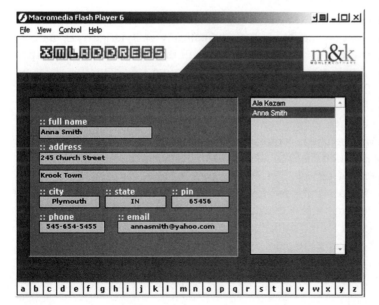

Figure 9-4. Address book application Flash MX front end.

Front End

The first task at hand is to understand the address book example. The address book application has a familiar interface, as shown in figure 9-4. The bottom of the movie consists of an A-to-Z index of letter buttons. Pressing one of these but-

tons would load up a corresponding entry in the combo box located on the right. Clicking on an entry within this combo box would load the data for the respective person into the corresponding text fields. In addition, when no entries are found for a particular letter selection, the combo box would provide the necessary feedback.

Back End

Figure 9-5. Address book application XML back end.

The back end of this application is what is really reusable and rugged. The application pulls its data from a single XML file. This XML has a predefined template structure for each node, as shown in figure 9-5. To add entries to the address book, you simply append an entry to this XML file, and the application is ready to rock and roll with the updated data. Each entry element in the XML file reflects certain characteristics that are vital to data retrieval within the application. (Conceptualizing and designing such XML files is discussed in material to follow.)

With the basics out of the way, let's break the address book example down from a conceptual and developmental standpoint. Let's examine how the XML structure for this application was developed.

XML Development

The very essence of XML is to allow for reusability and extensibility. However, XML documents are not automatically well designed by nature. It is up to you, the developer, to design with the future in mind, incorporating flexibility in terms of modifications, sharing, and extensions to your design. XML document design is truly an art, and takes a lot of experience to master. However, with a few rules in mind, you can easily conquer the basics well enough to brag that you are an XML developer.

The XML document could simply be provided to you ready-made and without explanation, but this would really defeat the purpose of this chapter. The intent of this chapter is to teach you how to handle XML within Flash MX and to instill good XML development skills. Unfortunately, few books and teachers stress the data design process, eventually leading to a weak foundation for the student. The rule of thumb is to spend 70% of your time conceptualizing the data, and the remaining 30% implementing it.

The sections that follow walk you through conceptualizing, assembling, and finalizing a custom XML template for the application in the

hope that along the way you will develop a sense of the entire process. The ability to build good XML documents is a talent that will prove both advantageous and profitable.

Listing Requirements

Anytime you need to design an XML template, the first thing you should do is get yourself a pot of coffee, a few sheets of scribble paper, and a good pencil. This process could take anywhere from a few minutes to a few days, depending on your list of needs. Regardless of how much time it may take, make sure you thoroughly analyze your template before you put it into production. Although for a small-scale project you could easily recover from a silly logical error or make modifications well after addition of entries, the same does not apply to a large project involving several teams and departments, potentially proving how lethal a badly designed XML document can be. This is definitely a situation you want to steer clear of.

The process is really not as bad as it sounds. Let's begin the actual process and you will realize this soon. The first task you must tackle is to list all requirements of the XML file. The best way to do this (if you are a beginner), is to write it out. It does not matter how you write it out, as long as it is comprehensible to you. The following is the write-up used by the authors.

> *The application shall track the following for each entry:*
> *- Full name*
> *- Address line 1*
> *- Address line 2*
> *- City*
> *- State*
> *- Pin*
> *- Phone number*
> *- E-mail address*

The application must be able to figure out the index of an entry (e.g., a, b, and so on). In addition, the owner should simply be able to append an entry to the document, without having to insert it in some predefined order to facilitate ordering within the application.

As you can see, our requirement list is not really very complicated. However, do not make the mistake of taking a task like this for granted simply because it is not complicated. You will soon see that the requirements list is not definitive, and often needs to be modified. With the requirements out of the way, let's see how an XML document is developed from it.

XML Design

The XML design process consists of making several drafts of the desired XML template, each draft refining the previous one. This process is iterative, and you must train yourself to ask the right questions as you carry it out. It is true that there is never a *right* answer to making an XML document. However, there is always a better way of doing it, and that is what you should work toward. Remember, the best XML documents are those that can be easily comprehended, as well as extended (does that remind you of OOP?).

Draft 1

Based on our requirements list, let's make an initial draft of the XML template. The initial draft is usually where you decide the name for the root node, and simply make each requirement an element. If you recall, selecting an apt name for the root node is usually the same as answering the question "What does my XML document store?" In this case, the document stores addresses. For the sake of simplicity, let's christen the root node *addressbook* (remember, no spaces). The first draft would look as follows.

```
<addressbook>
 <name></name>
 <line1></line1>
 <line2></line2>
 <city></city>
 <state></state>
 <pin></pin>
 <phone></phone>
 <email></email>
</addressbook>
```

Remember that each draft in this process needs to reduce the number of anomalies in the document. This is achieved by asking yourself the right questions. How do you know what questions are right? Here's a hint: look at the requirements list. All you need to do is check if the document fulfills every requirement you listed. Let's come up with a reusable set of questions for the remainder of this process. Based on our requirements, the questions would be as follows.

- Is there a mechanism for the application to figure out the entry's index?
- Would the owner be able to simply append another entry and not have to change the structure of the application?

Now that we have a list, let's answer it.

- Is there a mechanism for the application to figure out the entry's index?

The answer to this question is in a roundabout way, yes. The application could parse all name elements and extract the first character in each name element's text data. If this character matches the desired letter, the entry would be parsed and used. However, is this an efficient way of categorizing the entries? What if the last name and first name of an entry were interchanged? Also, what if the first name entered were a nickname? Essentially, you could keep counting the fallbacks of this approach. A rule of thumb is that if you hit a "what if" situation you probably need to refine the current approach.

- Would the owner be able to simply append another entry and not have to change the structure of the application?

Again, the answer is, in a roundabout way, yes. However, the only indicator of a new entry would be a name element. Also, the only way to extract an entry would be to parse the data between two consecutive name elements. This would work for the time being, but it goes against the idea of extensibility and modularity. In the future, if you were to add other attributes to the entries, you would have to append them to the last element for each entry and in turn change your parsing algorithm to reflect this change. According to our rule of thumb, this approach needs to be changed.

Draft 2

Now, let's rewrite the template to reflect the changes we decided upon in draft 1. To summarize, the following are the changes that need to be implemented.

- Add a categorizing mechanism
- Make entries modular

The first change involves the addition of a new XML tool. If you did not already think of it, this involves an attribute. Recall that attributes are best used as metadata for nodes. Although you want to be able to facilitate easy categorization of each entry, you do not necessarily want to display this data to the viewer. In fact, the best possible mechanism to achieve this change is by using an attribute.

The second change involves restructuring the document. To make anything modular, it must be encapsulated. The simplest way to achieve such encapsulation would be to introduce a new element into the picture. In this case, you want to encapsulate each entry in order to distinguish it from the next. Essentially, you could add another element in the nesting

hierarchy to contain all data for an entry within it. It follows that the element name < *entry* > would serve the purpose quite well. Examine the second draft of the XML document, as follows.

```
<addressbook>
 <entry id="[letter]">
  <name></name>
  <line1></line1>
  <line2></line2>
  <city></city>
  <state></state>
  <pin></pin>
  <phone></phone>
  <email></email>
 </entry>
</addressbook>
```

As you may already have noticed, the only change made to the previous draft was the addition of the following element.

```
<entry id="[letter]">
```

Let's examine how this element represents our desired changes. The addition of the *entry* element makes each entry unique and effectively encapsulates all data for that particular entry, thus fulfilling one of the desired refinements. The addition of the *id* attribute facilitates categorization of each entry. Each entry would now be required to have an *id* attribute to denote its alphabetical category. Note that this is extremely extensible, because the owner could add as many entries as he desired. You now have a pretty effective XML document, but it is not as perfect as it could be. The last draft should analyze the document from a qualitative standpoint. Remember, you are trying to incorporate flexibility for the future.

Draft 3

You have finally reached the point at which you are ready to finalize the XML template. Looking at draft 2, you should now ask yourself the following questions.

- Is the document extensible?
- Is it completely modular?

Again, let's answer these questions. *Is the document extensible?* Yes it is. In the future, you could easily expand on the data you would like to store for each entry, while keeping the structure of the document intact. You could also add new categorization attributes to facilitate faster search-

ing, incorporation of new data elements, and so on.

Is it completely modular? Here is a problem you cannot really answer yes to wholeheartedly. If you look at the document, although each entry is encapsulated, the data within it is not. To achieve true segmentation of data without going overboard, you need to be able to distinguish among subcategories. In the case of our address book document, all data is grouped. The key is to find relationships between the data, and each group of related data should be its own element.

The natural relationship in our document is that the one that exists between all elements that actually describe a complete address for an entry (i.e., all elements except *name*). Whereas *name* lists the entry's full name, the remaining elements are simply elements of the complete address. It follows that segmenting this data would definitely make the XML document more robust and readable. Examine the final change to the document, as follows.

```
<addressbook>
 <entry id="[letter]">
  <name></name>
  <address>
  <line1></line1>
  <line2></line2>
  <city></city>
  <state></state>
  <pin></pin>
  <phone></phone>
  <email></email>
  </address>
 </entry>
</addressbook>
```

With the addition of the *address* element, the data is now segmented into effective related chunks. What are the benefits of this? Practically speaking, now you could add various address categories (e.g., home, office, and so on). In addition, if you chose to add more information about the entry, you could come up with a user-specific element (such as *entryInfo*) to store information about the particular entry's demographics. The possibilities are, in fact, endless.

Congratulations! You are now an XML data design expert, for all practical Flash purposes. Let's continue by examining the ActionScript involved in the application itself.

Application ActionScript

This section dissects the address book application front end. You already examined how to design and finalize an XML document for use with the application. This section shows you how to parse the data and display it effectively. Let's examine the address book application ActionScript.

 NOTE: *The user interface of this application is quite neat and simple. Whereas the title and logo were imported as symbols from Freehand 10, the generic alphabet button was created within Flash itself. The remainder of the user interface consists of text fields and a Flash MX combo box component instance. We recommend that you examine each graphical asset within the movie library before you examine the main movie scripts. It is imperative that you understand how each asset interacts with others within the scope of the movie. In particular, examine the button movie clip.*

Declarations

As always, the first set of lines deals with declaring global variables specific to the application. Examine the following code.

```
URL = "addressbook.xml";
_global.currLetter = "a";
```

Here, the *URL* constant stores the location of the XML document. The global variable *currLetter* stores the initial alphabet for which entries should be displayed. This variable is declared globally because it is called by the alphabet button movie clips.

init()

By now, the *init()* function should be extremely familiar to you. For this particular application, this function sets all user-interface style attributes and loads the XML document designed in the previous section.

 NOTE: *For the purpose of demonstration, the XML template created in the previous section was used to develop a simple example document with dummy entries. Examine this document, named* addressbook.xml *(located in the* fmxas/chapter09/addressbook *folder on the companion CD-ROM) before you proceed.*

Examine code example 9-11 for the related code.

Code Example 9-11: The init() Function

```
function init() {
  globalStyleFormat.background = 0x999999;
```

```
globalStyleFormat.textSize = 11;
globalStyleFormat.selection = 0x666666;
globalStyleFormat.applyChanges("background", ¬
  "textSize", "selection");

nameList.setChangeHandler("displaySelectedEntry");

formatField(fullName);
formatField(line1);
formatField(line2);
formatField(city);
formatField(state);
formatField(pin);
formatField(phone);
formatField(email);

myXML = new XML();
myXML.ignoreWhite = true;
myXML.onLoad = xmlLoaded;
myXML.load(URL);
```

In code example 9-11, the first few lines are specific to the combo box component (*nameList*) this application utilizes to display a name list. The *GlobalStyleFormat* property is an instance property for all instantiated components subscribed to it. It is a property of the *FStyleFormat* component, and may be used to change specific format properties (e.g., arrow, background, and so on) for all component instances passed to it, using the following line.

```
globalStyleFormat.applyChanges("background", ¬
"textSize", "selection");
```

The next eight lines of code pass each text field on stage to a function called *formatField*. This function simply gives the field a new background color. The next line of code sets the event handler for the combo box component. An event in this case is defined as a user clicking on a list item. This event may trigger a callback function, as follows.

```
nameList.setChangeHandler("displaySelectedEntry");
```

The remaining lines simply load the XML document and assign it a callback function for its *onLoad* property. Note that the parameter *URL* is the location of the related XML file declared as a variable at the start of the script.

formatField(myField)

The *formatField(myField)* function, as mentioned previously, simply assigns a new background color to each field passed to it, as follows.

```
formatField = function(myField) {
 myField.backgroundColor = 0x999999;
};
```

xmlLoaded()

xmlLoaded() is the callback function assigned to the *onLoad* property of the XML object. It simply initiates the first loading of entries for the alphabet stored in *_global.currLetter*. Examine the code, as follows.

```
function xmlLoaded() {
 loadList(currLetter);
}
```

loadList(currLetter)

The *loadList(currLetter)* function might be considered the heart of the application. This function initializes and coordinates the loading of a new list. In this case, a list is defined as a collection of all entries sharing the same category ID. Examine the function, shown in code example 9-12, before proceeding.

Code Example 9-12: The loadList() Function

```
_global.loadList = function(currLetter) {
 nameList.removeAll();
 for (var i in _root) {
  if(typeof _root[i] == "object") {
   _root[i].text = "";
  }
 }
 var letter = currLetter;
 var total = 0;
 var nodes = myXML.childNodes[0].childNodes.length;
 var firstNode = myXML.childNodes[0].firstChild;
 var nextNode = firstNode;
 for (var i=0; i<nodes; i++) {
  if (nextNode.attributes["id"] == letter) {
   addToList(collectData(nextNode));
   total++;
```

```
  }
  nextNode = nextNode.nextSibling;
  }
  if (total == 0) {
  nameList.addItem("No Entries Found!!");
  }
};
```

As shown in code example 9-12, the *loadList()* function is declared as *_global*. Once again, this function needs to be called from different locations, and hence its scope has been made global. Whereas the first line of code simply clears out all items currently listed in the *nameList* combo box, the *for...in* loop that follows effectively resets the text in all text fields on the *_root* level to "". The next five lines of code initialize local variables. Table 9-5 summarizes the role of each.

Table 9-5: Local Variables Summary

Variable	Summary
letter	Stores the current letter passed
total	Stores the total number of matching entries for a letter
nodes	Stores the length of the entire document (i.e., number of entries)
firstNode	Stores a reference to the root node of the document
nextNode	Stores a reference to the current node being parsed

The *for* loop that follows simply iterates through every node (entry) and checks whether the entry matches the selected *letter*. In the event it does, the *addToList()* function is called, with an object argument returned by the *collectData()* function. (Each of these is discussed in material to follow.) In addition, the variable *total* is incremented. The following line forces the *for* loop to evaluate the next sibling < *entry* > element.

```
nextNode = nextNode.nextSibling;
```

The *if* loop that concludes the function simply outputs to the *nameList* combo box instance that no entries for the chosen alphabet category (i.e., *currLetter*) were found.

collectData(myNode)

The *collectData(myNode)* function essentially creates a new object called *dataObj* with all the element properties for an *entry*. This function is

passed an *entry* node used to populate this object. Once this object has been populated, it is returned to the calling function. Examine code example 9-13.

Code Example 9-13: The collectData() *Function*

```
function collectData(myNode) {
 var dataObj = new Object;
 var addressNode = ¬
  myNode.firstChild.nextSibling.firstChild;
 dataObj.name = myNode.firstChild.firstChild¬
  .nodeValue;
 dataObj.line1 = addressNode.firstChild.nodeValue;
 dataObj.line2 = addressNode.nextSibling¬
  .firstChild.nodeValue;
 dataObj.city = addressNode¬
  .nextSibling.nextSibling.firstChild.nodeValue;
 dataObj.state = addressNode¬
  .nextSibling.nextSibling.nextSibling.firstChild¬
  .nodeValue;
 dataObj.pin = addressNode¬
  .nextSibling.nextSibling.nextSibling.nextSibling¬
  .firstChild.nodeValue;
 dataObj.ph = addressNode¬
  .nextSibling.nextSibling.nextSibling.nextSibling¬
  .nextSibling.firstChild.nodeValue;
 dataObj.email = addressNode¬
  .nextSibling.nextSibling.nextSibling.nextSibling¬
  .nextSibling.nextSibling.firstChild.nodeValue;
 return dataObj;
}
```

Examine how each element is extracted from *myNode*. Although this process could have easily been achieved using a *for* loop in conjunction with the *childNodes* property, this approach was chosen to demonstrate XML traversals with some clarity.

 TIP: *To examine how the* dataObj *object is constructed, trace each property as it is appended.*

addToList(dataObj)

The *addToList(dataObj)* function, as follows, is called by the *loadList()* function. It accepts one argument, *dataObj*. This is the object constructed in the *collectData()* function. The function adds an item to the *nameList* combo box, passing it two arguments: the label and the associated *data* object.

```
function addToList(dataObj) {
      nameList.addItem(dataObj.name, dataObj);
}
```

displaySelectedEntry()

displaySelectedEntry() is the final function of the application. It is the call-back function assigned to the selection handler for the *nameList* combo box instance. Each time an item in the list is selected, this function is called. It simply updates the related text fields with that item's stored data (i.e., the *dataObj* assigned to it). Examine code example 9-14.

Code Example 9-14: The displaySelectedEntry() Function

```
function displaySelectedEntry() {
  var objData = nameList.getSelectedItem().data;
  fullname.text = objData.name;
  line1.text = objData.line1;
  line2.text = objData.line2;
  city.text = objData.city;
  state.text = objData.state;
  pin.text = objData.pin;
  phone.text = objData.ph;
  email.text = objData.email;
}
```

Note that the first line of code in this function creates a local variable that stores a reference to the data object for the selected entry. This reference is simply a pointer to the data object set as an item was appended to the *nameList* combo box.

mc_letter Actions

The first frame of the movie clip symbol *mc_letter* contains all code required for each letter button. This movie clip simulates a button rollover by using a graphic background controlled by the button's own

onRollOver() and *onRollOut()* event methods. Examine the code on frame 1 on the button, as shown in code example 9-15.

Code Example 9-15: mc_letter *Actions*

```
this.label.autoSize = true;
this.label.text = this._name;

this.onRollOver = function() {
  this.gotoAndStop(2);
};

this.onRollOut = function() {
  this.gotoAndStop(1);
};

this.onRelease = function() {
  currLetter = this._name;
  loadList(currLetter);
};
```

The first line of the code sets the *autoSize* property of the *label* text field to true. The *label* text field displays the label for each letter button movie clip instance, and this is set from the name of the clip as reflected in the next line of code (note that each instance on the stage has already been named appropriately). The *onRollOver()* and *onRollOut()* event methods simulate a button click by jumping back and forth between two frames.

Each frame bears a background graphic for that particular state. The *onRelease()* event method for each clip sets the *currLetter* variable to the current movie clip's name, and then calls the *loadList()* method to update the list. Hence, each time a user clicks on a button, the entries for that particular alphabet category are loaded from the XML object already populated with the XML file.

As you have seen, using an XML document is extremely advantageous, as it allows you to create applications that are at the same time extremely flexible and robust. It is hoped that this chapter has given you the confidence to advance your XML skills to a higher level.

▪ ▪ ▪ **Summary**

In this chapter you were taught XML from the ground up. You learned some extremely critical XML structure characteristics, the importance of well-formed XML documents, and got an overall picture of XML as a technology. In addition, you learned all about the XML object in Flash, and how it may be used to effectively develop robust applications. Although this chapter gave you a great kick-start into the world of XML, it did not explore server-side integration using XML, an area in which XML's power really comes to the fore. However, the final chapter does cover this topic in depth. In turn, this should prove to be a well-rounded XML experience for you.

XML is here to stay, whether you like it or not. The fact remains that more and more companies and applications have begun to see the effectiveness of XML data exchange, and in turn have begun implementing it in their structures. Terms such as *SOAP, XML-RPC*, and so on have become frequently used words, even in the average web development studio.

The future of e-commerce and the Internet as a whole will change due to the introduction of XML into the picture. HTML was the coolest thing when it first became popular. Only a few experts knew it initially. However, these days even 10-year-olds host web pages. You can expect XML to follow HTML's trend in the years to come. It is left to you to embrace it and stay ahead of the pack, or avoid it and feel handicapped in the future.

10

Math, Physics, and Interactivity

▪ ▪ ▪ Introduction

You have come a long way since the start of this book, having learned about topics such as OOP, server/client data exchange, XML, color models, and so on. These topics are not specific to Flash. In fact, each is a science unto itself. Technologies and studies such as these contribute to an application to make it more powerful. Flash by itself is nothing more than a blank canvas. It is the fusion of animation techniques, programming, motion graphics, music, the Internet, and an expansive array of other phenomena that constitutes the true power of Flash.

Mathematics is yet another dynamic aspect of Flash. When combined with the power of real-world principles of kinematics and dynamics, possibly the most practical branches of physics, Flash becomes a highly intelligent, robust, and interactive playground that pretty much redefines the Internet. The sciences of mathematics and physics add the final touches to a highly functional and usable piece of work when incorporated intelligently.

This chapter takes you on a tour of mathematics and physics concepts to the application of which will add an even more dynamic aspect to your Flash creations. You will explore the math behind concepts such as speed, velocity, acceleration, friction, and so on, as well as learn how to translate these into programmatic code usable in the Flash environment. Although you need not be a mathematician or physicist to understand this chapter, it would definitely be beneficial for you to have a solid understanding of high school trigonometry, simple linear algebra, and geometry.

Unfortunately, the topics explored herein are much too involved to cover in one chapter. However, the most important and vital concepts are covered in detail as they relate to adding motion and interactivity to your projects. It is hoped that you will gain an appreciation of the power of programmatic motion and interactivity through an understanding of the mathematics and physics examined here, and take it upon yourself to pick up where this chapter leaves off.

▪ ▪ ▪ Objectives

In this chapter you will:

- Learn about the uses of math and physics in interactivity.
- Understand basics such as coordinate systems, degrees, radians, trigonometric relationships, identities, and so on. You will learn how each applies to Flash MX.
- Learn concepts such as speed, velocity, acceleration, and so on, with appropriate examples in Flash MX.
- Get ideas of how to incorporate mathematics and physics into your projects to make them faster, more compact, and robust.
- Examine a simple example employing the concepts discussed.

▪ ▪ ▪ Mathematics and Physics: An Analogy

For some reason, mention of the word *math* intimidates most people. The phenomenon is like Pavlov's *classical conditioning*. Pavlov hypothesized that associations (such as his dogs salivating in anticipation of being fed) could easily be manipulated. His studies show that the process of learning is based on associations. Undesirable stimuli typically cause negative responses. For example, if math was always presented to you in an uninteresting manner and you were forced to complete difficult homework problems all through school, it would be natural for you to have developed a bad taste for mathematics.

In its natural form, however, mathematics can be much like the anticipated meal fed to Pavlov's dogs: desirable, tasty, satisfying, and (last but not least) necessary. Many are conditioned into believing that math is not fun. It is hoped that this chapter will serve to recondition you to reverse any negative memories.

This chapter deals with basic math concepts you must know and that are invaluable if you want to take your projects a step further, incorporating such things as traditional game design and theory or advanced programming. By the end of this chapter you will have a pretty good idea of

why the knowledge of linear and nonlinear algebra, trigonometry, kinematics, and dynamics are central to interactivity in Flash MX. We encourage you to use this chapter as a stepping-stone to furthering your math and physics skills, either through personal research or even enrolling in an educational institution and taking a few classes.

••• The Basics

This section assumes that you know nothing about mathematics and attempts to give you a quick overview of concepts you should know. For a more elaborate understanding, you are encouraged to obtain a good freshman-level college text and read up on these topics on your own. It will be an investment well worth the trouble.

Cartesian Coordinate System

Coordinate systems are the basis of any graphical representation of scientific data. Related to Flash, coordinate systems allow us to translate values into real points on the stage. These points may be single-dimensional, two-dimensional, or three-dimensional (assume the existence of these three dimensions for now). Flash's coordinate system is very similar to coordinate systems established for other software products. However, it is important to understand that it is simply a derivative of the Cartesian coordinate system.

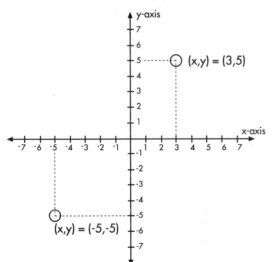

To define an object in a plane, the 2D Cartesian coordinate system is used. This consists of two perpendicular axes that intersect at the origin. Every point in the plane is assigned an ordered pair (x, y) to determine its location. Examine figure 10-1.

In figure 10-1,

- x = perpendicular distance of object from the y axis

- y = perpendicular distance of object from the x axis

Figure 10-1. The Cartesian coordinate system.

Flash Coordinate System

You are probably wondering where the origin is located on the main stage in your Flash movie. The top left-hand corner of the main stage is the origin (shown in figure 10-2). This means:

- The top edge of the stage is the *x* axis
- The left edge of the stage is the *y* axis

Hence,

- A positive *x* coordinate refers to a point on the right-hand side of the *y* axis (similar to the Cartesian system).
- A positive *y* coordinate refers to a point below the *x* axis (*contrary to what the Cartesian coordinate system follows*).

Figure 10-2. The Flash coordinate system.

It is important to note that you will often perform calculations in the regular Cartesian coordinate system or one of its derivatives, such as the cylindrical coordinate system or the spherical coordinate system. However, these calculations will need to be translated into Flash coordinates when you finally implement them in your applications. Due to this fact, it is important that you condition your mind to be able to think in either coordinate system. Just because Flash has a different coordinate system, do not assume that you will never have to use other ones. In fact, quite to the contrary, you will end up performing a majority of your calculations in the Cartesian system and then translating them into Flash coordinates.

 CD-ROM NOTE: *To see the related example, open the file* ch10_01.fla *located in the* fmxas/chapter10/ *folder on the companion CD-ROM.*

The Pythagorean Theorem

Pythagoras was one of the most influential mathematicians ever. However, he was also one of the most mysterious and least documented. Most of you probably recognize the term *Pythagorean theorem*. It is beyond the scope of this chapter to provide the proof for the theorem. The theorem, in its simplest form, relates the length of the three sides of a right triangle with the following identity:

$$a \wedge 2 + b \wedge 2 = c \wedge 2$$

where c *is the side opposite to the right angle (called the hypotenuse) and* a *and* b *are the sides adjacent to the right angle*

Figure 10-3 shows a graphical representation of the Pythagorean theorem. This is one of the most useful relationships in mathematics, as you will observe in the sections that follow. One very useful application of this theorem is the *distance formula* (covered in the next section). Related to Flash interactivity and motion, in one of its forms (trigonometric, vector, and so on), this theorem plays a role in almost every solution you might come up with.

Distance Formula

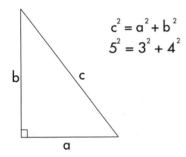

$$c^2 = a^2 + b^2$$
$$5^2 = 3^2 + 4^2$$

Figure 10-3. The Pythagorean theorem.

Every so often you need to find the distance between two points in 2D space. Whereas getting the distance between two points in a single dimension is quite straightforward, this is not the case for 2D space. The *distance formula* gives you the distance between two points in 2D space. The distance formula states that the distance d (P_1, P_2) between point P_1 (x_1, y_1) and point P_2 (x_2, y_2) in a plane is given by the relation

$$d(P_1, P_2) = \sqrt{(x_2 - x_1)^2 - (y_2 - y_1)^2}$$

Examine figure 10-4, which shows a graphical representation of this formula. Keep in mind that d (P_1, P_2) = d (P_2, P_1) and hence the order in which the x and y coordinates are subtracted is immaterial. (For the more curious, examination shows that the distance formula is derived from the Pythagorean theorem.) Although it is beyond the scope of this chapter to explicate the proof, it would definitely help you to take the time to understand how the distance formula is derived from the Pythagorean theorem.

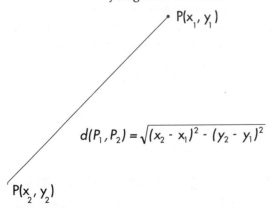

$$d(P_1, P_2) = \sqrt{(x_2 - x_1)^2 - (y_2 - y_1)^2}$$

Figure 10-4. The distance formula.

■ ■ ■ Trigonometry

Now that you are pretty well versed with the basics, let's revisit something you may have had experience with in high school – trigonometry. The word *trigonometry* is derived from the Greek *trigonon* (triangle) and *metria* (measurement). The applications of trigonometry are found in our day-to-day lives, and trigonometry serves as a basis for many physics and math studies. Believe it or not, trigonometry is

the foundation of most programmatic math and physics. Trigonometric identities, relations, and concepts are by far the most important elements of programmatic motion. If you plan on improving your programmatic motion and interactivity coding skills, you will need to know trigonometry inside out.

The sections that follow explore most of the crucial concepts subsumed by this vast topic. In the process you will examine some examples and create some of your own. It is a myth that trigonometry is useful only in game programming. If you like to play around with random behaviors, programmatic art, or kinematics-driven motion in Flash, you know that you need trigonometry at all points. Its applications are endless, as you will soon see. Let's begin exploring the particulars.

Radian Measure

The natural place to start our discussion is with the concept of a *radian*. Assuming you know what a *degree* is, this discussion will enable you to understand sections to follow. Radian measure is in fact used widely with several calculations in Flash, as it is much simpler and more efficient than the degree measure in many ways.

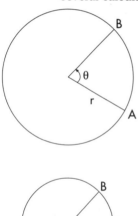

One radian is the measure of the central angle of a circle subtended by an arc equal in length to the radius of the circle. The radian measure is independent of the size of the circle. It is found by determining how many times the length of the radius of the circle is contained in the length of the subtended arc. If you consider a circle of radius r, an angle Ø with a measure of 1 radian intercepts an arc AB having length r, as shown in figure 10-5.

An alternative definition of the radian states that a central angle is said to be 1 radian in measure when its arc length is equal to the length of its radius. One important relationship you must remember is that of degrees to radians, as follows:

$$180° = \pi \text{ radian}$$

Radian measure has no units in representation. So, if an angle has radian measure 22, you would simply write Ø = 22.

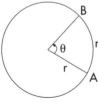

1 radian

Figure 10-5. The radian measure.

Converting Radians to Degrees, and Vice Versa

This is a very important section because of its direct application in ActionScript, and in programming in general. Several functions used in

ActionScript return the degree measure for rotation. Most of the time, we use degrees as our base unit for manipulations. However, Flash's trigonometric functions (sin, and so on) require radian values. You can obviously see the implications of mistaking a radian for a degree. A possible scenario would be your spaceship turning left when you intended to make it go higher. Not good! Table 10-1 outlines the conversion between the two angle measures.

Table 10-1: Converting Between Radians and Degrees

To Change	Multiply By
Degrees to radians	π / 180°
Radians to degrees	180° / π

Writing Prototype Conversion Functions

It is peculiar that Macromedia did not simply ship the Math object with two built-in methods for converting radians to degrees, and vice versa. Your first instinct would be to write two functions to enable this conversion and pass values to it as arguments. However, this could become really inefficient in the scope of a large project with several levels and depths, each containing objects that require the function. If this does not scream "prototype" to you, we recommend that you give Chapter 2 another shot.

The best approach to writing a function that would be available anywhere (globally) would be to create it via the prototype method. In this case, you want to add some functionality to the Math object, and hence need to add two methods to the Math object to reflect this functionality (i.e., conversions between radians and degrees). Examine code example 10-1.

Code Example 10-1: Adding Methods to the Math Object

```
Math.radian = function(degrees) {
      return (degrees * Math.PI/180);
};
Math.degree = function(radian) {
      return (radian * 180/Math.PI);
};
```

From code example 10-1, you can see what an easy task it is to add methods to the Math object itself. Remember, the Math object is simply of type Object, and hence all you need to do is assign functions to it directly (see Chapter 2 for more information on writing prototypes to extend existing objects). These methods will be available to all objects associated with the movie. To call these methods, you would simply write something similar to the following.

```
Math.radian(180); //3.14159265358979
```

 CD-ROM NOTE: *To see the related example, open the file ch10_02.fla located in the fmxas/chapter10/ folder on the companion CD-ROM.*

Figure 10-6. Regular angles of rotation.

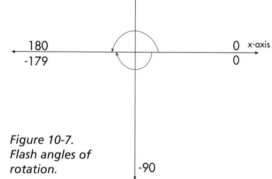

Figure 10-7. Flash angles of rotation.

Flash and Radians

It is important to know how to determine angles in Flash. Flash's *polar* setup is similar in peculiarity to its coordinate system setup. Figure 10-6 shows a regular coordinate axis with respective angles of rotation.

This should be familiar to most of you. Traditionally, the positive *x* axis is considered to be at 0 degrees, with the angle increasing in the counterclockwise direction. One complete revolution (or rotation, depending on how you are looking at it) accounts for 360 degrees of rotation in natural numbers. In contrast, examine the Flash coordinate system, angles of rotation of which are shown in figure 10-7.

As you can see, Flash has a peculiar setup for rotation angles. Whereas the starting point (positive *x* axis) is the same as for the Cartesian system, everything else is nonintuitive. The angle increases in the clockwise direction until it reaches 180 degrees. However, once you return to the second quadrant, it starts increasing from a value of -179 degrees (increasing in negative integers means getting closer to 0). Hence, the first and second quadrants are simply negative reflections of the third and fourth quadrants. If this does not seem clear, examine figure 10-7. A simple way to overcome this hurdle is to approach it as is done in the related example (*ch10_02.fla*) on the companion CD-ROM. Examine code example 10-2.

Code Example 10-2: Correcting Negative Rotation Values

```
if (dy<0) {
        radians = Math.atan2(dy, dx) + (2*Math.PI);
}
```

As shown in code example 10-2, whenever the value of *dy* (a variable that tracks the distance between the *y* coordinate and the origin) becomes negative, the actual radian value becomes negative. A simple fix to this is to add 2 radians (360 degrees) to the value to get the corrected value. For example, if the radian value were -179 degrees, after correction this value would become 181 degrees. If this seems unclear, or its application seems vague, simply continue reading and it will fall into place soon.

Trigonometric Functions

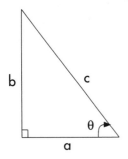

Trigonometric functions are very important to Flash development. Most programmatic motion is based on right-angled triangulations, and this is where trigonometric functions come into play. Trigonometric functions relate the sides of a right triangle using established ratios. Any triangle is a right triangle if one of its angles equals 90 degrees. Some of the most important trigonometric ratios in Flash development are *sine*, *cosine*, and *tangent*. Examine figure 10-8.

Figure 10-8. Trigonometric ratios.

If θ is any acute angle of right triangle *abc*, the most vital ratios to be considered are:

$$\frac{b}{c}, \frac{a}{c}, \frac{b}{a}, \frac{a}{b}, \frac{c}{a}, \frac{c}{b}$$

Trigonometric functions establish the fact that these ratios are dependent only on θ, and not the actual size of the triangle. For each θ, the six ratios have unique values. Because the ratios are dependent on θ they are called functions of θ. These are termed *trigonometric functions*. The importance of trigonometric functions will become clear as you proceed. However, for the time being, let's get the technical aspects out of the way (i.e., how to calculate trigonometric functions).

In figure 10-8, the side *b* is known as the *opposite* side (as it is opposite angle θ), and side *a* is known as the *adjacent* side (as it is adjacent to angle θ). These sides are abbreviated, respectively, *opp* and *adj*. As you already know, side *c* is known as the *hypotenuse* (abbreviated *hyp*). Based on this system of abbreviations, the six vital trigonometric functions (sine, cosine, tangent, cot, sec, and csc) are:

$$\sin\theta = \frac{\text{opp}}{\text{hyp}} = \frac{b}{c}$$

$$\cos\theta = \frac{\text{adj}}{\text{hyp}} = \frac{a}{c}$$

$$\tan\theta = \frac{\text{opp}}{\text{adj}} = \frac{b}{a}$$

$$\cot\theta = \frac{\text{adj}}{\text{opp}} = \frac{a}{b}$$

$$\sec\theta = \frac{\text{hyp}}{\text{adj}} = \frac{c}{a}$$

$$\csc\theta = \frac{\text{hyp}}{\text{opp}} = \frac{c}{b}$$

 NOTE: *It is beyond the scope of this book to elaborate any further on the trigonometric functions listed. It would be in your best interest to learn where they come from and what they do, either via an online resource or other text.*

The six functions are often denoted in terms of their *reciprocals*, known as *reciprocal relations*. They are as follows:

$$\sin\theta = \frac{1}{\csc\theta}$$

$$\cos\theta = \frac{1}{\sec\theta}$$

$$\tan\theta = \frac{1}{\cot\theta}$$

$$\cot\theta = \frac{1}{\tan\theta}$$

$$\sec\theta = \frac{1}{\cos\theta}$$

$$\csc\theta = \frac{1}{\sin\theta}$$

In addition, a few are also related via *quotient relations*, as follows:

$$\tan\theta = \frac{\sin\theta}{\cos\theta}$$

$$\cot\theta = \frac{\cos\theta}{\sin\theta}$$

At this point, you are probably wondering what the significance of all this jargon is. Incidentally, these are extremely important relations.

Typically, when you deal with programmatic motion, you have a set of variables you work with (e.g., velocity, direction angle, and so on). Obviously, when you want an object to move on stage, the values stored in the variables must change.

Even though the values are changing, the relationships between the variables remain constant (e.g., final velocity equals the sum of instantaneous velocity and acceleration times time). This is where relations come into play. Frequently, you must establish a relation and then update its variables to display motion. Sometimes the relations are as straightforward as the definition of the *sine* function. Most of the time, however, life is much more complicated and you need to derive a relation.

You have seen an example of derivation in code example 10-2, where the *inverse tangent* (i.e., *atan2*) function was used to determine the central angle the cursor made with the origin. *Inverse trigonometric* functions basically return the angle θ in a relation (as opposed to the actual ratio). Without the knowledge of *quotient relations* you would have to devise a rather lengthy workaround using sine and cosine values to achieve the same effect achieved by that single line of code.

Inverse Trigonometric Functions

 CD-ROM NOTE: *To see the related example, open the file* ch10_03.fla *located in the* fmxas/chapter10/ *folder on the companion CD-ROM.*

You already know that trigonometric functions return a ratio/value between sides of a right triangle, as follows:

$$\sin\theta = \frac{1}{\sqrt{2}}$$

However, often you will want to know the value of the angle θ itself. For instance, suppose you wanted to rotate an object to always face the mouse cursor on stage. In this case, the mouse cursor will make a right angle with the origin (i.e., where the object is placed on stage), as shown in figure 10-9.

As you can see in figure 10-9, calculating the rotation of the arrow is a simple matter of using an inverse trigonometric function (*atan2* in this case). A simple analogy would be the square root. Suppose you were given the following equation:

$$x^2 = 4$$

How would you find x in this case? You would use the square root formula, in the following manner:

$$x = \sqrt{4}$$

In this case, the square root is simply the inverse of square. We recommend that you familiarize yourself with the inverse tangent functions, as these are quite possibly the most useful functions in 2D programmatic motion in Flash. The general form for representing an inverse trigonometric function is as follows (note that *tan* has been used in the following case, but this form holds true for all trigonometric functions):

$$\theta = \tan^{-1}\left(\frac{y}{x}\right)$$

where θ is the angle in question.

Figure 10-9. Right angle relating the mouse cursor and the object.

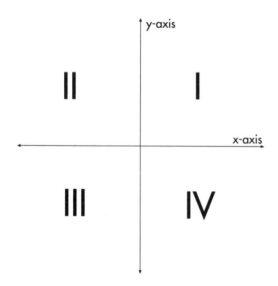

Figure 10-10. Cartesian coordinate system quadrants.

Quadrants

Once you get into some development, you will realize that trigonometric values are not always positive in sign. On the contrary, most of the trigonometric values you will have to deal with will be negative. The signs of the values depend on the positions of the arms of the triangle with respect to *quadrants*. (Cartesian coordinate system quadrants are shown in figure 10-10.) See table 10-2 to determine the sign of a trigonometric value.

There is a very simple way of remembering the content of table 10-2. Actually, there are a couple of simple ways. You could remember the acronym ASTC, which stands for "All, Sine, Tangent, Cosine", as shown in figure 10-11. This denotes the positive values in

Table 10-2: Special Angle Signs in Four Quadrants

Quadrant	Sin	Cos	Tan	Cot	Sec	Csc
First	+	+	+	+	+	+
Second	+	-	-	-	-	+
Third	-	-	+	+	-	-
Fourth	-	+	-	-	+	-

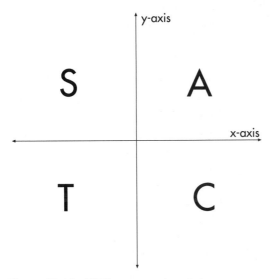

Figure 10-11. ASTC acronym breakdown.

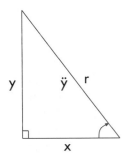

Figure 10-12. Alternative method of remembering signs in quadrants.

order of quadrants. For instance, all values are positive in the first quadrant, only sine values are positive in the second quadrant, and so on. If you remember your reciprocal identities, you can easily figure out the signs for the remaining three functions. Always remember, sin is the reciprocal of csc, cos is the reciprocal of sec, and tan is the reciprocal of cot. Hence, they have the same signs.

Another way to remember the table is to think of it logically. In the example triangle shown in figure 10-12, the adjacent side is arm x, and the opposite side is the arm y.

The sine function is the ratio of y to r. y is always positive above the x axis, and hence the sine function always has a positive value in the first and second quadrants. The cosine function is the ratio of x to r. x is always positive on the right of the y axis, and hence the cosine function has a positive value in the first and fourth quadrants.

The tangent function is the ratio of y to x. y and x have the same signs in the first and third quadrants, and hence the tangent function has positive values in these quadrants. Similarly, the remaining signs may be derived using the reciprocal identities table. All reciprocal functions have the same signs. Although it is not that important that you be able to recall these at will, this is definitely advantageous. It is nevertheless quite important that you understand quadrants and signs, as they come in handy quite often.

Vectors

Vectors are an extremely important concept in regard to the study of motion, including kinematics and dynamics. The following examines vectors in the context of vector components and their resolution. It is recommended that you look into vectors on your own, as they are a crucial part of the physical world and an understanding of them will enhance your work.

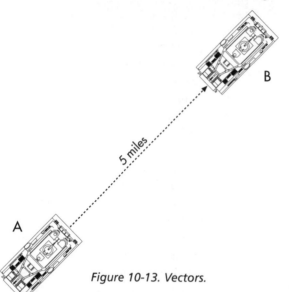

Figure 10-13. Vectors.

Vectors represent concepts such as displacement, velocity, acceleration, or whatever else requires depiction of motion. Vectors are defined as physical quantities that have magnitude, as well as direction, and are represented by a line with starts and end points, with an arrow denoting the direction of the vector. Let's elaborate on this definition. Examine figure 10-13.

In figure 10-13, the tank has moved 5 miles from A to B. If you were asked to describe the displacement of the tank, you might respond by saying, "The tank has moved 5 miles." But *all* this would tell someone is that the tank is 5 miles from its starting point. The tank could lie anywhere on the circumference of a circle of radius 5 miles, with A as its origin.

However, if you used a vector such as that shown in figure 10-13, you could pinpoint the exact location of the displaced tank. Your answer would look something like: "The tank has moved a distance of 5 miles (*magnitude* of the vector) in a direction 45 degrees north of east (*direction* of the vector)." This may seem like a lot to say when it comes to our little tank, but it makes life a lot easier when you start dealing with a tank moving around in the 2D plane of a computer game, and representing a point in 3D space simply becomes nearly impossible without using a vector.

A vector is a concept difficult to visualize immediately because of its abstract nature. Keep reading and it will make more sense in the context of real examples. But before you get your feet wet with some *kinematics*, you need to dig up a few more concepts.

Vector Basics

Before dealing with the most important vector topic related to Flash development, let's take care of some basic conceptual housekeeping. For

instance, you need to understand how vectors are represented, how their magnitudes are calculated, what their components are like, and so on. Let's quickly run through these topics.

 TIP: *It is recommended that you get a good text dealing with introductory mathematics and physics. This will serve as a good reference and will help you develop a taste for understanding the concepts you apply in Flash. It is not a good idea to blindly take the freely available ActionScript and simply paste it into your own work. Although this might help get a task done in the short run, it will definitely go against your best interests of becoming a well-rounded Flash developer.*

Representation

We use PQ to denote a vector with initial point P and terminal point Q. We use letters such as u and v to denote vectors with no terminal point.

Length or Magnitude

The length of a vector is simply the distance from the origin to the tip of the vector. It is denoted by $|u|$ and read as "the length of u." As you can see in figure 10-14, you can use the distance formula to find the length of a vector, as follows:

$$|u| = \sqrt{(x_f - x_o)^2 - (y_f - y_o)^2}$$

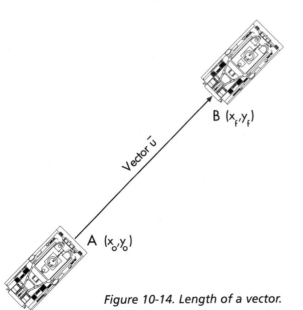

Figure 10-14. Length of a vector.

Vector Components

Vector components are the most useful tools vectors provide. They facilitate the creation of very simple to extremely sophisticated motion-based graphics programming. Understanding this concept itself is winning half the battle, as the rest that follows is simply application of these rules.

By definition, the perpendicular projections of the vector onto the x and y axes are called the components of the vector. The components of a vector u are simply two mutually perpendicular vectors (u_x and u_y) that are parallel to the x and y axes,

respectively, such that $u = u_x + u_y$. The component parallel to the x axis is called the *horizontal component*, and the component parallel to the y axis is called the *vertical component*. Take a look at the figure 10-15 and this will make more sense.

Figure 10-15. Vector components.

Let's explore this in regard to the tank. Examine figure 10-15. When the tank moves from A to B, its displacement vector is u. If you draw a vector (u_x) from A to C (parallel to the x axis) and u_y from C to B (parallel to the y axis) to form a right triangle of vectors ABC, then we call the vectors u_x and u_y the components of vector u. As you can see in the figure, u_x and u_y are mutually perpendicular. This opens up a world of opportunities for us to fool around with, and also supplies us with some invaluable relationships for making various calculations and transformations.

Resolving a Vector's Components

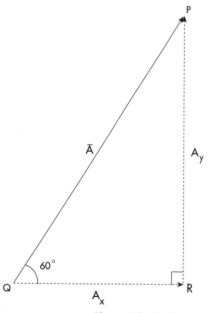

Figure 10-16. Vector components.

In the previous section it was noted that a right triangle's arms play an important role in the formation of vector components. That should scream out one word to you: *trigonometry*. Examine figure 10-16.

Figure 10-16 is a vector diagram similar to those you have seen previously. Now, just for a few minutes, think of it as a simple right triangle PQR, with angle PQR equal to 60 degrees. By definition,

$$\sin(60°) = \frac{RP}{QP}$$

$$\cos(60°) = \frac{QR}{QP}$$

Simplifying,

$$RP = \sin (60°) \bullet QP$$
$$QR = \cos (60°) \bullet QP$$

If we think of this in terms of our vectors, we get

$$A_y = r \bullet \sin (\theta)$$
$$A_x = r \bullet \cos (\theta)$$

The beauty of this is that if you know a vector's magnitude and direction you can easily compute its components using basic trigonometry. The following defines the process.

Given the magnitude (r) of a vector A and its direction (θ) with respect to the x axis, its components are given by the equations:

$$A_y = A \bullet \sin (60°)$$
$$A_x = A \bullet \cos (60°)$$

With the basic trigonometry and math out of the way, let's delve into some kinematics to add some life to our projects.

■ ■ ■ Kinematics Regarding Flash MX

When you think of physics as it relates to multimedia, it is difficult to pin down only those concepts that are important. Physics is a very broad science, and its implications to humanity are virtually endless. Similarly, the importance of physics in interactive multimedia, game programming, and motion-rich presentations is immeasurable. New technologies such as Flash provide developers with a blank canvas and a wide array of programming tools to incorporate real-world kinematics and dynamics into their creations.

Unfortunately, Flash is yet in its teens. The general population of developers is content with keyframe-based animation and cut-and-paste functions. Although these definitely enhance presentations and applications, they fall short of actually harnessing the available infrastructure provided by the scripting language. As discussed earlier, the power of Flash lies in an interdisciplinary knowledge of incorporating mathematics, physics, and computer science in the final product.

One does not need to be a rocket scientist to achieve a high level of interdisciplinary skills. Quite to the contrary, an individual with basic math and physics skills, some level of programming experience, and a considerable amount of common sense can easily master the art of blending these variables into the final equation of a presentation, web site, game, or any type of media-rich experience. You must simply develop a wide knowledge base in these various areas and learn how to maximize on what you know and what is available to you.

The following sections were intended to serve as a review and reference of essential physics concepts. However, they are far from complete, and will always remain works in progress. We have simply documented the most basic concepts for you. In addition, we do not intend to give you a series of cut-and-paste scripts, for those are available in plenty over the Internet. Instead, we hope that this chapter gives you a start on exploring the world of programmatic motion. You can think of it as a taste of what programming motion is all about. It is truly a fusion of several sciences, and the hard and fast fact is that you cannot get by ignoring any single one.

Mechanics

Motion, in a broad sense, has two main aspects. One aspect is the movement itself. For instance, is it fast or slow? The other aspect deals with the cause or origin of the motion. Both aspects are equally important to multimedia. However, the representation of both aspects is quite different in multimedia.

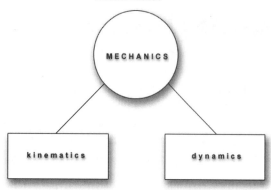

Mechanics is the branch of physics that focuses on the motion of objects and the underlying causes (forces) for the motion. Mechanics may be classified into two broad categories: kinematics and dynamics. *Kinematics* deals with concepts that describe motion without reference to the forces causing it. *Dynamics*, on the other hand, deals with how forces cause motion. The elements of mechanics are depicted in figure 10-17.

Figure 10-17. Elements of mechanics.

For the large part, we do not need to worry about dynamics for development at this level. Representation of forces is an abstract and advanced concept, best left to professional game developers. For our purposes, just about any type of motion (be it linear, circular, hyperbolic, oscillatory, projectile, or other) can be produced by manipulating variables.

The best part is that all of the work involved has already been done for us. Every equation and concept of kinematics applies to the world of programming and multimedia. The key lies in knowing how to manipulate existing equations and concepts. Most people give up, even if they know the concepts and have a sufficient amount of programming experience, simply because they cannot tie the two together. Our goal is to be able to

develop a problem-solving model that can help us tie these skills together to produce more dynamic applications, games, and presentations.

Kinematics

Kinematics deals with concepts that describe motion without reference to the forces causing it. The following concepts are covered in this section.

- *Displacement:* Shortest path of travel or final position minus initial position
- *Distance:* Length of path traveled
- *Speed:* Change in distance divided by change in time
- *Velocity:* Magnitude and direction of speed
- *Acceleration:* Change in velocity divided by change in time

After an examination of these concepts, you will learn how to apply them in simple game programming techniques and interactive multimedia to produce realistic results. Again, our main aim is to provide you with a firm idea of how things work, not to give you code snippets. Of course, there will be a few snippets to help conceptualize various routines, but we believe that with a strong understanding of kinematics you will be able to use the rest of the techniques you have learned to produce your own code. The mathematical quantities used to describe the previously outlined key concepts of kinematics may be classified into two broad categories.

- *Scalar quantities:* Fully described by their magnitude alone
- *Vector quantities:* Described by their magnitude as well as their direction

The following examples should clarify the difference between a scalar and a vector.

- *22 km/hr (scalar):* No direction specified
- *22 km/hr, NE (vector):* Direction is specified
- *1024 KB (scalar):* No direction specified
- *520 amps (scalar):* No direction specified
- *5 pixels per second, 45 degrees (vector):* Direction is specified

Displacement and Distance

Displacement and *distance* are terms often used interchangeably, yet there is a very important difference between them. Consider figure 10-18.

The difference Δx between points A and C gives the value of the displacement of the car. Simply put, *displacement* is the length (magnitude) of the shortest path between two points. On the other hand, the *distance* traveled by the car is equal to the sum of x and y miles (i.e., point A to B

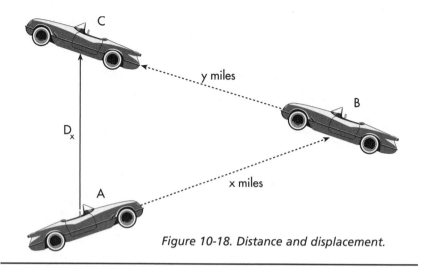

Figure 10-18. Distance and displacement.

and point B to C). Distance is defined as a scalar quantity that represents the total path traveled by an object. It is important to be able to make a distinction between distance and displacement. Several of the following sections will require you to use either distance or displacement in their definitions. If they are interchanged, you will yield an incorrect solution. In figure 10-18,

Displacement (Δx) = Final position (x_f) - Initial position (x_O)

Δx simply means "change in position." Delta is the nickname for "difference between" or "change in."

Speed and Velocity

Speed is the amount of time it takes to do something. When dealing with kinematics, speed is defined as the *distance traveled in unit time*, the formula for which follows.

$$Speed = \frac{Distance\ Traveled}{Elapsed\ Time}$$

The key point to remember is that you are dealing with distance and not displacement. Speed is a very useful concept in understanding velocity, because like distance and displacement, speed and velocity are very similar, and often are terms used interchangeably. However, speed is *not* the same thing as velocity.

Speed is a scalar quantity; that is, it has magnitude but no direction. Hence, speed does not require a vector for its representation. Speed can be represented completely by a number and a unit. For example, one can say that the speed of the plane is 200 mph. But what if we need to find out

how fast the plane is moving as well as the direction it is moving in? This is where we are introduced to the concept of *velocity*. Velocity is defined as the *displacement of an object in unit time*, the formula for which follows. Note the word *displacement* In this definition.

$$Velocity = \frac{Displacement}{Elapsed\ Time}$$

Due to the presence of displacement in the formula, velocity becomes a vector quantity. Recall that a vector quantity is one that has magnitude and direction. The magnitude of the velocity vector is given by the formula:

$$Velocity = \frac{Displacement}{Elapsed\ Time} \qquad (1)$$

We already know that

$$Displacement\ \Delta x = x_f - x_o \qquad (2)$$

Now let

$$t_o = time\ when\ motion\ started\ (time\ at\ x_o)$$
$$t_f = time\ when\ motion\ ended\ (time\ at\ x_f)$$

Then,

$$Elapsed\ time\ (\Delta t) = t_f - t_o \qquad (3)$$

Substituting (3) and (2) in (1), we get

$$|v| = \frac{x_f - x_o}{t_f - t_o} = \frac{\Delta x}{\Delta t}$$

The direction of the velocity vector is the same as the direction of its displacement vector. (You learned how resolve a vector's components in an earlier section.)

Acceleration

Constant velocity is not a practical phenomenon. It works well in theory, but in reality a moving object's velocity is bound to change over time. For example, the velocity of a car steadily increases when its driver steps on the gas pedal. Varying velocity is something that can be explained by *acceleration*. Acceleration is defined as the *change in velocity of an object in unit time*, the formula for which follows.

$$Acceleration = \frac{Change\ in\ Velocity}{Elapsed\ Time}$$

This concept is best explained by an example. Examine figure 10-19.

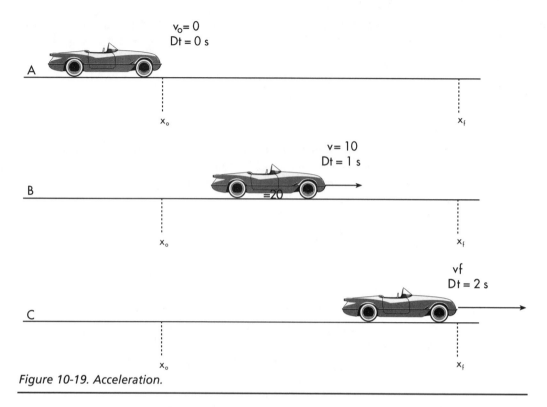

Figure 10-19. Acceleration.

A car is at rest, as shown in the figure 10-19 (A). At some point the driver steps on the gas pedal and the car begins to move with an acceleration factor of 10 km/hr/sec. This means that the car's velocity increases by 10 km/hr every second. So, as shown in figure 10-19 (B), after 1 second, its velocity is 10 km/hr, and after 2 seconds it is 20 km/hr. That is all there is to acceleration. We know that

$$Acceleration = \frac{Change\ in\ Velocity}{Elapsed\ Time} \qquad (1)$$

Given

$$v_o = Initial\ velocity$$
$$v_f = Final\ velocity$$

then

$$Change\ in\ velocity\ (\Delta v) = v_f - v_o \qquad (2)$$

We already know that

$$Elapsed\ Time\ (\Delta t) = t_f - t_o \qquad (3)$$

Substituting (3) and (2) in (1), we derive:

$$|a| = \frac{v_f - v_o}{t_f - t_o} = \frac{\Delta v}{\Delta t}$$

The acceleration vector points in the direction of the change in velocity and has a magnitude equal to the change in velocity.

■ ■ ■ Using Kinematics in Flash MX

Regarding all of the previous physics and mathematics, you are probably asking "How do I use this stuff in Flash?" And a justified question it is, for applying these concepts in Flash requires a little tweaking. It is not necessarily difficult to apply, but it definitely needs some explanation. The most significant problem occurs with application of the concepts to a frame-based environment. So let's understand frame-based environments first.

Frame-based Environments

 CD-ROM NOTE: *To see the related example, open the file* ch10_04.fla *located in the* fmxas/chapter10/ *folder on the companion CD-ROM.*

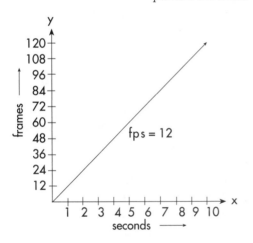

Figure 10-20. Frames-time graph.

Most of us have developed animations in Flash that are frame based. Whereas Flash's frame rate is set at 12 fps by default, you are probably accustomed to changing this value to 30 or 24 to achieve smoother animation. But what exactly are frames? How do they work? What is their significance to programmatic motion? Frames are simply a function of time. What do we mean by this? Examine figure 10-20.

As shown in figure 10-20, frames are simply a linear function of time. When you set the frame rate to 12, you simply tell Flash to set the speed of the playhead to advance 12 frames every second. Similarly, setting the frame rate to 24 would make the playhead advance twice as fast. Simply put, the higher the frame rate the faster the playhead will move. It follows that the higher the frame rate the more any *onEnterFrame()* event method will be called. However, keep in mind that frame rate is dependent on the end user's CPU power.

Whereas a frame rate of 12 fps may seem sufficient to carry out smooth motion on your own machine, it may appear too slow on another user's machine. Conversely, If you set the frame rate too high, it may end up to be too much for some machines to handle. The bottom line is that

frames are simply representatives of time. Hence, when using a frame-based environment, you can simply ignore the time variable in the equations of kinematics.

Tank Example

CD-ROM NOTE: *To see the related example, open the file* ch10_05.fla *located in the* fmxas/chapter10/ *folder on the companion CD-ROM. Play around with the controls to see how it works, and then proceed with the following sections.*

In this example, a simple object is moved around on stage using cursor keys. The objective of this exercise is to show you how to translate a simple equation of kinematics into code, as well as how to resolve vector components.

TIP: *There are four established equations of motion. It would benefit you to learn more about these and how they are derived. Even though we are using the most useful one in the tank example, the others shed some light on aspects it is beyond the scope of this chapter to cover.*

Overview

Let's establish what our tank should do. Upon pressing the Left and Right arrow keys, the tank will turn left and right, respectively. However, this should work in all situations, whether the tank is moving or stationary. Instead of the tank moving with a constant velocity, let's allow it to be accelerated by holding down on the space key. When the space key is released, the tank will decelerate before coming to a stop.

The toughest part of this exercise is figuring out how to keep the tank moving while oriented in the direction of rotation (i.e., to make the tank move in the direction it is pointing). If you were to simply rotate the tank and change its x and y positions, the tank would simply travel diagonally, as shown in the figure 10-21. In fact, you need the tank to behave as shown in figure 10-22, where it moves in the direction of rotation. This should tell you a very important thing: the tank's forward motion is dependent on its direction. Let's examine how to achieve this.

Using Vector Components

You have learned how to break up a vector into its components. Let's see how to apply this concept to correctly move the tank. Let's pick a specific example. Suppose the tank is traveling in the x direction and the Left

Figure 10-21.
Incorrect direction
of motion.

Figure 10-22.
Correct direction
of motion.

arrow key is pressed to orient it 45 degrees NE (pointing toward the upper right-hand corner of the monitor screen). This would mean that the tank would need to turn 45 degrees while moving, and continue moving with proper orientation in the correct direction at the same time. A simple way

to handle problems such as this is to break the problem up into smaller pieces. In this case, the following suggests how this might be done.

- Rotate the tank.

- Move the tank to the final x position.

- Move the tank to the final y position.

Rotating the tank is a piece of cake, and can be programmed easily. However, moving the tank to its final x and y coordinates is slightly tricky. This is because you need to calculate the change in x and the change in y based on the orientation of the tank. If the tank simply needed to go straight, this would amount to adding some value to the x coordinate and y coordinate to simulate that it was moving. However, this is not the case here.

What we have to remember is that even if the tank makes 45-degree turns, it is still contained in a 2D plane. Hence, its position at any point may be accurately described using the two dimensions of 2D motion: x and y axes. At a 45-degree angle, the tank is displaced by an x amount and y amount in each frame of motion. Our question is: "What are the values of these individual displacements?" Examine figure 10-23.

In figure 10-23, the tank is shown rotated 45 degrees. Its initial position is A, and its final position is B. Hence, the tank must be *displaced* along the vector u in some given time. The final x position is given by the x component of u, and the final y position is given by the y component of u. Using trigonometry, as explained previously,

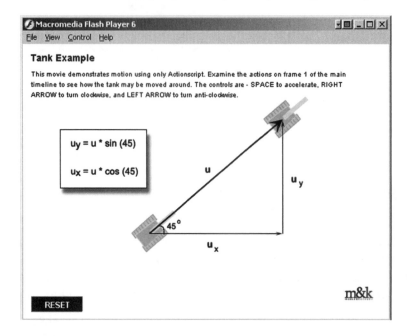

Figure 10-23.
Calculating x and y displacement of rotated tank.

$$Y \text{ component: } = > u_y = (u) \ (sin \ (45))$$
$$X \text{ component: } = > u_x = (u) \ (cos \ (45))$$

What is u in real terms though? Vector u is the distance you desire to displace the tank in every frame. The larger the u value, the farther the tank moves in each frame. Therefore, you have now found how to move the tank from A to B when the angle of movement is 45 degrees. The previous algorithm translates into:

- Rotate the tank to 45 degrees.

- Move the tank an amount equal to $u.cos$ (45).

- Move the tank an amount equal to $u.sin$ (45).

So how is this method implemented for all increments of rotation? Without question, it would be impractical to write code for every degree increment. If you examine the algorithm, you will notice a very important thing: the only thing that changes is the rotation angle while u remains constant. So, the x displacement and the y displacement are determined by the angle of rotation. Using this bit of information, you can rewrite the algorithm to accommodate all possible angles of rotation, even 234. 894657 degrees! Examine the revision to the algorithm, as follows.

- *Rotate the tank $\theta°$.*

- *Move the tank an amount equal to u.cos (Δ).*

- *Move the tank an amount equal to u.sin (Δ).*

Now that you know how to move the tank, let's figure out how to give it some life using an equation of kinematics.

Translating an Equation into ActionScript

First, let's examine the equation to be used. The equation is as follows.

$$v_f = v_o + at$$

Here, v_f is final velocity, v_0 is initial velocity, a is acceleration, and t is time. (You will see how to translate this into code in the following sections.) This equation is one of the established equations of kinematics. Equations of kinematics relate properties such as velocity and acceleration for a body when it is traveling with constant acceleration. The equations do not work when acceleration is variable. However, our little tank is going to use constant acceleration, so we can easily use this equation.

If you recall, frame-based motion was explored earlier in the chapter. There was a very important point made in that discussion: frames are a function of time. Based on this, you could rewrite the equation as follows.

$$v_f = v_o + a$$

Essentially, the tank will use its own *onEnterFrame()* event handler to move. Hence, frames simply function as time in the case of the tank. You can think of it this way: every time the playhead enters the frame, 1/n seconds have passed (here, n is the frame rate). With the equation simplified, you are one step closer to making it usable. The only problem at this point is that v is too abstract to translate into code. If you recall the discussion of velocity, it may be represented as follows.

$$v_f = v_o + a$$

Solving this equation for x, in its simple form the previous equation is shown as follows.

$$|v| = \frac{\Delta x}{\Delta t}$$

Solving this equation for x, in its simple form the previous equation is shown as follows.

$$x = v * t$$

Ignoring t, you are left with the relationship between velocity and displacement in a frame-based environment; that is, they are equal. Using this relation, our equation of motion could be represented as follows.

$$x = v + a$$

This final simplified version is definitely usable in the case of the tank. It gives you the amount the tank must be displaced in every frame. With static values set for v and a, you can easily write a set of functions to update the position of the tank using the previous equation. To decelerate the tank, you would simply subtract the acceleration. If this does not seem clear, the code explanations that follow will shed some more light on it.

Examining the ActionScript

Examine the code for this example, as follows.

```
Math.radian = function(degrees) {
      return (degrees * Math.PI/180);
};
```

This method needs no explanation, as it has already been discussed. It simply returns a radian value. The following code simply resets the tank onto the center of the stage.

```
reset.onPress = function() {
      tank._x = 275;
```

```
        tank._y = 200;
};
```

The following is the velocity value. It is simply equal to the number of pixels you wish to move the tank every frame while the space bar is held down.

```
v = 5;
```

The following is the instantaneous velocity. It simply stores the velocity of the tank at every *onEnterFrame()* instance.

```
vi = v;
```

The acceleration is stored in the following variable. You will see how this value is manipulated to simulate constant acceleration.

```
a = .5;
```

The following value simply marks a top velocity for the tank to ensure that it does not exceed its preset "speed limit."

```
MAX_V = 15;
```

The *onEnterFrame()* event method, as follows, simply listens for key presses and performs the appropriate tasks. The arrow keys rotate the tank 5 degrees every time they are pressed.

```
tank.onEnterFrame = function() {
        if (Key.isDown(Key.SPACE)) {
                this.accelerate();
        } else {
                this.decelerate();
        }
        // turns 5 degrees to the right
        if (Key.isDown(Key.RIGHT)) {
                this._rotation += 5;
        }
        // turns 5 degrees to the left
        if (Key.isDown(Key.LEFT)) {
                this._rotation -= 5;
        }
};
```

The *accelerate()* method, as follows, applies everything discussed in this section. Note that the x and y positions of the tank are updated using the simplified equation of kinematics combined with the vector component approach discussed previously.

```
tank.accelerate = function () {
    if (vi<MAX_V) {
        this._x += (vi+a)*this.getCos();
        this._y += (vi+a)*this.getSin();
        vi += a;
    } else {
        this._x += MAX_V*this.getCos();
        this._y += MAX_V*this.getSin();
    }
};
```

Note the following line of code.

```
vi += a;
```

Remember that you want to simulate that the tank is accelerating. Hence, the instantaneous velocity is always updated with the acceleration at that instant. The *if* condition in method in the following simply ensures that the tank is under its maximum velocity. In the case it is not, it forces the tank to move at maximum velocity. The *decelerate()* method, as follows, is called whenever the space bar is not depressed. Its effect is best illustrated when the space bar is released after accelerating the tank for some time. It simulates a tank slowing to a halt. The *if* condition makes sure the method remains inactive when the tank's instantaneous velocity and initial velocities are equal.

```
tank.decelerate = function() {
    if (vi != v) {
        this._x += (vi-a)*this.getCos();
        this._y += (vi-a)*this.getSin();
        vi -= a;
    }
};
```

The *getSin()* and *getCos()* methods, as follow, return the sine and cosine of the rotation angle of the tank. These are used to calculate the vector components for the tank's displacement vector.

```
tank.getSin = function() {
    return Math.sin(Math.radian(this._rotation));
};
tank.getCos = function() {
    return Math.cos(Math.radian(this._rotation));
};
```

With that, you have successfully solved a pretty complex programmatic motion problem. As you can see, a lot of thought is required for this type of code. The payoff for the effort is the fact that the code is so condensed and efficient. Without a proper understanding of the underlying concepts, you would be guaranteed a program thrice the size, and probably full of bugs!

▪▪▪ Summary

Now that you have gotten a good start in solving a programmatic motion problem, you are probably wondering what next. There is a lot of exploring left for you to do. This chapter scraped the tip of an iceberg, the size of which you can only imagine. You can truly simulate some wonderful motion graphics in Flash using only ActionScript. A good approach would be to understand the theoretical physics well, and then manipulate the concepts to suit your needs.

Flash MX's drawing API is a tool that may be used efficiently to make some serious graphics, anywhere from simple 2D games to highly animated 3D fractals. The key to developing complex motion is to be able to apply theoretical concepts effectively, as well as know how they may be manipulated. Flash is reaching the level at which you can apply traditional game programming theory to creations.

The best way to get better is to expose yourself to not only the Flash environment but to game programming environments in various languages, such as C++. These environments are time-tested development arenas for programmatic motion. The idea is to be able to translate concepts from other environments into Flash. Once you get into it, you will realize that much of the groundwork has already been done. Most of the time, if you are trying to accomplish an effect in Flash, chances are that someone has already done something similar in some other programming environment.

With that said, we will throw in our two cents to get the ball rolling. Open the file *ch10_06.fla* located in the *fmxas/chapter10/* folder on the companion CD-ROM. This file contains the start-up code for a tweening engine. A tweening engine enables you to tween any property of any object on stage programmatically. The start-up file includes a method that motion tweens an object between two points on the stage with a given velocity. In addition, it adds an "easing out" effect to the motion to make it more realistic.

The challenge for you is to take this file and add features such as various types of easing, support for tweening other properties (such as color,

alpha, and scale, and so on). Here's a hint: there are already open source tweening engines floating around on the Internet. We recommend that you try your best to make your own engine before resorting to an open source solution. This will give you a good idea of how you can improve your own and show you its fallbacks. Good luck!

11

The Digital Color Converter

▪▪▪ Introduction

Throughout this book you have been presented with various building blocks for creating Flash movies. From the overview of ActionScript and the OOP approach in chapters 1 and 2, to the explanation of mathematics and physics principles applied to Flash in Chapter 10, you have covered a lot of the interesting things that should be known for advanced Flash development.

The last two chapters of this book focus on two major examples created with Flash. One example, the color converter, is entirely self-contained, whereas the other shows an example that draws upon other resources, focusing not only on Flash but integration issues. It is our hope that these latter chapters help you "pull it all together," in that they provide further context for the content of previous chapters.

In Chapter 4 you were introduced to a major Flash application example called the Digital Color Converter. Although you indirectly examined some minor aspects of it through various other examples, the text did not specifically dissect the example nor explain how it was constructed. This chapter returns to this example and breaks it down toward an examination of how it was constructed and what makes the entire thing function. Some aspects of this example have been covered sufficiently, and will not be revisited.

■ ■ ■ Objectives

In this chapter you will:

- Learn about complex control elements
- Find out how to create complex gradients to create unique color selectors
- Discover how linear algorithms can be reverse-engineered to make UI components more extensible
- Examine how 3D is simulated within the Color Converter

■ ■ ■ Revisiting the Example

Before examining the Digital Color Converter example further, let's reorient.

 CD-ROM NOTE: *Begin by opening the file* converter.fla, *located in the* fmxas/chapter11/ *folder, installed from the companion CD-ROM.*

Once you have the example file open, shown in figure 11-1, use Test Movie to refresh your memory concerning how it functions. The example is designed to provide insight on how digital color models work, what their "numbers" mean, and the relationships among these numbers.

Figure 11-1. The Digital Color Converter example is the focus of this chapter.

In previous chapters you examined various aspects of this example. Recall the following.

- Chapter 4 provided a basic overview of the various color models and to what they are typically applied. Recall that RGB is related to screen, CMY is related to print, and HLS and HSB are related to computer graphics applications.

- Chapter 4 introduced the basic algorithms that permit conversion of a color specification from one color system to another. This included an explanation of hexadecimal RGB specifications.

- Chapter 4 explained CMY-to-CMY(K) conversion specifications.

- Chapter 5 explained how the incrementing and decrementing buttons are associated with each color field (such as R, G, B, and Hex Value fields in the RGB section). That chapter also described how recursion can be applied to this, significantly reducing the amount of code required.

- Chapter 6 described how the Key object is used to allow the user to enter data into a field and then press the Enter key to get the application to accept the new data.

These various aspects of the color converter have been described elsewhere and thus will not be elaborated on further. You may wish to revisit the appropriate sections if you do not remember how these things work. Nevertheless, although it may appear that there is not much else to cover, on the contrary, there is quite a bit. Let's get started.

The HLS Controls

Figure 11-2. The HLS-based controls are common to each section of the Digital Color Converter example.

One feature common to all sections of the Digital Color Converter example is the HLS-based Lightness slider and the Hue/Saturation space. Figure 11-2 shows these controls.

Deconstructing the Controls

Before examining the code associated with the controls, let's first deconstruct the symbols so that when the code is discussed you will understand the references to the stage instances. Let's begin with the Lightness slider.

Lightness Slider

When you tested the movie, hopefully you noticed that as you change the hue of the current color (either using the Hue/Saturation color space or any of the color field values) the color in the Lightness slider changes. As you can probably guess, this is a function of the Color object. But what you may be wondering is how the gradation occurs, independent of the

color in the Lightness slider. Let's take a look. Double click on the Lightness slider on the stage, to access its timeline. Within this symbol you will find several layers, as follows.

- *Pointers:* Contains a movie clip instance called *lpointer* that is the currently selected value (directly related to the lightness attribute in HLS). Remember that value or lightness is, in nonscientific terms, the amount of white or black in a color.

- *Base Elements:* Contains stage objects that give the control a 3D feel.

- *Black:* Contains a linear gradient fill that gradates from transparent to black.

- *White:* Contains a linear gradient fill that runs gradationally from transparent to white.

- *Bkrd Fill:* Contains a movie clip instance named *myfill*. It is this movie clip instance that is modified as the hue changes in the environment.

 TIP: *To help differentiate these items, you may have to hide all layers and turn on one at a time to be able to select items on the stage.*

Now that you understand the layer order, you see how the gradation can remain constant even though the background color of the Lightness slider changes. Now let's move on to the Hue/Saturation color space.

Hue/Saturation Color Space

If you are still accessing the Lightness slider, click on the Scene 1 link in the edit path (area between timeline and stage) and double click on the Hue/Saturation color space control to access its timeline. It is set up in a manner similar to the Lightness slider, except that it has fewer layers, as follows.

- *Pointer:* Contains the circular identifier used to point out the current hue/saturation combination. The instance name for this item is *pointer*.

- *Lines:* Contains stage-level lines used to give a 3D effect.

- *B&W Trans:* Contains a gradient fill that runs gradationally from transparent to "middle gray" (RGB specification 128, 128, 128, or hex specification #808080).

- *Color:* Contains multiple gradient fills that run gradationally between the primaries (red, green, and blue) and secondaries (cyan, magenta, and yellow).

The items of primary importance to examine here are the *B&W Trans* and *Color* layers. The gradient on the *B&W Trans* layer creates the "to-gray" transition as the colors approach the bottom of the control. The *Color* layer shows how the multicolor gradient was established. To provide greater accuracy as it relates to the distribution of the colors across the control, three separate gradients were used (as opposed to creating a single gradient with all colors within it).

Coding for the HLS Controls

Now that you have deconstructed the symbols, let's examine the code attached to each, beginning with the Lightness slider. You can either click on the Lightness slider in the open file or simply follow along in the text, as the code will be provided.

Code for the Lightness Slider

Let's begin with the first thing that happens; that is, the code executed when the slider is loaded, as follows.

```
onClipEvent(load) {
    this.myfill = new Color(this.myfill);
    _root.changeslider();
}
```

The first thing the movie clip instance does is to create an instance of the Color object that can be used by other parts of the code to set the Lightness slider's background color. It also sets the current position of the Lightness slider's pointer to a position representative of the current HLS lightness value via the function *changeslider()*.

 NOTE: *The* changeslider() *function is examined in material to follow.*

Now let's examine what happens when the Lightness slider is clicked on by the user. Note that there are three event handlers utilized, as shown in code example 11-1.

Code Example 11-1: Code Executed When User Clicks on Lightness Slider

```
onClipEvent (mouseDown) {
  if (hitTest(_root._xmouse, _root._ymouse, true)) {
    dragflag2 = 1;
    startDrag (lpointer, true, 18.7, 0, 18.7, 300);
    lpointer._y=_ymouse;
```

```
    _root.mylight = Math.round(-1/3*lpointer._y+100);
    _root.hlstorgb();
    _root.rgbtohsb();
    _root.dectohex();
    _root.rgbtocmy();
    _root.changecolorbox();
    if (_root.curtab=="rgb") {
     _root.setrgb();
    } else if (_root.curtab=="cmy") {
     _root.setcmy();
    } else if (_root.curtab=="hsb") {
     _root.sethsb();
    } else if (_root.curtab=="hls") {
     _root.sethls();
    }
   }
  }

onClipEvent (mouseUp) {
 dragflag2 = 0;
 stopDrag ();
}

onClipEvent (enterFrame) {
 if (dragflag2 == 1) {
  _root.mylight = Math.round(-1/3*lpointer._y+100);
  _root.hlstorgb();
  _root.rgbtohsb();
  _root.dectohex();
  _root.rgbtocmy();
  _root.changecolorbox();
  if (_root.curtab=="rgb") {
   _root.setrgb();
  } else if (_root.curtab=="cmy") {
   _root.setcmy();
  } else if (_root.curtab=="hsb") {
   _root.sethsb();
  } else if (_root.curtab=="hls") {
   _root.sethls();
  }
 }
}
```

Let's begin when the mouse is first pressed (the *mouseDown* section). When the user clicks, the code first checks (using the *hitTest()* method) to ensure that the user has clicked on the Lightness slider. Recall that if you do not use this, this movie clip will respond regardless of where you click. Next, the code sets a timeline variable (scoped to the Lightness slider) called *dragflag2*. (This is discussed in material to follow.)

The next line uses the *startDrag()* method to permit dragging of the *lpointer* instance (the movie clip that represents the current lightness). Note that the code for dragging of *lpointer* is attached to the Lightness slider instead of to the pointer itself (inside the Lightness slider), because whenever the user clicks on the Lightness slider, you want the *lpointer* instance to respond immediately. This makes it so that the user does not have to click directly on the pointer to get it to move. Wherever she clicks on the Lightness slider, the pointer will instantaneously move to that position as the starting point.

The next line, *lpointer._y = _ymouse;*, immediately moves the *lpointer* object to the current Y position of the mouse. The subsequent line changes the variable *mylight* (one of the major variables used in the movie; representative of the L value in HLS). As you look at that line, it states:

```
_root.mylight = Math.round(-1/3*lpointer._y+100);
```

You might perceive the use of an equation here, and indeed you would be correct. This is explored later in the chapter, in a section dealing with linear transformations. For now, simply note that the previous line of code sets the value of the variable *mylight* based on the position of the *lpointer* object in the Lightness slider.

The next five lines of the *mouseDown* code call functions that exist in the main timeline. These functions take care of converting the new color specification (based on the change in the Lightness slider) to all of the color model values (RGB, HSB, hexadecimal, and CMY), which are stored in variables. These functions were examined in Chapter 4. These variables and what they are for are explained in frame 1 of the *Global* layer in the main movie timeline. Examine the *init()* function, which includes comments that detail these variables. In essence, the variables are associated with each set of fields that appears on the stage in each section.

The *if* statement at the end of the *mouseDown* code takes care of transferring the new color specification to the "3D" graphical representation of the color models. As you will learn later, these are not really 3D, but rather an illusion. Nevertheless, depending on which section you are in, the appropriate function is called so that the 3D representation is updated based on the change in the Lightness slider.

The important thing to realize as we move on is that the code in the *mouseDown* handler executes only once—the moment the mouse button

is pressed. Yet, the Lightness slider's pointer can be dragged, and thus you need a way to constantly update the color values and the 3D color model representation as the user drags. Let's turn our attention to the *enterframe* handler and the *dragflag2* variable.

In the *enterframe* handler, you find code that resembles the code previously analyzed. Note here, however, that execution of the code is based on the state of *dragflag2*, which indicates whether the user is currently dragging the pointer. If she is, the value in *mylight*, the color model variables (via conversion functions), and the 3D graphic are updated at each frame occurrence. This is what keeps all of these items in sync during the drag of the Lightness slider's pointer.

To conclude this examination, turn your attention to the *mouseUp* code in code example 11-1. Two simple things are done here: the *dragflag2* variable is set to 0 (which stops the *enterframe* handler from executing), and the *stopDrag()* method is called to stop the dragging operation.

Let's move on to the code attached to the Hue/Saturation color space control. Not surprisingly, you will find some very similar things going on.

Hue/Saturation Color Space Control Code

Given the discussion of the code attached to the Lightness slider, you should be able to decipher much of what is going on with the code attached to the Hue/Saturation controls. To conserve space, we will simply acknowledge what is different. Click on the Hue/Saturation color space control to examine the code attached to it, or simply follow along in the text.

In the *onload* handler, you will note that similar to the Lightness slider the Hue/Saturation control calls a function that makes it "set itself up." This means that the control, when loaded, takes the current hue and saturation values in the environment and sets its point to the proper location to represent those values. This is so that if you are in the RGB section and jump to the About section (where the Hue/Saturation control is unloaded), and then back again, it remembers the color setting you were working with previously.

In the *mouseDown* handler, the difference you will see in comparison to the Lightness slider is that you must utilize two values for the pointer. That is, in the Hue/Saturation control the pointer can move along both X and Y, whereas in the Lightness slider the pointer only moves along Y.

Thus, in the *mouseDown* handler, you find that the pointer's X and Y locations are set to the mouse's X and Y, respectively. You will also find that two variables, *myhue* and *mysat*, are set. The variable *myhue* corresponds to the horizontal axis of the Hue/Saturation control, whereas the

variable *mysat* corresponds to the vertical axis. The equations for both of these are examined in material to follow.

In the *enterframe* handler, you will find that again the *myhue* and *mysat* variables are adjusted as the user drags the pointer in the Hue/Saturation control. Note that, like the Lightness slider, a variable (in this case *dragflag1*) is used to control the *enterframe* handler code.

The Importance of Linear Transformations

A very important aspect of this example is how the equations for setting the variables based on the controls were derived. This is foundational to getting maximum use out of controls you create. To some, this may seem odd in a book about "advanced" Flash. However, reverse-engineering such equations is elusive until you see one worked. Thus, let's briefly examine an example.

In the case of the Lightness slider, you have a component that is 300 pixels tall. You want to control a value that varies from 100 to 0. How do you make this happen? The obvious answer is, "Revise the slider so that it is 100 pixels tall, so that there is a 1-to-1 relationship between the control and the value you want to extricate from it." Indeed, that is one solution. However, there is a better and faster way that will permit you to use any control for any value, assuming both are linear. If you wanted a control that varies from 0 to 300 (on the *y* axis) that is to control a value on a scale of 100 to 0, you would apply the following formula.

$y = kx + b$

This is the basic equation for a line, but it can be applied in this situation to solve a change of scale. Here's how.

Let's create three sets of coordinates that represent an input value (from the control) and an output value (which you want the control to yield). When the slider is at coordinate position 0, the value you want output is 100. When the slider is at coordinate position 150, the value you want output is 50. When the slider is at coordinate position 300, the value you want output is 0. Thus, you have the following coordinate values.

`(0, 100) (150, 50) (300, 0)`

Using these value pairs for *x* and *y*, as well as $y = kx + b$, you can reverse-engineer an equation. Begin by plugging in the first coordinate points for *x* and *y* and solving, as follows.

$100 = 0 * k + b$

$100 = 0 + b$

$100 = b$

Next, plug in the second set of coordinates, along with the value you found for *b*.

*50 = 150 * k + 100*

-50 = 150 k*

-50/150 = k

-1/3 = k

Now use the final coordinate values, along with the values for *b* and *k*, and see if you end up with a true equation.

*0 = -1/3 * 300 + 100*

0 = -100 + 100

0 = 0 is true!

Thus, you have found the equation for making the slider control the value you are looking for.

y = -1/3 x + 100

When applied to the specific code examined earlier, it looks as follows.

```
_root.mylight = Math.round(-1/3*lpointer._y+100);
```

Let's examine one more of these to reinforce this, followed by a review of assumptions concerning the use of this method for determining linear equations. In the case the of the Hue/Saturation control, the width of the control is 300 pixels. When the Hue/Saturation control pointer is at coordinate position 0, you want the hue value to be 0. When the pointer is at coordinate position 300, you want the hue value to be 360. Both are linear, and therefore you can come up with the values and results outlined in table 11-1.

Table 11-1: Values and Results for the Hue/Saturation Control

(0, 0)	(150, 180)	(300, 360)
0 = 0 * k + b	180 = 150 * k	360 = 1.2 * 300
0 = b	180/150 = k	360 = 360
—	1.2 = k	Is true!

Thus, our equation is:

*y = 1.2 * x*

Applied, the code looks as follows.

```
_root.myhue=Math.round(1.2*pointer._x);
```

The examples used here are straightforward, but there are times linear transformations can be more involved. In the cases examined here, it was easy because in both instances you had zero in the data sets. When there are no zero values, you often have to draw upon a little more algebra experience in that you get into solving a variable with another variable. However, in these cases it still works.

One cautionary note: as it relates to controls, in about 90 percent of the cases this simple technique can be used to derive an equation for the control. However, if the control or the values it controls are not linear, this approach will not work as smoothly. This technique assumes that everything is linear. Yet, all the controls in the color converter are, and so the technique was used throughout to derive the equations for the elements.

Functions That Set the Controls

Earlier in the discussion of the Lightness slider and Hue/Saturation control, we ignored the *changeslider()* and *setguicontrols()* functions. Already you have seen the code that allows the user to use these controls to affect other things in the environment. These functions, on the other hand, are used to set the Lightness slider and Hue/Saturation control when the user interacts with the other elements in the environment. These "other elements" could be the 3D color model representation or the color field values. These two functions are located in frame 1 of the *Global* layer in the main timeline. Code example 11-2 shows the code for these two functions.

Code Example 11-2: Functions for Setting the HLS Controls Based on the User Interacting with Other Interface Elements

```
function changeslider() {
 var H, L, S, R, G, B, m1, m2;
 H = Number(myhue);
 L = .5;
 S = Number(mysat)/100;
 m2 = L*(1+S);
 m1 = 2*L-m2;
 if (S == 0) {
   H == 0;
   R = G=B=L;
 } else {
   R = calcHue(m1, m2, H+120);
   G = calcHue(m1, m2, H);
   B = calcHue(m1, m2, H-120);
 }
```

```
R = tohex(Math.round(R*255));
G = tohex(Math.round(G*255));
B = tohex(Math.round(B*255));
myslide.myfill.setRGB(parseInt(R+G+B, 16));
}
function setguicontrols() {
  cs.pointer._x = 5/6*Number(myhue);
  cs.pointer._y = -3*Number(mysat)+300;
  myslide.lpointer._y = -3*Number(mylight)+300;
}
```

The *changeslider()* function shown in code example 11-2 changes the background color of the Lightness slider when the current color specification has changed. The code within it bases the change on the current values within the HLS variables *myhue*, *mylight*, and *mysat*. It converts the HLS color specification to RGB, and then to hexadecimal RGB for use by the color object. The color change is applied using the *setRGB()* method.

The *changeslider()* function is set up this way so that when the user interacts with the 3D color model graphic or the color text fields the function can be called so that the slider remains the correct color, regardless of which of the interactive elements the user modifies. In a similar manner, the *setguicontrols()* function makes sure the pointer in the Lightness slider and the Hue/Saturation color space control are oriented in the correct place when a new color is selected via any of the controls.

▪ ▪ ▪ Examining the 3D Representations

Now that you have dissected the HLS controls, let's move on to the really fun part of the Digital Color Converter example: the "3D" color model representations. As alluded to earlier, these are not really 3D. Rather, they are convincing illusions. Let's see how they are made, and even more importantly why they can be made at all.

The RGB Model

To begin dissecting the 3D RGB representation, shown in figure 11-3, let's first examine how the gradational color planes are created. Access the RGB section in the main movie timeline and double click on it to access its timeline. This instance is a reference to the *rgb_cube* movie clip in the library.

Once inside the *rgb_cube* movie clip timeline, unlock all layers and then hide all the layers. Rather than give you a straight-up listing of the layers, let's take a little more time analyzing this symbol, because there is much going on.

Figure 11-3. The "3D" RGB color space representation.

Once all layers are hidden, turn the *Back Panels* layer to visible. This layer contains three symbol instances that are the representation of the color plane that makes up the back of the color cube. Double click on the color plane graphic instance that represents the bottom or base plane of the cube. This plane appears runs gradationally from black, to red, to yellow, and to green at each corner in a counterclockwise manner. This instance refers to the graphic symbol named *rg_plane (Static)*.

Constructing the Color Planes

Once in the timeline for *rg_plane (Static)*, note the various layers. Each of the RGB cube's planes consists four one-quarter slices of a circle that is a gradient from a color to transparent. Each of these partial circles is on a layer. As well, a layer contains bounding lines for the entire plane.

If you unlock all layers, hide them, and then turn them on one at a time, you will see how the plane's gradational colors are created. In

essence, it hinges upon transparency between the layers and the objects that are on them. When originally planning this creation, the first thought was to use bitmap graphics of the color gradients; in other words, to use one bitmap for each color plane. However, when this method was tested, the bitmaps increased the file size more than was desired. Thus, the technique of using gradients was chosen.

How were the gradients created so accurately in their skewed orientation? Rather than skew the individual components in the plane graphic symbol, the plane graphic symbols were constructed as normal components; that is, the *rg_plane (Static)* graphic is actually a square, not a parallelogram. If you go to the library, access the *RGB Cube Stuff/Graphic Planes* folder, and click on any of the planes, the library will reveal that the planes are square. When the planes were inserted into the *rgb_cube* movie clip, they were skewed into the isometric orientation within the *rgb_cube* movie clip.

Point Versus Plane View

Now that you understand how the graphical aspects of the RGB cube are created, let's turn our attention to a couple of other things. Return to the *rgb_cube* movie clip timeline. Assuming all layers except *Back Panels* are hidden, turn off the *Back Panels* layer.

When you tested the movie, hopefully you tried the various "modes" of color identification within the RGB color cube representation. These modes are associated with the drop-down menu present in the RGB and CMY tabs. The Color Point mode provides a simple pointer that shows the color's location in the 3D cube, as well as the RGB specification. The various color plane views allow you to move a cutting plane through the cube to see its locale.

If you did not work with the drop-down menu in the RGB, go back and test the movie and try using the drop-down menu to see how this feature works. Note that when in any of the plane modes (GR Plane, RB Plane, or BG Plane) you can use the 3D graphic to set a color specification by click-dragging on the point (in the plane) or by click-dragging the arrows at the sides of the plane. Once you see how this works, return to the following discussion.

Point Mode

Within the *rgb_cube* movie clip's timeline, you can see that there are four sets of frames. Each set is associated with one of the modes of color representation. The simplest one is the color point mode, which is the first set of frames (frame label: point). Place the playhead in frame 1 of the *rgb_cube* timeline and turn on the *Pointer & Lines* layer. When you do so,

you will find that the layer contains a movie clip instance named *pointer*, which is associated with the movie clip *rgb_point*. Double click on the pointer instance to access its timeline.

In the *rgb_point* movie clip timeline, you will find several layers. The lowermost layer, *Spot*, contains a stage-level white fill that flashes on and off while the movie clip plays. The next layer, *Box Bkrd*, contains a movie clip instance named *mybkrd* (which functions as the background for the text field that shows the R, G, and B value). This box is dynamically sized to accommodate the changing values of R, G, and B. The *Text* layer contains a dynamic text field associated with a variable called *myrgb*. The uppermost layer, *Actions*, contains code that constantly updates the value in *myrgb*, as well as the width of the *mybkrd* instance. If you click in frame 1 of the *rgb_point* and examine its actions, you will find the following code.

```
myrgb=_root.myred+","+_root.mygreen+","+_root.myblue;
mybkrd._width=myrgb.length*1.6;
```

Note that the code uses the values in the variables *myred*, *mygreen*, and *myblue* (variables scoped to the main timeline) as the basis for its text. The *mybkrd* instance is made to 160 percent of the length of the text it contains.

 TIP: *Note that at this point all you have examined is how the value in the point mode indicator remains updated. Material to follow examines the code that actually sets the position of the pointer instance within the* rgb_cube *movie clip. Because the RGB representation is not truly 3D, the pointer is not draggable—(that is, the color specification cannot be set via the RGB representation) when in point mode.*

Plane Modes

Now that you have examined the point mode, let's look at how the plane modes work. Return to the *rgb_cube* movie clip timeline and place the playhead in the set of frames with the frame label *GR*. Turn on the layer named *Moving Planes*.

In any of the plane modes, the user can set the current color specification using the 3D representation of the color model. When in point mode, the user cannot. In plane mode, the user can click-drag on the arrows that exist on the left or right side of the plane (to move the plane along one axis), or click on the point within the plane to move the point along the other two dimensions. Let's first deal with movement of the color plane along one dimension.

When the user clicks on either arrow, both arrows and the color plane move. The color plane also changes color, because as the plane moves along the axis you are either adding or subtracting a color from the totality of the plane. When examining the GR plane, the value of blue is modified. As the plane moves up, there is more blue. When it is moved down, there is less blue. Let's see how this works.

Movement of the Color Plane

To begin examining how the color plane is moved, let's examine the right arrow. Double click on the arrow to the right of the GR plane to access its timeline. Once inside the *scroller_right_rg* timeline, you will find an instance named *arrowr* on the stage. Code is attached to this instance, so select the instance (named *arrowr*) and open the Actions panel. The code for the element is shown in code example 11-3.

Code Example 11-3: Code Attached to the arrowr Instance

```
onClipEvent (mouseDown) {
  if (hitTest(_root._xmouse, _root._ymouse, true)) {
    drag = 1;
    startDrag (this, true, this._x, -255, this._x, 0);
  }
}
onClipEvent (mouseUp) {
  drag = 0;
  stopDrag ();
}
onClipEvent (enterFrame) {
  if ( drag == 1) {
    _parent._parent.left.arrowl._y=this._y;
    _parent._parent.gr._y=this._y
    _root.myblue = Math.round(-this._y);

_parent._parent.gr.gotoAndStop(Number(_root.myblue));
    _root.rgbtohls();
    _root.dectohex();
    _root.rgbtohsb();
    _root.rgbtocmy();
    _root.changecolorbox();
    _root.setguicontrols();
    _root.changeslider();
  }
}
```

As you can see in code example 11-3, the code sets up a basic drag scenario. The important part of the code is within the *enterframe* handler. In the *enterframe*, the first two lines of code following the *if* statement force the GR color plane instance, as well as the left arrow (both of which reside in the *rgb_cube* instance at the same level as the right arrow), to move in concert with the right arrow, which is being dragged when this code executes.

The next line, *_root.myblue = Math.Round(-this._y);*, sets the main variable associated with the blue component of the RGB specification based on the position of the right arrow (which is being dragged). Recall that as the plane is moved, in the case of the GR plane the amount of blue in the color is being modified.

The next line, *_parent._parent.gr.gotoAndStop(Number(_root. myblue));*, is what makes the plane appear to change color as it is moved up or down. This illusion is created using Flash's animation capability. Note that this line of code tells the instance *gr*, which is the GR color plane that was also moved in concert with the two arrows, to go to a specific frame.

A quick peek inside the *gr* instance will show that the change of color in the *gr* plane is due to animation. Click on the *rgb_cube* link in the edit path to return to its timeline. Then double click on the *gr* instance on the stage to access its timeline.

Once in the *gr* instance's timeline, note that there is a motion tween established. In essence, there is a motion tween that blends once color plane to another and ranges from frame 1 to frame 256 (that is, correlated to the values of blue that can occur with the RGB model). Thus, as the color plane is moved up or down using the left or right arrows, not only does the plane move but its current frame is modified such that it gives the perception that the plane is changing color as it is being moved by the user.

 NOTE: *The code attached to the left arrow is essentially the same as the code attached to the right arrow.*

Movement of the Color Plane's Point

Now that you see how the plane is moved, let's examine the color point within the plane. Assuming you are still accessing the *rg_plane* movie clip, note that there is a layer named *Pointer* that contains a movie clip instance named *pointer*. This is the "small" cursor that exists within the plane and is also movable. The code for the movement of the *pointer* instance works much like the Lightness slider and Hue/Saturation control you examined earlier; that is, the code to control the *pointer* is attached to the color plane instance, rather than to the pointer itself. It is done this way because when

the user clicks on the color plane there is only one thing you want to tran-spire: movement of the color point in the plane. Let's look at the code.

Click on the *rgb_cube* link in the edit path to return to its timeline. Once there, click on the *gr* instance on the stage and access the Actions panel. The code attached to the *gr* instance should primarily be old hat for you. Note, however, the following lines.

```
_root.mygreen = Math.round(pointer._x);
_root.myred = Math.round(pointer._y);
```

Note that the position of the pointer in the GR plane is directly corre-lated to the *mygreen* and *myred* variables. Thus, as the pointer is moved within the GR plane, these variables are constantly updated. Following these two lines, all remaining control elements and the variable in the environment are updated via function calls.

The RB and BG Planes

Now that you have examined the GR plane, the RB and BG planes should be relatively easy to decipher, as they are constructed in a similar way. The thing to note is that when moving the RB plane you are modifying the amount of green in the color. When moving the BG plane, you are modi-fying the amount of red in the color. In both cases, you are moving the plane and associated arrows along an angled line (rather than a vertical one). Thus, you must use trigonometry to establish the path of travel. For the movement of the RB plane, you use the following (within the code attached to the draggable arrows).

```
_parent._parent.rb._x=Number(_root.mygreen)*¬
Math.cos(Math.PI/180*30);
_parent._parent.rb._y=Number(_root.mygreen)*¬
Math.sin(Math.PI/180*30);
```

For the movement of the BG plane, you use the following (again, with-in the code attached to the draggable arrows).

```
_parent._parent.bg._x=-Number(_root.myred)*¬
Math.cos(Math.PI/180*30);
_parent._parent.bg._y=Number(_root.myred)*¬
Math.sin(Math.PI/180*30);
```

Setting the RGB Representation

Up to this point you have examined the aspects of the 3D RGB cube rep-resentation that allow it to function as an "input" component. When you modify the values in the RGB fields, Hex Value field, or HLS-based con-trols (Lightness slider and Hue/Saturation slider), the 3D representation

responds to it as well (functioning, therefore, as an "output" element as well).

As with previous components, let's see how the 3D representation is controlled by these other elements. In reality, it is all performed via a single function named *setrgb()*, which is a global function in this application. Access the main movie timeline and click in frame 1 of the *Global* layer. Open the Actions panel and scroll down and find the *setrgb()* function. As you examine the *setrgb()* function, you will find that it is very lengthy. Thus, let's break it into pieces and deal with it a bit at a time.

Setting the Color Point Location

Let's begin with the opening *if* statement. Depending on the current mode (that is, point versus specific plane mode), you do different things. As you can see, when in point mode there is a lot that has to be set in the graphic: the point indicator, all lines that connect the point to the origin of the graphic, and so forth.

Let's begin with what happens when in point mode; specifically, the setting of the color point location, followed by an examination of the connection of the locator lines to establish the color location. Code example 11-4 shows the section within the *if* statement, related to point mode, which sets the location of the color point. Keep in mind that when this code executes it means that the user has either entered a new value in one of the RGB fields, or in the Hex Value field, or by using the HLS-based controls.

Code Example 11-4: Section of setRGB() Related to Point Mode That Sets the Color Point Location

```
     ...
1    if (Number(myred)>Number(mygreen)) {
2      rgbcube.pointer._x = -(Number(myred)¬
     *Math.cos(Math.PI/180*30)-Number(mygreen)¬
     *Math.cos(Math.PI/180*30));
3    } else if (Number(mygreen)>Number(myred)) {
4      rgbcube.pointer._x = Number(mygreen)¬
     *Math.cos(Math.PI/180*30)-Number(myred)¬
     *Math.cos(Math.PI/180*30);
5    } else {
6      rgbcube.pointer._x = 0;
7    }
8    if (Number(myred) == 0 && Number(mygreen == 0)) {
9      rgbcube.pointer._y = -(Number(myblue));
```

```
10  } else {
11    rgbcube.pointer._y = Number(myred)¬
   *Math.sin(Math.PI/180*30)+Number(mygreen)¬
   *Math.sin(Math.PI/180*30)-Number(myblue);
12  }
...
```

Fundamentally, setting the position of the color point within the *rgb_cube* movie clip is based on the fact that the cube is in an isometric orientation. If the cube were in another orientation, it would be much more difficult to locate the point. Nevertheless, because the cube is in an isometric orientation, you can use basic logic and trigonometry to find the position of the point in the RGB representation.

To determine the placement of the color point in the graphic, you need to figure out the relationship of the red value in the RGB specification to the green value (see figure 11-4). If red is greater, you use trigonometry on the red value to determine the location for the point, as shown in figure 11-4a. If green is greater, you use trigonometry on the green value to determine the location for the point, as shown in figure 11-4b. If red and green are both zero, the task is much more simple. You simply place the color point in the middle and move it up by the value of blue, as shown in figure 11-4c.

If you compare figure 11-4 to code example 11-4, you will likely be able to see the relationship. Note that you are using the values stored in the variables *myred*, *mygreen*, and *myblue*.

Setting Up the Connector Lines

Once the location for the color point is established within the *setRGB()* function, lines are positioned to connect the color point to the model's origin to help the user better understand its position within the model. When viewing the *rgb_cube* movie clip, you probably noticed the sets of lines to the right of the stage. These lines are used in point mode to connect the color point to the origin of the RGB cube (the back corner).

When originally designing this movie, the first thought was to use the *attachMovie()* and *duplicateMovieClip()* methods to add the lines to the environment, rather than having them sit on the stage until needed. However, this approach led to much more complexity than was needed. (File size was only reduced by 1 K or so using this approach, so it was not worth the complexity of dynamically generating the lines.)

Thus, the code in code example 11-5 moves the lines located to the right of the stage into position during runtime, when the user is viewing in point mode. More or less, the code for each set of lines is the same; that

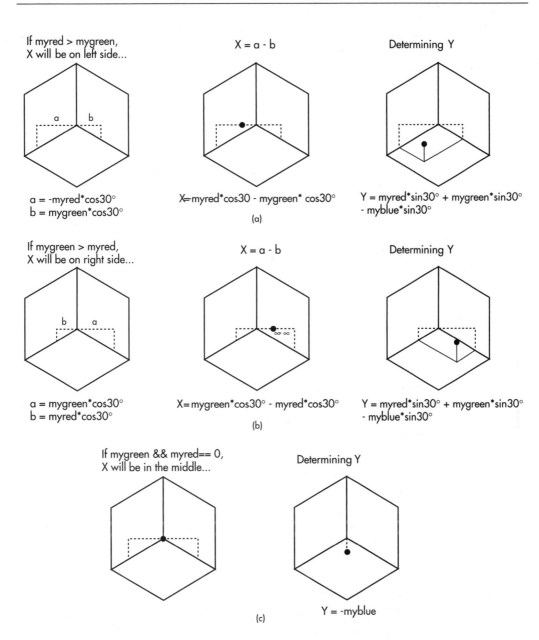

If myred > mygreen,
X will be on left side...

a = -myred*cos30°
b = mygreen*cos30°

X = a - b

X=myred*cos30 - mygreen* cos30°

(a)

Determining Y

Y = myred*sin30° + mygreen*sin30°
- myblue*sin30°

If mygreen > myred,
X will be on right side...

a = mygreen*cos30°
b = myred*cos30°

X = a - b

X=mygreen*cos30° - myred*cos30°

(b)

Determining Y

Y = myred*sin30° + mygreen*sin30°
- myblue*sin30°

If mygreen && myred== 0,
X will be in the middle...

(c)

Determining Y

Y = -myblue

Figure 11-4. Placement of the color point is based on the relationship of red to green.

is, there are three lines for each color component, two of which are the color of the component and one of which is white. Thus, let's examine just one of the sets of lines (as you should be able to figure out the rest). Code example 11-5 shows the code that sets up the green lines.

Code Example 11-5: Code That Positions the Green Lines in Point Mode

```
1    rgbcube.gline1.myline._width = Number(mygreen);
2    rgbcube.gline1._rotation = 30;
3    rgbcube.gline1._x = -(Number(myred))¬
     *Math.cos(Math.PI/180*30);
4    rgbcube.gline1._y = Number(myred)¬
     *Math.sin(Math.PI/180*30);
5    rgbcube.gline2.myline._width = Number(mygreen);
6    rgbcube.gline2._rotation = 30;
7    rgbcube.gline2._x = -(Number(myred))¬
     *Math.cos(Math.PI/180*30);
8    rgbcube.gline2._y = Number(myred)¬
     *Math.sin(Math.PI/180*30)-Number(myblue);
9    rgbcube.gline3.myline._width = Number(mygreen);
10   rgbcube.gline3._rotation = 30;
11   rgbcube.gline3._x = 0;
12   rgbcube.gline3._y = -(Number(myblue));
```

Before examining code example 11-5, note that for each color component there are three lines. The following examines code related to the green component. There is one white line (named *gline1*) associated with the green component, and two green lines (named *gline2* and *gline3*) associated with the green component.

In code example 11-5, you see that the white line (named gline1), associated with the green component, is set up first. The first four lines of code set it up as the white line. It is first scaled to the correct length using the value of *mygreen* (line 1). Next, the line is rotated so that it is parallel to the green axis (line 2). The line's placement is then established using trigonometry (lines 3 and 4). The calculation is based on the current value of *myred*.

As you examine the remainder of the code in code example 11-5, note that lines 5 through 8 set up *gline2*, and lines 9 through 12 set up *gline3*, using a process similar to that for *gline1*. In essence, code example 11-5 establishes the three lines that are parallel to the green axis. Although the code for this is not presented here, if you examine the remainder of the code in the *setRGB()* method associated with the point mode, you will find that the red lines are established in a manner not unlike the code just reviewed, except for the following.

- The rotation value is negative 150.
- The placement of the lines uses trigonometry using *mygreen*.

Concerning the blue lines (that is, *bline1*, *bline2*, and *bline3*), because the lines are vertical and move orthogonally, no trigonometry is needed. The length (actually width, but applied it is length) is set based on *myblue*, the rotation is set to 90 (vertical), and the position is based on the color point indicator (instance name *pointer*). In essence, the latter simply attaches the blue lines to the color point indicator.

Setting Color Planes

Now that you have examined what *setRGB()* does in point mode, let's see what it does in plane mode. Because the code does the same thing, regardless of color plane, we need only closely examine one of the remaining sections of the *if* statement within the *setRGB()* function.

If necessary, relocate the *setRGB()* function and find the first *else if* clause, shown in code example 11-6. This sets the RGB color model representation when the user has the GR plane selected in the drop-down menu and has changed either the text fields or the HLS-based controls.

Code Example 11-6: Section of setRGB() That Sets the GR Plane

```
...
1    } else if (rgb_dd.getValue() == "GR") {
2    rgbcube.gr._y = -(Number(myblue));
3    rgbcube.gr.pointer._x = Number(mygreen);
4    rgbcube.gr.pointer._y = Number(myred);
5    rgbcube.gr.gotoAndStop(Number(myblue+1));
6    rgbcube.left.arrowl._y = -(Number(myblue));
7    rgbcube.right.arrowr._y = -(Number(myblue));
...
```

Line 2 in code example 11-6 sets the location of the GR plane (instance name *gr*) to *(Number(myblue))*. Note that negative is used due to the relative location of the origin of *rgb_cube*. As *myblue* increases, you want the GR plane to move up (not down). In addition, the *Number()* method is used because when data is entered from a field (recall that *myblue* is associated with a text field) numbers that are entered are commonly interpreted as strings.

Lines 3 and 4 set the pointer within the GR plane to the proper location, whereas line 5 tells the *gr* movie clip to go to the correct frame based on *myblue + 1*. Recall that the animation that makes the plane appear to change color ranges from frame 1 to 256, whereas the value of *myblue* ranges from 0 to 255. Thus, *myblue + 1* is used, rather than the raw value in *myblue*.

The last two lines set the location of the left and right arrows. In the case of the GR plane, the arrows move up and down and thus only the $_y$ location is set. If you examine the code for setting the positions of the RB or BG planes, you will see that trigonometry must be used and that both $_x$ and $_y$ must be set. This is because the arrows (as well as the planes) move along an angled line, rather than a vertical line.

RGB Versus CMY Representation

You examined the RGB cube representation and should have a pretty good feel for how it works. Because the CMY representation so closely mimics the RGB representation, there is not a real need to cover it as intimately. The primary things you should keep in mind concerning the CMY representation is that RGB and CMY are simply mirror images of one another. The primaries of one are the secondaries of the other, and vice versa. Similarly, the location of white in one is the location of black in the other.

Given the previous analysis of the RGB representation, take some time to examine the CMY representation and see if you can figure out what is going on. Everything is essentially the same. The only differences are the primary variables upon which everything is based. The CMY representation's calculations are based on *mycyan*, *mymagenta*, and *myyellow*. In addition, the function that sets the CMY representation based on changes to the text fields or the HLS-based controls is called *setCMY()*.

The HLS Color Selector

Although a different shape, you will find that the HLS Color Selector works very similarly to the plane mode of RGB and CMY. In actuality, there is no point mode when working within either the HLS or HSB tabs. However, you will likely find that the HSL and HSB representations are actually easier to work with and understand, as there is no trigonometry involved.

Deconstructing the Movie Clip

The HLS color space representation includes a single plane that can be moved up and down within the 3D representation. The up and down movement of the plane represents the luminosity or lightness of the color. Within the plane, rotation represents hue, and movement from the other diameter toward the center represents saturation.

 NOTE: *See Chapter 4 for more information on this.*

Let's begin by examining the movie clip that represents the "slice" through the end-to-end cones of the model. Access the library and find the element called *color_plane HLS (ortho)*, located in the *HLS Cone* folder. Double click on the symbol in the library to open its timeline, shown in figure 11-5.

Figure 11-5. This symbol is the representation of the "slice" through the model.

Like the movable planes in the RGB representation, the element shown in figure 11-5 (although shown normal in the symbol) is actually scaled to appear 3D when used (explored in material to follow). Once you are accessing the *color_plane HLS (ortho)* timeline, you will find several layers. The bottommost six layers contain each radial fill for the colors that appear in the plane. Because the color plane is only used once, rather than have a separate symbol for the fills and the interactive components it is all placed in a single symbol.

Two other very important layers are also seen inside this movie clip. The first is the *Arrows* layer, which contains both arrows as a single movie clip. The instance name of this object is *arrowsMC*. The other object of importance resides on the *Line MC* layer, and its instance name is *line*. Inside the *line* instance (which is associated with the *lineMC_hls* movie clip) is another symbol instance named *point*.

When the user interacts with either of the arrows, both the *arrowsMC* instance and the *line* instance rotate. When the user clicks on the point (that lies on the line and within the *line* instance), the point is permitted to move along the line. Again, hopefully you tried this when you tested the movie.

The Draggable Arrows

Let's begin by seeing what happens when you click-drag on the arrowsMC instance. If you select this object and open the Actions panel, you will see the code shown in code example 11-7.

Code Example 11-7: Portion of Code Attached to the arrowsMC *Instance*

```
...
this._rotation+=180/Math.PI*Math.atan2(this._ymouse,¬
this._xmouse);
_parent.line._rotation=this._rotation;
if (this._rotation>=0) {
 _root.myhue2 = Math.round(180+(180-this._rotation));
} else {
 _root.myhue2 = Math.round(Math.abs(this._rotation));
}
...
```

As you can see in the Actions panel, a basic drag scenario is established. Like the RGB arrow code, the important part is within the *enterframe* handler, which is shown in code example 11-7. The first line adds to the current rotation of the *arrowsMC* instance the arc tangent of the current mouse position. Next, the rotation is transferred from the *arrowsMC* instance to the *line* instance.

The following *if* statement then checks to see if the *_rotation* property of the *arrowsMC* movie clip is positive. If so, it uses that value to calculate the value for *myhue2*. It does this because the colors in the circle have red at the 3:00 position. Red is 0 degrees as an HLS hue specification.

 TIP: *As it relates to the* _rotation *property, 9:00 to 3:00 is positive 0 to 180 (with 0 at 3:00). From 3:00 to 9:00 is a negative 0 to 180 (with 0 at 3:00).*

If the value returned from the *_rotation* property is negative, the second part of the *if* statement simply retains the absolute value of it (that is, the positive value) and inserts it into *myhue2*.

The Line and Point

Now that you have examined the arrows, let's take a look at the *line* instance and the instance inside it, *point*. All you need know about the *line* instance is that it contains a movie clip instance named *point*, which is the small crosshair and blinking circle. Select on the *line* instance, inside the *color_plane HLS (ortho)* timeline, and open the Actions panel. Code example 11-8 shows the code attached to it.

Code Example 11-8: Code Attached to the Line *Instance*

```
onClipEvent (mouseDown) {
     if (hitTest(_root._xmouse, _root._ymouse, ¬
     true)) {
          dragflag1 = 1;
          startDrag (point, true, 0, 0, 100, 0);
     }
}
onClipEvent (mouseUp) {
     dragflag1 = 0;
     stopDrag ();
}
onClipEvent (enterFrame) {
     if (dragflag1 == 1) {
          _root.mysat = Math.round(point._x);
          _root.hlstorgb();
          _root.rgbtohsb();
          _root.rgbtocmy();
          _root.dectohex();
          _root.changecolorbox();
          _root.setguicontrols();
     }
}
```

The first important thing to note about the code in code example 11-8 is the *startDrag()* method in the *mouseDown* handler. Note that a con-

straint is being used (0, 0, 100, 0) to constrain the point to a specific line. The other important thing is within the *enterframe* handler, where the raw *_x* location of the *point* instance is inserted into the variable *mysat*. Because the circle has been drawn with the center at 0,0 (and because the circle has a radius of 100), you can permit a one-to-one relationship between the movement of the *point* instance on the line and the value in *mysat*.

Vertical Placement of the Circle/Ellipse

Now that you have examined what is going on inside the HLS slice, let's examine how it is modified to make it look like its brightness is being adjusted. Return to the main timeline and then double click on the HLS representation on the stage to open its timeline.

Once inside the *hls cone* movie clip, note that there are several layers you can explore. The one you want to pay attention to is the *Hls Face* layer. Although you probably cannot see the HLS slice on the stage, there is a reason. Turn off all layers except for the *Hls Face* layer. Then, click on frame 1 of the *Hls Face* layer. When you do so, you will find that an invisible object is on the screen, in addition to the two arrows. Double click on the small "speck" between the arrows. This is a movie clip instance of the slice (it has been scaled way down).

Once you are in the *color plane ANIM HLS* movie clip, move the playhead to frame 51. When you do so, you will be able to see the circle. However, like the movable planes in the RGB cube, the circle has been skewed to create the illusion of 3D.

Now, to understand what is going on, you must understand what happens when the HLS slice is moved up and down in the model at runtime. First, when the slice is moved up and down, it turns gradationally to white (if moving up) and turns gradationally to black (if moving down). The pure colors are in the middle (of the vertical movement).

In addition to changing lightness when moving up and down, the slice must also change size to simulate movement inside the HLS double cone. As you can see in the timeline, the size and color change occurs within the color plane *ANIM HLS* movie clip, much like the simulated color change of the movable planes in the RGB representation.

Now return to the *hls cone* movie clip timeline by selecting it in the edit path. Once there, double click on the right arrow to access its timeline, and then select the arrow again (like RGB, there is a movie clip in a movie clip here). With the arrow selected, open the Actions panel. Examine the *enterframe* code. Note that the arrow code does the same thing the RGB arrow code did. It sets the other arrow and changes the value associated with its movement; that is, the *mylight* variable.

Setting the HLS Representation

To this point you have examined the HLS representation as an input component. Now let's look at the code that sets the HLS representation based on user interaction with the text fields or the HLS-based controls. Access frame 1 of the *Global* layer in the main timeline. Find the function named *sethls()*, which is shown in code example 11-9.

Code 11-9: The sethls() Function

```
1    function sethls() {
2      hls_cone.coneface._y = -(Number(mylight*2));
3      hls_cone.coneface.gotoAndStop(Number(mylight)+1);
4      hls_cone.coneface.cp.line._rotation = ¬
       -(Number(myhue));
5      hls_cone.coneface.cp.line.point._x = ¬
       Number(mysat);
6      hls_cone.coneface.cp.arrowMC._rotation = ¬
       -(Number(myhue));
7      hls_cone.left.arrowl._y = -(Number(mylight*2));
8      hls_cone.right.arrowr._y = -(Number(mylight*2));
9    }
```

Because the HLS representation does not have multiple modes like RGB and CMY representations, the code is pretty straightforward. Line 1 sets the Y location of the HLS slice based on the value in *mylight*. The height of the cone is 200 pixels, and thus the multiplication by 2. Line 3 tells the animation (white to black gradation of the face) to go to the appropriate frame. The lightness value starts at 0, whereas the animation starts at 1 (and thus the addition of 1).

Line 4 of code example 11-9 sets the rotation of the line based on *myhue*, whereas line 5 sets the location of the point on the line. Line 6 follows by rotating the *arrowMC* instance to coincide with the *line* instance. The last two lines set the position of the arrows associated with the placement of the HLS slice vertically. At all times, the slice and the two arrows should be in sync.

The HSB/HSV Representation

Given coverage of the HLS example, you should be able to easily dissect the HSB/HSV 3D representation. The primary difference between the two is that you deal with only one cone in HSB/HSV. In addition, the arrows

that move the elliptical slice up and down move on an angled line, rather than a strictly vertical one.

▪ ▪ ▪ Summary

In this chapter you have completely exhausted the Digital Color Converter example. Realize that there is much more that could be done to this example. You could dynamically generate all of the graphics using the dynamic drawing capabilities of Flash. This would likely reduce the file size significantly. You could also add any number of other color models or other explainable color concepts to the example to add further to its usefulness. Undoubtedly you will find that all examples such as this could be a forever-developing endeavor. The difficult choice is deciding where to stop adding features.

Continuing with the example methodology, the next chapter delves into another important example, called the IsoBoard. As you dissect it, you will learn more about applied OOP and integration of external technologies.

chapter

12

isoBoard

▪▪▪ Introduction

You are probably wondering what the *isoBoard* is. It is something that started as innocent fun, but soon found its way into this book because it demonstrates the range of issues discussed in this book. *isoBoard* is short for *"iso*metric message *board."*

When this project was conceptualized, the idea was to allow a user to visit the application to create a shape, character, and so on using isometric blocks (much like mini-Lego blocks) and let him save it to a database. Conversely, users would be given the opportunity to view other users' creations. The idea behind the *isoBoard* was to have a little fun. In fact, that is still the idea behind the *isoBoard*. However, there is a new twist in the equation of fun now.

The *isoBoard* version included in this book was developed specifically with you in mind. Almost every concept discussed thus far has been incorporated into the *isoBoard*, from OOP and multi-dimensional arrays, to XML data exchange and kinematics. Of course, this is not to say that *every* concept or idea discussed has been incorporated. The content of the *isoBoard* reflects the content of the book generally, and specifically where appropriate.

Another nice thing about this chapter is that it leads you through a complete development cycle. The *isoBoard* is an *isolated* application. What does this mean? It simply means that the *isoBoard* is a standalone application. This provides latitude in breaking some rules and concentrating on some user-centered and application-specific programming, rather than getting tied down by an extremely theoretical OOP approach. Before you continue, play around with the application. It is available at *www.tech.purdue. edu/textbooks/fmxas/*, along with other examples from this book. For questions on deploying this application, e-mail the authors.

▪ ▪ ▪ Objectives

In this chapter you will:

- Get a detailed idea of what the *isoBoard* is all about
- Examine data models, flow charts, and elements of the *isoBoard*
- Examine each screen of the *isoBoard* in detail, including comprehensive explanations of code where needed
- Learn the XML data exchange protocol employed in the *isoBoard*
- Learn about existing bugs in, and prospective future improvements to, the *isoBoard*

▪ ▪ ▪ Overview

If you have not already, take some time to play with the *isoBoard* online at the book's web site. As you play with it, look out for features, bugs, and so on you may see along the way. Once you are satisfied that you understand the *isoBoard* fairly well, proceed with this discussion.

As you have seen, the gist of the application is to allow a registered user to add and view iso messages. This entire process is facilitated by several interrelated screens and tasks. If you paid attention to the application while playing with it, you might have noticed that all occurring motion, whether it is a screen transition or a cube being deleted, is identical. How this was achieved is explored in the sections that follow. Before proceeding, however, let's examine each section of the application. The *isoBoard* consists of five individual movies that work in unison to make up the application.

login.fla

This movie deals with logging a user in. It is very similar to the example examined in Chapter 8. The only large difference between the two is that this one uses an XML data exchange protocol, as opposed to a traditional name/value pair protocol. The log-in movie provides the user with instructions about logging in, and allows a new user to be taken to a registration page.

register.fla

The registration movie allows a new user to register as a member. It simply requests some information about the user and uses XML to transfer this information to a server-side ASP script that writes the information to the database. This screen transfers a user to the *view* screen once the user has successfully registered.

post.fla

Essentially, this file facilitates the process of creating, validating, and transferring an iso message to the database. It contains a dynamically generated grid of isometric cubes that allows a user to "punch out" an isometric cube message. The cubes themselves utilize some dynamic tweening to add interactivity to the user's experience. The material that follows examines this movie in detail.

view.fla

The view section of the movie allows users to view their own, as well as others', messages. Again, this section is completely self-sustaining, in that you could make a simple modification to the code in the movie and run it as a standalone application. The view section uses the same idea as the post section. This movie is also explored in detail.

isoboard.fla

This is the main movie of the application. It serves as an initialization point and absolute reference for all other movies. Most of the important global variables and functions are declared in the main timeline of this movie. In turn, it is the only movie directly embedded in the HTML file that serves as the splash page of the application.

In addition to these five screens, there is also an external *actionscript* file that contains global variables, functions, and prototypes. A database is in the vicinity as well, discussed in material to follow. With the basics out of the way, let's examine each of the movies in detail before exploring how to bring the entire application together.

■ ■ ■ **Login (login.fla)**

CD-ROM NOTE: *To see a related example, open the file* login.fla *located in the* fmxas/chapter12/ *folder on the companion CD-ROM.*

The log-in process is quite simple for the *isoBoard* application. It is very similar to the log-in example examined in Chapter 8. However, the *isoBoard* makes use of XML to exchange data with the server, instead of simple variable name and value pairs. Following this, the log-in process communicates with the server using XML calls. This paradigm is examined later in the chapter. For now, let's concern ourselves with understanding the client-side elements of this application. Examine the log-in screen, shown in figure 12-1.

Simply put, this screen should need no explanation. The only important element of this screen is the log-in form (a self-contained movie clip).

Figure 12-1. Log-in screen.

Table 12-1: Client/Server XML Log-in Data Exchange

Client sends...
`<login username="foo" password="bar" />`

Server responds with...
`<loginResponse error="[int]" />`
or...
`<loginResponse error="[int]" userid="[int]" />`

Table 12-2: Log-in Error Codes

Error Code	Error Messsage
0	LOGIN SUCCESSFUL!
1	USERNAME NOT FOUND.
2	INCORRECT PASSWORD.
4	UNKNOWN ERROR.

Aside from this, the rest of the elements on this screen are simple graphics. We did not go overboard on the graphical aspects of this application so as to maintain a clear emphasis on the development process, and programming involved in it.

Note one main difference in the data exchange protocol used in this application. All data exchanged between the client and server is in the form of XML elements. For the log-in process, examine table 12-1 to see how client and server exchange information.

As you can see from table 12-1, the client constructs an XML element called *login*, with the attributes *username* and *password* to be sent to the server-side script. This script performs necessary validation and responds with either of the two XML nodes (in case of a successful log-in, the script sends back the *userid*). The *error* attribute simply holds a string (a number). Each error code corresponds to a specific error, as outlined in table 12-2.

Let's examine the log-in form movie clip (*mc_loginForm*). As you can see, the code for this movie clip is simple and elegant. It is a single-frame movie clip, with

all actions attached to the lone frame. The interface of the form consists of some text fields and a few buttons. Before proceeding, let's examine the button movie clip *mc_button*.

mc_button

A single movie clip button (*mc_button*) has been used throughout this application. This was facilitated by making the button movie clip self-contained and adding a simple constraint for using the *mc_button* button movie clip. This was accomplished as follows.

A handler function buttonAction() must exist in that particular button instance's parent's timeline. That is, if you place the button in a movie clip called *mc_button*, the timeline of that movie clip must have a function called *buttonAction()* to handle its *onRelease()* event. Let's examine the code attached to *mc_button*.

The following line assigns the name of the button movie clip to the text field *label*. Hence, if you were to name your button movie clip instance "*CLOSE*", the text field would display *CLOSE* as the button text.

```
this.label.text = this._name;
```

The next line simply simulates an "emboss" for the button label by placing a duplicate *label1* text field one pixel to the left and up, under the original *label* field.

```
this.label1.text = this.label.text;
```

The following lines set the text fields' auto-size properties to true so as to accommodate a button label (name) of any length.

```
this.label.autoSize = true;
this.label1.autoSize = true;
```

The following line declares an *onRelease()* event method that calls a function in the button movie clip's parent's timeline.

```
this.onRelease = function() {
 _parent.buttonAction(this._name);
};
```

The *onRollOver()* and *onRollOut()* functions, as follows, simply indicate a rollover or rollout to the user by slightly altering the button's size, making it appear as if it were being pulled.

```
this.onRollOver = function() {
  this._xscale = 115;
  this._yscale = 115;
};
this.onRollOut = function() {
```

```
 this._xscale = 100;
 this._yscale = 100;
};
```

With that, let's examine the movie clip *mc_loginForm*.

mc_loginForm

This movie clip encapsulates the complete log-in process. It interacts with the main movie in a few scenarios (discussed later in the chapter). Let's examine the code attached to the first frame of this movie clip. The following lines pass each input field to a global function called *formatField()*, which applies the specified background color to it.

```
formatField (usernameField, "0xCCCCCC");
formatField (passwordField, "0xCCCCCC");
```

This is the callback function for the *mc_button* instances in this movie clip. Because the *onRelease()* handler of a button simply defines a generic function call, the following function performs a *switch* scenario to carry out the appropriate task. In this case, a reset task (resets all input fields), a submit task (validates and calls the *submit()* method), or a register task (calls a global function that changes the current screen to the register movie) would be called.

```
buttonAction = function (myMode) {
 switch(myMode) {
  case "RESET":
      reset();
      break;
  case "SUBMIT":
      errorField.text = "";
      if(isValid()) {
       submit();
      }
      break;
  case "REGISTER":
   errorField.text = "";
      changeScreen(myMode);
        break;
   }
};
```

The following function resets all dynamic text fields as well as the user input fields.

```
reset = function() {
 usernameField.text = "";
```

```
passwordField.text = "";
errorField.text = "";
feedbackField.text = "";
loadingCube.gotoAndStop('stop');
};
```

The following is a validation function that makes sure all input fields are filled in by the user. It displays appropriate error messages and returns a Boolean value based on the success of the validation.

```
isValid = function() {
  if (usernameField.text !="" && ¬
  passwordField.text !="") {
    return true;
  } else {
    errorField.text = "Please fill all fields.";
    return false;
  }
};
```

The following function is the guts of the XML data exchange. Let's examine it.

```
submit = function() {
```

On a successful *submit()* function call, the following lines provide the user with visual feedback during the asynchronous submission process.

```
feedbackField.text = "COMMUNICATING WITH SERVER...";
loadingCube.play();
```

The following lines should be very familiar to you. They simply instantiate and initialize two XML objects: one to send the user log-in data, and one to receive the log-in response from the server.

```
loginXML = new XML();
loginXML.ignoreWhite = true;
loginResponseXML = new XML();
loginResponseXML.ignoreWhite = true;
loginResponseXML.onLoad = loginResponse;
```

The following lines of code construct an XML element for the *loginXML* object, as shown in table 12-1. It then performs a *sendAndLoad()* operation to send the XML element to *URL* (a global variable that stores the path to the server-side script).

```
loginElement = loginXML.createElement("login");
loginElement.attributes.password = ¬
passwordField.text;
```

```
loginElement.attributes.username = ¬
usernameField.text;
loginXML.appendChild (loginElement);
loginXML.sendAndLoad(URL, loginResponseXML, "POST");
};
```

The following function is the callback function for the XML object's *onLoad* property. It extracts the error code returned by the server-side script and performs a *switch* procedure with the error code as the condition. In the case of a successful log-in, the global variable *USERID* is set to the returned *userid* for the user. Each *case* also displays custom error feedback to the user.

```
loginResponse = function() {
 var error = Number(this.firstChild.¬
 attributes["error"]);
 var errorMessage;
 switch(error) {
  case 0:
      errorMessage = "LOGIN SUCCESSFUL!";
      _root.USERID = this.firstChild.¬
      attributes["userid"];
      changeScreen ("VIEW");
      loadMenu();
    break;
  case 1:
      errorMessage = "USERNAME NOT FOUND.";
      break;
  case 2:
      errorMessage = "INCORRECT PASSWORD.";
      break;
  case 4:
      errorMessage = "UNKNOWN ERROR.";
      break;
 }
 feedbackField.text = errorMessage;
 loadingCube.gotoAndStop('stop');
};
reset();
```

As you have seen, the log-in movie demonstrates one very important aspect of this application: task-specific independence. This process is not truly object-oriented. However, for this particular scenario, it is a better

choice because it keeps the tasks at hand fairly simplistic. At the same time, this process provides enough latitude to modify and extend the application. Let's move on to examine the registration process.

∎∎∎ Registration (register.fla)

CD-ROM NOTE: *To see the related example, open the file regis-ter.fla located in the* fmxas/chapter12/ *folder on the companion CD-ROM.*

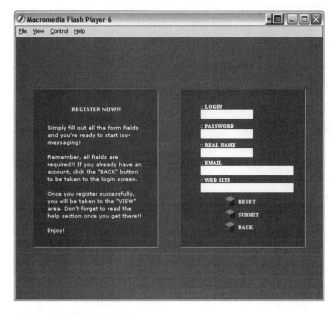

This section should be fairly concise, as the registration process is almost identical to the log-in process on the client side. Examine the registration screen, shown in figure 12-2.

Registration Data Exchange

There is also not much difference between the registration and log-in screens. Each has a form and some graphics. Similar to the log-in form, the registration form exchanges data with the server using XML as the carrier. Table 12-3 outlines the XML elements used in the data exchange.

Figure 12-2. Registration screen.

Table 12-3: Client/Server XML Registration Data Exchange

Client sends...
`<register username="foo" password="bar" realname="foobar ¬` `barfoo" email="foo@bar.com" url="www.foobar.com" />`
Server responds with...
`<registerResponse error="[int]" />`
or...
`<registerResponse error="[int]" userid="[int]" />`

As you can see from table 12-3, the client constructs an XML element called *register*, with all the registration information passed as individual attributes. This script performs necessary validation and responds with either of the two XML nodes (in case of a successful log-in, the script sends back the *userid*). The *error* attribute simple holds a string (a number) in this case. Each error code corresponds to a specific error, as outlined in table 12-4.

Table 12-4: Registration Error Codes

Error Code	Error Message
0	REGISTRATION SUCCESSFUL!
1	USERNAME ALREADY EXISTS.

The movie clip *registrationForm* is very similar to the *loginForm* movie clip from the previous section. For the sake of not being redundant, this is not examined in great detail. Let's quickly highlight the important aspects of the *registrationForm* movie clip.

mc_registrationForm

Although this form is very similar to the form examined in the previous section, there are a few subtle differences between them. Examine the following code, which highlights the difference between the *isValid()* methods between the two forms. The following code lists the *isValid()* method for the registration form, *mc_registerForm*. It simply tests for input in all input fields, failing which the user is given feedback about what criteria he needs to fulfill. The user is not allowed to enter an invalid e-mail address (i.e., an e-mail address that does not have the @ symbol in its string).

```
isValid = function() {
 var atSign = false;
 var l = emailField.text.length;
 for (var i=0; i<l; i++) {
  if (emailField.text.charAt(i) == "@") {
   atSign = true;
  }
 }
 if (usernameField.text == "") {
  errorField.text = "Username required.";
  return false;
 }else if (passwordField.text == "") {
  errorField.text = "Password required.";
  return false;
 }else if (realnameField.text == "") {
```

```
      errorField.text = "Realname required.";
      return false;
   }else if (emailField == "") {
      errorField.text = "Email required.";
      return false;
   }else if (!atSign) {
      errorField.text = "Enter valid email."
      return false;
   }else {
      return true;
   }
};
```

With the registration process out of the way, let's examine the most critical processes in this application: post and view.

▪ ▪ ▪ Post (post.fla)

CD-ROM NOTE: *To see the related example, open the file* post.fla *located in the* fmxas/chapter12/ *folder on the companion CD-ROM.*

The post process deals with allowing the user to post an iso message. It contains all elements necessary to creating an interactive isometric grid of cubes the user can click on to construct an isometric message. The post movie consists of the following important elements.

- *Isometric board (*mc_board*):* This is a dynamically generated board of isometric cubes that serves as the starting point for the cube message to be punched out by the user. Examine figure 12-3 for an illustration of the board.

Figure 12-3. The isometric board.

- *Isometric cube* (mc_cube): This is the isometric cube movie clip symbol that is instantiated dynamically on the board using the *attachMovie()* method of the Movie Clip object. This symbol serves as a template for all cube objects. Examine figure 12-3 to see how the cube objects are attached to the board.

- *Message form* (mc_postForm): This is the form that collects and transmits the cube message, as well as a textual message from the user to the server.

The following examines each one of these elements in detail. It is essential that you be fairly familiar with the library of this movie, to follow along with the rest of the discussion on the post process. However, before examining the movie clips, let's check out the actions on the main timeline of the *post* movie.

First Frame Actions

The actions on the first frame of this movie deal with global activities such as initialization of objects, setting up the stage, and so on. They also contain some of the methods and functions used by other objects in the movie. Let's examine the actions.

The following line creates an array called *cubeArray* to store the punched-out cube message. The array stores the names of the cubes. For example, *cubeArray = [c_01_02, c_05_06, c_01_01]* would be a cube message consisting of three cubes.

```
cubeArray = [];
```

The *init()* function, shown in the following, dynamically creates a screen. If you have not seen it already, when you click on the Next button the board slides out as the message form slides onto the screen. This scenario is possible due to the construction of the screen. Figure 12-4 should make this screen construction clear. As you can see from the figure, *board* and *form* movie clips are attached relative to *postContainer*. During transitions, the *postContainer* movie clip is moved 600 pixels up or down, using the *tweenTo()* method. This is how the entire stage appears to slide when you click on the Next or Back button.

```
init = function() {
  createEmptyMovieClip("postContainer", 0);
  postContainer.attachMovie("board", "board", 1);
  postContainer.board._x = 300;
  postContainer.board._y = 25;
  postContainer.attachMovie("postForm", "form", 2);
  postContainer.form._x = 300;
```

```
postContainer.form._y -= ¬
postContainer.form._height/2 + 250;
};
```

Figure 12-4.
Constructing the post
screen.

The following function slides the screen up or down based on the button clicked. It utilizes the *tweenTo()* method for the Movie Clip object (discussed in material to follow) previously declared globally. This method

tweens a property of a movie clip, applying an "easing in" effect (which accounts for the fact that when the screen slides it slows down as it approaches a stop).

```
changePostScreen = function(myScreen) {
  switch(myScreen) {
    case "BACK":
      postContainer.tweenTo("_y", 0);
      break;
    case "NEXT":
      postContainer.tweenTo("_y", 600);
      break;
  }
};
```

The following function should be familiar to you. It handles the button clicks for the Next button.

```
buttonAction = function (myMode) {
  changePostScreen (myMode);
};
```

The following function adds the name of the cube the user just clicked on to *cubeArray*. This array is used to send to the server-side script upon submission of the message. It tracks the board coordinates of each cube in any individual message.

```
pushArray = function (myObject) {
  cubeArray.push (myObject);
};
```

The following function simply does the exact opposite of the previous function. It removes the cube element from the array when a user clicks on a cube sitting on the ground (base).

```
pullArray = function (myObject) {
  var l = cubeArray.length;
  for (var i=0; i<l; i++) {
    if (myObject == cubeArray[i]) {
      cubeArray.splice (i, 1);
    }
  }
};
```

The following function resets all variables in the movie.

```
refresh = function() {
  postContainer.board.resetBoard();
```

```
postContainer.form.reset();
changePostScreen ("BACK");
};
init();
```

Now that you know how this movie is initialized, it is time to look at the various movie clips that form the main portion of the movie.

mc_board

This movie clip serves as the canvas on which the cubes are arranged, and moved around by the user. You can think of it as a container of the entire isometric grid (the cubes and the base). It is beyond the scope of this book to explore how the grid itself is constructed. We invite you to find online resources as well as books to help you understand simple tile-based programming mathematics. Instead, let's concentrate on the remainder of this movie clip. Let's examine the code, which follows.

```
for (var i=1; i<ROWS+1; ++i) {
  for (var j=1; j<COLS+1; ++j) {
   x = (baseWidth/2)*(j-i)+Xot;
   y = (baseHeight/2)*(j+i)+Yot;
   if (i < 10 && j < 10) {
    myCube = this.attachMovie("cube", "c_0"+i+"_0"¬
    +j, Dt, {y:y});
   } else if (i < 10) {
    myCube = this.attachMovie("cube", "c_0"+i+"_"¬
    +j, Dt, {y:y});
   } else if (j < 10) {
    myCube = this.attachMovie("cube", "c_"+i+"_0"¬
    +j, Dt, {y:y});
   } else {
    myCube = this.attachMovie("cube", "c_"+i+"_"¬
    +j, Dt, {y:y});

   }
   myCube._x = x;
   myCube._y = y;
   Dt++;
  }
}
```

Although this nested *for* loop contains mostly the process of mathematically arranging the cubes, one important concept needs to be highlighted: the naming convention for the cube objects. The *if-else if-else* con-

dition ensures that every cube object is named with the format *c_ii_jj*, where *ii* is a double-digit row coordinate for the cube, and *jj* is the double-digit column coordinate for the cube.

This is very important because the server-side script is expecting cube objects named with this convention. Once the cube array is sent to the server-side script, it performs string extractions based on the index of characters in the cube array string. Therefore, if the script encountered a cube such as *c_1_05*, the extraction would fail because the indices of all characters in the *cubeArray* string would have shifted one place to the left.

Another important thing to note is that each *attachMovie()* method utilizes the *initObject* parameter. Hence, every cube is passed its own *y* coordinate when it is instantiated. This helps in resetting the cubes later on.

The following method resets the entire board. In actuality, it simply takes each cube reference stored in *cubeArray* and sets its *y* coordinate to its own *y* property that was passed to it during instantiation (as explained in the previous code section). This function also sets the state of each cube to "up," so that it responds appropriately to the next mouse click it receives (in the case that the *state* variable is not initialized to "up," a cube that is in its original position would move upward instead of dropping when clicked).

```
resetBoard = function() {
 var arrayTemp = _parent._parent.cubeArray;
 var l = arrayTemp.length;
 for (var i=0; i<l; i++) {
  this[arrayTemp[i]]._y = this[arrayTemp[i]].y;
  this[arrayTemp[i]].state = "up";
 }
 _parent._parent.cubeArray = [];
};
```

The following function handles the *onRelease()* events for the buttons NEXT and RESET.

```
buttonAction = function (myMode) {
 switch(myMode) {
  case "NEXT":
   _parent._parent.changePostScreen (myMode);
   break;
  case "RESET":
   resetBoard();
   break;
 }
};
```

Our final topic for the post process discussion deals with the cube movie clip, *mc_cube*.

mc_cube

The cube movie clip itself is quite simple. If you think about it, a cube simply needs to figure out if it is "up" or "down" and act appropriately when clicked on. In essence, that is exactly what the actions in the first frame of the movie clip do, as follows. The following line sets the initial state of the cube.

```
this.state = "up";
```

The following code is the *onRelease()* event method for the cube. It figures out whether the cube is "up" or "down" and respectively drops it or makes it float back up to its original position. Once the cube is moved, its state is updated. When a cube is dropped down or floated to the top, the function ensures that the array *cubeArray* is updated by calling the *pushArray()* and *pullArray()* functions, discussed previously.

```
this.onRelease = function() {
  if (this.state == "up") {
   this.tweenTo ("_y", this._y + 150)
   this.state = "down";
   _parent._parent._parent.pushArray (this._name);
  } else {
   this.tweenTo ("_y", this._y - 150)
   this.state = "up";
   _parent._parent._parent.pullArray (this._name);
  }
};
```

At this point, it would be appropriate to talk briefly about the *mc_postForm* movie clip and the XML elements it exchanges with the server-side script.

mc_postForm

Simply put, this form functions pretty much like the previous two forms examined. The only major difference is the XML data it exchanges with the server. Table 12-5 outlines the data exchange between the client and the server when a message is posted.

As you can see from table 12-5, the process is quite similar to that discussed previously. Examine table 12-6 for the related error codes.

Let's now examine the final major section of this application: the view section.

Table 12-5: Client/Server XML Post Data Exchange

Client sends...
```<message cubedata="c_ii_jj,c_ii_jj, …" title="foo" description="bar" ¬ userid="[int]" />```
**Server responds with...**
```<messageResponse error="[int]" />```

Table 12-6: Post Error Codes

Error Code	Error Message
0	POST SUCCESSFUL!
1	UNKNOWN ERROR.

▪▪▪ View (view.fla)

The final section to be examined in detail is the view movie. This movie encapsulates the process of loading up database entries to create a menu of messages posted. When this movie loads up, it requests the server-side script to send back all message headers in the database (a message header is simply the *username* of the user that posted a message and the unique *id* of that message). The *username* retrieved from each of these headers is used to display as the label of *mc_userButton*, whereas the *id* is bound to the button movie clip for future use (to request a particular message). Table 12-7 outlines the message header requests between client and server.

Table 12-7: Client/Server XML Data Exchange for Viewing All Messages

Client sends...
No XML necessary. mode=6 performs the required action.
Server responds with...
```<messages>```
```<message id="[int]" username="Steve" />```
```<message id="[int]" username="Foobar" />```
```..```
```</messages>```

As you can see, this request could return quite a large data set. You might want to implement a simple preloader for this section in the future. The other scenario for viewing messages is when a user clicks on an *mc_userButton* instance. When this happens, and provided all conditions are met, the Flash movie requests the ASP script to send back a particular message identified by the *id* bound to that button movie clip. An example of the XML data exchange for this process is provided in table 12-8.

The information sent back by the server is parsed within Flash and displayed as soon as it arrives. Coupled with a great back end, this process works extremely fast, almost eliminating the need for a preloader. Let's examine the actual view elements now. The view screen consists of a few self-contained movie clips, as follows.

*Table 12-8: Client/Server XML Data Exchange for Viewing a Single Message*

**Client sends...**
```
<view id="[int]" />
```

**Server responds with...**
```
<message id="[int]">
 <realname>Steve</realname>
 <email>steve@ragan.com</email>
 <url>nil</url>
 <date>6/15/2002 2:47:49 AM</date>
 <title>foo</title>
 <description>bar</description>
 <data>
 <cube row="1" col="1" />
 <cube row="1" col="2" />
 </data>
</message>
```

- *Menu Button (*mc_userButton*):* This movie clip is used as a button for loading a new message.

- *Menu (*mc_userMenu*):* This movie clip encapsulates the menu that displays all messages in the database.

- *Isometric board (*mc_board*):* This is a dynamically generated board of isometric cubes similar to the one examined in the post section. The only difference between them is that this one has no user interaction features.

- *Isometric cube (*mc_cube*):* This is the isometric cube movie clip symbol that is instantiated dynamically on the board using the *attachMovie()* method of the Movie Clip object. It is simply graphical in nature.

- *View form (*mc_viewForm*):* This is the form that receives all user and message details for any particular message.

Again, before continuing, let's examine the frame actions on the first frame of the movie.

## First Frame Actions

The actions on the first frame of this movie are quite similar to those of the post screen. They serve the purpose of initializing the movie. Let's examine the actions. The following lines declare local variables. *currUser* is a variable that tracks the last user being displayed in the menu, *uncache* is a variable that stores a unique number each time it is called (this forces the browser to stop caching data), *listArray* is an array that stores all message headers as object properties *name* and *id*, and *viewCubeArray* is a 2D array that stores coordinates of a cube message after it has been parsed.

```
var currUser = 0;
var uncache;
var listArray = [];
_global.viewCubeArray = [];
```

The following function reveals or hides the *viewForm* movie clip.

```
_global.showForm = function (state) {
 viewForm._visible = state;
};
```

The following function is called each time the screen is changed. It simply instantiates an XML object and retrieves all message headers into it.

```
_global.loadList = function() {
 mode = "6&"+uncache;;
 URL="index.asp?mode="+mode;
 myListXML = new XML();
 myListXML.onLoad = parseList;
 myListXML.ignoreWhite = true;
 myListXML.load (URL);
};
```

The following is the callback function for the *onLoad* property of the *myListXML* object. It parses the message header data and stores it in *listArray*.

```
parseList = function () {
 myList = this;
 var totalNodes = 0;
 myList = myList.childNodes[0];
 listArray = [];
 if (myList.hasChildNodes()) {
 while (myList.childNodes[totalNodes] != ¬
 undefined) {
```

The following function call adds an object with *name* and *id* properties to the array *listArray*. This occurs for every message header sent to the

Flash movie by the server-side script.

```
 pushListArray(newUser ¬
 (myList.childNodes[totalNodes]));
 totalNodes++;
 }
 updateMenu("FORWARD");
 }
};
```

The following function is called each time the *Forward* or *Backward* buttons are pressed. It updates the *userMenu* movie clip buttons *user1*, *user2*, and so on.

```
updateMenu = function (myDir) {
 var L = listArray.length;
 switch(myDir) {
 case "FORWARD":
 for (var i=1; i<6; i++) {
 userMenu["user"+i].name.text = ¬
 listArray[currUser].name;
 userMenu["user"+i].index.text = currUser+1 ¬
 + ".";
 userMenu["user"+i].msgid = ¬
 listArray[currUser].id;
 currUser++;
 }
 break;
 case "BACKWARD":
 for (var i=5; i>0; i−) {
 userMenu["user"+i].name.text = ¬
 listArray[currUser-6].name;
 userMenu["user"+i].index.text = currUser-5 ¬
 + ".";
 userMenu["user"+i].msgid = ¬
 listArray[currUser-6].id;
 currUser−;
 }
 break;
 }
```

The following lines enable or disable the arrow movie clip buttons based on the number of objects in *listArray*.

```
 if (currUser >= L) {
 userMenu.FORWARD.arrow.enabled = false;
 } else {
 userMenu.FORWARD.arrow.enabled = true;
 }
 if (currUser - 5 == 0 || currUser == 0) {
 userMenu.BACKWARD.arrow.enabled = false;
 } else {
 userMenu.BACKWARD.arrow.enabled = true;
 }
};
```

The following function creates an object for a message header XML element and returns it.

```
newUser = function (myNode) {
 var temp = new Object();
 temp.name = myNode.attributes["username"];
 temp.id = myNode.attributes["id"];
 return temp;
};
```

The following function pushes an element into *listArray*.

```
pushListArray = function (myObject) {
 listArray.push (myObject);
};
```

The following function is called each time a *userMenu* button movie clip is pressed. It requests a message with the corresponding *id*. An XML element with the *id* of the message is sent to the server. The server responds by sending a message similar to the one shown in table 12-8.

```
_global.loadUser = function(msgid) {
 mode = "1&"+uncache;;
 URL="index.asp?mode="+mode;
 myUserXML = new XML();
 myUserXML.ignoreWhite = true;
 viewElement = myUserXML.createElement ("view");
 viewElement.attributes.id = msgid;
 myUserXML.appendChild (viewElement);
 myUserResponseXML = new XML();
 myUserResponseXML.ignoreWhite = true;
 myUserResponseXML.onLoad = parseUser;
 myUserXML.sendAndLoad (URL, myUserResponseXML, "POST");
};
```

The following is the callback function for the *onLoad* property of the *myUserResponseXML* object. It parses the XML and displays it in *viewForm*. In addition, it parses the cube data and creates a 2D array of cube coordinates.

```
function parseUser() {
 var totalCubes = 0;
 tempArray = viewCubeArray;
 _global.viewCubeArray = [];
 myUser = this.childNodes[0];
 //real name
 viewForm.realnameField.text = ¬
myUser.childNodes[0].firstChild;
 //email
 viewForm.emailField.text = ¬
myUser.childNodes[1].firstChild;
 //url
 viewForm.urlField.text = ¬
myUser.childNodes[2].firstChild;
 //date
 viewForm.dateField.text = ¬
myUser.childNodes[3].firstChild;
 //title
 viewForm.titleField.text = ¬
myUser.childNodes[4].firstChild;
 //description
 viewForm.descriptionField.text = ¬
myUser.childNodes[5].firstChild;
 //Construct a 2D Array of cubes
 myCubeData = myUser.childNodes[6];
 while (myCubeData.childNodes[totalCubes] != ¬
undefined) {
```

The following line pushes an array of the current cube's *row* and *col* into *viewCubeArray*. Trace this array to examine it further. An example may look like – *[[1,13],[2,5],[9,9]]*.

```
 viewCubeArray.push(¬
 new Array(¬
 myCubeData.childNodes[totalCubes].attributes.row, ¬
 myCubeData.childNodes[totalCubes].attributes.col));
 totalCubes++;
 }
```

```
showForm (false);
viewBoard.displayCubeMessage (tempArray);
}
```

The following function resets the entire movie.

```
refresh = function() {
 uncache = new Date().getTime();
 viewBoard.resetBoard(viewCubeArray);
 viewForm.reset();
 showForm (false);
 currUser = 0;
 loadList();
};
uncache = new Date().getTime();
showForm (false);
loadList();
```

Essentially, these actions are the heart of the view section. The movie clips in this movie are very similar to those from the post section. To avoid redundancy, these are not examined in detail. However, let's examine certain parts of the movie clip *mc_board*, particularly the functions that animate a cube message.

## mc_board

Although this movie clip is very similar to the mc_board movie clip examined in the post section, there are two important functions to be examined, simply because of the advanced approach they use. These functions play an important role in animating the cubes in every cube message one by one. Let's examine the code.

The following function starts the process of animating a cube message. It is called each time a particular *userMenu* button is clicked on, provided a message is not already playing.

```
displayCubeMessage = function (tempArray) {
 var i = 0;
 var l = viewCubeArray.length;
```

The following line clears any existing *setInterval()* function with *intervalID*.

```
 clearInterval(intervalID);
 if (resetBoard(tempArray)) {
```

The following *setInterval()* call defines an anonymous function that is called every 250 ms. You learned how to use *setInterval()* in Chapter 7. The anonymous function simply calls the *animateCube()* function, pass-

ing it the index of the cube to animate as an argument. If all cubes have been animated, the *setInterval()* function clears itself.

```
 var intervalID = setInterval (¬
function() { ¬
_global.animating = true; ¬
animateCube(i); ¬
i++; ¬
if (i>= 1) { ¬
clearInterval(intervalID); ¬
_global.animating = false; ¬
error(""); ¬
showForm (true); ¬
} ¬
 }, 250);
 }
};
```

The following function creates a name reference to a cube that exists at index *i* in the array *viewCubeArray*. For instance, assume that *viewCubeArray* looks as follows.

```
viewCubeArray = [[0,1], [8,10], [5,6], [4,4]]
```

For this example of the *viewCubeArray* array, $i = 0$ would return *[0,1]*. It follows that the index *0,0* would return *0* and the index *0,1* would return *1* (see Chapter 3 to learn more about multidimensional arrays). Once the name reference to a cube object has been created, its *tweenTo* method is called to animate it, as follows.

```
animateCube = function(i) {
 var myCube = this["c_"+ viewCubeArray[i][0] ¬
+ "_" + viewCubeArray[i][1]];
 myCube.tweenTo ("_y", myCube._y+150);
};
```

This completes examination of the four main sections of the *isoBoard* application. Let's briefly examine how they are all brought together in the main movie *isoboard.fla*.

# ▪ ▪ ▪ **Main Movie (isoboard.fla)**

The main movie, *isoboard.fla*, plays the role of a manager for the *isoBoard* application. Although it is not directly involved in any of the four main processes, it facilitates the existence and connectivity of each.

The idea behind this movie is very simple: it serves as the object that controls all other movies. It performs tasks such as switching screens, providing global functions and variables, and assembling the stage. In addition, it loads up the main menu. The most interesting part of this movie is how the other four movies are loaded into it, discussed in material to follow. Let's examine the actions on the first frame of the movie.

The following statement loads an external ActionScript file into the current movie. The functions within that file become available to this movie.

```
#include "isoboard.as"
_quality = "LOW";
```

The following variable sets the request mode for the movie, as outlined in table 12-9.

```
MODE = "2";
```

The following variable keeps track of the screen the user is currently viewing.

```
var currScreen;
```

The following are global variables storing the user's ID and the path to the server-side script.

```
_global.USERID;
_global.URL = "index.asp?mode=";
```

The following function is particularly interesting. It creates an empty movie clip called *container* and attaches the four movies (*login*, *register*, *view*, and *post*) edge-to-edge to it. This forms a 2400-pixel-wide movie clip called *container*. When the user navigates between screens, only *container* is moved around. This in turn moves all child movies attached in reference to the *container* movie's origin.

```
function init() {
_root.createEmptyMovieClip("container", 0);
container.attachMovie("screenContainer", "login", 1);
container.login.loadMovie("login.swf");
container.attachMovie("screenContainer", "register", 2);
container.register.loadMovie("register.swf");
container.register._x = 600;
container.attachMovie("screenContainer", "post", 3);
container.post.loadMovie("post.swf");
container.post._x = 1200;
container.attachMovie("screenContainer", "view", 4);
```

```
container.view.loadMovie("view.swf");
container.view._x = 1800;
_global.URL += MODE;
}
```

The following function is called when the user wants to navigate to another screen. It movies the *container* movie clip to the appropriate location using the *tweenTO()* method. In addition, it refreshes the last screen visited (in the case of toggling between the view and post screens) so as to reload newly added messages, as well as to prepare the stage to add or view new messages. It also sets the *URL* variable with the appropriate mode. All other movies use this *URL* variable to request the server-side script (with the exception of mode 1, which is programmed into the *view* movie).

```
_global.changeScreen = function(myScreen) {
 _global.URL = "index.asp?mode=";
 switch (myScreen) {
 case "LOGIN" :
 container.tweenTo("_x", 0);
 MODE = "2";
 _global.URL += MODE;
 break;
 case "REGISTER" :
 container.tweenTo("_x", -600);
 MODE = "5";
 _global.URL += MODE;
 break;
 case "POST" :
 container.tweenTo("_x", -1200);
 MODE = "3";
 _global.URL += MODE;
 break;
 case "VIEW" :
 container.tweenTo("_x", -1800);
 MODE = "6";
 _global.URL += MODE;
 container.post.refresh();
 break;
 }
 container.view.refresh();
 currScreen = myScreen;
};
```

The following function brings the main menu onto a visible location on the stage.

```
_global.loadMenu = function() {
 mainMenu.tweenTo("_y", 475);
};
init();
```

There are several other movie clips in this movie that are extremely simple to understand (*mc_menu*, *mc_help*, and so on). It would be worth your time to examine them. Let's wrap up the client-side discussion by looking at the external ActionScript file.

# ▪ ▪ ▪ External .as File

The external *.as* file contains two global functions that are used invariably by every movie in the application. They were placed in an external file to make it simple to test each movie as a standalone application. Let's examine the code in the file *isoboard.as*.

The following method has been directly attached to the prototype object of the Movie Clip object, making it available to all movie clips in the *isoBoard*. It is very similar to the tweening function discussed in Chapter 10. This method can tween any property of an object, as long as the target specified is valid for that property. It renders the calling object's *enabled* property to *false* while the object is moving, and sets it back to *true* once the object has reached its destination.

```
MovieClip.prototype.tweenTo = function(prop, val){
 this.enabled = false;
 this.onEnterFrame = function() {
 var dval = val - this[prop];
 if (Math.abs(dval) > 2)
 {
 this[prop] = this[prop] + dval * .2;
 }
 else
 {
 this[prop] = val;
 this.enabled = true;
 delete this.onEnterFrame;
 }
 };
};
```

The following function is called by all text fields upon loading up a movie. It changes the background color of the field to the specified color.

```
_global.formatField = function (myField, myColor) {
 myField.backgroundColor = myColor;
};
```

# ▪ ▪ ▪ Server Elements

As you have probably guessed, the server-side part of this application plays an extremely important role. In fact, without the dynamic back end, this application would be worthless. Let's take a quick tour of the server-side elements of this application: the middleware ASP script and the Access database.

Unfortunately, there is no really effective way of explaining the ASP script in simple terms. If you have not examined it already, do so now. As you can see, it is a pretty large script. Fortunately, it is not really very complicated. The most difficult part of the script is possibly the string deconstruction of the *cubeArray* message for insertion into the database. Spend some time with this script to familiarize yourself with efficient scripting practices.

We are providing this script as is, simply because it would be quite pointless to drone through it. In fact, we believe it would serve you better to figure it out yourself, as this will force you to understand what is going on in the background. Do not hesitate to use the ideas and methodologies presented in your own projects. After all, the fastest and most effective way to learn something is to imitate it. Let's examine the ASP script.

## index.asp

This script is the most hard-working element of the *isoBoard* application. It has several subroutines that encapsulate each of the major tasks: log-in, registration, view, and post. In addition, there are several private functions that work in conjunction with the main task functions to speed up update and response times. For your benefit, we have provided a simple ASP page called *cheat.asp*. This page allows you to choose a mode and input some XML to view results within the browser. This essentially simulates the query strings the Flash movie sends to the script.

To test this script, you need to set up the application on your own server. Otherwise, you are welcome to test the version hosted on this book's web site at *www.tech.purdue.edu/textbooks/fmxas*. Assuming you have chosen either of the two scenarios, and are ready to go, let's begin examining the script.

Each time the flash movie calls the ASP page, it passes the page a variable called *mode*. This variable represents the various scenarios, outlined in table 12-9

*Table 12-9: Request Modes*

Mode Value	Task Requested
1	View
2	Log-in
3	Post
5	Register
6	All message headers

Essentially, when Flash interacts with this script, it sends a request similar to the following.

```
index.asp?mode=1
```

This code would inform the script that you want to view a particular message. It follows that the script would expect an XML element similar to the following.

```
<view id="1" />
```

Note that if you fail to send the previous XML element, the script will throw an error. In fact, even a missed space or a slightly different format would result in an error. For example, the following XML element would produce an error.

```
<view id="1"/>
```

This is because of the way the script is set up. To increase the speed of updates and parsing, the elements are treated as strings. The only way to extract information from strings is by deconstructing them. therefore, if the script expects a string 14 characters long, and you send it one that is 13 characters in length, its subroutine fails.

*Table 12-10: Example XML Queries*

Mode Value	XML Element
1	`<view id="1" />`
2	`<login username="Steve" password="howdy" />`
3	`<message cubedata="c_01_01,c_01_02" title="foo" ¬` `description="bar" userid="1" />`
5	`<register username="Anna" password="coolbeans" ¬` `realname="Anna Smith" email="annsmit@aol.com" url="nil" />`
6	`No XML element necessary`

This would be an appropriate time for you to play around with *cheat.asp*. Try to enter the XML elements (outlined in table 12-10) in the text field, with their respective modes selected.

In addition, see what happens when you send the ASP file a format it cannot recognize. If you have detailed error messages turned on, your server will tell you the nature of the error the ASP file returned. In case you simply get a generic 500 error, we recommend that you visit

Microsoft's web site and learn how to turn on detailed error messages in IIS (assuming you are running a Windows server). Examine figure 12-5 for a detailed view of how the data exchange occurs between client and server for the *isoBoard*.

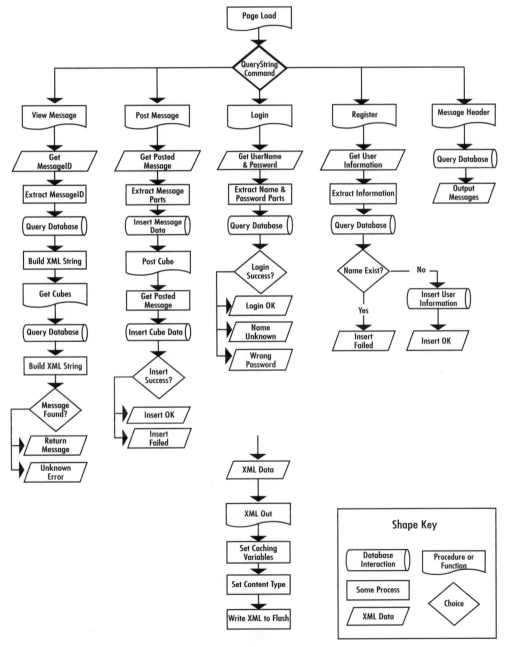

*Figure 12-5. Client/server data exchange.*

We also recommend that you examine the ASP script itself. Even if you do not understand ASP, the script will probably make a lot of sense to you based on your coding skills at this point. Understanding of the server-side aspect of this application is very important if you wish to develop dynamic applications using Flash. With that said, let's examine the database used for this application.

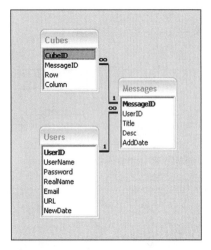

*Figure 12-6.* isoboard.mdb *relationship diagram.*

Field Name	Data Type
UserID	AutoNumber
UserName	Text
Password	Text
RealName	Text
Email	Text
URL	Text
NewDate	Text

*Figure 12-7. Design view of the* Users *table.*

Field Name	Data Type
MessageID	AutoNumber
UserID	Number
Title	Text
Desc	Memo
AddDate	Date/Time

*Figure 12-8. Design view of the* Messages *table.*

# isoboard.mdb

The database used for this application is slightly more complex than those examined previously in this book. Of course, this is owing to the fact that this application is a little more complex than anything you have explored thus far. An examination of the design of the database is beyond the scope of this book. However, it is important that you know what the various entities mean in the database, and how they are related. Examine figure 12-6 to view the relationship diagram for this database.

The moment you look at these relationships, you can easily deduce what they mean. You could relate the tables in the database as follows:

*Every user may post several messages. Every message may contain several cubes.*

It is as simple as that. Let's examine each table briefly before we proceed.

## Users

This table contains all user information. Its primary key is an *autonumber*, which ensures that every user is unique. Examine figure 12-7 for the design view of the *Users* table.

## Messages

As you may have already guessed, this table stores the actual messages posted by the user. However, the *cubedata* is not directly stored in this table. This table simply stores the textual message title and description, in addition to the primary and foreign keys. Examine figure 12-8 for the design view of the *Messages* table.

### Cubes

This table stores the cube coordinates for each cube in a message under the fields Row and Column. This simplifies the process when the cube message is retrieved, and is more reliable and allows for more usable XML. In the future, if you decide to incorporate more features into this application (such as searching for individual user messages or displaying statistics about the most popular row or column), the groundwork has already been laid out and all you would have to do is make a new search movie and add another subroutine in the ASP script. Examine figure 12-9 for the design view of the *Cubes* table.

Field Name	Data Type
CubeID	AutoNumber
MessageID	Number
Row	Number
Column	Number

*Figure 12-9. Design view of the* Cubes *table.*

That wraps up our database discussion for this application. As a final analysis, let's examine some flaws in this application as well as brainstorm some ideas for improvement.

# ▪▪▪ Bugs and Improvements

The *isoBoard* is far from perfect, but for a reason. We hope that a few of you will take it on, and make it better. We know of every bug that exists with it, and these are discussed in the material that follows. Our main objective in this section is to brainstorm a few ideas to expand the application. This will show you how its design is extensible.

We had to simplify several aspects of the *isoBoard* to gear it for you, the readers of this book. For the most part, we had to take most of the OOP practices out, and solidify the classes used in this application. With the amount of data being exchanged, this application definitely lacks some abstract classes that would make life a lot simpler. There are also quite a few things in this application that lack the *finesse* of good programming practice; namely, the following.

- Unprotected functions
- Interdependent methods
- No defined class structure

Making this application completely object oriented would amount to a lot more complex code, and advanced concepts such as multiple inheritance and interfaces. These, however, are beyond the scope of this book. Instead, we opted for a more *isolated* solution. The great thing is that we are not really losing any functionality in this version over an object-oriented one. In fact, one would tend to believe that you gain functionality

from this approach as long as you use it efficiently. At this point, let's examine some of the bugs in this application.

## Scrolling Mechanism and Frame Rate

A really touchy topic in Flash is frame rates. There is no real optimal frame rate in Flash MX. Developers who want fast-flowing motion need a frame rate of at least 24 to achieve such effects. However, often this frame rate is too much for the end user's computer to handle, and could very well bring the processor to its knees as it tries to redraw the screen at the speed of the frame rate. We chose a frame rate of 31 fps for the *isoBoard*. Why 31 and not 30? One trip to the many advanced Flash MX ActionScript discussions at *FlashCoders* and *were-here.com* would tell you why. Several users have observed anomalies on Macs with the frame rate set at 30.

Now the question is: Is this frame rate too high? The answer: Yes, it probably is. So why did we continue developing at such a high frame rate? The answer to this question is simple. The frame rate works perfectly well on newer processors. In fact, you can hardly tell the lag. Who would you expect to check out the *isoBoard* application? What is your target audience? Probably pretty tech-savvy users with decent machines.

The scrolling mechanism used in this application is based on a single method called *tweenTo()*. The screen is scrolled using this method. It is natural for the Flash Player to complain as it tries to scroll a 2400-pixel-wide vector element with a fair amount of lines at a frame rate of 31 fps! The best solution (if you feel wary about the scrolling mechanism affecting performance) would be to change the scrolling mechanism by making each of the movies scroll individually.

 **NOTE:** *Lower the frame rate and change the scrolling mechanism.*

## Preloading

As you may have noticed already, there is no preloader for this movie. Why? Because the final sizes of all movies combined is about 12 K. That is pretty impressive for an application that does so much. Nevertheless, it is usually a good idea to preload ActionScript frames. Although this is not a pressing concern, it is definitely one to think about.

 **NOTE:** *Add a simple preloader to the first frame of the main movie.*

## Logic

There are a few bugs that arise from the logic used in the program, and simply because of the way Flash works. For instance, when you click on

a user name to view a message, the application starts playing the message. During this process, if you were to click on another user name you would receive feedback asking you to wait until the message was done animating. This logic is based on the animation functions checking a Boolean called *animating*. When a message begins to play, *animating* is set to *true*. If you were to click on another user button, its handler would revert to the *else* loop, as shown in the following code.

```
if (animating == false) {
 loadUser (userid);
} else {
 error("Animation in progress. Please Wait!");
}
```

However, the moment the last cube has been passed to the *displayCubeMessage()* function, the value of *animating* is set to *false*. Therefore, for a brief period, even while the last cube is still dropping to the ground, the user could click on another user name and completely spoil the initialization process for the cubes. How serious is this bug? That is for you to judge.

Aside from this, you might find a few other bugs, such as time lag when you try to swap menus while a message is being animated. While these bugs may not be serious at all, they do nevertheless need some revision.

 **NOTE:** *Rethink the logic applied to a few scenarios.*

## Future Improvements

The sections that follow discuss ideas for improving this application. It would be instructive to try your hand at implementing these.

Figure 12-10. An isoBoard *with stackable cubes.*

### *Stackable Cubes*

An implementation of this exists (see figure 12-10). It was too advanced for this book because it uses a depth-sorting algorithm and adds a great amount of overhead to the application. In fact, the version developed with stackable cubes was developed for a PDA (which is what this chapter was meant to deal with initially). However, we realize that the Flash plug-in for embedded

devices at the time of writing of this book was still at version 4. The stackable cube version was designed using the Flash 5 plug-in, which is already available for devices such as Casio Cassiopeia.

### Colors, Sounds, and Shapes

Another aspect that could be easily implemented into the *isoBoard* is a greater amount of interactivity via the use of colors, sounds, and shapes. Cubes could very well be other shapes, and could have sounds. You could make a small palette of web colors to allow your users to colorize the cubes. You could also easily add a few fields to the *Cubes* table to incorporate these features into the database.

There are many other possibilities for improvement of the application. We definitely hope to see your own versions of the *isoBoard* soon. Hopefully you have learned a lot from this application. We decided to leave the bugs as they were so that a few very important considerations could be made clear to you regarding the design process.

# Summary

You have come a long way since Chapter 1. We hope that this chapter generally reflects the content of the other chapters in this book, as well as the philosophy we advance: form must follow function. Although the *isoBoard* leaves a lot to be desired, you now have the power and the knowledge to fulfill these desires. Between this application and the Digital Color Converter example discussed in the previous chapter, you have a wealth of information and code to work with. Good luck on your quest of becoming a better and more complete Flash developer!

appendix

# Flash MX Event Model

Flash 5 supported only the primary event actions *on()* and *onClipEvent()*. However, the days of two basic event actions are over. With Flash MX, Macromedia surprised the Flash community with a pleasant and much requested event model that changes a lot for the serious developer. Flash MX supports event handling not only in the form of actions, but in the form of methods attached to frames as well as objects. Code can now be concentrated in the first frame of the main timeline to handle events for the frame itself, as well as objects on stage. These new elements are typically called event methods or method functions. Flash 5 supported the following event handlers.

- Mouse clicks
- Keyboard clicks
- Movie clip interation (loading and unloading)
- Client/server interaction (via movie clips)

Flash MX supports all of these, as well as the following.

- Selection events
- Tab-order events
- Data events
- Text field events

What does this mean for you? It means that you not only have a wider array of events to play with but a better implementation model. You can control all events from a single frame, making it easy to find and debug code. In addition, things that required complicated coding in Flash 5 are now much easier in Flash MX.

# ▪▪▪ Event Actions

To understand how event handling has changed in Flash MX, it is important to understand how it was handled in Flash 5. The following sections review event actions pertaining to Flash 5.

## on()

The *on()* event handler primarily handled button events in Flash 5. For instance, if you wanted to handle a button release, you would attach the code in code example A-1 to the button.

---

### Code Example A-1: Script for Handling a Button Click Event

```
on (release) {
 _root.myBall._alpha -= 10;
}
```

---

This code attached to a button instance would change the alpha of the object *myBall* (more than likely a movie clip instance) to its current value minus 10.

## onClipEvent()

The *onClipEvent()* event handler primarily handled movie events in Flash 5. For instance, if you wanted to perform some actions every time the playhead entered a frame, you could attach the code in code example A-2 to a movie clip.

---

### Code Example A-2: Script for Handling a Movie Clip Repeatedly Entering a Frame

```
onClipEvent (enterFrame) {
 this._y += 1;
}
```

---

This code attached to a movie clip instance would move it 1 pixel in the positive *y* direction every time the playhead entered the frame.

# ▪▪▪ Event Methods

The new technique of event handling in Flash MX is aptly called an event method (also sometimes called a method function). Event methods do exactly what their title suggests: implement methods that handle events.

The most useful aspect of event methods is the way they are assigned to frames or objects. In Flash MX, movie clips not only have their own set of event methods but employ event methods for buttons. In essence, movie clips can really behave like buttons without the creator having to nest a button instance within a movie clip to trigger a click event for that movie clip. Code example A-3 shows the event method equivalents for the examples from the previous section.

### Code Example A-3: Event Method for Handling a Button Click Event

```
myBallButton.onRelease = function() {
 _root.myBall._alpha -= 10;
};
```

This code may be placed in frame 1 of the main timeline. It decreases the alpha of the *myBall* instance by 10 when the mouse is released over the *myBallButton* button instance. Code example A-4 shows the event method for handling a movie clip repeatedly entering a frame.

### Code Example A-4: Event Method for Handling a Movie Clip Repeatedly Entering a Frame

```
myBall.onEnterFrame = function() {
 this._y += 1;
};
```

This code may be placed in frame 1 of the main timeline. It would move the *myBall* instance 1 pixel in the positive *y* direction every time the playhead entered the first frame.

 **NOTE:** *Both of the previous two code examples have a semicolon (;) after the curly bracket that closes the function. This is the correct syntax for writing such a method, because this code is actually one long statement that could be written as a single line.*

Another detail of importance is the fact that a function is assigned to the event method. This is very logical if you think about it. Like most methods, event methods do not do anything by themselves. Methods do something meaningful when they are associated with some function. It follows that to use an event method, you need to assign a defined function to it.

Another great feature about the new event model is the fact that event methods and event actions may work hand in hand. For instance, if your *myBall* object has an *on(release)* action attached to it that scales it, and an associated *onEnterFrame* event method in the main timeline that moves it to a random position each time the playhead enters the first frame, the *myBall* movie clip instance will move around randomly on stage and also respond to mouse clicks that will scale it. Table A-1 provides a listing of the supported movie clip event methods in Flash MX and their event action equivalents. Table A-2 lists the supported button event methods and their event action equivalents.

*Table A-1: Movie Clip Event Actions and Equivalent Event Methods*

Event	Event Method
onClipEvent	
onLoad	onClipEvent (load)
onUnload	onClipEvent (unload)
onEnterFrame	onClipEvent (enterFrame)
onMouseDown	onClipEvent (mouseDown)
onMouseUp	onClipEvent (mouseUp)
onMouseMove	onClipEvent (mouseMove)
onKeyDown	onClipEvent (keyDown)
onKeyUp	onClipEvent (keyUp)
onData	onClipEvent (data)

*Table A-2: Button Event Actions and Equivalent Event Methods*

Event	Event Method
on (press)	onPress
on (release)	onRelease
on (releaseOutside)	onReleaseOutside
on (rollOver)	onRollOver
on (rollOut)	onRollOut
on (dragOver)	onDragOver
on (dragOut)	onDragOut
on (keyPress "__")	onKeyDown, onKeyUp

Again, movie clips can have button event methods associated with them, giving you the power of buttons in movie clips. Furthermore, movie clips may have button and movie clip event methods associated with them. This feature single-handedly facilitates the development of very complex and elegant event handlers with a great level of ease.

# ▪ ▪ ▪ Using the Keyword *this* in Event Methods

Although an event method may contain any code in its body, you often need to reference the object that called the method itself. For instance, if you wanted to perform an action on the *myBall* movie clip by calling its own *OnEvent* event method, instead of tracing an absolute or relative path to the movie clip, it would be wiser to use the *this* keyword to reference it.

At this point, it is important to understand the distinction between invoking the *this* keyword in a movie clip and a button. When the *this* keyword is invoked in an event method of a movie clip or a button movie clip (a movie clip with button event methods associated with it), it points to that particular instance of the movie clip. Examine code example A-5.

---

### Code Example A-5: onEnterFrame *Event Method for a Movie Clip*

```
myBall.onEnterFrame = function() {
 this._y += 1;
};
```

---

This code invokes the *this* keyword in the *onEnterFrame* event method. The *this* keyword in this case points to the *myBall* movie clip instance. What if you need to nest a button instance in a movie clip instance? Let's say a movie clip instance called *myBall* has a button called *myBallButton* nested in its timeline. Code example A-6 shows the code for an event method for the *myBallButton* button instance attached to the first frame of the *myBall* movie clip timeline.

---

### Code Example A-6: onPress *Event Method for a* myBallButton *Nested in the* myBall *Movie Clip Instance*

```
myBallButton.onPress = function() {
 this._y += 1;
};
```

---

What would this do? Ironically, in Flash MX, this actually does what it is supposed to do. That is, every time the *myBallButton* button is pressed, it moves the button itself 1 pixel in the positive *y* direction. This is very different from what would happen if you got rid of the event method for the *myBallButton* instance and attached the code *this._y + = 1;* to an *on (press)* event directly to the *myBallButton* instance (see code example A-7).

---

### Code Example A-7: on (press) *Event Action for a* myBallButton *Nested in the* myBall *Movie Clip Instance*

```
on (press) {
 this._y += 1;
}
```

---

This code still does the same thing in Flash MX as it did in Flash 5. That is, it moves the parent container of the button (the movie clip). Each time you click the button with the following event action attached to it, it will move the *myBall* movie clip 1 pixel in the positive *y* direction.

Unfortunately, this inconsistency has not been fixed by Macromedia. They address it in the following article available at their application development center web page at *www.macromedia.com/support/flash/action_scripts/event_methods/*.

# Assigning an Event Method to an Inherited Prototype Chain

It is possible (in fact, it is encouraged) to assign an event method to an inherited prototype chain. You can easily include event methods within classes and assign them to the prototype object of the respective class. What is the benefit of doing this? You end up creating one master event method for each event associated with your custom class. This saves tremendous memory in applications for which you need to instantiate numerous objects. This is because each instance simply references the event method associated with its prototype object for handling an event, instead of making copies of the same method for itself. Figure A-1 illustrates this concept.

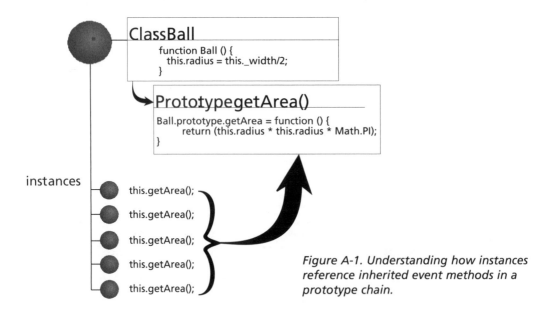

Figure A-1. Understanding how instances reference inherited event methods in a prototype chain.

Code example A-8 shows the code associated with the Ball class. Let's examine this code more closely.

---

***Code Example A-8: Ball Class with Prototype Event Methods***

```
#initclip
//Ball Class
function Ball () {
 this.radius = this._width/2;
}

//Inherit MovieClip Class
Ball.prototype = new MovieClip();

//Inherited event method to calculate area
Ball.prototype.getArea = function () {
 return (this.radius * this.radius * Math.PI);
}

//Inherited event method to update text field on
//stage
Ball.prototype.onPress = function () {
 _root.output = Math.round(this.getArea());
}

//Register the Ball class
Object.registerClass ("ball", Ball);
#endinitclip
```

---

This code declares a class no different than those used throughout the book. First, the constructor function sets the radius of the *Ball* instance based on its width. Then, the *Ball* prototype object is used to inherit the Movie Clip class methods and properties into the Ball class. Immediately following, two inherited event methods have been defined. The *getArea* event method calculates the area of the particular instance and returns it. The default *onPress* event method updates the text field on the main time-line with the area of this *Ball* instance. In conclusion, the Ball class is registered with ActionScript.

**CD-ROM NOTE:** *To see the related example file, open the file app_01.fla located in the fmxas/appendix_a/ folder, installed from the companion CD-ROM. Examine the class encapsulated in the ball movie clip.*

It is very important to understand what happens in the background when you click on a *Ball* instance. When a *Ball* instance is clicked, it looks at the prototype object and sees the *onPress* event method associated with it and performs the actions within the *onPress* event method function. This is true of all *Ball* instances. If you make a hundred instances of the *Ball* object, each instance will utilize the prototype object to calculate its area as well as handle the *onPress* event. This demonstrates the power of inheritance. Imagine what would happen without inheritance. You would create a hundred instances of identical *getArea* and *onPress* event methods. What a waste of resources and memory!

Flash MX marks a turning point in the history of ActionScript due to the numerous changes made in the way it handles a variety of processes. The new event model in Flash MX is one of the key changes that will facilitate the creation of a new breed of intelligent applications and web sites. Only the button and movie clip event methods were covered in this appendix because Macromedia has documented event method implementation for tab-order events, text field events, and data events quite well in the ActionScript dictionary.

# appendix

B

# Key Code Values

Tables B-1 through B-4 outline key code values for alphanumeric, numeric keypad, function, and other keys associated with Flash.

## Alphanumeric Keys

Table B-1 outlines alphanumeric key code values for Flash.

*Table B-1: Flash Alphanumeric Key Code Values*

Letter/ Number	Key Code	Letter/ Number	Key Code	Letter/ Number	Key Code
A	65	M	77	Y	89
B	66	N	78	Z	90
C	67	O	79	0	48
D	68	P	80	1	49
E	69	Q	81	2	50
F	70	R	82	3	51
G	71	S	83	4	52
H	72	T	84	5	53
I	73	U	85	6	54
J	74	V	86	7	55
K	75	W	87	8	56
L	76	X	88	9	57

# Numeric Keypad Keys

Table B-2 outlines numeric keypad key code values for Flash.

*Table B-2: Flash Numeric Keypad Key Code Values*

Numeric Keypad Key	Key Code	Numeric Keypad Key	Key Code
0	96	8	104
1	97	9	105
2	98	Multiply	106
3	99	Add	107
4	100	Enter	108
5	101	Subtract	109
6	102	Decimal	110
7	103	Divide	111

# Function Keys

Table B-3 outlines function key code values for Flash.

# Other Keyboard Keys

Table B-4 outlines other keyboard key code values for Flash.

*Table B-3: Function Key Code Values*

Function Key	Key Code
F1	112
F2	113
F3	114
F4	115
F5	116
F6	117
F7	118
F8	119
F9	120
F10	121
F11	122
F12	123

*Table B-4: Other Flash Keyboard Key Code Values*

Key	Key Code	Key	Key Code
Backspace	8	Right Arrow	39
Tab	9	Down Arrow	40
Clear	12	Insert	45
Enter	13	Delete	46
Shift	16	Help	47
Control	17	Num Lock	144
Alt	18	; or :	186
Caps Lock	20	= or +	187
Esc	27	- or _	189
Space Bar	32	/ or ?	191
Page Up	33	` or ~	192
Page Down	34	[ or {	219
End	35	\ or l	220
Home	36	] or }	221
Left Arrow	37	" or '	222
Up Arrow	38		

appendix

**C**

# ASCII Code Values

The following tables outline ASCII code values used in Flash. Table C-1 outlines the standard ASCII code values for characters and their results when used in the *.fromCharCode()* method of the String object. Table C-2 outlines the ASCII code values for nonstandard characters and their results on the Macintosh and PC. Squares (□) denote characters that have no representation.

*Table C-1: ASCII Code Values Used with String Object .fromCharCode() Method*

Key	Standard ASCII Code	*fromCharCode()*	Key	Standard ASCII Code	*fromCharCode()*
EMPTY or NULL	0		Ctrl-R	18	□
Ctrl-A	1	□	Ctrl-S	19	□
Ctrl-B	2	□	Ctrl-T	20	□
Ctrl-C	3	□	Ctrl-U	21	□
Enter (keypad)	3	□	Ctrl-V	22	□
Ctrl-D	4	□	Ctrl-W	23	□
Ctrl-E	5	□	Ctrl-X	24	□
Ctrl-F	6	□	Ctrl-Y	25	□
Ctrl-G	7	□	Ctrl-Z	26	□
Ctrl-H	8	□	Escape	27	□
Delete (Backspace)	8	□	Left Arrow	28	□
Ctrl-I	9	□	Right Arrow	29	□
Tab	9	Tab	Up Arrow	30	□
Ctrl-J	10	□	Down Arrow	31	□
Line Feed	10	Line Feed	Space	32	Space
Ctrl-K	11	□	!	33	!
Ctrl-L	12	□	"	34	"
Ctrl-M	13	□	#	35	#
Return	13	□	$	36	$
Ctrl-N	14	□	%	37	%
Ctrl-O	15	□	&	38	&
Ctrl-P	16	□	'	39	'
Ctrl-Q	17	□	(	40	(

Key	Standard ASCII Code	.fromCharCode()	Key	Standard ASCII Code	.fromCharCode()
)	41	)	U	85	U
*	42	*	V	86	V
+	43	+	W	87	W
,	44	,	X	88	X
-	45	-	Y	89	Y
.	46	.	Z	90	Z
/	47	/	[	91	[
0	48	0	\	92	\
1	49	1	]	93	]
2	50	2	^	94	^
3	51	3	_	95	_
4	52	4	`	96	`
5	53	5	a	97	a
6	54	6	b	98	b
7	55	7	c	99	c
8	56	8	d	100	d
9	57	9	e	101	e
:	58	:	f	102	f
;	59	;	g	103	g
<	60	<	h	104	h
=	61	=	i	105	i
>	62	>	j	106	j
?	63	?	k	107	k
@	64	@	l	108	l
A	65	A	m	109	m
B	66	B	n	110	n
C	67	C	o	111	o
D	68	D	p	112	p
E	69	E	q	113	q
F	70	F	r	114	r
G	71	G	s	115	s
H	72	H	t	116	t
I	73	I	u	117	u
J	74	J	v	118	v
K	75	K	w	119	w
L	76	L	x	120	x
M	77	M	y	121	y
N	78	N	z	122	z
O	79	O	{	123	{
P	80	P	\|	124	\|
Q	81	Q	}	125	}
R	82	R	~	126	~
S	83	S	Del (keypad)	127	
T	84	T			

*Table C-2: ASCII Nonstandard Character Code Values and PC/Mac .fromCharCode() Method Results*

ASCII Code	Windows .fromCharCode()	Macintosh .fromCharCode()	ASCII Code	Windows .fromCharCode()	Macintosh .fromCharCode()
128	€	□	165	¥	¥
129	□	□	166	¦	□
130	‚	□	167	§	§
131	ƒ	ƒ	168	¨	¨
132	„	□	169	©	©
133	…	…	170	ª	ª
134	†	†	171	«	«
135	‡	□	172	¬	¬
136	ˆ	□	173	-	-
137	‰	□	174	®	®
138	Š	∫	175	¯	√
139	‹	□	176	°	°
140	Œ	Œ	177	±	±
141	□	≠	178	²	□
142	Ž	≥	179	³	□
143	□	≤	180	´	´
144	□	∞	181	µ	µ
145	'	'	182	¶	¶
146	'	'	183	·	□
147	"	"	184	¸	□
148	"	"	185	¹	□
149	•	•	186	º	º
150	–	□	187	»	»
151	—	—	188	¼	≈
152	˜	□	189	½	□
153	™	™	190	¾	□
154	š	□	191	¿	¿
155	›	□	192	À	À
156	œ	œ	193	Á	□
157	□	□	194	Â	□
158	ž	□	195	Ã	Ã
159	Ÿ	Mac Rabbit	196	Ä	Ä
160	Space	Space	197	Å	Å
161	¡	¡	198	Æ	Æ
162	¢	¢	199	Ç	Ç
163	£	£	200	È	□
164	¤	□	201	É	É

ASCII Code	Windows .fromCharCode()	Macintosh .fromCharCode()	ASCII Code	Windows .fromCharCode()	Macintosh .fromCharCode()
202	Ê	□	229	å	å
203	Ë	□	230	æ	æ
204	Ì	□	231	ç	ç
205	Í	□	232	è	è
206	Î	□	233	é	é
207	Ï	□	234	ê	ê
208	Đ	Δ	235	ë	ë
209	Ñ	Ñ	236	ì	ì
210	Ò	□	237	í	í
211	Ó	□	238	î	î
212	Ô	□	239	ï	ï
213	Õ	Õ	240	ð	ð
214	Ö	Ö	241	ñ	ñ
215	×	◊	242	ò	ò
216	Ø	Ø	243	ó	ó
217	Ù	□	244	ô	ô
218	Ú	□	245	õ	õ
219	Û	□	246	ö	ö
220	Ü	Ü	247	÷	÷
221	Ý	Σ	248	ø	ø
222	Þ	Π	249	ù	ù
223	ß	ß	250	ú	ú
224	à	à	251	û	û
225	á	á	252	ü	ü
226	â	â	253	ý	Ω
227	ã	ã	254	þ	π
228	ä	ä	255	ÿ	ÿ

# About the Companion CD-ROM

The companion CD-ROM at the back of the book contains numerous instructional examples used throughout the text, as well as the demonstration versions of Macromedia Flash MX. The *fmxas* folder contains the example files used in conjunction with chapters. The following is a directory structure of the example files contained on the companion CD-ROM.

fmxas/
chapter01/

    ch01_01.fla  Communication among elements (absolute paths)

    ch01_02.fla  Communication among elements (relative paths)

    ch01_03a.fla  Accessing variables in the hierarchy (absolute paths)

    ch01_3b.fla  Accessing variables in the hierarchy (relative paths)

chapter02/

    ch02_01.fla  Classes, objects, and instances

    ch02_02.fla  Superclasses, subclasses, and inheritance

    ch02_03.fla  Encapsulating classes in movie clips (starter file)

    ch02_03s.fla  Encapsulating classes in movie clips (solution file)

    ch02_04.fla  Using *addProperty()* to call methods as properties

chapter03/

    ch03_01.fla  Populating arrays using linear insertion

    ch03_02.fla  Populating arrays using random insertion

    ch03_03.fla  Populating arrays using linear insertion recursively

    ch03_04.fla  Populating arrays using random insertion recursively

ch03_05.fla  Populating arrays with a single recursive function

ch03_06.fla  Using the *pop()* and *push()* methods

ch03_07.fla  Using the *shift()* and *unshift()* methods

ch03_08.fla  Using the *splice()* method

ch03_09.fla  Sample order functions and sorting

ch03_10.fla  Card Deck example using arrays – Showing the face

ch03_11.fla  Populating arrays using linear insertion

ch03_12.fla  Applied array manipulation

ch03_13.fla  Keeping track of objects with arrays

ch03_14.fla  Arrays and OOP

ch03_05.fla  Creating an array from a string

chapter04/

ch04_01.fla  Digital Color Converter 1.0 (Color models)

ch04_02.fla  Web-safe Color Cube 1.0 (Web-safe model)

ch04_03.fla  Building a rudimentary color palette

ch04_04.fla  Building a rudimentary color palette recursively

ch04_05.fla  Generating 228 colors

ch04_06.fla  Using a mathematical algorithm to place chips

ch04_07.fla  Using a mathematical algorithm to place chips recursively

ch04_08.fla  Swatch sorting algorithms

ch04_09.fla  Swatch sorting and placement algorithm

ch04_10.fla  Swatch sorting and placement algorithm using recursion

ch04_11.fla  Using the *setTransform()* and *getTransform()* methods

ch04_12.fla  Making a hexadecimal converter

ch04_13.fla  Making a hexadecimal converter using recursion

ch04_14.fla  Working with the HLS color model

ch04_15.fla  The Color Cruncher – All color algorithms

chapter05/

ch05_01.fla  Simple word search

ch05_02.fla  Multiple word search

ch05_03.fla  A find-and-replace function

ch05_04.fla  Changing a string to proper case

ch05_05.fla  Changing a string to proper case recursively

ch05_06.fla  Reversing a string

chapter08/

ch08_01/ Using the *LoadVars()* and *onData()* methods

ch08_02/ Using the *LoadVars()* and *onLoad()* methods

ch08_03/ Using the *send()* method

ch08_04/ Using the *sendAndLoad()* method

ch08_05/ Using the *getBytesLoaded()* and *getBytesTotal()* methods

authentication/ Creating an authentication system

logbook/ A simple log book

chapter09/

ch09_01.xml A basic XML document

ch09_02.xml An XML document with attributes

ch09_03.xml Escaping reserved characters

ch09_04.xml Escaping reserved characters using *CDATA*

ch09_05.fla Using the *attributes* property

ch09_06.fla Using the *childNodes* property

address book/ Creating an XML-based address book application

chapter10/

ch10_01.fla Flash coordinates

ch10_02.fla Flash rotation angles

ch10_03.fla Inverse trigonometric functions

ch10_04.fla Simple frame counter

ch10_05.fla Tank example

ch10_06.fla Programmatic tweening function

chapter11/

converter.fla The Digital Color Converter

chapter12/

isoboard/ The isoBoard application files

# Glossary

**< A >** An HTML tag for creating links to other pages or resources; an anchor tag.

**acetate** Clear plastic film typically used to create traditional cel animation; used as an analogy for how layers work in a graphics program.

**achromatic colors** Include hues that have no true color, such as black, white, and gray.

**ACT** The extension assigned to save Photoshop color palettes.

**action** Feature of Flash that allows you to assign functionality to elements in a movie.

**ActionScript** Flash's internal scripting language, which is modeled after the ECMAScript technical specification (see *www.ecma.ch*).

**Active Server Pages (ASP)** A server-side scripting language used in conjunction with Microsoft's HTTP server software, MIIS.

**ActiveX** Microsoft's approach to plug-ins, in which components are installed at the system level and accessible by all applications.

**adaptive differential pulse code modulation (ADPCM)** Compression algorithm commonly used in the WAV file format; a lossy sound compression format.

**additive colors** Color system used to create projected or displayed images via a cathode ray tube.

**additive primaries** Red, green, and blue.

**address field** The portion of a browser into which a universal resource locator (URL) can be typed.

**Adobe** A company well known for its raster and vector graphics applications (*http://www.adobe.com*).

**affordances** The controls in an interface that clue the user in as to functionality.

**Afterburner** Original name for the filter used to convert image and multimedia files created in Macromedia products to a form that is distributable over the Web. Most newer applications can convert data within the program and do not need the external converter.

**AI** The extension for an Adobe Illustrator file.

**algorithm** A mathematical or logical schemata for solving a problem.

**aliasing** Characteristic stair-stepped nature of vector lines on a display screen or in an extracted bitmap; caused by the physical limits of the output device as it relates to resolution.

**alignment** The positioning of text bodies in relationship to other screen elements.

**alpha** Controls the transparency (opaqueness) of a symbol in Flash.

**alpha channels** A special part of high-resolution files that can contain masking, gamma, or other information.

**alphanumeric character** A character (letter or number).

**ambient light** The amount of light present without any other light sources; representative of sunlight or moonlight; atmospheric light.

**analog data** Data consisting of a range of frequency variations; what the human senses are able to perceive.

**analog degradation** The decay of analog information as a result of copying an analog source to another analog device.

**analog source** A device, such as a VCR or a cassette tape, used to record or play back analog data.

**analog to digital conversion (ADC)** The process of converting analog data to digital

data; often performed by a hardware chip or software.

**animation** The phenomenon of quickly changing images, which give the perception of movement or change over time.

**animator** The portion of a 3D animation package that allows the operator to define changes over time.

**anti-alias halo** Discolored pixels that occur around the edges of an object as a result of previous anti-aliasing.

**anti-aliasing** The process of blurring the edges of an image or object to make it appear smoother.

**Apple** Manufacturers of the Macintosh computer (*www.apple.com*).

**applet** A small, self-contained executable application created in the Java language.

**application development** The process of creating software designed to perform a task.

**application state** The different conditions that may exist in an application. For example, one state may be where the computer presents a form and waits for the user to enter in data. Another state may be when the user has entered data and the computer outputs what they entered before passing the data to another source.

**arguments** Sometimes called parameters, they are optional bits of information you send to methods and functions. Usually, a method or a function will use the data sent to it in some way, and may return a value.

**array** A special type of variable that can contain multiple values.

**ASCII text** A standard and universal computer text format.

**associative array** An array that stores name and value pairs in addition to order.

**ASP** See *active server pages*.

**asymmetrical balance** Describes a layout in which there is an unequal amount of visual elements on each side of a page.

**attribute-based color** Color creation that is based on the visual characteristics of color; namely, hue, saturation, and lightness.

**AU** See *Sun Audio*.

**Audio Interchange File Format (AIFF)** A digital audio file format predominantly used on Macintosh and Silicon Graphics machines.

**Authorware** An interaction-based authoring program created by Macromedia (*www. macromedia. com*).

**Autodesk FLI and FLC** A digital animation format that uses frame differencing to write the frames in the animation.

**avant garde** Generally viewed as a paradigm shift or something that is out of the ordinary.

**AVI** See *Video for Windows*.

**balance** The equal or unequal amount of visual elements on a page; described as either symmetrical or asymmetrical.

**banding** The visual stripes that can appear in 256-color images as a result of interpolation.

**bandwidth** The amount of data that can be pushed over a network connection; measured in kilobits or megabits per second.

**bandwidth profiler** Feature available when testing a movie in Flash that allows the developer to simulate performance of a movie by limiting the data delivery rate.

**Bezier curves** Special spline curves that have control points that can be moved, thus changing the shape of the curve.

**binary compression (BIN)** A standard Internet external compression scheme.

**binary data** Data described using series of 0s and 1s; digital data.

**binary variable** A variable that can contain one only of two values: 0 (false) or 1 (true).

**bit depth** Determines the number of physical bits that can be used to represent a sample from an analog source.

**bit rate** The size of the chunks of data that are compressed in an MP3 sound clip.

**bitmap** A graphic in which the smallest element is the pixel (picture element).

**bitmap editor** An application designed to edit bitmap images.

**bitmap fonts** Fonts described using bitmap images.

**bitmap graphics** See *bitmap.*

**Bitwise operators** Operators that treat their operands (the values on either side of the operator) as bits (binary data) as opposed to decimal numbers.

**blending** Merging two or more items to obtain steps between the items.

**BMP** See *Windows bitmap.*

**bookmark** A browser convention that allows the user to copy URL locations that can be used at a later time to instantly access a web site.

**Boolean** A binary data type, meaning that it is either 0 (false) or 1 (true).

**Boolean operations** Logical operations that are used to create unique objects from a set of lower objects. The three primary operations are union, subtraction, and intersection.

**browser** A special application designed to view HTML pages from the WWW.

**bump mapping** A special feature of 3D animation programs that allows the user to specify textures through the use of other bitmaps. Depths are generated from grayscale values and applied to an object or surface.

**button symbol** A symbol that automatically behaves like a push-button control.

**byte** A series of 8 bits.

**cache** A special location on the hard drive at which a browser can temporarily store files for future use.

**Cameras** A special view created in 3D animation programs for rendering a 3D scene; a perspective view.

**cascading style sheets (CSS)** A client-side web technology that provides templates that can be used for a series of web pages; also provides layering and positioning capability.

**cathode ray tube** A tube that allows images to be projected from special guns to create colored images.

**cel** A single frame from an animation; derived from celluloid, a substance on which animation frames were first created.

**cel animation** Traditional method of creating animations in which each frame was hand drawn and painted on a celluloid or acetate substance.

**channels** Special saved selections (raster editor); a track of music in an audio program (mono versus stereo).

**chroma keying** A special compositing feature that allows one clip to substitute for a special color in the second clip.

**classes** Templates used to make objects that exist in an application.

**clip art** Pre-generated and generally public-domain graphics that can be used in derivative works.

**clipping paths** Objects used to clip or limit the display of other objects; typical in illustration programs.

**CLR** The extension assigned to save Flash color palettes saved out of the Colors dialog box.

**codec** Acronym for "compressor/decompression" generally used to describe the code that performs compression and decompression.

**color** The visual phenomenon that occurs as a result of absorption or projection of visible light.

**color cycling** An animation effect in which colors are substituted in an image, such as cycling from red to blue.

**color look-up table (CLUT)** The color matrix used in 8-bit images. Each color in the CLUT has a number, and each pixel in the image is associated with one number from the CLUT.

**color schemes** Sequences of color know to look visually pleasing when used together in images.

**color shifting** An unappealing visual affect in which colors shift from proper to inappropriate colors. Generally occurs when the computer has to interpolate colors.

**color space** The method of theoretically defining all colors that can be replicated or generated by a specific device.

**color wheel** A circular arrangement of all colors associated with a particular device.

**commands** What can be considered "utility" code words that do something in the environment.

**command line interface** An operating environment in which commands are typed in, one line at a time.

**comment** An action in Flash that permits the developer to add internal documentation to movies; are ignored by the player.

**common gateway interface (CGI)** A server-side technology that provides a bridge for communication between two dissimilar technologies.

**communication** The process of sending a message through a communication channel. The message must be received and interpreted correctly for communication to occur.

**compact disc read-only memory (CD-ROM)** A computer storage medium in which digital data is stored on a plastic-coated silver platter. CD-ROMs can contain from 550 to 650 megabytes.

**comparison operators** Operators used to compare two values, such as greater than or less than.

**compilation** A copyrightable work in which major portions of various works are used together to create a new work, such as combining songs from various artists to create a "Greatest Hits"-type CD-ROM.

**complementary** Colors that occur across the color wheel from one another such as blue and orange, red and green, and purple and yellow. Most color-blindness problems are the result of the inability to distinguish complementary colors.

**component-based color** Color creation that is based on primary hues that are used to create all other colors.

**compositing** The effect of merging media elements into one media element.

**compression** The process of reducing digital file size by either deleting unneeded data or substituting for redundant data.

**compression ratio** A description of a codec's effectiveness; obtained by comparing bits before and after compression.

**concatenate** To join two string elements into a single string element, such as "James" and " Mohler." The resultant would be the string result "James Mohler."

**consistency** Describes reoccurring elements that appear across multiple pages of a web site.

**content** The media elements used to convey a message, including the message being conveyed.

**contrast** A description of the value differences between adjacent items or colors.

**cool colors** Colors that tend to recede in a graphic, such as green, blue, and violet.

**copyright** The method of protecting creative works in the United States.

**CYMK** Describes the colors used in four-color process printing.

**CYMK color model** The conceptual color space used to describe the gamut of colors for printed output.

**data rate** The speed of the delivery of data, usually inside the computer; measured in kilobytes or megabytes per second.

**data type** A term that refers to the type of data inside a variable, property or that is expected as input for a method or function.

**daughter card** An add-on computer interface card that connects to an existing card within the computer, rather than to the computer's main system board.

**Debabelizer** A program used to convert graphic, sound, and digital video files (*www.debabelizer.com/*).

**decibels** A measure of frequency variations that are not necessarily associated with loudness.

**deformation** The act of deforming; something that is malformed.

**device dependent** Descriptive of a media element that has a fixed resolution; designed for output on a specific device.

**device independent** Descriptive of a media element that does not have a fixed resolution; can be adjusted for output on any device.

**device resolution** The number of dots per inch for a specific device.

**digital audio** An audio file that describes a waveform bit by bit as it occurs over time.

**digital audio tape (DAT)** A digital recording and playback device used in the music industry.

**digital data** See *binary data.*

**digital signal processor (DSP)** A special processor found on most sound cards that allows the sound card to process audio functions and commands.

**digital to analog conversion (DAC)** The process of converting digital data to analog data so that it can be interpreted by humans.

**Director** A time-based authoring program created by Macromedia (*www.macromedia. com/*).

**dithering** The process of scattering pixels during interpolation to overcome banding.

**dots per inch (dpi)** A measurement of the number of displayable or printable dots per square inch.

**dot syntax** Basic syntax for writing references to objects, methods and properties, where each hierarchical object in a location chain is separated by a period.

**dub** A slang term for copying a medium, or the product thereof.

**dynamic** Describes animated graphics, as opposed to static or unmoving graphics.

**dynamic HTML** A client-side web technology that provides the ability to include dynamic text and graphics, as well as interactive components.

**easing** Speeding up or slowing down the beginning or ending of an animation.

**edutainment** Software with an educational purpose that is entertaining as well.

**8-bit color** Describes an image that contains up to 256 colors. All colors are described in a matrix called the Color Look-up Table (CLUT).

**electromagnetic spectrum** The range of waveforms that occur in the environment.

**e-mail** Electronic mail; the capability to send text messages and other digital files across the Internet.

**< EMBED >** An HTML tag for including multimedia elements on web pages; causes the browser to use a plug-in.

**embedded programs** Self-contained applications that can be included in a web page.

**EMCA-262** Standard on which Macromedia Flash MX's ActionScript language is based.

**encapsulation** The act of enclosing code so that it is portable.

**Enhanced Metafile Format (EMF)** A metafile format developed by Microsoft; predominantly used in Microsoft products.

**events** Something that occurs during the playback of a movie that can be responded to, such as the click of a button.

**event handlers** Events to which a specific object can respond.

**executable application** A standalone program most often designed to perform a specific task. Requires no other programs for execution.

**Explorer** A web browser created by Microsoft.

**expression** Sequences of operators and operands (variable names, functions, properties, and so on) used to compute numerical or string results.

**Extensible Markup Language (XML)** A web technology that permits the data within a web page to be described to enable better search capabilities; does not refer to formatting.

**external file compression** Compression that occurs independently of any particular type of digital data.

**external link** A link in a web page that leads outside the current site.

**eye flow** The direction in which a user's eyes are drawn or directed across a page.

**farcle** A sharp and intense flash of refracted light, similar to a starburst.

**field** A text element that is editable during playback.

**field of vision** The range or cone of vision.

**file size** The size of a digital file, usually in kilobytes or megabytes.

**File Transfer Protocol (FTP)** An Internet service designed to distribute and retrieve files across the Internet.

**filter** A special add-on program that allows the user to create a special effect or perform some special function.

**FLA** The extension for a native Flash file that can be opened into Flash.

**Flash Player** The standalone program that can be used to play back Flash SWF files.

**FlashScript command (FS Command)** A specific action in Flash that allows two values to be passed to external web technologies such as JavaScript.

**flat shading** Rendering in which the scene or model is represented by wires and flat polygonal colors.

**FLI** See *Autodesk FLI and FLC*.

**FLV Flash** Video format; can be exported from a Flash library that contains an embedded video clip.

**font** See *typefont*.

**four-color process** Color printing technology that uses cyan, yellow, magenta, and black inks to create full-color reproductions.

**fps** Frames per second.

**frame** A single instance in time in an animation; one cel.

**frame number** The total number of frames in a digital animation or video.

**frame rate** Rate of frame flow measured as frames per second (fps).

**FreeHand** A vector-illustration program created by Macromedia (*www.macromedia. com/*).

**frequency** A method of describing a particular sound; measured in hertz.

**frequency variations** The fundamental basis for analog data; consist of waves.

**FrontPage** An HTML generator and site management tool created by Microsoft (*www. microsoft.com/*).

**functions** Sets of reusable code that typically receive a value, do something to that value, and return the result. There are typically two types: built-in and user-defined. Flash provides many built-in functions, most of which are designed to evaluate a type of data or to convert data from one type to another. User-defined functions can also be created using the function constructor.

**FutureSplash** The original name of Flash when owned by FutureWave.

**FutureWave** The original company that initiated the development of FutureSplash, Flash's predecessor.

**general MIDI mode** The specification that states the standard MIDI channel and instrument numbers.

**generation** Used to describe a hierarchy of copies in analog dubbing.

**GET** A method of sending data from one web technology to another. When defined as a GET action, data is sent in the form *Query_String*.

**GIF 89a** A special GIF file that can contain transparency data.

**global variables** Variables that are active and accessible during the entire movie and are defined using the *_global* keyword.

**Gopher** A text- and menu-based Internet search program.

**Gouroud** A rendering technique in which polygonal faces are rendered using surface normals; no shades and shadows.

**graphic (symbol)** Symbols that cannot include button symbols, interactivity, or sound. Graphic symbol instances stop playing when the main timeline stops.

**Graphic Interchange Format (GIF)** A special file format developed by CompuServe that can contain 256-color data as well as transparency information.

**grayscale** The scale of values from black to white.

**group** The ability to temporarily cluster elements so that they may be edited as a single object.

**guide layers** Special layers used as motion paths for symbols in motion tweening.

**handles** Small, square boxes used in vector illustration programs to represent points.

**helper application** An external application used to aid the browser in viewing certain types of files.

**hertz** A measure of waveform cycles per second.

**hexadecimal color** A base 16 mathematical scheme used to define colors.

**hierarchical linking** The ability to link one object to another so that changes to one object also affect the linked object.

**HLS** An acronym for hue, light, and saturation.

**HLS color model** A color model used to describe a gamut of colors by hue, light, and saturation.

**< H1 >** An HTML tag for creating headings of various sizes; importance of heading is denoted by number. 1 is the most important; 6 is the least important.

**horizontal space** The width of the letter M in a font.

**< HR >** An HTML tag for creating horizontal rules.

**hue** A characteristic of color that distinguishes it from other colors; the name of a color such as red, blue, and green.

**human-computer interface** An area of study that focuses on the development of effective interface design.

**hypermedia** Media that includes text, graphics, sound, animation, and video and is not confined to a single source medium.

**hypertext** Text that is nonlinear and nonsequential.

**Hypertext Markup Language (HTML)** The tag language used to describe the content of web pages; a derivative of the SGML language.

**icons** Graphic representations or abstractions.

**inheritance** The ability of an object to accede the methods or properties of a parent object.

**Illustrator** A vector illustration program created by Adobe (*www.adobe.com/*).

**image bit depth** See *bit depth*.

**image maps** Special graphics that can be used in web pages that are divided into regions; each region may be hotlinked to a different site or page.

**image resolution** A description of the number of pixels per inch in an image.

**image size** A description of an image's physical size in pixels.

**< IMG >** An HTML tag for including images within a web page.

**in-betweens** Automatically generated frames that occur in between the key frames in an animation; the key frames define the positions, sizes, orientations or colors effects of the objects.

**indexed** See *8-bit color*.

**inline image** An image inserted into a web page using the < A > tag.

**instances** The individual objects created based on a class; the stage occurrence of a symbol.

**interactive multimedia** Any combination of text, graphics, sound, animation, and video that is controlled by the user and displayed by a computer.

**interface** The point of interaction between a user and a computer.

**interlaced** A file stored so that it may be downloaded and displayed a chunk at a time.

**internal file compression** File compression that occurs as a result of the data in a particular file format.

**interpolate** To derive values based on other values.

**interpreter** A program that executes lines of code a line at a time.

**intersection** A basic Boolean operation in which the overlapping area or volume of two objects becomes residual, with all remaining area (nonshared) deleted.

**intrasite link** A link that jumps you to another page in the current site.

**inverse kinematics** The study of interrelationships among mechanical objects and their movements over time.

**Java** A universal, platform-independent, object-oriented programming language.

**JavaScript** A scripting language that is a simplified derivative of the Java programming language.

**Joint Photographic Experts Group (JPEG)** A graphic image file format that uses lossy compression and can contain image data up to 24-bit.

**kerning** The amount of space between letters or between words.

**keyframe** A frame in an animation in which a key action or change is taking place; defined the primary positions, colors, sizes, or orientations of objects defined within the timeline.

**kilohertz (kHz)** 1000 hertz.

**kinematics** The study of the relationship of movement as it relates to mechanical objects.

**kinesiology** The study of the relationship of movement as it relates to the human body.

**labels** Special markers associated with timeline keyframes that can be jumped to.

**layering** The capability of a graphics application to store objects distinctly and separately.

**leading** The spacing between lines of text.

**length** String or array function that determines the number of characters in a string.

**Lepel ZivWelch compression (LZW)** Lossless compression scheme most often used in the TIFF file format.

**letter spacing** The spacing between letters of a font. See also *kerning*.

**library** Collection of symbols; facility through which the symbols of any file may be accessed and imported into another file.

**license** A permission to use a copyrighted item, typically based on various parameters of use and for which a fee is paid.

**lightness** The amount of white or black in a color (or value, in artist's terms). In scientific terms it is the luminosity of a hue.

**linear** Pertaining to progression or straight movement.

**linear array** An array that is used to store a single characteristic of an object, such as its name, related to the order of something

**local variables** Temporary variables used within the context of user-defined functions, and they are defined using the *var* keyword.

**logical operators** Operators that are used to concatenate (join) two comparison statements.

**lossless** Compression programs in which no data is lost; the uncompressed file creates an exact replica of the original.

**lossy compression** Scheme in which certain amounts of data are sacrificed for higher compression ratios.

**Macintosh PICT** Native Macintosh metafile format that can house both vector and raster information.

**mapped** Pertaining to 8-bit color mapping.

**mask layers** Special layers used to mask out portions of other layers.

**metafile** A file format that can contain multiple types of data.

**metaphor** A likeness, construct, or similarity to some other device that is used in an effort

to more quickly familiarize the audience with an information device.

**methods** The predefined things an object can do (action verbs for the object), typically identified by the parentheses that follow their name, as in *getURL()*.

**modeler** The portion of a 3D animation package that is used to create or import modeling data.

**modifiers** Optional settings for the tools in Flash.

**mono-aural** Describes a single-channel digital audio file.

**monochromatic** An image using only tints and shades of a single hue.

**monospaced fonts** Fonts in which there is no letter spacing variations from character to character.

**morph** The ability to smoothly interpolate between two or more images.

**motion guide** See *guide layers*.

**Motion Picture Experts Group (MPG)** A digital video format commonly found on the Web.

**motion tween** A tween animation based on position, orientation, size, or color changes; only one object can be tweened per layer and the object being tweened must be a symbol, group or unbroken text (an overlay object).

**mouse events** See *events*.

**MOV** See *QuickTime*.

**movie clip (symbol)** A special timeline in a movie that permits any object to be inserted within it. Movie clip symbols continue to play even if the main movie stops.

**MPEG** See *Motion Picture Experts Group*.

**MP3** A compressed audio format for the Web; see also *Motion Picture Experts Group*.

**multidimensional array** An array that allows you store any number of attributes related to a specific object.

**multimedia** Any combination of text, graphics, sound, animation, and video displayed and controlled by the computer.

**Multiple Master** A special type of vector font.

**multiprotocol** Descriptive of the capacity to communicate using various network protocols.

**Multipurpose Internet Mail Extension (MIME)** The method of associating Internet file types with specific extensions with applications that can open them.

**Musical Instrument Device Interface (MIDI)** A method of digitally describing audio using instrument and note descriptions.

**negative space** Describes white space, or areas without visual elements, on a web page.

**nested symbols** Symbols that contain other symbols.

**nonlinear** Nonsequential.

**nontransient information** Information that remains stable or accurate over a period of nine months to a year.

**Non-Uniform Rational B-Splines (NURBS)** A parametric modeling environment in which surface points may be easily edited; allows for very complex organic surfaces and objects.

**null** A keyword representing no data.

**numeral** An actual number on which mathematical operations may be executed.

**numerical operators** Operators that perform mathematical calculations.

**numerical value** A number.

**< OBJECT >** An HTML tag for including multimedia elements on web pages; causes the browser to use ActiveX components.

**objects** A group of functions and properties that adhere to a class.

**object-oriented** Programming A programming methodology in which tasks are approached as objects to which and from which, messages may be sent.

**onion-skinning** A carryover technique from traditional cel animation in which the content of adjacent frames are composited to enable comparisons of motion.

**opacity** Describes the visual solidness of surfaces; transparent is the opposite of opaque.

**operators**  Programming elements that perform calculations (operations) or comparisons on two values to reach a third resultant value.

**origin**  In relation to the 3D coordinate system, the origin is the location 0,0,0.

**overlay object**  A theoretical organization level in Flash that contains groups, symbols, and unbroken text elements.

**overriding**  Changing a property or method within an instance by redefining it for the instance only. Overriding occurs within the instantiation of an instance.

**< P >**  A block-level HTML tag that creates a paragraph of text offset from other elements by a carriage return (line feed).

**palette**  See *color look-up table (CLUT)*.

**palletized**  See *8-bit color*.

**particle systems**  A special function within a 3D animation program that allows the animator to create effects such as rain, snow, and tornadoes.

**path of motion**  The path on which animated objects travel; defined by keyframe positioning and orientation.

**persistence of vision**  The visual phenomenon of the eyes and brain perceiving an image after it has been removed from sight.

**perspective**  A pictorial drawing in which the lines in the scene tend to converge to the horizon.

**phong**  A rendering engine capable of generating smooth surfaces and calculate highlights and shadows based on lights positioned in the environment.

**Photoshop**  A raster editing application created by Adobe (*www.adobe.com/*).

**PICT**  See *Macintosh PICT*.

**pitch**  The relative position of a tone in a scale, as determined by its sound-wave frequency.

**pixels (picture element)**  The smallest element of a bitmap image, computer monitor, or television display.

**pixels per inch (ppi)**  The number of pixels per square inch.

**plug-ins**  Add-on programs that extend the capability of a web browser by allowing it to view a wide range of files, such as animations, digital videos, or multimedia elements.

**point size**  Describes the size of a font in points.

**point**  A unit of measurement for lines and text; 72 points equals 1 inch.

**polygonal mesh**  A surface model that uses polygons, most often triangles, to define the surface of a model.

**polymorphism**  The capability to assume various forms; in programming it is the ability of a method or function to take on various forms in different situations.

**Portable Network Graphics (PNG)**  A nonproprietary graphics format designed to unify the formats used on the Web. Boasts all of the features of both JPEG and GIF in a single format.

**positive space**  The areas of a web page that contain visual elements such as text or graphics.

**POST**  A method of sending data from one web technology to another. POST method is sent as a standard input stream.

**Postscript**  A page description language developed by Adobe that is used by most vector drawing programs.

**pragma**  A standardized form for a comment (usually in some specific syntax) that has special meaning to a compiler or interpreter.

**preloader**  An introductory portion of a movie that plays while the remainder of a movie is streamed to the end user.

**Premiere**  A digital video editing program created by Adobe (*www.adobe.com*).

**primary color**  The main colors of any given color system; all other colors in the system are derived from the primary colors.

**procedural language**  A programming language in which programs are written as procedures the computer is to follow.

**procedural mapping**  A method of adding surface textures to 3D objects through the use of algorithms.

**progressive JPEG**  A special type of JPEG image that allows the browser to begin viewing the image before it is fully downloaded.

**projector**  A standalone Flash movie that is executable and does not require the Flash Player.

**properties**  Attributes of some object.

**property array**  An array in which each name and value pair can be uniquely identified.

**prototype**  A means of accessing a classes methods and properties.

**public domain**  Media elements or works that can be used freely, without a license or release.

**quantization**  The process of averaging color based on subsampled blocks.

**QuickTime (MOV)**  A digital video format, created by Apple, originally designed for use on the Macintosh (*www.apple.com/*).

**radiant light**  A light source in which light is projected in all directions with no decrease in intensity.

**radiosity**  The most photorealistic type of 3D rendering; takes into consideration all light within a scene.

**random**  Numeric function that generates a random number.

**random access memory (RAM)**  The main memory of the computer that is used to temporarily store data.

**raster-based graphics**  See *bitmap*.

**raytracing**  A rendering technique that traces light rays within a scene; does not calculate scattered light rays.

**RCA-type**  A typical cable connector used with digital video and digital audio.

**reflected light**  See *additive colors*.

**reflectivity**  An object property that describes its shininess and how much of the scene is reflected in the surface.

**release**  A permission to use a copyrighted item without payment or fees; often usage has certain limitations.

**remapping**  Pertains to changing the color palette of an image.

**renderer**  The part of the 3D animation program that generates a raster image or animation.

**rendering engine**  Special code that uses the 3D scene to create a flat raster image; includes *wireframe, flat, Gouroud, phong, raytracing,* and *radiosity*.

**resolution**  The photorealism of an image; describes the ratio of image resolution to image size.

**RGB**  Acronym for red, green, blue.

**RGB color**  See *24-bit*.

**RGB color model**  Theoretical color space used to describe the range of colors available on a computer monitor.

**roll**  Relates to rotation about the Z axis.

**run length encoding**  See *Windows bitmap*.

**S-Video**  A video cable connector commonly found on U.S. devices.

**sampling**  The process of converting analog data to digital data.

**sampling rate**  Measure of how frequently samples in a sound clip or image occur.

**sans serif**  Typefaces (fonts) without serifs. See also *serif*.

**saturation**  Describes the purity of a color, or how much of a color is in a hue.

**Scalable Vector Graphics (SVG)**  A web specification being developed by a W3C working group composed of a variety of leading companies, including Microsoft, Adobe, and Macromedia (*www.w3.org/TR/WD-SVG*).

**scan lines**  The horizontal lines of pixels in a computer monitor.

**scenes**  The main timelines within a movie.

**scope**  Refers to the length of time a variable exists in memory or the object to which a variable belongs.

**serif** The stroke projecting from and finishing off the top and/or bottom of a character in some typefaces.

**serif fonts** Fonts displaying the serif characteristic.

**shade** Area of a surface opposite the light source.

**shadows** Areas of a surface blocked from a light source by another feature or object.

**shape hints** Reference points used within shape tweening to control the way one object morphs to another. See also *in-betweens* and *shape tweens*.

**shape tweens** Animations consisting of objects that morph; must be stage-level objects such as lines, arcs, fills, or broken text.

**Shockwave** A plug-in created by Macromedia for viewing multimedia and vector elements on the Web. Shockwave components may be generated from Director, Authorware, or Flash.

**Shockwave Flash (SWF)** The generic movie format used to distribute movies on the Web; requires the Flash Player for playback; can be protected or unprotected.

**simple text** The standard Macintosh ASCII text editor.

**SIT** A compressed file create by Aladdin's Stuffit Deluxe.

**site map** A planning tool for charting the content of a web site.

**size report** An ASCII text file that details the file size requirements of the objects in a movie.

**SND** See *System 7 sound files (SND)*.

**solid model** A model that has theoretical volume and engineering properties.

**Sound Blaster Vocal Files (VOC)** A digital audio format designed by Creative Labs.

**spatial** Relating to 3D coordinate space or spacial relationships.

**spline** A curve with weighted control points.

**spot light** A directed light source.

**sprite** An element or object in a 2D animation program.

**stage** The area of the Flash application that will be viewed by the audience during run-time.

**stage-level object** A theoretical organization level in Flash that contains ungrouped elements, basic objects (such as lines and fills), and broken elements (such as broken text).

**Standard Generalized Markup Language (SGML)** An advanced markup language commonly used to produce electronic versions of large texts such as encyclopedias and dictionaries.

**static** Pertaining to images that do not change or are not animated.

**stereo** A multiple-channel digital audio file.

**stereoscopic field of vision** The area created by the overlapping cone of vision from each eye; field in which depth is perceived.

**stereoscopic vision** The ability to perceive depth.

**storyboard** A thumbnail representation often used for planning an animation, multimedia, or hypermedia product.

**streaming** The process of delivering small chunks of a digital file over the Internet for instant execution.

**string literal** A value entered into an Action field; a variable that is text.

**string operators** Operators used to manipulate text. Flash has only one concatenate.

**string value** See *string literal*.

**structured programming** Quality standards that were established to make computer programs more easily read and maintained; a more verbose and straightforward method of coding.

**Stuffit Expander** A compression program used on the Macintosh platform.

**subsampling** The process of breaking an image into component blocks that are then color averaged.

**substring** String function that extracts a portion of a string variable by defining a string, an index (starting position for extraction), and a count (ending position for extraction).

**subtraction** One of the basic Boolean operations; the volume or area of one object is subtracted from the volume or area of another.

**subtractive colors** Colors produced on a white page by applying hues.

**subtractive primaries** Cyan, yellow, magenta, and black.

**Sun Audio (AU)** Audio format predominantly used on the UNIX operating system.

**surface mapping** The process of applying qualities to 3D objects so that they look realistic.

**surface model** A model consisting of surfaces with no volume characteristics.

**symbol** A special reusable component in Flash that has its own timeline.

**symmetrical balance** Descriptive of a layout in which there is a relative balance of visual elements in the area of a page and/or between facing pages.

**synthesis** The ability to create a waveform (analog data).

**System 7 sound files (SND)** Standard Macintosh system sound format.

**system palette** The color palette or color look-up table associated with a 256-color environment.

**Tagged Image File Format (TIFF)** A raster graphic file format designed to contain high-resolution image data for print purposes.

**target** An object reference in Flash. You target objects so that you can call their methods or access their properties or variables.

**text editor** A program designed to edit plain ASCII text files.

**this** A keyword that refers to the object to which the code it is contained in is attached.

**3D animation** An animation file generated from a 3D model or scene.

**3-D Studio Max** A 3D animation package created by Kinetix (*www.ktx.com*).

**TIFF** See *Tagged Image File Format*.

**tiles** Bitmaps used as repeating segments over the background of a browser; a tiled background.

**timeline** The location in the Flash application where you define the timing and duration of the elements that appear and disappear during movie playback.

**timeline variables** Any variables that are defined without the *var* or *_global* keyword; exist as long as the timeline they belong to is loaded into the player.

**tint** Adding white to any hue.

**transient information** Information that is rapidly changing; generally changes within nine months.

**translation** A basic manipulation of an object; includes *move, rotate,* and *scale.*

**translucent** The ability of light to pass through a surface.

**transparency** The ability to see through an object.

**triad** A color scheme using three colors that are equally spaced from one another on the color wheel.

**trigger** Slang for a button that has only a hit state.

**true color** See *24-bit color.*

**TrueType** A typical type of vector font.

**tweens** See *in-betweens.*

**24-bit color** Describes an image that can contain up to 16.7 million colors.

**2D animation** An animation file created using a package in which every frame's content is defined through either vector or bitmap descriptions.

**Typeface (font)** A unique set of characters that have similar characteristics; examples are Helvetica, Geneva, and Times New Roman.

**typography** The study of type and its various characteristics.

**undefined** A keyword used to represent a variable that has not been assigned a value.

**union** A basic Boolean operation in which overlapping volume or area between two objects is joined, or "welded," to create a single object.

**Universal Resource Locator (URL)** The unique naming address scheme used on the Web.

**value** Pertaining to the lightness or darkness of a color. Adding black to a hue creates a shade; adding white to a hue creates a tint.

**variable** A container for data and is defined by a scope (length of existence) and a data type [such as string (text) or numeral].

**VBScript** A web-based scripting language.

**vector fonts** Fonts described using vector descriptions.

**vector-based graphics** Graphics in which the smaller drawing elements are points, lines, and arcs.

**vector markup language (VML)** An XML-based format for vector graphics, developed by Microsoft (*http://msdn.microsoft.com/standards/vml/*).

**Video for Windows (AVI)** A common digital video format created for use on the Windows platform.

**Virtual Reality Modeling Language (VRML)** A markup language designed to deliver 3D environment descriptions for viewing on the Web.

**visible light** The small portion of the electromagnetic spectrum that humans can perceive.

**VOC** See *Sound Blaster Vocal Files*.

**warm colors** Colors that tend to come toward the viewer; includes colors such as red, yellow, and orange.

**WAV** See *Windows Waveform Files (WAV)*.

**WebCGM** An ISO standard metafile format for the Web that can store raster data, vector data, or both. Currently, no browsers or authoring environments support it (*www.w3.org/TR/REC-WebCGM*).

**weight (of a font)** The thickness of the lines that constitute the characters of a font.

**white space** See *negative space*.

**Windows Bitmap (BMP)** Raster format created by Microsoft for bitmap images.

**Windows Waveform Files (WAV)** The standard Windows digital audio format.

**wireframe model** A model consisting of connecting lines and points but with no surfaces between these elements.

**wireframe rendering** A rendering in which the lines of the object are rendered but no surfaces are rendered.

**WordPad** The Windows 95 and Windows NT ASCII text editor.

**work area** The gray pasteboard area that surrounds the stage in the Flash application.

**XML** See *Extensible Markup Language*.

**yaw** Rotation about the Y axis.

**ZIP** A compressed file created by PKWARE's PKZIP program.

# Index